# Seizing the Light

## A SOCIAL HISTORY OF PHOTOGRAPHY

# Seizing the Light

A SOCIAL HISTORY OF PHOTOGRAPHY

second edition

ROBERT HIRSCH

*Director of Light Research*

Boston   Burr Ridge, IL   Dubuque, IA   Madison, WI   New York   San Francisco   St. Louis
Bangkok   Bogotá   Caracas   Lisbon   London   Madrid
Mexico City   Milan   New Delhi   Seoul   Singapore   Sydney   Taipei   Toronto

## Higher Education

The McGraw·Hill Companies

Published by McGraw-Hill, an imprint of The McGraw-Hill Companies, Inc., 1221 Avenue of the Americas, New York, NY 10020. Copyright © 2009, 2000. All rights reserved. No part of this publication may be reproduced or distributed in any form or by any means, or stored in a database or retrieval system, without the prior written consent of The McGraw-Hill Companies, Inc., including, but not limited to, in any network or other electronic storage or transmission, or broadcast for distance learning.

4 5 6 7 8 9 0 DOW/DOW 10 9 8 7 6 5 4 3 2 1

ISBN:  978-0-07-337921-0
MHID:  0-07-337921-2

Editor in Chief: *Michael Ryan*
Publisher: *Lisa Moore*
Developmental Editor: *Betty Chen*
Editorial Assistants: *Meredith Grant and Rachel Bara*
Marketing Manager: *Pamela S. Cooper*
Senior Production Editor: *Carey Eisner*
Manuscript Editor: *Jennifer Bertman*
Design Manager and Cover Designer: *Margarite Reynolds*
Interior Design Revisions: *Pam Verros*
Lead Photo Research Coordinator: *Alexandra Ambrose*
Photo Researcher: *Robin Sand*
Senior Production Supervisor: *Tandra Jorgensen*
Composition: *10.5/12 Times by Lachina Publishing Services*
Printing: *70# Sterling Ultra Web Dull, R R Donnelley*

Front cover: *Bill Brandt.* Portrait of a Young Girl, *Eaton Place, 1955. Gelatin silver print.*
© *Bill Brandt Archive.*
Back cover: *Julia Margaret Cameron.* Sir John Herschel, *1867. 12 x 9 1/2 inches. Albumen silver print. Courtesy George Eastman House, Gift of Alden Scott Boyer.*

**Library of Congress Cataloging-in-Publication Data**

Hirsch, Robert.
  Seizing the light : a social history of photography / Robert Hirsch. — 2nd ed.
      p. cm.
  Includes bibliographical references and index.
  ISBN-13: 978-0-07-337921-0 (alk. paper)
  ISBN-10: 0-07-337921-2 (alk. paper)
  1. Photography—History.  I. Title.
  TR15.H557 2009
  770.9—dc22

2008042155

**www.mhhe.com**

*To my wife, Adele Henderson, and my mother, Muriel Hirsch, for their support and love; Spin and Kiki for companionship and inspiration; and to photographers, past and present, who have made this project so enlightening.*

**"I have found a way of fixing the images of the camera! I have seized the fleeting light and imprisoned it! I have forced the sun to paint pictures for me!"**

—L. J. M. Daguerre to Charles Chevalier at his Paris optical shop

Daguerre's energized words—the inspiration for our title—reflect the powerful desire to make permanent images through the action of light. These pages convey the fascination surrounding this process we call photography throughout its development over the centuries. *Seizing the Light: A Social History of Photography,* second edition, offers an updated and revised resource for history of photography courses while providing a highly accurate and readable introduction to the photographic arts for the general reader.

I had a number of new goals for this edition. As an educator, I wanted to provide a concise and discerning chronological account of Western photography, rather than an overwhelming encyclopedic world survey. As a curator, I wanted to offer a fundamental starting place to view the diversity of makers, inventors, issues, and applications. As a former director of photographic arts organizations and galleries, I sought to present intriguing images that would inspire people to visit galleries and museums. And as a photographer, I wanted to explore the artistic, critical, and social aspects of the creative process that motivate people to make, look at, and interpret images. The knowledge I gained from researching this project has deepened my understanding of photographic practice; it is my hope that others will find the result to be an accessible starting point for open inquiry and discussion.

*Seizing the Light* reflects how photography is represented within the context of the artistic, cultural, scientific, technological, and utilitarian forces that have shaped Western society. The text examines how photography developed from centuries of Western imagemaking and how photographers have struggled to discover the medium's own visual syntax. The book also examines how capitalism and market forces have shaped photographic practices by standardizing equipment, materials, and procedures, as well as how public applications, desires, expectations, and demands affect our understanding of images. It offers an initial site for thinking about why we have so embraced photography as a medium, and why and how we make, view, and decipher billions and billions of photo-based images every year.

*Seizing the Light* takes the position that it is necessary to know one's own visual history before it is possible to understand works from another culture. Therefore, the second edition provides a coherent, representational view of select people, events, processes, and movements in order to outline a starting pathway that defines the extensive roles and meanings of Western photographic practice. This approach builds a solid, in-depth foundation of how photography interacts and affects our lives; hence the new subtitle: *A Social History of Photography*. In addition, a variety of new topics—from the photobooth to the effects of 9/11 and the Internet—have been given in-depth coverage. Other featured topics, which provide a fuller understanding of how photography can play with the meaning of cultural images, include the body, the landscape, the portrait, time and space concepts, typologies, and urban life.

Technology has always had an effect on how information is shaped, transmitted, and understood; today's digital technology is no exception. This book looks at how digital technology has changed our notions about photographic truth and how it has affected our conception of galleries and museums as image presenters and repositories. This history continues to be written with research assistance from people all over the world through emails, listservs, and Internet sites.

I gratefully acknowledge and seek to represent the canon of photographic history composed of luminary figures such as Julia Margaret Cameron, Alfred Stieglitz, and Edward Weston; however, *Seizing the Light* also aims for thorough coverage of photography since the 1950s. This has been a time of explosive growth in the number of people working within the photo-related arts, and it demands greater study if we are to understand its diversity and richness. Attention is given to contemporary artists who are expanding the practice of photography and bringing their works to a broader audience, as well as to ethnically diverse and female photographers throughout photographic history. In addition, the text moves beyond the canon in focusing on certain overlooked vernacular genres of historic practice such as stereographs and snapshots.

For this edition we are striving to achieve high production values, including full-color reproductions, with large-sized images that pay special attention to maintaining the subtle tonal variations. Readers need to bear in mind that all reproductions are just approximations of the work—viewers should make the effort to see actual pieces in local galleries and museums. We hope the images chosen to represent a particular artist or movement will kindle a passion in our readership to further investigate the abundance of our photographic heritage.

I am particularly grateful to Greg Drake, independent photographic scholar and editor, for his extremely close and sympathetic editing of the manuscript for this edition, which has enhanced its accuracy and readability. Additional research assistance for this edition was provided by Mark Jacobs, independent scholar and collector; Brian Taylor, professor at San Jose State University; Anna Kuehl, Visual Studies Graduate Student at SUNY/Buffalo; Theresa Leininger-Miller, associate professor at the University of Cincinnati; and members of the History of Photography discussion group (PhotoHistory@yahoogroups.com). I am grateful for the comments from the following reviewers: Janet Bonsall, University of Central Missouri; James DeSario, Suffolk County Community College; Mark Dungan, Utah State University; Sylvia Montana, Saddleback College; and Anthony Thompson, Grand Valley State University.

At McGraw-Hill, I wish to thank development editor Betty Chen, production editor Carey Eisner, copyeditor Jennifer Bertman, production supervisor Tandra Jorgensen, marketing manager Pamela Cooper, and editorial

assistant Meredith Grant. Robin Sand, photo researcher, managed a myriad of details to get us the right images.

From the first edition I want to express my continued thanks to the publisher's readers, who provided guidance and feedback at various stages of draft: William Allen, Arkansas State University; Donald R. Anderson, University of Louisville; Thomas Barrow, University of New Mexico; Kathleen Campbell, Appalachian State University; Richard Colburn, University of Northern Iowa; David L. DeVries, California State University, Fullerton; Gregory T. Moore, Kent State University; Tom Patton, University of Missouri; Paul S. Sternberger, Columbia University; Stan Strembicki, Washington University; Brian Taylor, San Jose State University; and Rene West, Tarrant County Junior College.

At the George Eastman House, Rochester, New York, I am grateful to Dr. Anthony Bannon, director; Jim Enyeart, former director; David Soures Wooters, print archivist; Janice Madhu, former assistant archivist; Joseph Struble, assistant archivist; Rachel Stuhlman, librarian; Becky Simmons, former associate librarian; and Barbara Galasso, photographic services supervisor.

At the Visual Studies Workshop, also in Rochester, my thanks go to Bill Johnson, and John Rudy, both former Coordinators of the Research Center.

Special thanks to professor Marie Antonella Pelizzari, Hunter College, New York, NY, and the former members of the History of Photography discussion group (photohst@asu.edu; Richard Pearce-Moses, former owner) who were generous in answering numerous queries.

*Robert Hirsch*
Buffalo, New York

# Contents

## chapter five

# Prevailing Events/
# Picturing Calamity

## chapter six

# A New Medium of
# Communication

## chapter seven

# Standardizing the Practice:
# A Transparent Truth

## chapter eight

# New Ways of Visualizing
# Time and Space

chapter sixteen
# New Frontiers: Expanding Boundaries

chapter seventeen
# Changing Realities: Alternative Visions

chapter eighteen
# Thinking About Photography

# Advancing Toward Photography

*The Birth of Modernity*

## A Desire for Visual Representation

The idea of photography existed long before the invention of the camera. A primary function of visual arts originates in the desire to create a likeness of someone or something that was deemed worth commemorating. This human urge to make pictures that augment the faculty of memory by capturing time is at the conceptual base of photography. Since ancient times, artists and inventors have searched for ways to expedite the picturemaking process, eventually concentrating efforts on how to automatically capture an image directly formed by light.

As early as the fifth century B.C.E., the Chinese philosopher Mo Ti discovered that light reflecting from an illuminated object and passing through a pinhole into a darkened area would form an exact, though inverted, image of that object, offering a prototype of the pinhole (lensless) camera. In the West, the first recorded description of the pinhole was made by the Greek philosopher Aristotle, who around 330 B.C.E., during a partial solar eclipse, observed the crescent-shaped image of the sun projected through a small opening

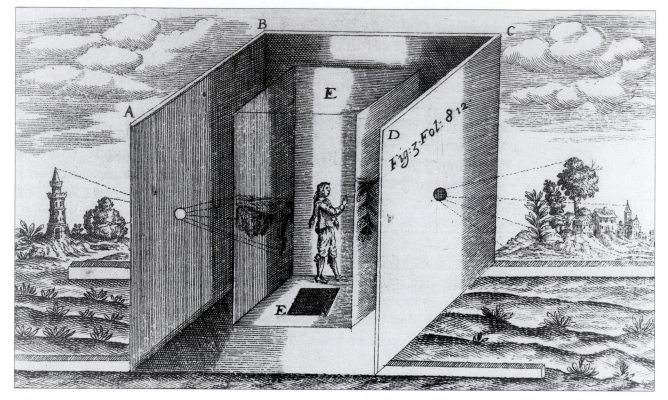

1.1   Athanasius Kircher. *Large Portable Camera Obscura*, 1646.
Engraving.   Harry Ransom Humanities Research Center, The University of
Texas at Austin.

between the leaves of a tree. When these observations were first formalized into a camera remains uncertain, but by the tenth century C.E., the Arabian mathematician Alhazen (Ibn Al-Haitham) demonstrated how a pinhole could be an instrument and that images formed through an aperture became sharper when the opening was made smaller. Although Roger Bacon's treatises, *Perspectiva* and *De multiplicatione specierum* (ca. 1267), do not specially mention the camera, they indicate he used the optical principles to contrive an arrangement of mirrors in order to project images of eclipses as well as street scenes and interior views of his house. In *Perspectiva communis* (1279), John Peckham, the Archbishop of Canterbury and a likely student of Bacon, remarked about observing a solar eclipse through a pinhole in a dark place.

During the Renaissance the evolution of the camera can be linked to a new Western concentration on science. With new discoveries based on experiment and observation, fifteenth-century scientists provided a veritable process that meant people no longer had to accept the authority of the unprovable. Instead, they could look to an open system that was not predicated on belief and magic. Science offered an alternative to blind faith, and the foundation of belief for educated society began shifting toward objective, documentable, repeatable facts. In addition to praying for their invisible souls to be accepted into an unknowable heaven, scientifically minded people also built large ocean-going sailing ships and complex machines to carry their physical bodies out of the Old World and into a new material world.

## Perspective

Perspective drawing allows artists to depict a three-dimensional space on a flat surface. Although a system of perspective was known to the Romans, not until around 1413 did Filippo Brunelleschi of Italy devise the linear perspective we know.[1] In this system objects are foreshortened as they recede into space and lines converge to vanishing points that correspond to the spectator's viewpoint. Leon Battista Alberti's treatise *On Painting* (1435) was dedicated to Brunelleschi and provides descriptions for using geometrical linear perspective in picturemaking. Alberti compared the picture plane to a window:

> Let me tell you what I do when I am painting. First of all, on the surface which I am going to paint I draw a quadrangle of right angles of whichever size I want, which I regard as an open window through which the subject to be painted is seen.[2]

Other artists soon converted Alberti's theoretical window into an actual one by drawing on a vertical piece of glass while looking through an eyepiece

located opposite the center of the pane, establishing the visual convention of constructing a scene through monocular vision: viewing through one eye at one place at one time. This artificial window was subsequently replicated when light was passed through a pinhole onto a vertical plane to form an image in the manner noted by Mo Ti.

Improvements in mapmaking during the fifteenth century reduced three-dimensional space into two-dimensional guides, producing geometrically consistent maps and changes in pictorial description. For the first time, mapmakers began to refrain from looking through opaque surfaces, veering around corners, or adjusting the size and position of a site according to its cultural significance. Such improvements, made possible by scientific thinking, coincided with the advent of printed, illustrated books and meant that identical, mass-produced, visual information reached a wider audience.

## Thinking of Photography

In 1490, Leonardo da Vinci (1452–1519) wrote the earliest surviving description of the *camera obscura* (dark chamber), a device designed to reproduce linear perspective.[3] The camera obscura, the prototype of the photographic camera, was a large dark room that an artist physically entered. Light filtered through a small hole in one of the walls and projected a distinct, but inverted, color image onto the opposite wall that could then be traced. Art historian Kenneth Clark stated that before Leonardo "Alberti invented a device which seems to have been a sort of camera obscura, the images of which he called 'miracles of painting.'"[4] German artist Albrecht Dürer (1471–1528) was one of the first to ingeniously adapt these camera-based principles of perspective and proportion to his drawings.[5] In 1558, Giovanni Battista della Porta published his treatise *Magiae naturalis (Natural Magic)*, describing the camera obscura and how it could make drawing easier:

> The manner in which one can perceive in the dark the things which on the outside are illuminated by the sun, and with their colors . . . will make possible for anyone ignorant of the art of painting to draw with a pencil or pen the image [made by a camera obscura] of any object whatsoever.[6]

In 1589 della Porta discussed the use of a mirror to reverse the image that was reflected backward in the camera obscura; this is the basis of the modern-day single-lens reflex camera. He also told of staging nighttime, torch-light dramas, accompanied by live music, and employing the camera obscura to view them on a screen inside his house, demonstrating that the camera could be used for narrative purposes.

Girolamo Cardano's *De Subtilitate* (1550) mentioned attaching a biconvex lens (a lens curved on both sides so it is thickest in the middle) to a camera obscura,

making its image brighter and sharper. Daniele Barbaro's treatise, *La Practica della perspettiva* (1568), described how fitting a diaphragm to the biconvex lens allowed the amount of light passing through the lens to be controlled, enhancing depth-of-field—the range in front of and behind a focused subject in which detail appears sharp—and forming a sharper image. By 1611, Johannes Kepler had built a proto-portable camera: a human-size tent that could be dismantled and transported to make drawing easier. By the mid-seventeenth century, a scaled-down modification of Kepler's device meant that one did not have to enter into the camera but could remain outside of it and view an image projected onto a translucent window, a forerunner to the first truly portable cameras.

By the end of the seventeenth century, advances in lens making included the correction of aberrations to give better resolution. Also, the ability to vary focal lengths allowed the production of different image sizes based on the specific needs of portrait and landscape artists. Image size is proportional to a lens's *focal length,* the distance from the center of the lens to the point of sharp focus; the longer the focal length, the greater the magnification of the image. Instruction manuals for matching lenses with cameras and situations appeared.

The optics of the camera obscura were simultaneously ideal and natural, reflecting the empirical, scientific, and humanitarian trends of the Enlightenment. Drawing shifted from the private act of a highly trained individual, to a broader commercial enterprise that incorporated ideas of mass production and standardization as seen in rationalistic works such as Denis Diderot's *Encyclopédie* (1751–1777). By the close of the eighteenth century the camera had been tailored along the lines of Renaissance pictorial standards to help fulfill a cultural demand to make drawing easier and quicker.

## Camera Vision

Although they were organized by machines—cameras—early photographs resembled drawings and paintings because they depicted the world according to linear perspective. The camera obscura was popular with artists because it automatically modified a scene by compressing form and emphasizing tonal mass according to pictorial standards. The camera was not designed as a radical device to unleash a new way of seeing, but evolved to produce a predefined look that took into consideration formulas and procedures such as composition, angle and point of view, quality of light, and selection of subject matter. *What* was being represented remained unchanged. This does not diminish the camera's importance in defining an image. As with most inventions, unforeseen side effects create

unintentional changes. As imagemakers became more sophisticated they routinely used specific cameras and lenses to shape an image, and knowledgeable viewers can often trace the connections between the camera/lens and the resulting picture.

Scholars have debated whether the idea of photography grew from a need for new images reflecting a profound cultural transformation, from a fabrication of Western pictorial traditions, from an increasing desire to make pictures of what is personally important, as an offshoot of the discoveries of chemists and opticians, or, perhaps most likely, from some combination of these happenings. A discussion surrounding the rise of *camera vision,* how a camera visually organizes a scene, often focuses on Dutch painter Jan Vermeer (1632–1675). While adroit artists like Vermeer, who most likely used a camera, did not need one to physically produce their pictures, the camera did act as a gathering device of fresh approaches for composing space, observing light, and portraying cultural models in innovative ways.[7] Vermeer's uncanny domestic interiors possess qualities now considered photographic: very tight use of space, "unbalanced" compositions, unexpected points of view, exact descriptions of light at specific times of day, concentration on what is happening on the edges of the frame, attention given to detail, use of points of focus, and representation, through stillness, of time.[8] His work demonstrates how the camera doesn't merely capture nature or reflect existing beauty but originates entire new ways of visualizing the world.

## The Demand for Picturemaking Systems

In the eighteenth century, a rising commercial class wanted to purchase the status of being commemorated in the same pictorial style as the rich. Inventors had commercial incentives to harness the camera to portrait making, as less training would decrease the cost of making a picture. Machine-based systems for producing multiple copies of objects were on the threshold of overtaking handmade methods. One such picturemaking machine was the *physionotrace.* Invented by Gilles Louis Chrétien in 1786, it combined two inexpensive methods of portraiture, the cutout silhouette and the engraving. An operator could trace a profile onto glass using a stylus connected to an engraving tool that replicated the gestures of the stylus onto a copper plate at a reduced scale. A tracing could be done in about a minute, and multiple copies of the image could be made from the plate. Although it was not a camera, the physionotrace reduced portrait making to a mechanical operation that required only moderate hand-eye coordination. It expanded the portrait market to the middle class while imitating the style of the miniaturist paint-

ers. The physionotrace satisfied a desire for an accurate visual description of one's presence and social status. The mechanical/scientific nature of the process gave the it a power of authenticity. A prototype for an entity like photography, it possessed a key characteristic of what society wanted but had not yet developed: a system for the multiple reproduction of a directly transcribed truth.

The start of the nineteenth century saw the introduction of Aloys Senefelder's 1796 invention of *lithography* that provided a more cost effective means for the mass production and distribution of printed pictures.[9] About this time wood engraving was also revitalized to meet the demand for multiple pictures. Other devices to facilitate personal picturemaking followed. The *camera lucida,* invented in 1807 by the English scientist William Hyde Wollaston (1766–1828), was an optical instrument (not a camera) supposed to help one overcome a lack of drawing skill. The camera lucida consisted of a glass prism, held at eye level by a brass rod attached to a flat, portable drawing board. One looked into a peephole at the center of the prism and simultaneously saw both the subject and the drawing surface. The idea was to let one's pencil be guided by the "virtual" image and to trace that image onto a sheet of paper attached to a drawing board. In practice it was difficult to operate, and frustration with this machine would lead a later photographic pioneer, Henry Fox Talbot, to find an automatic way to record a scene without lifting his pencil.

## Proto-Photographers: Chemical Action of Light

As alchemy, the precursor of science whose central notion is that buried minerals are in the process of developing into gold, evolved into modern chemistry in the seventeenth century, manufacturing industries were now able to produce and supply experimenters with reasonably reliable chemicals and equipment. By 1614 Angelo Sala had recorded the darkening effects of silver nitrate on exposure to sunlight. In the 1700s, various salts of silver, especially silver nitrate, were found to dye feathers, furs, and leather permanently black. Each new discovery and invention suggested that combining the camera and optical systems with the chemical action of light could produce an automatic image directly from life.

In 1727, Johann Heinrich Schulze (1687–1744) set out to repeat an alchemist's experiment to make a luminescent substance he called phosphorous. One of the ingredients Schulze used, aqua regia (nitric acid), was impure; it contained silver. When he mixed it with calcium carbonate (chalk), Schulze accidentally created calcium nitrate and silver carbonate, which to his surprise turned a deep purple on exposure to sunlight. He repeated the experiment using heat from a fire and

1.2  CAMERA LUCIDA.  From *Chambre Claire*.
Courtesy George Eastman House.

In *With a View to a New Art of Dying and Painting* (1794), Elizabeth Fulhame suggested that maps could be made using silver imprinted by the action of light. Her work demonstrated that the chemistry to make a photographic process was in place; what was needed was the motivation to combine the components into a new form. The character of the thing called photography was not found at a single source. Hindsight reveals protophotographers had multiple purposes and destinations.

At the opening of the nineteenth century, Thomas Wedgwood (1771–1805) experimented with placing flat objects and painted transparencies on top of white leather and paper sensitized with silver nitrate. His experiments verified the feasibility of chemically transferring images of objects and pictures through the agency of light. His work was described by the British chemist Humphry Davy (1778–1829) in the *Journals of the Royal Institution* for 1802:

> White paper or white leather, moistened with solution of nitrate of silver, undergoes no change when kept in a dark place; but, on being exposed to day light, it speedily changes colour, and, after passing through different shades of grey and brown, becomes at length nearly black. . . . When the shadow of any figure is thrown upon the prepared surface, the part concealed by it remains white, and the other parts speedily become dark.[12]

The paradoxical problem with these profiles, antecedents of photograms (cameraless photographic images), was that the light that created them and was needed to view them also brought about their destruction. Wedgwood could not stop the action of additional light from causing an image to darken until it disappeared into blackness. Consequently, he could only show the profiles by candlelight. Still, Wedgwood's underlying concept was vital, which according to Davy was to "copy" images of the camera obscura "by the agency of light upon nitrate of silver" instead of hand tracing. Although he did not achieve this goal, the rationale suited the emerging tenets of the modern era by substituting mechanical work for human labor. His efforts point toward the invention of a photographic system that brings together the direct action of light to chemically record an image constructed by a camera.

observed no change, deducing that this chemical reaction was caused by light, not heat. Schulze wrote:

> I covered most of the glass with dark material, exposing a little part for the free entry of light. Thus I often wrote names and whole sentences on paper and carefully cut away the inked parts with a sharp knife. I struck the paper thus perforated on the glass with wax. It was not long before the sun's rays, where they hit the glass through the cut-out parts of the paper, wrote each word or sentence on the chalk precipitate so exactly and distinctly that many who were curious about the experiment but ignorant of its nature took occasion to attribute the thing to some sort of trick.[10]

Schulze had uncovered a new method of representing an image—ironically, of text—by the action of light in conjunction with silver. By the 1760s, the prediction that something on the order of photography would be generated as the result of information accrued through scientific inquiries into chemistry, color, and light appeared in Norman Tiphaigne de La Roche's allegorical novel, *Giphantie* (1760). (English translation is *Giphantia*, 1761). Tiphaigne equated a large hall to a camera obscura, whose walls carried a "painting" that precisely traced a storm at sea. He then imagined "elementary spirits" that "fix these passing images" on material soaked in a "very subtle substance," making a permanent image "much more precious than anyone can produce, and so perfect that time cannot destroy it."[11]

## Modernity: New Visual Realities

The nineteenth century ushered in the urban, industrial-based movement known as modernity. The modern era

unleashed vast new resources in finance, management, science, and technology, leading to self-sustaining capitalist growth that swept away the foundations of ancient European regimes. These economic, political, and demographic changes, without precedent in scale and significance, were accompanied by potent new directions in science, philosophy, and the arts. Such fundamental displacements produced ruptures in the societal framework that allowed the camera and its optics to be recast.

The new expanding capitalist economy and its urban labor force demanded more visual information. Daily life was accelerating and changing as never before. Machines, such as the railroad, the steamship, the telegraph, and the iron printing press, were moving people and information at paces once considered impossible. With the advent of state-subsidized education in England and France, literacy was on the rise. The more people learned, the more information they wanted. Newspapers and the penny presses increased circulation, their pages filled with new human interest stories and engraved illustrations. Publishers learned that pictures helped sell their product, and by 1842 the world's first picture weekly, the *Illustrated London News,* was circulating. *Realism,* depiction without distortion or stylization, was on the rise in literature and in painting. People wanted to know exactly what their world looked like, and the photographic image arrived at the right moment with the type of proof people had been prepared to accept.

The classical view of nature as a perpetual, immobile entity had begun to shift with the dynamics of industrial revolution. Pre-photography thinkers like Johann Wolfgang von Goethe (1749–1832), Georg Wilhelm Friedrich Hegel (1770–1831), and Immanuel Kant (1724–1804) were transforming nature into an active, living, and tumultuous organism that shifted form and appearance depending on who was observing it. In Paris and London in the 1770s, Philippe Jacques de Loutherbourg combined magic lanterns (a predecessor of the slide projector), automatas with clock drives (that is, mechanical toys), and painted transparencies to create a new form of visual entertainment. The invention in 1784 of the *Argand Oil Lamp,* the first modern lighting system, made it possible for a concentrated beam of light to project images onto a screen, giving Loutherbourg the idea for his *eidophusikon.* The eidophusikon was a protean television, consisting of a miniature theater with a stage 6 feet high, 10 feet wide, and 8 feet deep. Colored glass slides, illuminated by concealed Argand lights, produced a multitude of colors. Sound and weather effects were created by revolving cylinders filled with shells and stones and thin sheets of copper, while a harpsichord provided music. Loutherbourg's financial success allowed him to create a visual show based on Captain Cook's voyages, which the *Daily Universal Register* (later *The Times*) in 1788 hailed as "the most magnificent [spectacle] that modern times

has produced. . . . bring[ing] into living action the customs and manners of distant nations—to see exact representations of their buildings, marine vessels, arms, manufactures, sacrifices and dresses."[13]

In Paris in 1800, Étienne-Gaspard Robert and Paul de Philipsthal unveiled the *phantasmagoria* (see Figure 1.3). Illuminated by the Argand Oil Lamp, the phantasmagoria was an advanced magic lantern that created rear-screen image projections of ghosts, skeletons, and celebrities in a semidarkened theater. Special effects of lightning, thunder, and smoke enhanced the eerie atmosphere. One popular scene, "Dance of the Witched," used multiple light sources to create moving projections that appeared to advance on the audience, only to vanish just as they seemed ready to leap off the screen. A group of magic lanterns with comblike shutters focused on the same spot on the screen, so that one image could blend into the next, making viewers less conscious of the mechanics and more likely to be swept away by the visual illusions.

In 1826 the Drummond Light, popularly called *limelight,*[14] replaced the Argand light. Limelight not only transformed the look of stage productions, it permitted magic lanterns to project a more powerful and accurate beam of light, increasing the audience for projected images. The acceptance of the camera-projected image as fact changed the perception of the magic lantern from a toy of amusement to a tool for education and social change. These innovative devices typify how the science-based industrial revolution was transforming how the world was viewed, altering public desires, and signaling an emergence of new forms of representation in the visual arts.

Gothic horror was what the public came to see in these live productions, but these new devices utilized in popular theater also retrained people in what they would accept and expect in a system of visual representation. As the demand for beauty and truth was thus reshaped, many minds set out to satisfy the new hunger. Artists, realizing verisimilitude was an avenue to acceptance and financial success, felt the pressure to get the details right. Various visual presenting systems, such as the Cosmorama, Goerama, Neorama, and Uranorama, were tried, but the one that captured the public's imagination as being visually authentic was the *panorama.*

The panorama was a picture on a cylindrical surface, with the spectator in the center, or else a picture that unrolled in front of the viewer to reveal its parts in sequence. In 1794, the painter Robert Barker built a circular exhibition space in London's Leicester Square and presented a 1,479-square-foot painted canvas of the city. Barker's multi-sheet, bird's-eye view situated the audience in the center of London. It was a commercial hit and the idea was widely imitated in other countries, including the United States.

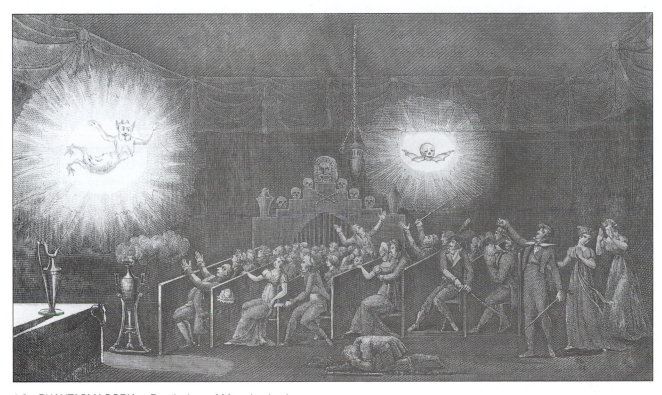

**1.3  PHANTASMAGORIA.**   Frontispiece of *Memoires* by James Robertson.   Courtesy George Eastman House.

In 1815, **Louis Jacques Mandé Daguerre** (1787–1851) was considered Paris's leading scene designer. His *trompe l'œil* (fool the eye) theatrical effects were particularly successful. Trompe l'œil refers to the illusion that one is seeing an actual subject and not a two-dimensional representation of it. In 1822, Daguerre opened his first 350-seat *diorama*. The diorama consisted of a dark circular chamber in which large painted scenes on translucent linen were represented. Each picture was seen through a 2,800-square-foot calico window that was painted half opaque. The opaque portion was frontally lit and the translucent part was illuminated from behind, producing the illusion that the picture emitted a radiant light and was not on a flat surface. The color, brightness, and direction of the light was controlled through a system of cords, pulleys, shutters, and slides, and its pictorial effects were soon enhanced with real animals, stage props, and sound effects.[15] The diorama was an immediate success and Daguerre later built an elaborate amphitheater in London, with 200 seats capable of pivoting viewers from scene to scene.

Daguerre's dioramas altered the way the public experienced a picture. The moving diorama is a harbinger of how mechanical devices can control human behavior. In it viewers gave up their autonomy and became part of a machine that determined how much time they would spend looking at a scene. Daguerre's dioramas also col-lapsed the single point-of-view perspective that painting had built up over centuries. All this happened without audiences objecting to giving up their familiar way of seeing. In fact, novelty was sought out as amusement. Associating the "new" with being creative and good became a hallmark of modernity. Other early nineteenth century visual phenomena, such as *anamorphic drawings* (distorted drawings or projections that appear visually correct when viewed from a specific point or reflected by a special mirror) reveal a fascination with and demand for systems that reorder visual information.

## Optical Devices

A burgeoning middle class, concerned with appearances that would convey its ideas of status, was eager to consume new images of reality. New visual thinking, based on ideas from machines, altered cultural constructs and perception while retraining public expectations of how the world was represented. The kaleidoscope, invented by Sir David Brewster (1781–1868) in 1815, mechanically re-formed visual experience through repetition and symmetry. The device exemplifies how science and technology give a subject the appearance of simultaneously being repeated and fragmented, challenging the traditional narrative framework of the visual arts.[16]

The optical phenomenon of retinal *afterimage,* the presence of a visual sensation in the absence of a visual stimulus, as discussed by Goethe in his *Theory of Colors* (1810), began to affect how science observed the world.[17] Goethe stated that whatever a healthy eye saw

was "optical truth," that there was no such thing as optical illusion. The eye was a model of autonomous vision: The optical experience is produced by and within the person. Goethe's theory challenged the Aristotelian truthfulness of optical perception by tethering the act of observation with the body, fusing time and vision.[18] Additional empirical studies of Goethe's ideas were carried out in Germany during the early 1820s by Jan Purkinje, who was able to time how long it took the eye to become fatigued and how long for the pupil to contract and dilate.

Such studies gave rise to scientific optical devices that were transformed into popular entertainment. The *thaumatrope,* or "wonder-turner," was manufactured in 1825 as an optical toy based on afterimage research. It consisted of a disk, about two inches in diameter, with a drawing on each side and strings attached through holes drilled at opposite ends of the circle. One side of the disk might picture a bald-headed man, the other side a wig. When the disk was spun, the man would appear to have hair on his head. The wonder-turner proved that perception was not instantaneous and demonstrated the contrived and delusionary nature of image formation. Such devices demonstrated the fracture between perception and the subject being perceived.

Joseph Plateau's afterimage experiments in the late 1820s defined the theory of *persistence of vision.* The theory states that if several objects that differ sequentially in form and position are rapidly viewed one after another, the impression they produce on the retina is of a single object that's changing its form and position. Since an image impression lingers for a fraction of a second, individual images appear to be in continuous motion, as in a flip-book. Devices like this and the *zoetrope,* a rotating cylinder with slits, through which one or more people could see sequential, simulated action drawings of acrobats, boxers, dancers, and jugglers, permitted an immobile viewer to have a machine-generated visual experience unfold over time.

## Images Through Light: A Struggle for Permanence

As a new scientific and technological order emerged in the nineteenth century, the old ways began to wobble and fail from the pressure of new experiences, and innovative theories were needed to contain them. The invention of photography resulted from the application of quantifiable knowledge to fulfill a capitalistic cultural demand for a practical, automatic picturemaking system, based on light and optics. Its invention marked the establishment of aesthetic, professional, and social practices governing how these pictures would be made, used, understood, and accepted.

**Joseph Nicéphore Niépce** (1765–1833) developed the first system for making images permanent through the action of light. Niépce (pronounced Nee-epps) was enthralled with lithography, but he lacked the drawing skills the process required. Originally, he sought to automatically transfer an image to a lithography stone without having to draw it, but in 1814 Niépce and his elder brother, Claude, shifted direction and undertook experiments to "spontaneously" create original pictures through the camera instead of copying previous existing images. This makes Niépce the first to actively pursue a process of making a permanent camera image.

By 1816 the major technical elements for the invention of photography were present in Niépce's experiments. Niépce was able to precisely describe to his brother Claude his first photographic procedures, with the use of cameras, biconvex lens, and diaphragm. These experiments, on paper sensitized with "muriate d'argent" (silver chloride), were abandoned by Niépce only because he obtained negatives. Niépce could temporarily "fix" the prints by washing them and was able to send some of these "epreuves" (prints) to Claude. Photographic historian Andre Gunthert remarks: "What is a print on sensitized paper, from an outdoor view, realized into a camera obscura, that could be sent by post and observed by a distant viewer, some days later, if not a photographic picture?"[19] If we accept this proposal, then 1816 can mark the beginning of what people would call photography.

In 1822, Niépce discovered that bitumen of Judea, a lithographer's material made from asphaltum (a natural tar pitch), was sensitive to light. Niépce knew bitumen of Judea was soluble in lavender oil and would harden when exposed to light. His vital discovery was that bitumen of Judea loses its solubility in lavender oil after exposure to light. Niépce was able to take a paper engraving, place it in contact with the treated lithography stone, and expose it to sunlight for about two hours. He then "developed" it in a solution of petroleum and lavender oil, realizing the cultural dream of an "automatic" picture (although the stone was not camera-based). Today we would say that Niépce made a latent (unseen) image, that when developed formed a negative (reversed) image of the original.

As early as 1824, Niépce used this process to make his first actual camera image from nature on a lithographer's stone, which he referred to as a *point de vue.* There is still disagreement among historians as to when Niépce first made a permanent view from nature with a camera. Some state it was as early as 1822, others say it was 1824, and still other groups claim 1826 or even 1827. A book written by Niépce's son Isidore in 1841 indicates 1824 was the first time Niépce "achieved definitive fixing of images from the camera obscura onto his screen. Although these marvelous products were still imperfect, the problem had been resolved."[20]

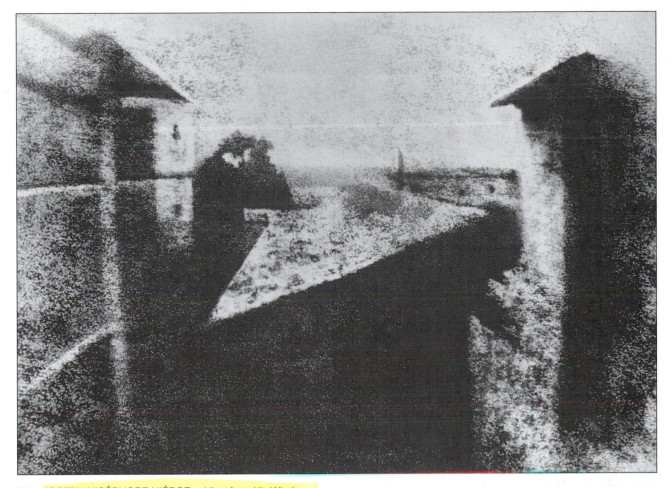

**1.4  JOSEPH NICÉPHORE NIÉPCE.** *View from His Window at Le Gras, ca.* 1826–1827. **Heliograph.**  Harry Ransom Humanities Research Center, The University of Texas at Austin.

This remains a fluid situation, based on evidence and semantics, and this date may change. Niépce refined the process, coating a piece of pewter with bitumen of Judea dissolved in lavender oil, placing the plate into his camera obscura, and making an extended daylight exposure.[21] The improvements resulted in what is believed to be the oldest surviving photographically based camera-made picture. The image is difficult to recognize; nevertheless, this picture (see Figure 1.4) can still convey its original sense of magical wonderment. Niépce wrote to his brother Claude:

> I succeeded in obtaining a *point de vue.* . . . from my workroom in Gras using my C[amera] O[bscura] and my largest stone. The image of the objects is represented with a clarity, an astonishing fidelity, complete with myriad details and with nuances of extreme delicacy. To get the effect, one must look at the stone from an oblique angle . . . and I must say my dear friend, this effect is truly something magical.[22]

By the late 1820s, Niépce had revised his working techniques to use silver-surfaced copper plates to deliver a problematic, one-of-a-kind positive image that lacked a full tonal range, had excessive contrast, was hard to see, and required extensive time to make.

Because Niépce's camera images were not able to withstand the chemical treatment he devised to produce prints in ink, a process he named *héliogravures,*[23] he reconceptualized them as unique images, which he called *héliographs.* However, Niépce realized his process needed crucial revisions to be productive.

In 1825 Daguerre wrote to Niépce proposing they collaborate.[24] Daguerre's enormous diorama paintings were made in a realistic picturesque style by Daguerre and the artist Jean Boulton and took an enormous amount of time to produce. An automatic picturemaking device would save the diorama's creators both time and money. In December of 1829 Niépce and Daguerre agreed to share all knowledge, honor, and profit from their collaboration. Daguerre's assets included funding for research, determination, energy, experience in gauging public taste, friends in prominent places, and credibility and recognition as an artist with public acclaim. The pair worked separately and corresponded in coded letters. In the summer of 1833, with success still eluding them, Niépce died of a stroke. His son, Isidore Niépce (1805–1868), replaced him in the partnership, but he did not offer much new research. Daguerre, with the benefit of Niépce's knowledge, continued on his own.

By 1831, Daguerre had been taking highly polished, silvered plates, sensitizing them in the dark with heated

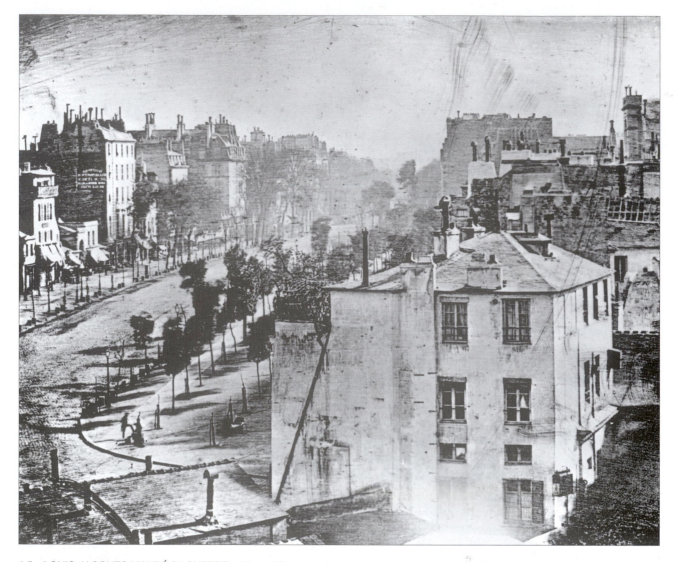

1.5  LOUIS JACQUES MANDÉ DAGUERRE.  *View of Boulevard du Temple,* c. 1839. Daguerreotype. Daguerre's exposure time was so long (likely between 10 and 20 minutes) he could not capture the moving figures and traffic on this bustling Paris street. Only a man who remained still while a bootblack polished his shoes was recorded, making this anonymous individual the first person to be photographed.  Bayerisches Nationalmuseum, Munich, Germany.

iodine crystals vapor (forming silver iodine), and immediately placing them in the camera and making one-hour exposures in bright sunlight. This process delivered, without development, a highly detailed negative image. A breakthrough came in late 1834, when Daguerre sensitized the plates *after* the exposure with heated mercury vapor. Although Daguerre claimed he discovered the usefulness of mercury accidentally, chemical ingredients like mercury have their roots in alchemical texts. Mercury was considered to be the dissolver, the active principal of things, making it a logical choice for experiments.[25] A whitish amalgam of silver and mercury formed on the plate where it had been exposed to light, making a fragile but incredibly detailed, camera-recorded image. When the shiny, mirror-like surface reflected a dark background, the picture was positive. When the background was bright or light-colored the picture appeared as a washed-out negative image. The mercury development had the beneficial side effect of reducing exposures to 20 minutes in bright sunlight. By late 1837, Daguerre was able to make the image stable by treating it in a strong bath of sodium chloride (table salt).

Daguerre and Isidore Niépce tried to market their secret process by subscription in 1838, which proved difficult. Daguerre knew the acceptance of his discovery would depend on more than its merits. He sought influential advocates and found an ideal personage in François Arago, an important scientist and politician.[26] Arago immediately recognized the invention's promise and wanted to make it France's gift to the world. He persuaded Daguerre to abandon his subscription appeal and in coming months put together a cunning accord with the French government to award lifetime pensions to Daguerre and Niépce and present the process to the world. It would be free from licensing fees, except in

1.6   WILLIAM HENRY FOX TALBOT.   *Latticed Window at Lacock Abbey,* 1835. Photogenic drawing.

England where Daguerre applied for a patent before the deal with the French government was finalized. But first the world needed to hear of the invention, and on January 7, 1839, Arago presented it to the Académie des sciences in Paris. Though the details remained secret, the news was out.

John Herschel (1792–1871), an astronomer and chemist, informed Daguerre of his own discovery that hyposulphite of soda ("hypo") would "fix" his camera pictures and make them permanent. With this technical problem solved, Daguerre turned to the conceptual dilemma of whether his process actively made an image of nature or simply made it possible for nature to "imprint" an image of herself. Daguerre neatly addressed the issue by writing: ". . . the DAGUERREOTYPE is not merely an instrument which serves to draw Nature; on the contrary it is a chemical and physical process which gives her the power to reproduce herself."[27]

On August 19, 1839, amid rhapsodic promises of "economic advantages, immense service to art, [and how it would] excel the works of the most accomplished painters, in fidelity of detail and true reproduction of the local atmosphere,"[28] Arago described Daguerre's process before an overflowing and electrified joint session of the Académie des sciences and the Académie des Beaux-Arts. Despite the expensive equipment and supplies, "Daguerréotypomanie" struck with force, hitting educated, upper-class society and its growing voracity for realistic images.[29]

Daguerre published a manual and arranged for the manufacture and sale of lenses and wooden cameras, but his interest in daguerreotypes rapidly subsided and he made very few after 1839. He moved to the country, revamped his gardens, and made illusionist paint-ings. Was Daguerre exhausted, was he satisfied with his accomplishments? Did the fire of 1839 that destroyed his diorama along with most of his works and papers leave him unable to work, or did he not wish to compete with the rest of the world on improving his process? He died in 1851, in relative obscurity and without much money.

The news from across the Channel in January 1839 must have shocked **William Henry Fox Talbot** (1800–1877): Talbot, known as Henry, was an English gentleman (he inherited Lacock Abbey estate), scientist (he was elected to the Royal Society in 1832), and scholar (he earned a Master of Arts degree from Cambridge), who had independently devised a camera-based imaging process in 1834, using the light-sensitivity of silver salts. In Talbot's time, a well-educated person was expected to possess numerous skills, including the ability to draw. Talbot did not draw well and depended on optical devices for assistance. He later recounted his frustration with drawing, using the camera lucida and the camera obscura, during his honeymoon at picturesque Lake Como, Italy:

> And this led me to reflect on the inimitable beauty of the pictures of nature's paintings which the glass lens of the Camera throws upon the paper in its focus—fairy pictures, creatures of a moment, and destined as rapidly to fade away. . . . It was during these thoughts that the idea occurred to me . . . how charming it would be if it were possible to cause these natural images to imprint themselves durably, and remain fixed upon the paper![30]

In 1834, Talbot invented the *salted paper print,* a *printing-out process* that allowed him to make camera-less images of botanical specimens, engravings, pieces of lace, and even solar photomicrographs.[31] For his first salted paper prints Talbot coated sheets of ordinary writing paper with sodium chloride, permitted them to dry, and then recoated them with silver nitrate, forming silver chloride. He had discovered that silver chloride was more sensitive to light than silver nitrate

and thus reduced exposure time. In Talbot's method the image and the paper became one, as there was no separation between the emulsion and its support.[32] In the printing-out process, the sensitized paper darkened swiftly when exposed to light. The image appeared spontaneously during exposure without chemical development. Once the image was complete, it was fixed, removing or inactivating the unexposed silver chloride. Talbot, like his predecessors, had difficulty fixing the image, eventually stabilizing prints with a strong solution of salt or potassium iodide. These images were negatives, and Talbot wanted direct positives. He solved the reversal problem by taking the negative image and reprinting it in direct contact with an unexposed, treated piece of paper, establishing a nascent negative/positive photographic method. Although he had a successful conceptual solution, Talbot's materials did not make a negative dense enough to produce a positive print with acceptable contrast and detail.

To increase the sensitivity of the paper, Talbot repeatedly brushed it with alternating coats of salted water and silver nitrate, then commenced to make his first camera negatives. Talbot used tiny cameras that his wife Constance, who also took and developed images, making her the first woman photographer,[33] referred to as "little mouse traps." These instruments enabled the lens to focus the light onto a very small concentrated area, reducing exposure times to an hour or two. Talbot had set aside this work when the news of Daguerre's process jolted him back into action. In January 1839, Talbot hurriedly sent some of his work to England's Royal Society, stating:

> I obtained [with a tiny camera] very perfect, but extremely small [negative] pictures; such as without great stretch of the imagination might be supposed to be the work of some Lilliputian artist. They require indeed examination with a lens to discover all their minutiae. In the summer of 1835 I made in this way a great number of representations of my house in the country [Lacock Abbey]. . . . And this building I believe to be the first that was ever yet known *to have drawn its own picture.*[34]

*Photogenic drawing,* the term Talbot used to describe this early salted paper process, is the archetype for the silver printing-out papers of the nineteenth century. As it incorporated the textural imprint of the paper into the picture, the process produced a broad tonal range that favored volume and shape over detail. Talbot's exposure times were excessive and the process appeared overly complex, involving a second series of steps to produce a finished image. The photogenic drawings also did not compete with the verisimilitude of the daguerreotype. When the two processes were first compared, the future seemed to lie with the daguerreotype, which met the aesthetic expectations of how a picture was supposed to look by supplying an easily recognizable trace of the subject.

Daguerre, with his background in optical entertainment, was an experienced businessman who knew how to commercially promote his process. Talbot was a scientist and an intellectual with interests in astronomy, linguistics, literature, mathematics, and optics. His earliest photography publication, *Some Account of the Art of Photogenic Drawing* (January 1839),[35] indicates an awareness that the temporal premise of his process was different from other tracing methods; it brought together transitory and permanent elements. Talbot wrote that it took no less time or effort to record a simple subject than it did a complex one. For Talbot, photography's purpose was to depict a subject in a fixed compositional order from a lived moment, making time itself the ultimate subject of all photographs.

Talbot's regard for learning led him to devise a new procedure, *iodized paper,*[36] for making negatives. His breakthrough came accidentally. Having made an exposure that revealed no visible image, Talbot set it aside. When he looked at it later, an image had been formed. Talbot deduced that the gallic acid with which he brushed the paper prior to exposure had acted as a developer, causing an invisible latent image (encoded by light) to appear. Talbot called his new method *calotype,* from the Greek words *kalos* and *tupos,* meaning "beautiful print." The calotype involved taking an exposed sheet of iodized paper into the darkroom and brushing it with gallic acid until a potent negative was developed. This negative was contact-printed onto unexposed, salted paper in sunlight to form a positive. The procedure formalized photography as a two-step process beginning with one tonally reversed (negative) image from which an infinite number of tonally correct positive copies could be produced. This concept formed the foundation for the silver-based photographic system still in use today: A camera with a lens was used to record an unseen image on light-sensitive material that was chemically developed out to make a photograph.

Herschel had discovered in 1819 that hyposulphite of soda would dissolve silver salts. Learning of the work of Daguerre and Talbot, Herschel launched his own research into the light-sensitive properties of various silver halides and other chemicals. He made a negative image on paper, through a telescope, which he made permanent by treating with hypo. By freely sharing this information with the early pioneers, Herschel provided the missing link in all their processes, of how to make images permanent. Herschel, with a volatile, soaring imagination, is an ideal of learning: He set aside nationalism; openly shared knowledge; did not patent his findings; and did not commercially exploit his discoveries. Although Herschel never considered himself a photographer, his contributions shaped the founding concepts of photographic practice. He helped to establish basic terminology by consistently using the broader terms "photography" and "to photograph,"[37] instead of the individualistic descriptions of heliography and photogenic drawing, creating a sense of unity where there had been none. Herschel also introduced

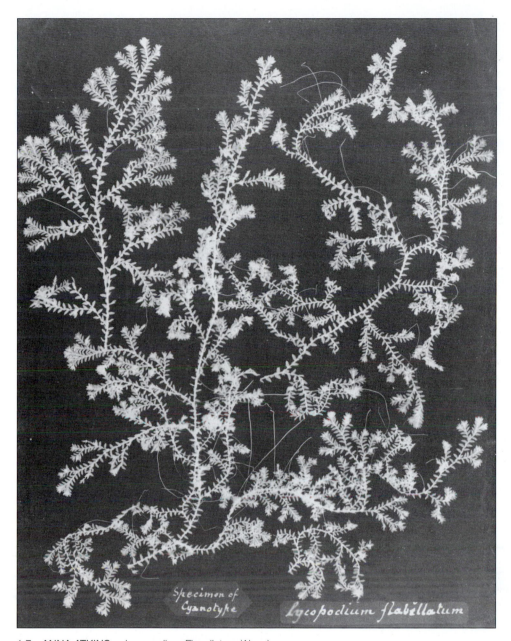

1.7   ANNA ATKINS.   *Lycopodium Flagellatum* (Algae),
1840s–1850s. Cyanotype.   Harry Ransom Humanities Research
Center, The University of Texas at Austin.

the terms "negative" and "positive" (based on the study of magnetism with which Talbot was also familiar) and "emulsion," helping institute a common nomenclature.

In 1839, Herschel told Talbot that waxing the paper negative after processing would make it more transparent and easier to print.[38] By the end of the year, he had invented a method of sensitizing a glass plate with silver halides and proceeded to photograph his father's telescope, making the first glass-plate negative, from which he made prints on paper. Next, Herschel invented a method of making direct positive images on paper. Then, he prefigured the ambrotype by demonstrating how his glass negative could be backed with black opaque material to produce a positive image. He

discovered silver bromide was the most light-sensitive of the known silver halides, pointing the direction for reduced exposure times that would make portraiture practical. Hershel was able to record, but not fix, a natural color image of the spectrum, without the use of dyes or colorants, on silver chloride material, promoting the possibility of full-color photographs.

In 1842, Herschel invented the *anthotype,* a paper process sensitized with various plant juices that formed the final image by removing the unwanted parts of the emulsion through a bleach-out method, a forerunner of the silver-dye-destruction processes, such as Ilfochrome (formerly known as Cibachrome), often used to make prints from transparencies. He rounded out the year with the *cyanotype* (blueprint) process, which he devised to make fast copies of his notes, foreshadowing the electrostatic copier. In the cyanotype process iron salts were absorbed into the

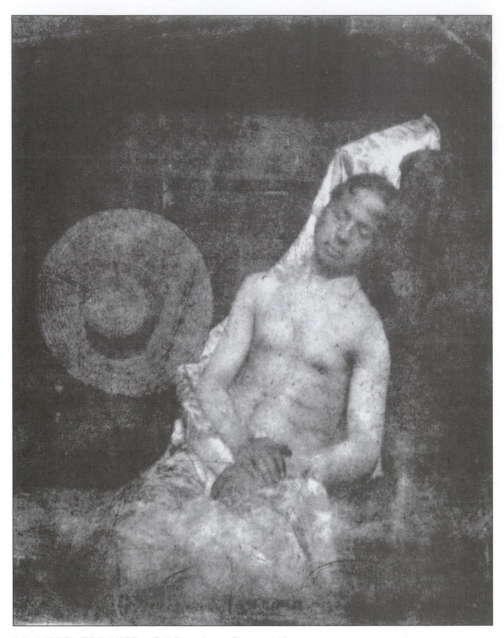

1.8  HIPPOLYTE BAYARD.  *Self-Portrait as a Drowned Man,* 1840. Direct paper positive.  © Société Française de Photographie, Paris.

paper that was exposed to sunlight in contact with a negative or a drawing on tracing paper, producing an image in Prussian Blue which was fixed by washing in water (see Mungo Ponton's shadowgraphs in the next section). Used by amateurs, mostly after the introduction of small, flexible, roll film cameras, cyanotype was also adopted by shipbuilders to copy their working plans and utilized to copy line-based documents. In 1853 Herschel described methods to reduce images to microscopic size for easier storage and preservation and then enlarge them again when needed.

**Anna Atkins's** (1799–1871) *British Algae: Cyanotype Impressions,* privately published and distributed, was the first book to be printed and fully illustrated by Herschel's cyanotype.[39] Her effort was the earliest to use photo-based technology for producing cameraless pictures for scientific investigation, "predating by several months any of Talbot's commercially published camera-based photographic books."[40] Although artistic expression was not her main intent, the works show a strong aesthetic sense for translating three-dimensional forms into two-dimensional space. Her influence was limited to a tiny audience, due to the book's subject matter and the restricted means of production. In the introduction to her book, Atkins described her intent: "the difficulty of making accurate drawing of objects as minute as the Algae and Conferva, has induced me to avail myself to Sir John Herschel's beautiful process of Cyanotype, to obtain impressions of the plants themselves, which I have much pleasure in offering to my botanical friends."[41]

# Other Distinct Originators

Niépce, Daguerre, and Talbot were not alone in their quest to make pictures directly by the action of light. In March 1839, **Hippolyte Bayard** (1801–1887), a French civil servant, independently obtained his first direct positives on paper in the camera. In May, Bayard showed examples to Arago, unaware that Arago was championing Daguerre's cause. Arago pressured Bayard not to publish, thus guaranteeing that Daguerre's process would receive all the attention. Bayard exhibited thirty pictures in Paris in June 1839 and was presented with a small cash award by the French government. However, by the time Bayard made the details of his process public, in February 1840, it was old news.[42] Bayard expressed his disappointment with a mini-series of self-portraits and accompanying "suicide" text, opening a discourse on photography's relationship to death, the use of text to control meaning, and the medium's ability to commingle fact and fiction. On the back of one print the martyred Bayard, an early photographic casualty, returns from the dead with this message:

> The corpse you see is that of M. Bayard. . . . The Academy, the King, and all those who have seen his pictures admired them, just as you do. . . . This has brought him prestige, but not a sou [penny]. The government, which has supported M. Daguerre more than is necessary, declared it could do nothing for M. Bayard, and the unhappy man drowned himself. . . . he has been at the morgue for several days, and no-one has recognized or claimed him. Ladies and Gentlemen, you'd better pass along for fear of offending your sense of smell, for as you can observe, the face and hands of the gentleman are beginning to decay [Bayard's hands and face were sunburnt from working in his garden].[43]

Word of these discoveries circulated, and the eagerness to photograph became apparent as people from across the Western world—Brazil, Germany, Spain, Switzerland—stepped forward with claims that they too had invented a photographic process.[44] Creating a spin-off method based on Talbot's process, Scotsman Mungo Ponton (1801–1880) sensitized paper with potassium bichromate (potassium dichromate) instead of silver salt to produce cameraless *shadowgraphs*. He made them by placing objects on top of the paper and exposing his set-up to sunlight. The image was processed by washing with water. The areas affected by light did not dissolve during washing, but the unexposed coating under the object did. Since all the unexposed bichromate was removed, the washing operation also served to fix the image. The final result was a white silhouette of the object on an orange background. The process showed that the solubility of potassium bichromate was proportional to the amount of light it received, and was cheaper and easier than Talbot's method. Ponton demonstrated his technique to the Society of Arts of Scotland on May 25, 1839, and correctly predicted that it would be an important aid to lithography. Although he never pursued the process, it was the basis for a number of non-silver processes and for most of the photomechanical reproduction methods of the nineteenth century.

The notion of *simultaneous consciousness,* that an idea can independently occur to different people, in different places, and at the same time, is evidenced in the experiments of Antoine Hércules Romuald Florence (1804–1879), a French artist who resided in Brazil. His surviving notebooks, written between 1829 and 1837, record Florence's early imagemaking with a camera obscura and silver nitrate in January 1833. He altered the conceptual direction of his experiments from making images with a camera to concentrate on what would become a fundamental application of all such photochemical discoveries: using a master image to produce copies. According to Professor Boris Kossoy:

> Florence used master glass plates coated with a mixture of gum arabic and soot. He outlined his designs and texts with a burin, then copied them through sunlight exposure on paper sensitized with silver chloride or, preferably, gold chloride, thus obtaining printout images. In testing chemical preparations that would prevent his gold-chloride copies from being altered when again exposed to light, he first used a solution of urine (for the ammonia in its composition) and water. Later he used caustic ammonia (ammonium hydroxide) as a fixer for the copies prepared with silver chloride.[45]

What is also astounding is that a detailed examination of his manuscripts by the Conservation Laboratory at the Rochester Institute of Technology in 1976 confirmed that Florence used the word "photographie" to describe the product of his endeavors in 1833 and "photographer" in 1834, half a decade before Herschel recommended "photography" to Talbot in 1838. Although none of Florence's camera images have survived, his contact prints of a diploma and labels for pharmaceutical bottles made before 1837 are in the possession of his descendants.

The formation of a process to address divergent picturemaking desires seemed to converge everywhere, all at once. Today we can point to notions that photography worked the borders of reality and representation, culture and nature, objectivity and subjectivity, permanence and transience, and speculate that early imagemakers were striving to show that these boundaries were false. But such contemporary thinking bypasses what photography is fundamentally about: empowering people with the means to make a visual representation of their reality, a model capable of tracing a subject's presence. Daguerre summed up the desire best:

> **I have found a way of fixing the images of the camera! I have seized the fleeting light and imprisoned it! I have forced the sun to paint pictures for me!**[46]

## Endnotes

1   Martin Kemp, *The Science of Art: Optical themes in Western Art from Brunelleschi to Seurat* (New Haven: Yale University Press, 1990), 9–15, 344–45.

2   Leon Battista Alberti, *On Painting and on Sculpture*, ed. and translated by Cecil Grayson (London: Phaidon Press, Ltd., 1972), 55.

3   For a fictional, philosophical account linking the camera obscura from Mo Ti to the present, see David Knowles, *The Secrets of the Camera Obscura* (San Francisco: Chronicle Books, 1994).

4   Kenneth Clark, *Landscape into Art,* new edition (New York: Harper & Row, Publishers, 1986), 44.

5   Kemp, 53–60.

6   Georges Potonniée, *The History of the Discovery of Photography*, translated by Edward Epstean (New York: Arno Press, 1973), 11. Trans. *Histoire de la découverte de la photographie.* (Paris, 1925). First English edition, New York: Tennant and Ward, 1936.

7   Vermeer's vision is the result of constructing images from things seen in the natural world and things seen in his mind: Vermeer transcended the camera. It is the act of seeing and thinking, rather than the limited focus on what is seen and how it is ordered, that enables such an artist to suggest an intricate inner world.

8   Some of Vermeer's later work, such as *A Girl Asleep* (1656), when reproduced in a small black-and-white format can at first be mistaken for a late nineteenth-century snapshot.

9   Lithography is a method of printing based on the aversion of grease and water. A drawing is made with a crayon, pencil, or ink that contains grease and pigment and is chemically fixed to the top of a limestone or a smooth metal surface. This surface is wetted and rolled with oily ink, which adheres only to the greasy drawing; the rest of the surface, being damp, repels the ink. Prints are made in multiple copies, referred to as *editions*, on paper in a press.

10   Johann Heinrich Schulze, "Scotophorous [bringer of darkness] Discovered Instead of Phosphorous; or, A Noteworthy Experiment of the Action of the Sun's Rays." A translation can be found in R. B. Litchfield, *Tom Wedgwood, the First Photographer* (London: Duckworth & Co., 1903), 218–24.

11   Norman Tiphaigne de La Roche, *Giphantia* (London, 1761), printed for Robert Horsfield, original in French, 95–97. Reproduced in Georges Potonniée, *The History of the Discovery of Photography,* trans. Edward Epstean (New York: Tennant and Ward, 1936), 44.

12   Humphry Davy, "An Account of a method of copying Painting upon Glass, and making profiles, by the agency of Light upon Nitrate of Silver. Invented by T. Wedgwood, Esq. with Observations by H. Davy," *Journals of the Royal Institution*, vol. 1 (1802), 170–74.

13   R. D. Altick: *The Shows of London* (Cambridge, MA: Belknap Press, 1978), 120–21.

14   In 1826 Thomas Drummond applied a mixture of oxygen and hydrogen to small balls of lime to produce a powerful and steady source of illumination for coastal lighthouses. The entertainment business quickly adapted the Drummond Light, renaming it *limelight,* as a replacement for the Argand light.

15   See Helmut and Alison Gernsheim, *L. J. M. Daguerre, The History of the Diorama and of the Daguerreotype.* Reprint. (New York: Dover Publications, 1968), 14–47.

16   See Sir David Brewster, *The Kaleidoscope: Its History, Theory, and Construction* (1819; reprinted London, 1858).

17   Johann Wolfgang von Goethe, *Theory of Colours*, translated by Charles Eastlake [1840] (Cambridge, MA: MIT Press, 1970).

18   Jonathan Crary, *Techniques of the Observer on Vision and Modernity in the Nineteenth Century* (Cambridge, MA: MIT Press, 1990), 98.

19   Andre Gunthert, email discussion with author, December 17, 1998.

20   Isidore Niépce, *History of the discovery improperly called daguerreotype* (Paris: Astier, August 1841), 17.

21   Most previous publications have indicated an exposure time of about eight hours. However, according to Jean-Louis Marignier and Michel Ellenberger, "L'invention retrouvée de la photographie," *Pour la science*, No. 232, Feb., 1997, 42, Niépce never indicated the precise exposure time he used. The authors, using a similar type of lens and emulsion that Niépce used, found that their summer daylight exposure times varied between 40 to 60 hours.

22   Letter from Joseph to Claude Niépce dated 16.7bre [September] 1824, in *Dokumenty po istorii izobreteniya fotografii,* T. P. Kravits, ed. (Moscow: Academy of Sciences of the USSR, 1949), 148–49 [*Documents in the History of the Invention of Photography,*

The Correspondences of J. N. Niépce, L. J. M. Daguerre, and Others]. Note that Niépce apparently photographed this scene numerous times over many years, adding to the difficulty in dating the surviving example.

23   An early outgrowth of Niépce's research was the first photomechanical process, the héliogravure, an elementary version of photogravure. After the treated plate was exposed and developed it was placed in an acid bath. The acid etched out the unprotected areas, leaving an intaglio plate that could be inked and printed. The process worked when used to make traditional prints, but not with camera-made images that depended on midtone values to be effective. Later Niépce's nephew, Claude Abel Niépce de Saint-Victor, refined the process to include a broader range of midtones.

24   Daguerre learned of Niépce's work from Charles Chevalier, son of the Paris optician, from whom both bought equipment. In 1828, Niépce's co-experimenter brother Claude died in London while trying to raise funds for the picturemaking system. The loss of his brother and his need for money made Niépce amenable to a partnership.

25   See Hugh W. Salzberg, *From Caveman to Chemist: Circumstances and Achievements,* American Chemical Society, Washington, D.C., 1991, 38, 44–45.

26   François Jean Dominique Arago (1786–1853) was a recognized mathematician, astronomer, and physicist, who served as an astronomer and one-time director of the Paris Observatory, and as secretary of France's Académie des sciences. Also an astute politician, he was a member of the Chamber of Deputies when he took up Daguerre's cause and later led important government ministries.

27   Daguerre, as quoted in Helmut and Alison Gernsheim, *L. J. M. Daguerre* (New York: Dover, 1968), 81.

28   For a detailed account of the events of 1839 see Gernsheim, *L. J. M. Daguerre,* 79–97.

29   For a detailed description of the era in which the daguerreotype was introduced see Rachel Stuhlman, "Luxury, Novelty, Fidelity: Madame Foa's Daguerreian Tale," *Image,* vol. 40, nos. 1–4, (1997).

30   H. Fox Talbot, *The Pencil of Nature* (London: Longman, Brown, Green & Longmans, 1844). Facsimiles, New York: Da Capo Press, 1969; and New York: H. P. Kraus, 1989. Unp.

31   An early microscope fitted into a wall so as to collect sunlight and project it through a specimen into a darkened room where the enlarged image was viewed on a screen.

32   Salted paper prints became the mainstay of silver printing-out papers until they were superseded in the 1850s by albumen paper. Salted paper prints produce a reddish-brown image tonality. They are stable to light when properly processed, but the unprotected silver image is extremely susceptible to airborne pollutants, which cause yellow fading.

33   See H. J. P. Arnold, *William Henry Fox Talbot: Pioneer of Photography and Man of Science* (London: Hutchinson Benham, Ltd., 1977), 119–20.

34   William Henry Fox Talbot, *Some Account of the Art of Photogenic Drawing* (London, 1839). Reprinted in Beaumont Newhall, *Photography: Essays & Images* (New York: The Museum of Modern Art, 1980), 28.

35   Ibid.

36   Talbot made iodized paper by brushing potassium iodide and silver nitrate (the same active ingredient as in the daguerreotype) onto high-quality writing paper. Prior to camera exposure, the paper was brushed with "gallonitrate of silver" (a solution of silver nitrate, acetic, and gallic acid usually referred to as gallic acid) and put into the camera while still moist. This cut exposure times from minutes to 10 to 60 seconds in direct sunlight.

37   The first printed use of the word can be found in an article on Talbot's invention by the German astronomer Johann H. von Madler in the *Vossische Zeitung* of February 1839. Herschel used it in print in a paper to the Royal Society on March 14, 1839.

38   Waxing increased the apparent resolution, as the wax made the negative more translucent and diminished the visibility of the paper's fibrous structure. The process was popular with European amateurs for architectural and landscape work until it was supplanted by the distinctly different *waxed paper process* and the wet collodion process in the 1850s.

39   In October 1843, Atkins began publishing *British Algae: Cyanotype Impressions.* The illustrations were photogenic drawings produced by the cyanotype process. The text and captions were photographic copies of Atkins' handwriting. In 1850, she began to issue massive volumes, completing the publication of three volumes in 1853, which were designed to have 14 pages of text and 389 plates.

40   Larry J. Schaaf, *Sun Gardens: Victorian Photographs by Anna Atkins* (New York: Aperture, 1985).

41   A. A. [Anna Atkins], *British Algae: Cyanotype Impressions.* 3 volumes. Halstead Place, Sevenoaks: privately published, 1843–53. As cited in Larry J. Schaaf.

42   Bayard treated paper with silver chloride and exposed it to light until it turned dark. Then he bathed the paper in potassium iodide and exposed it in his camera. The light bleached the paper in direct proportion to its intensity, forming a unique direct positive picture and solving the problem that had confounded Niépce and Daguerre. Bayard also used Herschel's hypo to fix his images.

43   Collection of the Société française de photographie; reproduced in Lo Duca, *Bayard* (Paris: Prisma, 1943), 22–23.

44   For a list of those who came forward after Daguerre's announcement claiming to be the inventor of photography see Geoffrey Batchen, *Burning with Desire: The Conception of Photography* (Cambridge, MA: MIT Press, 1997), 35 and 50.

45   Boris Kossoy, "Photography in Nineteenth-Century Latin America: The European Experience and The Exotic Experience" in Wendy Waitriss and Lois Parkinson Zamora (eds), *Image and Memory: Photography From Latin America 1866–1994* (Austin: University of Texas Press in association with FotoFest, Inc., 1998) 23. Complete references to Kossoy's writing on Florence can also be found in this text.

46   Daguerre to Charles Chevalier at his Paris optical shop, ca. 1839, quoted in Helmut and Alison Gernsheim, *L. J. M. Daguerre: The History of the Diorama and the Daguerreotype,* second revised edition (New York: Dover Publications, 1968), 49.

# The Daguerreotype

*Image and Object*

Daguerreotypes reigned from 1839 through the 1850s. In this first period of picturemaking millions of daguerreotypes, from street corner scenes to the Acropolis, were made of almost any subject on which light would shine. All the major cities and tourist destinations were daguerreotyped, but the new process had its most revolutionary impact in portraiture. Before the nineteenth century, only the wealthy had the means to act on the desire to commemorate their likenesses. Industrial-age products, like the physionotrace and the camera lucida, had begun to expand the picturemaking process, but the daguerreotype was the great equalizer, providing ordinary people with access to pictures of themselves and their loved ones. Whether a commissioned portrait or a genre picture, before the daguerreotype it was unusual for tradespeople—say, vegetable sellers—to have been individually commemorated (see Figure 2.2). For the first time, everyday people could now make their own visual history, collecting images that said, "This is *mine*—my family, my house, my dog, my trip to Niagara Falls." Commercial, industrial,

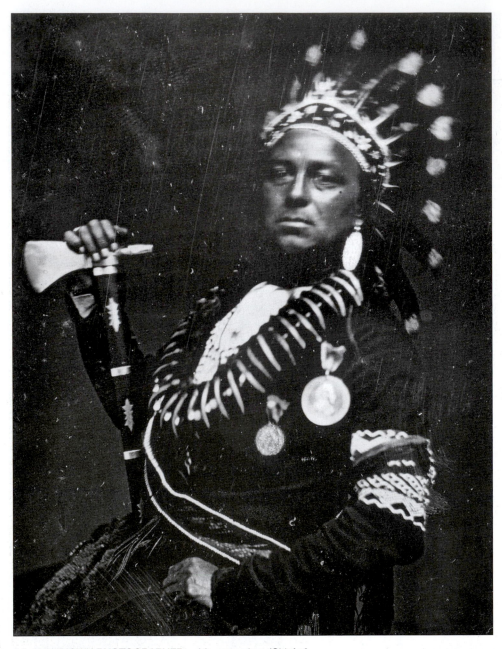

2.1  UNKNOWN PHOTOGRAPHER.  *Maungwudaus* (Chief of the Ojebway Tribe), ca. 1845. Quarter plate daguerreotype with applied color.   Courtesy George Eastman House.

and scientific applications rapidly followed. By the 1850s a new information age was underway as millions of daguerreotype portraits and views, as outdoor scenes were called, gained circulation.

## What Is a Daguerreotype?

In the winter of 1838–1839, American painter and inventor Samuel F. B. Morse (1791–1872) was in Paris to demonstrate his electric telegraph and arranged a meeting with Daguerre.[1] After seeing Daguerre's process Morse wrote to his brother that daguerreotypes "resemble aquatint engraving; for they are in simple chiarooscuro [sic], and not in colors, but the exquisite minuteness of the delineation cannot be conceived. No painting or engraving ever approached it. . . . The impressions of interior views are Rembrandt perfected."[2]

The daguerreotype is a physical container of information, having the properties of both a two-dimensional image and a three-dimensional object. The daguerreotype does not look or feel like a contemporary paper photograph, nor is it made like one. Its image rests on the highly polished, silvered surface of a copper plate whose mirror-like brilliance provides unparalleled visual depth and also makes viewing problematic. A daguerreotype must be viewed from a specific angle or its image will appear as a negative, that is, tonally reversed. Above all, each image is unique. The daguerreotype's greatest

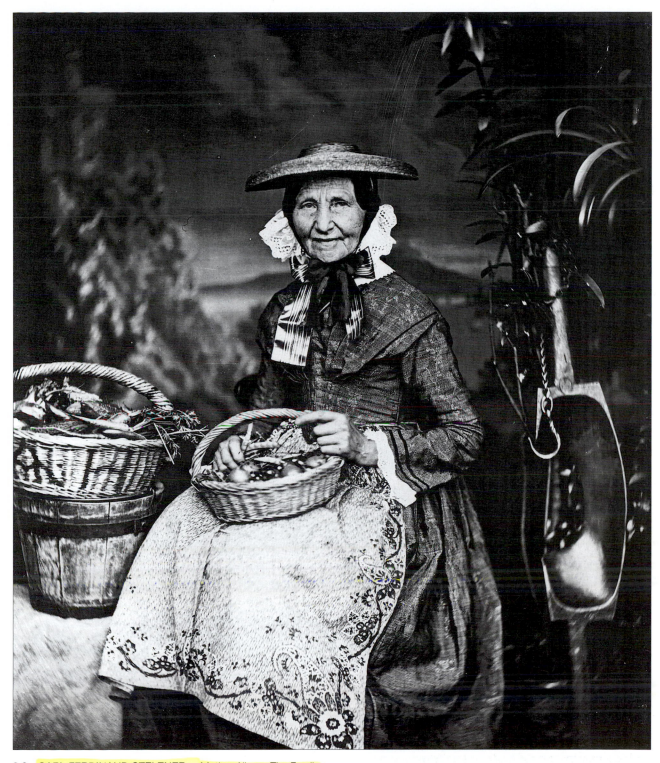

2.2  CARL FERDINAND STELZNER.  *Mother Albers, The Family Vegetable Woman,* ca. 1845. 5⅝ × 4⅝ inches. Daguerreotype. Photography democratized portraiture by making it economically feasible for ordinary working people to have their likeness memorialized.  © Museum für Kunst und Gewerbe, Hamburg.

technical advantage is its ability to render incredible detail. Its shimmering surface is a physically luxurious one that can beautify an ordinary subject by anointing it with a sense of visual splendor. At its best, the image can seem to rise from the surface, giving a sense of a subject's three-dimensionality. The daguerreotype's subtle perfection and ephemeral personality, its sparkling, gemlike quality, lend it a sense of magical realism, which does not translate onto the printed page.

In viewing, a daguerreotype's mirrored surface often includes the viewer in the image. One can adjust the viewing distance so that the viewer's face and the face of the portrait's sitter synchronize. As the eyes of

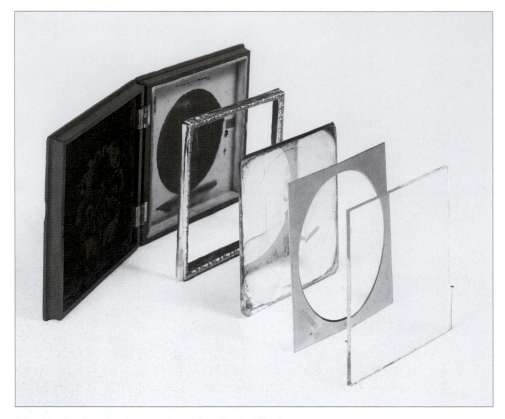

2.3   Construction of a daguerreotype: hinged, velvet-lined case, plate, frame, matte, and glass.   Courtesy George Eastman House.

viewer and subject overlap, one can experience a sense of traveling backward and forward in time and space. The daguerreotype's delicate surface is protected in a small, closed case, making the viewing experience intimate and private. Designed to be held in one's hand, not seen on a wall, a daguerreotype can create a beguiling sense of tension as it flickers between the positive and the negative surface image. It can simultaneously convey two views of a person, providing an extra dimension into the character of the sitter.

Details of the daguerreotype process spread swiftly after Arago's public announcement, but its long exposure times meant that initially, its finest subjects were immobile. Daguerreotyping was not a spontaneous act. As in a portrait painting, a daguerreotype was planned and *made* rather than casually *taken*.[3] Early daguerreotypes recorded premeditated poses constructed over many minutes of exposure time. This built-in sense of time was evident in the daguerreotype and encouraged viewers to linger, to study, and to think about the image.

The daguerreotype immediately revealed the potential for photographic processes to replace hand-done procedures carried out by skilled artisans. Within days of its public announcement, *Le Lithographe* printed a lithograph of the Cathedral of Notre Dame in Paris drawn from a daguerreotype view, forging a new alliance between photography and printmaking. Western audiences were especially eager for views of historical European sites, and an immediate market developed for cultural icons. Daguerreotype views of famous places in Europe, the Middle East, and America were traced and transferred onto copper plates by the *aquatint process*[4] and published in Paris between 1841 and 1843 as *Excursions Daguerriennes: Vues et Monuments les plus remarquables du globe*. Within a few years, most major natural formations, such as Niagara Falls, and man-made monuments, including the Kremlin, had been daguerreotyped.

## The Daguerreotype Comes to America

On September 20, 1839, Daguerre's instruction manual for his process arrived in New York, and within days David William Seager[5] was exhibiting his work (now lost) at the establishment of Dr. James R. Chilton, a chemist and scientific supplier located on Broadway. A week after the manual's arrival, Samuel F. B. Morse exhibited his own view of the city's Unitarian Church (also lost). Within two weeks the first American portraits, with the sitter's eyes shut to diminish movement caused by blinking during the long exposures, had been made. John W. Draper (1811–1882), a chemistry professor at what is now New York University, dusted his sister's

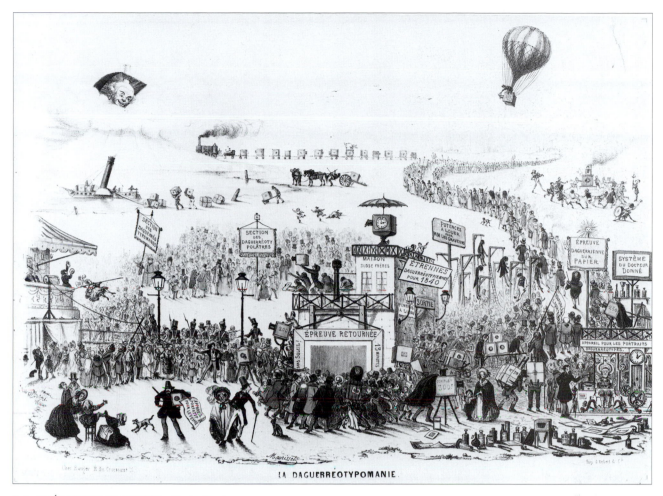

LA DAGUERREOTYPOMANIE.

2.4 THÉODORE MAURISSET. *Fantasies: La Daguerreotypomanie,* December 1839. 9⅖ × 14⅛ inches. Hand-colored lithograph. Courtesy George Eastman House.

face with white flour (to increase light reflectance and reduce the exposure time), made her daguerreotype, and sent it to Sir John Herschel in England. Draper wrote: "I believe I was the first person here [America] who succeeded in obtaining portraits from the life."[6] Despite its difficulties, other daguerreotypists quickly followed, furthering the process of democratizing visual representation by challenging the conventions of who did the depicting, what was depicted, and what the depiction revealed about the subject, and establishing a new basis for portraiture.

## The Early Practitioners

The earliest American daguerreans[7] were amateurs, generally men of some means and education who possessed a measure of scientific, technical, or artistic training. This was not without reason: the process was an expensive and technically difficult one. Few stayed at it for long. After exposing some plates to local buildings or scenes (exposure times were still too long for pleasing portraiture), most of these early adopters then set their new gadgets aside. Rapid advances in photographic chemistry soon made portraits possible, though not easy, to realize. The next group of daguerreotypists, who came along within months of the invention's introduction, were aspiring professional portraitists. Most were men without formal arts training and were refugees from other lines of work. Again, few would remain in the field. It took yet a third wave of practitioners, following further improvements in chemistry, as well as lenses and the economy, before a true class of professional daguerreans would emerge.

The late 1830s saw America's first modern economic depression. Ironically, the daguerreotype, on the verge of destabilizing the business of picturemaking, offered some unemployed and entrepreneurs an opportunity to live the American Dream of the second chance. This ideology grew out of the European "New World" myth that saw America as a land of Eden where one could be restored through will power and hard work.[8] The newness of the daguerreotype appealed to the youthful country's frontier mentality and its infatuation with machines that made tasks easier to perform.

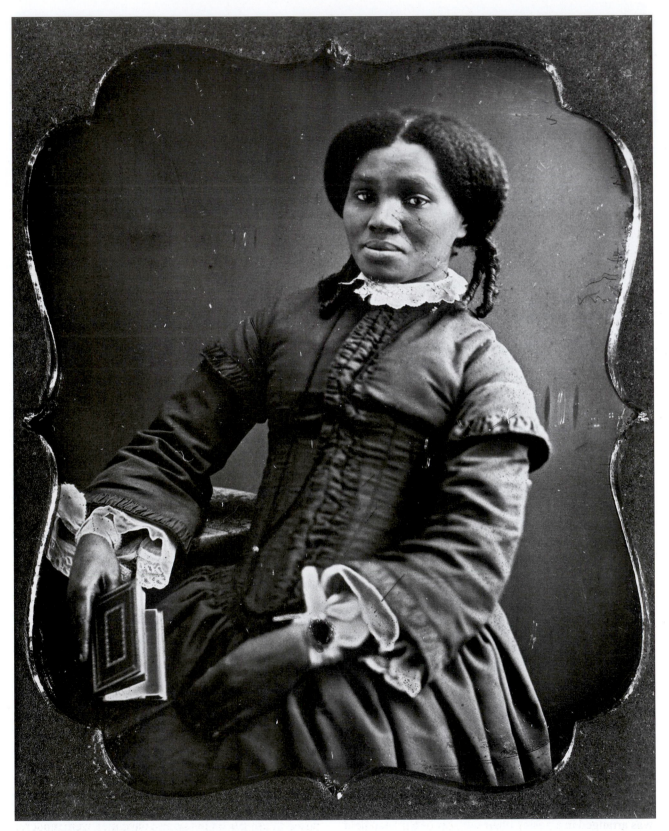

**2.5  UNKNOWN PHOTOGRAPHER.**  *Portrait of an Unidentified*
*African-American Woman,* ca. 1850. Sixth plate daguerreotype
with applied color.   Courtesy George Eastman House.

Most daguerreotypists were largely self-taught, after learning their basic skills through apprenticeship or the taking of a few lessons. Nathaniel Hawthorne's daguerreotypist in *The House of the Seven Gables* (1851) sets the tone for how people viewed the profession. By the age of twenty-two Holgrave, the hero, had been a schoolmaster, a salesman, a political editor, a peddler of Cologne water, a dentist, a supernumerary official aboard a packet-ship, a public lecturer on Mesmerism,[9] and a daguerreotypist. The narrator describes what many people thought of daguerreotypists:

> His present phase, as a Daguerreotypist, was of no more importance in his own view, nor likely to be more permanent, than any of the preceding ones. It had been taken up with the careless alacrity of an adventurer, who had his bread to earn; it would be thrown aside as carelessly, whenever he should choose to earn his bread by some other equally digressive means.[10]

These itinerant daguerreotypists, oblivious to the academic rules of painting, introduced to portraiture the idea that anything was possible. Daguerreotypists were free to decide what was important and how to record it, making up their own hierarchy. They brought a fresh, uncomplicated sense of ordering and the freedom to document the vernacular, emphasizing the surface appearance of everyday subject matter. The lack of European formality in America allowed pictorial space to be arranged in a more informal, intuitive, and naturalistic manner. This sense of playfulness foreshadows the arrival of the snapshot and can also be seen in other works such as *Leaves of Grass* (1855), in which Walt Whitman's free verse celebrations of individual freedom and dignity, democracy, and brotherhood are part of the same spirit that was captured in many daguerreotypes. Perhaps not surprisingly, Whitman, whose attitude made him a great admirer of the daguerreotype, was a friend of Gabriel Harrison (1818–1902), a celebrated Brooklyn daguerrean, local aesthete, and theater personality.

## Early Daguerrean Portrait Making

Alexander S. Wolcott (1804–1844) and John Johnson (1813–1871) opened what the March 4, 1840, New York *Sun* exclaimed was "the first daguerreotype gallery for portraits." People having their daguerreotypes made at this studio were in for a few surprises. A sitter was arranged in a posing chair with his or her head held stationary by an iron clamp on back of the chair.[11] Two large mirrors, hanging over the street from the third floor, directed light into the studio. Sunlight bounced from the lower mirror onto the upper mirror and was then reflected through a rack of glass bottles, filled with a blue solution of copper sulphate to soften the quality of the light, directly onto the face of the sitter, who was staring so hard into the light that tears became a regular part of the process. Initially, portraits were usually undertaken only on sunny days, when exposures could be made in about one minute. On cloudy days exposures could last 8 minutes or longer, making it impossible for people to remain still enough to get a sharp likeness. The camera did not have a shutter; the exposure was made by removing the lens cap for a period of time, tracked by a pocket watch, that varied according to the intensity of the light. Since daguerreotypists prepared their own plates, exposure time was based on the operator's previous experience. One sitter recalled the tribulation:

> [He sat] for eight minutes, with strong sunlight shining on his face and tears trickling down his cheeks while . . . the operator promenaded the room with watch in hand, calling out the time every five seconds, till the fountains of his eyes were dry.[12]

Some people, including the French novelist Honoré de Balzac, considered the daguerrean portrait perilous for metaphysical reasons. Balzac believed that physical bodies were made up of an infinite number of leaf-like skins and that every time one's daguerreotype was taken, one of these layers was removed from the body and transferred to the image. Each exposure meant the irreplaceable loss of another ghostly layer, the very essence of life.[13]

In the medium's earliest days, most people had more concrete reasons to dread the sitting for their daguerreotype. Since lengthy exposures could make the daguerrean portrait an ordeal, operators, as daguerreotypists were called, were judged for their ability to be quick and painless. The practice of painting faces white and dusting hair with white powder didn't make the occasion any more pleasant or the result particularly natural. It is not surprising that today's viewers of daguerrean portraits comment on how unnatural or serious people appear. One story tells of an operator who:

> had tried all sorts of suasions [to keep his sitter quiet], when it occurred to him that the strongest of all human motives is fear. As soon as he had completed his adjustments, he suddenly draws a revolver, and leveling it at the sitter's head, he explains in a voice and with a look suggestive of lead and gunpowder: "Dare to move a muscle and I'll blow your brains out."[14]

Another operator printed business cards proclaiming: "Photography in all styles without pain." He proposed to use gas on his sitters; once they were rendered unconscious, he would make the exposure.[15] A third suggested: "A good dose (of laudanum [opium]) will effectively prevent the sitters from being conscious of themselves, or the camera, or anything else. They become most delightfully tractable, and you can do

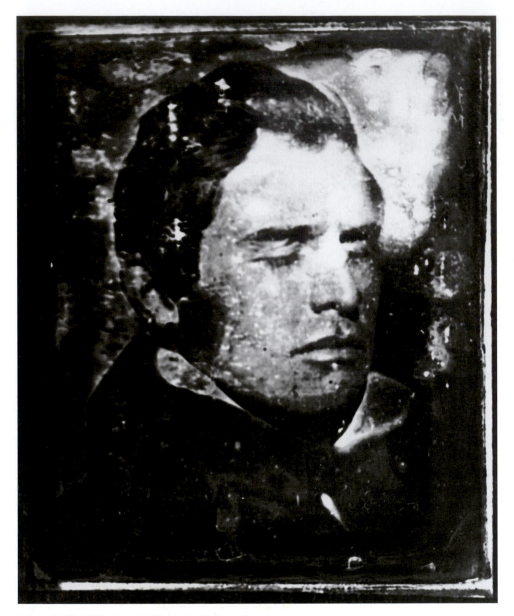

2.6  HENRY FITZ, JR.  *Self-Portrait with Eyes Closed,*
ca. November 1839/January 1840. Ninth plate daguerreotype.
In October 1839, Wolcott and Johnson built a miniature camera
(4 × 2 inches) that utilized a concave mirror instead of a lens to
focus the light. Johnson sat for five minutes in full sunlight to make
what he called a profile portrait that was not quite ⅜ inch square.
With the assistance of the telescope maker Henry Fitz, Jr., the two
built a bigger concave mirror camera and commenced working
with 2 × 2½-inch plates. Wolcott patented the camera in 1840.
This corpselike self-portrait made by Fitz, with his eyes closed,
is believed to be from those first trials.   Smithsonian Institution,
Washington, DC.

background with the sitter gazing straight toward the
camera. What the camera saw is what was delivered;
there was no retouching. People accustomed to hand-
drawn portraits that flattered the sitter were startled
by the camera's direct representation. Long exposures
necessitated stationary poses that produced experiences
like the one Ralph Waldo Emerson related:

> In your zeal not to blur the image, did you keep every finger
> in its place with such energy that your hands became clenched
> as for fight or despair, and in your resolution to keep your face
> still, did you feel every muscle becoming every moment more
> rigid; the brows contracted into a Tartarean frown, and the eyes
> fixed in a fit, in madness, or in death? And when, at last you
> were relieved of your duties, did you find the curtain drawn
> perfectly, and the hands true, clenched for combat, and the
> shape of the face or head?—but, unhappily, the total expression
> escaped from the face and the portrait of a mask instead of a
> man? Could you not by grasping it very tight hold the stream of
> a river, or of a small brook, and prevent it from flowing?[17]

anything with them under such circumstances . . . the
procedure entails a certain loss of animation."[16]

The emphasis, clearly, was on getting a physical
"likeness" as opposed to probing a sitter's inner state of
being. Poses were typically ¾ length against a neutral

## Technical Improvements

In 1840 Richard Beard (1801–1885) bought the patent rights to the daguerreotype process in England and hired John Frederick Goddard to increase the plate's light sensitivity, which would reduce exposure times and make portraiture more practical. Goddard refined the iodized surface of the plate with bromide, and his accelerator, known as quickstuff, could increase the speed 5 to 10 times, reducing a 10-minute exposure to 1 minute.[18] Antoine Francois Jean Claudet (1798–1867), a competitor of Beard, also invented a chlorine and iodine vapor accelerator in 1841 for the same purpose.[19] At the same time, Armand Hippolyte Louis Fizeau (1819–1896) invented a technique called gilding[20] to improve the plate's contrast and make it less susceptible to abrasion and oxidation, thus increasing its life expectancy. These improvements enabled Beard to open the first high-quality daguerreotype portrait studio in London, and probably in Europe, in March 1841. The need for improvements was related by photographer Thomas Sutton's pre-accelerator experience at Claudet's studio, which opened shortly after Beard's:

> [Claudet] informed me, with the utmost gravity, that to achieve anything like success or eminence in it (daguerreotyping) required the chemical knowledge of Faraday, the optical knowledge of Herschel, the artistic talent of a Reynolds or a Rembrandt, and the indomitable pluck and energy of a Hannibal; and under these circumstances he strongly dissuaded anyone from taking it up as an amusement.[21]

In the United States, where Americans embraced the daguerreotype as if it was their own invention, a series of technical improvements, known as the *American Process,* took American daguerreotypes to the highest level of excellence.[22] The American Process included plates re-silvered by electrotyping and polished with power-driven buffers. Cheaper and more compact cameras, with the first accordionlike bellows, were used, and materials were standardized through mass-produced equipment (see list below). Late in the daguerrean era, a finished plate was often housed in what was called a Union Case, marking the first industrial use of thermoplastic in 1853.

Daguerreotype plates were first commercially produced by silversmiths in various sizes that became internationally standardized.

**Whole plate:** 6½ × 8½ inches

**Half plate:** 4½ × 5½ inches

**Quarter plate:** 3¼ × 4¼ inches

**Sixth plate:** 2¾ × 3¼ inches

**Ninth plate:** 2 × 2½ inches

## Expanding U.S. Portrait Studios

Yankee mechanical ingenuity propelled the expansion of American portrait studios. In 1841, **John Plumbe, Jr.** (1809–1857) established the United States Photographic Institute in Boston as a commercial enterprise, taking portraits (see Figure 2.7), selling apparatus and materials, and providing instruction. By 1843 he was advertising his ability to make a "color" portrait by electroplating portions of the finished plate, fueling a demand for colored images. The first colored daguerreotypes were hand-painted after processing. For an extra fee, the operator made notes about the color of the sitter's clothes. Color was hand-applied, based on these notations, directly onto the finished plate.

Plumbe's national studio network advanced the concept, started by galleries in New York, of collecting celebrity portraits. He had the unique images copied and published as lithographs in *The National Plumbeotype Gallery. Craig's Daguerreian Registry* claims that Plumbe had 25 galleries in 1845 from New York to Dubuque, Iowa, that eventually offered daguerreotypes for as little as one dollar, all stamped "Plumbe." The actual daguerreotypist was not credited, establishing a precedent that other chain studios followed, thus making it difficult to attribute a daguerreotype to an individual operator. Most large studio owners managed and promoted their business and rarely worked as operators, yet all the work carried the studio's credit-line. The operator was generally considered a skilled production worker who performed a repetitive, machine-like task. The poses were standardized into ritual formulas, a convention still seen in countless yearbooks and in the display cases of chain studios from J. C. Penney to Olan Mills.

In 1843, **Albert Sands Southworth** (1811–1894) took **Josiah Johnson Hawes** (1808–1901) as a partner in his Boston daguerreotype studio. Both men were among the earliest of professional American daguerreans and coincidentally were first introduced to the process in the early spring of 1840 when they independently attended a daguerreotype lecture and demonstration by François Gouraud (ca. 1808–1847),[23] a Frenchman who was the American agent for Giroux et cie, Daguerre's authorized camera manufacturer.

Some five years after joining with Southworth, Hawes married his partner's sister, Nancy, who had been working at the gallery coloring plates. Later, another Southworth brother, Asa, also worked there as an operator. This family unit produced exceptional work and became a model daguerrean portrait studio. Although individuals at Southworth & Hawes had specific tasks to perform, the collaborative nature of the portrait studio makes it difficult to determine who was responsible for many aesthetic and technical improvements. A side effect of this method of working was to rupture the concept of a single

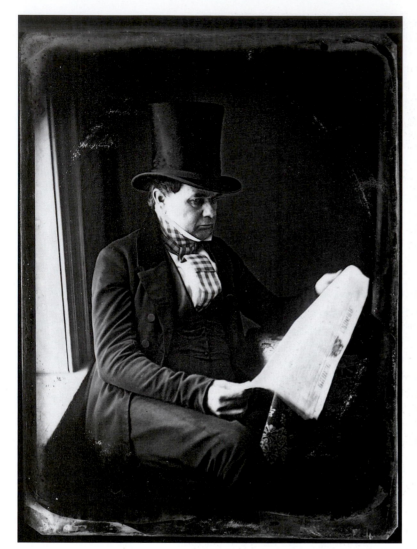

2.7  JOHN PLUMBE, JR.  *Portrait of a Man Reading a Newspaper,* ca. 1842. Sixth plate daguerreotype.  The J. Paul Getty Museum, Los Angeles.

author who directed, supervised, and took credit for the work produced in a studio setting. Under a skylight studio referred to as the "operating room," the South-worth & Hawes group created bold and direct portraits of Boston's cultural elite (see Figure 2.8). Ignoring stereotypical poses, they demonstrated how a daguerrean portrait could be more than a detailed physiographic map and could speak in its own physically rich and often sensual language. Southworth commented:

> It is required of and should be the aim of the artist-photographer to produce in the likeness the best possible character and finest expression of which that particular face or figure could ever have been capable. But in the result there is to be no departure from truth in the delineation and representation of beauty, and expression, and character.[24]

Mathew B. Brady (ca. 1823–1896) helped pioneer the celebrity portrait. Already a daguerreotype case-maker, he opened his first Daguerrean Miniature Gallery in New York in 1844 and became an expert at utilizing

daguerreotypes in public relations. Brady sent his daguerrean celebrity portraits and the interior views of his fashionable gallery to the new picture papers, where they were converted into wood-engraved illustrations for publication. This free publicity not only promoted his portrait business but signaled the role daguerreotypes would play in the budding mass communications arena by increasing the number and type of images in public circulation. Brady undertook his first historical project in 1845 by making daguerreotypes of American public figures and having a selection of images reproduced in *Frank Leslie's Illustrated Newspaper* so they could be seen by a wide audience. In 1850 Brady continued to unite portraiture, history, and publishing through his *Gallery of Illustrious Americans,* a collection of twelve lithographic portraits, based on the studio's work, that included John James Audubon, John Calhoun, Henry Clay, and Daniel Webster. *Humphrey's Journal of the Daguerreotype,* June 15, 1853, describes the atmosphere of manufactured elegance at Brady's Broadway studio where, for a modest fee, one could fabricate a vision:

> The floors are carpeted with superior velvet tapestry, highly colored. . . . The walls are covered with satin and gold paper. The ceiling frescoed, and in the center is suspended a six-light gilt and enameled chandelier. . . . The harmony is not the least disturbed by the superb rosewood furniture—tête-à-têtes, reception and easy chairs, and marble-top tables, all of which are multiplied by mirrors from ceiling to floor. Suspended on the walls, we find Daguerreotypes of Presidents, Generals, Kings, Queens, Noblemen—and *more nobler men*—men and women of all nations and professions.[25]

## The Art of the Daguerrean Portrait

Before the daguerreotype most portraiture was done by artists specializing in hand-size miniatures. Many artists, afraid the daguerreotype would destroy their livelihood, mocked the new form as third rate and its practitioners as untalented. This fear voiced itself in one of photography's most frequently quoted aphorisms, that of the artist Paul Delaroche who has been misquoted in numerous texts as stating upon seeing his first daguerreotype that painting was "dead."[26] J. J. Grandville's *Scenes from the Private and Public Life of Animals* (1842) lampooned this anxious outlook with the tale of a budding portrait painter turned daguerreotypist. The story tells of a tal-

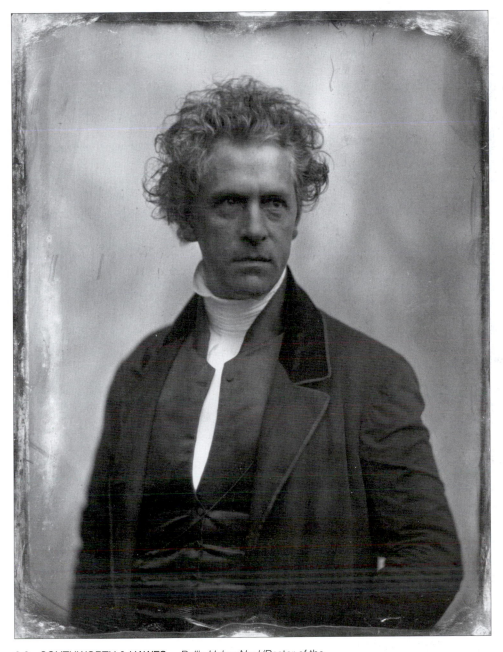

2.8  SOUTHWORTH & HAWES.  *Rollin Heber Neal* (Pastor of the First Baptist Church, Boston), ca. 1850. 8½ × 6½ inches. Whole plate daguerreotype.    Courtesy George Eastman House.

ented monkey studying painting in Paris, who discovers that creativity, rather than imitation, is needed to be an artist. To overcome his lack of imagination, the monkey buys a daguerreotype outfit and returns to his native Brazil to open the first daguerrean portrait gallery. He becomes fashionable when all of the jungle society come to have their pictures made. At the pinnacle of success, he is ruined by the narcissism of a king and in despair throws himself into the Amazon River.

Despite the mockery, portrait miniaturists saw their sales plummet. Some, such as **Carl Stelzner** (1805–1894) of Germany (see Figure 2.2), became daguerreo-

typists; the French painter J. Mansion joined Antoine Claudet's London studio, where he colored and retouched daguerreotypes. Many artists who continued to make miniatures incorporated the photographic process into their working methods. Instead of drawing a portrait by hand, they painted directly on top of a daguerreotype image. Other portrait painters used daguerreotypes in lieu of their subject to lessen the misery of having a person sit for a portrait, but by 1860, miniature painting was defunct.

Since there was no formal school or aesthetic of photography, the "art" was passed from one practitioner to the next. As the primary studio agenda was to make money, technique rather than aesthetics was stressed. Individuals like Morse were important because they taught others, including Southworth, Brady, and Edward Anthony, who then played key roles in establishing an

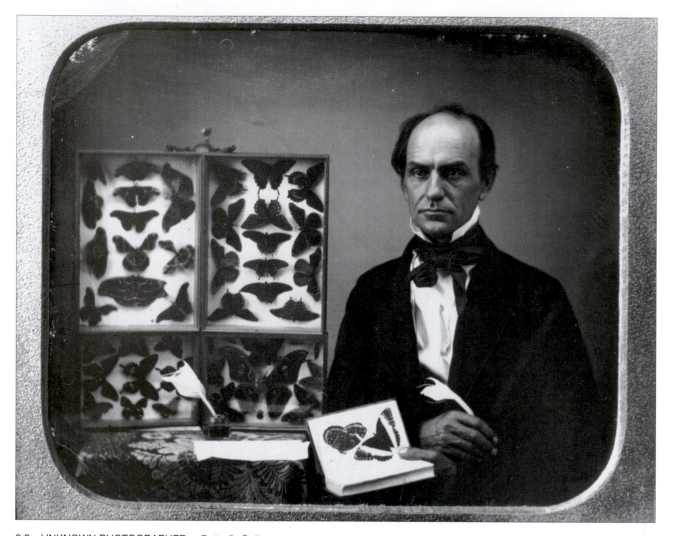

2.9  UNKNOWN PHOTOGRAPHER.  *Butterfly Collector*,
ca. 1850. 2¾ × 3¼ inches. Sixth plate daguerreotype.
Courtesy George Eastman House.

American photographic practice. Sophisticated stu-
dios, especially Brady's, wanted to fashion poses that
revealed more than the outer facade of a sitter. Brady
and other studio owners looked for inspiration in such
publications as Johann Kaspar Lavater's *Essays on
Physiognomy* (1789), which encouraged artists to dis-
cover "the interior of Man by his exterior—of perceiv-
ing by certain natural signs, what does not immediately
attract the senses."[27]

Most mass market studios, like Plumbe's, combined
capitalism and democratic experience: Everyone got
the same product, leading the public to think the pho-
tographic process was *automatic*. An operator's job
was simply to allow each sitter's portrait to be directly
recorded by the action of light, giving authorship to the
sitter and not the operator. Such daguerreotype studios
chronicled ordinary faces, which added up to a synthe-
sized national personality. After viewing hundreds of
daguerrean portraits one is struck by the plain ordinari-

ness of the sitter's faces rather than their exceptional
beauty. A new portrait genre appeared emphasizing
everydayness as its theme, with tradespeople such as
cobblers and seamstresses commemorating their labors
and the middle class often showing off their posses-
sions (see Figure 2.9).

## Daguerrean Portrait Galleries and Picture Factories

In 1853, it was estimated that 1,000 New Yorkers,
including women and children, were working in the pho-
tographic trade. There were only a few women opera-
tors, but many more were engaged behind the scenes,
especially in hand-coloring plates. Thirty-seven of New
York's estimated eighty-six daguerrean studios were
located on a single stretch of Broadway. People strolling
down Broadway would have seen studio banners and
display cases tempting them to walk up the stairs to have
their portrait made. Many of the galleries followed the
lead of Edward Anthony's *National Daguerreotype Min-
iature Gallery* and displayed celebrity portraits, to give
people the chance to see popular figures—and to encour-

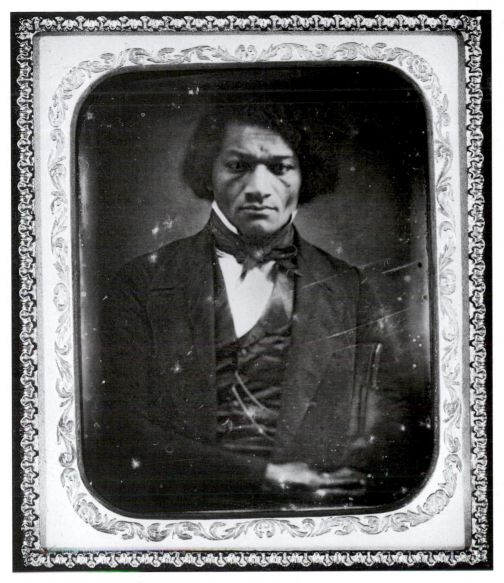

2.10  UNKNOWN PHOTOGRAPHER.  *Frederick Douglass,*
ca. 1847. Sixth plate daguerreotype.  National Portrait Gallery,
Washington, DC.

age them to buy a duplicate portrait or have one made of themselves (see Figure 2.10). The implication was that one could have one's portrait made at the same studio that catered to the luminaries. In reality, most of these portraits had been appropriated from other galleries, copied, and displayed without crediting the original maker.

At the time, a skilled laborer earned about $1.50 per day, a common laborer $1.00 a day or less.[28] To meet the needs of working people *picture factories,* with wooden benches and bare walls instead of overstuffed stairs and chandeliers, made portraits for fifty cents or less. Picture factories were criticized for their sloppy work practices, but the real fear was that their price-cutting methods would take business away from the ornate galleries. The standards of the 50-cent galleries were often not up to par. The most frequent complaint, "blue bosom," resulted when white articles of cloth-

ing appeared with a Prussian blue cast. This was due to slapdash working methods that induced the Sabattier effect (a.k.a. solarization), causing a reversal effect which rendered the white highlight areas as blue. In the picture factories the goal was not fantasy, but resemblance. These "50-cent men" were considered unprofessional and were roundly attacked by reputable studio operators in the trade press:

> Their rooms are frequently the resort of the low and depraved, and they delight in nothing more than desecrating the Sabbath by daguerreotyping these characters in the most obscene positions.[29]

In fact, the frankness and voyeuristic quality of the camera image allowed it to take over the underground market of erotic art. Among the Broadway operators, rumors circulated about unscrupulous individuals making illegal pornographic daguerreotypes after hours and on Sundays. The realism of the daguerreotype added to the licentiousness of such imagery. Their illegal nature and no doubt premium price kept the audience for these secretive pictures limited.[30]

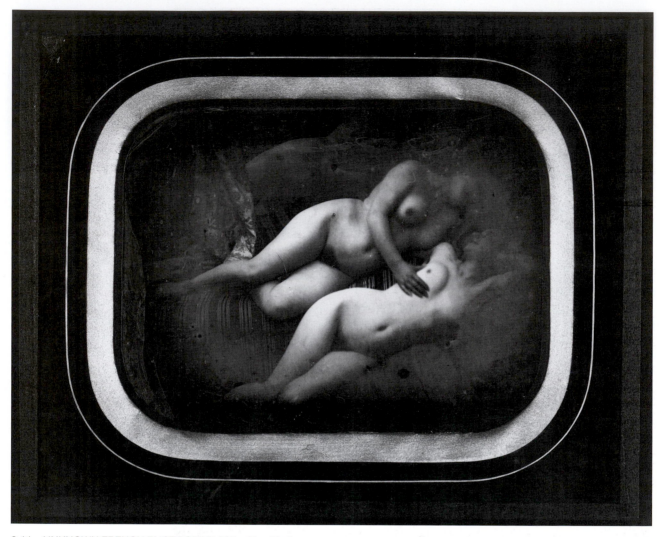

2.11   UNKNOWN FRENCH PHOTOGRAPHER.   *Two Nude Women Embracing,* ca. 1848. Half plate daguerreotype with applied color.   The J. Paul Getty Museum, Los Angeles.

Picture factories prospered due to management practices that promoted aggressive advertising, used smaller-sized plates to cut expenses, relied on a division of labor to speed up the operation, and encouraged a relaxed attitude towards aesthetic and technical standards. Broadway's Reese & Company used an assembly-line approach, with each employee performing a specialized task. A customer purchased tickets for the desired number of sittings and an operator made a corresponding number of plates, following rigid posing formulas. The plates had been prepared by a polisher and a coater, and then brought to the operator for the posing. Next, the exposed plates were passed to a "mercurializer" who developed them through fuming with mercury. A gilder toned them, and, for an extra fee, an artist would hand-tint them. After being set into individual casings, the plates were delivered in as little as fifteen minutes. Generally, the camera operator never saw the finished pictures. Sitters kept the ones they wanted and

disposed of the rest; no refunds or reshoots were given. Abraham Bogardus recalled a customer who protested that, "My picture looks like the *Devil*." The Broadway portraitist responded, "I had never seen that personage and could not say as to the resemblance, but sometimes a likeness ran all through families."[31]

## African-American Operators

African Americans were in the business as well, building a wealth of images in a community where it previously did not exist. Jules Lion is credited with inaugurating the daguerreotype in New Orleans. From 1843 to 1853 **Augustus Washington** operated daguerrean studios in Hartford, CT, before moving to Liberia, where he also made daguerreotypes. In New York City, Berthe Wehnert ran a calotype studio.

James Presley Ball, Sr. (1825–1904), a free light-skinned, African-American man[32] became a daguerreotypist after studying with John B. Bailey, a black daguerrean from Boston, at White Sulphur Springs, (now West) Virginia. Born in Virginia, he spent his youth in Cincinnati. Between several attempts to establish a gallery in his hometown, Ball worked as an itinerant

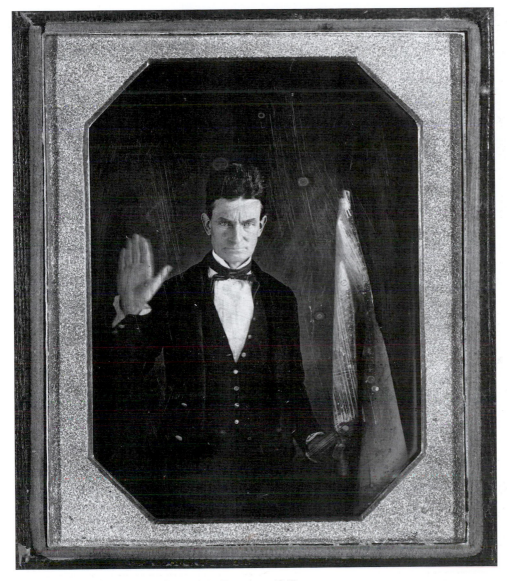

2.12  AUGUSTUS WASHINGTON.  *John Brown, ca. 1847.*
Quarter plate daguerreotype. This daguerreotype of abolitionist John
Brown was taken by African-American photographer Augustus
Washington twelve years before Brown led his aborted slave
insurrection in Harpers Ferry, West Virginia. Before the introduction
of the daguerreotype, it is unlikely that a working man like Brown
would have left his image for future generations to ponder.   National
Portrait Gallery, Washington, DC.

operator, before succeeding there in 1849. He opened a
second Cincinnati gallery on New Year's Day in 1851,
the nationally-known "Great Daguerrean Gallery of the
West." An active abolitionist, he commissioned *Ball's
Splendid Mammoth Pictorial Tour of the United States
Comprising Views of the African Slave Trade* . . . .[33] an
1,800 foot long panorama that depicted scenes related
to slavery, from capture in West Africa to freedom in
Canada. Thousands viewed the painting in Cincinnati
and Boston. Ball's gallery was destroyed by a tornado
in 1860 and his friends helped re-outfit it, which would
gain the reputation as "the finest photographic gallery

west of the Allegheny Mountains"[34] and draw prominent
sitters like Frederick Douglass and the family of Ulysses
S. Grant. Working with his son, James P., Jr., he later
opened studios in Minneapolis; Helena, Montana; and
Seattle. Ball's best-known series was made in Helena in
1896, of the execution of William Biggerstaff, who was
convicted of murdering a black man. A group of cabinet
cards show Biggerstaff first sitting pensively in a chair,
then hooded and suspended from the hangman's noose,
and finally stiffly laid out in his coffin. A similar series
depicts William Gay, Biggerstaff's cell mate and another
convicted murderer.

## Rural Practice

Most Americans in the mid-1800s lived in rural areas,
and resourceful daguerreotypists saw they could make
money by bringing portraits to smaller communities that
lacked studios. The most enterprising traveled in spe-
cially made horse-drawn wagons, called "Daguerreotype
Saloons." Following the practice of earlier itinerant

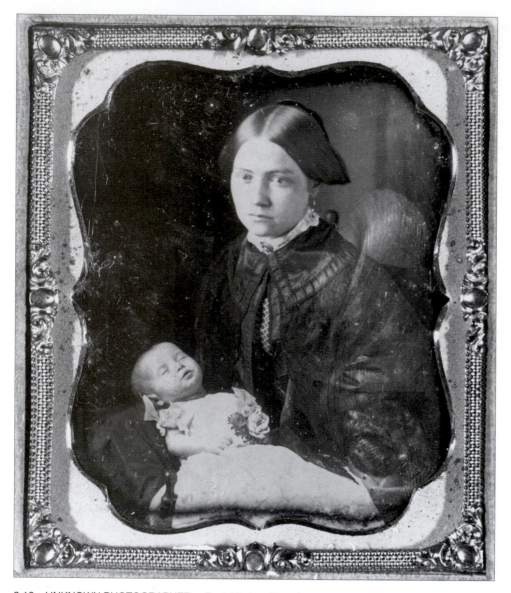

2.13 UNKNOWN PHOTOGRAPHER. *Post-Mortem Portrait, Woman Holding Baby,* ca. 1855. Sixth plate daguerreotype with applied color.    Courtesy George Eastman House.

portrait painters, the typical traveling daguerreotypist would come to town, rent a few rooms, pass out handbills or place an ad in the local paper, and wait for customers. If the pictures proved satisfactory, word-of-mouth kept business lively, and when demand dropped off, the daguerreotypist moved on. Rural families, like their urban counterparts, dressed up to present an idealized image that reinforced societal notions about who made up a "normal" family and how they should look.

## Post-Mortem Portraits

The daguerrean portrait permitted everyone to join the immortals by leaving their image for the future. Even death could be cheated as those who had not found the time in life for a daguerreotype could be memorialized in death. Often considered morbid by contemporary audiences, post-mortem images (see Figure 2.13) were commonplace in the nineteenth century, where death occurred in the home and was an ordinary part of life.

It is natural for people to want something by which to remember loved ones, just as they do today. The difference is today's ubiquitousness of photographs. Now, the first photographs of a person are often taken within moments of birth or even during the birthing process. Due to photography's newness, it is reasonable to assume many daguerreotype post-mortem portraits, especially those of infants and young children, were probably the only photographs ever made of the "sitters."

Funerary pictures can fascinate and provoke questions about the effect of photographs. Do such images preserve the "presence" of the dead or do they make us more aware of their absence? Do photographs that picture someone who no longer exists recall death, or

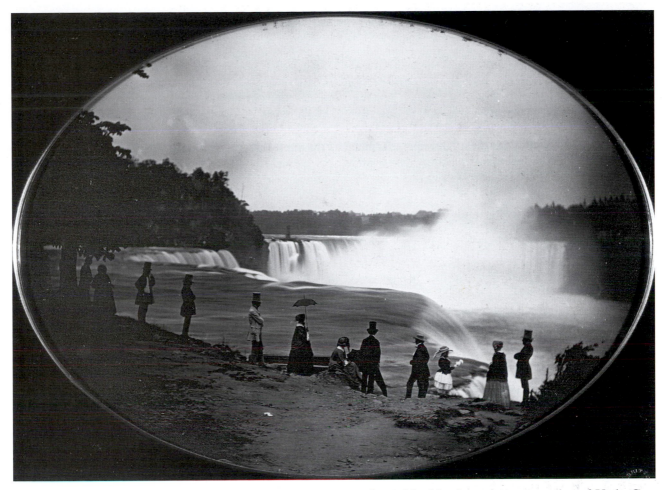

2.14 PLATT D. BABBITT. *Tourists Viewing Niagara Falls from Prospect Point*, ca. 1855. Whole plate daguerreotype with applied color.   Courtesy George Eastman House.

life? Are *all* photographs funerary in the sense that they show us something from the past that will never be that way again?[35]

## The Daguerreotype and the Landscape

American daguerreotypists quickly found new uses for daguerreotypes outside of portraiture. James Renwick, who headed a U.S. government survey of the disputed northeast boundary between the United States and Canada, invited Edward Anthony to make daguerreotypes of the area.[36] In 1842, these plates were submitted to a joint commission and reportedly influenced its decision, thus setting a precedent for the use of photographic images as topographical evidence.

John Charles Frémont, who unsuccessfully attempted to make daguerreotypes on his first expedition to the Oregon Trail in 1842, hired Solomon N. Carvalho to make pictures of his fifth Rocky Mountain crossing in 1853—a trip that turned into an ordeal when the group

nearly perished in the snowy mountains of Utah. Carvalho later recounted:

> I succeeded beyond my utmost expectation in producing good results and effects by the Daguerreotype process, on the summits of the highest peaks of the Rocky Mountains with the thermometer at times from 20 degrees to 30 degrees below zero, often standing to my waist in snow, buffing, coating, and mercurializing plates in the open air.[37]

Carvalho's daguerreotypes and copy negatives were later destroyed in a fire. (Fires were not uncommon during the early studio era due to the use of volatile chemicals in unsafe working conditions and a general lack of concern about safety measures.) During the late 1850s photographic apparatus began to be included in western expeditions. American daguerreotypists were now documenting such faraway places as Hawaii, Mexico, the Philippines, and South America. They were also often the first to introduce photography to Central and South America, building large-scale portrait practices that established a working model for local people to follow.

The desire to see nature's wonders, and the railroad's ability to inexpensively transport people to previously inaccessible areas, converted natural sites into tourist attractions. The most popular nineteenth-century North American tourist destination was Niagara Falls,[38] which was first daguerreotyped in 1840 by Hugh Lee Pattinson

(1796–1858), an English metallurgist visiting the continent to scout a potential mining investment. The views he made on the Canadian side are the first recorded use of daguerrean process in Canada, and one was the basis for a plate in *Excursions Daguerriennes* in 1841.[39] On the American side, **Platt D. Babbitt** obtained a monopolized concession for making daguerreotypes by 1853. His convention of showing tourists taking in the view and thus joining them to the scene, became a formula, fostering a new bourgeois visual pastime: the vacation picture (see Figure 2.14).

## The Daguerreotype and Science

By the mid-1800s, optical devices like the telescope and the microscope had altered how the world was conceived, revealing an immense, systematic cosmos behind the visible appearance of nature. Aesthetic attitudes toward nature shifted with those of science. The daguerreotype, with its built-in wealth of detail and geometric perspective, was quickly accepted as a reliable scientific witness that also conditioned viewers to embrace photographic representation as the normal appearance of things. This acceptance allowed photographs to be used for study purposes instead of actual subjects. As William M. Ivins, Jr., (1881–1961) stated, it would be "through photography that art and science have had their most striking effect upon the thought of the average man of today."[40] As early as 1840, William H. Goode of Yale University was making daguerreotypes from a (solar) microscope,[41] setting the precedent for the miniaturization of data. By 1840 Goode and Professor Benjamin Silliman were attempting to make daguerreotypes with artificial light. In 1850, using fifty pairs of Bunsen's carbon batteries, Silliman reported his success and its future importance:

> In the United States, where fine sunlight may be obtained almost any day . . . these trials may be considered of minor importance. . . . But in the dark and murky atmosphere of London, it may become an important auxiliary in the art.[42]

*The Daguerreian Journal,*[43] the world's first photographic magazine, reported in July 1851 that **John Adams Whipple** (1822–1891) had brought together science and daguerreotyping in his Boston studio. He used a steam engine to clean his plates, heat his chemicals, distill his water, and fan his clients in the summer.

Whipple's scientific background as a chemist and his mechanical inventiveness gave him the credentials to realize the desire of Harvard astronomers to make a daguerreotype of the moon (see Figure 2.15).

Whipple began his experiments in December 1849 at what was then the world's largest telescope. In July 1850 he made the first clear daguerreotype of a star other than the sun. In March 1851 Whipple made the first successful daguerreotype of the moon through a telescope. The image won him a medal at the Great Exhibition in London that same year. The immediate ramifications of this event were recorded in a report by members of the American Philosophical Society who had viewed two of Whipple's daguerreotypes of the moon:

> Hitherto any attempt to portray the scenery of the moon by drawing, has been entirely unsatisfactory in conveying a true impression of its diversified appearance through a telescope; but he now hoped, from the constant improvement in the art of daguerreotyping, that an enlarged picture of the moon's disc may be obtained from which engraved maps might be made, so that selenography of our satellite may be studied in our schools, in conjunction with the geography of our planet.[44]

Such activity was indicative of the appetite for photographic images of natural occurrences. About this same time, T. M. Easterly of St. Louis and Alexander Hesler of Chicago both made daguerreotypes of lightning.

Whipple copied one of his moon plates with his own *crystalotype process* (a glass-plate negative process that used egg white to hold the light-sensitive emulsion in place) to produce paper prints, which were tipped (glued) into the July 1853 issue of the *Photographic Art-Journal*. Previously only a few people had seen the surface of the moon. The daguerreotype dispersed new knowledge to a large audience, offering fresh ways of knowing the universe. The nineteenth century, which had opened with people believing that what was reasonable was true, would conclude with photography encouraging people to believe that what they saw was true.

At the start of the 1850s the daguerreotype appeared to be reigning triumphant, but the expanding picture market demanded cheaper, easier, and faster methods of reproduction than the process could provide. By 1854 the daguerreotype was in decline as influential studios turned to the new collodion method. Within a few years, the flow of daguerreotypes had slowed to a trickle, with more portraits and views being made in the collodion process than by all others combined.[45] The era of unique daguerreotypes was about to be toppled by Henry Fox Talbot's concept of a repeatable, negative/positive system of "photography." But the speed at which the daguerreotype had been accepted and disseminated clearly demonstrated that it was an archetypal invention that fulfilled the desire for realistic commemoration that the world had been waiting to receive while transforming society's sense of how time and space were visually represented.

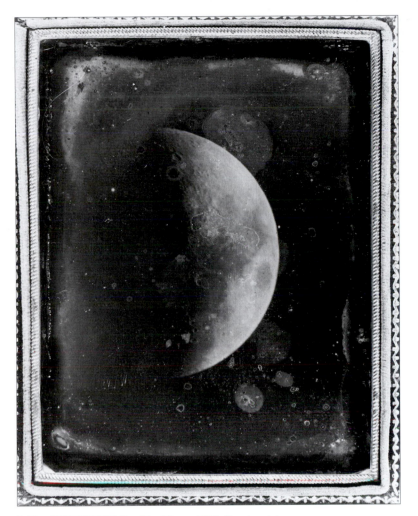

2.15   JOHN WHIPPLE.   *The Moon,* 1852. Quarter plate
daguerreotype.   Courtesy Harvard College Observatory.

# Endnotes

1   On March 8, 1839, while visiting with Morse to inspect the telegraph, Daguerre's diorama burnt to the ground.

2   This letter was published in *The Observer* (New York), April 20, 1839, and reprinted in many newspapers around the country.

3   A common misconception seems to locate the origin of the expression to have one's *portrait taken* within the practice of photography. In fact, as is common to the medium, the term is an extended use of existing artistic vocabulary. According to the sixth edition of the *Shorter Oxford English Dictionary* (2007), the use of the word *take* to mean "draw or delineate" predates photography by about four centuries. Thanks to Greg Drake for pointing this out.

4   Aquatint is an etching method characterized by extensive tonal graduations, from pale gray to velvety black, and possessing a granular visual effect. The name derives from its resemblance to works done with watercolor washes, and it was often used to make color prints.

5   Little is certain about D. W. Seager, as he has always been known in the secondary photographic literature. A British citizen, he may have been a dentist as well as the brother of artist and drawing instructor Edward Seager (1809–1886). In *The Daguerreotype in America* (Greenwich, CT: New York Graphic Society, 1968, revised ed., 158) Beaumont Newhall cites a pamphlet Seager wrote, *The Resources of Mexico Apart from the Precious Metals* (Mexico City: Printed by J. White, 1867). After Seager's death, this work was published in a Spanish translation prepared by his daughter that included her father's given names: *Recursos de Mexico ademas de los metales preciosos. Opúsculo escrito en Inglés por David Guillermo Seager en 1867. Traducido al Español por su

hija Laura Seager en 1884. (México: Imprenta de Francisco Diaz de Leon, 1884). Biographical details and bibliographic citations courtesy Greg Drake.

6   Marcus A. Root. *The Camera and the Pencil.* (Philadelphia: M. A. Root, etc., 1864), 342. This is America's first photographic history book.

7   Despite the efforts of lexicographer Noah Webster (1758-1843), spelling and pronunciation in antebellum America were far from standardized. Daguerreotype (da-GAIR-a-type) was no exception. In fact, confusion was such that "The Daguerreotype," Edgar Allen Poe's article on the still new invention published in the January 15, 1840, issue of *Alexander's Weekly Messenger* (Philadelphia), opened with a lesson on his recommended spelling and pronunciation, which favored the word's French origins. Although Poe's advice never caught on, he followed the already established (and eventually abandoned) convention of capitalizing the medium's name in deference to its inventor. The greatest variation will be found in the adjective form, with *daguerrean* appearing to be the most common spelling of the period and the one used in this text, except in quotation of another usage (e.g. *The Daguerreian Journal*).

8   For more on this theme, see Leo Marx, *The Machine in the Garden: Technology and the Pastoral Ideal in America* (Oxford: Oxford University Press, 1964).

9   Mesmerism, also known as animal-magnetism or hypnotism, was popularized by the Austrian doctor, Franz Anton Mesmer (1734–1815).

10   Nathaniel Hawthorne, *The House of the Seven Gables* (Oxford & New York: Oxford University Press, 1991), 176–77. Edited with introduction by Michael Davitt Bell.

11   The headrest was not invented for daguerreotype portraits but was already in use by portrait painters. The daguerreotype transformed it into a vernacular object by removing it from its painterly context.

12   Letter signed "G" discussing his visit to Wolcott's studio in New York City in 1840, where Wolcott was setting up a room for making daguerreotype portraits, *American Journal of Photography,* 1861, 42.

13   See Nadar, *My Life as a Photographer* (Balzac and the Daguerreotype), Thomas Repensek (trans.), in *October: The First Decade, 1976–1986,* Annette Michelson, et al (ed.), (Cambridge: MIT Press, 1987), 19.

14   "Talk in the Studio/How to Take a Fidgety Sitter." *American Journal of Photography,* 1861. Reprinted in *The Photographic News,* vol. 5, no. 125, January 25, 1861, 48.

15   "Talk in the Studio/Painless Photography," *Western Photographic News.* As quoted in *The Photographic News,* May 7, 1875, 228.

16   *The Amateur Photographer,* February 22, 1915, 4 (supplement).

17   Ralph Waldo Emerson, *Journals, 1841–1844* (Boston: Houghton Mifflin Company, 1911), 100–01.

18   Goddard published repeatable results in December of 1840. Other daguerreotypists refined the method so that exposures could be made within a 20- to 40-second range. When coupled with the Petzval lens, exposure times could be reduced to 10 seconds or less, opening the profitable gates of the portrait market.

19   Claudet's active mind led him to make numerous contributions to the field, including using a red "safe" light to see in the darkroom; designing painted backgrounds for pictorial effect in portrait making (1841); building a camera with a red safelight window so the plate could be developed inside the camera, thereby eliminating the need to always have a darkroom; making improvements in the hand-coloring of plates (1845); building the first light meter (1848); building a "dynactinometer" to compare the speed of different lenses (1850); and developing a shutter-type device that created the illusion of movement (1853).

20   Gilding was performed after the daguerreotype was fixed. The plate was heated over a low flame and a solution of gold chloride was poured over it. This produced a warm brown tone, adding detail to the highlight areas and improving the contrast. The gold coating helped to render the fragile surface of the plate less susceptible to abrasion, increasing life expectancy of the plate. Since gold is more stable than silver, gilding helped to protect the image from oxidation and tarnishing. After its introduction in 1840, gilding became a standard part of the process.

21   "Reminiscences of an Old Photographer," by Thomas Sutton, *The British Journal of Photography,* vol. XIV, no. 382, August 30, 1867, 413.

22   The high quality of the American images became a source of national pride in international competitions, like the Crystal Palace Exposition in London (1851), where American mechanical products—axes, clocks, hoes, nails, ploughs, screws—were hailed for their ingenuity. Horace Greeley, who founded (1841) and edited the *New-York Tribune,* wrote of the London exhibition that in "Daguerreotypes . . . we [Americans] beat the world."

23   Obituary. "Died," *New-York Daily Tribune,* June 17, 1847, 3. Courtesy Greg Drake. Email correspondence with early American daguerreotypy expert.

24   *British Journal of Photography,* XVIII (1871), 583.

25   *British Journal of Photography,* XVIII (1871), 583.

26   Delaroche was one of the first important painters to publicly endorse the use of photography by artists. There is no evidence that Delaroche ever made any such apocalyptic statement.

27   Johann Kaspar Lavater, *Essays on Physiognomy* (1789), quoted in Elizabeth Anne McCauley, *Likenesses: Portrait Photography in Europe, 1850–1870* (Albuquerque: Art Museum, University of New Mexico, 1980). The theory that character could be determined by one's facial characteristics and profile was reflected in silhouette portraits. Lavater's simple theories on aesthetics and posing appeared in photographic journals and manuals and were used in professional practice. They later found a sinister use by providing a basis for ethnic and racial stereotyping.

28   *Historical Statistics of the United*

*States* (Washington, D.C.: Bureau of the Census, 1975), Part 1, 164–65.

29   *The Photographic Fine Art Journal,* Old Series, VIII, New Series V. 2, (1855), 76.

30   For additional information, see Michael Koetzle, *1000 Nudes: Uwe Scheid Collection* (Köln: Taschen, 2001).

31   *Anthony's Photographic Bulletin,* vol. XV (1884), 63.

32   James P. Ball appears in the U.S. Census for 1860, 1870, and 1900. His race is recorded variously as Mulatto, Black, and White, respectively. His parents, William and Susan, also appear in the 1860 census; their race is given as Mulatto. Courtesy Greg Drake. Thanks to Theresa Leininger-Miller, who is researching Ball's biography, for details of his career.

33   See: Deborah Willis (ed.), *J. P. Ball: Daguerrean and Studio Photographer* (New York: Garland Publishing, 1993) for a facsimile of *Ball's Splendid Mammoth Pictorial Tour of the United States Comprising Views of the African Slave Trade; of Northern and Southern Cities; of Cotton and Sugar Plantations; of the Mississippi, Ohio and Susquehanna Rivers, Niagara Falls, &C* (1855), a pamphlet published to accompany the panorama. Also included is a visual inventory of many of Ball's known images.

34   George W. Williams, *History of the Negro Race in America from 1619 to 1880: Negroes as Slaves, as Soldiers and Citizens 2* (New York: G. P. Putnam's Son's, 1883), 141. Quoted in Willis, J. P. Ball, xvii.

35   For more on this topic, see Stanley Burns, *Sleeping Beauty: Memorial Photography in America* (Santa Fe: Twelvetrees Press, 1990) and Stanley and Elizabeth A. Burns, *Sleeping Beauty II: Grief, Bereavement in Memorial Photography American and European Traditions* (New York: Burns Archive Press, 2002).

36   The United States claimed there were highlands on the border while the British denied their existence. Anthony's daguerreotypes (now lost) apparently showed these highlands.

37   *The Photographic and Fine Art Journal,* Old Series, vol. V., New Series Volume 2, Number 8, 124–25 (1855).

38   The opening of the Erie Canal, from New York to Buffalo, NY, in 1825 saw a marked rise in public transportation. Railroads soon followed the same route, spurring the growth of the tourist industry.

39   Graham W. Garrett. "Canada's First Daguerreian Image." *History of Photography*, vol. 20, no. 2 (Summer 1996), 101–103.

40   William Ivins, *Prints and Visual Communication* (London: Routledge & Kegan Paul Ltd., 1953). Excerpt in *Photography in Print: Writing from 1816 to the Present.* 387–88.

41   Microdaguerreotypes, reducing printed material to Lilliputian size for reading under magnification, were reported in 1843 when an experimenter copied a Boston newspaper on a plate just 1 × 1½ inches, which could be read with a twelve-power microscope.

42   *American Journal of Science and Arts,* vol. 11, (May 1851), 418.

43   *The Daguerreian Journal* was edited by S. D. Humphrey of New York. It began publication on November 1, 1850, and continued under various other mastheads until 1870. Another important publication, *The Photographic Art Journal,* was edited by H. H. Snelling of New York. The first issue was dated January 1851 and it also materialized under a series of different titles before ceasing publication in 1860. Both were important assets for the American daguerreotypist, providing a national forum on the latest technical improvements and lively debates about current practice and setting the stage for future publications.

44   *Proceedings of the American Philosophical Society* (July–December 1851), 208.

45   "The Collodion Process—its Use and Abuse," *Humphrey's Journal,* vol. 7, no. 18 (January 15, 1856), 281–82.

# Calotype Rising

*The Arrival of Photography*

## The Calotype

The introduction and acceptance of new mechanically-based devices of visual representation began to alter the viewing content and expectations of imagemakers and the public. Lithography, mezzotint,[1] and wood engraving fueled the remunerative market for the mass production of prints. Daguerre's direct-positive image-making method was an ideal fit for these visual conceptions. The possibility that Talbot's two-step, negative/positive print system was a more advantageous process was not at first seriously considered. Daguerre's necromancy had mesmerized viewers with its detailed, miniature, monochrome reflections of the world. Even Talbot's friend Herschel said of daguerreotypes that "Certainly they surpass anything I could have conceived as within the bounds of reasonable expectation."[2] Daguerre also held the economic and political advantage, as the British government offered Talbot neither a pension nor honors for his discovery. Talbot had to advocate his own cause, patenting his process in February 1841 and demanding a high license fee, which added to its production cost. His patents not only proved unprofitable, but they also had the deleterious side effect of inhibiting the growth of

3.1 WILLIAM HENRY FOX TALBOT. *The Open Door*, 1843.
Salted paper print from a calotype negative. Plate VI of *The
Pencil of Nature* (London, 1844–1846).

photography in England by confining its commercial use to those few with capital to invest.[3] Later in 1841, Talbot contracted with Antoine Claudet, who had opened a London daguerreotype studio in June, to offer calotype portraits, but his success was negligible. The calotype process was extremely slow, impure chemicals gave uncertain results, prints often faded, and the highly visible paper fibers produced a soft and grainy look that many found undesirable. The process was considered unreliable, and as a consequence nobody wanted calotype portraits. Nevertheless, the limitations of the daguerreotype, especially in terms of reproducibility, started to become apparent. Upon reconsideration, people realized that Talbot's linkage of light and paper furnished a conceptual and technical vault that united printmaking and science. This in turn provided an engine for mass-produced pictures that Europeans had been developing since the Renaissance, making art more "accurate" and accessible and causing the daguerreotype to finally become obsolete.

The initially perceived "faults" of Talbot's negative/positive system actually gave it a versatility that proved to be its strength. The calotype's visual softness neutralizes singular detail in favor of the universal. Its matte surface image, with a limited tonal range, makes contrast and mass, and not sharp line, the major visual impulse. In nineteenth-century academic art theory, the intense detail of the daguerreotype was considered detrimental to *effect*. The calotype excelled in *effect,* the emotional atmosphere created by the artist's handling of *tonal masses* (colored areas) as distinguished from linear elements. As photographers considered the artistic potential of their medium, they adopted these painterly concepts, considering photographic detail a mechanical imprint, and the control of tonality as the mark of artistry.

The calotype's flexibility allowed photographers to manipulate the image before a print was produced. To increase its light sensitivity, albumen and iodizing solutions were applied to the paper before exposure. Waxing the negative with beeswax made the paper more transparent and increased visual detail. Retouching was common; pencil, graphite, and watercolor were used to remove surface defects, to add highlights, and to create points of visual emphasis. India-ink was commonly applied to black out the sky portion of a negative so it would print as a clear blank space. Long exposures did not stop

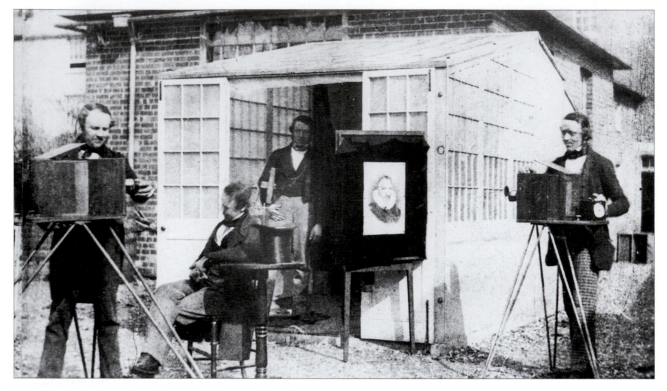

3.2 Talbot's photographic printing establishment at Reading, ca. 1845. Harry Ransom Humanities Research Center, The University of Texas at Austin.

movement, and blurry clouds and/or dense and uneven skies gave a mottled effect. Blacking out the sky also hid the imperfections of the paper matrix that were brought out by subjects with little surface detail. India-ink was also used to eliminate some parts of the camera-made image and to add others, such as mountains on a flat horizon.

## Romantic Aesthetic

The calotype was grounded in the Romantic aesthetics of its generation, which reached its zenith in 1800, the year of Talbot's birth. Romanticism, which prized emotional experience, was a reaction against the established state, Church, and rational Enlightenment thought, and a manifestation of the political spirit of the American and French revolutions.[4] The Romantic ideal emphasized the picturesque and featured rushing brooks, overgrown foliage, and tumbledown structures. It began in England during the late eighteenth century as a method for examining nature and as a guide for making gardens. Providing a construct for seeing what in nature would make a good picture, it gave viewers a prescribed route through an image. Detail and texture were of prime importance, and people were often incorporated into a picture as a device to help viewers negotiate the space and find their place in nature.

The picturesque landscape of Romanticism was built on the pictorial concepts of the sublime and the beautiful, opposing schema that cannot commingle.

The *sublime*, like a storm on the ocean, locates its origins in awe, terror, and vastness, while the *beautiful*, a calm harbor sunset, situates its lineage within the organization of society. Characteristics of the sublime include astonishment, darkness, infinity, solitude, and vastness. It features intense directional light and a dynamic interaction between highlights and shadows. Being delicate, rounded, smooth, and well-proportioned, the beautiful is less powerful and favors a soft, diffused light. It was admirable, but it was not capable of arousing great passion.

Talbot's *Sun Pictures in Scotland* (1845) are a pictorial tribute to Sir Walter Scott's Romantic concepts of the gothic and picturesque, featuring disintegrating structures, dramatic use of light emphasizing highlight and shadow areas, secluded settings, and serpentine, undisturbed vistas. Their warm, luxurious tones and soft delineation of form naturally express Romantic pictorialism.

## Early Calotype Activity

Talbot photographed the daily activities of his estate, family, and servants, providing a model for future backyard snapshooters. During his travels in Britain and Europe during the early 1840s, Talbot made as many as twenty calotypes a day, showing his enthusiasm as well as the ease with which calotypes could be made. The negative material could be prepared the evening before, freeing the calotypist from needing a darkroom for every exposure. While traveling on business, Talbot would develop his paper negatives each evening and mail the results to Lacock Abbey. There they were printed by Constance Talbot, making her

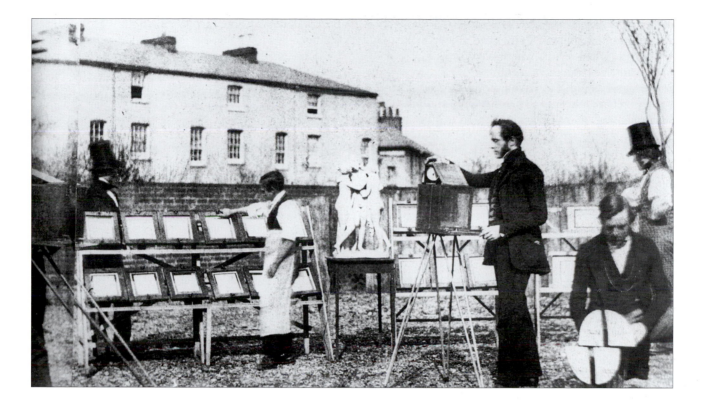

the first woman photographic processor, and Nicolaas Henneman, Talbot's Dutch valet, photographic assistant, and business manager.

Talbot's *The Pencil of Nature* was the first book to be fully illustrated by calotypes (earlier he had issued a pamphlet with a calotype on the cover).[5] Published by subscription, with fewer than 300 copies released in six installments between June 1844 and April 1846, *The Pencil of Nature* realized Talbot's dream of "every man being his own printer and publisher" and of "poor authors [making] facsimiles of their works in their own handwriting."[6] The progenitor of the photographically illustrated book promoted Talbot's calotype and provided the inventor's first commentary on the aesthetics of the medium. The introduction to *The Pencil of Nature* traces the invention of the process, and the succeeding twenty-four sections illustrate and discuss its possible applications, including artistic expression, documentary uses, art duplication, scientific illustration, and study and teaching assistance. The book's calotypes feature architectural studies, still-life compositions, and works of art alongside a page or two of text discussing the purpose of each image, setting a precedent, derived from printmaking, for pairing photographic images with words. Choosing to make more than a picture book, Talbot used words to provide the image with a directed context, indicating an awareness of how an image's meaning can be affected by the text accompanying it.

Talbot's image selections illustrate his belief that subject matter is "subordinate to the exploration of space and light."[7] Three plates show that the calotype excelled in such explorations while securing the ethereal nuances

of light reflected by objects. In the two plates of *The Bust of Patroclus*, Talbot demonstrates the medium's pictorial possibilities and creative control involving choice of angle of view, type of light, and scale. In his text to *The Open Door* (see Figure 3.1), Talbot compares vernacular photographic realism, the forerunner of the snapshot, to Dutch genre painting, and reveals his allegiance to the Romantic picturesque landscape conventions:

> We have sufficient authority in the Dutch school of art for taking as subjects of representation scenes of daily and familiar occurrence. A painter's eye will often be arrested where ordinary people see nothing remarkable. A casual gleam of sunshine, or a shadow thrown across his path, a time-withered oak, or a moss-covered stone may awaken a train of thoughts and feelings, and picturesque imaginings.[8]

Other pictures reveal the calotype's ability to trap "a multitude of minute details which add to the truth and reality of the representation,"[9] that may have even gone unobserved by the photographer. His book also foreshadows the future strength of photographic image-making in its ability to produce multiple (positive) prints from a camera-made matrix (negative).

Talbot founded his own photographic printing factory (the first photo finishing lab), The Talbotype Establishment, in Reading in the fall of 1843. It was a multipurpose facility, producing prints for books and reproducing prints of art objects and valuable documents that were sold through retail outlets. Here paper negatives were placed in contact frames with unexposed silver chloride printing-out paper and exposed, for a couple of minutes to over an hour, in direct sunlight until an image appeared. Afterwards the

prints were fixed, washed, and dried. As production procedures were refined, Talbot was able to make thousands of original prints, which were tipped-in (pasted) to illustrate *The Pencil of Nature.*

Here one could also have a portrait made, take lessons, purchase a license to practice, buy equipment and materials, and make arrangements to use the printing and distribution network. These services, plus systematic distribution methods, created standards of practice, bringing together aesthetic ideas and technical inventions that had defied standardization.

However, the high cost of producing a limited edition calotype album or book doomed the calotype in the new, congested domain of commercial printmaking.[10] The search for a photo-based process capable of reproducing editions of hand-created art at affordable prices led to the invention of numerous processes, the first being *cliché-verre.* Devised shortly after Talbot announced his photogenic drawing, *cliché-verre* was the product of three English artists and engravers, John and William Havell and J. T. Wilmore, who exhibited prints from their technique in March 1839. Cliché-verre combines the handwork of drawing with the action of light-sensitive photographic materials to make an image. Originally a piece of glass was covered with a dark varnish and permitted to dry, and then etched with a needle. The finished glass was used as a negative and was contact-printed onto photographic paper. Later, Adalbert Cuvelier modified the process to use the wet-plate process.

High costs and technical difficulties prevented Talbot from receiving any economic benefits from his discoveries. The first prosperous artistic and economic fusion of the calotype was achieved through the collaboration of painter **David Octavius Hill** (1802–1870) and chemist **Robert Adamson** (1821–1848) in Scotland, where Talbot did not patent his method. When a large group of clergymen broke from the Church of Scotland at an Edinburgh assembly in 1843, Hill decided to commemorate the event with paint. The idea of obtaining likenesses of the hundreds present, most of whom would leave town shortly, seemed unworkable until Sir David Brewster introduced Hill to young Adamson, who was instructing Brewster in the calotype process. The intersection of diverse ages, backgrounds, and interests produced a blend of aesthetic and technological abilities that made Hill and Adamson's calotype portrait studies among the finest ever done. Hill's giant painting, *Disruption,* not completed until 1866, used the camera to replace the eye and hand of the artist in making preparatory sketches, but its unprocessed agglomeration of 457 figures reflects the difficulty of translating the unique physical effects of the photographic medium into paint.

The pair's calotype portraits, made under Hill's direction, reflect the artistic and stylistic concerns of Dutch genre and Scottish portrait painting. Generally, the compositions are direct and simple, with each person posed alone, outside, in open daylight.[11] Hill diffused the deep shadows that the summer sunlight produced by bouncing light into the scene with a concave mirror, which made for dramatic *chiaroscuro* lighting (a pictorial treatment favoring the play between light and shadow). Hill and Adamson understood that the calotype was matchless at revealing a subject's interaction with the surrounding space and that the lack of specific detail could amplify a subject's specific characteristics. In a letter written in 1848 Hill said:

> The rough surface, and unequal texture throughout of the paper is the main cause of the Calotype failing in details, before the process of Daguerreotypy—and this is the very life of it. They look like the imperfect work of a man—and not the much diminished perfect work of God.[12]

Hill and Adamson, traditional shorthand for the partnership that operated as D. O. Hill & R. Adamson, expanded their efforts and soon were doing general portraiture in their outdoor studio and among the monuments of the Greyfriars cemetery. Before Adamson's early death in 1848, the partners produced some 1,500 works, including a flawlessly composed series of seemingly casual portraits of the fishing people in nearby Newhaven.

In the George Eastman House collection of Hill and Adamson's work, the fingerprints of the creators can be seen along the edges of many of their prints, along with the watermark of the J. Whatman "Turkey Mill" paper.[13] The softness of the calotype, juxtaposed with the hard-line quality of the daguerreotype, invites a subjective reading of the image. Since the calotype portrait is two-dimensional, and has a nonreflective surface, one does not have the sensation of merging with the subject in the picture that is possible with a three-dimensional, mirrored daguerreotype. A viewer becomes detached, more a witness than an active participant. Hill and Adamson made the calotype's suppression of detail an asset. There is a feeling of intimacy and subtle beauty in their tight expressionistic compositions, along with an overwhelming sense of atmosphere as light itself becomes a subject. Hill and Adamson realized that the person in front of the lens was not always the only subject of the picture.[14] They knew that good photographs were the result of conscientious photographers, of what modern photographers call *previsualization,* the awareness that one cannot just point the camera at a subject and expect a miraculous representation to come forth. A good calotype was the result of controlling the process, being acutely aware of the light, constructing a vision, and knowing how it would look photographed. Hill and Adamson understood the subjective nature and the limitations of the calotype. While their images are dependent on established styles, their thoughtful, shadowy pictures are alive and speak directly of the inner, as opposed to the outer, characteristics of their subjects.

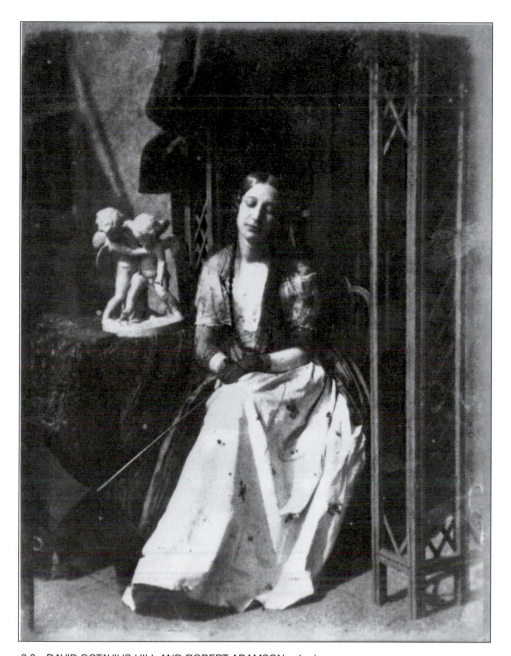

3.3   DAVID OCTAVIUS HILL AND ROBERT ADAMSON. *Lady Elizabeth Eastlake* (Miss Rigby), ca. 1845. 7⅞ × 6 inches. Salted paper print from a calotype negative.   Courtesy George Eastman House.

London's Crystal Palace Exhibition of 1851 featured the international splendors of artistic, scientific, and technical progress (see Figure 3.4). It included about 700 camera images from six countries, which proved jarring to the small British photographic community. The Americans took the top honors in daguerreotypes, and the French exhibited such high-quality calotypes that Hill and Adamson received only an honorable mention. This was intolerable to Britain's gentlemen-amateur calotypists, many of whom knew Talbot. In 1852, the presidents of the Royal Academy and the Royal Society, Sir Charles Eastlake and Lord Rosse, sent Talbot a letter affably stating that "the French are unquestionably making more rapid process than we are [and] some judicious alteration of the patent restrictions would give great satisfaction, and be the means of rapidly improving this beautiful art."[15] Talbot, realizing that even his friends no longer supported his efforts to profit from his calotype process, relaxed his rights over amateur work. However, he continued to retain patent rights in professional portraiture.

A massive four-volume series of books printed at the conclusion of the Exhibition summarized the best of everything shown.[16] These volumes reveal the Victorian appetite for identifying, categorizing, and labeling all the new products of the industrial age. They also

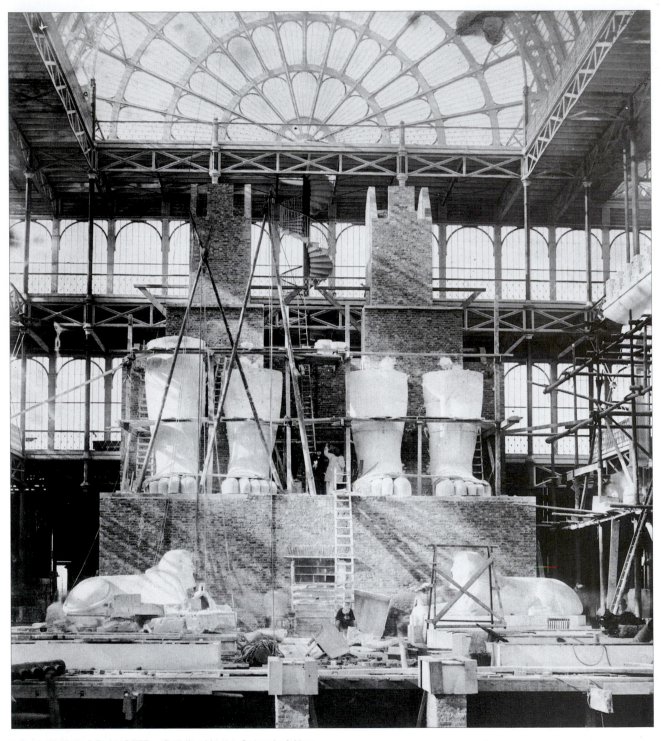

3.4    PHILIP H. DELAMOTTE.    *Building Up the Colossi of Aboo Simbel* (London, 1855). Salted paper print from a calotype negative. Plate #95, Volume II of *Photographic Views of the Progress of the Crystal Palace, Sydenham.*    Courtesy Collection of the Juliette K. and Leonard S. Rakow Research Library of the Corning Museum of Glass, Corning, NY.

make clear the underlying belief that society could be made better by enlightened technical advancement. This optimistic "can-do, we are right, and we will make the world better" British attitude is exemplified in the series' factual celebration of the new machine-based culture in which the camera now played a major role as an automatic conveyor of the type and style of information that was in demand. The volumes included salted paper prints of the products that were deemed truly worthy by the Victorians: large blocks of coal (which had been placed outside the exhibit hall and numbered); marine and locomotive engines; a turbine; a steam hammer; an electro-magnetic apparatus; an Indian Rubber boat and pontoons; and a model house for working-class families promoted by Prince Albert (the photograph

is credited to the prince, an amateur photographer) to "place within the reach . . . those comforts most conducive to health, to habits of cleanliness and decency, hitherto been enjoyed as luxuries only by the few."[17]

Finally able to make calotypes without a license, British calotypists experienced a brief (1852–1857) golden period. In January 1853 the Photographic Society of London (called the Royal Photographic Society of Great Britain after 1894) was created with Sir Eastlake as president.[18] The Society commenced publishing its *Journal of the Photographic Society* in March 1853 to facilitate the exchange of information.

A paper, "Upon Photography in an Artistic View," was presented at the group's first meeting by Sir William Newton (1787–1869) and published in the *Journal of the Photographic Society*. It touched off a tempest that has never completely settled.[19] Newton, a miniaturist painter who took up photography, advised photographers making photographs intended as studies for painting to put their subject "a little *out of focus,* thereby giving a greater breadth of effect, and consequently more *suggestive* of the true character of nature." He also advocated the process of altering the negative "by a chemical or other process" to achieve a "picturesque effect," emphasizing areas of light and shade while downplaying detail or to make up for defects that occurred in the process. Newton did say that "When photography is applied to buildings for *architectural* purposes, then every effort should be exerted to get all the detail as sharp and clean as possible." However, his interest lay in how photography could best serve the painter by "applying photography as an assistant to the Fine Arts," not in how it might function as an independent art.

Newton's paper set the terms of the ongoing debate between those who believe that photography's heart lies in its ability to provide "exactitude of delineation which completely sets at nought the exertions of *manual* ingenuity," and those who believe that artistic effect takes precedence over precision. As in the parlor game of "telephone," Newton's statements became distorted as they were repeated. Over time people allied "artistic" photographs with unsharp photographs, forgetting that Newton was only referring to photographs made for use by artists. At a later meeting Newton reiterated, to no effect, his belief that when making "record" photographs the focus should be as sharp as possible.

Newton's paper also opened the continuing discussion on the qualities a photograph must have to be considered art. One side, the realists, claimed then as now that photography's intrinsic quality is its ability to provide a precise representation of reality. They believe that this straightforward, objective characteristic makes photography a unique art form, and that it should be held sacred. The other side, the expressionists, believe the photographic process to be a series of manipulations of reality, postulating that additional reworking is justified to introduce the imagemaker's subjective concerns and

to remove the photograph from the realm of mechanical reproduction. As the medium grew, these questions would expand into a larger controversy as to whether photography was capable of being an independent art form.

Thomas Keith (1827–1885), an Edinburgh physician, was an amateur who practiced the waxed-paper calotype from 1851–1856. A friend of Hill's who admired and collected some of his calotypes, Keith made penetrating factual architectural studies of the Edinburgh environs, including the Greyfriars Cemetery. He was fastidious in his materials preparation and only made images before seven in the morning or after four in the afternoon, when atmospheric pollution (caused by burning coal and wood) was less severe and the angle of light was low enough to best reveal surface detail and texture. His city views revel in an air of Romanticism and ignore the new machine age constructs, lamenting the loss of a place that has been altered by the effects of industrialization.

## Calotypists Establish a Practice

The calotype was widely and richly practiced in France. Without Talbot's patent restrictions the calotype was cheaper to make, easier to use, and provided countless positive prints, giving daguerreotypists numerous reasons to take up the process. One of the most accomplished calotypists was Louis-Désiré Blanquart-Evrard (1802–1872), who in 1847 discovered that soaking the paper in the emulsion, rather than brushing it, made the paper more sensitive, eliminated streaking, and produced a longer and more continuous tonal scale. This generated more radiant highlights and greater detail in the shadows, making the calotype less ephemeral and more representational. He also devised a practical method of reducing exposure time by chemically developing-out the invisible (latent) image, which became the model for future negative/positive systems.

In 1850, Blanquart-Evrard introduced his albumen-coated paper, whose emulsion layer was applied *after* it was coated with egg white, which gave a print more detail and contrast. This solved a major public aesthetic barrier, for the image no longer rested *in* the paper but *above* it, on a separate, glossy, smooth surface. The downside was that the glossy surface reduced the visual intricacy the paper fibers provided and diminished a sense of depth, as the picture floated ever so slightly aloft from its support base. Prints made from this process are known as *albumen silver prints,* and they became the principal medium for photographic printing until the end of the nineteenth century, when they were superseded by gelatin silver prints.

The biggest technical obstacle facing the commercial use of the calotype was the problem of fading. In England, the Photographic Society formed a Committee on

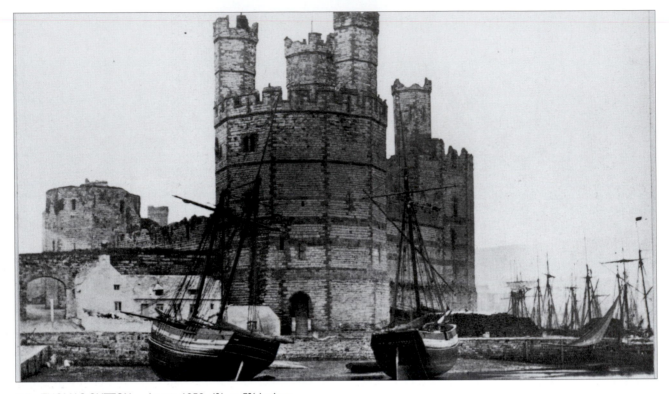

3.5   THOMAS SUTTON.   *Jersey,* 1856. 4⁵⁄₁₆ × 5⅝ inches.
Salted paper print from calotype negative.   Courtesy George
Eastman House.

Fading to investigate the issue.[20] The Committee dis-
covered that the major culprit of fading was improper
fixing that left a residue of hyposulfite of soda in the
paper fibers. Blanquart-Evrard's prints, however, were
so uniform in quality that they did not suffer from
fading as Talbot's did, and Blanquart-Evrard's techni-
cal improvements enticed people to use the calotype.
Blanquart-Evrard opened a printing enterprise at Lille
in September 1851. He devised a method of increas-
ing the number of prints made from a single negative
from three or four a day to 200 or 300, then expanded
production up to 5,000 prints a day, lowering the cost
of making books with tipped-in photographs. The Lille
facility was an assembly-line operation, employing up to
forty people in a division of labor in which procedures
were individualized and carried out in special rooms.
The paper was sensitized in one room and exposed in
another. Each employee conducted an isolated piece of
the process, without ever being involved in the creation
of a unified product, demonstrating that the process
could be standardized and industrialized just like the
daguerreotype. His printing enterprise had an immense
impact on French calotype production and spurred a
number of imitators, but it was not financially success-
ful and closed in 1856. British calotypist Thomas Sutton
convinced Blanquart-Evrard to collaborate with him in
Jersey (1855–57), bringing the British and French photo-
graphic communities closer together. This endeavor too
was doomed as the public taste had switched to albumen

prints, which were made from glass plate negatives and
eliminated the deficiencies of the paper negative.

However, these early printing companies established
the photographic print as a vehicle capable of providing an
accurate representation in a mass communication setting.
The French printing firms produced calotypes in a wide
range of colors, from slate-gray, to purple-black, to a series
of red tones ranging from pale rose to a dark oxblood, to
an occasional yellow print. The range of colors produced
by the French printing firms matched the look of litho-
graphs and mezzotints familiar to the public, placing the
calotype in an established visual system. Through their
circulation the public became acquainted with convenient,
inexpensive, and practical photographic prints.

Blanquart-Evrard's Lille printing establishment pro-
duced the prints for three important archeological books:
Maxime du Camp's *Egypte, Nubie, Palestine et Syrie*
(1852), J. B. Greene's *Le Nil* (1854), and Auguste Salz-
mann's *Jerusalem* (1856). Blanquart-Evrard also edited
and published a series of albums, including *Mélanges
photographiques* and *Galerie photo-graphique*, featur-
ing photographs of architecture and works of art, and
provided printing services for other photographers.

**Thomas Sutton** (1819–1875) learned the calotype
process when he moved to the pastoral island of Jersey in
1850. He was so astonished by Blanquart-Evrard's print-
ing improvements that he had Blanquart-Evrard print his
album, *Souvenir de Jersey* (1854), and embarked on a
series of experiments to equal Blanquart-Evrard's methods.
Sutton actively promoted the calotype by writing books,
including *A Handbook to Photography on Paper* (1855);
running a Photographic Institute in Jersey where lessons
and photographic outfits were available; and publishing a

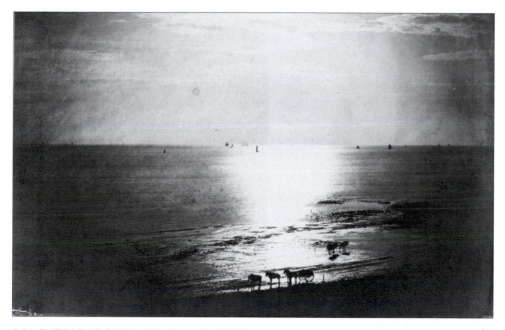

3.6   GUSTAVE LE GRAY.   *The Sun at Zenith, Normandy,* ca.
1855. 12¾ × 16⅝ inches. Albumen print from paper negative.
In addition to being fast enough to stop action like breaking
waves, the practicality and reproducibility of Le Gray's process
also made it excellent for making architectural views and was
used by many of the photographers who documented France's
endangered national historical sites.   Courtesy George Eastman
House.

journal, *Photographic Notes* (1856–1867), to express his
ideas on calotype aesthetics. Sutton considered the prints
of Blanquart-Evrard superior to other calotypes and com-
parable to any "chaste works of art."[21] Sutton recalled how
Blanquart-Evrard's prints first visually affected him:

> Nobody's printing . . . satisfied me. . . . I fell in love at first
> sight with its [Blanquart-Evrard's] rich, deep velvety tones,
> to which nothing in pictorial art seems to approach, and com-
> pared with which prints upon albumenised paper seemed in-
> tolerably vulgar.[22]

Sutton applied the visual criterion of lithography to
the calotype, favoring prints that looked like "proofs on
India paper." He did not care for the practice of using
a hypo-toning bath that gave a yellow-green color, and
he disliked the glossiness of albumenized paper. Sutton
devised a whey-coated paper, rather than salt, utilizing
a developing-out process that relied on a gold-toning
bath before the fixer to achieve its visual richness and
permanence.[23] He had a repugnance for the deadness
of prints produced from negatives in which the sky had
been blacked out.[24] Sutton dealt with movement in his
pictures by making his views of the Jersey harbor at
low tide, when the boats were securely anchored (see
Figure 3.5). Sutton's drive to resolve issues of perma-
nence and improve the calotype's printmaking aesthetic
assisted photographers in discovering their own com-
positional structure and set photography on the road to
becoming a recognized art form and cultural influence.

Four important calotypists, Roger Fenton, Charles
Nègre, Henri Le Secq, and **Gustave Le Gray** (1820–
1884) took up photography after studying painting at
Paul Delaroche's atelier, demonstrating the active inter-
change of ideas among a close circle of practitioners.
Like Blanquart-Evrard, Le Gray's refinements got more
people interested in the calotype.

Le Gray improved the waxing of calotype negatives.
Unlike Talbot's, in *Le Gray's process*[25] the negative was
waxed *before* it was sensitized. His method allowed
the paper to be prepared in advance, provided greater
retention of detail, and reduced exposure times that per-
mitted moving subjects like the ocean to be recorded (see
Figure 3.6). Le Gray used the process for his *Forest of
Fontainebleau* series in which he tackled the calotypist's
nightmare of moving foliage. Foliage movement had been
such a problem that other practitioners, such as Newton,
favored making images of trees when they didn't have
any leaves. Le Gray was able to retain the velvety, ethe-
real shimmer of rich foliage, permitting viewers to move
into the deep space of a forest setting. The original bronze-
colored prints reflect the concerns of the Barbizon School
of landscape painters, who rendered their subjects from
direct observation of nature. This straightforward, anti-
classical style fit with how the camera was being used.
The attitude of academically trained painters towards the
calotype was summed up in Le Gray's introduction to one
of his books on photographic technique:

> The artistic beauty of a photographic print consists almost
> always in the sacrifice of certain details, in such a manner as
> to produce *une mise à l'effet* which sometimes reaches the
> sublime of art.[26]

**Charles Nègre** (1820–1880) learned the waxed-
paper process from Le Gray in order to make studies
for his genre paintings. Unlike most historical painters,
who only saw photography as a visual dictionary, Nègre

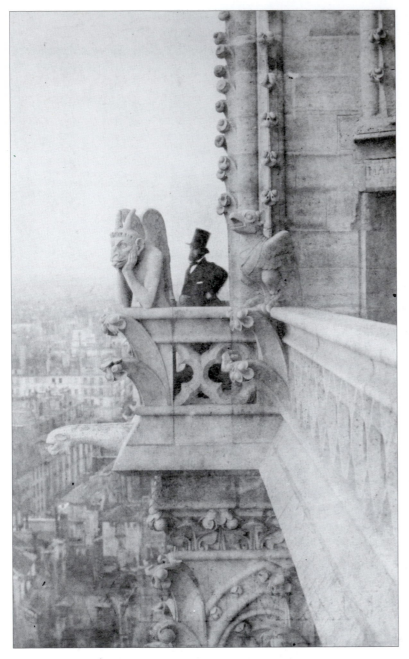

3.7   CHARLES NÈGRE.   *The Vampire* (Henri Le Secq at Notre Dame Cathedral, Paris), 1853. 33 × 23.4 cm. Salted paper print.
National Gallery of Canada, Ottawa.

rethought the position of the photograph and by 1851 was making finished works in both media. Nègre is a model for the artist/photographer who used observation and reason to produce highly selected, subjective renditions of what he saw through the camera.

His *The Little Ragpicker* (1851), which was regarded as being "no longer a photograph" but rather a consciously envisioned act of art,[27] signaled his readiness to photographically explore genre scenes of Parisian street life featuring working people such as chimney sweeps. This marked another turn in the "who" being pictured, expanding what was important to be "saved"

for the future. Imagemakers no longer had to concentrate only on subjects endowed with upper-class substance and began to represent the ordinary scenes of daily life. To satisfy this pre-snapshot impulse for instantaneous street pictures, Nègre fabricated a "fast" lens, with increased *lens speed*,[28] that could stop most action, giving them the spontaneous quality of a snapshot. These concerns culminate in Nègre's last major photographic commission, of the Vincennes Imperial Asylum for disabled workmen. Working inside with available light, Nègre made remarkable environmental portraits of the personnel and the patients engaged in their everyday routines. Nègre also knew how to calotype architecture so that it retained a strong physical and emotional presence. He often printed his paper negatives on salted paper, which allowed him to emphasize form and tonal mass to give a sense of pictorial depth while letting go of optical clarity.[29] Commenting on his work at Chartres, Nègre said:

> I have sacrificed a few details, when necessary, in favor of an imposing effect of a kind that would give a monument its real character and would also preserve the poetic charm that surrounded it.[30]

One of Nègre's remarkable visions is *The Vampire* (1851), made from the balustrade above the Grande Galerie of Notre Dame. It juxtaposes monumental shapes with differentiating light and dark sectors to produce a magnetic force across the picture surface. The visual, directional thrusts come together on the platform where a man in a top hat, Nègre's friend Henri Le Secq, stands out against the white sky. Exercising aesthetic control, Nègre opaqued the negative for emphasis and used pencil shading to accentuate highlight areas of the vampire gargoyle, the floral design on the top of the balustrade, the building below, and aerial perspective. The compressed tonal range of the salted paper print provides warmth and a strong tactile sense of the stone surfaces of the church. The space becomes self-animated, possessing a vibrant glowing quality of movement.

## Calotype and Architecture: Missions héliographiques

The calotype's field serviceability and ability to provide numerous copies was important in a series of architec-

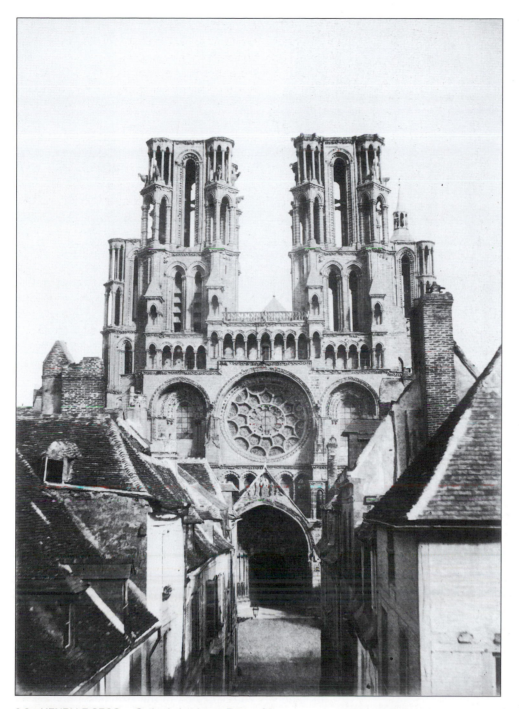

3.8  HENRI LE SECQ.  *Cathedral at Laon, France* (View between houses to Cathedral Portal), 1851. 12 × 8⅝ inches. **Calotype.**  Courtesy George Eastman House.

tural and archeological documentary projects of the early 1850s. In 1851, the *Missions héliographiques* was formed to record France's important monuments, which were endangered by deterioration and indifference. Five photographers, Édouard Baldus, Hippolyte Bayard, Gustave Le Gray, Henri Le Secq, and O. Mestral (whose first name has been lost), were hired and assigned to different regions, marking the first government sponsorship of a major photographic project.

The project was fraught with the problems artists face when they accept state patronage: the risk of becoming agents of national policy and compromising their own standards of purpose and quality. Yet aesthetically this survey set a standard for future governmental projects and began a worldwide trend of documenting historical sites.

A core group of the Missions héliographiques photographers was instrumental in forming the Société héliographique, the world's first photography association, predating London's Photographic Society by about two years. The Société was organized in 1851 to disseminate information, professionalize the practice,

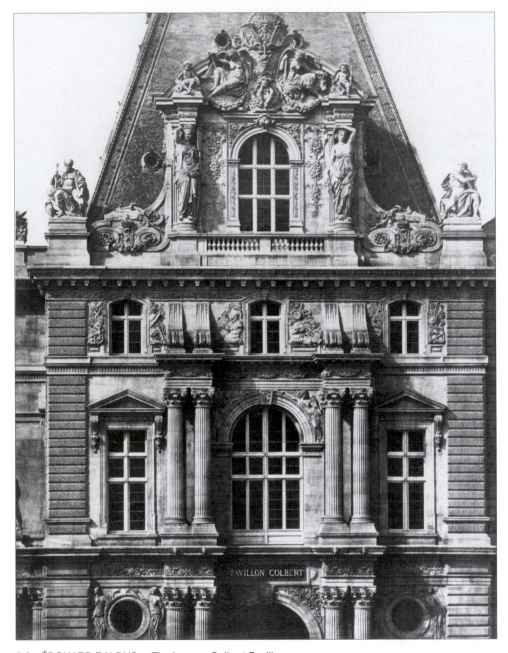

3.9   ÉDOUARD BALDUS.   *The Louvre, Colbert Pavilion,* ca. 1857–1858. 17⁵⁄₁₆ × 13⁷⁄₁₆ inches. Albumen silver print from glass plate negative?   Courtesy George Eastman House.

provide a forum for practitioners, and publish Europe's first photographic journal, *La Lumière* (1851–1860). Such early journals, on both sides of the Atlantic, were major sources of photographic information and provided forums for readers to discuss and advertise practices and products.

**Henri Le Secq** (1818–1882) learned the calotype process from Gustave Le Gray and made a series of architectural investigations for the Missions project. His work revealed a new structural strategy of formal, frontal composition that concentrated on the relation-

ship between the building and the angle of the camera. To Le Secq, the visual order of the cathedrals and monuments corresponded to the structure imposed by the camera on the photographer (see Figure 3.8). The perspective of the camera, as well as the photographer's sense of composition, determined how best to photograph an architectural site. At each site, Le Secq typically made a general view emphasizing the organization and symmetry of the structural mass and a series of details revealing the intricacies of sculptural minutia (he collected ironwork). His images show an ordered approach of a person in control of the medium, relying on the repetition of line to form a powerful flow of upward, directional movement, representing the spiritual quality of geometry. His final project, before he

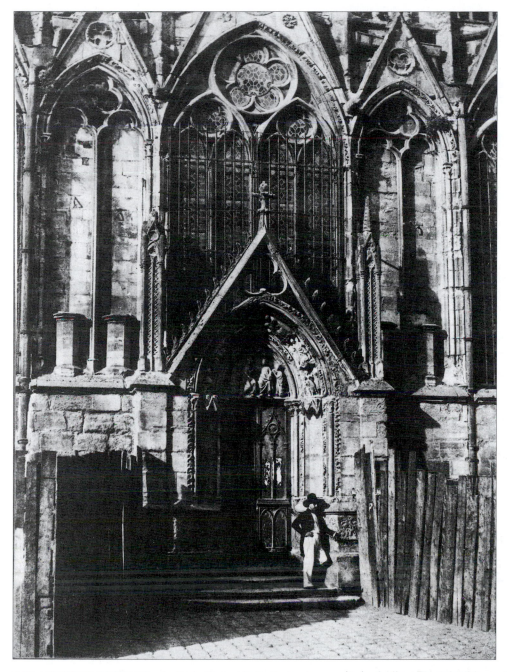

3.10   CHARLES MARVILLE.   *La Porte Rouge, Notre Dame de Paris.* 8⅛ × 6⅛ inches. Salted paper print. Plate 46 of the album *Mélanges photographiques* (Paris, 1851), Blanquart-Evrard, editor.   Courtesy George Eastman House.

gave up photography in 1856, was a deft series of still lifes.

**Édouard Baldus** (1813–1889), a painter of portraits and religious subjects, got interested in photography in 1849 and became the "official" photographer of his generation, completing numerous government and private commissions between 1851 and 1859. Working for the Commission des monuments historiques, he photographed the monuments of Paris and areas south of

it, including Fontainebleau, Burgundy, the Rhone Valley down to Arles, and Nîmes. He also photographed the Midi under a commission by the Ministry of the Interior, and executed other commissions including the architectural motifs and sculpture of the Louvre's new facade (see Figure 3.9); the building of Baron James de Rothschild's railroad; the flooding of the Rhone; and the new railroad line from Paris to Lyon. Baldus recognized the importance of choosing a vantage point that illuminated the three-dimensional nature of the subject. In addition to the traditional frontal views of his contemporaries, he often favored oblique points of view. His compositions rely on balancing competing planes of pictorial space through the use of horizontal

and vertical counterpoints, eliminating distractions, and concentrating the viewer's focus within the pictorial organization of his frame.

Baldus, an expert printer, regularly retouched his prints with ink and pencil. He relied on three printmaking methods to create *effect*. First, he used the softness of the salted paper to tone down the hard-edged effects of retouching and to provide a lithographic texture. Second, he favored salted paper that was albumenized after printing to supply a surface sheen that resembled a varnished oil painting. Lastly, Baldus counted on the albumen paper to deliver unrivaled detail and tonality. Even when Baldus switched to the wet-collodion glass-plate process in the mid-1850s, he used a printing style that allowed him to retain the visual character and artistic effect of the paper negative. His exquisitely sharp, open, yet poetic printing style favored full highlight detail while retaining an airy translucency in the shadows, communicating a tremendous amount of visual information. The degree of visual organization, compositional tension, and a full, rich printing style that accented relief helped establish standards of documentary practice. Baldus continued to make new images until about 1874, after which he devoted his energies to publishing photogravures of his views.

**Charles Marville** (1816–c.1879) was an engraver, lithographer, and painter before taking up photography in 1850. His early landscapes and architectural photographs began to appear in Blanquart-Evrard's folio collections in 1851 (see Figure 3.10). Beginning in 1852, and continuing for almost 20 years, Marville methodically recorded the cobbled, medieval Paris neighborhoods that were being destroyed in Napoleon III's massive urban renewal project. He photographed all phases of the project: the old structures, their demolition, and the new site construction. His early work was done in calotypes, but sometime in the latter 1850s he switched to collodion glass plates. Marville set a precise standard for the seemingly artless mapping of an urban area that other photographers, such as Eugène Atget, later expanded. His balanced city compositions, often devoid of people, reveal an eye for detail. Marville's romantic style favored chiaroscuro, allowing the separate parts of a scene to achieve autonomy from the general site.

## The End of the Calotype and the Future of Photography

The calotype never found its place in the American consciousness, which appeared immune to its merits. Americans overwhelmingly favored the brilliant, dazzling detail of the daguerreotype, and with the ideals of the American Revolution not that distant, the idea of paying a commercial licensing fee to a British aristocrat was not a popular one. In 1849, the German-born William (1807–1874) and Frederick (1809–1879) Langenheim made a deal with Talbot for the American rights to his process in hopes of promoting their Philadelphia studio, but a year later the brothers had not sold a single license. In any case, the 1850s saw the refinement of a practical method of making glass negatives with a wet-collodion process on albumen paper, bringing the calotype as well as the daguerreotype era to an end and ushering in a new system for making photographs.

Nevertheless, the calotype shaped photography's future. Technical improvements to the calotype in terms of delineation of detail, expanded tonal range, print permanence, and mass-production methods placed photography in a position to succeed as an international print medium. The printing establishments, by publishing the work of early photographers, animated the vital role that photography would carry out in the mass communication of visual information. Aesthetically, the calotype offered important new interpretive controls to assist the young medium in finding its own visual language. The negative/positive printmaking system gave the photograph the intense power of chiaroscuro, and the means, through retouching, to alter a camera image after exposure. These key conceptual steps were necessary for photography to become an independent medium rather than a robotic hand-maiden to the other arts. The molding of these characteristics by outstanding calotypists demonstrated that the camera could be an instrument of individual artistic expression with the potential to become a driving social force.

# Endnotes

1   Mezzotint is an engraving method on copper or steel accomplished by burnishing or scraping away a uniformly roughened surface. This technique of reverse relief printing produces form in tonal areas rather than in line. It was widely used for color reproductions of paintings in the eighteenth and nineteenth centuries and became obsolete with the introduction of photoengraving and photogravure.

2   Beaumont Newhall, *Latent Image: The Discovery of Photography* (Garden City, NY: Doubleday & Company, 1967), 84.

3   See H. J. P. Arnold, *William Henry Fox Talbot: Pioneer of Photography and Man of Science* (London: Hutchinson Benham Ltd., 1977), 175–216.

4   Educated and visually literate, Talbot was familiar with these concerns. He valued Classical art, enjoyed his Uncle William Fox-Strangway's collection of Italian Renaissance paintings, and had seen European art collections. He knew the work of the foremost seventeenth century landscape artist Claude Lorrain, who used lyrical variations of light to dissolve detail for *effect* much like the calotype. This last concern can be seen in Talbot's investigations of light and space, which subordinate the subject.

5   Talbot later produced *The Talbotype Applied to Hieroglyphics* (1846) and *Annals of the Artists of Spain* (1847).

6   Letter of March 21, 1839. Herschel Collection. The Royal Society, London.

7   Gail Buckland, *Fox Talbot and the Invention of Photography* (Boston: David R. Godine, 1980), 15.

8   H. Fox Talbot, *The Pencil of Nature* (London, 1844–1846), reprint (New York: Da Capo Press, 1969), Unp.

9   Ibid.

10   Talbot was not able to commercially establish any of his photographic printmaking methods. By 1846 he had sharply reduced his license fee, yet even this failed to improve his market share. The following year the printing factory went out of business, so Talbot had Henneman open a portrait studio, which also failed.

11   The long exposure times, starting at about 10 seconds and often running into minutes, provide a sense of movement within time. The sitter is not frozen for examination, as in a daguerreotype, but is often blurred and appears alive and fidgeting before the camera. When the figures are still, they can lose their individual identity and take on an archetypal presence. This could be due to the direct, contrasty lighting style that causes a loss of detail in the shadow areas of the print that would reveal human attributes, such as the eyes, placing further emphasis on form and shape.

12   David Octavius Hill to Mr. Bicknell, January 17, 1848, George Eastman House, Rochester, NY.

13   In some instances the fading adds to the sensation of a hand-produced image. To the contemporary eye, its dapple-like effects seem impressionistic. In other prints, the now yellow/brown color gives a nostalgic sense of time past, while stains and other blemishes show the chaotic, transitory nature of existence.

14   The competition between the light and dark areas of Hill and Adamson's compositions are strikingly similar to those of the Dutch masters such as Rembrandt. The dark, uncluttered backgrounds provoke an atmosphere of mystery that enables the face and hands to be compositionally paramount. Many of the male sitters wore white shirts and black ties, producing an internal contrast that drew the viewer's eye first to the face and then to the hands.

15   The Eastlake-Rosse letter and Talbot's response were printed in *Times* (August 13, 1852). The Eastlake-Rosse letter is reprinted in Gernsheim, *History,* 180–81.

16   *Great Exhibition of the Works of Industry of All Nations, 1851.* Reports by the Juries in Four Volumes (London: W. Clowes and Sons Printers, 1852).

17   Ibid. Vol. 2, 439.

18   It replaced the Calotype Society, an elite club of about a dozen English gentlemen founded in 1847, whose members adhered to the Victorian principle of amateurism, in which the educated upper class was expected to adequately perform in the arts and sciences for the sheer joy of it (part of the Anglo/American tradition of volunteering for the public good).

19   All quotes in this section are from Sir William Newton, "Upon Photography in an Artistic View, and Its Relation to the Arts," *Journal of the Photographic Society,* vol. 1 (March 3, 1853), 6–7.

20   The committee announced that the use of gelatin as a mounting substance and sulphur in the atmosphere contributed to fading. Their first findings were published in the *Journal of the Photographic Society II,* 36 (November 21, 1855), 251–2.

21   See *Journal of the Photographic Society* II, 31 (June 21, 1855), 178–80.

22   "Reminiscences of an Old Photographer," Thomas Sutton, *British Journal of Photography,* Vol. XIV, No. 382 (August 30, 1867), 414.

23   In the developing-out process an invisible (latent) image is chemically developed to completion. Available from the 1840s on, the developing-out process was infrequently used as the contrast was hard to control and the public was not familiar with the neutral black color of the developed prints. In Talbot's

printing-out process the image was visible, which had the advantage of stopping the printing process at any time. However, the long, sunlight exposures limited the number of prints that could be produced.

24    See *Journal of the Photographic Society* II, 23 (October 21, 1854), 53–54.

25    For details on Le Gray's process, see J. Towler, M. D., *The Silver Sunbeam* (Hastings-on-Hudson, NY: Morgan & Morgan, 1969), 175–76. Facsimile 1864 edition with an introduction by Beaumont Newhall.

26    Gustave Le Gray, *Photographie— Traité nouveau sur papier et sur verre* (Paris: Lerebours et Secretain, 1852), 2.

27    Francis Wey, "Album de la Sociétéz Héliographique," *La Lumière* I, No. 5 (May 18, 1851), 58.

28    Lens speed is the measure of the maximum light-transmitting power of a lens, usually taken as the *f*-number of the lens's largest aperture, such as *f*/1.4.

29    Nègre's knowledge may have resulted from the ébauche technique taught by the nineteenth century ateliers. The ébauche method consists of a broad laying-in of the forms and masses in a final painting to aid as an underpainting to the picture, helping to suggest the effect of light and shade. Since it was generally monochromatic, its relationship in representing tonal mass could be correlated to the calotype. This type of training makes it apparent how Sir William Newton would accept a calotype that was manipulated to reduce detail and enhance a broad pictorial effect.

30    Charles Nègre, *Le Midi de la France photographié,* 1854–1855, unpublished MS, c.1854, National Archives, Paris. Cited in James Borcoman, *Charles Nègre as Photographer* (Ottawa: National Gallery of Canada, 1976), 34.

# Pictures on Glass

*The Wet-Plate Process*

## The Albumen Process

The 1840s saw the cornerstones of modernity, capitalism, and science applied to photography, as inventors searched for a low-cost, easy-to-use process that would combine the detail of the daguerreotype with the reproducibility of the calotype. Activity centered on making glass negatives, which were an ideal emulsion support base, cheaper than a silvered plate, and free from the drawbacks of the paper process. The chief obstacle in devising an efficient glass-backed process was finding a way to keep the silver salts from dissolving or floating off the glass during processing. In 1847 Claude Félix Abel Niépce de Saint-Victor (1805–1870), a cousin of Nicéphore Niépce, discovered that albumen (egg white) provided an excellent binder for silver salts on glass plates. While this breakthrough blended the desired attributes of the daguerreotype and the calotype, the process's five-minute minimum sunlight exposure time was not conducive to making portraits.

In 1849 Frederick Scott Archer (1813–1857), who had learned the calotype process as a visual aid for his portrait bust business, turned his "attention to collodion as a substitute for paper, with the hope that by its means a surer

and more delicate medium might be produced to work upon than paper was ever likely to be."[1] Archer coated a glass plate with iodized collodion and exposed it while it was wet. This proved to be the recipe for success, where as previous investigators had failed using collodion as a dry base to which iodide of silver was applied.[2] The so-called collodion process provided a finely detailed nega-tive, one that was endlessly reproducible and required less exposure time than Niépce's method.

Archer did not patent his method, but Talbot claimed that Archer's process, wherein a latent image was imprinted on a light-sensitive surface that had to be developed out and fixed, was an infringement on his own calotype patent. Talbot announced that he would prosecute any commercial portrait photographers who used the collodion process without his license. In December 1853, Silvester Laroche resisted an injunc-tion issued by Talbot against his Oxford Street studio. The case went to trial and on December 20, 1854, a jury declared Laroche not guilty, freeing England at last from Talbot's threats and patents. Since Talbot did not appeal or renew his calotype patent, and Daguerre's English patent had expired in 1853, England's profes-sional photographers were now able to use any process without paying a licensing fee.

The *collodion process* became known as the wet-plate process because all the procedures had to be car-ried out while the plate was damp, since the ether in the collodion rapidly evaporated. The coating procedure required speed, on-the-spot darkroom access, and the ability to follow preparation directions that read like a cookbook. Before making an exposure it was nec-essary to pour the collodion, with potassium iodide, a mixture of alcohol, ether, and nitrated cellulose (known as guncotton due to its explosive nature), onto a clean prepared glass plate under darkroom conditions (see Figure 4.1). The photographer had to tilt the plate back and forth to ensure an even coat or the pour marks would be visible in the negative. Next, the plate was dipped into a sensitizing bath of silver nitrate and then immediately placed into the camera and exposed (sen-sitivity dropped greatly as the collodion dried). As soon as the exposure was made, the plate was developed in pyrogallic acid and fixed with cyanide or sodium hypo-sulphite (hypo).

Photographers were willing to put up with these dif-ficulties as the collodion's increased light sensitivity meant that small, highly detailed portraits could be made in as little as two seconds. Also, as glass plate negatives printed faster than paper negatives, prints could be pro-duced more quickly and cheaply. Collodion's raw mate-rials were inexpensive, and once mastered tended to be more constant and predictable than the paper processes. By 1855 the majority of commercial photographers had added collodion to their repertoire. Collodion ushered in a period of growth and good fortune for the budding

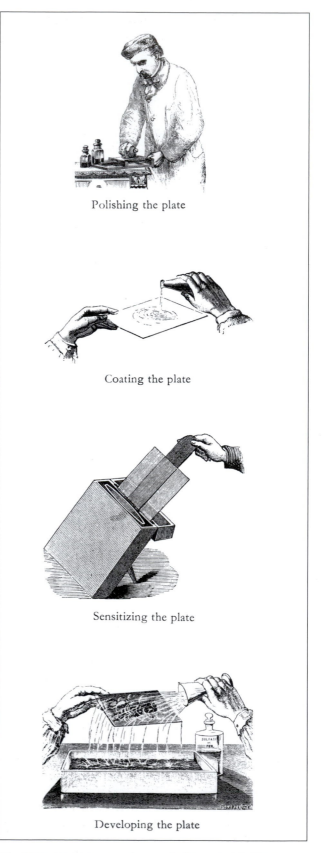

Polishing the plate

Coating the plate

Sensitizing the plate

Developing the plate

4.1   Preparing and processing a collodion wet-plate. From Gaston Tissandier, *A History and Handbook of Photography* edited by John Thomson, 1878.

commercial photographic community. It would eventually dethrone the daguerreotype, calotype, and albumen processes and reign until the introduction of the gelatin dry plate in the 1880s.

## The New Transparent Look

The introduction of the collodion process solved a series of technical problems and heralded a new aesthetic ideal as well. Photographers had been dissatisfied with "the imperfections of paper photography" and wanted a negative capable of delivering "fineness of surface [and] transparency."[3] They desired a negative/positive process capable of rendering a consistent tonal range with ample density and detail in the highlight and shadow areas. Collodion's transparent glass support solved these difficulties and resolved the aesthetic concerns of clarity, chiaroscuro, and resolution, signaling the demise of what D. O. Hill saw as the artistic virtues of the calotype—its rough and unequal texture.

"Transparency" referred to a direct translation of reality in which subjects were not "suggested," as in the calotype, but were clearly stated and defined without overt intervention, as in the daguerreotype. *Naturalism* began to be the benchmark of photographic practice. Its goal was not to interpret or interact but to concretely represent the world, naturally, with previously unmatched depth of clarity, capable of preserving enormous amounts of visual information. The glass support of the collodion replaced the obscure shadow areas of the calotype with a clear, distinct, and unobstructed view. The idea of naturalism would lead to a decline in retouching the negative for serious artistic effect, and indirectly supported the notion that photography was an authorless process in which the subject imposed its presence onto a plate. Such an uncompromised *natural* image was thought to be "truer," easier to see and understand than anything previously obtainable.

A new printing paper was essential to retain the detail and sharpness of the glass negative. The first practical *albumen paper,* with a smooth and glossy surface, was designed by Blanquart-Evrard in 1850 and rapidly supplanted the matte surface of the calotype, remaining in use until the end of the nineteenth century. According to J. Towler's 1864 edition of *The Silver Sunbeam,* when making albumen paper, one was supposed to use only fresh eggs and then get "the white of egg, entirely freed from the germ and yolk, and beat the egg up well with a wooden spatula until it is completely converted into froth. This operation must be performed in a place as perfectly free from dust as possible; and then the albuminous mixture is covered with a clean sheet of paper and put aside to settle for a number of hours." Fortunately, while photographers could make their own albumen paper, it also could be purchased already prepared, spawning the beginning of the manufacture of presensitized paper.

The laborious steps in the albumen paper process included beating the mass of egg white; allowing it to froth in earthenware vats; fermenting it in tall glass jars; filtering it, beating it again, refiltering it, and salting it with chlorides; and dying it pink, mauve, or blue. Then paper, such as Rives B. F. K., was floated by hand in the mixture. Next, the paper was dried and stored for three to six months, so the albumen could completely harden, and then it was coated again and hung up to dry in the reverse direction to equalize the unevenness of the first coating.

Albumen paper gave a new look and consistency to photographic printmaking, allowing for the production of *editions,* where the first to the last images all look the same. Such consistency had not been possible with the calotype, where differences in the surface and texture of the paper support and the hand-applied emulsion produced noticeable changes when multiple prints were made. This new found consistency diminished the distinctive differences of the individual print, causing it to lose its uniqueness and reducing its market value as an artistic object. Another major attribute of the paper print—its replaceability—also meant that people did not give the photograph the respect they had given the daguerreotype. A damaged albumen print was not considered a catastrophe, as another print could be made.

This idea of the replaceability of photographs was encouraged as the photograph became synonymous with other machine-produced objects of the industrial culture. Photography became commercially viable, as more of its components could be carried out by a division of labor that allowed a few skilled managers to control an operation of unskilled employees. Assembly-line production techniques and attitudes replaced those of a personally crafted object. By 1894, the Dresden Albumenizing Company's staff of 180 opened 60,000 eggs daily for the production of double-albumenized paper.[4] Repeatability had substituted for the calotype's distinctive atmosphere and character, as easy replication became the order of photographic business by the end of the 1850s.

The collodion process produced a tremendous demand for albumen paper. The new paper not only provided more detail than a salted paper print, but it changed the surface look of the paper photograph. The albumen's glossy surface sheen gave photo-based images a novel appearance. This glossiness was considered very modern and machine-like and was accepted as part of the new system of representation. It also further removed the photographic print from traditional printmaking, where shininess was an undesirable characteristic. In collodion's early days, practitioners diluted their albumen with salt water to reduce the gloss to a luster. As the wet plate's popularity grew, photographers used undiluted albumen to reveal the abundant detail of their glass negatives, raise the contrast level, and provide a

greater luster to the print. By the 1860s double-coating of the paper with albumen became a standard practice, giving prints a truly glossy appearance.

The base color of the paper, once the dominion of each photographer, became standardized as commercially prepared papers, with a limited range of colors, achieved market domination. These new surface changes provided unmistakable evidence that the image originated from a photo-based process. Albumen prints were *gold-toned* to make the print more stable and alter their intense red-brick color to a more acceptable warm purplish-brown or even a blue-black hue.

## The Ambrotype

The rapid commercial adoption of the collodion process and the immediate invention of a series of spin-off processes—the ambrotype, the tintype, and the carte de visite—ensured collodion's rapid domination of the field. The *ambrotype* was a collodion, positive-looking image on glass that when first introduced was referred to as a "collodion positive." The name ambrotype was devised by the Philadelphia daguerreotypist Marcus A. Root in 1855, from a Greek word meaning "imperishable." When first shown in the United States, in December 1854, they were called daguerreotypes on glass and often were mistaken for daguerreotypes because they too are laterally reversed, one-of-a-kind objects that are frequently hand-colored, made in the same-size formats, and put into similar cases. In Europe ambrotypes were generally referred to as *amphitypes*. The ambrotype lacked the highly reflective surface of a daguerreotype and appeared somewhat dull in comparison, but it was less expensive to make. Frederick Archer and other calotypists discovered that the density of a collodion negative could be varied through a bleaching process. When such a bleached image was viewed by reflected light against a dark background, it appeared as a positive. This effect can be observed with any negative, even without using a bleaching process. In practice, most photographers underdeveloped or underexposed the glass plate to achieve the same effect. After processing, the plate was varnished on the front to protect the image surface and then lacquered with an opaque black on its backside or placed against black paper or velvet. It is often possible to identify an ambrotype because its backing has deteriorated. When the black varnish starts to crack and fracture the image can give a visual sense of separation and physical relief (fake 3-D) as well as a ghostlike translucence.

Ambrotypes often were set in elaborately designed, molded, and hinged cases called *Union Cases*. Introduced in the early 1850s, Union Cases marked the beginning of thermoplastic molding in the United States and were produced in hundreds of designs featuring scenes derived from classical works of art and popular culture concerning history, nature, patriotism, and religion. Sometimes the photographer's name and hometown were imprinted on the gold-colored interior mat or the case's velvet "pillow" as an abbreviated form of advertising; other times, a printed card with greater detail would be secured inside the case. The case gave the ambrotype a physical weight. Secured with a catch, it also maintained an element of surprise, a sense of drama as one held a jewel box-like object in one's hands, wondering what was going to be pictured inside. As the case was opened this sense of theater became part of the viewing experience.

Ambrotypes were generally used in portraiture. The posing was usually intimate, featuring tight head and shoulder shots, which worked well with the small format generally chosen. The glass surface of the ambrotype could reflect a viewer's image into the scene, though not as intensely as the daguerreotype. A negative image could be produced by holding the ambrotype at different angles to the light, but it was still much easier to view than a daguerreotype. Unlike most American daguerreotypes, some ambrotype cases had hooks on the back for wall hanging, and others had pop-up legs to allow the picture to stand upright in its frame. By the mid-1850s the ambrotype had surpassed the daguerreotype as the portrait medium.

In July 1854, James Ambrose Cutting (1814–1867) tried to profit from the American portrait business by patenting a method for sealing collodion images in their cases.[5] Outraged over Cutting's "ambrotype patent," American photographers banded together for the first time, eventually forming the National Photographic Convention, to fight what they considered to be an illegal patent. The patent was reversed in 1868 thanks to this organized effort and to the rising popularity of new imaging systems such as the stereograph and the carte de visite. By 1861, however, the ambrotype was on the way out and the making of collodion pictures on paper was in.[6]

## Pictures On Tin

A second collodion spin-off method was the *ferrotype*, first described by French photographer Adolphe Alexandre Martin in 1853. The name ferrotype (in Latin *ferrum* is *iron*) was originally used by Robert Hunt in the mid-1840s for a paper negative process (Energiatype) that utilized an iron-compound developer. Basically an ambrotype made on a thin piece of sheet iron instead of glass, the ferrotype was an enameled black or brown-black plate that was coated with collodion and sensitized just before exposure. The process was patented in February 1856 by Hamilton L. Smith (b. 1819), who assigned his patent rights to his collaborator Peter Neff. The patent only covered how to produce what Neff advertised as *melainotypes*. Neff attempted to exploit the process's commercial potential by building a tinplate factory, sending out teachers to instruct daguerreotype operators

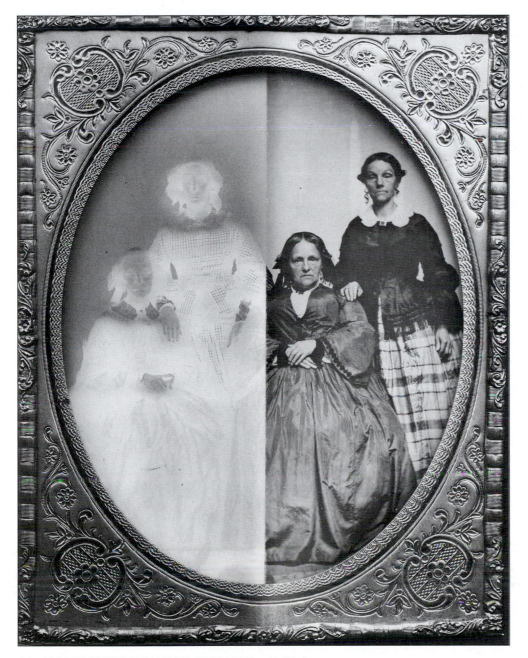

4.2  UNKNOWN PHOTOGRAPHER (AMERICAN).  *Untitled Portrait,* ca. 1858. Ambrotype with half the backing removed to show positive and negative effect.  Harry Ransom Humanities Research Center, The University of Texas at Austin.

in the new method, and giving away a 53-page manual, *The Melainotype Process, Complete.* Tintypes, as they were known in America, were made in a variety of sizes, the most common being 2¼ × 3½ inches (the same size as the carte de visite), and were often hand-colored. The name, *tintype,* evolved from popular usage. The tintype never achieved a high level of market influence, but it did find a niche and outlasted all the wet-plate processes (a dry tintype process was introduced in 1891). It was used by itinerant and street photographers until it was replaced by the Polaroid process in the 1950s.

Tintypes were the visual currency of soldiers and their families during the American Civil War because they were lightwight, durable, and cheap, with little "gem" sized tintypes, taken with a multilens camera, being sold in multiples for 25 cents. Many tintypists were unskilled in other photographic processes, and occupied the lowest rung on the photographic ladder. In fact, big city studio photographers considered tintypes to be low-class pictures practiced by "cheapjacks" who were only interested in making quick money, who knew nothing about photography, and whose deceitful practices diminished the profession's reputation. Those who specialized in the process often traveled from town to town, working on the street, out of a wagon, or in a rented room, using a modified camera that doubled as a tiny darkroom and allowed all the processing to

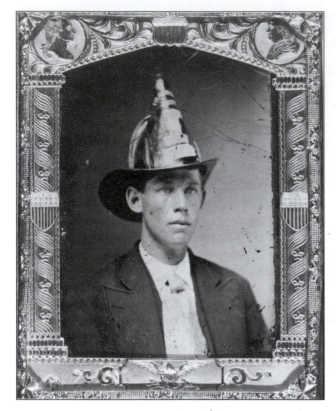

4.3   UNKNOWN PHOTOGRAPHER.   *Fireman,* ca. 1865.
Quarter plate tintype.   Courtesy George Eastman House.

take place inside the camera. Such cameras had slotted bottoms to hold canisters of developer and fixer for processing. After fixing, the plate was given a quick rinse in a bucket of water, waved through the air to speed drying, and handed to the customer. It was considered an instant process since it could be done in about a minute. The tintype was never as popular in Europe, where it was used almost exclusively by street and seaside photographers. Like most daguerreotypes and ambrotypes, tintypes are generally unsigned works. Its practitioners are the largely forgotten and unnamed photographers we know today as "anonymous" or "unknown photographer."

The tintype's image did not jump out at the viewer but lay flat as if it were rolled onto the tin surface. The tintype's tonal range appeared uniform because its black backing absorbed a great deal of light, and it did not possess the mirrorlike sheen of the daguerreotype or the glass depth of the ambrotype to enhance contrast. However, what the tintype lacked in aesthetic qualities it made up in social significance: Citizens could have their likeness recorded for less than 25 cents, further democratizing the process of commemoration. The tintype's universal affordability also spoke to the nineteenth-century American notion that societal position was not solely predetermined by one's birth status, visually denoting the American Dream of pos-

sible upward mobility. Democracy not only gave the industrial classes a taste for the arts and letters, it also brought a technological spirit to the arts.

The tintype's lower price, its practitioners' lack of formal artistic training, and its immediacy reduced the specialness surrounding the act of having a picture made. Pictures became less serious, more spur-of-the-moment affairs. The idea of casual pictures for amusement became popular with tintypes and was further encouraged when tintypists introduced humorous background scenes of painted canvas with cutouts through which sitters could insert their heads. People's "camera attitude" shifted as they played and acted informally for the camera. This type of unpremeditated silliness and lack of respect had seldom been previously pictured. Discounting any technical limitations due to long exposures, smiles had been considered inappropriate for an occasion that was seen as making a social statement about the sitter. The spontaneous tintype spirit of picturing the vernacular was the precursor of the snapshot sensibility, which can also be observed in photobooth portraits (see chapter 12).

## The Carte de Visite and the Photo Album

The third spin-off from collodion was the *carte de visite,* or visiting card. A number of photographers claimed credit for introducing the carte de visite, but the idea was patented by **André-Adolphe-Eugène Disdéri** (1819–1889) and introduced to the public in Paris in 1854.

The concept of using photographs on documents such as licenses, passports, permits, and visiting cards was proposed by Louis Dodero of Marseilles in 1851. The carte de visite, or *carte,* was a 2¼ × 3½-inch photograph, usually a full- or bust-length portrait, mounted on a 2½ × 4-inch paper card. A number of exposures were made with a multilens camera on a single collodion wet-plate and were contact-printed onto albumen paper. Individual exposures were cut apart and mounted on cards. The multilens, referred to as *tubes,* could be individually uncovered (there were no shutters), making possible a variety of poses on a single plate. The intent was to take the time and expense needed to make one print and divide it by many prints, reducing the cost of each unit. Numbers were the deciding factors; the more cartes people had made, the greater the photographer's profit. Enhanced savings were also realized since retouching was not needed, as many defects were not noticeable in the small prints, and the processing procedures could still be performed by unskilled labor. Daguerreotypists like Abraham Bogardus initially dismissed the carte. Bogardus recalled his first impressions of the carte as "a little thing; a man standing by a fluted column, full length, the head about twice the size

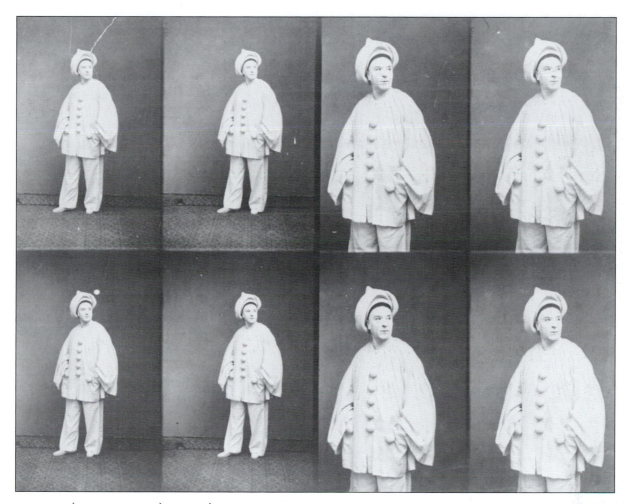

4.4  ANDRÉ-ADOLPHE-EUGÈNE DISDÉRI.  *Paul Legrand*
(clown in white face), ca. 1860–1865. Uncut carte de visite, 7⅞
× 9½ inches. Albumen print.    Courtesy George Eastman House.

of the head of a pin. I laughed at that, little thinking I
should at a day not far distant be making them at the
rate of a thousand a day."

After a slow start the carte became a hit in May 1859
when Napoleon III, leading his army out of Paris on a
military campaign against Austria, stopped to have a
publicity portrait made at Disdéri's studio. It proved a
successful public relations tactic for both men as people
flocked to have their carte made at the same place as the
emperor. Disdéri became a celebrity and was appointed
Court Photographer. In 1860 Disdéri redecorated his
studio, the "Palace of Photography," in the ornate Sec-
ond Empire style with portraits of della Porta, Niépce,
Daguerre, and Talbot along with allegorical statues sig-
nifying Chemistry, Painting, Physics, and Sculpture.
The Apotheosis of Light was painted on the ceiling. By
1861 Disdéri was reported to be the richest photogra-
pher in the world, eventually opening branch studios
in London, Madrid, and Toulon. His Paris studio had a
staff of 90, could make thousands of prints a day, and
promised 48-hour delivery.

The carte did not become chic in England until August
1860, when John Jabez Edwin Mayall (1813–1901),
who learned daguerreotypy working in a Philadelphia
gallery and returned home to become one of London's
most elegant studio photographers, published his *Royal
Album,* consisting of fourteen carte portraits of the
royal family (see Figure 4.5). Hundreds of thousands of
cartes of Queen Victoria and Prince Albert were sold,
leading to an explosion of celebrity photographs. Pho-
tographers courted personalities to sit for them, often
paying a fee to the sitter and/or royalties based on sales.
The practice of collecting and exchanging photographs
and placing them in embellished, manufactured albums
began with the *Royal Album* cartes. Mayall's carte busi-
ness reportedly generated more income than any other
English photographer's, with his studio turning out a
half million cartes a year. Mayall also patented the *Ivo-
rytype* in 1855, a method in which a photographic image
was printed on artificial ivory that had been sensitized
with either albumen or collodion. This imitation effect
was popular as it played off the association of ivory as
a valuable object reserved for the power elite.

The royal family itself was keen on photography.
Queen Victoria was said to have over one hundred photo
albums, many arranged and inscribed by Prince Albert.

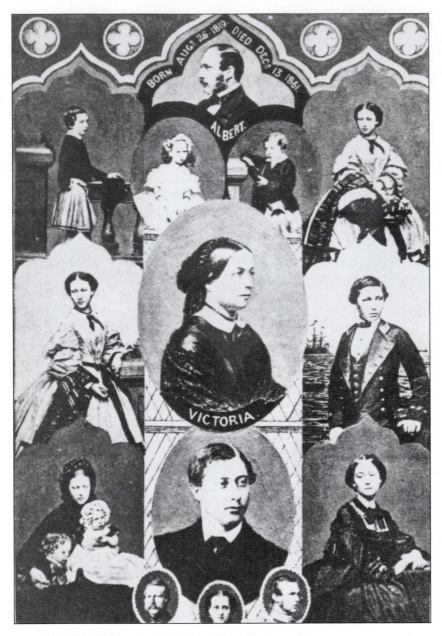

4.5   JOHN E. MAYALL.   *Death of Prince Albert* (Montage of Royal Album). 4 × 2½ inches. Carte de visite.   Courtesy George Eastman House.

The Queen enjoyed giving and sending photographs. The royal family not only consented to the sale of their cartes but commissioned numerous portraits, collected contemporary photographs, were patrons of The Photographic Society, and even had a darkroom installed at Windsor Castle for their private use, increasing interest in photography and giving it status and credibility.

The carte was a formula picture; no particular effort was made to reveal the sitter's character. Even though posing equipment was still required, shorter exposure times allowed more naturalistic styles to evolve, and people appeared less rigid and stern. In various poses controlled by the photographer, from vignetted heads whose undefined edges merged into the background to full-length images, the sitter could look either directly at the camera or gaze off to one side. The backgrounds could be neutral, or they could be elaborate painted settings. Most scenes included props, such as fancy upholstered chairs, balustrades, columns, drapery, and furniture. People often wore clothes or held objects that revealed their status or their aspirations. Cartes were personal, hand-held portraits made to be preserved in albums and stir memories: "This is what I look like, this is what I do, this is who I am."

Cartes of royalty, actors, politicians, and people in the news were widely circulated. In 1861, the Chicago & Milwaukee Railroad Co. issued identity cartes for their season-ticket holders. Abraham Lincoln credited his election to his Cooper Union speech and to his carte made by **Mathew Brady**. Stage figures, such as Mag-

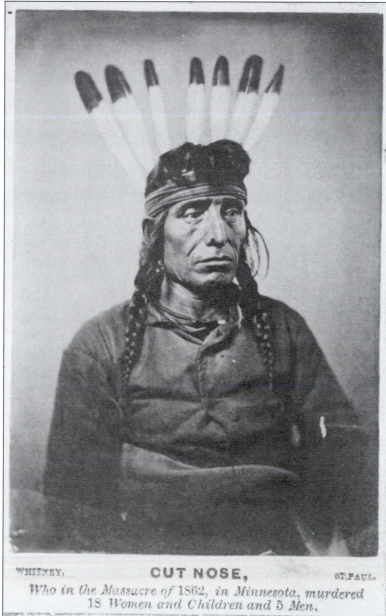

WHITNEY,    **CUT NOSE,**    ST.PAUL.

*Who in the Massacre of 1862, in Minnesota, murdered*
*18 Women and Children and 5 Men.*

Entered according to Act of Congress, by J. E. Whitney, in the year 1862
in the Clerk's Office of the U.S. District Court for Minnesota.

4.6    J. E. WHITNEY STUDIO, ST. PAUL, MN.    *Cut Nose,* 1862.
Carte de visite. If the information on this carte is true, it raises
a macabre point about social behavior—why would a person
purchase an image of a murderer? Today electronic media has
taken this phenomenon to levels unimaginable in the nineteenth
century with movies about serial killers and websites that contain
outright lies about history and promote hate against minority
groups.    Courtesy Visual Studies Workshop, Rochester, NY.

George Sand, and Victor Hugo. In addition,
leaders of reform movements, including
the American abolitionists Frederick Dou-
glass and Harriet Beecher Stowe, were in
demand.

Cartes catered to the armchair traveler
with views of moated castles and foreign
lands, to the sophisticated with works of
art, to the believers of "Manifest Destiny"
with bare-breasted natives who could be
both ogled and looked down on, and to the
morose with "freaks of nature" like a per-
son with no arms who could write with his
feet. Cartes provided the realistic images
the public now expected at affordable
prices and furthered the picturing of more
diverse subjects.

Typically, the front of the carte had the
photographer's name imprinted below the
image, and for celebrity and other public
portraits, which most cartes were not, a
caption and statement of copyright were
added. Many of the backsides carried
advertising logos that generally included
the photographer's and/or publisher's name
and address. Additional notes reminded
the public that copies of the carte could be
reordered, with pronouncements such as:
"Negatives preserved, Duplicates can be
had at any time."

Some of the cartes that are most interest-
ing as social documents were peddled as
fundraisers. One carte of three small chil-
dren stated that

> The copies are sold in furtherance of the
> National Sabbath School effort to found
> in Pennsylvania an Asylum for dependent
> Orphans of Soldiers; in memorial of our Per-
> petuated Union. This picture is private property,
> and can not be copied without wronging the
> Soldier's Orphans for whom it is published.[7]

**J. E. Whitney's** carte of *Cut Nose* shows how words
attached to a picture not only supply meaning but raise
critical issues concerning accuracy. Photographers
strategically titled their cartes. As allegorical subjects
gained popularity in the mid-1850s, many photogra-
phers titled their portraits with the names of Greek dei-
ties so that viewers could bring their formal knowledge
to bear. Such practice was exclusionary, closing out the
less educated. Photographers who did not wish for this
type of interchange or who wanted to be more ambigu-
ous and less directional could leave their work unti-
tled. Such an open-ended viewing situation made it the
viewer's responsibility to supply the meaning.

As cartes were not deemed inviolable objects, the
public joined the titling process, adding inscriptions to

gie Mitchell with her trademark mischievous gamine/
urchin role, became cult personalities in the United
States through the publicity supplied by their cartes.
Besides celebrities there was a market among the edu-
cated for cartes of authors, such as Charles Dickens,

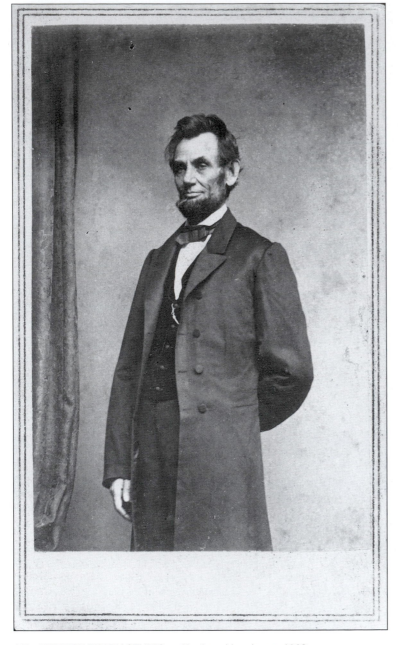

4.7  MATHEW BRADY STUDIO.  *Abraham Lincoln,* ca. 1863. 3⅓ × 2³⁄₁₆ inches. Albumen *Cabinet Card.*  Courtesy George Eastman House.

"Do you know me?" A piercing example of the reality of war can be seen in a Civil War portrait album that contains brief penciled comments recording each person's name and what happened to him: "killed at . . . , wounded at . . . , lost leg, died of wound, eye shot out at . . . , lost arm." A portrait of four soldiers in uniform, with devil-may-care looks, was inscribed: "All killed in battle."

## The Cabinet Photograph: The Picture Gets Bigger

The carte fad peaked about 1866, and as the fad began to decline photographers such as Edward Wilson bemoaned the change and searched for something else to reinvigorate declining sales:

> The adoption of a new size is what is wanted. In our experience, we have found that fashion rules in photography as well as in mantua-making and millinery, and if photographers would thrive, they must come into some of the tricks of those whose continual study it is to create fashion, and then cater to its tastes and demands.[8]

The answer to this dilemma came in the cabinet photograph, essentially an enlarged carte designed for portrait work. The name predates photography and may refer to the fifteenth and sixteenth century Augsburg cabinets that were produced for well-to-do bourgeois to hold collectible items or the small cabinet canvases made by the Dutch and Flemish painters for merchants' houses. The cabinet card format was introduced in 1862 by Marion & Co. of London with the publication of a series of 6¾ × 4½-inch views by G. W. Wilson. The format gained popularity when F. R. Window's London studio applied it to making portraits in 1865–1866. The increased image size showed more detail and was considered more aesthetically gratifying than the smaller carte. In the United States, the carte did not yield ground until the early 1870s. However, as time passed the cabinet swept the portrait field, and photographic suppliers began to make new card mounts and albums as the collecting mania that had faded with the carte craze began anew.

Cabinet pictures were made in a method similar to the carte. The glass plate for the negative was first coated with a thin layer of albumen and the collodion was flowed on. Next, the plate was sensitized in a silver nitrate bath. It was exposed while still moist and was immediately developed in an acetic-acid/iron-sulfate solution that also contained alcohol, silver nitrate, and

the backside, or verso, of the cartes, anticipating the role that snapshots and postcards have often served. A carte of a dapper young man asked: "Please acknowledge the receipt of this by returning one of yours. J. Crane." A middle-aged man thought his image was worth many cartes: "Aunt Susan, you must be sure and send me some of *all* of you as soon as you can. Me." Others provided factual information about the sitter: "Ma when 16." Still others offered commentary: "The arch traitor Jeff Davis." A woman in a long dress, holding a straw hat, wondered whether it was really possible to be known through one's carte. On the verso she wrote:

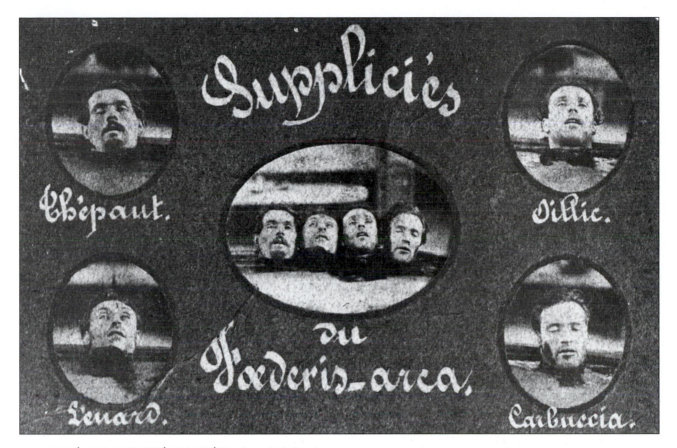

4.8  ANDRÉ-ADOLPHE-EUGÈNE DISDÉRI.  *Suppliciés* (Louis Napoléon Album, Heads of Executed Men), ca. 1850s. 4 × 2½ inches. Carte de visite.    Courtesy George Eastman House.

nitric acid, and was fixed with potassium cyanide. The completed negative was often varnished to prevent the thin collodion film from being scratched. Prints were made on albumenized stock that was commercially available in several surface finishes. The paper too had to be sensitized before printing by floating it, albumen side down, in a bath of silver nitrate. The paper was sometimes fumed with ammonia after being sensitized, in order to increase its speed. The negative and paper were placed in a printing frame and exposed in sunlight. Next the paper was toned with gold chloride to give it a brown appearance and was fixed in hypo, washed, and dried. The cabinet was offered in three sizes: No. 1, 5¼ × 4 inches (the most popular); No. 2, 5¾ × 4 inches; and Special, 6 × 4¼ inches. All were mounted on a 6½ × 4¼-inch card.

The cabinet created a demand for larger pictures.[9] The increase in image size changed the photographic viewing experience from an intimate affair to a public display on a mantle or wall. The bigger sizes provided photographers with more space to orchestrate, and new aesthetic possibilities could be realized as light and pose were used to reveal a sitter's character. As the image's size and cost increased, the public paid closer attention to what was happening within the frame. These changes in turn encouraged photographers to push the boundaries of the portrait to express each sitter's character.

The cabinet style peaked with the collecting of stage personalities in the 1880s. Its decline began at the turn of the twentieth century as folding cameras, with which people could make their own postcard-size pictures, gained popularity. By World War I the cabinet had just about vanished from the commercial scene.

Since photography was still young and not yet considered an independent medium, many developments in the field stemmed from market demands. *What* was pictured continued to expand, as pet portraits, still lifes, and reproductions of art became more commonplace, reflecting the idea of the camera as an all-seeing gatherer of information. The larger image area of the cabinet encouraged more photographers to try their hand at the rudimentary practice of *montage,* cutting apart photographs, pasting selected pieces onto a board, and rephotographing them to form a new context and viewing experience. Like combination printing, montage was devised to overcome aesthetic and technical limitations. The concept of removing a photograph from its original context and placing it into a new one has had profound effects on the viewer's willingness to accept as "real" visual information supplied by the photograph. Montage broke the rules about representing perspective, point of view, space, and time, yet people were willing to accept it as long as it remained photographically based.

## The Studio Tradition

The affordability of the collodion processes led to the rapid expansion of portrait making. In 1841 there were only three portrait firms in London; in 1851 there were less than a dozen, but in 1861 more than 200.[10] Skilled posing, lighting, and retouching allowed photographers to push the boundaries of portraiture, expanding the enterprise of studio photography.

One of the most highly skilled studio portrait makers was Gaspard Félix Tournachon (1820–1910), known as **Nadar**. Originally an acclaimed caricaturist, becoming a photographer was a natural extension of his talent for recording a subject's essential characteristics. His ability to create stinging caricatures earned him the nickname "Tourne à dard" (one who stings), which he shortened to "Nadard" and then to "Nadar."[11] His studio was a meeting place for Paris's intelligentsia, and where Nadar produced portraits of his guests: Charles Baudelaire, Alexandre Dumas, Gustave Flaubert, Victor Hugo, Franz Liszt, and George Sand. Acting as an artistic director, he posed his best-known clients but relied on his staff to carry out the actual work. This arrangement was taken for granted and typifies the teamwork that went into the making of the majority of images attributed solely to most well-regarded studio photographers.[12]

Nadar's original approach was direct and simple, making use of plain dark backgrounds and, when possible, full natural light. Later, through the aid of reflectors, screens, veils, and mirrors, he made considerable use of side lighting to model the features of the face. Possibly influenced by his friend, Adam-Salomon, who employed unusual lighting methods and poses learned from his painter associates, Nadar positioned his sitters in such a way that often hid their hands in order to emphasize facial expressions and bodies. Favoring three-quarter views, he organized his subjects around recognizable gestures and looks that revealed the character's essence while breaking down the sense of distance between subject and photographer. Sitters were encouraged to discover their own poses with a minimal use of props. Nadar knew his sitters, and the intimacy of the portraits, and his understanding of their often familiar human fragility, record the bonds of friendship and remembrance of shared events. Although a comrade, Nadar was not necessarily reverent: He did not flatter his sitters, but often seemed on the verge of revealing one of their secrets. His restrained portraits of French novelist George Sand (see Figure 4.9) unobtrusively convey her dominating personality as a literary talent and nonconformist who protested the unequal treatment of women by openly wearing trousers, smoking cigars, and taking lovers like a man.

The subjects in many of Nadar's portraits seem to have been participating in the act of photography rather than just undergoing it. Spontaneity was in play, often revealing a part of the sitter's inner psychological being. Nadar understood the wet plate's ability to render detail, but he was not obsessed with it. He knew how to suppress detail and sharpness, moving sitters through different levels of focus to bring out their essence. In his work, the sitter's clothes were an important element of personality, used to build an atmosphere of class, ethnic, and social character previously unachieved in photography. These qualities, combined with his talent as a caricaturist, enabled Nadar to go after the "moral intelligence" of the sitter and expand the boundaries of the social portrait.

In 1856, Nadar observed:

> Photography is a marvelous discovery, a science that has attracted the greatest intellects, an art that excites the most astute minds—and one that can be practiced by any imbecile.... Photographic theory can be taught in an hour, the basic technique in a day. But, what cannot be taught is the feeling for light.... It is how light lies on the face that you as artist must capture. Nor can one be taught how to grasp the personality of the sitter. To produce an intimate likeness rather than a banal portrait, the result of mere chance, you must put yourself at once in communion with the sitter, size up his thoughts and his very character.[13]

Always experimenting, Nadar made the first aerial photographs in 1858, coating his wet-plate while in a hot-air balloon. In 1861 he photographed with artificial light, using Bunsen batteries in the catacombs of Paris. The failure of the revolutionary Commune of Paris financially ruined Nadar, and in 1871, he handed the business over to his son Paul (1856–1939), who continued on as a fashionable commercial portraitist through the turn of the twentieth century, photographing such notables as French writer Marcel Proust and many of those characterized in his monumental work *In Search of Lost Time* (1913–1927).

A French aristocratic and amateur photographer, Camille Silvy (1834–1910) ran a lavish London portrait studio and had a style that was the antithesis of Nadar's. Silvy favored intricate sets of his own design, with painted backdrops creating the proper atmosphere for his upscale clients. He specialized in posing the fashionable in front of mirrors, to soften the light and to manufacture a luxurious glow that accented the sitter's attire and hairstyle. Known for his exemplary taste and understanding of how to pose women, Silvy cultivated his reputation by publishing a series of cartes called *The Beauties of England,* which were acclaimed for their elegance, refinement, and vivacity. He closed his studio, which employed forty people, when the carte fad fizzled. Silvy's photographic career, lasting just over a decade, was cut short due to health problems—associated, perhaps, with the collodion process. (In fact, Silvy's death was probably hastened by his exposure to photographic chemicals. Numerous reports tell of early photographers being made ill or poisoned by improper handling of photographic chemicals.)

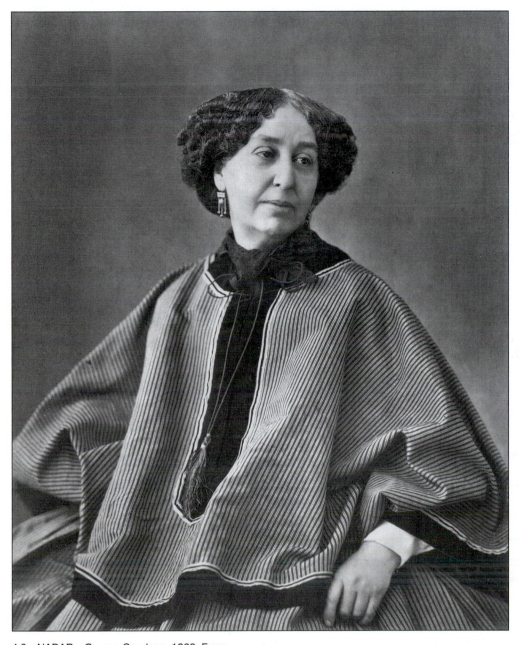

4.9 NADAR *George Sand,* ca. 1860. From
*Galerie Contemporaine,* 1877. 9⅛ × 7⅝ inches.
**Woodburytype.** Courtesy George Eastman House.

**Antoine Samuel Adam-Salomon** (1811–1881) was
a Parisian sculptor who took up photography part time
in 1858. Using his knowledge of modeling clay, Adam-
Salomon was able to bring forth the *plastic,* three-
dimensional effects of his two-dimensional subjects. He
introduced what was called *Rembrandt Lighting,* the use
of high side light to achieve distinct visual projection of
a sitter's face after the style of the Dutch painter (see
Figure 4.10). Greater facial contour enhanced the char-
acterization of the sitter. Adam-Salomon, whose prints
were known for their rich range of luxurious tones, also
paid homage to painting by draping his sitters in vel-
vet and posing them in the style of the Old Masters.
Since his work venerated the traditions of painting it
was appreciated by critics who believed the insemina-
tion of classic artistic ideas was necessary to elevate
photography from a means of mechanical reproduction
to an art. Yet Adam-Salomon's work was also criticized
for downplaying the individual attributes of subjects in
favor of making them part of a formal configuration. In
1867–1868 he became embroiled in controversy when
he was accused of achieving his effects by retouch-
ing (a microscopic examination revealed that he did
retouch his prints).

**Napoleon Sarony** (1821–1896), born in Quebec the
year Napoleon Bonaparte died, opened his first New
York studio in 1864. No taller than his namesake, Sar-

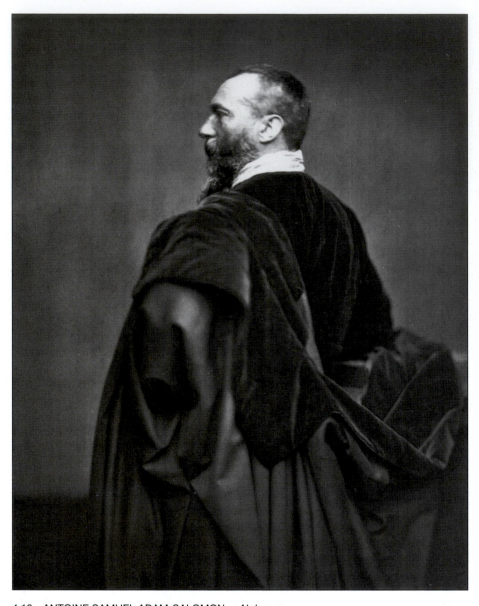

4.10  ANTOINE SAMUEL ADAM-SALOMON.  *Alphonse Karr* from *Galerie Contemporaine,* 1877. 9⁵⁄₁₆ × 7⁷⁄₁₆ inches. Woodburytype.   Courtesy George Eastman House.

ony was referred to as "the Napoleon of Photography" because of his flamboyant and volatile approach to making portraits. A natural actor, Sarony enjoyed parading down Broadway in an astrakhan cap and a calf-skin waistcoat (hairy side out), with his pants tucked into highly polished cavalry boots.

Sarony's studio was equally flamboyant. His Wunderkammer or *wonder room,* as it was called, took up an entire building and featured a hydraulic elevator, an Egyptian mummy, stuffed birds, Russian sleighs, Chinese gods, armor, statues, musical instruments, bamboo umbrellas, chests, Indian pottery, a maze of pictures, and a crocodile suspended from the ceiling. The forerunner of the modern museum in the sixteenth and seventeenth centuries, the wonder room was a place where the nobility and the wealthy kept their collections of diverse objects for the purpose of celebrating the strange and marvelous. The contents were selected solely according to the owner's fancy and were presented unsystematically, in a way designed to astonish and amaze.

Sarony was an early photographic specialist, who concentrated on theater personalities, reportedly making 40,000 portraits of members of the profession. Skilled at retouching, he used this concentration to achieve "effect" and to satisfy the vanity of his clients. As a photographer he was the equivalent of a modern-day director, cajoling, parodying, and even intimidating his sitters to elicit dramatic and expressive representations. To overcome the difficulties of 5- to 60-second exposures, Sarony used a mechanical "posing machine" that allowed a sitter to maintain a more flexible and natural position. This device enabled him to capture the emotional energy of the fictional roles of his actor clients, freeing them from

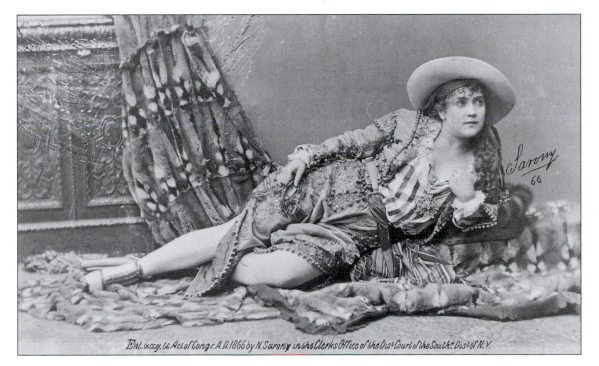

4.11 NAPOLEON SARONY. *Adah Isaacs Menkin as Mazeppa,* 1866. 2⁹⁄₁₆ × 3⁹⁄₁₆ inches. Albumen carte de visite. Courtesy George Eastman House.

conventional portrait poses. Uninterested in the mechanics of photography, Sarony worked with Benjamin Richardson, his cameraman, to whom he gave credit, to make the pictures he desired. Sarony positioned the sitter while Richardson deftly captured his vision. Richardson offered this account of Sarony's technique:

> When he photographed Jim Mace, the pugilist, on his first visit to this country, he danced around him, slapping him on the chest and in the ribs in a way which fairly astonished the champion, who enjoyed it hugely.[14]

One of the first photographers to display the *copyright notice* on his card mounts,[15] Sarony sued a lithography firm for copyright violation over his portrait of Oscar Wilde. He not only won the suit, but established the legal precedent that photography could be an art.[16]

## Retouching and Enlargements

Although hand-coloring of images was widely practiced, photographers often balked at retouching, for it was time consuming and expensive, and many considered it fraudulent. Hence, anything that Sarony or Adam-Salomon achieved by retouching was of no value to those who believed that making revisions to the negative was blasphemous, which showed how quickly the negative achieved the status of an inviolable container of truth.

However, the new larger-sized cabinet prints revealed characteristics many sitters did not find flattering. Customers demanded that the camera image be softened and facial imperfections eliminated. Photographers thus began to offer sitters the option of having an idealized portrait made, marking the beginnings of *image* (fantasy) taking precedence over reality. As photographers became more proficient in their use of light, pose, and retouching, they could now modify human appearance and offer illusionary beings as role models, triggering new standards for looks and fashion. Problems surfaced as people forgot that these images were constructions and began to use them as yardsticks to measure their own appearance and came up lacking. This conflict between reality and how that reality is pictured generates the question: Do photographs show how things are or how they look photographed?

Before the collodion era, almost all photographic images were the size of the original camera exposure. John Draper experimented with enlarging daguerreotypes in 1840, and in 1843, Alexander Wolcott patented an enlarging device that permitted a daguerreotype to be rephotographed onto a larger plate or a piece of calotype paper. Others, including Talbot, conducted enlarging experiments, but the process was impractical and rarely done. In the early 1850s, however, photographers began to make enlargements with cameras that used reflectors and a copying lens to transmit sunlight through a glass plate negative onto a bigger piece of albumen paper. The first practical *solar enlarger* was patented by David A. Woodward in 1857. Based on the solar microscope in use since 1740 and designed to make enlargements onto a canvas that would later be painted over, the enlarger was a horizontal device that

used a mirror to relay sunlight to a condenser lens the same size as the negative. This light passed through the negative to a copy lens that focused the image onto an easel where the albumen paper was placed for exposures of 45 to 60 minutes. By the mid-1860s, solar enlargers could be seen on the roofs and in the windows of major photographic establishments, and, with improvements, they continued in use until the 1890s. The first vertical enlarger had been designed in 1852 by Achille Quinet of Paris. In 1858, J. F. Campbell's take on this idea used a camera in an opening in his studio roof to make enlargements on a table below. Campbell continued to refine his device until it came to resemble our modern-day enlarger.

Larger images increased the demand for more photographs, which led to more companies producing manufactured photographic goods and services, thus imposing standardization on the practice. Retouching and spotting became everyday procedures, as small defects were now noticeable. As bigger pictures were hung on walls instead of being placed in albums, photographs became more directly related to drawing and painting, causing confusion as to the aesthetic criteria needed to evaluate a photograph.

The concept of *enlarging* meant that a print did not have to adhere to the original construction of the negative, but could act as raw material for the postcamera operations that defined the final image. This was a radical departure from how pictures were previously put together, and it came to shape much of twentieth-century practice. Thomas Skaife's single-lens miniature camera, the *Pistolgraph* (1858), took instantaneous "shots" by means of a spring shutter that was operated by rubber bands when its trigger was fired. (Skaife was almost arrested for "shooting" Queen Victoria with his "pistol." The image was lost when Skaife had to open his camera to convince police he was not an assassin.) The tiny plates, 1½ inches in diameter, were "hand-enlarged," that is, the processed negatives were projected to their chosen size, but the image was hand-traced onto a piece of paper rather than transferred by photographic means.

Charles Piazzi Smyth (1819–1900), Astronomer Royal for Scotland, devised a miniature camera that made 1-inch-square negatives, which he used to capture unrehearsed street scenes during a visit to Russia. In 1865, Smyth used his tiny camera to make photographs of the Great Pyramid's interior with magnesium light. During a lecture at the Edinburgh Photographic Society in 1869, Smyth exhibited enlargements from these negatives and explained why his "poor man's" technique was superior to that of the "London wealth" whose servants made contact prints directly from large negatives:

> the poor man, with his little box of very little negatives brought home modestly in his waistcoat pocket . . . sits him

down at a table, having a compound achromatic microscope . . . and . . . wanders . . . over the various parts of each picture . . . and . . . decides whether a positive copy should be shaped as a long, i.e. horizontal, rectangle, or as a tall, i.e. vertical, rectangle . . . or whether some special scientific purpose may not be better served by extracting one little subject . . . and making a very highly magnified picture of that one item.[17]

## The Stereoscope

The phenomenon of stereo vision—the appearance of three-dimensionality based on *binocular vision*—was observed as early as 280 B.C.E. by Euclid. In his *Treatise on Painting,* Leonardo calls attention to the topic and regrets that painting cannot render volume as persuasively as the eye can perceive it. Regardless of how well chiaroscuro and perspective are used to create the illusion of depth, they rarely overcome the obstacle of surface flatness. The invention of photography offered a practical way to create and view convincing stereo scenes.

In 1832, experiments by Sir Charles Wheatstone (1802–1875) led to the discovery that the illusion of depth could be created by looking at two slightly different drawings of a subject side by side through a binocular device that approximated human vision. Our eyes are set about 2½ inches apart and transmit two slightly dissimilar images to the brain, which fuses them into a single image. Wheatstone's device, which he called a *stereoscope,* allowed the right eye to view only the right image and the left eye only the left image. When the brain combined these separated images, a viewer got the visual sensation of 3-D.

When Daguerre and Talbot announced their new methods in 1839, Wheatstone had stereographs made in both daguerreotypes and calotypes. The daguerreotypes produced reflections, and the calotype proved too slow for portraits and did not hold up well under close inspection. Stereo pictures designed for Wheatstone's elaborate and expensive reflecting stereoscope were sold in London during the 1840s, but did not receive much notice.

However, the process was nurtured by Sir David Brewster's (1781–1868) *refracting stereoscope,* a greatly simplified version of Wheatstone's cumbersome design, which Brewster first exhibited in 1849. It duplicated the 2½ inch separation between the eyes by placing a pair of lenses, side by side, in a small box with a small door on the side to admit light (the center points of the two pictures were also 2½ inches apart). A slot on the bottom allowed the insertion of a mounted pair of stereoscopic pictures. The base was made of frosted glass to allow the viewing of transparencies by refracted light. During the Great Exhibition of 1851 Queen Victoria became captivated by this stereoscope. After a special one was made for her, 250,000 stereo-

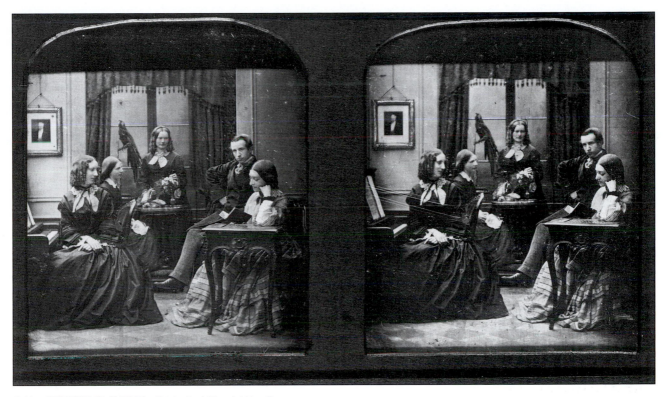

4.12  ANTOINE CLAUDET.  *Portrait of Claudet Family,* ca.
1855. 3⁹⁄₁₆ × 7 inches. Daguerreotype stereo view with applied
color.   Courtesy George Eastman House.

scopes and millions of stereo cards were sold in London
and Paris within three months. Due to this royal boost,
London's top daguerreotypists, Beard, W. E. Kilburn
(1818–1891), T. R. Williams (1825–1871), Mayall, and
Claudet, began hotly making stereoscopic views at the
Crystal Palace site of the exhibition.

The meteoric rise of stereoscopic views touched off
lawsuits and feuds. Jules Duboscq, the optician who
made Brewster's device, patented the stereoscope in
1852 and seized the stereo apparatuses and images of
his chief competitors until his patent was declared void
in 1857. Brewster published *The Stereoscope* (1856) and
followed that with a series of letters to the London *Times,*
in which he challenged Wheatstone's claims to the dis-
covery of the stereoscope's principle and invention of the
actual device (Brewster's assertions were unfounded.)

**Antoine Claudet,** using two cameras set up side by
side, was able to make successful stereo group portraits
and became a devotee to the process. He patented a
folding pocket stereoscope designed for daguerreotypes
in 1853 and an improved viewer in 1855, one with the
lenses set in adjustable tubes as well as a giant ste-
reoscope capable of holding one hundred stereoscopic
slides for viewing. Claudet also experimented with
"moving photographic figures" that linked the zoetrope
with the stereoscope to create three-dimensional mov-
ing pictures. The quality of his own work set significant
standards for others to follow.

## The Stereo Craze

The stereograph was introduced to America by the
Langenheim Brothers. In 1854 the brothers' American
Stereoscopic Company began to sell stereo views (both
glass transparencies and card-mounted prints) of Ameri-
can scenery originally recorded as *hyalotypes.*[18] Clones
of Niépce de Saint-Victor's process that used albumen
to bind a silver salt emulsion to a glass plate, hyalotypes
(from the Greek *hualos,* meaning glass) were almost
identical to John Adams Whipple's previously patented
crystalotype albumen plates. The brothers used the hya-
lotypes to produce magic lantern slides, making the first
photographically based images designed for projection.
This forerunner of the present-day PowerPoint presen-
tation proved so profitable that by the start of the Civil
War all their efforts were directed at producing glass
lantern slides.

By 1856 the London Stereoscopic Company, whose
motto was "No home without a stereoscope," had sold
an estimated half million inexpensive stereo viewers.
The ease of reproducing collodion images insured cheap
paper stereo cards. Mass production allowed the "opti-
cal wonder of the age" to find its way into middle and
upper economic level homes, and made the stereo craze
photography's biggest nineteenth-century bonanza,
remaining enormously popular until about 1910. The
company's staff of photographers, under the guidance
of William England (d. 1896), traveled the world and
compiled a stock of 100,000 views.

The American physician and writer, Oliver
Wendell Holmes (1809–1894), was frustrated by

Brewster's viewing device, which gave him headaches. In 1861 Holmes and Joseph L. Bates designed a hand-held viewer with a sliding T-bar that allowed the viewing distance to be individually adjusted. The Holmes-Bates Stereoscope made viewing paper stereo cards less strenuous, and was lighter weight, easier to handle, and less expensive than any previous device. Since neither man patented the improvement, their device became the standard viewing appliance, adding to the growing popularity of stereoscopic work.

Stereo pictures became a sensation because they provided affordable home entertainment. Their small size (3½ × 7 inches) made them convenient to handle, and there was a magical quality to the illusion. No matter how often one looked at them, a sense of wonderment remained as the two flat images merged, offering a visual sense of depth that transcended the physical size of the picture. Stereo cards made it possible to be amused, to travel, and to expand one's knowledge without leaving home. Claudet wrote:

> It [the stereo card] introduces to us scenes known only from imperfect relations of travelers, it leads us before the ruins of antique architecture, illustrating the historical records of former and lost civilizations; the genius, taste and power of past ages, with which we have become familiarized as if we had visited them. By our fireside we have the advantage of examining them, without being exposed to the fatigue, privation, and risks of the daring and enterprising artists who, for our gratification and instruction, have traversed lands and seas, crossed rivers and valleys, ascended rocks and mountains with their heavy and cumbrous photographic baggage.[19]

Photographers courted the mass market by making pictures of scenes people wanted in the style people recognized and understood. Although the viewing experience of the stereoscope was radical, the subject matter was conservative and did not push the boundaries of the visually acceptable. The vast majority of stereo work recorded views or group scenes, as individual portraits did not provide a dramatic sense of visual depth. Views were especially spectacular, as they offered distinct fore-, middle-, and backgrounds that enhanced the audience-pleasing, three-dimensional effect. The augmented 3-D meant that while an individual might order a dozen stereo portraits, a photographer could easily sell more copies of a single view. Printed text was often linked with a card to anchor the image's context according to the maker's wishes.

Many top photographers did not respect the stereo card. Its small images created an illusion of depth considered too close to reality to be aesthetically gratifying. Serious photographers were brought up with the notion that good picturemaking involved the successful translation of three-dimensional space to a flat surface. Many deemed stereo photography a betrayal of this tradition and its practitioners charlatans. As a consequence, some photographers took stereo views only after they had made their "real" picture, with a monocular camera, and then only to enhance their profits. Scottish photographer J. Craig Annan (1864–1946) offered this criticism:

> The stereoscopic effect is an endeavor to imitate nature, while the object of an ordinary photograph, or drawing is only to reproduce an impression of nature. The failure of the stereoscope in its greater aim is more marked than the less ambitious but more practical endeavor to reproduce on a flat surface an impression of what we see.[20]

Photographers worked by visiting a locale and making stereo views of the important structures. The majority of stereo cards are direct, straightforward tracings of the world that reflect the viewer's expectation for an informational map, rather than artistic expression. The stereo image's small size did not require retouching, and, generally speaking, no effort was expended to uncover the unique qualities that distinguished one town's courthouse from the next. The way to make money was to rapidly cover a market and move on to the next before the competition got there. Except for those done by photographers who published their own work, most stereo cards did not credit individual photographers. If not a strictly local view, a typical stereo card had the publisher's name, address, name of the series, sometimes the photographer's name, and/or a caption printed on the front. Occasionally the verso provided a printed list of other available views. Stereo views were mainly printed on albumenized paper; hand-coloring was most prevalent for genre scenes, especially those made in Europe. Unlike cartes, stereo cards were rarely personalized with greetings, messages, and inscriptions.

The stereo card became the home encyclopedia for the eye, providing an authoritative and comprehensive reference of facts that was a consummate manifestation of the empiricism of the Enlightenment. In the Age of Reason, the empirical mindset depended on direct experience and/or observation. The camera, with its seemingly neutral recording, could represent the naive, ideal, and rational. If an encyclopedia is a source where data is collected, then anyone with a camera could collect evidence. The concept that one could be educated through the use of photographs and that history could be recorded and learned by means of photography got a boost from the stereo card.

Since each stereo image was no bigger than 3 × 3 inches the lens for the stereo camera could be of a shorter (wide angle) *focal length* than the lenses used in portrait work. The focal length of a lens establishes its angle of view, magnification, and the exact point at which a sharp image of a distant object will be formed. Think of the light that forms an image as a lever bar. As the light passes through the lens it rotates in a circular motion until a complete image is formed. If there is movement at one end of this imaginary lever bar, the image being formed at the other end will also move.

The shorter the arm of the lever bar behind the lens, whose size corresponds to the focal length of the lens, the less-blurred motion within an image.

A short focal length lens offers more depth of field at any given aperture than a longer focal length lens, adding visual information to the view. It also diminishes the amount of perceptible movement, permitting live-action scenes to be recorded without ghostly blurs while delivering a still sharp image at larger apertures, thereby reducing exposure time. Shorter exposures made possible the instantaneous stereo cards that freed photographers from the anchor of static subject matter, allowing the capture of transitory moments.

Stereo cards may not have been noted for artistic effect, but they did provide a plenitude of representations, and people clamored to see anything they couldn't see for themselves. Holmes proposed creating a comprehensive stereographic library, "where all men can find the special forms they particularly desire to see as artists, or as scholars, or as mechanics, or in any other capacity."[21] E. & H. T. Anthony of New York met the demand by issuing metropolitan views of Broadway, the elevated railroad, Coney Island, and the Vanderbilt mansions, as well as a series on Niagara Falls. Travel views promoted tourism, which further increased the demand for pictures. Comic, idealized, and sentimental images of domestic life, like *The Happy Homes of England* series, became common fare. Religious edification was met with *Scenes in the Life of Christ,* twenty different cards portraying Christ under a giant halo, being beaten by Roman soldiers. Everyday activities—men drinking beer, families having dinner, a hometown band playing—appeared as a presnapshot innovation.

The financial crash of 1873 put many photographers out of business and caused others to cease making new views. Pirating views was a common way to cut expenses, but it also lowered quality, which disrupted the stereo illusion. The 1880s saw Underwood & Underwood deploying college students door-to-door selling cards. Mass production and marketing doomed the small independent operators, allowing corporate publishers to gain control over how and what was pictured. In the 1920s, by concentrating on the educational sector, Keystone View Company dominated the market. Keystone survived the Great Depression of the 1930s, the rise of picture magazines, and the expansion of motion pictures and radio, only to succumb to color television in 1964. Inexpensive plastic View-Master 3-D viewers and their companion Stereo Reels, featuring 14 color transparencies (that provide seven separate views) in a circular paper mount that rotates through the viewer by pushing a finger operated lever, can still be found at major tourist destinations and toy stores.[22]

The popularity of stereo cards, made possible by the collodion process, demonstrated that people not only wanted images of themselves and their loved ones but also of their world and everything in it. This reveals what most people considered the primary function of the typical nineteenth century photographer: To find and record people and scenes from the flow of real-world time for future contemplation. This photographic act of remembrance evolved into an *aesthetic of finding.* The influence of this ritual can later be seen in the rethinking of the definition of art that inspired artists to incorporate actual objects and representations into their work. It also affected ordinary people who developed an appetite for collecting items from the material world. This desire for visual information, and the profits that could potentially be made by supplying it, led photographers into situations that had previously been thought unpictureable.

## Endnotes

1   Frederick Scott Archer, *The Collodion Process on Glass,* second edition, enlarged (London: Printed for the author, 1854) 10.

2   Archer credited Gustave Le Gray's pamphlet of 1850 as the first published account of collodion and its possible use, but he pointed out that Le Gray never provided the details that would qualify him to call it a photographic method. Archer released the first account of his process in the March 1851 issue of *The Chemist* and followed it up with his self-published *Manual of the Collodion Photographic Process* (1851).

3   Frederick Scott Archer. "The Use of Collodion in Photography," *The Chemist,* no. 2 (March 1851), 257.

4   *The Photogram,* vol. I, 1894, 159.

5   Cutting and Isaac Rehn, his friend and business partner, both took out patents covering several photographic ideas that were not their own. Nevertheless, the U.S. Patent Office gave Cutting the legal right to sell licenses for the use of collodion photography. He hired agents in several areas of the country to sell permits ($100 per town of 5,000 people) and bring legal proceeding against photographers who were making collodion pictures without a license.

6   In 1862 Cutting was committed to the Worcester, MA, Insane Asylum and remained there until his death in 1867. The administrator of Cutting's estate filed for an extension of his patent. Some of America's most influential photographers, including Mathew Brady, Abraham Bogardus, John Carbutt, Alexander Hesler, and John Whipple, met on April 7, 1868, at the Cooper Institute in New York to form the National Photographic Convention for the purpose of establishing America's first national photographic

organization and to fight the ambrotype patent.

7 *Anthony's Photographic Bulletin,* vol. 15 (1884), 65.

8 *The Philadelphia Photographer,* vol. 3, 311–13.

9 New sizes featured the Promenade, 7½ × 3¾ inches; the Boudoir, 8¼ × 5 inches; the Imperial, 10 × 7 inches; and the Panel, 13 × 8 inches.

10 Helmut Gernsheim, *The Rise of Photography 1850–1880: The Age of Collodion* (New York: Thames and Hudson, 1988), 23.

11 Helmut and Alison Gernsheim, *The History of Photography, 1685–1914,* (New York: McGraw-Hill, 1969), 306–07.

12 Many of Nadar's works were reproduced in the *Galerie Contemporaine,* a series of 241 portraits by 28 photographers of artistic, literary, and political figures in France, which was published in Paris between 1876 and 1894.

13 Translated from Jean Prinet and Antoinette Dilasser, *Nadar* (Paris: Armand Colin, 1966), 115–16 (Nadar's testimony in a lawsuit).

14 *Wilson's Photographic Magazine,* vol. 34, no. 482 (February 1897), 69.

15 Copyright protection was extended to photographs in 1865, but it took several years before most photographers started to claim copyright.

16 "Sarony v. Burrow-Giles Lithographic Company," *Federal Reporter,* vol. 17, no. 600, (1883) as quoted in *Photography in Nineteenth Century America,* "The Portrait Studio and the Celebrity" by Barbara McCandless (Amon Carter Museum, Fort Worth, TX and Harry Abrams, NY, 1991), 69–70.

17 Charles Piazzi Smyth, *A Poor Man's Photography at the Great Pyramid in the Year 1865* (London: Henry Greenwood, 1870), 14.

18 The Langenheim brothers made their first *Hyalotypes* (lantern slides) in 1849, while A. and C. M. Ferrier of Paris began, in 1851, to produce albumen transparencies for use with Brewster's stereo viewer.

19 A. Claudet, "Photography in its Relations to the Fine Arts," *The Photographic Journal,* vol. VI, June 15, 1860.

20 *The Amateur Photographer,* vol. 15 (1892), 328.

21 Oliver Wendell Holmes, "The Stereoscope and the Stereograph," *Atlantic Monthly,* vol. 8, June 1859, 728.

22 A few contemporary makers continue to work with the traditional stereo method. A notable example was Jim Pomeroy's (1945–1992) installation/exhibition *Stereo Views* (1988) that was produced by Light Work and also shown at CEPA Gallery. The project featured a publication that included a View-Master and three custom stereo reels that provided 21 stereo views of his work.

# Prevailing Events/
# Picturing Calamity

Once, life was primarily rural, and local events had the greatest
impact on people's lives. As Western society became industri-
alized and urban, events outside of the immediate surround-
ings began to have a pronounced influence on daily existence.
Improvements in communications and transportation during
the nineteenth century narrowed distances between peoples
and reduced isolation. People were curious and wanted more
information about the world outside their community. As see-
ing was equated with knowing, the more people saw, the more
they could feel that they possessed knowledge of the world.
The photograph was uniquely positioned to fulfill this desire,
and people took the opportunity to try and make a profit. The
photograph faced technical obstacles; the process couldn't stop
action, and there was no cost-effective way to immediately get
news photographs to large audiences. And of course a photog-
rapher had to be on the scene to capture the event sometime
after 1839. However, the premise of the photograph as a con-
tainer of information and carrier of cultural values was estab-
lished and accepted by society at large.

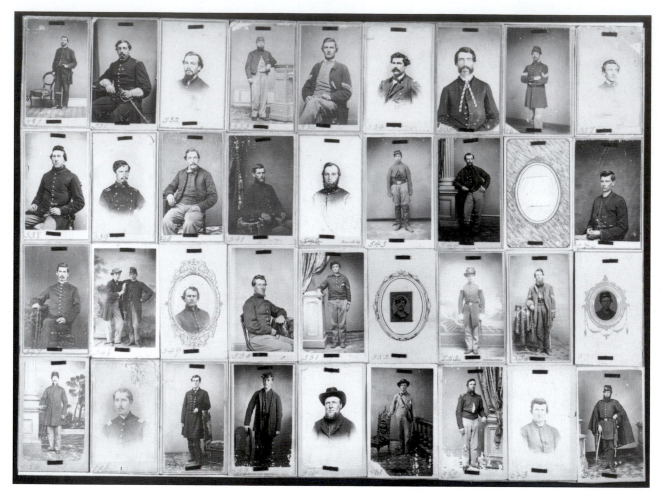

5.1  UNKNOWN PHOTOGRAPHER. *Soldiers' Photographs at United States Post Office Dead Letter Office*, 1861–1865. Albumen silver prints and tintypes. An unusual grouping of soldier portraits was assembled at the U.S. Post Office's dead letter office and displayed to see if anyone would claim them. Someone took the undeliverable cards and laid them out in a grid, attached them to a board with brass brads, and gave each image a number. This homemade display visually raises the question of the fate of all the men pictured and indirectly references the essential maleness of war, as women are rarely seen in any Civil War imagery.  Courtesy George Eastman House.

Working from the notion of photographic "transparency," the job of a good wet-plate photographer was to make "everyperson" views, that is, to give people the impression that the photograph was what they would have seen had they been there themselves. This working mode also demanded an impeccable technical performance, one that allowed the subject to reveal itself with the utmost clarity. Truth and accuracy were believed best served by showing the "wholeness" of a scene. This was done by making broad views with an abundance of visual information for the viewer to sort through and decide what was important. Typically, photographers would position themselves some distance from the subject, place the camera at eye level, and aim straight ahead. Close-ups of three feet or less, isolating a subject from its surroundings, were rare, as *more* information meant *better* information. It was unusual for a photographer to impose an unconventional vantage point or idiosyncratic perspective. As an authentic photographic syntax was just evolving, photographers relied on the painter's vocabulary[1] and on picturesque lithographs to determine how and what was being pictured in photographs. Religion, with its notion that art should be instructive and morally uplifting, also played a role. Since a photograph's form was driven by its subject, the frame was left *open,* encouraging viewers to meander within its confines to decide what was meaningful. Sometimes this distancing defeated the possibility of obtaining important visual information. Consequently, contemporary viewers, facing images that have *deteriorated,*[2] lacking the context of the times, and accustomed to seeing action close-ups, find that early nineteenth-century images possess a static sameness.[3]

## Current Events

Although he used a medium unfavorable for reportage, Carl Ferdinand Stelzner (1805–1894) made one

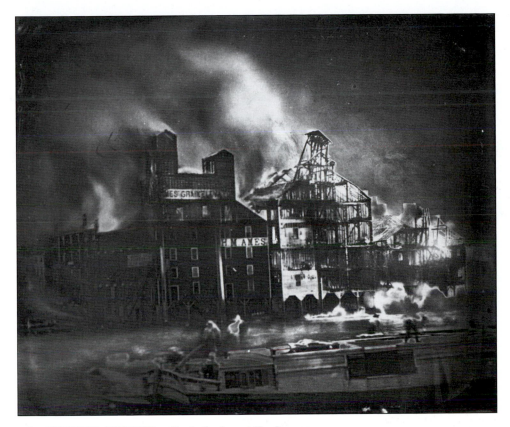

5.2  GEORGE N. BARNARD. *Fire in the Ames Mills, Oswego, NY,* 1853. 2¾ × 3¼ inches. Sixth plate daguerreotype with applied color. The smallness of Barnard's hand-tinted, sixth plate daguerreotype, one of the earliest American action news pictures, transforms the tragedy to a compact, illusory event.  Courtesy George Eastman House.

of the first camera images of a current event with his daguerrean overview of the incinerated ruins of Hamburg, Germany, after the fire of 1842. Because the early methods could not stop motion, the action was inevitably elsewhere and at another time, forcing photographers to make pictures before, after, or surrounding an event. Artifacts from the scene and views of the site or of the area were considered worthy subjects. Photographers involved with this type of work can be compared to police crime scene photographers, always arriving after the fact. They described what had occurred, but never captured the actual event. Although today these images could hardly be considered news photographs, at the time they were regarded as dynamic, factual, and timely.

## Early War Coverage

Daguerreotypes were made of nearly every possible subject, and reportage was considered crucial to photography's future. People wanted to see current events as reported by the camera. They believed photography to be a part of the new scientific method, assigning it an objectivity that other media didn't possess. This belief helped to legitimize the role of the arts as a vehicle that would encourage the growth of knowledge and promote moral progress.

War was an ancient ritual whose deadly effects were felt worldwide, yet its depiction was often abstract and idealistic. Photography was about to change that by recording and circulating pictures of actual events that in turn instituted new patterns for the vital utilization of the medium. The earliest surviving images of a military campaign are from the Mexican War (1846–1848) between the United States and Mexico over the annexation of Texas. A deteriorated image, now in the Amon Carter Museum, made by an unidentified (Mexican?) daguerreotypist, shows General Wool and his staff posing on their horses in the town of Saltillo, Mexico, during the winter of 1846–1847. While it is not exactly a war scene by today's standards, it was well within the expectations of visual accuracy and interest of the time.

The Crimean War (1853–1856) was the first major conflict to be covered by newspaper reporters, artists, and photographers. The war was unpopular in England, and during the winter of 1854–1855 William Howard Russell, a reporter for the London *Times,* sent back dispatches detailing the horrifying conditions under which the soldiers lived. **Roger Fenton** (1819–1869) left England in February 1855 to photograph the war zone. Financed by Thomas Agnew, a Manchester publisher who intended to profit by selling pictures of historical

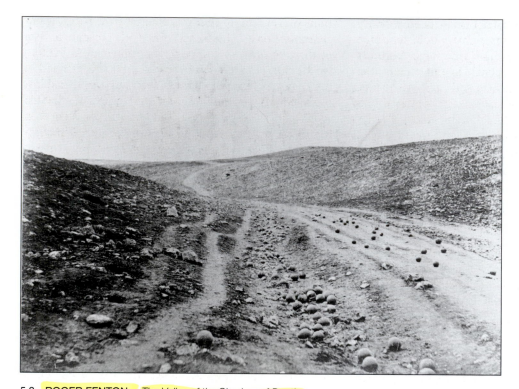

5.3   ROGER FENTON.   *The Valley of the Shadow of Death,* *1855.* Salted paper print. Fenton attempted photographs under battle conditions, but the vast, horizontal desert landscape made his van an easy target. Fenton wrote: "The Russians fired constantly. . . . The ground here is covered with cannon balls. . . . I could hear by the whir and thud that the balls were coming up the ravine on each side. . . . The 68-pounders especially almost burst the ears. . . . The awful clangour as if hell had broken loose and legions of Lucifer were fighting in the air."[4] Here the barren and rocky landscape, littered with cannon balls, tells the terror and fieriness of battle without violating the dictums of his backers or their Victorian sensibilities.   Harry Ransom Humanities Research Center, The University of Texas at Austin.

interest to an upper-class market, the expedition was made under royal patronage with assistance from the Secretary of State for War, who sought to boost public support for the campaign. These factors provide the context surrounding the type of images Fenton produced. None dealt directly with the havoc, death, or human suffering brought on by the mismanagement and lack of medical facilities reported in the press that forced the government to resign.

Fenton, an experienced documentary photographer who had traveled abroad, was the ideal candidate for the Crimean assignment. In the early 1840s he had studied in Paris at the atelier of Paul Delaroche along with Gustave Le Gray, Charles Nègre, and Henri Le Secq. In 1844 he returned to England to study law and later practiced as a solicitor. As a member of the elite Calotype Club he proposed a photographic group modeled after the Société héliographique, which led to the

formation of the Photographic Society in 1853. In 1852 he went to Russia to photograph the construction of a suspension bridge at Kiev and the architecture of Moscow and St. Petersburg. Trained as an artist, Fenton knew how to arrange compositions that invoked classical beauty and its related Victorian moralistic values. He was connected with influential people in the government and was aware of their public positions. Fenton's upper-class affiliations and sympathies made it unlikely he would disturb the artistic or political status quo. Understanding that the basis of camera vision is subtractive composition, Fenton knew what to exclude, but in some instances he may have subtly subverted his backers' interests.

Fenton arrived at Balaclava on March 8, 1855, with a wagon, a driver, and a photographic assistant. The wagon, with "photographic van" painted on its sides, had been modified for darkroom work, cooking, and sleeping. Fenton's outfit consisted of five cameras, 700 glass plates, all the necessary darkroom chemicals and paraphernalia, a tent, tools, and tinned food. By April, Fenton's working conditions had become dreadful due to heat, dust, and flies. He reported that "When my van door is closed before the plate is prepared, perspiration is running down my face, and dropping like tears. . . . The developing water is so hot I can hardly bear my hands in it."[5]

By June, Fenton was making portraits at 4 AM to avoid the glare of the sun; it was so intense that by 10 AM Fenton's subjects could barely open their eyes. The harshness of the light created contrast problems, which caused a loss of detail in his negatives, a major flaw in a working mode where clarity and detail were

gauges of success. Fenton's backers wanted morally instructive and uplifting pictures that would reinforce their war propaganda. Fenton thus made staged portraits of officers, generals on horseback in full regalia, the staff at headquarters, and pashas and their attendants, while complaining that ordinary soldiers pestered him to take their pictures to send back home. Fenton's pictures of the accessories of war, from the harbor clogged with ships to mortar batteries, established the descriptive stylistic basis for photographers of the upcoming American Civil War.

Fenton never photographed a dead body. Instead, an image of a nurse seated by a man with a perfectly wrapped, pristine head bandage implied that the dreadful hospital conditions reported in the press had been ameliorated. If seeing is believing, then Fenton's pictures proved that getting wounded was nothing to worry about. But should it happen, a heroic nurse would dress your wound and take care of you. However, the image is subversive: it reported that people do get wounded.

At the end of June, after a large Allied attack on Sevastopol failed, Fenton, suffering from cholera, returned to England, where he secured royal support to publish his prints. Although the photographs present the British military positively, they are not the usual depictions of wartime valor that people were accustomed to seeing in paintings. Fenton castigated such pictures for their "total want of likeness to reality."[6] His photographs produced no public heroes, but they did introduce a new photographic standard of depicting reality, one that began to debunk the romantic war fantasies promoted by painters and sketch artists. With the emergence of this new standard, photographs were getting the nod as being the most *real*.

Fenton's backers did not reap financial rewards, but their idea that photographs could be propaganda was given a field trial. The underwriters had hoped his photographs would override the written journalistic accounts of the war. This was not the case, as the war ended before their publication. Still time has shown the underwriters' aim to be an effective strategy. The idea has been refined in the twenty-first century, where images have a tremendous impact on political opinion. While today's audience is more visually sophisticated about how images are constructed, it continues to wish to accept the photograph as a custodian of reality.

James Robertson (ca. 1813–1888), the British superintendent and chief engraver of the Imperial Mint at Constantinople, and **Felice Beato** (ca. 1834–ca. 1906), his brother-in-law and photographic assistant, worked together making views in Constantinople, Athens, Malta, Cairo, and Palestine. The pair's Crimean War series, made with a different set of intentions and standards than Fenton's, picks up the story where his pictures left off. Their images continue and complete Fenton's Crimean documentation with coverage of the ruins of Sevastopol after its capture by the Allies. Concentrating on the landscape, the work presents a vista of the aftermath of the siege. As happened to Fenton, by the time their work was exhibited and illustrated in the London press, the war was over and people had lost interest in the subject. In hindsight, it points out that the effectiveness and profitability of war images depend on immediately getting the pictures to the intended audience, for once the conflict ends most people want to forget it. At the war's conclusion Robertson and Beato traveled to India to cover the aftermath of the Indian Mutiny of 1857–1858.

Beato, a naturalized British subject from Venice, was fascinated by the British army's colonialist campaigns. His photographs of the capture of Fort Taku near Tientsin by the British and French fleets in 1860, at the conclusion of the Second Opium War in China, unflinchingly show battle dead (see Figure 5.4). Beato covered the fighting in the Simonaki Straits of Japan in 1862, providing early European views of this recently opened society. In 1870, he returned to China to record massacres resulting from renewed anti-foreign sentiment. His war work concluded with the British campaign of 1884–1885 during the siege of Khartoum.

An outsider with inside connections, Beato was twice-removed: once as a foreigner who had adopted the British outlook, and again as a witness from the occupying military force who could see things that born-insiders took for granted. His meticulous work has been referred to as aloof, dispassionate, even ghoulish. Although Beato does present the colonial view of "underdeveloped natives" as curiosities, he was the first to photographically show the horrific, unglamorous side of war to the British public. The precise coolness of Beato's work reveals his underlying belief that the unmanipulated photograph possessed the power of truth. Beato's urge to categorize, define, and label typifies the Enlightenment belief that understanding is achieved through description. From this perspective, Beato's work represents the quintessential nineteenth-century documentary photograph.

## The American Civil War

The American Civil War began on April 12, 1861. The North was swiftly evolving into urban, capitalistic, industrial centers that were organized around factories, mass production, and a free, diverse, and skilled labor force. Northerners believed that the war would be short, and photographers expected it to generate a demand for souvenir pictures of dashing, uniformed men who would slay the dragon in an afternoon and be home for dinner that night. As it turned out, the war lasted four bloody years, saw 2.9 million men in uniform, and produced as many casualties—over one million, including at least 623,000 deaths—as all other American wars,

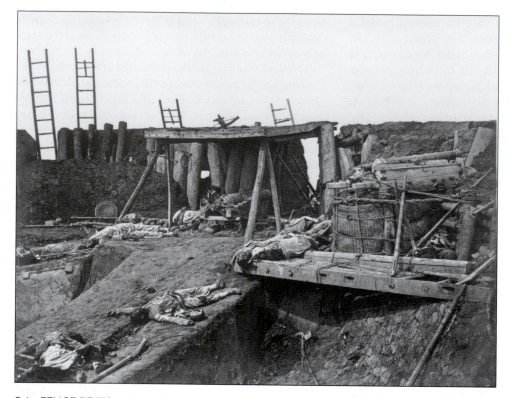

**5.4  FELICE BEATO.** *Interior of Fort Taku in North China Immediately after Capture*, 1860. 9⅝ × 12⅜ inches. Albumen silver print.    Courtesy George Eastman House.

from the Revolution to Iraq, combined.[7] By the war's end, the demand for images had diminished; people were exhausted from the events and did not want any more war mementos. Nevertheless, the war offered photographers new opportunities to hone their craft, try new methods, improve their aesthetics, link images with text, and get photographs in front of more people's eyes than ever before.

To profit from an audience anticipating a quick victory, studio owner and photographer Mathew Brady quickly organized a group of field photographers to make photographs under actual wartime conditions. On July 21, 1861, three months after the start of the Civil War, Brady and his cameraman Timothy H. O'Sullivan parked their photographic wagon on a bluff overlooking the Bull Run battlefield. The anticipated great Union victory turned into a calamitous retreat. Brady claimed to have made views of the battle and to have lost them in the chaotic flight.[8] Although his deteriorating eyesight is often cited as the reason he made few battlefield photographs, he had generally stopped working behind the camera long before. After Bull Run, Brady rarely went to the front. Instead, he spent the war managing his New York studio and supervising twenty units of field photographers who amassed at least 7,000 negatives, the most complete coverage of a major event to date. Brady's approach supports traditional images of

national identity etched in our consciousness by heroic narrative painting such as Emanuel Leutze's *Washington Crossing the Delaware* (1851). Brady's collection continues to capture our imagination, showing that the notion of freedom that became emblematic of the Union cause still persists in our culture in photographic exhibitions, books, and television and film portrayals of the Civil War.

Due to the length of the war and the high casualty count, nobody wanted souvenir pictures after the struggle ended. They needed to forget. Financially ruined, though eventually awarded $25,000 by the government in recognition of his unique historical endeavor, Brady continued to make portraits in a small Washington, D.C., studio until the early 1890s. He died in the indigent ward of a New York hospital in 1896, half blind and broke, after being run over by a delivery wagon.

**Alexander Gardner** (1821–1882), a self-taught master of the wet-plate process, was in charge of Brady's Washington studio in 1861. With war imminent, he arranged for E. & H. T. Anthony, the country's biggest dealer in photographic goods, to print and distribute pictures of officers and soldiers with the inscription "Brady's National Photographic Art Gallery." The mechanism for producing war hero pictures was thus set up before the fighting even started. Preparations for the war around Washington, D.C., were documented by the Brady team and published as part of a series called *Incidents of the War* that carried the credit line, "Photograph by Brady." These images were not considered to be news pictures due to the time lag between the taking

and their publication. However, they were considered to be collectable visual references.

Gardner joined General George McClellan's staff as a civilian photographer and made his first battle pictures of the carnage at Antietam in September 1862. These first photographs of battle corpses removed the society's prohibition against picturing actual war dead. Nobody in America had ever seen such unromantic war pictures. These inescapable records destroyed the myth of the beautiful battlefield death. Broken, bloated, distorted, and decomposing, the dead bodies offer visceral proof that war is not glorious. Whether by collusion or societal pressure, such disturbing death scenes were reproduced on only about six occasions in the illustrated press.[9] Oliver Wendell Holmes's response to Gardner's Antietam pictures explains why:

> It was so nearly like visiting the battlefield to look over these views, that all the emotions excited by the actual sight of the stained and sordid scene, strewed with rags and wrecks, came back to us, and we buried them in the recesses of our cabinet as we would have buried the mutilated remains of the dead they too vividly represented. Yet war and battles should have truth for their delineator.[10]

When Gardner's Antietam work was shown at Brady's New York gallery, written about in the newspapers, and reproduced in *Harper's Weekly,* it was identified as Brady's, even though Gardner held the copyright. This custom, common in the early photographic studios, was frustrating to talented portrait photographers and infuriating for field photographers who bore the dangers and hardships of the Civil War. By extensively publishing such images under his own name, Brady formed a brand association between his name and Civil War photography that endures to this day.

Asserting his independence from Brady, Gardner opened his own Washington studio in 1863. The majority of Brady's finest photographers, including Timothy H. O'Sullivan, Egbert Fowx, T. C. Roche, and D. B. Woodbury, went to work for Gardner, who credited the maker of any picture he published. Gardner's practice acknowledged that photographic vision was not generic and that photographers did have a personal vision. Declaring that the photographic image was worthy of an individual's signature elevated photography's status and declared that photographers should receive the same treatment as other visual artists.

The decisive land battle of the war was fought at Gettysburg from July 1 to July 3, 1863. It generated 51,000 casualties—dead, wounded, captured, or missing. Gardner, O'Sullivan, and James F. Gibson arrived at the battlefield on July 5 to photograph the bodies being gathered and moved for burial. Gardner constructed the photograph, *Home of the Rebel Sharpshooter,* for artistic effect (see Figure 5.5). He moved the body of a Confederate infantryman about forty yards and added a Springfield musket (not a sharpshooter's rifle) to the

scene, and turned the corpse's face toward the camera, thus forcing the viewers to gaze directly into the tragedy of a violent and premature death.

Civil War photographers expanded the definition of photographic documentation. Technical limitations and thick battlefield smoke enforced a standard of accuracy different from today's. Photographic truthfulness was not only a question of picturing what chance placed before the camera, but of depicting the experience of war. Creating a field representation, rather than accepting only what could be recorded as it happened in front of the camera, was an inventive act. If a studio photographer's duty was to arrange the sitter for a specific effect, and if the resulting image was considered reality, then where were the boundaries of truthfulness when a photographer went outside the studio?

No one questioned Gardner's right to "set the scene" for the camera. It was accepted as an accurate overall representation of that situation. This established a silent compact between the viewer and the photographer, giving the photographer license to adjust a situation to deliver a truer, more complete sense of a subject, something artists in other media, not just visual, had been doing for a long time. The "liberties" Gardner took reflected the upheavals within American society over truth and righteousness. Since the dawn of civilization, the concept of slavery had been accepted by most cultures, including America's. Lincoln's Gettysburg Address, in just 272 words, remade America by introducing the idea of equality, which is not actually stated in the U.S. Constitution. His speech—"That this nation, under God, shall have a new birth of freedom—and that government of the people, by the people, for the people, shall not perish from the earth"—not only changed the direction of the Union cause, but altered the nation's political future by calling into question previously unchallenged concepts pertaining to individual freedom.

After 1863, Gardner rarely went into the field, acting instead as a producer for other photographers covering the war. At the conclusion of the war Gardner wrote, produced, and published a significant photographic chronicle of the conflict, *Gardner's Photographic Sketch Book of the War* (1866). Gardner's title, "sketch book," implies an artist's spontaneous reaction to selected subjects, not an exhaustive visual record. The book presents 100 pictures (from about 3,000 made by Gardner and his colleagues) together with interpretive text designed to provide a Northern, moralistic overview, characteristic of the entire conflict that speaks of the cataclysmic repercussions of taking on an allegiance to an immoral crusade. It is the first extensive, thematic photo essay, offering an astute, emotional view of the war, with the battle of Gettysburg as its nucleus. It was an expensive ($150) limited edition (200 copies), containing actual prints, designed to be sold to an elite audience.

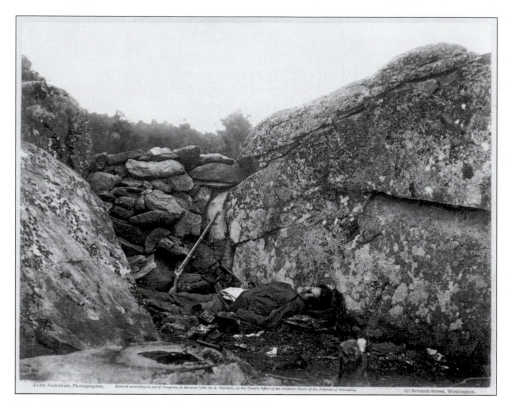

5.5  ALEXANDER GARDNER.  *Home of the Rebel Sharpshooter, Gettysburg,* 1863 (from *Gardner's Photographic Sketch Book of the War*). 6⅞ × 8⅞ inches. Albumen silver print. Gardner's *Sketch Book* offers us a window into the adage that it is the winners who write history. The text with this image reported "that his suffering must have been intense. What visions, of loved ones far away, may have hovered about his stony pillow!" The text then skips ahead four months and transmits the ultimate fate of a Rebel: "The skeleton of the soldier lay undisturbed within a mouldering uniform. . . . None of those who went up and down the fields to bury the fallen, has found him. 'Missing,' was all that could have been known of him at home, and some mother may yet be patiently watching for the return of her boy, whose bones lie bleaching, unrecognized and alone, between the rocks at Gettysburg."[11]  Courtesy George Eastman House.

The arrangement of the images and text reflected the feeling of many in the North. The blockade of Southern ports and the Confederacy's general economic straits greatly restricted the number of photographs made from the Southern perspective, giving the Union the historic advantage of having most of the surviving Civil War images represent a Northern point of view. Gardner interprets and manipulates the viewer's response with such words as "devilish," "distorted dead," "buried unknown by strangers, in a strange land," and "they paid with life the price of their treason" when referring to the Confederates. The parable of Old Testament justice for the insurgents can be seen in his descriptions of the Union dead as having "passed away in the act of prayer," with "a smile on their faces," "having friendly hands . . . prepared them for burial," and "appealing to heaven." The *Sketch Book* demonstrates that photography has never been impartial and that the history it presents is in part a construct of the photographer's imagination. As much an ethical literary allegory as it is historical documentation, the *Sketch Book* relies on image sequencing and text to elucidate and supply meaning.

One of the last images in the *Sketch Book* is **John Reekie's** *A Burial Party, Cold Harbor, VA,* 1865, which pictures a group of freed slaves performing the grisly job of gathering up the remains of Union troops (see Figure 5.6). Reekie's focus is on the foreground, where a man sits next to a hospital litter that bears five skulls and a leg with a boot on top of a disgusting mix of decaying battle-ruined clothes and, ironically, a canteen. The postwar public did not have the stomach for such legend-breaking images and until recently this picture was not widely reproduced. In spite of its social importance, American painters rarely dealt with the Civil War. Audiences expected art to provide a remedy for the shadowy side of life and did not want to look at scenes of ghastly suffering. Photographic work like the *Sketch Book* broke down such notions by providing a ringside view of a fratricidal horror show.[12]

The *Sketch Book* text reminds readers about the moral failings of the entire rebel cause; one that did not bury the dead. "It speaks ill of the residents of that part of Virginia, that they allowed even the remains of those they considered enemies, to decay unnoticed where they fell."[13]

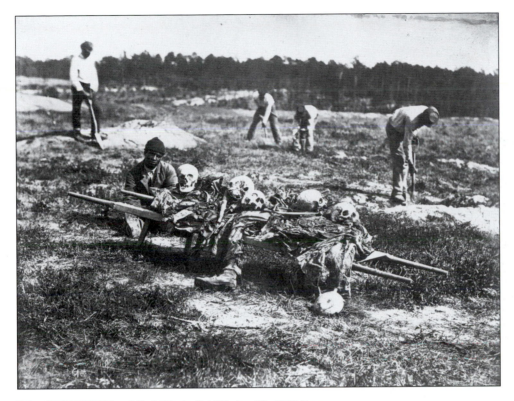

5.6   JOHN REEKIE.   *A Burial Party, Cold Harbor, VA,* 1865 (from *Gardner's Photographic Sketch Book of the War*). 7 × 9 inches. Albumen silver print.   Courtesy George Eastman House.

Gardner also made portraits of President Lincoln and prison studies of Lincoln's assassination conspirators (*The Lincoln Conspiracy Album,* 1865). For their executions Gardner set his camera on a roof overlooking the gallows and made a series of seven exposures. This sequence is considered the first photographic picture story of an event that unfolds over actual time. It took on the dual photographic role of picturing the news and acting as a document. It also provides evidence of the vital function sequential photographs would perform in future news reporting. Gardner went on to photograph the Union Pacific Railroad, the Great Plains Indians and the Indian delegates to Congress, and a rogues gallery for the Washington, D.C., police before contracting tuberculosis and dying in 1882.

Timothy H. O'Sullivan (1840–1882) worked at Brady's Washington studio under Gardner's supervision before joining Gardner's staff in 1862. Civil War photographs, powerful as they may be, tend to have a sense of sameness about them. Their level, straight-on, maximum depth-of-field view, made at a genteel distance from the subject, discourages us from thinking of a photographer as having personal impressions that direct our concentration to specific facets of a site. In the aftermath of Antietam and Gettysburg, O'Sullivan began breaking this precedent by incorporating intrinsically photographic forms, like selective focus, into compositions to elicit powerful visceral responses. Gardner recognized O'Sullivan as a sophisticated picturemaker and his *Sketch Book* used 44 of the photographer's images, nearly half the book's total.

In one such image, *A Harvest of Death* (see Figure 5.7), O'Sullivan presents a sharply focused middleground of bloated bodies while the fore- and background are explicitly out of focus. This uncommon practice has the macabre effect of centralizing our attention on a corpse whose mouth is open in an apparent death-scream. The visual rhythm of the arched corpses produces a sense of trepidation that visually echoes into the surrounding landscape. The highly expressionistic selective focus actively manipulates our concentration to re-experience O'Sullivan's sense of amazement, horror, and motionlessness. Such methods encourage the audience to fasten onto subjective sensations rather than concentrating on analytical facts.

O'Sullivan executed the same selective focus technique in *Field Where General Reynolds Fell,* in which the swollen corpses are not only the subject of the composition but are the only objects in critical focus. This view and the title inform us that the field where Reynolds was killed is significant and worthy of depiction. In terms of social status it is noteworthy that General Reynolds's body is nowhere to be seen, as he was no doubt given a prompt and proper burial. As for the five ballooning bodies so sharply pictured in the frame, they are the classic unknown soldiers. The image questions the notion of the romantic last hurrah by showing us the anonymous, undignified deaths of the everyday

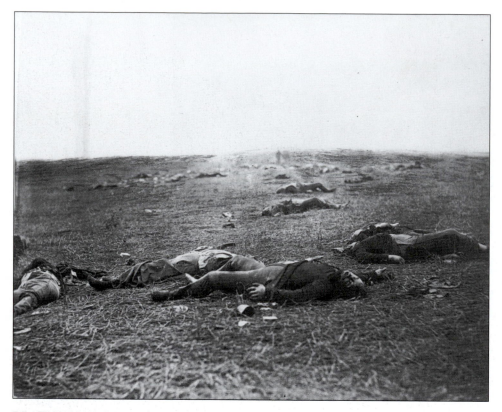

5.7 TIMOTHY H. O'SULLIVAN. *A Harvest of Death, Gettysburg, PA,* 1863 (from *Gardner's Photographic Sketch Book of the War*). 6¼ × 7¹³⁄₁₆ inches. Albumen silver print. The *Sketch Book* removes the veneer of war pageantry and matter-of-factly reports: "The rebels represented in the photograph are without shoes. These were always removed from the feet of the dead on account of the pressing need of the survivors. The pockets are turned inside out also show that appropriation did not cease with the coverings of the feet. Around is scattered the litter of the battle-field, accoutrements, ammunitions, rags, cups and canteens, crackers, haversacks, and letters that may tell the name of the owner, although the majority will surely be buried unknown by strangers, and in a strange land . . . they paid with life the price of their treason, and when the wicked strife was finished, found nameless graves, far from home kindred."[14]  Courtesy George Eastman House.

soldiers, buried where they fell with their stories untold.

**George N. Barnard** (1819–1902) opened his daguerreotype studio in Oswego, NY, in 1843 (see Figure 5.2) and moved to New York City about 1859 to make stereographic views for E. & H. T. Anthony and to work in Brady's portrait studios. When the war broke out Barnard began to make views for Brady and later for Gardner, often working with James F. Gibson. In 1864 he became a Union army photographer in a division commanded by General William Tecumseh Sherman and recorded the destruction of Atlanta by Federal troops. In November 1866 Barnard issued his

*Photographic Views of Sherman's Campaign,* a limited-edition book (about 100 copies) of 61 original 10 × 14-inch prints that sold for $100.

Barnard's images possess a serenity that projects a sense of sadness and loss. After the soldiers left the battle sites, Barnard often returned to the empty fields to record their sense of tranquility that, paradoxically, evoked the tempestuous nature of the fray. The ferociousness of battle is vicariously experienced in *The Hell Hole, New Hope Church, GA,* picturing trees that were shot down during combat. The tormented landscape replaces the mutilated soldiers' bodies, expressing the social rupture of war. The credit line ironically reads: "Photograph from nature by G. N. Barnard." This sense of calm after the passing tempest can also be seen in *Ruins in Charleston, SC,* as two men, one with a pipe, sit seemingly contemplating the rubble that was once the city.

Barnard relied on symbolic devices and pictorial effect for emotional impact. In *Scene of General McPherson's Death,* a horse's skull, human bones, and pieces of explosive shot were arranged, depicting death in a more allegorical manner than O'Sullivan's *Field Where General Reynolds Fell.* Barnard's use of combination printing—making separate cloud negatives and printing them into the sky portion of the original landscape—indicates that his photographs were not meant to be read as war news, but as personal, artistic statements about the war. In *Rebel Works in Front of Atlanta,* the clouds are heavily printed into a depopulated view. They blend into the tops of the moving trees (blurred

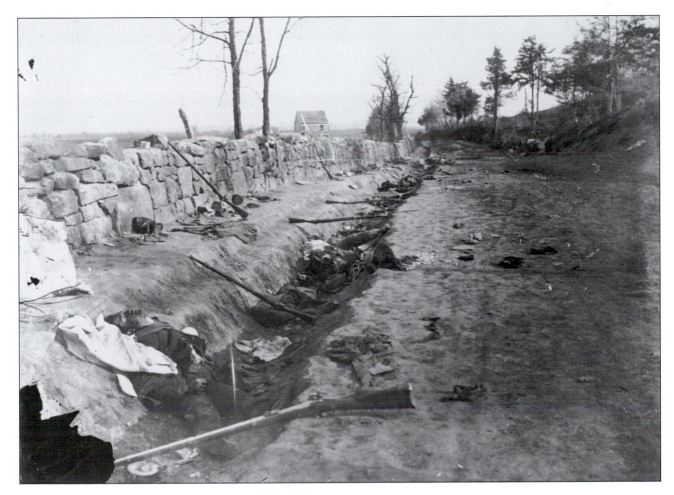

5.8   ANDREW J. RUSSELL.   *Stone Wall, Rear of Fredericksburg, with Rebel Dead,* May 3, 1863. 9¹⁹⁄₃₂ × 13⅛ inches. Salt print. In this view we are confronted with the bloody face of a dead soldier, lying on his back in a shallow ditch, next to his rifle. Our sight line leads us down the ditch of crumpled, dead soldiers, compositionally reinforced by a parallel stone wall as far as we can see, suggesting an endless line of wrecked manhood.   The J. Paul Getty Museum, Los Angeles.

due to the long exposure time) and feel as though their celestial forms dare not get any closer or risk being punctured by the rows of *chevaux-de-frise* (logs with fixed sharpened wooden stakes) that form the trench lines and palisades of hell.

**Andrew Joseph Russell** (1830–1902) was a Union captain assigned to document the work of Herman Haupt, an innovative engineer known for his experiments in transporting troops and for the construction, repair, and destruction of railroads and bridges. Russell was an experienced artist and photographer, who emphasized pictorial qualities even when making instructive pictures.[15] As Russell's audience was the officers of the Corps of Engineers, he had no commercial restraints, and he was able to make stereo views from unusually low angles, and some battlefield photographs featured atypical close-ups of dead soldier's faces.

The number of Civil War casualties created an unparalleled demand for medical care in an era when diseases were little understood and surgical procedures primitive. To increase medical effectiveness the Surgeon General established the Army Medical Museum in 1862 to analyze military medicine. Photography played a new role, as the Museum established its own photographic department headed by **William Bell** (1830–1910). The editor of the *Philadelphia Photographer* gave this account of Bell's activities:

> [T]he principal work of the photographer is to photograph shattered bones, broken skulls, and living subjects, before and after surgical operations have been performed on them. . . . We saw a picture of one poor fellow as he came from the field, with his face almost torn asunder by a shell. After surgery had exercised its skill upon him, he was again photographed, and looked much better than any one could be expected to look with his lower jaw gone.[16]

The Museum's photographers re-photographed patients whose conditions were being monitored, in one of the first such projects. These images are different than the war views. They are often close-up, extremely deadpan examinations of broken bodies against a neutral background (see Figure 5.9). The pictures document injuries with cool detachment and label them with baffling professional jargon that does not provide

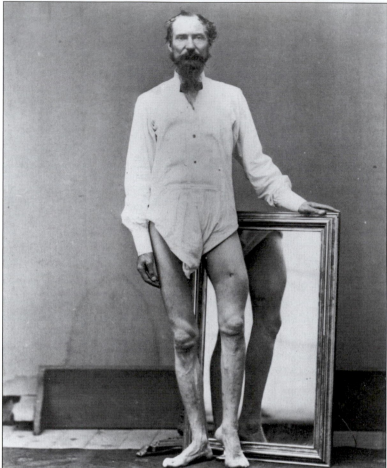

5.9  WILLIAM BELL (OR STAFF).  *Gunshot Wound Middle Third of Left Femur,* 1866. 8 × 6⁹⁄₁₆ inches. Albumen silver print.    Gilman Paper Company Collection, The Metropolitan Museum of Art.

the layperson with any context to understand what has happened. The combination separates cause and effect, removing the ruined bodies from their warfare context. When we look at these grim pictures there is no correlation between the shattered men and the war that caused their condition. This distancing effect reinforces the fact that the bodies are no longer sites of beauty, fashion, joy, or pleasure, but of disfigurement, ugliness, suffering, and pain.

## How Photographs Were Circulated

Carte portraits of individual soldiers were much in demand and made up the bulk of photographic work during the war years. These inexpensive cards were not intended as artistic portraits, but to impartially preserve the likeness of a soldier going off to war. War scene cartes, sold by subscription and collected in albums, established a precedent for marketing future disasters, from the Johnstown flood of 1889 to the San Francisco

earthquake and fire of 1906. By the war's end, the popularity of these paper prints had finished the ambrotype, which was too fragile to be sent through the mail. The mailing of cartes was so common that the Federal government imposed a tax stamp, requiring a two-cent stamp for card-size photographs sent through the mail, between September 1, 1864, and August 1, 1866.

The majority of field views were made with stereographic cameras, as they were lighter than view cameras and used smaller plates, which were easier to prepare, thus allowing operators to work more quickly and prolifically. The first true combat photographs were stereoviews taken in Fort Sumter by Southern photographer George S. Cook.[17] The selling of Civil War stereo cards was a big business fraught with unauthorized copying.[18] By the war's end, Edward Anthony's catalog listed more than 1,400 stereo views selling at $4.50 a dozen. Along with ambrotypes, tintypes, and photographically derived wood engravings in popular magazines, such as *Harper's Weekly* and *Leslie's Illustrated,* the endless, inexpensive supply of paper prints made the Civil War the first conflict to be brought directly into people's parlors.

What do these records of wartime experiences add up to? Did the photographers believe that their war pictures might reduce the chance of its recurrence? There is not much photographic evidence that they had such feelings. A line of text that accompanies O'Sullivan's *A Harvest of Death* in Gardner's *Sketch Book* is an exception. It reads: "Here are the dreadful details! Let them aid in preventing such another calamity falling upon the nation."[19] In general, photographers seem to have accepted war as part of life. The war photographs are not so much authentication of history as they are themselves history. They reveal that the camera is not an impartial observer, but a human-guided tool that makes contrived and coded images open to interpretation. They show us how photographs are in flux, their meanings constantly reinvented and used for contrasting purposes depending on what the photographer wants to represent. The Civil War moved photography out of the studio and into the field, demonstrating that photographs could perform other functions in addition to making portraits. The formation of private, for-profit, photographic corps gave photographers rigorous, hands-on training for the government surveying expeditions of the uncharted territories between the Great Plains and the Pacific Coast that resumed after the war.

Although the demand for portraits was very high, public exposure to war views remained limited, as there

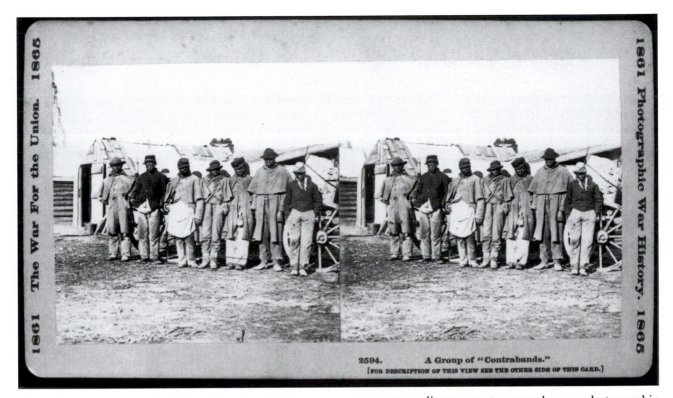

1861  The War For the Union.  1865
1861  Photographic War History.  1865

2594.    A Group of "Contrabands."
[FOR DESCRIPTION OF THIS VIEW SEE THE OTHER SIDE OF THIS CARD.]

**5.10  UNKNOWN PHOTOGRAPHER.** *Contrabands.* 6⅝ × 8⅞ inches. Albumen silver stereo card. In conjunction with their text, stereo views provide a contextual window for understanding prevailing social attitudes. Northern racial stereotypes are on view in *Contrabands* as seven black men, all wearing hats and tattered clothes, are pictured standing in front of a shanty. The text reads: "The negroes who ran away from slavery and came into the union lines, were employed by the government as teamsters, laborers, tea, & c. They were happy, good-natured fellows, and made lots of fun for the soldiers." Courtesy George Eastman House.

was yet no direct way to reproduce a photographic image in a newspaper or magazine. Those images that were published had to be translated through woodcuts, which significantly altered them. The depicted horrors of warfare were thus only truly seen by a few people at the time, so that in all likelihood they had little impact on public sentiment. Their power and influence built up over time in their use as historical documents for future generations of photographers and viewers.

# Endnotes

1   John Burnet's *A Treatise on Painting: In Four Parts . . .* (1822), had an impact on early photographic picture-making. It remained in print through World War I.

2   See James M. Reilly, *Care and Identification of 19th Century Photographic Prints* (Rochester, NY: Eastman Kodak Publication No. G-25, 1986).

3   Problems of image deterioration affect today's viewers of nineteenth-century prints. Albumen prints are predisposed to *yellowing,* which occurs in direct proportion to the thickness of the albumen layer, and to *foxing,* a type of paper staining characterized by blotchy, reddish-brown patches, often circular or irregular in shape. These conditions alter the aesthetic quality of the print and can affect the quantity and quality of discernible information.

4   Quoted in Helmut and Alison Gernsheim, *Roger Fenton: Photographer of the Crimean War* (London: Secker & Warburg, 1954), 64–65.

5   Quoted in Lena R. Fenton, "The First Photographer at the Crimea in 1855," *Illustrated London News,* vol. 92 (1941), 590.

6   Roger Fenton to William Agnew, April 19, 1855; Ibid, 62.

7   E. B. Long with Barbara Long, *The Civil War Day By Day: An Almanac 1861–1865* (New York: Doubleday and Co., 1971; reprint (New York: Da Capo Press, 1985), 705–12.

8   See William F. Stapp, "Subjects of Strange . . . and of Fearful Interest," in Marianne Fulton, *Eyes of Time* (Boston, Toronto, and London: Little, Brown and Company, 1988), 16.

9   William A. Frassanito, *Grant and Lee: The Virginia Campaigns 1864–1865* (New York: Charles Scribner's Sons, 1983), 342–43.

10   Oliver Wendell Holmes, "Doing of the Sunbeam," *The Atlantic Monthly* 12 (July 1863), 1–15. As reprinted in Beaumont Newhall, *Photography: Essays &*

*Images* (New York: Museum of Modern Art, 1980), 73.

11   Alexander Gardner, *Gardner's Photographic Sketch Book of the Civil War* (New York: Dover Publications, 1959), unp. (Plate 41). Reprint that combines volume 1 and volume 2 of the original and adds the word "Civil" to the title for purposes of clarification.

12   For an outstanding account of the American struggle to cope with the unprecedented carnage of the Civil War see Drew Gilpin Faust, *This Republic of Suffering: Death and the American Civil War* (New York: Alfred A. Knopf, 2008).

13   Gardner, unp. (Plate 94).

14   Gardner, unp. (Plate 36).

15   Haupt distributed thousands of Russell's photographs to political and military leaders to secure continued support for his work. A limited edition album was put together for engineers and generals to instruct and promote ingenious solutions to complex, practical, and technological problems.

16   *Philadelphia Photographer,* vol., 3, n. 31 (July 1866), 214.

17   Bob Zeller, *The Civil War in Depth: History in 3-D* (San Francisco: Chronicle Books, 1997), 65–67.

18   The backside of Brady's Album Gallery war cards carried this admonition: "The photographs of this series were taken directly from nature, at considerable cost. Warning is therefore given that legal proceeding will be at once instituted against any party infringing the copyright."

19   Gardner, unp. (Plate 36).

# A New Medium
# of Communication

## Photography: Art or Industry?

The introduction of the wet-plate process and the relaxation
of Talbot's patent restrictions led to an explosive increase in
the number of people making their living in photography.[1]
During the 1850s, some of England's most notable photog-
raphers, including Roger Fenton, Robert Howlett, and Henry
Peach Robinson, abandoned their amateur status and turned
professional. Photography had become a business with a
widening division of purpose between amateurs and profes-
sionals. The professionals were motivated by market forces
to produce salable products. The amateurs pursued their per-
sonal inclinations and claimed the moral high ground of art,
beauty, and truth, relegating the professionals to the corner of
crass commercialism. The professionals perceived the ama-
teurs as elitists who ignored the basic photographic needs of
the majority of people. Amateur groups, such as the Royal
Photographic Society of London, championed their role as
keepers of the flame whose duty was to pursue photography
for its own sake. The publication of Sir William Newton's
article, "Upon Photography in an Artistic View" (1853),
brought to a boil the issues surrounding the purpose of

photography (see Chapter 3). Was photography the handmaiden of art or could it be an art unto itself? Was it a technical process or did it possess its own syntax that set it apart from other mediums? Was photography's purpose to objectively reproduce what was before the camera or could it be controlled for artistic concerns?

Some well-educated people viewed photography as an upstart whose popularity and commercialization threatened the position of high art. They believed photographers were failed artists who were mere slaves to reproducing the natural appearance of their subjects, and doubted whether the process could be manipulated to create works based on inner feelings and thoughts. Charles Baudelaire (1821–1867), the French Symbolist poet who claimed to hate having his photograph taken (and yet did so any number of times), unleashed a diatribe on the role of photography in the arts and society and the public's lack of imagination, which took the position that photography fails to critically address the world in which it functions. He blamed the situation on the ascendance of science and mechanical inventions. Baudelaire wrote:

> Since photography gives us every guarantee of exactitude that we could desire (they really believe that, the mad fools!), then photography and Art are the same thing. From that moment our squalid society rushed, Narcissus to a man, to gaze at its trivial image on a scrap of metal. As the photographic industry was the refuge of every would-be painter, every painter too ill-endowed or too lazy to complete his studies, this universal infatuation bore not only the mark of a blindness, an imbecility, but had also the air of a vengeance. . . . It is time, then, for it to return to its true duty, which is to be the servant of the sciences and the arts—but a very humble servant, like printing or shorthand which have neither created nor supplemented literature. . . . let it be the secretary and clerk of whoever needs an absolute factual exactitude in his profession. . . . But if it be allowed to encroach upon the domain of the impalpable and the imaginary, upon anything whose value depends solely upon the addition of something of a man's soul, then it will be so much the worse for us![2]

Not everyone thought photography was bound up by its technical limits. Lady Elizabeth Eastlake (1809–1893), married to Sir Charles Eastlake (1793–1865), Director of the National Gallery of Art in London and the first president of the Photographic Society of London, published an early, unsigned history of photography, offering an astute appraisal of the medium's position in relation to art. After indexing photography's inadequacies when compared with painting, she dismissed the position taken by critics like Baudelaire as "mistaken" and described photography's future as an autonomous "new medium of communication." Eastlake wrote:

> The broader the ground which the machine may occupy, the higher will that of the intelligent agent be found to stand. If, therefore, the time should ever come when art is sought, as it ought to be, mainly for its own sake, our artists and our patrons will be of a far more elevated order than now: and if anything can bring about so desirable a climax, it will be the introduction of Photography.[3]

A turning point in photography's quest to be recognized as an independent medium occurred in 1861 when the French studio of Mayer & Pierson accused another studio, Thiebault, Betbéder & Schwabbé, of unauthorized copying, claiming their celebrity photographs were protected under French copyright laws that applied to the arts. To be covered under these laws, photography first had to be declared an art. In early 1862, the court ruled against Mayer & Pierson. Later that year, however, the court declared on appeal that photography was indeed an art and entitled to legal protection. After the second decision, the artist and social satirist Honoré Daumier released *Nadar Raising Photography to the Height of Art,* a lithograph featuring Nadar in his balloon, taking pictures above Paris, in which every building was labeled with the word "Photography" (see Figure 6.1). A group of artists, fearful of the effects this decision would have on their profession, signed a petition objecting to the appeal court's decision, which the court rejected. Photography was held to be the product of thought and spirit, of taste and intelligence, and to bear the imprint of the individual personality; therefore, it could legally be considered a legitimate art. Mayer & Pierson published *La photographie* (1862), a book on aesthetics and technique that proclaimed the importance of the photograph. That same year André-Adolphe-Eugène Disdéri brought out *L'Art de la photographie,* in which he discussed the artistic controls available to photographers and compared his studio methods to those of contemporary painters, proclaiming the camera could be controlled like a painter's brush. The joining of photographic form to the arts was officially underway.

As Lady Eastlake noted, one of the major obstacles blocking the recognition of photography as art was the wet plate's insensitivity to all parts of the spectrum except blue and ultraviolet radiation, which gave colors an inaccurate translation into black-and-white tones.[4] Red or green subjects were not properly recorded and appeared in prints as black. Exposures, calculated to record detail in the land, overexposed the sky. The amount of overexposure was uneven and produced areas of low density in the negative. When the negative was printed these sections appeared gray and mottled, an effect not suitable for picturesque landscapes.

There were two ways to correct the problem. The first was to outline the horizon area of a negative with opaque paint and cut a mat to cover the sky portion of the negative. This resulted in a print with an open, solid white sky that was still unpicturesque. The artistic solution was to make a *combination print* that was complicated, time-consuming, and expensive. It involved making two separate negatives, one for the ground and a

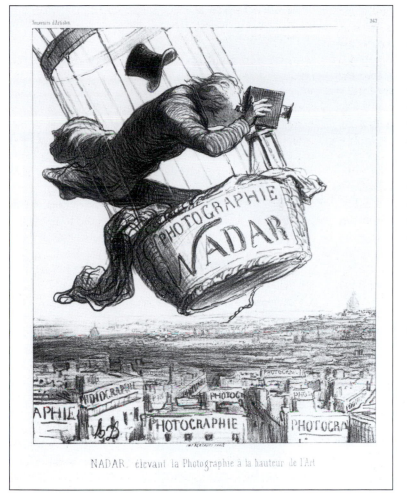

6.1  HONORÉ DAUMIER.  *Nadar Raising Photography to the Height of Art,* 1862. 5⁹⁄₁₆ × 4 inches. Lithograph.  Courtesy George Eastman House.

ardo and Titian painting over the *abbozzo.*[5] Wall complained that artists repudiated colored photographs because they were not paintings and that photographers rejected them because they were not true photographs. He saw no reason for censuring work that combined "the truth of the one with the loveliness of the other." Composite and hand-colored images took time and deft handwork. Time added translated into value added: As photography became less mechanical and more artistic the result was increased fees for work, which encouraged photographers to portray subjects previously reserved for painters.

## Discovering a Photographic Language

During the mid-nineteenth century *realism* became a force in the arts.[6] Realism sought to counter the idealized subject matter of Romantic and Neoclassical painting with direct and frank views of everyday life. The first Realist exhibition was organized by Gustave Courbet (1819–1877), who used the camera for nude studies in paintings, in protest against the rejection of his works by the Academy. As the public became acquainted with photography's veracity and ability to give significance to everyday experiences, their expectations about how reality should be represented and what subjects were worthy of depiction changed. Confusingly, photographs were considered more artistic when they looked less photographic, and retouching methods were developed that made a photograph resemble a painting. Paintings, on the other hand, were thought to be more artistic if they featured "photographic" detail. This paradox resulted in a public opinion that valued neither medium for its own inherent characteristics.

To enhance the artistic value of their work, educated photographers looked to the painterly style of the *symbolic, narrative allegory,* the figurative treatment of one subject under the appearance of another. Their subjects often appeared as representations of abstract moral and/or spiritual qualities, related as a fable or parable. The *Pre-Raphaelite Brotherhood,* a group of English painters and poets founded by Dante Gabriel Rossetti in 1848 to protest the low standards of British art, reacted against the material world of an industrializing England by embracing the beauty and simplicity of the medieval world through symbolism. They were a major influence on photographers with artistic aspirations. This initial

second for the sky. After processing they were masked, with the land's features printed in from the first negative and the sky's from the second. Landscape photographers often made a stock collection of sky negatives, which were used in printing future views. Gustave Le Gray's seascapes were considered spectacular for not only stopping the action of waves but for their dramatic cloud formations, achieved from separately made cloud negatives. His prints demonstrated that photographers could translate feelings into their work and control their medium just as other artists did. Oscar G. Rejlander's allegorical work, *Two Ways of Life* (see Figure 6.6), so clearly verified the artistic potential of combination printing that it became an accepted practice.

The practice of hand-applying color overcame photography's lack of color. Alfred H. Wall promoted the practice in his *Manual of artistic colouring as applied to photographs* (1861). Wall, a former miniature and portrait painter, said that painting over a photograph was no more unacceptable than painters such as Leon-

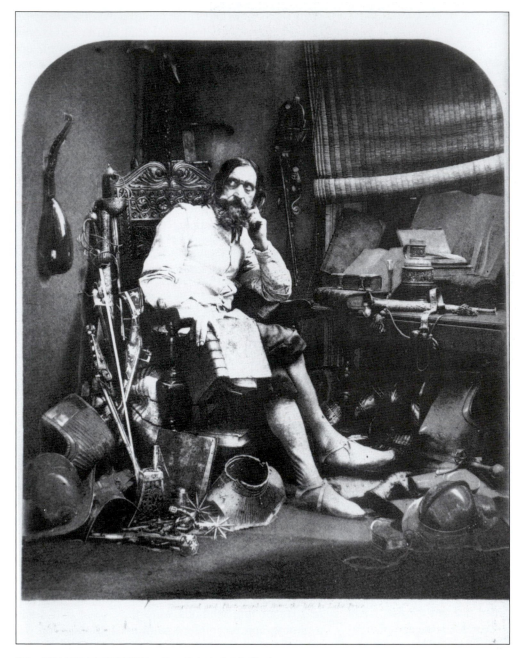

6.2  WILLIAM LAKE PRICE.  *Don Quixote in His Study,* ca. 1855. Albumen silver print. The simplest way for photography to appear artistic was to take on the trappings of painting. William Lake Price (1810–1896), a watercolor painter, took this literal approach by dressing up his subjects in the style of the Royal Academicians. The problem with this imitative manner is that it did not go past the surface appearance and explore photography's innate language.  Harry Ransom Humanities Research Center, The University of Texas at Austin.

process of imitating accepted artistic styles put photographers on track to discovering their medium's own bona fide artistic characteristics.

Amateur calotypists realized that the calotype's inherent "imperfections" also provided a key to unlock its innate strengths. This reinforced the discoveries of

Hill and Adamson's genre work that connected a subject with the space around it and amplified its distinct identity. With the inclination, time, and resources to experiment, amateur calotypists saw that the beauty and power of their calotypes came from their broad, soft, grainy portrayals, where the human figure can be perceived as form and mass. The professionals favored the detail that the wet-plate system offered, even though it required methodical planning that discouraged spontaneity. The calotypist could make a negative in ten minutes, whereas the wet-plate maker needed an hour. In addition to the extra time necessary for execution, a wet-plate negative was more expensive. Often, if it did not deliver the desired result, a photographer would scrape off the emulsion and reuse the glass. Calotypists, in contrast,

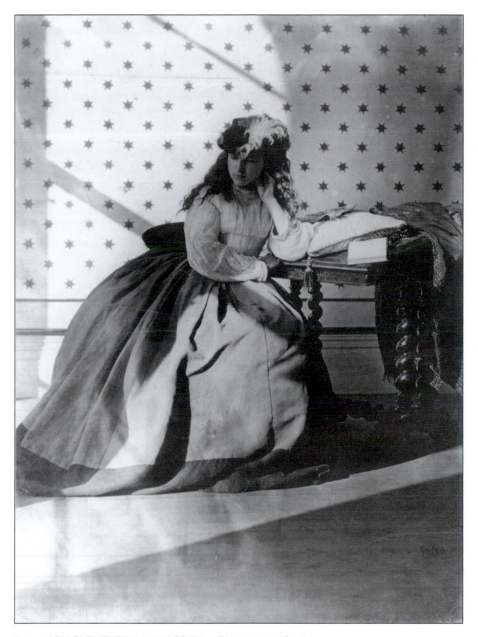

6.3  LADY CLEMENTINA HAWARDEN. *Photographic Study,* early 1860s. 7⅞ × 5⅝ inches. Albumen silver print.  Gilman Paper Company Collection, The Metropolitan Museum of Art.

were stuck with their mistakes because the paper negative was not reusable, which gave them time to reflect on these accidental happenings. Many such unplanned negatives were printed to see what the photographic process had revealed. These fresh and unique camera-induced ways of seeing incorporated unexpected, chance occurrences into the visual outcome, offering an alternative to natural vision and Renaissance models for portraying the world.

A homemade portrait album from the 1850s in the Eastman House Collection by an unidentified, probaby English, photographer shows us the family pictures of a well-to-do amateur who seemed aware of posing strategies used by other calotypists, including Talbot. Mixed

in with the formalistic concerns of composition and light is an unmistakable *snapshot impulse*. We find photographs of what has become the traditional snapshot subject matter of family and home: a slightly blurry, smiling little girl with her doll, looking directly into the camera; a mother and her baby; a mother with her son and his grandmother; a close-up portrait of the family dog; a group portrait of mother, father, and six children. One image is of a girl in a black dress holding her small, moving white dog, which has turned into a multiplasmic ghost. Such early family albums capture and relay a sense of everydayness and commemorate these previously undepicted scenes.

In Europe, since a structure already existed for clubs that provided a sense of community, organization, and common purpose to upper-class amateurs with a shared interest, photographic groups formed naturally.[7] The

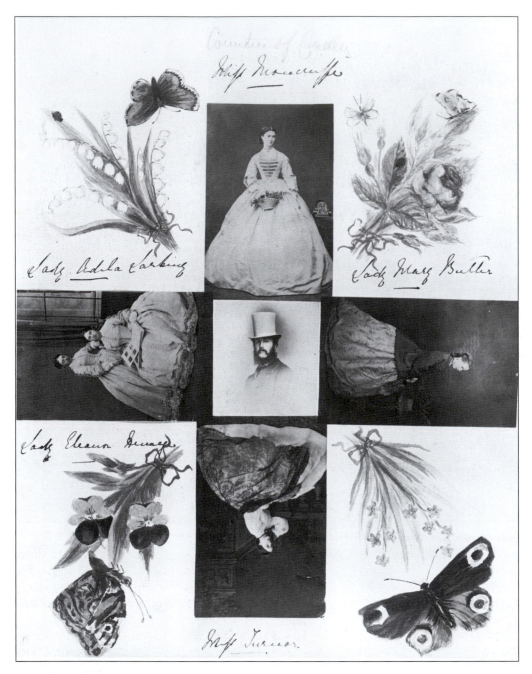

**6.4   LADY FILMER.**   *Untitled,* circa 1864. 11¼ × 9 inches. Watercolor with collaged photographs.   Courtesy University Art Museum, University of New Mexico, Albuquerque, NM.

British *Exchange Club* membership featured prominent practitioners such as Roger Fenton, Oscar G. Rejlander, **William Lake Price**, and William Newton. Not as well known were women members like Lady Caroline Nevill, Lady Augusta Mostyn, and Mary E. Lynn. A jury would select picturesque landscapes, still lifes, genre scenes, exotic foreign subjects, historic sites, and allegorical compositions from the membership for an annual album.[8] To meet the increasing demand to learn photography, in December 1865, King's College, the Univer-

sity of London, became the first site of higher learning to offer photography classes. By the start of the 1860s, there were at least twenty-four different photographic societies in Great Britain. Some, such as the Amateur Photographic Association (1861–1905), mounted exhibits of up to a thousand photographs. The images, often in ornate frames, were squeezed onto the wall from the floor to the ceiling, forcing viewers to assume an "all fours" position to see some of the pictures. Borrowing from existing practices of art exhibition, this densely packed style of presentation continued through the end of the century.

Amateurs pushed the boundaries of accepted practice and explored a more personal style of expression than the commercial studios. Rejecting the genteel and

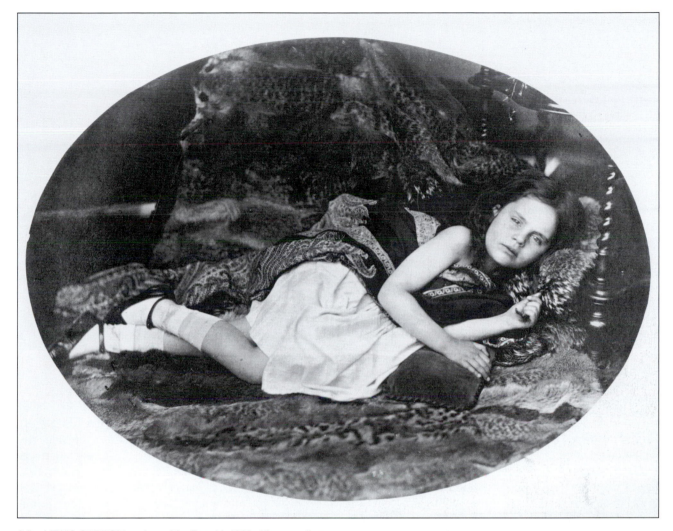

6.5  LEWIS CARROLL.  *Irene MacDonald*, 1863. Albumen silver print. 5⅝ × 7½ inches.  Harry Ransom Humanities Research Center, The Univeristy of Texas at Austin.

preordained poses of the commercial studio in favor of a more active image, they pictured a wider range of facial expressions and postures. One such amateur, **Lady Clementina Hawarden** (1822–1865), working with family and friends, provides glimpses into the dynamics of the intimate female world of the well-to-do Victorians where passion is kept hidden. Through the languor that surrounds Hawarden's restrained subjects, viewers search the frame for a trace of desire.

Another amateur, **Lady Filmer** (1840–1903), made early collages that combined carte-de-visite portraits with watercolor designs of butterflies and floral arrangements (see Figure 6.4). These pieces, with their occasional sexual allusions, reveal a pre-Freudian spirit of *unconscious association,* aspects of mental life not subject to recall at will, that could only be expressed in pictures—the language for such a discussion did not exist at the time. Photographic montage allowed people of various levels of artistic skill to take everyday events and reorient them in time and space. This positioned photography as a medium that invited artists to delve in the cut-and-paste, free-association world of dreams, enabling the unconscious, repressed residue of socially unacceptable desires and experiences to come to conscious recognition.

**Lewis Carroll**, the pseudonym of Reverend Charles Lutwidge Dodgson (1832–1898), began making photographs in 1856 that mirror the concerns he wrote about in his Victorian fantasy novels *Alice's Adventures in Wonderland* (1865) and *Through the Looking Glass* (1872). Carroll's adroitness in the company of prepubescent girls enabled him to compose images revealing their natural sense of dexterity and intuitive spontaneity. Influenced by the Pre-Raphaelite ideals of feminine innocence and virgin beauty, Carroll's images probed beneath the surface of the sitter, and have come to play a role in creating our conception of Victorian childhood. His preference for moralizing works also led Carroll to endow his young sitters with his own adult, melancholic emotional and sexual dilemmas (see Figure 6.5). Criticized for photographing young girls in the nude (Victorians rarely made the distinction between poetic representations and pornography),

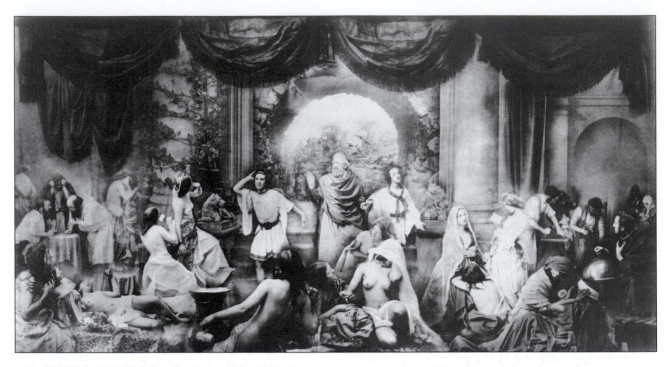

6.6    OSCAR G. REJLANDER.    *Two Ways of Life,* 1857. 16 ×
31 inches. Albumen silver print.    Courtesy Royal Photographic Society,
Bath, England.

Carroll destroyed those negatives that he said "so utterly
defied convention."

**Oscar Gustav Rejlander** (1813–1875) learned the
basics of photography one afternoon in 1853 in order
to make studies for his paintings. Within two years he
had opened a photographic portrait studio. In 1857 the
influential Manchester Art Treasures Exhibition allowed
photography to be displayed alongside painting, draw-
ing, sculpture, and engraving for the first time, signaling
an acceptance of artistic photographs. This was a break-
through, as photography was often shown in segregated
categories under industrial, scientific, and technical
headings. Regarding the camera as a machine with both
diagnostic and interpretive capabilities, Victorians saw
its practitioners as scientists and technicians first, and
artists second (if at all). As the standards for artistic pho-
tography were based on painting, the sharp, mechanical
literalness of the photograph was considered a hin-
drance in achieving high art. To overcome this obstacle
photographers began to use second-rate optics, smear
their lens, or kick the tripod during exposure to suppress
photographic sharpness. Finally, in order to compete
with allegorical painting, photographers' work had to
be morally uplifting and instructive. This was accom-
plished by constructing complex *tableaux,* an arrange-
ment of persons and/or objects to form a scene. This
style of working allowed photographers to overcome
the medium's mechanical status while circumventing
the technical limits of the wet-plate process. Rejlander
set out to create a photograph requiring "the same oper-

ations of mind, the same artistic treatment and careful
manipulation"[9] as works done in crayon or paint.

Rejlander produced *The Two Ways of Life,* an elabo-
rate allegorical photomontage contrasting Philosophy
and Science. During a six-week period Rejlander did
sketches, hired models, and made thirty separate nega-
tives which he masked, printed on two pieces of paper,
and connected. This marvel of combination printing
was then rephotographed, and editions were repro-
duced. The photograph's unusually large size, 16 ×
31 inches, made people stop and notice, enabling it to
hold its own on a gallery wall. *The Two Ways* repre-
sents "a venerable sage introducing two young men into
life—the one, calm and placid, turns towards Religion,
Charity and Industry, and the other virtues, while the
other rushes madly from his guide into the pleasures
of the world, typified by various figures, representing
Gambling, Wine, Licentiousness and other vices; end-
ing in Suicide, Insanity and Death. The center of the pic-
ture, in front, between two parties, is a splendid figure
symbolizing Repentance, with the emblem of Hope."[10]

*Two Ways* did not sell well and provoked debate on
the ethics of combining negatives to manufacture an
image that never existed, marking an early instance
of critical thinking about the medium. The picture's
detractors claimed it was a violation of the "true
nature" of photography; works of "high art" could
not be accomplished by "mechanical contrivances."[11]
In the Victorian age, when piano legs were costumed
with pantaloons, the photographic nudity of *Two Ways*
was shocking.[12] The process of combination printing
led to the first photographic montages designed for a
public audience, providing a refreshing set of repre-
sentational possibilities. Since it questioned established

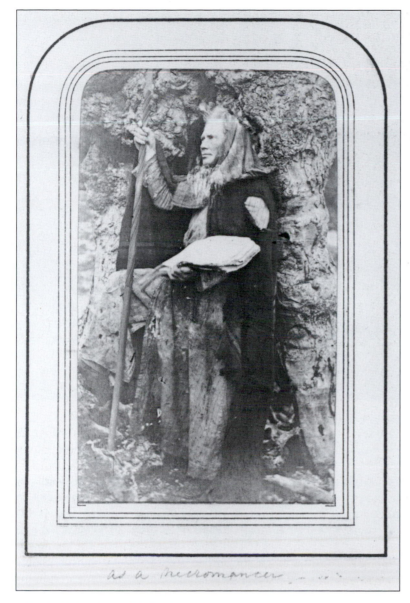

*as a necromancer*

6.7  RICHARD COCKLE LUCAS. *A Necromancer,* from *Studies of Expression.* Albumen silver print. Following the lead of British artist and sculptor R. C. Lucas (1800–1883) who made a series of role-playing self-portraits, Rejlander used himself to catalog human emotional responses before the camera in *Studies of Expression* (1865). These became well-known when they appeared as illustrations in Charles Darwin's *The Expression of the Emotions in Man and Animals* (1872). Rejlander also made children's portraits, attracting the notice of Lewis Carroll and Julia Margaret Cameron.    Courtesy George Eastman House.

Photography as a fine art also faced resistance from art dealers who saw photography as a threat to their investments and sought to keep photographs out of their galleries. Rejlander complained that "picture-dealers are, or have been, from interested motives, the greatest opponents to photography."[14] But even as photography was being denounced, the very fact that important minds, such as Baudelaire's, were critically discussing the medium increased its credibility, importance, and visibility. The rise of photography as an art form would transform art's traditional function of portraying reality. This encouraged artists to explore new directions that eventually included *abstraction,* in which the concept of art as imitation of nature was abandoned. Rejlander's efforts have been criticized as being "imitations," yet they were a necessary step in expanding the boundaries of photographic practice, inspiring others to enlarge photography's dialogue and role. The artistic criticism and financial hardships took their toll on Rejlander, however, who only made a few more combination prints; none of them approached the polemic nature and scale of *The Two Ways.*

Rejlander produced numerous formula-driven portraits, but he also created other images that broke with accepted working practice. *Hard Times* (1860) made conscious use of double exposure, converting an error into an authentic photographic form, one not based on painting's prescriptions. In *The Bachelor's Dream,* which resembles no other photograph from that time, Rejlander grapples with visualizing a mental impression by incorporating the fashionable woman's skirt hoop into the composition. Its phantomlike qualities blend fantasy and reality, raising questions while providing no answers. The photograph invites viewers to interpret it, challenging the audience to think about and question whether photography can convey complex intellectual thoughts.

**Henry Peach Robinson** (1830–1901) was a painter who took up photography in 1852 and opened a photographic portrait studio five years later. Rejlander's *The Two Ways of Life* inspired Robinson to undertake combination printing. In 1858, Robinson exhibited *Fading Away* (see Figure 6.8). Made from five negatives, it shows a young girl on her deathbed with her grieving mother, sister, and fiancé in attendance. By Victorian standards this sorrowful scene was scandalously morbid as it did not conform to accepted ideas about

viewing rules, many felt threatened and rejected the new way of picturemaking. The concept that art was a matter of ideas and not limited to specific practices was given voice by the French naturalist Louis Figuier, who believed photography could improve artistic eloquence and public taste, and that "what makes an artist is not the process but the feeling."[13]

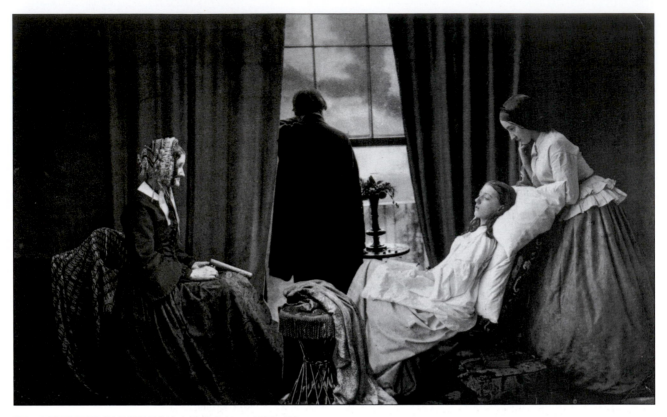

**6.8 HENRY PEACH ROBINSON.** *Fading Away,* 1858. 9⅝ × 15⅝ inches. Albumen silver print. Courtesy George Eastman House.

what photography should picture. Far more distressful scenes were painted, but because *Fading Away* was a photograph people perceived it as a literal representation. In an age when death was not hidden away, most people were familiar with such scenes. After Robinson revealed that his primary model "was a fine healthy girl of about fourteen, and the picture was done to see how near death she could be made to look,"[15] the work was criticized for being manufactured.

The combination prints of Rejlander and Robinson challenged the belief that painters alone had the right to create scenes while photographers could never be more than mere mechanical extensions of their equipment. For photography to make its way in the art world it had to debunk such limiting ideas. Robinson championed combination printing as Prince Albert purchased *Fading Away* and gave Robinson a standing order for every pictorial image he created. Once audiences overcame the shock of the combination print, they accepted it, realizing that Robinson's fundamental ideology embraced their notions of art. This made Robinson the most popular, emulated, and well-to-do photographer of the second half of the nineteenth century. Robinson's books and articles energetically articulated his position and influenced the development of future photographers. His *Pictorial Effect in Photography* (1869), which advocated the basic canons of painting, "compo-

sition and chiaroscuro," as the "guiding laws" of an art photograph,[16] was the most widely read photography textbook of the nineteenth century.[17]

Robinson sought methods for uniting the rational with the subjective, to allow photographers to achieve the picturesque. He believed that combination printing gave "much greater liberty to the photographer and much greater facilities for representing the nature of nature."[18] Critics were outraged by Robinson's constructed images for violating their sense of photographic veracity. Combination printing was acceptable in landscapes as the public was conditioned by painting to expect idealized renditions, but when it came to portraying humans, viewers associated photography with unarranged truth. Robinson was able to expand photography's reach and get the public to embrace his combinations as expressing the accepted allegorical ideals and standards of the day. Robinson's work possesses a duality common to educated practitioners born before the invention of photography who thought like painters. Although Robinson's representations broke no new ground, he showed that photography could achieve the same artistic goals as painting, thus allowing the next generation to explore photography's own morphology.

In the short term his work had the opposite effect. Robinson's allegorical ideas, magical theatrical techniques, and moralizing sentiment were so successful that they dominated photographic discourse and stifled other ways of thinking photographically until the 1880s. Robinson's striving for a literary image, reminiscent

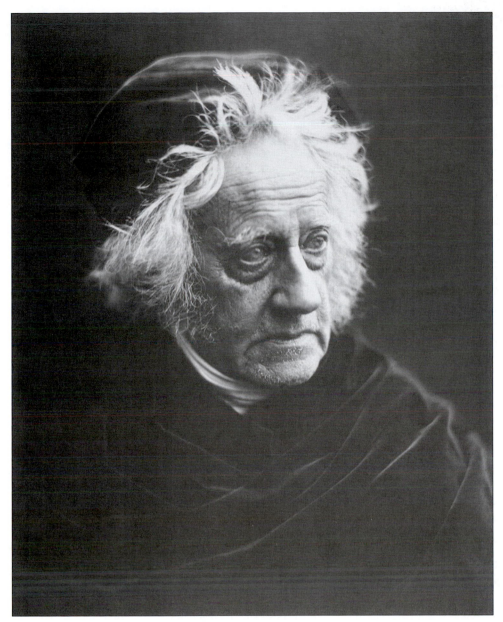

6.9  JULIA MARGARET CAMERON.  *Sir John Herschel,* 1867. 12 × 9½ inches. Albumen silver print. "When I have such men before my camera my whole soul has endeavored to do its duty towards them in recording faithfully the greatness of the inner as well as the features of the outer man. The photograph thus taken has almost been the embodiment of prayer."[19]  Courtesy George Eastman House.

of nineteenth-century painting, was in critical eclipse for most of the twentieth century. Yet today Robinson's practices look like progenitors of the postmodern photographers who stage tableaux before the camera and digitally manipulate their materials.

**Julia Margaret Cameron** (1815–1879) lived in India as a member of the socially privileged British-Indian colonial system before returning with her family to England in 1848, where their home became a meeting place for people in arts and letters. When Cameron was forty-nine, her daughter gave her a camera and she taught herself the collodion process. Her goal was to make romantic, allegorical photographs capable of expressing the ideals of the Pre-Raphaelites, who saw evil in industrialization and wanted the return of heroes who believed in God, honor, and morality. Cameron wrote: "My aspirations are to ennoble Photography and to secure for it the character and uses of High Art by combining the real & Ideal and sacrificing nothing of Truth by all possible devotion to Poetry and beauty."[20] Toward these ends, Cameron made a glass-roofed chicken-house her studio, where maids and family modeled, and converted a former coal-house into a darkroom. Cameron's status as an aristocratic amateur, who did not have to make a living with her photography, enabled her to embark on a series of portraits that were uniquely photographic in nature. She tossed aside many standard working practices in order to photographically

record the spiritual essence of her sitter. The spontaneous quality of her earliest work, such as *Kathy Kuhn and Her Father* (1864, *Watts Album* in the Eastman House Collection), reveals a proto-snapshot sensibility.

Cameron brought her camera close to her subjects, fashioning a close-up portrait that brought to the forefront the subject's distinctive intellectual and psychological qualities. Her head portraits (see Figure 6.9) were made on large plates (about 11 × 14 inches) with a giant 30-inch focal length lens! They were so unusual Cameron would sometimes write below the print: "From Life Not Enlarged." Cameron's use of directional light rendered the features and modeling of each sitter. Although Cameron's exposures averaged about five minutes, she did not use a headrest, instead allowing the sitter's natural motion to add spiritual life to the picture. The idea that the blur could be used as a tactic was a conceptual break from the portrait ideal in which a sitter was rendered absolutely still and part of the viewing pleasure was in examining idiosyncratic detail. Cameron played down photographic veracity in favor of a subjective response that included bodily sensations, merging the rational and immaterial levels of reality.

Cameron's most innovative work involved capturing a sitter's spiritual qualities. Her blurry image of Herschel, with its competing areas of light and dark and its tracts of absolute obscurity, is meant to evoke an atmosphere that suggests her sitter's inner likeness as much as a physical one. The head, surrounded by darkness, radiates a metaphysical endowment as exactitude loses all consequence. Cameron was not ignorant of standard methods, but she chose to go her own way, making what others considered blunders part of her style. Cameron's *Sappho* (circa 1866) had a big crack in the lower left portion of plate, and rather than discarding it she printed it.[21] Casting against type and selecting a heavy featured, middle-aged woman for Sappho, Cameron's rendition of the Greek lyrical poet from the island of Lesbos succeeds on its own terms. Rather than concealing the nature of the photographic process, Cameron exults in it, even allowing processing drips to remain visible in the final image, thereby establishing a direct visual connection between the process and the product. She lets the viewer know that her accomplishment was done through the agency of photography, paving the way for the formation of an inherent, rather than imitative, photographic language.

Cameron also disobeyed the rules of focus to create fresh visual forms and points of emphasis. She was influenced by the photographic work of the English painter David Wilkie Wynfield, from whom she took photography lessons, who pictured his friends dressed-up in Renaissance costumes. A critic of the day had this to say about Wynfield's work and its relationship to the boundaries of photographic portrayal:

A photographer's grand aim is get everything into an "artificial focus," which is widely different from that of the human eye. . . . Mr. Wynfield—has actually produced a set of photographs which are intentionally and confessedly "out of focus" . . . they ought to revolutionize photographic portraiture.[22]

The issue of focus was critical in defining serious nineteenth-century artistic practice. During the 1860s, Cameron's work helped establish the issue of selective focus as a criterion of peerless practice. The making of "out-of-focus" photographs was considered an expressive remedy that shifted the artificial, machine-focus of a camera toward a more natural vision. Cameron stated that "my first successes in my out-of-focus pictures were a fluke. That is to say, that when focusing and coming to something which, to my eye, was very beautiful, I stopped there instead of screwing on the lens to the more definite focus which all other photographers insist upon."[23] As the aesthetics of practice changed in the early 1870s, coming to rely on the transparent exactitude of the wet plate as the photographic standard, Cameron shifted too and made "in-focus" pictures.

Cameron's roots were those of a family photographer who celebrated the lives and values of those closest to her, establishing transcendental principles still being pictured by millions of family snapshooters. Inspired by her friendship with allegorical artist George Watts, Cameron's idealized, mythical pieces picture women in marriage and motherhood, and illustrious women from history, literature, and religion. Cameron was the first photographer to stress the power and significance of women's roles.[24]

## Americans and the Art of Nature

Americans approached the spiritual image not through the religious icons of Italian master painters but through nature, in an optimistic movement known as *transcendentalism*. Espoused by Thomas Carlyle, Ralph Waldo Emerson, and Henry David Thoreau in the mid-1800s, transcendentalism emphasized individualism, self-reliance, the rejection of authority, and the mystical unity of nature. A reaction against scientific rationalism, transcendentalism relied on intuition as the way to understand reality and stressed that redemption is only to be found in one's own intuition and soul. Its ideas also affected the viewing of images. The transcendentalists believed that sight was related to insight, or a kind of hypervision, suggesting that clear perception is a precursor to understanding. Thus a focused viewer became a *seer*. In *Nature* (1836), Emerson describes this mystical state of intense perception as becoming a "transparent eyeball; I am nothing; I see all; the currents of the Universal Being circulate through me; I am part or parcel of God."[25]

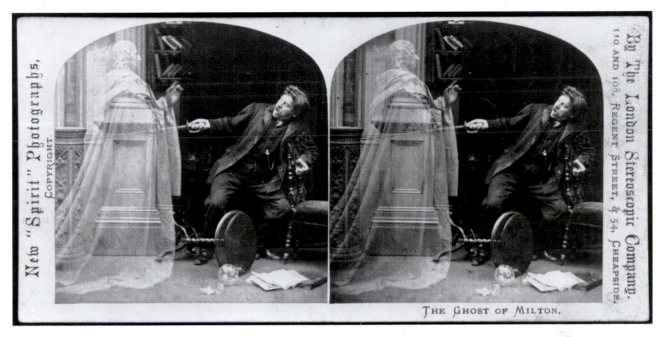

**6.10   UNKNOWN PHOTOGRAPHER.**   *The Ghost of Milton.*
3½ × 7 inches. Albumen silver stereograph. Ghosts were
created when a veiled figure entered the scene for a portion of
the exposure, producing a transparent phantom. To maintain
believability, less scrupulous operators concealed their methods
from the public and used ploys such as: a plate with a previously
recorded ghost image, a transparency of a ghost image placed
in front of the lens, a miniature ghost transparency placed behind
the lens, or a ghost image reflected into the lens during exposure.
Courtesy George Eastman House.

A segment of this movement was *spiritualism,*
founded in Rochester, NY, in 1848 by the medium
Margaret Fox and her sisters, who later admitted their
activities were fraudulent. Spiritualists believed that
the human personality survived death and could com-
municate with the living through a medium who was
sensitive to the spirit's vibrations. This gave rise to
so-called spirit photography, which purported to make
visual records of ectoplasmic manifestations of per-
sons in a state beyond death. William Mumler, who
ran a spirit photograph studio in New York in the late
1860s, was arrested as a swindler, though the charges
were eventually dismissed because trickery was not
proved.[26] Nevertheless, spirit photographs attracted a
large audience of predisposed believers who paid no
attention when it was demonstrated that spirit photo-
graphs were produced by double exposure or multiple
printing. Other photographers used these techniques
and got into this commercially viable escapade without
making any supernatural claims. To help sell his stereo-
scope, Sir David Brewster suggested making "ghost"
stereo cards for fun; they quickly became a fad (see
Figure 6.10). Although Americans did not get involved
with allegorical combination printing, spirit pictures

encouraged experimentation with multiple exposure
and acceptance of this style of depiction. Even though
ghost cards were known to be fabricated, the fact that
they were done photographically gave the appearance
of truth. Spirit photography spread to Europe during the
mid-1870s and again in the 1890s. These were times
of recession for portrait studios, and ghosts were good
for business. Spirit photographers also experienced a
resurrection following World Wars I and II, as grief-
stricken survivors attempted to maintain their access to
the dead through photography.

## Positivism

While a small fellowship of amateurs struggled to rep-
resent photography as art, the majority were interested
in the photograph's ability to commemorate people,
places, and things. During this time the philosophy
of *positivism,* as put forth by Auguste Comte, was in
vogue. Positivism stated that social progress and human
knowledge were dependent on precise ordered observa-
tion, classification, and comparison of external events.
The philosophy accepted the technical exactitude of sci-
ence and the machine over the relativity of human per-
ception, and declared that reality, the physical facts, is
precisely what we perceive. Its followers were opposed
to metaphysics, the supernatural, and earlier pseudosci-
entific ideas. According to Dennis Grady:

> Comte relies upon science to find relationships among
> facts—laws—thus leading to the ability to make predictions.
> In applying this idea to human behavior Comte became the
> founder of sociology. Positivistic politics . . . has the goal of
> finding the social order most attuned to man's happiness and
> progress. . . . Eventually, photographers became aware of the
> power of photography to effect social change . . . to use the
> photographic documents to improve the lot of mankind.[27]

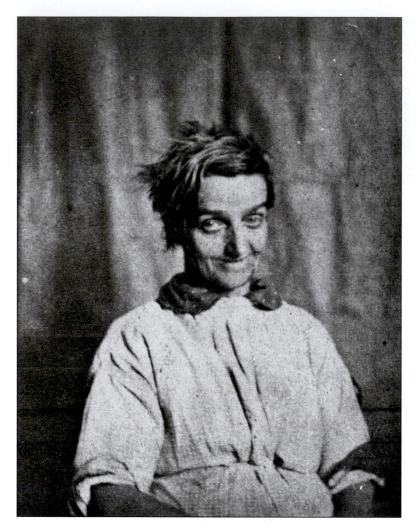

**6.11   DR. HUGH WELCH DIAMOND.** *Mental Patient,* 1855. Lightly albumenized salt print. Photography seemed to be a mechanism that could produce faithful records whose authenticity could be certified by the institutions of power and control from which they arose. As the British medical journal *Lancet* proclaimed: "Photography is so essentially the Art of Truth—and representative of Truth in Art—that it would seem to be the essential means of reproducing all forms and structures of which science seeks for delineation."[28]   Courtesy Royal Photographic Society, Bath, England.

spiritual beings. The differences between metaphysical idealism and positivism represent the division between two Western ways of looking at the world: "Is Truth a priori, apart from and above man and sensation—or simply material nature as seen by the human eye?"[29]

During the second half of the nineteenth century, positivist philosophy was applied in social institutions, including law enforcement and hospitals, that were given more centralized power to control individual behavior. The positivists put their ideas into practice with the perfect positivistic tool—the photograph. Beginning in the 1840s, police began making identification pictures that led to the use of photographs as courtroom evidence. **Dr. Hugh Welch Diamond** (1809–1886), the superintendent of the Female Department of the Surrey County Lunatic Asylum and founding member of the Royal Photographic Society, combined positivism, aesthetics, photography, psychiatry, and physiognomy in a new institutional order. Using an unadorned background and frontal posing, Dr. Diamond made portraits of his patients that direct attention to the face and hands of the sitter. Diamond claimed clinical photography aided his patient's treatment, provided a record for medical guidance and physiognomic analysis, and offered a means of identification. He saw photography as a method of securing "with unerring accuracy the external phenomena of each passion."[30]

Photography began to be incorporated into the activities of institutions concerned with observing and controlling behavior. **Thomas John Barnardo** (1845–1905), who in 1871 founded the "Home for Destitute Lads," established a photographic department in 1874 which produced some 55,000 isolated portraits between 1874 and 1905 in order "to obtain and retain an exact likeness of each child and enable them, when it is attached to his history, to trace the child's career."[31] Individual dossiers containing a portrait, personal history, and statistics were prepared for each child. Albums were made up to show to parents, police, and visitors. Before and after pictures were commissioned, purporting to show children arriving in a motley state and then cleaned and industrious under the guidance of the Home. Barnardo was brought to court on charges of capitalizing on the children by putting them into fictitious settings and altering their appearance to benefit his fundraising operations. Nowadays charities regularly send out appeals for contributions in which picture/text combinations are used that convert the bodies of those being observed into advertising commodities.

In terms of art, photographers were trying to make pictures that would find acceptance and credibility in the academic establishment. The *Realist movement,* typifying the positivistic spirit, believed that unaffected authenticity and naturalness would reveal truth. In its quest for approval, art photography embraced the old-fashioned values of *metaphysical idealism* and not those of Realism, which was snubbed by the Academy and not considered to be High Art. Metaphysical idealism proposes that reality has an ultimate nature that sense impressions do not reveal, that knowledge of that ultimate reality is attainable through reason and intuition, and that people are not mere physical matter but

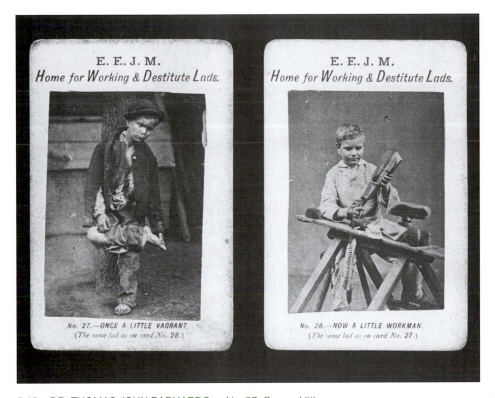

6.12 DR. THOMAS JOHN BARNARDO. *No. 27, Once a Little Vagrant,* and *No. 28, Now a Little Workman,* ca. 1875. Cartes de visites. Tactics used by Dr. Thomas John Barnardo have caused contemporary critics, such as John Tagg, to express concern with how photography had been deployed as "a means of surveillance." Tagg wrote: "We have begun to see a repetitive pattern: the body isolated; the narrow space; the subjection to an unreturnable gaze; the scrutiny of gestures, faces and features; the clarity of illumination and sharpness of focus; the names and number boards. These are the traces of power, repeated countless times, whenever the photographer prepared an exposure, in police cell, prison, consultation room, asylum, Home or school."[32] Courtesy Barnardo Photographic Archive, Essex, England.

This push for cataloging and standardizing society along the scientific model, through the tenets of positivism, found a willing partner in photography's encyclopedic impulse. The idea of truth in the optical and chemical processes of photography was often in direct contradiction with the ideal of photographers who sought to discover artistic truth beneath the veneer of reality. The jockeying for position between these two practices continues to divide the profession and the public over photography's role in society.

# Endnotes

1  *The Photographic News,* vol. 5, no. 152, (August 1861), 370, reported that the 1841 census did not list photography as a profession. Ten years later, 51 photographers were recorded; by 1861 there were 2,879. In 1851, a Miss Wigley was the only woman professional; ten years later there were 204 women. In 1861, no fewer than 33,000 Parisians claimed to make their living from photography.

2  Charles Baudelaire, "The Salon of 1859," translated by Jonathan Mayne, *The Mirror of Art: Critical Studies by Charles Baudelaire* (London: Phaidon Press, 1955). Reprinted in Beaumont Newhall, *Photography: Essays & Images* (New York: The Museum of Modern Art, 1980), 112–13.

3  Elizabeth Eastlake, "Photography," *Quarterly Review* [London], April 1857, 442–68. Reprinted in Newhall, *Photography: Essays & Images,* 81–95. This quote appears on pp. 94–95.

4  *Photography: Essays & Images; Illustrated Readings in the History of Photography,* Beamont Newhall, ed. (New York: The Museum of Modern Art, 1980), 90.

5  *Abbozzo* is Italian for sketch. In painting, it refers to the first outline or drawing on the canvas; also to the first underpainting.

6  See Aaron Scharf, *Art and Photography* (London: Allen Lane, 1968), 131–34.

7  Most American photographers of this time had to rely on photographic trade magazines to communicate, as only a handful of photo clubs emerged in the States before the advent of the hand camera and sufficient numbers of amateur photographers in the 1880s. The

few early American clubs include the Amateur Photographic Exchange Club and Photographic Society of Philadelphia, both of which were founded in the 1860s. APEC lasted only a few years, while Photographic Society of Philadelphia is still active.

8    The photographers who had work selected sent the negative and the club printed an edition. The elaborate, polished leather bound albums contained lustrously printed images on albumen paper, as there was not an effective way to print the photographs on an ink press.

9    O. G. Rejlander, "On Photographic Composition with a Description of Two Ways of Life," *The Photographic Journal,* vol. IV, no. 65, April 21, 1858, 191–96.

10    *Humphrey's Journal of Photography,* vol. 9, no. 6, July 15, 1857, 92–93.

11    Unknown author, "Fifth Annual Photographic Exhibition," *Art Journal,* April 1, 1858, 120–21.

12    When the Photographic Society of Scotland showed the work, they draped the unrespectable part of the composition.

13    Louis Figuier, *La photographie au salon de 1859* (Paris, 1860), 14.

14    *Photography in Print: Writing from 1816 to the Present,* Vicki Goldberg, ed. (Albuquerque: University of New Mexico Press reprint 1988), 146.

15    Henry Peach Robinson, *The Elements of Pictorial Photography* (Bradford, England: Percy Lund & Co., Ltd., 1896), 102.

16    See Henry Peach Robinson, *Pictorial Effect in Photography,* Preface, unp. Reprinted by Helios, Pawlet, VT, 1971, second impression 1972.

17    Henry Peach Robinson, *Pictorial Effect in Photography* (London: Piper & Carter, 1869). This book's publication record indicates the significance and acceptance of its concepts. British editions in 1869, 1879, 1881, 1893; American: 1881, 1892; French: 1885; German:

1886. The text was based on the art education system of the Royal Academy and relied on Joshua Reynold's eighteenth century *Discourses on Art* and John Burnet's *Treatise on Painting* (1822). Unlike earlier texts, such as Disdéri's *L'art de la photographie* (1862) and Marcus A. Root's *The Camera and the Pencil* (1864), Robinson devoted most of his discussion to handling the figure in landscape rather than to the making of studio portraits.

18    Robinson, 198.

19    Julia Margaret Cameron, "The Annals of My Glass House," 1874, *Photo Beacon* (Chicago) 2 (1890), 157–60. Reprinted in Beaumont Newhall, ed. *Photography: Essays & Images* (New York: Museum of Modern Art, 1980), 136.

20    Julia Margaret Cameron to Sir John Herschel, December 31, 1864, collection of the Royal Society of London, quoted in full in Colin Ford, *The Cameron Collection: An Album of Photographs by Julia Margaret Cameron* (London: Van Nostrand Reinhold with the National Portrait Gallery, 1975), 140–41.

21    Cameron printed on albumen paper, toned in a gold chloride solution to alter its reddish-brown color to a cooler purplish-brown. The toning made the image more stable and increased the apparent contrast by making the highlight details easier to see. These prints do not look the same as when they were created. Deterioration produces *yellowing,* a loss of detail in the highlight areas, and color shifts to a warm reddish-brown. Although these effects can be aesthetically pleasing, this was not the original intent.

22    Unknown author, "Fine Arts," *Illustrated London News* 44 (March 19, 1864), 275.

23    Cameron, "The Annals of My Glass House" as reprinted in Newhall, *Photography: Essays & Images,* 137.

24    See Joanne Lukitsh, *Cameron: Her Work and Career* (Rochester: International Museum of Photography at George Eastman House, 1986), 29.

25    Brooks Atkinson, ed., *The Selected Writing of Ralph Waldo Emerson* (New York: Modern Library, 1940), 6.

26    Stories later surfaced that Mumler hired a man to remove photographs of deceased relatives from homes, bring them to Mumler to be copied, and then return the pictures. This agent then directed the relatives to Mumler's studio, where through a combination of double exposure and manipulation Mumler produced the desired results—a spirit image of their dead loved one. Many people thought Mumler was legitimate. Mary Todd Lincoln visited Mumler's studio and came away with a photograph of a ghostlike Lincoln standing behind his widow, his hands upon her shoulders.

27    Dennis P. Grady, "Philosophy and Photography in the Nineteenth Century," Thomas F. Barrow, Shelley Armitage, William E. Tyeman (eds.), *Reading into Photography: Collected Essays 1959–1980* (Albuquerque: University of New Mexico Press, 1982), 151–52, 157. Reprinted from *exposure,* February 1977.

28    *Lancet,* 22 January 1859, 89, quoted in S. L. Gilman, ed., "Hugh W. Diamond and Psychiatric Photography," *The Face of Madness* (Secaucus, NJ: Brunner-Mazel, 1976), 5.

29    Thomas F. Barrow, et al., *Reading into Photography: Selected Essays, 1959–1980* (Albuquerque: University of New Mexico Press, 1982), 153.

30    *The Photographic Journal,* vol. 3, no. 44, July 21, 1856, 88–89. Summary of Diamond's paper "On the Application of Photography to Physiognomic and Mental Phenomena of Insanity."

31    Quoted in Valerie Lloyd and Gillian Wagner, *The Camera and Dr. Barnardo* (Hertford: Barnardo School of Printing, 1974), 14.

32    John Tagg, *The Burden of Representation: Essays on Photographies and Histories,* "A Means of Surveillance," (Minneapolis: University of Minnesota Press, 1993), 87.

# Standardizing the Practice

## *A Transparent Truth*

## Mechanical Photography

During the age of Western industrial development and colonial expansion, with its pocket watches, steamships, and railroads changing society's sense of time and space, people believed that the machine's ability to accurately perform repetitive tasks held the key to a better life. Photographers recognized the demand for accurate pictures of historic sites, and the latest technical improvement to the photographic repertoire, transparent collodion materials, was a way to meet this need. The collodion process's increased sensitivity, retention of detail, and ease of reproduction made it and paper prints the new professional standard. As the Pre-Raphaelite painters struggled for photographic accuracy, people took pleasure in a photograph's ability to let them count every brick in a wall. In *Modern Painters* (5 volumes, 1843–1860), John Ruskin (1819–1900) reveled in photography's ability to preserve evidence:

> My drawings are truth to the very letter—too literal perhaps; so says my father, so says not the daguerreotype, for it beats me grievously. I have allied myself with it. . . . It is certainly the most marvelous invention of the century; given us just in time to save some evidence from the great public of wreckers.[1]

7.1 **MAXIME DU CAMP.** *The Colossus of Abu-Simbel, Nubia,* 1850. 8⅞ × 6⁵⁄₁₆ inches. Salted paper print from a calotype negative by L. D. Blanquart-Evrard. Plate 107 of the album *Égypte, Nubie, Palestine et Syrie* (Paris, 1852). Du Camp's work was published in several volumes by Blanquart-Evrard. One of the first and most profusely photographically illustrated books issued in France, *Égypte, Nubie, Palestine et Syrie* (1852), contained 122 calotypes. Du Camp later founded the *Revue de Paris,* which featured works such as Flaubert's *Madame Bovary* (1857). Courtesy George Eastman House.

The idea of seeing it all had immense appeal. This verbatim style of representation was labeled "mechanical-photography" by C. Jabez Hughes to distinguish it from art photography, whose purpose was aesthetic and personal. Hughes specified:

I do not mean the term *mechanical* to be understood depreciatingly. On the contrary, I mean that everything that is to be depicted exactly as it is, and where all the parts are to be equally sharp and perfect, is to be included under this head. I might have used the term *literal* photography, but think the former better. This branch, for obvious reasons, will always be the most practised; and where the literal unchallenged truth is required, is the only one allowable.[2]

By the mid-1850s, the practice of commercial photography was established to satisfy the demand for architectural wonders, works of engineering and industry, and scenic views. This new class of photographers specialized in the mechanical style, one that required a virtuoso technical performance featuring maximum detail and sharpness. Accurate and affordable pictorial records were now available in a manner unimaginable fifteen years before.

## The Traveling Camera

Taking the wet plate out of the studio was not an impromptu affair, as its complicated preparation made field work problematic. Small stereographic cameras were utilized to make stereo cards, but exhibition prints were done with large, wooden folding cameras. Cameras with flexible, corrugated leather bellows that formed a light-tight passageway between the lens and the film plate were slow to be adopted and often were not steady enough for long, windy, outdoor exposures. As enlarging was not yet feasible, a large picture meant a glass plate of $10 \times 12$ or $12 \times 16$ inches had to be exposed in order to make a contact print of the same size. A Scottish photographer recalled the ordeal of taking a large-format camera into the field:

> I reached the railway station with a cabload consisting of the following items: A $90 \times 110$ brass-bound camera weighing 21 lbs. A water-tight glass bath in wooden case holding over 90 ozs. of solution [silver nitrate] and weighing 12 lbs. A plate box with a dozen $90 \times 110$ [glass] plates weighing almost as many pounds. A box $240 \times 180 \times 120$ inches into which were packed lenses, chemicals, and all the hundred-and-one articles [scale, measures, funnels, trays, fixer, and a pail for water] necessary for a hard days work, and weighing something like 28 lbs. The advent of folding tripods had not come [circa 1857], . . . and so I had perforce to encumber myself with one that when closed looked like an Alpine-stock over 5 ft. in length. It weighed about 5 lbs. Lastly, there was the tent, that made a most convenient darkroom, about 400 $\times$ 400 inches and 6½ ft. high, with ample table accommodation; the whole packed into a leather case and weighed over 40 lb. . . . We did not care to walk far.[3]

Three approaches to making travel pictures were established: amateur, official, and commercial. Talbot set the precedent for amateur travel pictures with his excursions to popular tourist destinations like Lake Como. Such images, embryonic snapshots, were done for personal satisfaction. Governments employed photographers to document official sites of interest. These images, of everything from historic monuments to railroad bridges, were seen by small, elite audiences and sometimes offered for sale in limited-edition albums of original prints. Finally, commercial photographers produced marketable images, such as the pyramids, as quickly and cheaply as possible. To get to out-of-the-way locations, they outfitted wagons as traveling darkrooms, but they still needed dark-tents for pictures that were not being made close to the wagon. In the field, photographers relied on one-person tents, where they coated and processed the plates at folding tables in odorous and stifling conditions. Water, if it was not readily available, had to be hauled. Since the wet-plate lost sensitivity as it dried, it was inadvisable to pitch the dark-tent more than a three-minute walk or run from where the camera was set up. To make six successful exposures a day required hard work, skill, and luck, and quick exposures from multiple vantage points were rare. The amount of energy needed to make a view drove photographers to select sites they knew would appeal to accepted notions of picture composition and subject matter, rather than try to discover innovative ways of depiction. Under these circumstances, the first photographic travels were launched.

A fascination with Egypt led French journalist **Maxime Du Camp** (1822–1894) on an extended photographic assignment to the Middle East from 1849 to 1852.[4] Trained by Le Gray in the waxed calotype process for its field versatility, Du Camp took advantage of its improved clarity and made calotypes at the hours when the angle of light revealed the form and texture of the monuments. Du Camp favored including a human figure in his compositions as a scale reference (see Figure 7.1).

**John Beasly Greene** (1832–1856), an amateur archeologist from Boston, used the calotype to record his explorations. Greene's calotypes along the Nile interpret the desert environs by emphasizing space, often by allowing the sky to dominate the composition. With the calotype's granular look, this strategy unified the space, giving the sky and water the same organization as the desert sands, reinforcing a feeling of dislocation and timelessness (see Figure 7.2). In other photographs the subjects are composed to accentuate, rather than command, the extended horizon line.

In the spirit of documenting historical sites, the French Ministry of Public Instruction commissioned **Auguste Salzmann** (1824–1872) to photograph the remaining monuments of the Crusades erected by the Knights of the Order of St. John in Crete, Cyprus, Jerusalem (see Figure 7.3), and Rhodes. While carrying out this work, Salzmann also photographed monuments of disputed attribution for the archeologist Louis-Félicien-Joseph Caignart de Saulcy. In 1853 Salzmann made waxed calotype negatives in support of de Saulcy's theory that Jerusalem's ancient monuments could be correctly re-dated by their physical construction. Done in the instructional style of archeological illustration, Salzmann's images go beyond the draftsman's model, meditating on patterns created by the play of light and shadow. Most of the details are tightly composed from a centered, frontal point of view, relying on directional light to accent texture and focus attention on the masonry construction used to date most of the monuments. The unrelenting frontality solved the problems of

7.2 JOHN BEASLY GREENE. *Bank of Nile at Thebes,*
1854. 9 1/16 × 10 7/8 inches. Salted paper print. In this ambiguous
landscape Greene sacrifices information for pictorial effect. Nothing
is clearly defined; everything is suggested. Greene's work was also
published by Blanquart-Evrard in an album *Le Nil: Monuments,
paysages, explorations photographiques* (1854). Courtesy George
Eastman House.

depth-of-field associated with view cameras of the time,
that lacked the proper controls to adjust the front and
back standards—swings and tilts—to make perspective
corrections, flattening the image and emphasizing line,
mass, and pattern. This photographic way of seeing
simplified and abstracted the close-up view while con-
veying a sense of the heaviness of the stone structures.
The calotype's graininess and lack of shadow detail
added a dark, foreboding atmosphere of mystery. The
contrasty prints of this series created a visual sense of
contradiction, presenting viewers with an unsolvable
riddle implying that when these monuments were built
wasn't really what was most important about them.

John Shaw Smith (1811–1873), an Irish amateur
calotypist, took an extended grand tour of the Mediter-
ranean, Egypt, and the Holy Land between 1850 and
1852. Exposing his paper negatives while they were
damp, Smith's visual souvenirs show his understand-
ing of the historic legends of these foreign locales.[5]
While mindful of the rules of conventional pictorial
practice, Smith experimented with sequential view-
points, such as circling St. Peter's Square with his
camera to create a panoramic effect. Smith blackened
the sky portion of the negative with Japanese ink so
that it printed clear, without the calotype's characteris-
tic mottled effect. Smith also altered the photographic
truth by outlining objects along the horizon with ink
on the negative or with pencil on the print, making
them stand out against the sky. In other cases he elim-
inated unwanted objects, and sometimes he added
clouds. Smith was willing to use the camera as a point
of departure for his own interpretations, leaving visual
evidence of an enterprising amateur spirit that helped
define early practice.

7.3  AUGUSTE SALZMANN.  *Jerusalem.* 9¼ × 13 inches. Salted paper print. Salzmann's general views of Jerusalem's ancient monuments rely on picturesque landscape models, favoring asymmetrical compositions that document the massive walls of the city. The soft, pencil-like quality of the salted-paper prints links the city with the site. Blanquart-Evrard published this work as *Jerusalem, époques judaïque, romanine, chrétienne, arabe, explorations photographiques par A. Salzmann* (1854). Courtesy George Eastman House.

By applying the latest wet-plate methods to the landscape, **Francis Frith** (1822–1898) became a major publisher of English and European views, eventually boasting a stock of one million images sold in more than 2,000 shops. Frith's picturesque views satisfied Victorian curiosity and reconfirmed the positivist belief that knowledge was a collection of facts. After traveling to the Near East, the photographer boated through the dangerous white waters of the Nile, fought off wild dogs, battled bandits, encountered desert princes "blazing with jewelled-hilted swords and gold-mounted firearms,"[6] and watched his collodion boil as he poured it onto his glass plate. Perhaps as a result of such hardships, Frith pioneered comprehensive coverage, often systematically photographing from a distance and then, from different angles, closer up, allowing the viewer

to reconstruct the scene. His trademark composition juxtaposed human figures with giant statues, providing a sense of mass and scale (see Figure 7.4). Frith's status came from his numerous books, illustrated with mounted photographs and accompanied by descriptions and dialogue. In *Sinai and Palestine* (ca. 1862), each large albumen print was accompanied by facts and commentary to coach the viewer to the same conclusions as the maker. The text accompanying *The Sphynx and Great Pyramid, Geezeh* reads:

> The day and hour in a man's life upon which he first obtains a view of "The Pyramids," is a time to date from for many a year to come; he is approaching, as it were, the presence of an immortality which has mingled vaguely with his thoughts from very childhood, and has been to him unconsciously an essential beautiful *form,* and the most majestic mystery ever created by man.

In an era before mass-produced picture book production, Frith's books stand out for allowing the subject to control the format. *Cairo, Sinai, Jerusalem and the Pyramids of Egypt* (ca. 1860) had 16 × 20-inch views on 21 × 29-inch pages; they conveyed a grand sense of contrast, space, and texture. *Upper Egypt and Ethiopia* (1863), with its oversized pages, leather binding, gold leafing, and marbleized endpapers, is an *objêt d'art.* After Frith completed his Near East tours, he hired photographers to make views of Europe, Great Britain, and

**7.4    FRANCIS FRITH.** *The Sphinx and Great Pyramid Geezeh.* 6⅝ × 9 inches. Albumen silver print. The sheer amount of visual information available on the hard, smooth surface of Frith's contact print, with its staggering shadow detail and creamy warm eggshell highlights, gives us hope that the mysteries of the pyramids can be solved. In his publications like *Lower Egypt, Thebes and the Pyramids* (ca. 1862), Frith also provides hard facts—the largest pyramid has a base of 746 feet, is 450 feet high, and covers about 12 acres—as if they would somehow give insight into these enigmatic structures. Then Frith reveals the conflict the Sphynx creates for his picturesque ideals: "The profile, as given in my view, is truly hideous. I fancy that I have read of its beautiful calm, majestic features; let my reader look at it, and say if he does not agree with me, that it can scarcely have been, even in its palmiest days, otherwise than exceeding ugly."    Courtesy George Eastman House.

America, utilizing the principles of industrial standardization to produce workmanlike, topographical portfolios. These images reflected the new photographic axiom that to see all was to know all. This industrious output sums up the ideal of "mechanical picturesque" photography as F. Frith & Co. became England's largest supplier of architectural views, landscapes, and *postcards.*[7] Frith & Co. continued to operate and sell postcards until 1971.

**Robert Macpherson** (1815–1872) took up photography in 1851 to sell tourists views of classical Roman sites. In 1856 Macpherson began making carefully composed, large wet plates (from 12 × 16 inches to 18 × 22 inches) of cultural emblems from his travels around Italy. These refined views culminated in the publication of a Vatican guidebook in 1863, illustrated with Macpherson's photographs of over 300 sculptures (see Figure 7.5). Commercial photographers like Macpherson had an extensive, well-organized, and ongoing dialogue with tourists and delivered views that met the travelers' expectations of souvenirs to share with their friends.

While a small band struggled to win a place for photography in the art world, its topographic applications had the greatest impact on visual literary. European commercial photographers, such as James Anderson (1813–1877), realized that accurate reproduction of artwork could increase the circulation of culturally significant subjects and be profitable as well. In the 1850s, photographers commenced publishing photographic prints of Western art masterpieces, establishing the photograph's role as the provider of visual artifacts. Even those who said photography was not art heralded its use for chronicling art works: It made people familiar with masterworks that could inspire their spirit, cultivate their taste, and assist in daily aesthetic decision making.

7.5   ROBERT MACPHERSON.    *Biga* (Statue of Horses and Chariot), ca. 1863. 8⅞ × 14⅞ inches. Albumen silver print. MacPherson's precise delineation and feeling for chiaroscuro elaborate the majesty of the ancient ruins and provide an experience of the place, leading the *Art Journal* to say: "You are struck with surprise at seeing so much that you never saw before. . . . In the light and shade of these ruins there is a sentiment which, with the stern truth of the photograph, affects the mind more deeply than a qualified essay in painting."[8]   Courtesy George Eastman House.

Leopoldo Alinari (1832–1865) opened his first studio in 1859 and was joined two years later by his brothers Giuseppe (1836–1890) and Romualdo (1830–1890) to form "**Fratelli Alinari**, Fotografi Editori." Relying on standard straightforward rules of composition, the Alinari brothers made unequivocal documents of Italian architecture, art, and landscape, conveying the Romantic look and myth of Italy. The Alinaris understood the public's visual expectations and supplied the market with art reproductions and stereocards. In the 1870s, they hired photographers to follow the firm's prescribed practices for chronicling the cities and art treasures of Italy. Thus photographic style began to move from the idiosyncratic characteristics of individual photographers to an industrial/corporate model that insisted on standardization. It is from this corporate model of hiring people to work as instructed that the Alinaris drew their effectiveness—the strength of numbers, with tourists being able to order views from a catalog. They were a team with a collective point of view,

whose patterned images were most effective when seen in organized sets.

Louis-Auguste Bisson (1814–1876) opened a daguerrean portrait studio in Paris in 1841 with his brother, Auguste-Rosalie Bisson (1826–1900), after being introduced to the process by Daguerre himself. For over a decade **Bisson frères** produced craftsmanlike portraits of artists and political figures tailored to meet public demand. In 1851, they switched to the wet plate and expanded their subject range. Since people wanted to see the Alps, but few could afford the trip, the brothers used photography to vicariously fulfill this arduous desire. The Bissons failed in their ascent of Mont Blanc in 1860, but the following year Auguste made a second attempt, using a guide and 25 porters to haul his gear. On the third day, after a difficult and frigid climb, the Bisson party conquered the 16,000-foot peak. A darkroom tent was set up and three 8 × 10-inch plates were coated and exposed.[9]

## Picturing Industrialization

The industrialization of society posed problems for romantically-trained photographers, who attempted to impose picturesque ideals onto man-made landscapes. As photographers gained experience, new treatments for photographing industrial settings evolved. Relying on the transparent negative and its companion glossy paper, the notion of suggestion was abandoned in favor of a strategy in which everything is specified, shifting the budding, individualistic documentary style from allusion to machinelike utilitarianism.

**7.6    FRATELLI ALINARI (GIUSEPPE AND LEOPOLDO).**
*Il Portico Degli Uffizi E Il Palazzo Vecchio,* ca. 1860. 13½ × 9⅞ inches. Albumen silver print. The practice of organizing groups of photographs around a theme reflects the narrative tradition that expects pictures to tell stories, a practice reinforced by picture magazines. The Alinaris understood these expectations and capitalized on them in creating their catalog of Italy, founded on their desire to portray "Bella Italia." The company is still a major photographic publisher of illustrative material with an archive of over 200,000 negatives.    Courtesy George Eastman House.

Following the Great Exhibition of 1851, **Philip Henry Delamotte** (1820–1889) was commissioned to document the dismantling of London's Crystal Palace in Hyde Park and subsequent reconstruction at Sydenham. He photographed the site weekly for three years (1851–1854), from its inception through the installation of exhibits, eventually publishing an album, *Photographic Views of the Progress of the Crystal Palace* (1855). At a site dedicated to new commercial products, Delamotte juxtaposed the repetition of the iron against the geometric rhythms of the arched roof frame (see

Figure 7.8). This sense of sameness was an exemplary metaphor for the Iron Age, venerating engineering feats in ironic duality. Within the recreation, the divergence between the old, heavy-handed, stone construction and the new modern, light, delicate, and airy machine methods of glass and iron is apparent.

During the 1850s, the camera was used to chronicle feats of mechanization. The partnership of Cundall & Howlett photographed the building of a huge coal-driven steamship, the *Great Eastern*.[10] Joseph Cundall (1818–1895), who favored compositions showing the entire ship, did most of the early construction photographs, including two-plate panoramas that reveal a giant, ugly, hulking shape, while **Robert Howlett** (ca. 1830–1858) covered the remaining stages of production by photographing what he saw, rather than contriving situations. Instead of showing the entire boat, Howlett made tighter compositions that emphasized the ship's imposing proportions (see Figure 7.9). Through his fresh approaches to daily industrial activities, Howlett raised the issue of which approach should be the standard for documentary camera work: one that presents

7.7    AUGUSTE-ROSALIE BISSON (BISSON FRÈRES).
*Ascension of Mont-Blanc,* from the album *Haute-Savoie, Le Mont Blanc et Ses Glaciers: Souvenir du Voyage de M. M. L'Imperatrice* (Paris, 1860). 11¼ × 14⅛ inches. Albumen silver print. The Bisson brothers' alpine accomplishments resulted in a 24-photograph album, dedicated to the Emperor and Empress of France, featuring majestic views of crevasses, ice, snowfields, and mountain tops. *Ascension au Mont Blanc* provides a sense of the sublime as the humans making their way through the snowfield appear as insects in this landscape.    Courtesy George Eastman House.

as much of a subject as possible or one that only shows a selected portion?

Nineteenth-century photographers like Howlett attempted to resolve the issue of where the perimeters of their composition lay, to decide what could be subtracted from the scene while maintaining pictorial integrity. Portrait photographers used neutral backdrops, vignettes, and oval-shaped overmats to obliterate everyday detritus and offer an artistic setting for the sitter to materialize within. Landscape photographers borrowed the painterly device of using deep shadows along the periphery to keep the eye from wandering outside the frame. Architectural photographers established points of view from a distance, making a structure appear to be naturally incorporated into its surroundings. Many workaday commercial photographers nonchalantly placed their subject in the middle of the frame and let the edges fall where they may, accounting for much of the perfunctory architectural and travel work of the 1860s and 1870s.

The precise orderliness of the railroads and their industrial paraphernalia altered the landscape, making them sites for photography's developing documentary style. Edouard Baldus's visual affidavits, such as the album *Chemin de Fer du Nord, ligne de Paris à Boulogne,* celebrate the building of Baron James de Rothschild's railway lines in France in 1855 and 1859. His images use the apparent rational, visual logic of the wet-plate process to ponder the illusion of symmetry produced by the repetition of industrial shapes. Baldus's depictions transcend their utilitarian origins and furnish visual gratification in a formal pictorial poetry of light, shape, and line. Most of the early railroad views explore a fascination with the regulated, geometric design elements that made up these machined constructions, focusing on the product and not on the human conditions surrounding their construction.

Leisure time expanded in the nineteenth-century industrial society. **Camille Silvy's** *River Scene, France* (see Figure 7.10), presents people relaxing at a place where urban and country values intersect—the river. Constructed from two negatives, one for the land and another for the sky, and reworked with ink and pencil for pictorial effect, Silvy printed a number of renditions, some dark and moody, others light and open. The success of Silvy's picturesque composition lies in its binary nature. From top to bottom, the river mirrors the sky and makes an affable connection. From left to right, an affluent couple can be seen in a boat, commanding the water, juxtaposed with the landbound working people who admire the water from the bank. The scene

7.8   PHILIP H. DELAMOTTE.   *Stuffed Animals and Ethnographic Figures.* Plate #100, vol. II of *Photographic Views of the Progress of the Crystal Palace, Sydenham* (London, 1855). The colonial attitude about "white man's burden" is represented amidst models of unindustrialized, half-naked people and wild animals. The endless high-technology geometric iron columns and frames imply that the wilds are confined and under control.   Courtesy Collection of the Juliette K. and Leonard S. Rakow Research Library of the Corning Museum of Glass.

instructs us on Romantic aspirations concerning beauty, its rejuvenating benefits, and the moral uplift possible from the natural world.

One of the ways people used their newfound leisure time was by looking at sites they were unable to visit. Western interest in the British colony of India led to an outpouring of photographically illustrated albums and books starting in the 1860s and 1870s (see Figure 7.12). **Samuel Bourne** (1834–1912) arrived in Simla, India, in 1863 and swiftly formed a partnership with Charles Shepherd, the owner of the oldest Anglo-Indian photographic firm and leading provider of Indian views. Bourne was a tireless traveler who journeyed in India, Burma, Ceylon, and Kashmir (see Figure 7.11). His daring undertakings culminated in 1868 with views made in the Himalayas at 18,600 feet. Bourne, a former banker, made meticulous images in regions where no Europeans had previously gone, during trips that lasted up to nine months (in 1864) or required up to sixty bearers (in 1868) to transport his gear.[11]

## Urban Life

**John Thomson** (1837–1921) moved to the Far East in 1862 and commenced ten years of photographing China, Cambodia, Formosa, Siam, and Vietnam. His topographic and ethnographic studies of native cultures, published as albums, recorded vanishing civilizations and made him a progenitor of early social documentation and travel. Thomson journeyed into remote tropical areas of the Orient to survey "principal antiquities" like the temple at Angkor Wat, resulting in his first album, *The Antiquities of Cambodia* (1867). His Asian voyages culminated in the four-volume work *Illustrations of China and its People* (1873–1874), which contained 200 tipped-in albumen prints. Thomson selected subjects of colonial interest by spotlighting social customs and distinctive types of people who fit into recognizable Victorian social types. These photographs were accompanied by text that was often based on *phrenology,* a pseudoscience that alleged a person's character could be determined by examining the outer surface of the head.[12] In his introduction Thomson wrote that he "frequently enjoyed the reputation of being a dangerous geomancer, and my camera was held to be a dark mysterious instrument, which combined with my naturally, or supernaturally, intensified eyesight gave me power to see through rocks and mountains, to pierce the very souls of the natives." His encyclopedic drive helped formulate a Western style of typecasting and foreshadowed his later work, *Street Life in London* (1877).

**7.9  ROBERT HOWLETT.** *Leviathan* (The Great Eastern), *Side View of Hull,* ca. 1857. 11¼ × 14⅛ inches. Albumen silver print. In this composition the bulk of the vessel is cut off and the camera is positioned upward so that the hull towers over us. Backlighting causes the two figures on the bow to almost vaporize, giving the sensation that the humans are inconsequential. Howlett's tight framing utilizes the edges of the frame, leaving the impression that the ship goes on indefinitely.  Courtesy George Eastman House.

Thomson's *Street Life in London* (1877),[13] made with writer Adolphe Smith, harnesses the photograph to social reform. The introduction states: "The unquestionable accuracy of this testimony will enable us to present true types of the London Poor and shield us from the accusation of either underrating or exaggerating individual peculiarities of appearance."[14] Thomson's previous experiences taught him how to pose people in an unrehearsed manner, to picture trades practiced by working people: street doctor, flower seller, public disinfector. *Street Life,* issued in serial form, contains thirty-six *Woodburytypes*[15] from photographs Thomson made to illustrate Smith's dramatic and moralistic text. This format helped establish the social documen-

tation practice of linking image and text to present a desired meaning. Smith wanted the episodes to increase middle-class sensitivity to the dilemmas of the urban poor and make them more willing to improve working-class living conditions (see Figure 7.13). The project had at least one tangible result, the construction of an embankment to stop the flooding on the Thames River that had been plaguing London's poor.

As urban renewal projects got underway in Paris, London, and Glasgow, photographic surveys were organized to record the doomed historical architecture (see Chapter 4). In 1868 and again in 1877, the Glasgow Improvement Trust commissioned the Scottish photographer **Thomas Annan** (1829–1887) to document the buildings and streets of the city.[16] The first part of his assignment appeared as albumen prints in 1868 and later as photogravures in *Old Closes* [unsavory, narrow passageways between multistoried buildings] *and Streets of Glasgow* (1900). Annan's images "afford a peep into dark and dismal dens unvisited by the great purifying agencies of sun and wind, and in surveying them, we instinctively feel that human life born, bred, or led within their shades is sorely handicapped, and that the day of their extinction is more than due."[17]

7.10    CAMILLE SILVY.    *River Scene, la Vallée de l'Huisne, France,* 1858 (print: 1860s). 10⅛ × 14 inches. Albumen silver print.    The J. Paul Getty Museum, Los Angeles.

Although Annan did not concentrate on people and the project's aim was romantic and sentimental rather than reformist, his attention to light reveals the dark tactile sensations of dampness and slime that make up the unhealthy character of the buildings inhabited by the working poor (see Figure 7.14). Annan's gloomy, realistic depiction of inner city slums, rarely encountered in British art, can be seen as a reflection of a God-fearing capitalist's obligation to care for those who labor for society. The work helped to establish an urban documentary style and can be linked with John Thomson and the later work of Jacob A. Riis and Eugène Atget.

## The Other

Picture/text combinations, as in Figure 7.15, allow us to more accurately decipher how photographers contextualize their subjects. Contemporary postcolonial cultural critics, such as Edward W. Said (*Orientalism,* 1978), have argued that Western cultures have systematically misrepresented non-Western peoples as exotically

*the Other* in order to achieve political and economic dominance. The concept of *the Other* refers to groups including women, people of color, inhabitants of the Third World, and gays and lesbians, that have traditionally been denied economic, political, and social power. Psychoanalysis has expanded into loose designation to include those mental constructs that do not fit into mainstream thinking. Western depictions often fail to grant *the Other* the same humanity and psychological complexity as their male European counterparts. *Others* are viewed as static objects rather than active subjects who possess the same desires and needs as the viewer. Adherence to these traditions make up the foundation of Western prejudice and its psychic armament against understanding anyone who is different from the mainstream culture. Control of production and distribution allow dominant societies to regulate history and its interpretation. In *Culture and Imperialism* (1993) Said critiques the Western military along with media and consumer cultures that have been used to erase native values. Said maintains such policies are counterproductive because they give rise to virulent forms of anti-imperialism, including fundamentalism, nativism, terrorism, and ethnic identity politics.

7.11  **SAMUEL BOURNE.** *The Viceroy's Elephants,* ca. 1866–1867. 9¼ × 11¼ inches. Albumen silver print. Photographs like *The Viceroy's Elephants* portray the exotic and powerful trappings of the British Imperial Administration (the raj) who took over the Indian government from the East India Company. Pax Britannia was maintained by a large military and a minimum of mixing with the native peoples. Bourne's work maintained a Western appreciation for the subcontinent's splendors and cultures without questioning the whites-only social policies.   Courtesy George Eastman House, Gift of Eastman Kodak Company: ex-collection Gabriel Cromer.

## The American West: The Narrative and the Sublime

At the end of the Civil War, America's attention shifted from pessimistic devastation to the optimistic development of its Western frontier regions. The American West, unlike Europe, was not a fixed culture. Its perceived attraction was that no culture, group, or government was seen as having hegemony over others. The West was an escape from enclosure to a wide-open space without history. It was a dynamic force of physical and transcendental freedom, waiting for someone to act upon. The American spirit was not housed in a cathedral but within people who believed that spiritual growth necessitated breaking free from society's constrictions and moving instead toward purifying solitude, toward nature, toward Walden. "I go and come with a strange liberty in nature,"[18] said Thoreau. The West combined these mythic ideals of American *exceptionalism,* a contract with nature that distrusted authority and strove for dignity through performance. In the West, the easterner was a dude, a comic character encumbered with useless knowledge who was too bogged down by theory to act. The completion of the transcontinental railroad, connecting the east and west coasts in 1869, made the West an economic site for government-planned programs of expansion and settlement that outwardly manifested the restless American spirit. The railroads hired artists, photographers, and writers to produce narrative, informational stories (propaganda, in fact), designed to excite would-be settlers, travelers, investors, and the public about the region's potential. They were assigned

**7.12 LÁLÁ DEEN DAYAL.** *Water Palace Deeg,* 1893, from *Indian Ancient Architecture Album.* 7⅝ × 10⁹⁄₁₆ inches. Albumen silver print. Indian photographer Lálá Deen Dayal (1844–1910) started working about 1870, becoming the official photographer to the viceroy and later to the nizain (ruler) of Hyderabad. At the turn of the century he made before-and-after images of starving children who were fed by the nizam to provide evidence of his government's relief programs. In his *Indian Ancient Architecture Album* (1893), symmetrical landscape compositions and effective use of light, as in *Water Palace Deeg,* create a sense of timelessness. Dayal's photography business is still run by his descendants today. Courtesy George Eastman House.

to replace the vacancy of the Great American Desert with promotional images of an Eden-like farmland that would get viewers to commit their families and savings, sight unseen, to a landscape pictured in a book.[19] These storytellers relied on the *Manifest Destiny* theme, the duty and the right of the United States to expand its territory and influence throughout North America, reflecting a can-do spirit in a time of increasing population and recession. Manifest Destiny provided a rationalization for the westward expansion of American civilization that would dominate this intercultural contact zone, conquering the wilderness and its native peoples. It all occurred

in front of a backdrop of romanticism that portrayed the sublime grandeur of nature, particularly the mountains, as evidence of the role a supreme deity played in the Creation. Public curiosity and tall tales about the West fueled demand for photographic documents that constructed an emblematic narrative landscape of accomplishment; gorges bridged, mountains tunneled, and nature subjugated (see Figure 7.16).

Photography had to compete with the size, symbols, and dramatic license of artists who were the principal Western storytellers to a public expecting to be entertained and informed. George Catlin (1796–1872) put on theatrical presentations of his Indian paintings in the 1830s and followed them with his "Indian Gallery," designed for European audiences, which featured artifacts and live Indians. During the 1850s, magic lantern shows accompanied by narrative dialogue became popular. Words enabled storytellers to take even inconsequential photographs and make them part of a larger tale. In the spirit of entertainment, information, and theater, painted panoramas, incorporating music and spoken narratives, became fashionable. The panorama's sequential linear format was spatially suited for celebrating and documenting the expansive growth and prosperity of America's vast, horizontal, western space.

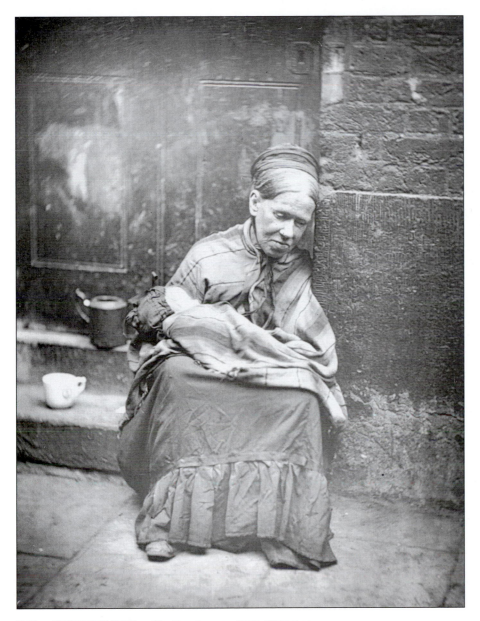

**7.13   JOHN THOMSON.** *The Crawlers,* ca. 1876–1877, from *Street Life in London,* 1877. 4½ × 3⁷⁄₁₆ inches. Woodburytype. The crawlers "are old women reduced by vice and poverty to that degree of wretchedness which destroys even the energy to beg."[20] They were so feeble from hunger and lack of sleep that they crawled on their hands and knees to get their primary form of sustenance, bread and hot water for tea. The crawler in this photograph was keeping a baby while its mother worked in a coffee shop.   Courtesy George Eastman House.

Clarence King's (1842–1901) motives were not commercial but scientific and theological when he participated in and led geological and topographical expeditions in the American West. Profoundly interested in the relationship between God and geology, King rejected the prevailing belief, *uniformitarianism,* that all geological functions took place slowly and evenly over time. King believed that periods of calm were interrupted by catastrophic intervals of what he called Divine Creation that compelled life forms to alter or perish. For King, geology offered a way to use scientific knowledge to confirm the Old Testament's account of God's violent creation of the world. As a supporter of John Ruskin's belief in the symmetry of art and science, King believed artists should blend their capability to communicate with scientific observations about nature to transcend specific situations and make universal statements. Much of nineteenth-century American landscape imagery was formulated on the model of the picturesque, the sublime, and the beautiful, dealing with the virtues of nature and its transcendental ramifications (see Chapter 3). The American West was the place where the hand of God could be best cherished in its authentic splendor. Expressions of these beliefs are disclosed in the images of the photographers with whom King worked, including Carleton E. Watkins and Timothy H. O'Sullivan.

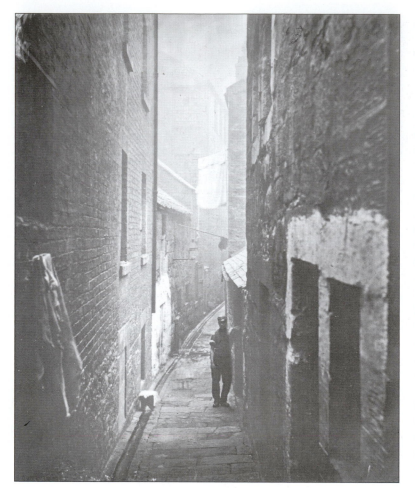

**7.14 THOMAS ANNAN.** *Close, No. 31 Saltmarket,* from *Old Closes and Streets of Glasgow,* 1868–1877. 10⅞ × 9 inches. Albumen print. The lack of detail in the man standing against the wall in shadow takes away his human individuality. The long exposure produced a ghostly three-legged child, seeming to say that this environment can distort life. The broken windows, laundry hanging from buildings, and waste water running in an open sewer ditch convey a depressing, claustrophobic feeling of a worn, medieval stone city. Courtesy George Eastman House.

After apprenticing with California photographic pioneers James Ford and Robert H. Vance and photographing mines and the Mission Santa Clara, **Carleton E. Watkins** (1829–1916) undertook his series of Yosemite views. Yosemite, the sublime dream place of romantic painters, was discovered by white settlers in the early 1850s and was an organized tourist site by 1856. Following Ruskin's precepts, Yosemite was considered to be a finished, natural work of art, and beginning with C. L. Weed in 1859, photographers confronted Yosemite with deliberate discretion and impeccable technique. Often using a mammoth plate camera (18 × 21 inches), Watkins initiated the cardinal construct of American landscape photography: God was in the details, a concept that was brought to a climax a hundred years later by Ansel Adams. His large, toned albumen prints emphasize the abundant richness of highlight detail and embellish the dark shadows and black tones, while adding contrast that makes the mountains appear to rise out of the background. Watkins countered the wet plate's extra sensitivity to blue light by creating layered compositions that increase the illusion of depth. Utilizing compositional devices, especially water, Watkins leads the eye upward towards mountain peaks, adding to an image's three-dimensionality. Watkins favored dome-topped prints (rounded on the top corners) to hold the eye at the crest of the print (see Figure 7.17). Aside from studying the established subject matter of painters, Watkins found a formal voice for the Western landscape and its sense of space directly from natural sources, formulating a sophisticated practice that personified the artistic and societal values America was searching to affirm.

In 1867, **Timothy H. O'Sullivan** became the photographer for Clarence King's Geological Explorations of the Fortieth Parallel. O'Sullivan's views mark a departure from representing nature as a place of salvation. O'Sullivan saw the West with "eastern" eyes, as a hostile place where one must struggle to survive (see Figure 7.18). Whether this vision was influenced by the horrors he had witnessed during the Civil War or by campfire talks with Clarence King, O'Sullivan presented the West in the ancient spirit of the sublime, as a place that is astonishing, demanding, and terrifying. Since the main purpose of the photographs was scientific, O'Sullivan did not have to be overly concerned with the paying public or with sticking to conventional straight presentations, and it is now known that he tilted his camera to make formations appear more menacing.[21]

In 1870, O'Sullivan was hired as the photographer for the Darien survey that was attempting to determine a route for a canal across the Panamanian isthmus. In 1871, he commenced working with Lieutenant George M. Wheeler's survey, which ascended the Colorado River through the Grand Canyon. He spent 1872 back with King's survey and did his final field work again with Wheeler during the 1873 and 1874 seasons. Since the majority of O'Sullivan's images were seen as original prints in albums by only a handful of influencial decision makers, they did not have a great influence on public perception or on photographic practice. In late 1880, O'Sullivan was appointed chief photographer for the U.S. Treasury Department. He succumbed to tuberculosis in early 1882.

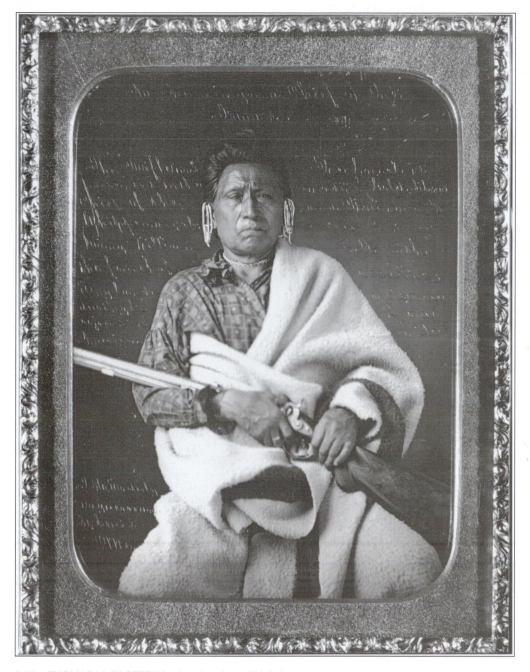

7.15    THOMAS M. EASTERLY. *Na-che-ninga, Chief of the Iowas,* 1849. Daguerreotype. Numerous photographers undertook ethnological studies, mostly to satisfy curiosity, but few were designed like *Street Life* to reach an audience that could influence decisions. In America, daguerreotypists such as Thomas Easterly (1809–1882), applied a straight-ahead portrait approach to Native American sitters, giving them the same grave demeanor as everyone else who sat for a daguerreotype. Later stereographs, made by expedition photographers who used the camera to reaffirm their stereotypical beliefs, became the popular method of distributing studies of Native American groups to white society.    Courtesy Missouri Historical Society, St. Louis.

After serving in the Union Army, **William Henry Jackson** (1843–1942) opened a photographic studio in Omaha, NE, in 1868, doing portraits and documenting the building of the Union Pacific Railroad. In 1870, Ferdinand V. Hayden, the director for the U.S. Geological and Geographical Survey of the Territories, made Jackson the official photographer of his survey team, enabling him to spend most of the summers between 1870 to 1879 making photographs in the field. In 1871, the Hayden team began to explore the bubbling mud pots, steaming geysers, exotically colored hot springs, and rushing waterfalls of Yellowstone. Using a mule named "Hypo" and an ambulance to haul his equipment and 400 glass plates, Jackson worked with the

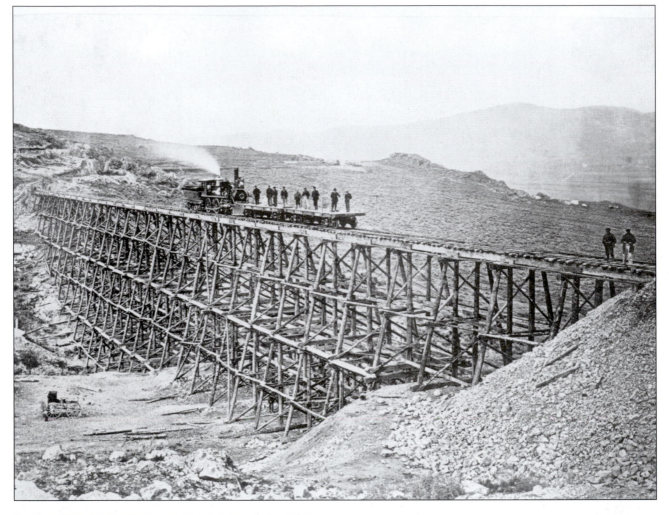

**7.16 ANDREW J. RUSSELL.** *Trestle Work, Promontory Point, Salt Lake Valley,* ca. 1868–1869, from *Sun Pictures of Rocky Mountain Scenery,* 1870. 6 × 8 inches. Albumen silver print. Andrew J. Russell painted panoramas before documenting the Civil War and the construction of the Union Pacific Railroad during 1868–1870. Russell replicated the panorama's narrative, linear approach in his railroad pictures, accounting for one section of track after the next, hardly getting out of sight of the rails. The photographers accompanying the government surveys, traveling along invisible meridian and parallel lines, labeled their prints with their precise locations. Russell not only documented the joining of the rails but also the engineering accomplishments of a multinational work crew made up largely of Chinese immigrants. The appendages of the steam locomotive, tracks, trestles, and water towers added new elements into the natural landscape and became popular subjects in literature and painting. Courtesy George Eastman House.

survey's landscape painter, Thomas Moran, to "solve many problems of composition."[22] Jackson's vision tempered the sublime with the picturesque, representing the West as a classically beautiful milieu while providing mythic publicity images for Hayden's project. Jackson's dramatic narrative context provided an official voice, giving a face to a restless society's search for its national character while answering fables about the West. His famous image of *Old Faithful in Eruption* was instrumental in Yellowstone's development as a tourist attraction. Hayden placed Jackson's images in an album, *Yellowstone's Scenic Wonders* (1872), and circulated it among prominent Washington officials, helping persuade Congress to pass legislation making Yellowstone the country's first national park. In 1874, Jackson and Ernest Ingersoll of the New York *Tribune* became the first white people to rediscover and document the Rio San Juan cliff dwelling ruins (ca. 800s) in what is now Mesa Verde National Park. Ironically, these first white explorers seemed to realize that their descriptions would change these pristine areas, which would require government protection in order to survive.

Jackson's most famous image was *The Mountain of the Holy Cross* (1873) (see Figure 7.19). Since the time of the Spanish explorers there were rumors about a mountain with a snow-filled cross. Jackson wrote how he and two companions carried his photographic equipment up Notch Mountain, across the ravine from the Holy Cross, where Jackson made eight exposures as "the long flamelike shadows on Holy Cross were rapidly sweeping down into the valley. Since 1873 I have

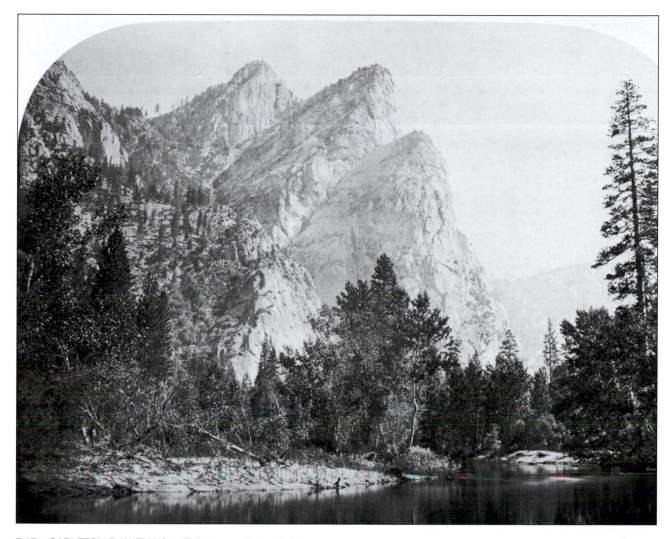

**7.17 CARLETON E. WATKINS.** *El-Eachas or Three Brothers,* ca. 1861. 16 ³⁄₁₆ × 20¹⁰⁄₁₆ inches. Albumen silver print. Watkins's huge plates capture the detail and awe-inspiring scale and sublime potency of Yosemite, enabling photographers to compete with monumental landscape painters such as Albert Bierstadt, Frederick Church, and Thomas Moran. Watkins's images helped to photographically establish the mountain landscape as an emblem of transcendental idealism by accentuating the energetic attributes of these formations. Courtesy George Eastman House.

been back four or five times. I have used the best cameras and the most sensitive emulsions on the market. I have snapped my shutter morning, noon, and afternoon. I have never come close to matching those first plates."[23]

In early 1879, Congress curtailed all survey activities. Jackson moved to Denver and became a prominent industrial photographer, opening his photographic and publishing business, which he ran until 1898. Western railroads commissioned him to photograph their operations, opulent accommodations, and spectacular scenery to encourage commerce and travel. As railroads ran by measured clock time they promoted corporeal rather than geological time that linked capitalism and technological achievements to present a public image of an imaginary future of boundless progress. The railroads wanted images that depicted a tamed and organized landscape that could be converted from a phenomenon of contemplation into a commodity of profit.

As the frontier closed, Jackson made a business arrangement with the Detroit Photographic Company (1898–1924) to convert his images into postcards and *chromolithographs,* colored prints made by lithography, using a separate stone or plate for each color. The postcard was an ideal medium to distribute the commissioned views of tourist interest for the railroads and related businesses like the Fred Harvey company that ran hotels and restaurants.[24] Jackson's business acumen got his images into the hands of the public, extensively influencing how the nation saw the West. Jackson remained vigorous into his nineties, taking credit for over 80,000 pictures[25] and writing his autobiography, *Time Exposure* (1940). His images cast the American West as a stupendous, pristine, and generous Valhalla, permeated with astonishing phenomena and remaining ever benevolent.

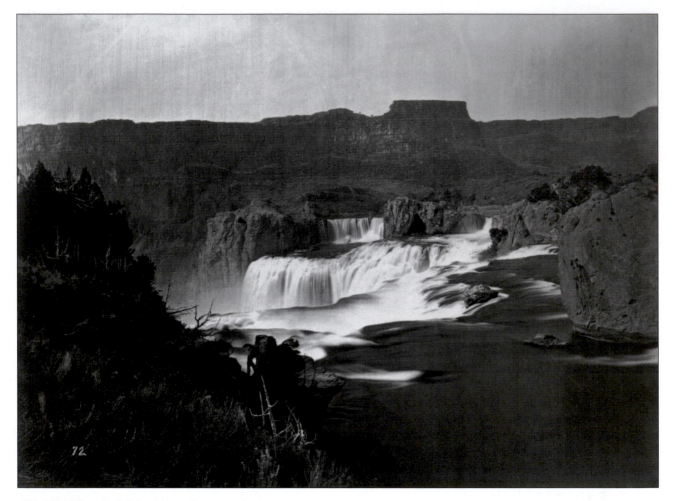

**7.18**   TIMOTHY H. O'SULLIVAN.   *Shoshone Falls, Idaho,* 1868.
7¾ × 10⅝ inches. Albumen silver print. O'Sullivan's views at the
Falls of Soshone speak of danger and the power of nature. His
views of the vastness of the West embrace themes of isolation,
silence, and solitude. O'Sullivan's views point out the insignificance
of people and are reflective of Clarence King's writing: "No
sheltering pine or mountain distance of uppiled [sic] Sierras guard
the approach to the Shoshone. You ride upon a waste—the pale
earth stretched in desolation. Suddenly, you stand upon a brink. As
if the earth has yawned, black walls flank the abyss. . . . You turn
from the brink as from a frightful glimpse of the Inferno, and when
you have gone a mile the earth seems to have closed again. Every
trace of the cañon has vanished, and the stillness of the desert
reigns."[26]   Courtesy George Eastman House.

**Eadweard J. Muybridge** (1830–1904) began life in
England as Edward James Muggeridge, but he changed
his name and went to America in 1852. He worked for
Carleton Watkins in the early 1860s, before publish-
ing his own views of Yosemite. These and subsequent
"examples of the perfection to which photography can
attain in the delineation of sublime and beautiful scen-
ery"[27] brought Muybridge an international reputation.
The full plate views, about 6 × 8 inches when trimmed,
were distinguished by splendid cloud effects (see

Figure 7.20). Muybridge devised a "sky shade," a shut-
terlike device permitting various exposures to be made
on a single plate, to compensate for the wet plate's
over-sensitivity to blue light. This let Muybridge make a
single negative, instead of the combination printer's two,
and more accurately portray a range of tones. To position
himself squarely within the grand landscape tradition,
Muybridge returned to Yosemite Valley in 1872 with a
mammoth-plate camera (20 × 24 inches) that yielded
18 × 22-inch prints. During this time Muybridge was
associated with the landscape painter Albert Bierstadt,
who reportedly made on-site consultations and acted as
a patron. The lengths that Muybridge would go to make
his views were reported in the *Alta California:*

> he has waited several days in the neighborhood to get the
> proper conditions of atmosphere for some of his views; he
> has cut down trees by the score that interfered with the cam-
> eras from the best point of sight; he had himself lowered by
> ropes down precipices to establish his instruments in places
> where the full beauty of the object to be photographed could
> be transferred to the negative; he has gone to points where
> his packers refused to follow him, and he has carried the ap-
> paratus himself rather than to forego the picture on which he
> has set his mind.[28]

Between 1865 and 1880 numerous Western expe-
ditions included photographers to document findings.

106. MOUNTAIN OF THE HOLY-CROSS

**7.19** WILLIAM HENRY JACKSON. *The Mountain of the Holy Cross,* 1873. 10¼ × 13¼ inches. Albumen silver print. Numerous photographers have tried to duplicate Jackson's image without success.[29] Today the picture is a curiosity, but to the viewers of that time, besieged by theories of positivism and Darwinian evolution, the image was widely viewed as a concrete symbol of Christian faith and a solid manifestation of God's law. Courtesy George Eastman House.

John Wesley Powell (1834–1902) was a geologist and ethnologist who surveyed the Colorado River in 1869, becoming the first white person to pass through the Grand Canyon by boat—a feat for a man who had lost an arm in the Civil War. John K. Hillers (1843–1925), originally an oarsman, became the group's photographer, producing some bold compositions that captured a sense of place and the quality of light while making ethnological studies of the indigenous peoples. Hillers remained Powell's photographer from 1873–1879, when he was appointed Chief Photographer for the newly established U.S. Geological Survey, which Powell was instrumental in creating and headed from 1881–1894. William Bell (see Chapter 5) became the photographer for Lieutenant George M. Wheeler's 1872 expedition in Arizona and Utah.

Frank Jay Haynes (1853–1921), who obtained the first official photographic concession at Yellowstone, followed the formal compositional artifice of the times, but his pictures often revealed how intruding humans were changing unsullied nature. Improvements in reproduction technology reduced the demand for original views, shifting the marketing and distribution of photographs from individual photographers to national companies. Haynes arranged with Photochrom Company,[30] the postcard branch of the Detroit Photographic Company, to reproduce his work. Postcards increased image production but diminished the scale of landscape and altered it through the inclusion of text. Coloring techniques softened photographic description through abstraction and sensualization, manufacturing romantic and impressionistic notions about the West.

The 1880s saw the closing of the frontier. Commercial interests demanded the West be made safe for development. In this burgeoning climate of commercial travel, Isaiah West Taber (1830–1912) issued *View Album and Business Guide of San Francisco,* a protean Yellow Pages of local businesses whose purpose was to "combine art and advertising . . . for businessmen . . . in hotels and mail steamers of America, England, and Australia [that] will be able to relieve the tedium of travel on industries and products of California, and gain some idea, or renew their acquaintance with, its beautiful scenery. . . . **TREAT THIS BOOK KINDLY.**"[31]

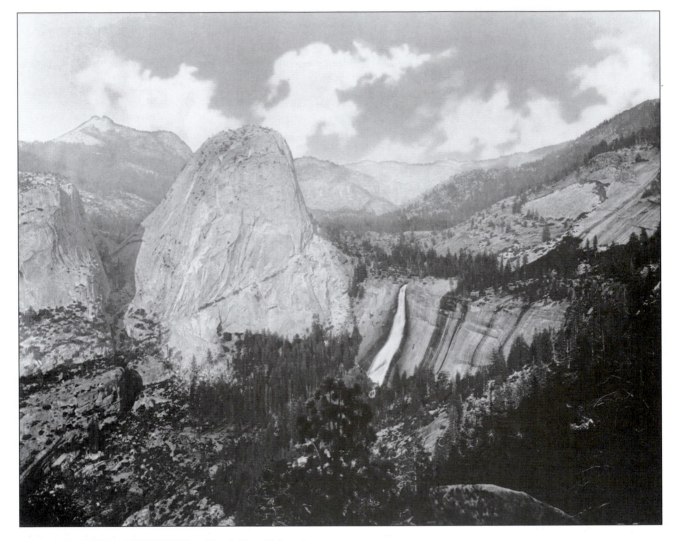

7.20  EADWEARD J. MUYBRIDGE.  *Clouds Rest, Valley of the Yosemite*, ca. 1870 (print ca. 1874). 16⅞ × 21⁷⁄₁₆ inches. Albumen silver print. Muybridge's views of Yosemite demonstate young America's nature worship and nationalism. Muybridge did not include people; his pictures are of unadulterated wilderness, giving visual form to the notion that God created this abundance for a new chosen people. Here was paradise regained, the proof of Manifest Destiny—that it was God's wish for Americans to transfigure the uncultivated land into a useful Garden of Eden. The dark side of this concept can be seen in Muybridge's Modoc War (1872–1873) stereocards,[32] which pictured racial stereotypes and were produced for a white audience who used them as proof that their prejudices could be documented by the camera.    Courtesy George Eastman House.

The fragmentation of the Indian alliance and the use of industrial technology by the whites, including fire-arms, telegraph, and railroads, and the byproducts of clashing cultures, such as smallpox and the slaughter of the buffalo, ensured European control of the Western lands and its indigenous peoples. As curiosity about the West diminished, so did the demand for views, forcing photographers to develop new markets.

Breakthroughs in vision and technology redefined and reorganized cultural ideals. The new concepts of scientific and mechanical time and space enabled European culture to control the means of distribution and monopolize the practice of representation. The wet plate's transparency clouded the issues surrounding its so-called empirical sense of genuineness. By dominating the mechanical structuring of space within the frame, photographers determined not only what was represented but *how* it was represented. The consumers of such images were likely to identify with the structure and aims of a viewmaker who reaffirmed their beliefs. People curious to see what they had never seen before, but naive about how these documents were formulated, were vulnerable to a viewmaker's scheme. This vulnerability allowed the values behind the views to be absorbed by viewers and shape their thoughts about what they were seeing. People had not yet learned to actively question the motivations driving the creation of photographs. The lesson that photographic truth is as transparent and changeable as any good negative had yet to be formulated.

# Endnotes

1   John Ruskin, *Works,* eds. E. T. Cook and A. Wedderburn (London, 1906), vol. 3, 210. Letter to W. H. Harrison, August 12, 1846.

2   C. Jabez Hughes, "On Art Photography," *American Journal of Photography,* new series vol. 3, no. 17, February 1, 1861, 261–63.

3   Dr. John Nicol, "Photography in the Field," *British Journal of Photography,* vol. XXXIV, no. 1403, March 25, 1887, 184–86.

4   Du Camp's traveling companion for the French Ministry of Education commission, Gustave Flaubert, provides a connection between topographical photography and the realistic novel. Flaubert was known for his efforts to find the exact word (*le mot juste*) and for his aim for complete objectivity. Flaubert, who assisted Du Camp, began working on *Madame Bovary* (1857) upon his return from this voyage. For an intriguing interpretation of this journey, see Francis Steegmuller, *Flaubert in Egypt: A Sensibility on Tour* (Boston: Little, Brown & Co., 1972).

5   Maria Antonella Pelizzari, *John Shaw Smith, An Irish Traveler with the Calotype Process (1849–1852).* An unpublished paper presented at the University of New Mexico, Spring Symposium, 1993.

6   Bill Jay, *Victorian Cameraman; Francis Frith's Views of Rural England 1850–1898* (Newton Abbott, David and Charles, 1973), 17.

7   The postcard appeared as a hybrid of the mass-produced albumen print and the carte-de-visite in Europe about 1869. Its straightforward approach filled the void for imagery of historical and tourist sites, making it popular as a collectible, low-cost method of communication. When coupled with new photomechanical processes, it helped elevate the level of visual literacy. The postcard imparted the value of the straight-on stare and the appreciation of the vernacular.

8   *The Art Journal,* New Series I, November 1862, 227.

9   See "Photography on Mont Blanc," *The Photographic News,* vol. V, no. 155, August 23, 1861, 401–02.

10   *Great Eastern,* three years in the making and capable of transporting 4,000 passengers plus a crew of 400, was a symbol of imperialist pride. It was launched in 1858 and laid the first transatlantic cable.

11   See Samuel Bourne, "Narrative of a Photographic Trip to Kashmir and Adjacent Districts," *British Journal of Photography,* vol. XIII, no. 335, October 5, 1866, 474–75. This article was published in 9 installments running through vol. XIV, no. 353, February 2, 1867, 63–64.

12   For an overview of this subject see Michel Frizot "Body of Evidence: The Ethnophotography of Difference" in *A New History of Photography,* Michel Frizot, ed. English edition (Cologne: Könemann, 1998), 258–271.

13   *Street Life in London* was modeled on Henry Mayhew's *London Labour and London Poor* (1850), which was illustrated by wood engravings based in part on daguerreotypes made under the direction of Richard Beard and "cleaned up" by the engravers. The engraving process separated the subjects from their surroundings, causing them to lose their veracity. Mayhew's combining of interviews and photographs of London's urban poor became the model for legitimate sociological documentation.

14   John Thomson and Adolphe Smith, *Street Life in London* (London: Sampson Low, Marston, Searle and Rivington, 1877), preface.

15   The Woodburytype was a photomechanical process, patented by Walter B. Woodbury (1834–1885) in 1864, in which a negative was exposed to bichromated gelatin to produce a shallow relief mold, following the contours of the image, that was placed in contact with a block of lead. The block was coated with pigmented gelatinous ink and transferred to paper by means of a hydraulic press. The Woodbury print often displays a visible relief, but reveals no structural grain, thus possessing all the tonal delicacy of the original photograph. They were widely used for book illustrations in the 1870s and 1880s.

16   Annan operated studios that did portraits, architecture, art reproductions, and landscapes and was the father of photographer J. Craig Annan (1864–1946) who was active in the Pictorialist movement.

17   William Young, introduction to Thomas Annan, *The Old Closes and Streets of Glasgow* (Glasgow: James MacLehose & Sons, 1900), 22.

18   Henry David Thoreau, *Walden, or Life in the Woods* (New York: Library of America, 1985), 425.

19   See Jonathan Raban, *Bad Land: An American Romance* (New York: Pantheon Books, 1996).

20   John Thomson and Adolphe Smith, *Street Life in London,* 81–84.

21   See *Second View: The Rephotographic Survey Project* essay by Paul Berger; Mark Klett, chief photographer; Ellen Manchester, project director; JoAnn Verburg, project coordinator (Albuquerque: University of New Mexico Press, 1984), 17, 20–21.

22   *Time Exposure: The Autobiography of William Henry Jackson,* intro. Ferenc M. Szasz (Albuquerque: University of New Mexico Press, 1986). Reprint. Originally published: New York: Van Rees Press, 1940.

23   Ibid., 218.

24   See Edward Buscombe, "Inventing Monument Valley: Nineteenth Century Landscape Photography and Western Film" in Patrice Petro ed., *Fugitive Images: From Photography to Video* (Bloomington: Indiana University Press, 1995), 101–02.

25   The Colorado Historical Society has 53,879 glass plate negatives made west of the Mississippi River and the Library of Congress has 30,000 negatives associated with the east and with foreign countries. Some of the negatives were acquired or made by associates, but unlike Mathew Brady, Jackson produced the lion's share. Also, tens of thousands of contact prints made from the original negatives are in the collection of the Henry Ford Museum in Dearborn, Michigan. See: http://www.thehenryford.org/exhibits/pic/2001/01.jun.html

26   Clarence King, "The Falls of the Shoshone," *The Overland Monthly,* vol. 5, no. 4 (October 1870), 379–85.

27   From Muybridge's 1868 brochure cited in Mary V. Jessup Hood and Robert Bartlett Haas, "Eadweard Muybridge's Yosemite Valley Photographers 1867–1872," *California Historical Society Quarterly,* vol. XLII, no. I (March 1963), 10.

28   Ibid, 18.

29   Some critics claimed Jackson retouched the snowy cross portion of the image. Handwork does appear in the shadowy stream (lower right center) leading up to the cross, but not in the area around the cross itself. There is nothing unusual about this practice, as wet-plate photographers relied on handwork for effect as well as to correct for deficiencies in the process. It is probable that erosion has caused the arm to retain less snow.

30   Photochrom was a Swiss-developed photolithographic process for making a continuous-tone color rendition of a black-and-white photograph using multiple impressions from color-inked lithographic stones.

31   Isaiah West Taber, Introduction to *View Album and Business Guide of San Francisco,* ca. 1884.

32   The Modoc Indians lived in northern California and southwest Oregon. They violently clashed with early white settlers and were forced onto a reservation in 1864. Their chief, Captain Jack, led a band of rebels back to California, triggering the Modoc War of 1872–1873 that finally divided the tribe, who now live mainly in Oregon.

# New Ways of Visualizing Time and Space

## The Inadequacy of Human Vision

The technical innovations of the nineteenth century altered
and expanded the perimeters of human vision in art and sci-
ence. As early as 1834, Sir Charles Wheatstone observed that
an object painted on a revolving disc appeared to be station-
ary when illuminated by intense electric light. He also noticed
that flying insects seemed to be fixed in mid-air by the same
means. In 1851, Henry Fox Talbot attached a page of the
London *Times* to a swiftly revolving wheel in a darkened
room, uncapped the lens of his camera, and made an exposure
of about 1/100,000 of a second by means of an electric spark,
sharply freezing the action of the moving paper. Talbot con-
cluded that pictures of moving objects could be made by illu-
minating them with a sudden electric flash. By the 1860s, as
we have learned, photographers were making instantaneous
stereoscopic views that arrested the action of people walking
on the street. In 1887 Ernst Mach, an Austrian scientist, used
an electric spark (the precursor of flash) as a lighting source
to make postage-sized, stop-action images of projectiles

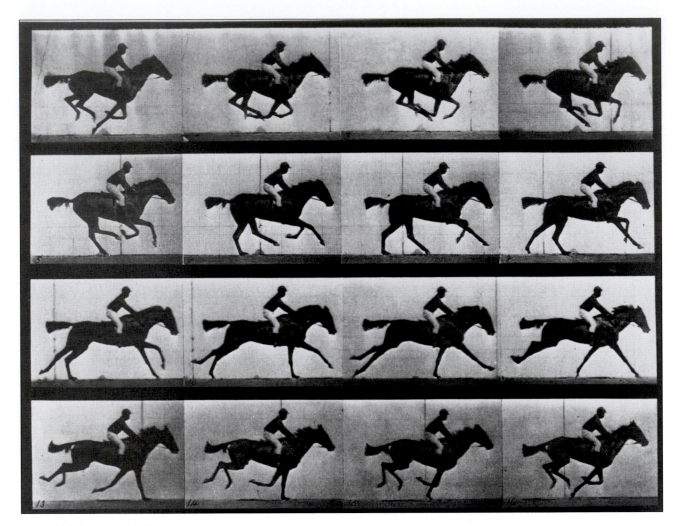

**8.1 EADWEARD J. MUYBRIDGE.** *Galloping Horse, Motion Study—Sallie Gardner,* owned by Leland Stanford, running at a 1.40 gait over the Palo Alto track, June 19, 1878. 9⅜₆ × 12 inches. Collotype.   Courtesy George Eastman House.

moving at about 765 miles per hour. By the mid-1890s, spark exposures of one-millionth of a second were being made by scientists such as Lord Rayleigh and Théodore Lullin (who photographed dripping tap water) and A. M. Worthington (who photographed splashing milk), providing the first images of previously unseeable occurrences. What these photographs depicted was often startlingly different from earlier visual depictions, making it obvious that human vision was unreliable for detecting events that unfolded in fractions of a second. New methods developed that affected the look and content of photographs and further altered society's sense of how time and space were visually represented.

## Locomotion

In 1872 Leland Stanford, a former governor of California and future U.S. Senator, president of the Central Pacific Railroad, and wealthy horse enthusiast, hired

**Eadweard J. Muybridge** to photographically demonstrate that at some point in its gait a horse runs with all four feet off the ground at the same time.[1] Due to the slowness of the wet-plate process, initial results were inconclusive. Before additional experiments could be carried out, Muybridge went on trial for killing his wife's lover. Although a jury acquitted him in early 1875, he left the country for Central America, where he spent most of the year photographing. When he resumed the work for Stanford, he used a *ripened emulsion,* one aged for several days at 90°F to increase its sensitivity. It produced underexposed negatives of a silhouetted horse with all four hooves off the ground. Because Muybridge had retouched the pictures "for the purpose of giving a better effect to the details,"[2] however, their authenticity was challenged. To alleviate doubts, the experiment was redone and expanded from a single camera to a battery of cameras.

Under radiant California sunshine, against a white background on a limed track, Muybridge arranged twelve cameras at right angles to the line of motion. Threads, connected to electric switches, were strung across the track. The horse raced by, breaking the threads, firing each shutter at about 1/2000 of a second.

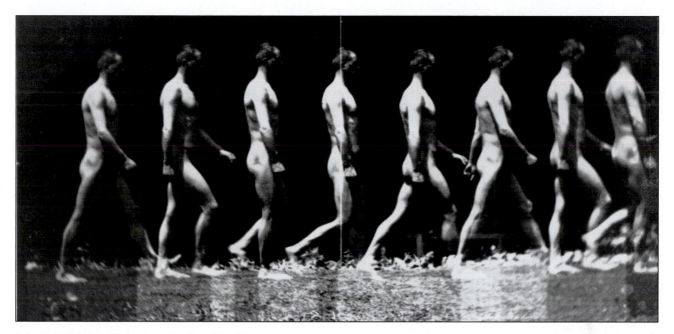

8.2 **THOMAS EAKINS.** *Jesse Godley,* 1884. Chronophotograph taken with a single-disk, Marey-wheel camera. Philadephia Museum of Art.

As Stanford anticipated, these silhouetted images confirmed that the horse had all four feet off the ground at once. The surprise was that this happened *only* when the horse had its feet tucked under its abdomen. None of the photographs pictured the popular conception of a galloping horse, which was with its front and back legs fully extended, in a painterly hobbyhorse pose. People were astounded and found them preposterous because they did not match the accepted modes of representation. Realizing the importance of such pictures, Stanford commissioned Muybridge to photograph additional animals and people in motion.[3]

Muybridge used photographic images and the phenomenon of *persistence of vision,* the sensation that images are continuous, to show an audience moving pictures. Eighteen drawings from the horse series were reproduced in the October 19, 1878, issue of *Scientific American.* Readers were instructed to cut and paste the images onto paper strips to be placed, image side out, into the interior compartment of a *zoetrope.* A simple hand-held device, a zoetrope is a rotating drum with an open top that utilizes the persistence of vision to produce the illusion of motion by blending the sequential pictures as they are viewed through a series of slits in the turning drum's side. Muybridge began a lecture tour of America and Europe and illustrated his talks with his *zoopraxiscope,* a modified zoetrope in which transparencies of the images were mounted on a rotating circular glass and projected by a magic lantern. The visual uncertainty in Muybridge's presentation can be likened to the sensation of sitting in a train at a platform as a train on the next track pulls out. While looking out

the window of the stationary train, a passenger may perceive the still train as moving.

While lecturing in Philadelphia in 1883, Muybridge met realist painter **Thomas Eakins** (1844–1916), who used the horse pictures as visual source material in his own paintings and incorporated the camera in his teaching. Eakins suggested Muybridge include a measurement scale in the background of future photographs so artists could easily copy them. Furthermore, Eakins convinced the University of Pennsylvania to underwrite Muybridge's plan for a vastly expanded photographic study of animal locomotion. Muybridge commenced working in a specially built outdoor studio in June 1884 and concluded the next summer. His subjects included more horses and some animals from the local zoo, but mostly nude and semi-nude men and women, engaged in numerous activities. In 1887 the project's results were published by subscription as *Animal Locomotion,* eleven volumes of 781 collotype plates compiled from 19,347 individual photographs. Eakins worked alongside Muybridge during the first part of the summer, using a *wheel* or *disk camera*[4] to record the successive phases of movement on one plate. Each facet of the action in an Eakins photograph could be analyzed to give viewers a more accurate visual analysis of the spatial relationships of the animal's anatomy as it moved through time.

Muybridge continued to use multiple cameras whose shutters were controlled by an electromagnetic device, enabling them to be fired at selected intervals, but he switched to gelatin dry plates, which were easier to use. His models were photographed against a black background, which was divided by white threads into a grid of squares that provided a conceptual Renaissance device so that the images could be more effortlessly analyzed and drawn. He used a variety of camera arrangements, typically in groups of twelve, to make

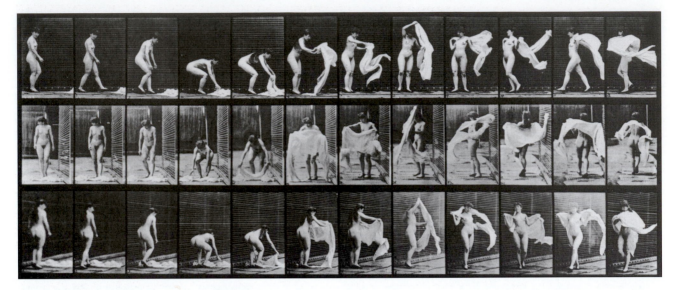

**8.3**   EADWEARD J. MUYBRIDGE.   *Toilet; Stooping, Throwing Wrap Around Shoulders* (Miss Louise, July 23, 1885). 6⅞ × 16½ inches. Collotype.   Courtesy George Eastman House.

his images. The first group of cameras was stationed parallel to the subject and the other two groups were set up at angles of sixty and ninety degrees. By the end of the summer of 1885, Muybridge had adopted a single camera with a row of twelve shooting lenses and a thirteenth for viewing; this multilens apparatus substituted for an entire battery of camera, allowing all the images to be made on a single plate.

Muybridge wanted to formulate a visual dictionary of human and animal locomotion for artists. As an artist, not a scientist, Muybridge was concerned with *how* subjects in motion looked. He took single images and arranged (collaged) them to form an assemblage that was rephotographed and printed to produce the illusion of movement. His sequencing techniques used persistence of vision to encourage the belief that the action was continuous when it was not. Muybridge chose artistic pictorial effect over a scientifically accurate and complete recording of movement, and to that end even altered the numbering system of his negatives to construct a sequence whose individual elements came from different sessions.[5] Taking fragments and individual images, he built elaborate narrative sequences in which tiny stories unfolded. While his constructions may not be verifiably scientific for the analysis of locomotion, Muybridge's cinematic montages impacted artists interested in redefining the vocabulary of motion that lay beyond the visual threshold.

Muybridge's work can also be examined for its gender commentary. In his photographs men perform bricklaying and carpentry while women do the sweeping and washing. Under a pseudoscientific guise, Muybridge made visible what was hidden by social convention—a masculine, voyeuristic, erotic fantasy. Muybridge made

more plates of nude women than of any other subject, covering a variety of sexual proclivities. His short action sequences of women kissing, disrobing, pouring water into and over each other, and smoking in the nude, as well as naked men pole vaulting, wrestling, throwing a discus, and batting a baseball invite viewers to join in these provocative constructions.

Muybridge used the authority of the camera to convince viewers that what they were seeing was accurate, even when it did not conform to anything they had ever seen. Each image frame enclosed a slice of time and space in which formerly invisible aspects of motion were contained. This new reality disturbed the thinking of artists who relied on "being true to nature" as their guiding force. It made clear that what was true could not always be seen and that what could be seen was not always true. Muybridge demonstrated that for many artists *truth* was just another word for conformity. Some artists adjusted their work to bring it in line with Muybridge's results, but others saw their interests collide with the alleged veracity of the photograph. The sculptor Auguste Rodin said:

> It is the artist who is truthful and it is photography which lies, for in reality time does not stop, and if the artist succeeds in producing the impression of a movement which takes several moments for accomplishment, his work is certainly less conventional than the scientific image, where time is abruptly suspended.[6]

Unlike Muybridge, **Étienne-Jules Marey** (1830–1904) was a scientist who wanted to make an unseen world visible in an objective manner. A physiologist grounded in the tenets of positivism, which sought knowledge by describing a phenomenon, he wanted hard, measurable facts to analyze animal and human movement. In the late 1850s, Marey built mechanical and pneumatic devices that were directly attached to his subject; they activated a pen resting on a band of moving paper, which recorded the unobservable move-

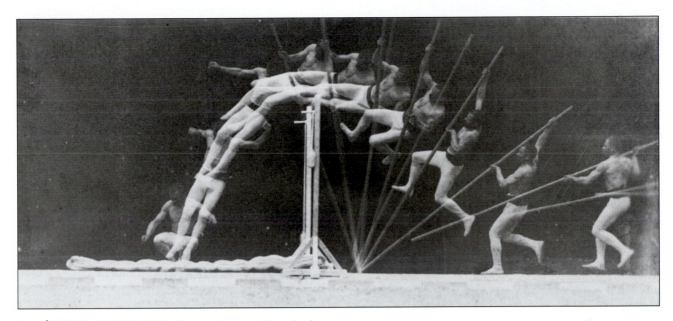

8.4  ÉTIENNE-JULES MAREY.  *Chronophotographic study of Man Pole Vaulting.* 1890–1891. 2¾ × 4³/₁₆ inches. Albumen silver print. Marey's picturing of the "all at oneness" of time, its flow as a progression of events, broke with the traditional Renaissance representation of a still, solidified moment. His work was indicative of how art and science were combining to change the way people saw the world.  Courtesy George Eastman House.

ments that make up human locomotion. In contrast to Muybridge, Marey's interest in animal and human locomotion was how it *worked* rather than how it *looked*. His search for a technique that would simultaneously display the relationship of all the body's moving parts in time and space led Marey to photography. The quest was to picture a body's "all at oneness"—to picture time as a progression of events in which patterns blend and circulate together and can be simultaneously observed. This thinking was a break with the Renaissance representation of the still frame. It indicated a rupture in the Western perception of time, formed in the fourteenth century with the introduction of clocks that gave a consistent, universal, two-dimensional representation to the previously invisible. Marey was curious about subjective, individual time that flowed at irregular intervals and could not be measured to the uniform rhythm of a clock. He wanted to portray the formation of the new modern instant of "now" in which "moments" were realized as a collection of events that needed to be comprehended all at once. This evolving notion of simultaneous time formed what is now known as *stream of consciousness* and helped to steer a new course in Western art and science in the twentieth century.

Marey's interest in locomotion led him to invent graph methods of recording skeletal and muscle movements. To that end, he designed the fusil photographique

(the photographic gun), a camera with a rotating plate capable of taking a rapid sequence of separate images, to provide an accurate, schematic diagram of muscular movement. Concluding that he would get more factual information if the sequential movements appeared on the same plate, Marey made systematic, multiple exposures on a single plate, *chronophotographs*, using a rotating slit shutter. To eliminate unwanted details, Marey had his models dress in black, with bright metal bands attached to the sides of their arms and legs, and move in front of a black backdrop, thus producing a white, linear graph of geometric movement.

Marey also devised a method to accurately photograph the free flight of birds, which would be of interest to early aviators such as the Wright Brothers. Although he never made moving pictures, Marey's method of recording a subject with one camera from a single vantage point was precinematic in concept, and he created a film projector (1892) to analyze his motion studies. In essence Marey reinvented the camera, taking it from a machine of a single moment to one of a flow of moments. This new way of making pictures re-educated the eye, expanded the visual syntax, and revolutionized the representation of the passage of time. Marey's descriptions of human locomotion were applied to physical training programs. His techniques were used to recast how people performed industrial work on assembly lines. His cinema camera would become a cornerstone of the motion picture industry. Artists studied Marey's and Muybridge's images to represent humans and animals in motion, and their works were echoed by the avant-garde.[7] Unfortunately for Marey, he was unable to commercially develop his research and his accomplishments were not widely recognized.

Marey's overlapping images offer an industrialized sense of motion, speed, and time. His images visually link the concepts put forth by Charles Lyell in

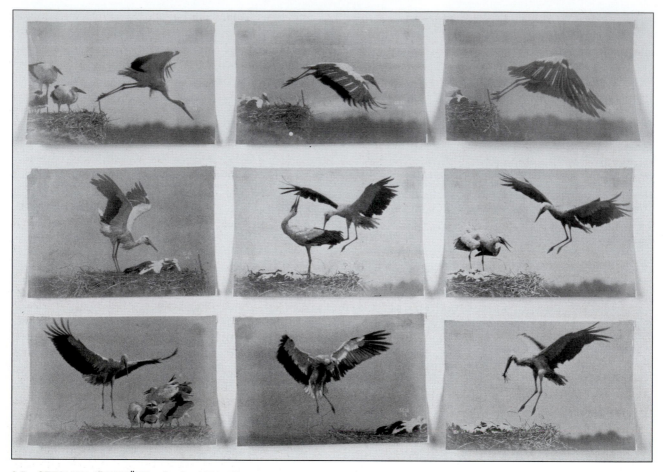

8.5  OTTOMAR ANSCHÜTZ.  *Storks,* 1884. 3¾ × 5½ inches.
Albumen silver prints.    © Rheinisches Bildarchiv. Museum Ludwig/Agfa
Foto-Historama Koln.

*Principles of Geology* (1830) and Charles Darwin in *On the Origin of Species* (1859) that the earth is not a static environment, governed by a biblical clock, but a continuum of time. Marey also influenced the French philosopher Henri Bergson (1859–1941), whose *Matter and Memory* (1896) argued that time is not made up of individual, measurable pieces but is a continuous and indivisible movement. In place of static values Bergson substituted those of change and motion ("I am a thing which continues"). Bergson's thinking was popular among artists of the early twentieth century and affected writers such as Marcel Proust (*Remembrance of Things Past,* 1913–1927) and James Joyce (*Ulysses,* 1914–1921). Paradoxically, Marey's analytical chronographs were eventually used by others to undermine positivism and launch new methods of seeing and thinking about time and space. Initially, however, the repetitious rhythms and compressed space of Marey's chronophotography can be seen in works such as Georges Seurat's (1859–1891) last study for *Chahut* (1889) and later in the overlays of Edgar Degas's (1834–1917) *Frieze of Dancers* (ca. 1895). The displacement of static time into an endless flow of movement altered the artist's rendition of time and space in such depictions as Marcel Duchamp's *Nude Descending a Staircase* (1912). Its role in the development of futurism can be seen in Giacomo Balla's *Dynamism of a Dog on a Leash* (1912).

In 1882, the German photographer **Ottomar Anschütz's** (1846–1907) animal-motion studies led him to develop a folding hand camera with a *focal-plane shutter,*[8] considered the prototype of the folding bellows, flatbed-type press camera, which allowed exposures to be made at 1/1000 of a second. His pictures of nesting storks, featuring detailed images of the birds in flight, amazed the photographic and scientific communities in 1884. Starting in 1886, Anschütz improved Muybridge's multiple camera system to allow faster sequential human and animal locomotion studies. His *tachyscope,* a modified zoetrope with a vertical rotating drum instead of a horizontal one, allowed these studies to be seen in motion. Anschütz's *electrotachyscope,* in which transparencies were placed on a revolving disk and illuminated from behind by an electric spark, let a few people view the image at one time (the images were not projected). Following the lead of Ernst Mach, Anschütz also made electric spark photographs of projectiles in flight at the Krupps weapons plant.

# Transforming Aesthetics: Technical Breakthroughs

Although the wet-plate process was universally adopted, it was difficult and cumbersome. The first collodion dry plates were formulated by French scientist J. M. Taupenot and produced in limited quantity in England in 1860. They were more manageable, but required exposure times six times longer than wet collodion, making them useful only for static subjects. In 1864, B. J. Sayce (1837–1895) and William Blanchard Bolton (1848–1899) improved the speed with *collodio-bromide* dry plates that needed only three times the exposure of a wet plate. A major breakthrough was made by physician and amateur photographer Richard Leach Maddox (1816–1902), who substituted gelatin for collodion. This greatly simplified the picturemaking process, permitting plates to be sensitized in advance and developed at a later time, thereby encouraging photographers to make pictures that were less conventional in their content and construction. The dry plate disposed of all the equipment and procedures needed to prepare a wet plate and eliminated the dangerous and odorous alcohol and ether fumes associated with the process—fumes that aggravated chronic health conditions in practitioners like Maddox. Maddox published his finding in the *British Journal of Photography*.[9] Stating that his medical practice did not allow him time to refine his work, he urged others to further the effort.

Improvements in Maddox's method led to the manufacturing of the first practical dry plates in 1878, in which a glass plate was coated with a silver bromide emulsion that had been prepared with a special gelatin binder. These plates were less contrasty and about ten times as sensitive as the wet plates they were supplanting. Initially, their increased sensitivity was a problem for photographers accustomed to the wet plate, they overexposed the new gelatin plates and then complained about their poor quality. During the 1880s, the glass was replaced with celluloid. The dry plates freed photographers from having to be their own platemakers, allowing fieldwork without a portable darkroom. Dry plates remained sensitive for months and did not have to be processed immediately. Ripening increased the emulsion's sensitivity, permitting daylight exposure times of a fraction of a second. These breakthroughs opened stop-action images to all photographers, allowing subjects to be represented in ways that were previously not possible, astounding and changing people's perceptions of their world. Edward L. Wilson, editor of *The Philadelphia Photographer*, took gelatin dry plates on a 22,000-mile voyage and developed them upon his return, eight months later. He proclaimed: "It has been the salvation of photography. . . . Blessed then be the dry plate!"[10] The gelatin emulsion changed photographic practice, encouraging photographers to make their lives easier by accepting the commercial standardization of materials, equipment, and processes. Visually, the gelatin emulsion advanced the investigation of motion by providing material access to more practitioners. Scientifically, it encouraged research that extended the emulsion's sensitivity into the green, yellow, orange, and red bands of the spectrum.

Early photographic materials were sensitive only to the blue-violet and ultraviolet portions of the spectrum. In 1873, German photochemist Hermann Wilhelm Vogel (1834–1898) discovered that the addition of certain dyes to an emulsion made it sensitive to the spectral region that was absorbed by the dye, opening up the field of dye sensitization of emulsions. Preoccupation with the introduction of the gelatin process prevented Vogel's discovery from being actively pursued. However, in 1884 Vogel, along with Johann Obernetter, formulated the first truly commercial orthochromatic (sensitive to all parts of the visible spectrum except red) gelatin silver dry plate (a gelatin binder that contained the light-sensitive silver emulsion). Although it suffered from fog (unwanted density not produced by camera exposure) and loss of sensitivity, pictorially it provided a more accurate black-and-white tonal translation of a subject than the wet plate, delivering a wider range of gray print tones. As the first professor of photography at the Institute of Technology in Berlin, Vogel published an important textbook, the *Handbook of Photography* (1867); his students developed the first *panchromatic* emulsions (sensitive to all wavelengths in the visible spectrum) and, with them, color photography (see this chapter's section on color).

Meanwhile, British scientists and amateur photographers Vero Charles Driffield (1848–1915) and Ferdinand Hurter (1844–1898) found it "intolerable to practice an art whose principles were so little understood."[11] They devised scientific methods to study and measure development, exposure, and sensitivity to light, leading to the formation of *sensitometry*—the process of determining the response of photographic materials to light and processing. Driffield and Hurter asserted that: "The production of a perfect picture by means of photography is an art; the production of a technically perfect negative is a science."[12] Their discoveries permitted photographers to make exposures and process film based on scientific study instead of experience and luck. The scientists showed that an emulsion could be developed for a predetermined amount of time at an exact temperature to obtain specific levels of tonal contrast instead of by visual inspection under a safelight. Emulsions processed in total darkness could be made sensitive to all parts of the spectrum and safely developed without safelight fog. Increases in emulsion speed and expanded spectrum range, on the other hand,

necessitated developing a precision shutter mechanism to control discrete segments of time, the most common being the *between-the-lens shutter,* placed between the lens's elements.

Refinements in lens design, such as *anastigmat* lenses (1886), solved basic lens aberrations, especially that of *astigmatism,* which causes an object being imaged to blur around the edges. Previously, photographers had to stop-down their lens to small apertures to avoid this problem and be content with a narrow field of sharpness (about twenty-five degrees). The widespread use of anastigmat lenses at the beginning of the twentieth century improved overall image sharpness, provided larger (faster) useful working apertures for low light and action situations, and let photographers show more of a scene by sharply covering a wider field of view (70 degrees).

By the 1890s new printing materials were impacting how the image was made and seen. *Gaslight paper*[13] allowed photographers to make prints without the sunlight usually required to expose printing-out papers. It also freed the photographer from using an expensive, ventilated gas safelight with the new and much faster bromide papers. These papers caused the albumen papers to become extinct by the start of the new century; they were obsolete themselves by 1920, except for making portrait proofs.

## The Hand-Held Camera and the Snapshot

Until the late 1880s, the expense, difficulty, and physical size of the equipment kept most people from making their own photographs. Technical advances during the late nineteenth century enabled designers to make the camera a hand-held instrument, freeing it from the tripod. The market responded with cheap, mass-produced, simple-to-use cameras with names like Compact, Hawk-Eye, and Instantograph, emphasizing their size and concepts of vision and speed. Some used a *magazine,* a rigid, lighttight, often reloadable container for holding up to a dozen plates, enabling quick, stealth-like exposures, earning these machines the nickname of "detective cameras."

One camera is mythically associated with amateur photography—the *Kodak.* Coined by George Eastman (1854–1932), a former bank employee from Rochester, NY, the Kodak name began as a camera model but quickly became a brand and company name that dominated the amateur market. Introduced in 1888, the first Kodak was a simple 3¾ x 3¼ x 6½-inch box camera, weighing about 25 ounces, including film. It had a 57mm f/9, fixed-focus lens and a barrel shutter that could make 100 circular images, 2½ inches in diameter (see Figure 8.6). For $25 (a tidy sum at the time), a Kodak came factory loaded with paper-backed "Eastman's American Film," ready for a user to point, shoot, advance film, and shoot again. Ninety-nine more exposures later, the roll was completed and the camera ready to ship back to the Eastman factory for processing and printing, thus making what soon would be known as Eastman Kodak Co. the first nationwide photofinishing concern. Contact prints were made from each negative and mounted on gilt-edged, chocolate-brown cards, then returned with the camera; for another $10, the camera was reloaded with film. In 1889, the new "Eastman's Transparent Film" allowed the photographer to do the processing, though most still left the messy task to the manufacturer. In 1891, daylight loading film allowed the camera to be loaded without a darkroom.

Eastman's conceptual breakthrough was to divorce the photographic act of exposure (seeing) from the mechanical details and chemical steps of the process. His strategy and populist slogan, "You press the button, we do the rest," enabled Eastman to market the Kodak and its successors to the many people who had never taken a photograph or owned a camera, redrawing the boundaries of photographic practice by providing an industrial support system capable of producing standardized materials to maintain it. The Kodak's simplicity transformed a decentralized practice into a mass retail market of goods and services, and contradicted the proclamations of artists and scientists that special equipment and training were needed. It enabled a broader cross-section of the population to become part of the process, making images of their own choosing whenever they wished, bringing the act of photography to everyday middle-class life. The Kodak initiated a new dialogue between viewer and subject, continuing photography's ability to level hierarchy, and creating a sense of visual democracy. Eastman referred to the Kodak as:

> A photographic notebook. Photography is thus brought within the reach of every human being who desires to preserve a record of what he sees. Such a photographic notebook is an enduring record of many things seen only once in a lifetime and enables the fortunate possessor to go back by the light of his own fireside to scenes which would otherwise fade from memory and be lost.[14]

Images made with a hand-held camera became known as "snapshots," adopted from the hunting term meaning to shoot instinctively without taking aim. The snapshot is based on vernacular (colloquial) attitudes rather than the trained sensibilities of Western European art. Since the typical hand-held camera user was unschooled in picturemaking strategies and the proper use of equipment and materials, the classical aesthetic criteria of content, form, and technique did not apply. The attitude of the snapshooter was direct, spontaneous, and matter-of-fact, casually exploring the pleasures of everyday life rather than the subject of photography. Typically, the hand-held

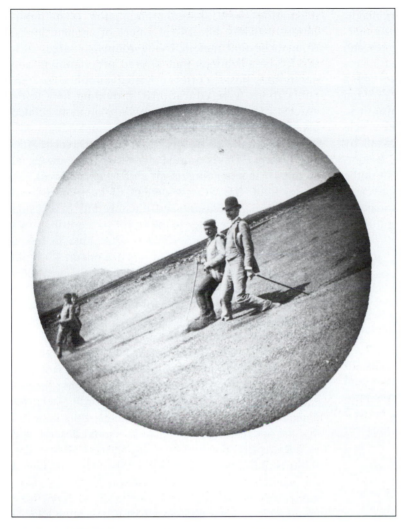

8.6 R. K. ALBRIGHT. *Descending Vesuvius,* ca. 1890. 2⅞-inch diameter (Kodak #1 snapshot). Albumen silver print. Courtesy George Eastman House.

camera acted as a democratic collector of memories, and the combination of the snapshot and its accompanying album functioned as a visual diary of the familiar. The snapshooter's interest was almost exclusively personal and the values presented were life-affirming. This uninhibited and unpretentious outlook had a deceptively simple sensory freshness capable of changing the attitude of an observer toward a subject.

The snapshot genre was not the invention of an individual but an extended collaborative process of exploring the prosaic that relied on idiomatic consensus to establish meaning. The will of the individual was set aside in favor of community consent, with a partiality for familiar moments positioned in the center of the frame with little thought to what was occurring in the rest of the scene. The snapshot's proliferation meant professionals were no longer needed to make basic record pictures, forcing them to become proficient in highly specialized applications, such as *gum printing,* in which the image-

receiving paper was brushed with a pigmented solution of gum bichromate emulsion, that were beyond the scope of hobbyists. The small negatives produced by hand-held cameras renewed interest in making prints that were larger than the original negative, encouraging enlarging and its accompanying aesthetics, like post-camera cropping, to become universal practice.

The snapshot personified a natural desire to recreate what we think we believe, know, or have seen. The circular image of the early Kodak was revised into a rectangle to conform with the standards of how a picture was supposed to look. But the snapshot led a dualistic existence. The ease and relative low cost of producing a snapshot encouraged people to take chances just to see what would "come out." The sheer number of photographs being taken increased the impact of chance, leading George Bernard Shaw to say: "The photographer is like the cod which produces a million eggs in order that one may reach maturity."[15] Through its million incarnations, the snapshot altered the visual arts. While meeting certain pictorial expectations, the snapshot invited the unexpected. This element of surprise could reveal a subject without adornment, covering another or a different kind of truth. The snapshot attitude became provocative when gaffes, previously eliminated by professionals, were adopted as working methods by serious imagemakers of other mediums like painting. What were initially accidents, such as informal framing, unexpected cropping, unbalanced compositions, skewed horizon lines, unusual angles, weird perspectives, banal subject matter, extremes in lighting, out-of-focus subjects, blurring, double exposures, extended time exposures, and poor quality optics, grew into conscious design. These ideas and ways of seeing transformed pictorial convention, influencing modern art movements, including surrealism and dadaism, that set themselves in opposition to the ideals of the classical, empirical scientific models of thinking.

The explosion of snapshooters changed the societal relationship between photographers and their subjects. Before the hand-held camera, the act of making a photograph required the cooperation of both parties. Now the hand-held camera made it possible to surreptitiously photograph without a subject's consent. Not only hunting terminology but also hunting strategies were incorporated into how people used the miniature camera, including stealthily stalking and shooting a subject before it could protect itself. The number of amateurs "kodaking" everything everywhere were considered a

social annoyance and were ridiculed as camera fiends. The expansion of subject matter by the snapshooters collided with society's restrictions about decency and good taste. Without a subject's consent, photographers faced an ethical dilemma of whether or not to take a picture. On August 20, 1884, *The New York Times* ran a story about "The Camera Epidemic," equating it to cholera and labeling it a "national scourge." The article related how healthy people were being harassed by those who had contracted the camera disease. It complained no one could walk down the street or sit in the woods with a young lady without a dozen or more cameras trained on them by "camera lunatics." As amateurs became bolder the public became more resentful, as this response indicates:

> There is but one remedy for the amateur photographer. Put a brick through his camera whenever you suspect he has taken you unawares. And if there is any doubt, give the benefit to the brick, not the camera. The rights of private property, personal liberty, and personal security—birthrights, all of them, of American citizens—are distinctly inconsistent with the unlicensed use of the instantaneous process.[16]

The situation got so bad that there were calls for laws against public photography in America and Europe (none were passed). Camera magazines published proposed rules for snapshooting in public. *Punch* lampooned the topic with its own "Regulations for Camera-Fiends" which included:

> 8. Biograph [motion picture] operators who attack a large assemblage of persons with a wide-angle lens in broad daylight shall be liable to three years' imprisonment in a dark room.

Although hand-held cameras were still too expensive to be used universally, they expanded the ranks of the snapshooters that made up half of the middle-class population—women—who were no less enthusiastic than the men.[17] At one point, during a trip to America, Prince George of Greece was "pursued by 150 ladies who persisted in photographing him, despite his protests."[18]

The clandestine use of hand-held cameras made the ethics of street photography a controversial matter. How could the subject's rights of personal privacy be reconciled with the photographer's freedom of expression and the public's right to know? *The Amateur Photographer* sarcastically observed that "Our moral character dwindles as our instruments get smaller."[19] The snapshot, by breaking aesthetic and societal rules, altered how we see and what we are allowed to picture.

Camera clubs and their publications grew to meet amateur photographers' demands for guidance and exhibition opportunities. Big societies, such as *The Camera Club of New York* and *The Camera Club* in London, had "advanced" members whose ideas and work would come to influence the entire practice of photography (see Chapter 9). In turn-of-the-century America, a dozen club magazines, with photographic

illustrations, were in regular circulation. Many publications acted as the official voices of amateur clubs, from those that met in living rooms to large, full-service organizations that offered programming and darkrooms. Besides offering visual stimulus, the club publications were educational, providing how-to-do articles, exhibition reviews, roundups of photo-related happenings, product advertisements, and advice columns with tips like the one from C. W. Davis of Athens, Georgia. Davis trained a canary to sing on signal so that "The sitter forgets all about the head-rest, the trying light, the wearisomeness of keeping a fixed position. . . . A pleasant and unconscious expression on the face of the sitter is the result of the little bird's melody."[20] Soon photographers were able to buy a mechanical bird that chirped when a pneumatic bulb was squeezed—and "watch the birdie" became a command at portrait sessions.

Writers and artists who had no intention of becoming professional photographers were infatuated with the snapshot and used the camera as an adjunct to their other aesthetic activities. **Émile Zola** (1840–1902), author of highly detailed novels about French society, took up photography late in his career. As the leading literary exemplar of *naturalism,* a style based on the accurate depiction of people, places, and things, Zola believed that the novelist, like the scientist, should observe and record dispassionately. Given his interest in everyday subjects, the camera seemed to be the ideal instrument for accurate depiction. Zola remarked: "In my opinion, you cannot say you have thoroughly seen anything until you have got a photograph of it, revealing a lot of points which otherwise would be unnoticed, and which in most cases could not be distinguished."[21] Zola made observant snapshots of family, friends, and architectural subjects (see Figure 8.7). This style of photography can be seen as a response to Baudelaire's plea for art (although he was antagonistic towards photography as an art) that would take the "heroism of modern life" as its subject.

## Time and Motion as an Extended Continuum

Until the 1880s, most people considered photography to consist of single images that depicted and made a subject known to the viewer. The work of Muybridge, Marey, and others opened the possibility of learning more about a subject through a series of photographs that occurred over time. These new ways of conceptualizing time and motion shifted society's understanding of the present moment as a singular instant to that of a temporally extended continuum. This profound transformation in understanding and experiencing time encouraged photographers like Nadar to experiment in the portrait studio

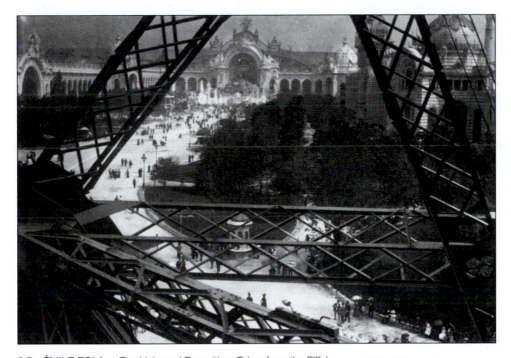

8.7 ÉMILE ZOLA. *The Universal Exposition, Taken from the Eiffel Tower, Paris,* 1900. Zola's image, taken from an unusual vantage point, foreshadows the concerns of photographers in the 1910s and 1920s who would more fully investigate the enigmatic spatial arrangements of the new machine age. © The Museum Association of Émile Zola, Medan France.

What I have to purpose may appear a dream, . . . by snapshot . . . the representation of scenes in action—the vivid and lifelike reproduction and handing down to the latest posterity of any transaction in real life . . . where any matter of interest is enacted within a reasonably short time, which may be seen from a single point of view.[23]

with extending the amount of visual time a viewer had to know a subject by presenting an extended collection of moments. In 1886 Nadar published a photo-interview, *The Art of Living a Hundred Years,* based on a series of twenty-one exposures made by his son **Paul Nadar** (1856–1939) as Nadar conversed with the French scientist Michel-Eugène Chevreul on his 100th birthday (see Figure 8.8). Chevreul's commentary formed the captions to the photographs, which could be reproduced via the new halftone process that allowed photographs and text to be simultaneously printed together. The serial use of sequential photographs combined with an interview resulted in the first photo essay.

Alexander Black (1859–1940) used the halftone process in conjunction with the concept of the *tableau vivant* (living picture, a representation of a scene by suitably costumed and posed people) to reproduce a sequence of still images to illustrate his short story, "Miss Jerry," for *Scribner's Magazine* in 1895. Black wanted the tableaux vivants to act progressively, so that the illusion of reality would be created not by suspending action in isolated pictures but by visually fusing many images together.[22] Sir John Herschel had anticipated these events in 1860 when he discussed the possibility of taking a series of *snapshots* and showing them in a *phenakistoscope,* an apparatus comparable to a zoetrope used to present animated drawings:

## Moving Pictures

By the 1890s, a cluster of autonomous inventors was simultaneously bringing Herschel's vision to fruition. The first continuous-film motion picture viewing machine to gain public acceptance was developed and marketed by Thomas Alva Edison (1847–1931). The *Kinetoscope* was designed for Edison by William Kennedy Laurie Dickson. It was a 1½-minute peepshow. An individual peered through an eyepiece at a continuous, 50-foot loop of 35mm positive film, permanently threaded through rollers. As the crank was turned, the film moved past an electric light bulb and a whirling slotted disk (an intermittent shutter) that interrupted the light as each frame changed at the rate of 46 frames per second. To make certain the film moved at a constant rate without slipping, Dickson perforated the edges of the film so it could be driven by toothed sprocket wheels with the same design as the Kinetoscope. Edison contracted George Eastman to make this film, establishing the 35mm format as the *motion picture* standard. Little thought was given to subject matter. The first Kinetoscope Parlor, with ten machines, opened in New York in April 1894, and featured snapshots in motion. In June machines were shipped to San Francisco, and by September they were in London and Paris.

The problem with the Kinetoscope was that its small image size allowed only one person at a time to view its pictures. Using the magic lantern shows as a model,

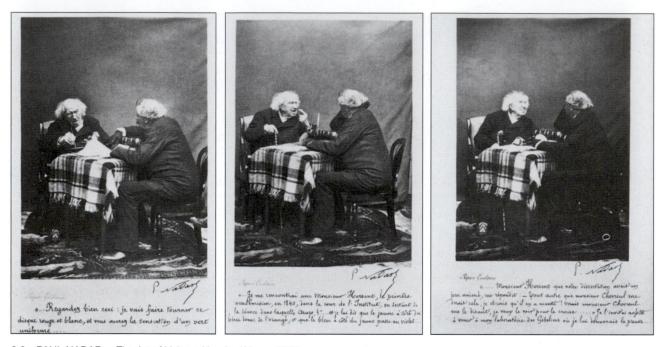

**8.8  PAUL NADAR.** *The Art of Living a Hundred Years,* 1886. Each image is 5¾ × 4 inches. Photogravures.   Courtesy George Eastman House.

numerous inventors set about to design a machine that would enlarge the image onto a screen. The breakthrough occurred on December 28, 1895, when Auguste (1862–1954) and Louis (1864–1948) Lumière projected very short films of vernacular subject matter (such as a train coming into a station) to a Parisian audience by means of the *Cinématographe.* The Cinématographe projector, constructed by Jules Carpentier, used a clawlike device to pull the perforated 35mm celluloid film at the required intermittent speed. Similar devices were invented almost simultaneously by William Friese-Greene and Birt Acres in England and by Charles Francis Jenkins and Dickson, Edison's designer, in America. Edison and the Lumière family were able to link science and business to make cinema commercially viable. Through the corporate research laboratories of Edison's Kinetoscope and the Lumière's Cinématographe, teams of people, rather than a solitary inventor, marketed their inventions through mass-production and distribution. By the close of 1896, moving pictures were being projected regularly throughout Europe and America (see Figure 8.9).

These simple moving snapshots rapidly evolved a new visual vocabulary based on juxtaposing nonsuccessive events, altering the Renaissance tradition of using a continuous, single point of view to represent time and space. The editing methods that developed in early films, such as *The Great Train Robbery* (1903), proved people could conceptually leap through time and space, and link together discontinuous events. Grounded in scientific thought and industrial technology, moving pictures became a reality.

## Color and Photography

Since photography's inception, people complained about its lack of color. In 1840, Sir John Herschel reported recording, but not fixing, blue, green, and red on silver chloride-coated paper, suggesting that color photographs could be made directly from the action of light on a chemically sensitive surface. Other experimenters, including Edmond Becquerel in the late 1840s and early 1850s and Niépce de Saint-Victor in the 1850s and 1860s, recorded colors directly on daguerreotypes, but they were unable to make them permanent. In early 1851 **Levi L. Hill** (1816–1865), a Baptist minister from Westkill, New York, announced a secret, permanent, direct color process. When Hill's *A Treatise on Heliochromy* was finally published in 1856, it did not contain any workable instructions for his process and was dismissed as a hoax (see Figure 8.10). However, recent findings show that Hill did discover a method to photographically capture several natural colors. Conversely they also confirm he was a bit of a charlatan in "that Hill began adding additional pigments to his color plates by hand, doctoring them to look more multi-hued than the originals."[24]

Hill was not alone in the quest to make color photographs. The most popular solution was to hand-color a photograph. Artists who once made their living painting miniature portraits soon applied their skills to brush colored pigments mixed with gum arabic onto the surface of daguerreotypes. The coloring could be made permanent by the heat given off as the colorist breathed on its mirror-like surface.[25] Many women found employment as colorists in addition to being assistants and receptionists in daguerrean studios.[26]

The first true color photograph was made in 1861 under the direction of James Clerk Maxwell (1831–

color image (not a photograph) of the multicolored ribbon.

Projected additive color photography was also the basis for what was the most successful color process prior to the invention of the autochrome (see below). Developed in 1888 by the American inventor Frederic Eugene Ives (1856–1937), the Photochromoscope was a single-plate camera that exposed three separate black-and-white negatives on a single glass plate through blue-violet, green, and red filters. As with the earlier Maxwell experiment, glass positives were made from these negatives and then placed and viewed through a device called a Chromoscope viewer. The viewer had the identical color filters as the camera in addition to three mirrors which superimposed the three positives creating the illusion of a full color projected image. Ives marketed his viewer under the name Kromskop and the images under the name Kromograms.[27]

Russian photographer Sergei Mikhailovich Prokudin-Gorskii (or Gorsky) (1863–1944) used a similar method, which was based upon the system developed by the German scientist and photographer Professor Adolf Miethe (1862–1927). Gorskii's images of Tsarist Russia remain as vibrant as when they were made, since there are no color dyes in the original black-and-white negatives to fade over time.[28]

Despite the claims made by Ives to have invented the Photochromoscope, the theoretical underpinnings of that method and nearly every other color photography process until the advent of Kodachrome in 1935 can be traced to French scientist Louis Ducos du Hauron (1837–1920). In *Les Couleurs en Photographie: Solution du probleme* (*Color in Photography: the solution to the problem,* 1869), he proposed that the additive theory could be used to make color photographs more simply. He speculated that a screen ruled with fine lines in the primary colors of red, yellow, and blue would act as a filter, producing a color photograph with a single exposure instead of the three Maxwell required.

In 1894 John Joly, a Dublin physicist, patented the first line-screen process for additive color photographs, but it was not commercially practical. A major breakthrough in the making of additive screen color photographs was patented in 1904 by Auguste and Louis Lumière (aka Lumière frères), with manufacture beginning in 1907. In their *Autochrome* system, a glass plate was dusted with microscopic grains of potato starch that had been dyed with red-orange, green, and blue-violet. A fine powder of carbon black was used to

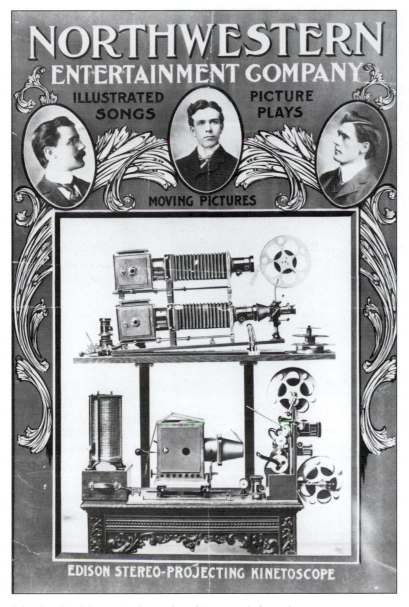

8.9 An advertising poster for moving pictures made for and viewed with Edison's stereo-projecting Kinetoscope that allowed the images to be seen by a group of people on a screen, 1902.

1879), a Scottish scientist, based on the *additive color theory* developed by Thomas Young and refined by Hermann von Helmholtz. The theory held that all colors of light can be mixed optically by combining different proportions of the three primary colors of the spectrum: red, green, and blue. Photographer Thomas Sutton made three black-and-white negatives of a tartan plaid ribbon through separate blue-violet, green, and red filters. Maxwell then projected the black-and-white positives made from these negatives through three magic lantern projectors fitted with the corresponding blue violet, green, and red filters used to make the original negatives. When all three positives were simultaneously projected and aligned, the result was a projected

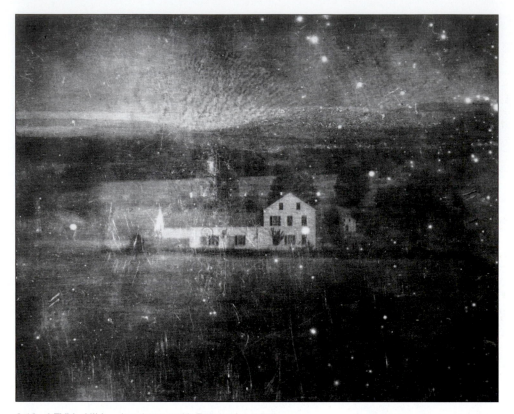

**8.10   LEVI L. HILL.** *Landscape with Farmhouse,* 1851. Hillotype. Until his death in 1865, Hill maintained that he had made color photographs, though he confessed to having done so accidentally. He revealed that he had spent the last fifteen years of his life attempting to repeat the accidental combination without success. Recently new scientific evidence has suggested that Hill may have indeed stumbled onto a direct color process.[29]   Courtesy Division of Photographic History, National Museum of American History, Smithsonian Institution.

fill in any spaces that would allow unfiltered light to pass through this filter screen, eliminating the need for colored lines to act as filters. A newly developed panchromatic emulsion, which greatly extended the accurate recording of the full visible spectrum, was then applied to the plate. The exposure was made through the back of the plate, with the dyed potato starch acting as tiny filters. The plate was then developed, re-exposed to light, and finally redeveloped to form a positive transparency made up of tiny dots of the primary colors. Autochrome could be used in any regular plate camera, giving serious amateurs and professionals access to color. Autochrome was the first color process to get beyond the novelty stage and become commercially successful. It cracked a major aesthetic barrier and was taken seriously for its picture-making potentialities, enabling professional and amateur photographers to explore the visual possibilities of color. By the end of World War I, magazines like *National Geographic* were using Autochromes to make color reproductions. Autochrome provided the missing layers of believability and realism for the system that would conduct most future forms of public representation.

Autochrome remained the standard until 1935, when Kodak released Kodachrome, the first monopack (three-layer emulsion) subtractive color film. Kodachrome is unique because it contains no dye-forming color couplers to produce a color image; instead, they are added during the development process. In the *subtractive color method* a subject is reproduced in color by superimposing three images, made up from a single exposure, by the subtractive primary colors—magenta, yellow, and cyan. These colors selectively screen out the complementary additive colors—red, blue, and green—that are present in the white light of a photographed scene to form a color image. The subtractive process is the basis for today's most common multilayer color films, which have image-forming dye couplers built into their emulsion.

The Autochrome look was grounded in the romantic tradition of feminine beauty, the exotic, the "primitive," and the otherworldly.[30] Although Autochrome did not render color accurately, its soft, suggestive, pastel representation connected the democratizing influence of the snapshot with a complex and elusive representation impulse of the time: *symbolism*. Symbolism reacted against positivism, industrialization, and secularism, emphasizing interior states, especially dreams. As we will see in the next chapter, symbolism emphasized emotions and sensations and would become part of the modernist groundwork for abstract art.

One process that was neither additive nor subtractive was first presented to the public in 1891 by Gabriel Lippmann (1845–1921). Sometimes referred to as "direct color"[31] or the *interference* method, Lippmann

8.11    FRED PAYNE CLATWORTHY.    *Indian Chief,* ca. 1922.
5 × 7 inches. Autochrome. This image was reproduced
in "Scenic Glories of the Western United States," *National
Geographic Magazine* August, 1929, Volume LVI, Number Two.
The image caption read: "Eagle Feathers Adorn the Headdress
of the Brave. Santa Clara Indians wear striking costumes in
their tribal dances. Each detail in the crown of plumes has its
traditional meaning." A self-taught photographer, Clatworthy
(1875–1953) was known for his Autochromes, black-and-
white, and hand-colored photographs that he promoted in his
Estes Park, CO, studio to visiting tourists. Over one hundred of
his Autochromes appeared in *National Geographic Magazine*
between 1923 and 1934. In addition to his stunning work
documenting the Western United States, Clatworthy traveled
widely, photographing scenic wonders in Mexico, New Zealand,
and Hawaii.    Image courtesy of Collection of Mark Jacobs.

made full-color plates by causing interference between
wavelengths of light (the addition or superposition of
two or more waves that result in a new wave pattern)
without the use of colorants or dyes. The plate resem-
bled a negative in transmitted light but turned into a
brilliant, iridescent positive when viewed by placing
the emulsion against a mirror and shining light into
it at the proper angle. Though Lippman received the
1908 Nobel Prize in Physics for this work, it was not
commercially viable. The emulsion was about 100,000
times slower than that of ordinary film, the process
was extremely complex, and the plates were difficult
to view. Nevertheless, the principles behind the light
interference method eventually lead to the development
of holography.

# Endnotes

1   In the nineteenth century, industrialists began to replace royalty and religious leaders as patrons of the arts, often hiring photographers to document and commemorate their achievements.

2   "A Horse Photographed at Full Speed," reprinted in *Photographic News,* vol. 21, no. 994, September 21, 1877, 455–6.

3   Muybridge's work with Stanford ceased in 1879. In 1882, while Muybridge was in Europe, Stanford published the work as *The Horse in Motion* with a text written by Dr. J. D. B. Stillman. The introduction Muybridge had written was not used, relegating him to the role of a technician and damaging his ability to secure European backing. He initiated a lawsuit for copyright infringement, which he lost in 1885.

4   Eakins's specially built single lens wheel, or disk, camera had a single revolving plate based on the *photographic revolver.* The lens was located inside a large gun barrel behind which were placed two slotted-disk shutters. The first shutter had twelve slots and made a continuous revolution in eighteen seconds. The second shutter had a single slot in an anchored position. A circular daguerreotype plate was installed behind the shutters. A handle activated the clockwork gearing system, producing an exposure every one and a half seconds when the two slots overlapped, or 48 in 72 seconds. By the end of the summer he began using an improved two-plate disk camera.

5   Marta Braun, *Picturing Time: The Work of Étienne-Jules Marey (1830–1904)* (Chicago: The University of Chicago Press, 1992), 238.

6   Aaron Scharf, *Art and Photography* (New York: Viking Penguin, 1986), 226. First published in Great Britain by Allen Lane. The Penguin Press 1968.

7   See Marta Braun, *Picturing Time,* Introduction, xix.

8   The focal-plane shutter consists of one or more opaque springloaded roller blinds closely mounted to the surface of the film inside the camera. When the shutter release is activated, a narrow slit in the curtain moves across the back of the camera, progressively exposing the film. It is used by most single-lens-reflex cameras.

9   Richard Leach Maddox, "An Experiment with Gelatino-Bromide," *British Journal of Photography,* vol. 18, no. 592, September 8, 1871, 422–23.

10   *The Philadelphia Photographer,* vol. 20, no. 237, September 1883, 305–06.

11   Quoted in William Bates Ferguson, *The Photographic Researches of Ferdinand Hurter and Vero C. Driffield* (London: The Royal Photographic Society of Great Britain, 1920), 6.

12   Ibid., 76

13   Gaslight paper is the old name for gelatin silver chloride contact printing paper. Introduced when gaslight was the normal source of artificial illumination, gaslight paper was slow enough to be handled under dim artificial light but sensitive enough to be exposed by brighter artificial light. When making a print, a regular gas jet was set to low during preparation, turned up to full intensity for making the exposure, and turned back down for processing. Initially made popular by amateurs, its convenience made it a professional favorite as well.

14   George Eastman, "The Kodak Manual," manuscript, Richard and Ronay Menschel Library, George Eastman House, Rochester, NY.

15   George Bernard Shaw, "Preface, Photographs by Mr. Alvin Langdon Coburn, 1906", in Bill Jay and Margaret Moore, eds., *Bernard Shaw on Photography,* (Salt Lake City: Gibbs Smith Publisher, 1989), 103.

16   *The Amateur Photographer,* September 25, 1885, 397. Reprinted from an unnamed American periodical.

17   For anthologies see Peter E. Palmquist *Camera Fiends and Kodak Girls I: 50 Selections By and About Women in Photography 1840–1930* and *Camera Fiends and Kodak Girls II: 60 Selections by and About Women in Photography 1855–1965* (New York: Midmarch Arts Press, 1989 and 1995).

18   *The Photographic News,* vol. 35, no. 1717, July 31, 1891, 544.

19   *The Amateur Photographer,* vol. 53, no. 1357, October 4, 1910, 340.

20   *The Photographic News,* "Talk in the Studio," July 18, 1879, 348.

21   *Photo-Miniature,* vol. 2, no. 21 (December 1900), 396.

22   Alexander Black, "Miss Jerry" (a picture-play), *Scribner's,* vol. 18 (1895), 357.

23   Sir J. F. W. Herschel, "Instantaneous Photography," Photographic News, vol. 4, no. 88, May 11, 1860, 13.

24   Press release from The Smithsonian's National Museum of American History (NMAH), the Getty Conservation Institute (GCI), and the Getty Foundation, October 29, 2007. www.getty.edu/news/press/center/hillotypes_release_102307.html.

25   James Newman, *Harmonious Colouring As Applied to Photographs* (London: W. Kent & Co., 1859).

26   Keith F. Davis, *The Origins of American Photography: From Daguerreotype to Dry-Plate, 1839–1885* (Kansas City: The Nelson-Atkins Museum of Art, 2007), 62.

27   Louis Walton Sipley, *A Half Century of Color* (New York: Macmillan, 1951) and Sipley's *Frederic E. Ives: Photo-Graphic-Arts-Inventor* (Philadelphia: The American Museum of Photography, 1956).

28   www.loc.gov/exhibits/empire/gorskii.html.

29   Herbert Keppler, "The Horrible Fate of Levi Hill: Inventor of Color Photography," *Popular Photography,* vol. 58, no. 7 (July 1994), 42–43, 140.

30   See John Wood, *The Art of the Autochrome: The Birth of Color Photography* (Iowa City: University of Iowa Press, 1993), 6–8.

31   Jack H. Coote, *The Illustrated History of Colour Photography,* Surbiton, Surrey: Fountain Press, 1993, 11.

# Suggesting the Subject

## The Evolution of Pictorialism

### Roots of Pictorialism

By the 1880s, public fascination with photographic reality was losing its luster as hordes of snapshooters could now make their own photographs. People were questioning the previously semi-magical position of professional photographers and the level of intelligence, sensitivity, and skill required to make photographs. The photographer's status as a shaman suffered a body blow. The professional portrait business declined as amateurs made more photographs of people. The photography studios needed something to restore their authority and their business.

In response, organizations such as the Photographers' Association of America formed (1880) to "reach out beyond the chemistry, optics, art, and mechanics of our art-science, and take hold of the morals of the craft, [and encourage all in the profession to] respect themselves more, and the public to honor us in a larger degree than they have."[1] Schools, like the Chicago College of Photography (1881), validated a photographer's skills by offering certificate courses in photography.

A graduate would presumably "possess the art, character, and tone" of a knowledgeable professional and thus command "a higher money value. . . for his work."[2]

At the time, artists, disenchanted with claims of the omnipotence of scientific observation and deduction, were searching for ways to express abstract and subjective viewpoints. This also could be good for the photographic profession. If the role of a trained photographer switched from depicting an objective likeness to portraying subjective conditions that reveal an inner state of the subject, then the expressive abilities of the individual photographer took on significance, becoming as important as the subject before the lens. This elevated the stature of the maker of the photograph over the taker of the snapshot, making the name of the photographer a viable commodity, someone who provided the customer with a unique vision.

Throughout the arts, a loss of faith in science and technology was communicated by the banishment of literalness and scientific objectivism. This led to the rise of *symbolism,* a revolt against realism and its minute descriptions of an objective, external reality. The symbolists turned inward to express the shifting, subtle state of the human psyche, using symbols and metaphors to evoke and suggest subjective emotions. Instead of positivism, they allowed spiritualism and the role of dreams to be their guide. Symbolist artists and writers such as Charles Baudelaire, whose subtle poems spoke of the world as a magical "forest of symbols," believed allusion and suggestion, rather than delineation and description, evoked the imagination and raised their work above the mechanics of objective description. As long as photography was thought to be based only on reality, the photograph was expected to be sharp and precise, for this was science; but if the offering of ideas in a photograph had a basis in the arts, then the photograph had the prerogative of being allusive and suggestive.

## Pictorialism and Naturalism

During the 1880s amateurs, influenced by the ideas of Henry Peach Robinson, and technologists, concerned with process, dominated photography, and artistic practice slid into the doldrums. **Peter Henry Emerson** (1856–1936) reacted to the combination printers and the incoming tidal wave of amateur work in March 1886 with a lecture at The Camera Club in London, "Photography, A Pictorial Art,"[3] attacking the self-conscious, painting-derived compositions favored by the chief arbiters of artistic and photographic taste, John Ruskin and H. P. Robinson. Emerson saw photography as an independent medium combining art and science, and the photographer as the one who determines the camera's own intrinsic attributes. Emerson's goal to elevate the status of photographic art was shared by

a movement known as pictorialism, which was founded on his premise that camera images could engage the senses and emotions in a naturalistic manner. Naturalism explains all phenomena through natural forces rather than the supernatural, and looks for causes instead of reasons. When applied to the arts, naturalism asks that the artist, like the scientist, should observe and record dispassionately. According to Emerson's naturalistic theory of photography, enduring art is made directly from nature; the artist's role is to imitate these effects on the eye. Emerson believed photography had shortcomings, but "in capable hands" it could be "a work of Art." Emerson's method was to photograph his subjects within their natural environment, without so-called artificial manipulations, relying on the selection of subject, lighting, framing, and selective focusing to make an artistic camera image.

Emerson followed up his lecture with *Life and Landscape on the Norfolk Broads,* a limited folio edition of forty platinum prints that put his ideas into practice through his portrayal of the amphibious life of the marsh dwellers of East Anglia.[4] The *platinum process* is a contact printing process in which the image is partially printed out with ultraviolet radiation. After exposure the image is chemically developed out to completion.[5] These "straight"—that is, containing no overt post-camera manipulation of the photographic materials—formally composed photographs recorded the customs and manners of Fenland people.

The prints were accompanied by text written by Emerson and the painter T. F. Goodall, his guide and friend. The text described the landscape and documented the disappearing customs of these working rural people, often in their own voice. Made on location, the prints' feeling of immediacy was in unswerving opposition to Robinson's strictures for constructed pictures. Emerson released six more books on the Norfolk Broads, illustrated with *photogravures,* or photo-etchings, a photomechanical process invented by Henry Fox Talbot that became commercially viable around 1880. To make a photogravure, an original negative is etched into a metal plate, inked, and printed in an etching press. Often regarded as a direct photographic printing method, photogravure was popular with many pictorialists in the 1890s and 1900s for its ability to maintain subtle tonal variations and delicate luminosity. It also alleviated the problem of making thousands of platinum prints while delivering a softer and more artistic rendition, proving that photography required the same creative energies and skills as painting.

In *Naturalistic Photography for Students of the Art* (1889), Emerson counseled developing negatives the day they were taken, while the experience was still fresh, and scorned the hand-held camera, enlarging, and retouching in favor of the delicate detail of a contact print made in platinum or photogravure. While

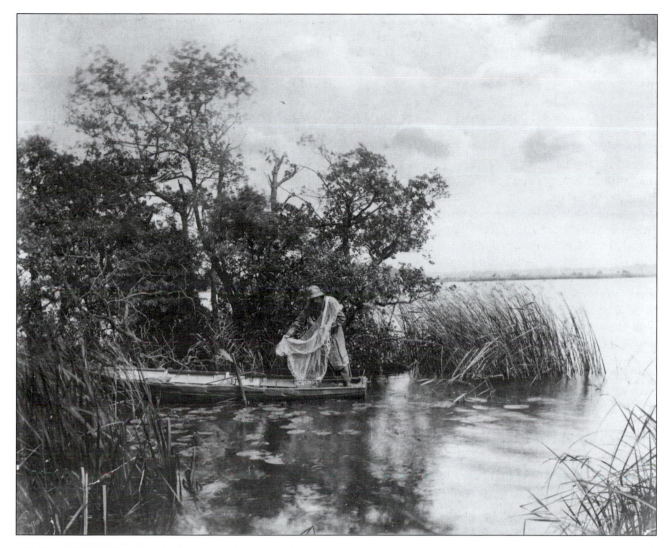

9.1  P. H. EMERSON.  *Throwing the Cast Net. Norfolk Broads,*
ca. 1886. 9⅞ × 11½ inches. Platinum print. To situate his subjects
within their environment, Emerson often made low-angle views that
incorporated the foreground. Visually, he presented the elemental
forces of nature as all-encompassing while simultaneously leading
the viewer to the main figures of the composition.   Courtesy George
Eastman House.

Emerson's choices in printing processes were appreci-
ated, his theory of differential focus, loosely derived
from the numerous optical discoveries made by Her-
mann von Helmholtz about the structure and action of
the eye, caused consternation. Emerson believed that
only the central portion of the human field of vision is
sharp and that the borders are "only roughly sketched
in." Emerson stated:

> Nothing in nature has a hard outline, but everything is seen
> against something else, and its outlines fade gently into that
> something else, often so subtly that you cannot quite distin-
> guish where one ends and the other begins. In this mingled
> decision and indecision, this lost and found, lies all the charm
> and mystery of nature.[6]

To reproduce this effect, Emerson instructed pho-
tographers to make images slightly out of focus, so the
subject would be "just as sharp as the eye sees it and
no sharper," while all other parts of the picture would
be "subdued." These recommendations, which com-
bine bits of science and mysticism, renewed debate
about how to create "art" photographs. Emerson's
working style proved difficult in the hands of the less
sensitive or skilled and his focusing methods, devel-
oped in moist, light-scattering English air, did not take
into account different climates. Emerson's statement,
combined with the continued misinterpretation of Sir
William Newton's "Upon Photography in an Artistic
View . . ." (1853) led many amateurs to confuse out of
focus with "art." Many applied numerous techniques
to manufacture a "look," referred to as "fuzzygraphs,"
without the content.

Emerson engaged in heated editorial battles with
those who disagreed with his ideas until January 1891,
when he suddenly recanted his position in letters to
major photographic magazines, addressed "TO ALL
PHOTOGRAPHERS," requesting forgiveness from his

supporters and from those he had attacked. Emerson said that he had misinterpreted Hurter and Driffield's study of exposure, development, and speed of materials (see Chapter 8) and had therefore failed to understand how tonal values could be manipulated through exposure.[7] This mistake led Emerson to incorrectly conclude that photography could not be controlled by the maker, that photographers could not be artists, and that the medium "must always rank the lowest of all arts."[8] Emerson's retraction was shortly reprinted (probably in February) in a pamphlet, *The Death of Naturalistic Photography*. After this episode, Emerson quit publicly campaigning for photography as an independent art form. However, he continued, until the turn of the century, to make and publish photographs that reflected his belief that photographic art resulted from the direct recording of natural subjects in their surroundings. Emerson's ideas marked the beginnings of a modernist aesthetic philosophy, modeled on human vision instead of the mechanical objectivity of the camera, that would guide photography into a dialogue with modern art movements such as Impressionism, that were also influenced by optical theories.

## The Development of Pictorial Effect

The pictorialist movement thrived between 1889 and the start of World War I by stressing beauty over fact. Optical sharpness and exact replication of subjects were seen as inhibitors of individual expression. The movement broke with Emerson and other purists as many of its practitioners embraced the hand-manipulation of the print as a meaningful aspect of self-expression. The pictorialists asserted that artistic photographs were the equivalent of works in other media and should receive equal treatment by the art establishment.

The 1890s saw the evolution of "pictorial effect" based on the methods of the painters from the *Barbizon School,* such as Jean-François Millet (1814–1875), whose softened brushwork created atmospheric effects. Pictorialists wanted unique images that relied on post-camera techniques, linking their work with the public's expectations of a one-of-a-kind masterpiece. The pictorialists favored processes like carbon, gum-bichromate, platinum, and later *bromoil*[9] that allowed considerable leeway for interpreting the negative. They preferred printing on hand-coated artist paper for its expressive implications and tactile suggestiveness, thus asserting control over their craft during a time of commercial standardization. Their prints convey visual information emotionally due to a strong physical presence based on tonality, texture, and the manipulation of detail.

To counter what they considered to be the anonymous qualities of photography, artistically minded photographers embraced the allegorical and genre traditions of painting. Relying on light and line, these photographers sought to make sensitive and intuitive images that symbolically communicated what could not be stated in words. **George Davison** (1854–1930) advocated photographic impressionism, the renouncing of objectivity and realistic representation, as in Impressionistic painting, in favor of transitory visual impressions. To create a monochromatic image directly from nature, Davison substituted a pinhole for the lens on his camera (see Figure 9.2). Davison's stylistic synthesis of naturalistic subject matter and impressionistic strategies that concentrated on effect rather than the naturalistic truths of the land and its inhabitants influenced others. His ideas induced the Vienna Club der Amateur-Photographen to mount a major exhibition in 1891 of artistic photographs juried by painters and sculptors, thus establishing a model for exhibiting photographs based on their aesthetic qualities that was adopted by salons throughout Europe.

The photographer's ability to suppress unwanted detail, add colors, alter the tonal range, and synthesize negatives showed that photography could be an art, subject to the will and hand of the maker. If the photograph was not limited to presenting reality, then the relationship between the photographer, the subject, and the viewer was up for grabs. By defying expectations, the pictorialists created a breach between photography and science, cleaving artist/photographers from amateurs, professionals, scientists, and technicians. For pictorialists, what was important was not the subject in front of the lens but how the artist controlled images to express ideas. By separating photography from its scientific history, the pictorialists broke the link between the photograph and reality, challenging photography's machinelike authenticity.

Although much of pictorialism never rose above the imitation of graphic art, the movement increased the discussion about the aesthetic character of photography, enhanced awareness of the medium's specific attributes, and encouraged contemplation of photography's relationship to the modern world.

## The Secession Movement and the Rise of Photography Clubs

The early 1890s saw the commercial and scientific values of earlier photographic (and art) societies challenged by supporters of the new aesthetics. The *Secession movement* reflected the disenchantment of younger artists with the practices and exhibition policies of established Western art societies and led to the formation of alternative institutions in Berlin, Munich, and Vienna, among other places. In photography it led to the creation of the Wiener Kamera Klub in 1891, the

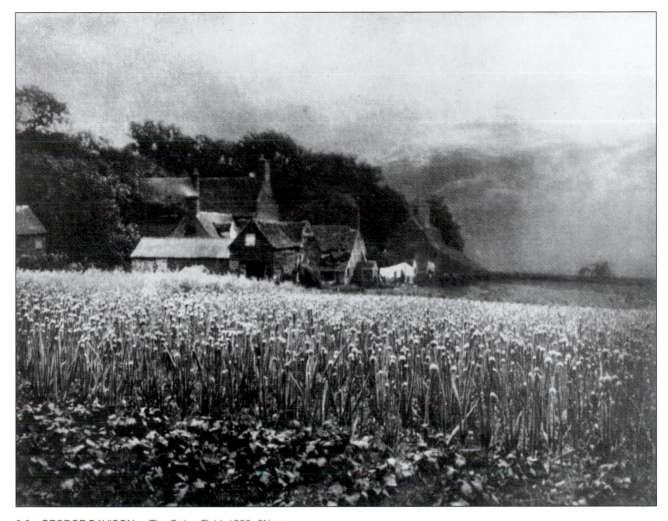

9.2   GEORGE DAVISON.   *The Onion Field*, 1889. 6⅛ ×
8 inches. Photogravure. George Davison's *The Onion Field* visually
embodies the painterly principles of photographic impressionism
that emphasized mood. The concept was controversial with those
who felt it was an imitative process that betrayed the true nature
of photography. Emerson was a severe critic: "photographic
impressionism indeed!—a term consecrated to charlatans and
especially to photographic imposters [sic], pickpockets, parasites,
and vanity-intoxicated amateurs."[10]   Courtesy George Eastman House.

Linked Ring in London in 1892, the Photo-Club de
Paris in 1894, and the Photo-Secession in New York
in 1902.

The Brotherhood of the Linked Ring, a loose
group of photographers disenchanted with the Pho-
tographic Society of London's exhibition practices,
was one of the most influential secession groups. The
"Links" found alternative venues to display and pro-
mote photography as an independent medium whose
works could be evaluated in their own context and
terms rather than by their ability to imitate other
media. This privileged club (membership by invita-
tion only) was founded by educated men, including
Emerson, Robinson, Alfred Maskell, George Davison,

and Alfred Horsley Hinton, editor of *Amateur Photog-
rapher,* begun in 1884 as the first magazine to cater to
amateurs. Their first exhibition of some 300 prints in
1893, generated a stir for being mindfully hung, asym-
metrically, breaking with the Photographic Society's
Victorian tradition of cramming pictures of different
sizes and subject matter frame to frame from the floor
to the ceiling. The Links wanted more stringent exhi-
bition standards: They were fed up with all types of
photographs on a gallery wall, awarding medals to
mediocre formula pictures, and using non-photogra-
phers to jury show entries. To this end, they adopted
a motto: "no medals and rigid selection." The Links
wanted to separate utilitarian work, whose goal was to
record facts, from aesthetic photographs, whose goal
was to express beauty. They sought "complete eman-
cipation of pictorial photography . . . from the retard-
ing . . . bondage of that which was purely scientific
or technical [so it could pursue] its development as
an independent art."[11] Their annual Salon of Pictorial
Photography continued to be an important exhibition
venue until the group dissolved in 1910.

In 1893, Alfred Lichtwark (1852–1914), director
of the Kunsthalle in Hamburg, Germany, put together

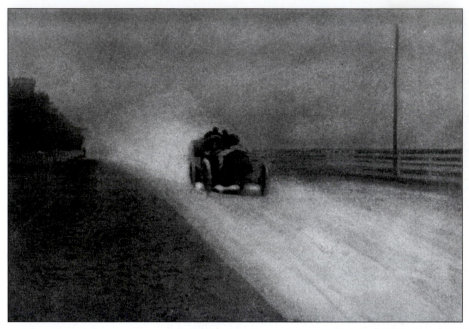

**9.3  ROBERT DEMACHY.** *Speed.* From *Camera Work* #7 July 1904. 4⅞ × 7 inches. Photogravure.   Courtesy George Eastman House.

the "First International Exhibition of Amateur Photographs" in a museum setting. Believing that only amateurs had the economic freedom and time for experimentation, Lichtwark displayed 6,000 amateur photographs in hopes of revitalizing the art of photographic portraiture, which he felt had become artificial and formally constrained. Lichtwark wanted to use artistic amateur photography to infuse portrait painting and commercial illustration with innovative concepts and heightened aesthetic standards. An international network of pictorial photographers evolved to promote pictorial concepts and exhibit and publish each other's work, thereby spreading their personal influence and recognition. Even though this network possessed the reciprocal nature of an "old boys" club, other photographers looked to these groups for direction and paid the compliment of imitation.

Photo clubs and publications mushroomed. In 1880 there were about ten camera clubs or societies in the United States composed mostly of people with professional connections to the field. By 1895, there were over 150 such groups, made up largely of white upper middle-class amateurs who could afford the equipment, supplies, and annual membership dues. Although women were active in these groups, many members asserted that a woman's place was in the home, leading some women to challenge their limited opportunities and the unequal treatment they often endured. As an early proponent for women in photography Catharine Weed Barnes (1851–1913) wrote, "Why Ladies Should be Admitted to Membership in Photographic Societ-

ies," (1889) that called on photographic establishments "to give us a fair field and no favor . . . [as] the day is coming . . . when only one question will be asked as to any photographic work—'Is it well done?'"[12] Many clubs did not permit professionals to join either, fearing they would use the club to promote their own work and inventions. The club members' amateur status gave them financial autonomy and aesthetic independence from commercial interests, and they insinuated that the professionals' aesthetic sense could not be trusted as their values had been compromised by the exchange of money. Such attitudes widened the gulf within the field between amateurs and professionals.

## The Aesthetic Club Movement

Reformist aesthetic notions gained popularity during the 1890s under the *Art Nouveau* movement (1880–1914). Art Nouveau rejected the academic painting of historical events and scenes from legends and literature and advocated a withdrawal from the uniform, mechanical vulgarity of the industrial age by promoting the arts as an indispensable part of daily life. This was done through aesthetic self-improvement clubs that encouraged the procurance of splendid objects and the pursuit of music, poetry, and picturemaking. Photography offered members of this new "Aesthetic Club Movement" a way to bring art into their lives by becoming picturemakers without years of training. These clubs and movements filled a power vacuum of their own making, creating their own local authorities to bestow the status of art in a picture, changing the amateur movement into a "high art" undertaking with its own aesthetic, social network, exhibitions, publications, writers, and critics.

One of the effects of the Industrial Revolution was the rise of the bourgeoisie and a larger audience for

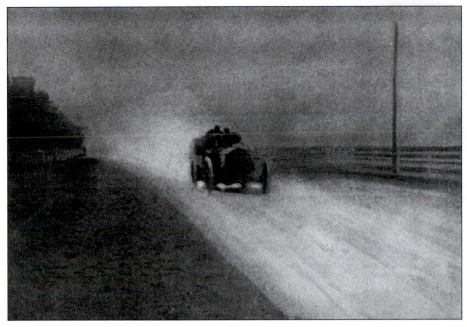

9.3  ROBERT DEMACHY.  *Speed.* From *Camera Work* #7 July 1904. 4⅞ × 7 inches. Photogravure.   Courtesy George Eastman House.

the "First International Exhibition of Amateur Photographs" in a museum setting. Believing that only amateurs had the economic freedom and time for experimentation, Lichtwark displayed 6,000 amateur photographs in hopes of revitalizing the art of photographic portraiture, which he felt had become artificial and formally constrained. Lichtwark wanted to use artistic amateur photography to infuse portrait painting and commercial illustration with innovative concepts and heightened aesthetic standards. An international network of pictorial photographers evolved to promote pictorial concepts and exhibit and publish each other's work, thereby spreading their personal influence and recognition. Even though this network possessed the reciprocal nature of an "old boys" club, other photographers looked to these groups for direction and paid the compliment of imitation.

Photo clubs and publications mushroomed. In 1880 there were about ten camera clubs or societies in the United States composed mostly of people with professional connections to the field. By 1895, there were over 150 such groups, made up largely of white upper middle-class amateurs who could afford the equipment, supplies, and annual membership dues. Although women were active in these groups, many members asserted that a woman's place was in the home, leading some women to challenge their limited opportunities and the unequal treatment they often endured. As an early proponent for women in photography Catharine Weed Barnes (1851–1913) wrote, "Why Ladies Should be Admitted to Membership in Photographic Societ-

ies," (1889) that called on photographic establishments "to give us a fair field and no favor . . . [as] the day is coming . . . when only one question will be asked as to any photographic work—'Is it well done?'"[12] Many clubs did not permit professionals to join either, fearing they would use the club to promote their own work and inventions. The club members' amateur status gave them financial autonomy and aesthetic independence from commercial interests, and they insinuated that the professionals' aesthetic sense could not be trusted as their values had been compromised by the exchange of money. Such attitudes widened the gulf within the field between amateurs and professionals.

## The Aesthetic Club Movement

Reformist aesthetic notions gained popularity during the 1890s under the *Art Nouveau* movement (1880–1914). Art Nouveau rejected the academic painting of historical events and scenes from legends and literature and advocated a withdrawal from the uniform, mechanical vulgarity of the industrial age by promoting the arts as an indispensable part of daily life. This was done through aesthetic self-improvement clubs that encouraged the procurance of splendid objects and the pursuit of music, poetry, and picturemaking. Photography offered members of this new "Aesthetic Club Movement" a way to bring art into their lives by becoming picturemakers without years of training. These clubs and movements filled a power vacuum of their own making, creating their own local authorities to bestow the status of art in a picture, changing the amateur movement into a "high art" undertaking with its own aesthetic, social network, exhibitions, publications, writers, and critics.

One of the effects of the Industrial Revolution was the rise of the bourgeoisie and a larger audience for

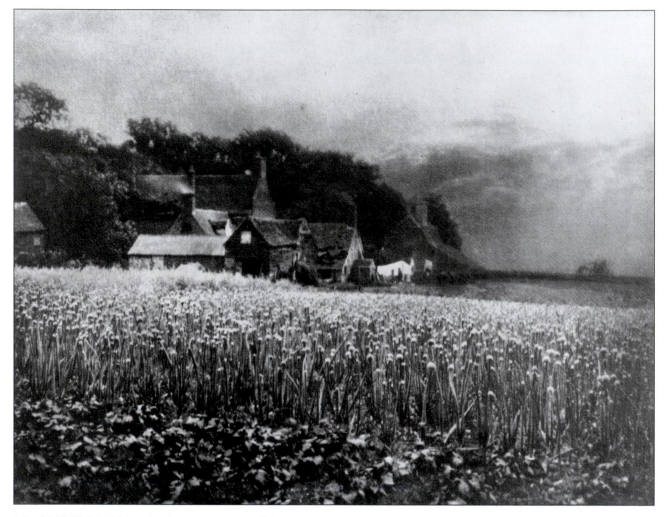

9.2   GEORGE DAVISON.   *The Onion Field,* 1889. 6⅛ ×
8 inches. Photogravure. George Davison's *The Onion Field* visually
embodies the painterly principles of photographic impressionism
that emphasized mood. The concept was controversial with those
who felt it was an imitative process that betrayed the true nature
of photography. Emerson was a severe critic: "photographic
impressionism indeed!—a term consecrated to charlatans and
especially to photographic imposters [sic], pickpockets, parasites,
and vanity-intoxicated amateurs."[10]   Courtesy George Eastman House.

Linked Ring in London in 1892, the Photo-Club de
Paris in 1894, and the Photo-Secession in New York
in 1902.

The Brotherhood of the Linked Ring, a loose
group of photographers disenchanted with the Pho-
tographic Society of London's exhibition practices,
was one of the most influential secession groups. The
"Links" found alternative venues to display and pro-
mote photography as an independent medium whose
works could be evaluated in their own context and
terms rather than by their ability to imitate other
media. This privileged club (membership by invita-
tion only) was founded by educated men, including
Emerson, Robinson, Alfred Maskell, George Davison,

and Alfred Horsley Hinton, editor of *Amateur Photog-
rapher,* begun in 1884 as the first magazine to cater to
amateurs. Their first exhibition of some 300 prints in
1893, generated a stir for being mindfully hung, asym-
metrically, breaking with the Photographic Society's
Victorian tradition of cramming pictures of different
sizes and subject matter frame to frame from the floor
to the ceiling. The Links wanted more stringent exhi-
bition standards: They were fed up with all types of
photographs on a gallery wall, awarding medals to
mediocre formula pictures, and using non-photogra-
phers to jury show entries. To this end, they adopted
a motto: "no medals and rigid selection." The Links
wanted to separate utilitarian work, whose goal was to
record facts, from aesthetic photographs, whose goal
was to express beauty. They sought "complete eman-
cipation of pictorial photography . . . from the retard-
ing . . . bondage of that which was purely scientific
or technical [so it could pursue] its development as
an independent art."[11] Their annual Salon of Pictorial
Photography continued to be an important exhibition
venue until the group dissolved in 1910.

In 1893, Alfred Lichtwark (1852–1914), director
of the Kunsthalle in Hamburg, Germany, put together

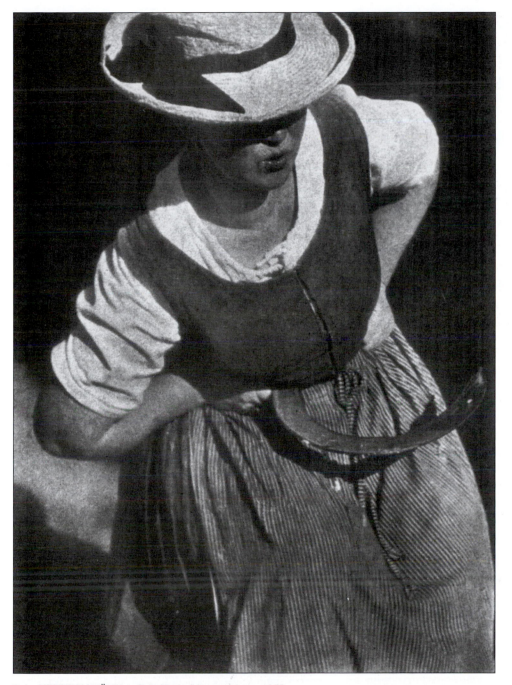

9.4  HEINRICH KÜHN.  *Schnitterin (Harvester)*, ca. 1925.
11⁵⁄₁₆ × 8¼ inches. Photogravure.   Courtesy George Eastman House.
Copyright: Galerie Johannes Faber, Vienna.

the arts, one with ready capital and leisure time. The photographic industry, recognizing that amateur artistic ambitions could translate into increased sales of equipment and supplies, began to advertise in amateur publications and to sponsor shows featuring serious amateur photographers. The aim was to imply that anyone could make photographic art by investing in the proper equipment and materials. Publications plugged their advertisers' goods. Product ads sometimes headlined the endorsement of a well-known photographer.

Commercial support added credibility to the small artistic movement and amplified its message. The January 1905 issue of *Camera Work* contained a full-page editorial announcement: "The reader of *Camera Work* who does not buy through these pages does himself an injustice—good photography depends much upon good material and up-to-date methods."

## Working Pictorially: A Variety of Approaches

**Robert Demachy** (1859–1936) was a wealthy European amateur who took up photography in 1880,

9.5   FREDERICK H. EVANS.   *Kelmscott Manor, Attics,* ca. 1897. 6⅛ × 8 inches. Platinum print. Evans counseled photographers to "Try for a record of emotion rather than a piece of topography. Wait till the building makes you feel intensely . . . then try and analyse what gives you that feeling, see if it is due to the isolation of some particular aspect or effect, and then see what your camera can do towards reproducing that effect, that subject."[13]   Courtesy George Eastman House.

championing the pictorialist cause in Paris with an outpouring of prints and articles. Demachy was a founding member of the Photo-Club de Paris, and with his English cohort, Alfred Maskell (born ca. 1857, active 1890s), he exhibited prints made with the *gum-bichromate process* at the group's first show, the French Photographic Salon. In the gum bichromate process a negative is placed over a support material that has been coated with gum arabic containing a pigment (watercolor or tempera) and with a light-sensitive chemical (ammonium or potassium dichromate). The negative is then exposed to UV radiation. Gum arabic is hardened by such exposure and made insoluble in direct proportion to the density of the negative. The areas that are not hardened remain water soluble and are washed

away, along with the unneeded pigment, during development. The hardened areas are left intact and bond the pigment to the support. Control of the final image can be exercised through choice of paper and pigment, by localized development, by recoating the support with a different color, or by using different negatives for additional exposures. It can also be combined with other processes, such as platinum, to create greater visual depth. Brushstrokes are often left visible, giving the print a handworked look that can replicate the look of a watercolor painting. The process was created in 1855 by Alphonse Louis Poitevin (1819–1882), but was recast in 1894 by A. Rouillé-Ladévèze (active 1884–1894), from whom Demachy learned the process. Gum printing was popularized by the pictorialists under the name Photo-Aquatint and was used from the 1890s through the 1920s. The process was inexpensive, as it contained no silver metal salts, and was very permanent. It experienced a revival in the late 1960s as part of a resurgence in alternative processes.

After making its debut in the pictorial arena, gum printing was embraced for the controls it provided in constructing a print for pictorial effect. The promoting of the pictorial cause led to Demachy's election to

9.6  PIERRE DUBREUIL.  *Interpretation Picasso: The Railway,*
1911.  Centre Georges Pompidou, Paris.

the Linked Ring in 1895. Maskell, a founding member of the Links, collaborated with Demachy on *Photo Aquatint, or The Gum Bichromate Process* (1897), a guide for pictorial imagemakers. Opponents dismissed their work as "fakery," but both men defended gum printing by pointing out how the alteration of negatives and prints was a photographic tradition in the form of adding clouds, vignettes, and posing portraits against handpainted backdrops.

Demachy's prints, ranging from portraits to nudes to urban landscapes, often reverberated with the impressionistic style and always revealed the hand of their maker. Technically brilliant, Demachy was disdainful of the clarity of detail and the automatic trace of reality of the "straight," unmanipulated print and defended the painterly image:

> A straight print may be beautiful, and it may prove superabundantly that its author is an artist; but it cannot be a work of art. . . . A work of art must be a transcription, not a copy of nature. . . . there is not a particle of art in the most beautiful scene of nature. The art is man's alone, it is subjective not objective. If a man slavishly copies nature, no matter if it is with hand and pencil or through a photographic lens, he may

be a supreme artist all the while, but that particular work of his cannot be called a work of art.[14]

The "Trifolium" of the Vienna Kamera-Club, formed in 1896 and active until 1903, was a collective made up of **Heinrich Kühn** (1866–1944), Hugo Henneberg (1863–1918), and Hans Watzek (1848–1903). They adopted Demachy's gum process and exhibited under the collective known as *Das Kleeblatt* (Cloverleaf) and were a driving force of the Austro-German secession/pictorialist movement. Kühn, an amateur since 1879 and a member of the Linked Ring, made multilayered landscapes and portraits in gum and, later, oil-pigment printing (a variation of the bromoil process). His characteristic style featured bold, emblematic compositions on textured paper, printed in inviting brown or blue hues. His approach, to sometimes photograph from above eye level, broke with the stagnant habits of professional portraitists and began a progressive photographic movement in Germany that reflected the concerns of similar pictorial groups that sprang up worldwide.

Pictorialism was not exclusively about manual alteration of negatives and prints. During the early 1880s another amateur, **Frederick H. Evans** (1853–1943), studied photography with George Smith, a specialist in microphotography (scientific photography involving a microscope) and a zealous "purist" who believed that "any artistic effect desired can be faithfully done by pure photography without any retouching whatever."[15] Evans absorbed Smith's lessons and championed straight-from-the-camera photography.[16] Evans's aesthetic concepts were rooted in the *Arts and Crafts Movement* that stressed the dignity of work, the beauty of fine materials, and the spiritual importance of the preindustrial life. In 1895, Evans began a photographic meditation on medieval cathedrals in England and France. He mastered tight compositions, often through the use of repeating lines, capturing a strong sense of chiaroscuro. His exquisite sense of space and volume gave his interior views, laden with physical texture, a sensation of uplift. His exterior cathedral prints could transcend earthbound architectural detail and give the viewer a visual sense of a spiraling medieval spirit reaching up to the heavens. In this series Evans favored the early morning light and used neutral density filters to extend exposure times and give the impression that the images were made when a cathedral was first erected. If something entered his field of view that "dated" the image, Evans capped his lens, waited for the unwanted object to leave, then uncapped the lens and continued the exposure, purging evidence

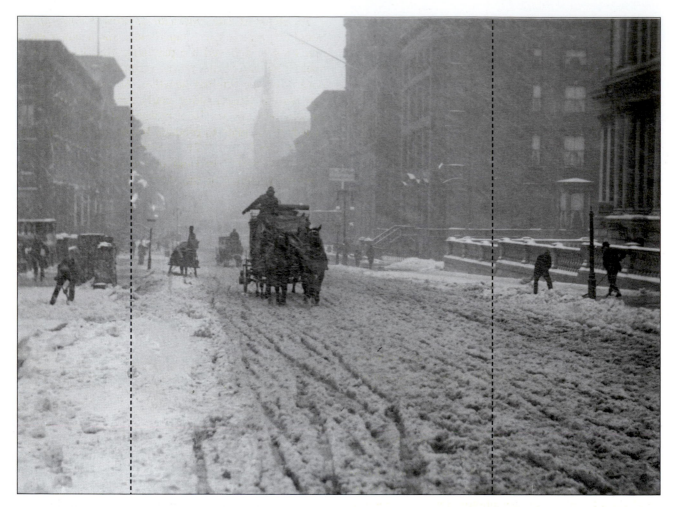

**9.7  ALFRED STIEGLITZ.** *Winter on Fifth Avenue,* 1892. 15¾ × 12⅞ inches. Gelatin silver print. "My picture, *Fifth Avenue, Winter,* is the result of a three hours' stand during a fierce snow-storm on February 22nd, 1893, awaiting the proper moment. . . . the result contained an element of chance. . . . I remember how upon having developed the negative of the picture I showed it to some of my colleagues. They smiled and advised me to throw away such rot. . . . when the finished picture was shown to these same gentlemen it proved to them conclusively that there was other photographic work open to them during the "bad season". . . . This incident also goes to prove that the making of the negative alone is not the making of the picture. . . . My experience has taught me that the prints from the direct negatives have but little value as such."[17] The two broken lines on the left and the right sides of the full plate show the portions that Stieglitz cropped to form the final image in the central picture area, converting the original horizontal into a vertical photograph.   Courtesy George Eastman House.

of the contemporary world, leaving only the beautiful and the eternal. His *Kelmscott Attic* pictures transform a utilitarian space into a sacred site much like a cathedral and are unprecedented in their luxurious delicacy, detail, and subtle brilliance.

Elected to the Linked Ring in 1900, Evans hung the group's 1902 Salon in an extraordinary fashion. After covering the walls with canvas, Evans used two-inch-wide battens to make vertical divisions, suspended white cloth beneath the skylight to diffuse the light, and grouped pictures on the vertical panels without regard to authorship. The care manifested by the presentation signaled that the photographs were works of art. One critic wrote, "Each section of the wall is itself a sermon in massing and composition."[18] Evans hung the next three Salons, initiating a re-evaluation about how photographs were presented in galleries.

Another major influence on pictorialism was Japanese art, referred to as *Japonism,* which came to Europe after the opening of Japan by Commodore Perry in 1854. Western artists incorporated the Japanese print-makers' use of clear and vibrant color, forceful outline, foreshortened and aerial perspectives, and asymmetrical and cropped compositions at the same time many of these devices were also being discovered through photography. Many of these attributes can be seen in work by **Pierre Dubreuil** (1872–1944), an affluent amateur known at the turn of the century for his soft-focus, impressionist, *oil-pigment prints*[19] with the Photo-Club de Paris and later as a "Link." Around 1908, Dubreuil's compositions began to emphasize the two-dimensional flatness of the image by sharply focusing on nones-

sential objects, making them stand out, while placing the main subject in the background and out of focus, destroying traditional visual hierarchies. Between 1908 and 1912, Dubreuil experimented with abstraction by using his camera to fragment key subjects within the scene, as in his *Interpretation Picasso: The Railway* (1911). Here Dubreuil diagonally printed a negative of a locomotive and repeatedly effaced the surface of the print with a rectangular form, producing a transparent overlapping of geometric planes. This projection of the rectangular form introduced abstraction of the subject and provided one of the critical ingredients—the other being the return to sharp focus—that would re-define modernism in photography around 1916.

## American Perspectives

While the battle for photography as an independent art was being waged in Europe, American photographers continued to improve commercial photography, leaving the culturally high-minded still looking towards Europe for inspiration. In 1881, **Alfred Stieglitz** (1864–1946) went to Berlin to study mechanical engineering and met Hermann Wilhelm Vogel, whose experiments with orthochromatic emulsions and active role in photographic societies convinced Stieglitz to pursue photography. Under Vogel, Stieglitz became a master technician and learned about pictorial photography. Returning to America in 1890, Stieglitz decided to pursue a life in photography that would take him to the forefront of the crusade for photography's acceptance as an independent medium.

The fight for the independence of photography in the New World held special appeal for a first American-born son of a Jewish immigrant like Stieglitz who wanted to leave behind many customs of the old country. Although Stieglitz did not practice Judaism one can speculate how Jewish culture might have influenced him. Since Judaism is based on the word and not the image, Stieglitz's making of photographs could be interpreted as an act of rebellion against the authority of the Old Testament, a rejection of Judaism's fear of the eye, saying NO to the taboo on graven images.[20] By indirect mechanical means, the camera allowed Stieglitz to break this prohibition and embrace Christian pictorialism (without endorsing its history of church-sponsored art) on a new, wide-open playing field. This enabled Stieglitz to fulfill a role as a "chosen one," guiding his people out of the slavery of old practices. Stieglitz could be a rabbi (teacher), leading services of a new monotheistic, aesthetic order. Instead of studying the Torah and writing expositions, Stieglitz would polemicize and publish the order of modernism from the position of the persecuted outsider. Instead of being tormented by anti-Semites, Stieglitz was harassed by uncultured barbarians.

As editor of *The American Amateur Photographer* Stieglitz promoted the hand-held camera when most practitioners believed it a plaything. Stieglitz shocked readers by stating that it was acceptable to use only a portion of the original negative. According to Stieglitz, serious imagemaking could occur after the shutter was pressed, and he demonstrated it by using less than half his plate to produce *Winter on Fifth Avenue* (1892) (see Figure 9.7). Stieglitz joined together the "proper moment" in front of the camera with post-camera strategies in the darkroom. He showed that weather conditions did not have to be a deterrent in making pictures and that chance operations could be incorporated into the process. Stieglitz gained a reputation for using a hand camera to capture unretouched, precisely observed moments from real time, whether at night (*Reflections, Night,* 1896), in the rain (*A Wet Day on the Boulevard,* 1894), or under difficult lighting conditions (*Sunlight and Shadows, Paula,* Berlin, 1889). These aesthetic revelations that Stieglitz called "snapshots" broke with the attitudes of the painted image, furthering photography's quest to define itself based on its intrinsic elements. Ironically, the proponent of using hand cameras, which almost anyone could operate, was not interested in the democratic aspects of the process; Stieglitz adamantly believed that only inspired artists could make fine images.

In 1897, The Society of Amateur Photographers and the New York Camera Club merged to form The Camera Club of New York. Stieglitz recast its journal, *Camera Notes* (1897–1903), into a high-quality international quarterly that presented America's first concrete claim for photography as a fine art. *Camera Notes* featured splendid reproductions, perceptive articles, and critical reviews, representing Stieglitz's standards of aesthetic excellence that other photographers could look to for aesthetic guidance.[21]

*Camera Notes* portrayed the emerging style of the American pictorial movement, which was typified by subjects that steered clear of topical issues, placing importance on how a subject was handled rather than the subject itself. Soft focus was used to evoke mystery and de-emphasize photography's connection with reality. Simplified compositions, manually manipulated to eliminate extraneous elements, removed images from their dependence on the real world and fitted them into a new definition of what constituted art. Stieglitz challenged his readers to do more than impersonate another medium's achievements and to discover their own photographic medium's visual models.

Stieglitz desired to produce a major exhibition reflecting the principal pictorialist concerns that stressed elaborate printing processes, post-camera manipulations, atmospheric effects, and the tonal values of the image over the subject matter. Such a show would demonstrate that photography was a tool, like

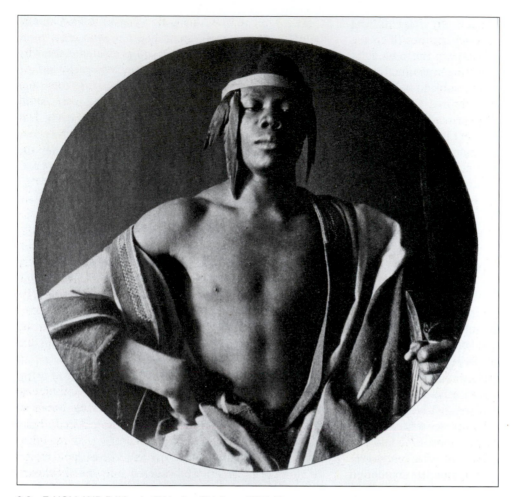

9.8    F. HOLLAND DAY. *An Ethiopian Chief,* ca. 1898. From *Camera Notes* Vol. 1. No. 2. 1897. 4⅝ × 4⅝ inches. Photogravure. Courtesy George Eastman House.

a paintbrush, for achieving aesthetic effect. Stieglitz was unable to make this exhibition happen at the Camera Club. Instead, John G. Bullock (1854–1939) and Robert S. Redfield (1849–1923) of the Photographic Society of Philadelphia produced a show under the patronage of the Pennsylvania Academy of Fine Arts in 1898. According to the catalogue, the purpose of the Philadelphia Salon was to present work with "distinct evidence of individual artistic feeling and execution." That same year, the Munich Secession group hung photographs alongside paintings in an effort to inject new concepts and vigor into German art. Other groups soon followed suit.

In early 1901, a political coup at the Photography Society of Philadelphia toppled the leadership, replacing it with a group who believed there was "a little too much art" in photography and who wanted to "popularize" the Salon, which led to its demise. Stieglitz, realizing that camera clubs would no longer support the standards he valued, opened his first independent exhibition space. As he solicited work, Stieglitz was forming a new group of photographers that would be known as the Photo-Secession.

## The Photo-Secession

The *Photo-Secession* was founded on February 17, 1902, "loosely to hold together those Americans devoted to pictorial photography in their endeavor to compel its recognition, not as a handmaiden of art, but as a distinctive medium of individual expression."[22] The group was made up of American pictorial photographers who shared the same philosophies as the Linked Ring, the Photo-Club de Paris, and the German secession movements that had rebelled against academic authorities and organized their own exhibitions. The founders included Stieglitz, as director of the Council, John Bullock, Frank Eugene, Gertrude Käsebier, Joseph Keiley, Robert Redfield, Eva Watson-Schütze, Eduard Steichen, and Clarence White.

Stieglitz resigned as editor of *Camera Notes* in 1902 and immediately launched a new quarterly, *Camera Work,* assisted by Joseph T. Keiley (1869–1914), who had worked with him as an associate editor for *Camera Notes.* Keiley was also a member of the Linked Ring and, as a founding member of the Photo-Secession, became its historian. Fifty issues of *Camera Work,* with a press run of only 1,000 copies, were published between 1903 and 1917.[23] Stieglitz covered the evolution of the pictorial movement through the new hard-edged modernism and introduced the new art movements of Fauvism,

Cubism, and Futurism (see Chapter 10). Stieglitz was conscious of how a medium's physical nature affects the information it carries, and great care was taken with the reproductions. He favored presenting individual artist portfolios by means of photogravure on thin Japanese paper, tipping the pictures in on brown or gray submounts. The quality of these reproductions often gave them a delicacy and depth absent in the original, showing what the mechanical printing process was capable of (printers were given credit lines). Paul Rosenfeld wrote that *Camera Work:*

> Is itself a work of art: the lover's touch having been lavished on every aspect of its form and content. . . . Many of the reproductions are actual pulls from photogravure plates made directly from the original negatives; and all are printed in the spirit of the original pictures and retain their intrinsic qualities. They are actually original stamps.[24]

*Camera Work* spotlighted monographs of the Photo-Secessionists and leading European practitioners, along with the historic works of Hill and Adamson (crediting only Hill), and Julia Margaret Cameron. Articles by noted critics, such as Charles Caffin (*Photography as a Fine Art,* 1901) and Sadakichi Hartman (*The History of American Art,* 1901), and by authors such as George Bernard Shaw and Gertrude Stein raised the level of critical discussion.[25] *Camera Work* had a decidedly intellectual appeal, claiming to be "published for those who know or want to know."[26] In 1905, Stieglitz took out a lease at 291 Fifth Avenue, giving the group a permanent exhibition and operations center. Later known as "291," the gallery featured the leading pictorialists of America and Europe. During its later years, from 1911 to 1917, "291" was the only place in America that steadily presented modern artists and engaged in a dialogue of their ideas.

## The Decadent Movement and Tonalism

**Fred Holland Day** (1864–1933), a prosperous bibliophile, became the third American member of the Linked Ring. As cofounder of the publishing firm Copeland & Day (1888), he produced noncommercial titles such as those illustrated by Aubrey Beardsley. George Davison brought Day's work to the notice of Stieglitz in 1895, and Stieglitz featured Day's images in *Camera Notes* in 1897 and gave him a one-person show at the Camera Club. Day was influenced by the *Decadent Movement* (a.k.a. dandyism) and was friends with Oscar Wilde and William Morris of the *Arts and Crafts Movement.* In the manner of Beau Brummell, artists of the Decadent Movement (at its height towards the end of the nineteenth century) were fashionably dressed and displayed exquisite manners. Their value system prized artificiality, self-consciousness, and a disdain for bourgeois values, expressed through intellectual skepticism, humor, and a withdrawal from conventional society. They rejected the notion that art should imitate nature and emphasized amorality, play, and relief from the mounting social and spiritual problems caused by untethered industrialism. Decadent Movement artists often saw themselves as extensions of their work, and Day enjoyed dressing in exotic costumes. Day posed his models in unconventional dress in historical and mythological settings, often eliciting an idyllic homoerotic sense of ancient Greece or an atmosphere of Orientalism (Africa and the Middle East).[27]

Day used the subjects before his camera to raise significant issues dealing with sex, religion, race, and the physical perfection of youth. He created a stir by making images of adult full-frontal female and male nudity. In separating the nude from the lewd, pictorialists had stylistically photographed women to stress beauty rather than sensuality: Sexual details such as nipples and pubic hair were suppressed. With its ability to confront the body, photography helped end the tradition of concealing the female nude in an allegorical setting, letting the body be seen as a sensuous, aesthetic form. However, the undraped male body was considered too sexual for mixed audiences. Journal articles suggested using young boys, believing their bodies would be less sexually titillating than a woman's.[28] Photographers like Frank Meadow Sutcliffe (1853–1941) and Kühn portrayed nude boys in down-to-earth, Barbizon-type settings, such as swimming in the sea, to give the body a sense of spontaneity. These depictions were considered immoral, however; Sutcliffe was excommunicated from the Roman Catholic Church for depraving women and children after his picture, *Water Rats,* featuring nude boys swimming, was exhibited. Day's images directly acknowledged the beauty and sensuality of the adult male body, implying a forbidden homosexual lifestyle and demonstrating how photography can hint at the secret life.

Day was condemned for the double sin of judiciously portraying a nude black man. The model was Day's chauffeur and confidant, whom he photographed for years. The images were shocking because Day cast them against type. Nudes were supposed to be female, not male, and white society was comfortable with images of blacks in clinical studies or in subservient positions, not as individuals and certainly not as equals. Day forged new ground by portraying his sitter as a fellow human being.

During the summer of 1898, Day caused a sensation in Boston by making hundreds of exposures on the theme of Christ's last days. Day starved himself and grew his hair down to his shoulders so he could model as Christ, a role he also wanted to play as the artistic leader of photography. Day sought to affirm that photographs could reveal the same spiritual sensations as paintings with religious themes. By casting himself as artist and savior, Day projected the romantic belief that fine culture and sacred beliefs can be revived through an understanding of the arts.

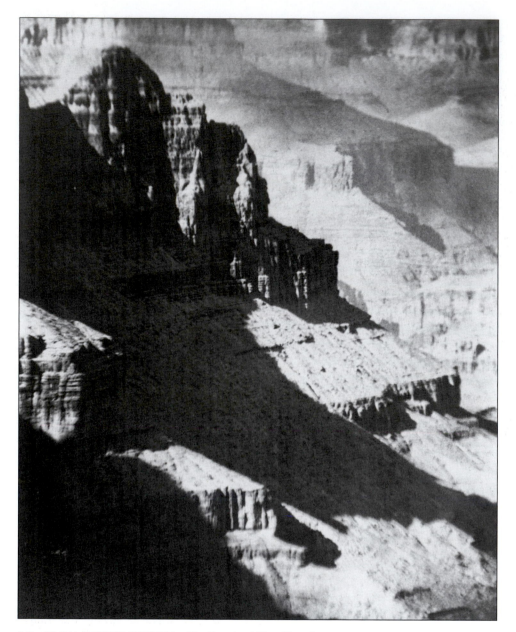

**9.9   ALVIN LANGDON COBURN.**   *The Temple of Ohm (Grand Canyon),* 1911. 16 × 12⅝ inches. Gelatin silver print.   Courtesy George Eastman House.

A fervent competition developed between Stieglitz and Day to be the first to prove that photography could hold its own in the art world. In 1900, Day organized the *New School of American Photography,* an exhibition of 300 prints and offered it to the Linked Ring. Stieglitz saw Day stealing his thunder and intervened, and the show was refused. Day got the Royal Photographic Society to take the exhibition instead and then traveled it to the Photo-Club de Paris in early 1901. The exhibition was a critical success, helping establish photography's place in the art world and boosting the reputation of American pictorialists in a hostile environment in which the old-guard photographic societies resisted aesthetic change.

Day's strong character and independence of thought fostered a rivalry with Stieglitz for leadership of the American pictorialist movement, but it was a struggle that he was not temperamentally suited to win. Stieglitz was better connected and possessed the appropriate mixture of charisma and intellectual prowess that enabled him to maintain a following of major talent. Day made very few photographs after 1904, when a fire destroyed his studio and most of his work. In 1917, Day took to his bed and remained secluded until his death in 1933.

The connecting of European and American pictorial movements received an assist from **Alvin Langdon Coburn** (1882–1966), an American photographer who later settled in Britain, becoming a citizen in 1932. Coburn took up serious photography as a teenager and in 1900 helped his cousin, Fred Holland Day, organize Day's *New School of American Photography* exhibition

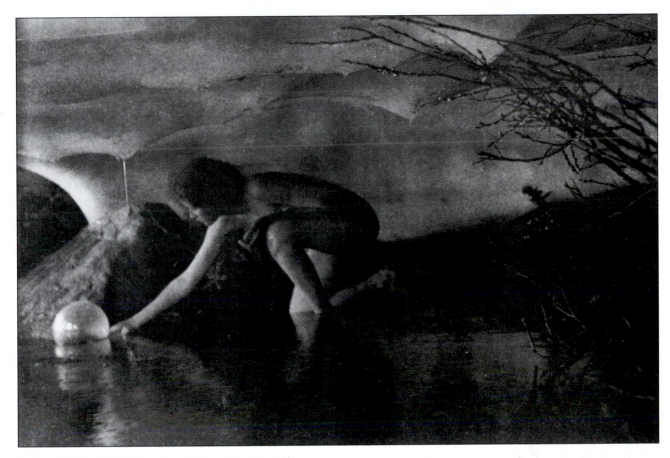

**9.10  ANNE W. BRIGMAN.**  *The Bubble,* 1907. 6⁵⁄₁₆ × 9⁵⁄₁₆ inches, Photogravure. Anne W. Brigman (1869–1950), actress, photographer, and champion of woman's rights, separated from her husband to "work out my destiny." Brigman received acclaim and notoriety for her innovative interpretations of the female figure in nature, often inhabiting the landscape with her own nude body. Brigman's interpretation of the landscape removed the female body from the gaze of a clothed man in the confines of his studio.  Courtesy George Eastman House.

in Europe. His work was included in the show. A founding member of the Photo-Secession who also was elected to the Linked Ring, Coburn was influenced by *tonalism,* a turn of the twentieth century, American artistic movement in painting and photography that was typified by an idealized, often melancholic, mysterious, personal, romantic interpretation that favored muted color and mood. In 1910 and 1911, he traveled through the American West, pursuing the tonalist's favorite subject—the natural landscape. At the Grand Canyon, Coburn's series of poetic representations reflected the nature-based spiritualism of Thoreau and the transcendental harmony of Ralph Waldo Emerson. The series tackled the difficulty of conveying the Grand Canyon's sense of scale. Coburn's tightly composed serial views concentrated on specific aspects of the Canyon instead of trying to portray it in a single image (see Figure 9.9). The work has a sequential logic and is most effective when seen as a set. Coburn's

textured, gritty prints render a visual playback of the canyon's shale landscape. The soft-focus, sometimes almost blurry effect adds an other-worldly feeling to the scene. It also distorts the sense of distance by manufacturing a near *bas-relief*[29] effect of physical relief in the background. In other views the visual sense of distance is collapsed and perspective is diminished. This creates spatially flat images that rely on the abstracting of atmospheric patterns to bond the composition together. Both styles generate a visual paradox, making the images appear solid yet unattainable while conveying an awareness of the eternal. The prints feel old and give viewers a sense of historical time. Coburn's use of chiaroscuro adds a dramatic, emotionally uplifting grandeur to the land. Other views incorporate atmospheric effects, such as aerial perspective, to provide a sense of distance.

## Women Pictorialists

Feminists in the late 1890s began actively crusading for equal rights and greater opportunities in all areas of life. Admitted as members to the major camera clubs in New York, Buffalo, Chicago, Boston, San Francisco, and Los Angeles, women came to reject the idea of receiving separate segregated awards and agitated for genderless categories. Catharine Weed Barnes summed up the position: "Good work is good work, whether it be by man or woman, and poor is poor by the same

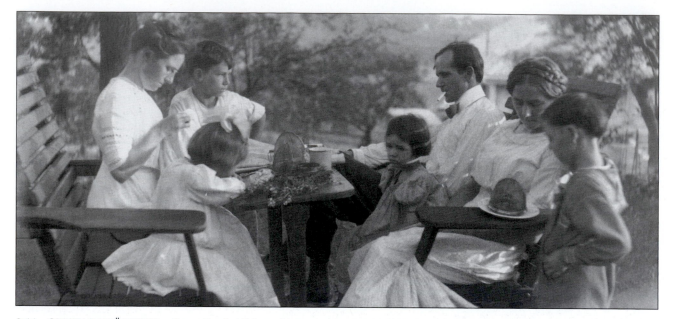

9.11 GERTRUDE KÄSEBIER. *Turner Family, Woburn, Mass.,* ca. 1912. 4⁵⁄₁₆ × 9¼ inches. Platinum print. Courtesy George Eastman House.

rule."[30] Although the majority of the 105 mem- bers of the Photo-Secession were East Coast men, 21 were women. Alice Boughton, **Anne W. Brigman** (see Figure 9.10), Sarah C. Sears, Eva Watson-Schütze, and Gertrude Käsebier played active roles as artists. They also served the movement's symbolic foundation as archetypal nurturing mothers and primal forces of nature, both major themes of the pictorialists.[31]

**Gertrude Käsebier** (pronounced KAY-za-beer) (1852–1934), apprenticed herself to a chemist and later worked for a portrait photographer before opening her own studio in New York in 1897. Her work was recognized at the first Philadelphia Salon of 1898, followed by a solo show at The Camera Club of New York in 1899 and inclusion in Day's *New School of American Photography* exhibition. The first American woman elected to the Linked Ring in 1900, Käsebier was also a founding member of the Photo-Secession. Stieglitz featured her work in the first and subsequent issues of *Camera Work* as well as in shows he organized at "291" and elsewhere. She went on to help found the Pictorial Photographers of America in 1916.

Up until World War II, women photographers often specialized in portraits, flowers, and child and baby work. Such work could be done from the home, thus preserving the traditional family hierarchy, and was appreciated by critics. And, because women were trained and expected to be more sensitive to the needs of others, such work seemed a natural specialization. Käsebier is known for her unconventionally composed scenes that depict the subtle complexities of mother-child relations and evoke a tranquil sense of intimacy. She reformed pictorialist practice by ridding scenes of idealized, middle-class

domestic life of their Victorian backdrops and emphasizing the individuality of the subjects as they would be found in their everyday settings. Her goal was to "make likenesses that are biographies, to bring out in each photograph, the essential personality that is variously called temperament, soul, humanity."[32]

**Alice Boughton** (1865–1943) was among the women pictorialists who not only celebrated the beauty of young women, but also wrote about the qualities required to produce images of people:

He [the photographer] must have tact, the social instinct and infinite patience. In doing children, for instance, he must amuse, watch for the right moment, be constantly and continually alert, and work for the unconsciousness which is one of their charms.[33]

A Kodak ad in *Camera Work* #26 (April 1909), in which Boughton's images appear, shows two women going into a darkroom to develop film with the new Eastman Plate Tank (a daylight developing tank). The caption reads: "Where the tank enters, the dark room worries end." While the ad implies that even a woman can use the Kodak tank, it also recognizes the involvement of women in photography and as potential customers. At a time when women in the United States still did not have the right to vote, such ads reveal the photographic industry's awareness that women's relationship to photography was changing from being the ones depicted to being the ones doing the depicting.[34]

## The Pictorial Epoch/ The Stieglitz Group

Stieglitz was able to assemble a core group of photographers that played key roles in developing and expressing the pictorial aesthetic. In 1900, en route to Europe, **Eduard Jean Steichen** (1879–1973), who would later

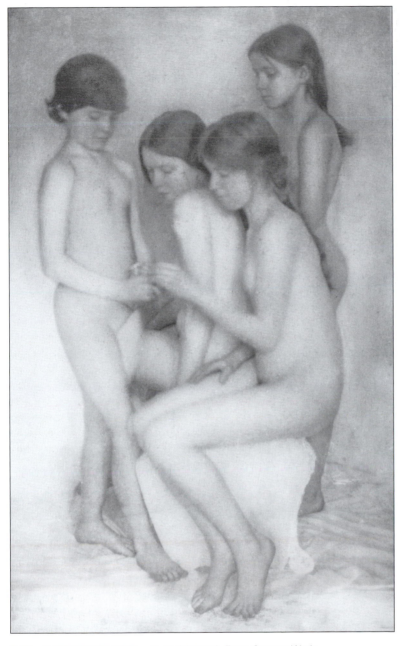

9.12 ALICE BOUGHTON. *Nude* (children). From *Camera Work* #26. April 1909. 8⅝ × 5¼ inches. Photogravure. Courtesy George Eastman House.

spell his name Edward, visited Stieglitz and sold him three of his photographs for five dollars each. In 1901, Day included Steichen's prints in his *New School of American Photography* exhibition. Steichen was also elected to the Linked Ring and began a friendship with the sculptor Auguste Rodin, of whom he would make numerous portraits (See Figure 9.3).

In 1902 Steichen returned to New York from Europe to become a founding member of the Photo-Secession and take studio space at 291 Fifth Avenue. During his European trip of 1906 Steichen sent Stieglitz works by practitioners who would later be featured in *Cam-*

*era Work* and at "291." Steichen's aesthetic sensitivity, combined with enormous and diverse productivity and technical virtuosity, made him one of the most extensively published and critically examined members of the Secession. Steichen's prints met the avant-garde requirement of what art was supposed to be: A subjective response to the visible world, forcing an acknowledgment that a photograph could be an expressive statement. His gum prints and use of copy negatives in combination with other alternative photographic printing processes reflect the late nineteenth century propensity for moody, meditative fantasy. The subject, reinforced through the controls of gum printing and soft focus, demonstrated Steichen's emotional fascination with photography's prime mover: light. In prints like *Moonlight: The Pond,* Steichen created a dark, enigmatic atmosphere of nostalgia and sensuality that initiated a visual dialogue between the transitory archetypal powers of light and shadow. Steichen's prints sum up the Secessionist aesthetic of suggestiveness, of evoking the mystery of an echo rather than a replica of the original, that takes one beyond the visible experience.

Baron **Adolph de Meyer** (1868–1949), a European involved with the issues of pictorial photography, corresponded with Stieglitz, had his first exhibition in the Photo-Secession Galleries in 1907, and in 1908 had his images published in *Camera Work* and was listed as Fellow of the Council of the Photo-Secession. In 1903 de Meyer began to use a specially constructed *soft-focus lens*[35] to control the sharpness in his large-scale portraits and still lifes. De Meyer's still life set-ups of glass containers on a glass tabletop use transparency to produce visual ambiguity between the subject and the background. He employed artificial lights to make a high-key sparkle and even "blinded" his lens by shooting into the light for effect (see Figure 9.14). De Meyer circulated with and photographed the stylishly wealthy. When World War I broke out, de Meyer came to the United States as a photographer for *Vogue* and *Vanity Fair.* In this capacity he produced high-key, soft-focus, idealized portraits of American celebrities in elegant settings throughout the 1920s, expressing a range of feeling from joy to ennui. With the coming of the Great Depression and a shift towards social realism de Meyer's work fell out of favor and has been largely forgotten.

**Frank Eugene (Smith)** (1865–1936), a painter who evolved into a photographer, was a member of the Linked Ring and a founder of the Photo-Secession.

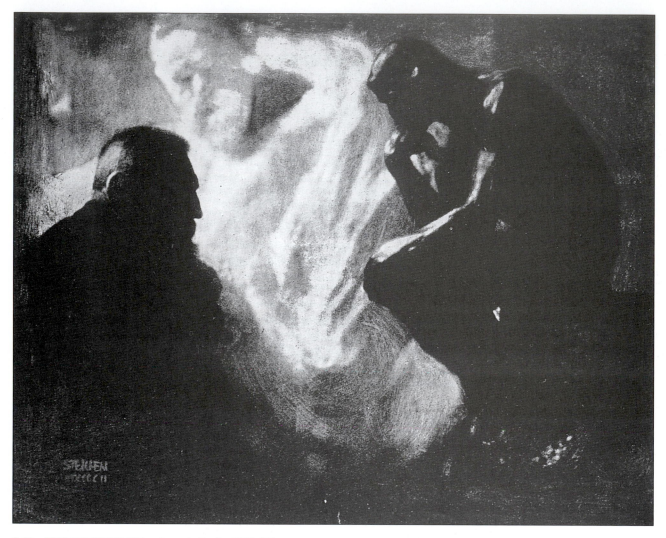

9.13   EDWARD STEICHEN.   *Auguste Rodin,* 1903. 8½ ×
6⁵⁄₁₆ inches. Photogravure.   Print courtesy George Eastman House.
Reprinted with permission of Joanna T. Steichen, Carousel Research.

His approach to making negatives with optically cor-
rected lenses was atypical of the Secessionists. Rather
than relying on printing methods to introduce subjec-
tive interpretation, Eugene hand-altered his negatives
by scratching on the emulsion with an etching needle
(see Figure 9.15). He maintained the photographic
character of his subject while adding a painterly physi-
cal presence, permitting a subjective postcamera inves-
tigation into the psychological nature of his subject.
His working methods were viewed with horror, even by
some of the Secessionists, for violating the sacred sur-
face of the negative, but Stieglitz supported the work
through publication and exhibition.

**Clarence Hudson White** (1871–1925) was a self-
taught photographer whose work in the 1898 Philadel-
phia Salon came to the attention of Stieglitz. Eventually
White and Stieglitz collaborated on a series of nude
studies and, later, with the Autochrome process. White's
simple early compositions of family and friends fea-

tured common, middle-class settings and relied on his
use of natural light to inject emotion (see Figure 9.16).
Favoring soft, early morning light, White used back-
lighting to bring forth accepted romantic notions of
midwestern domesticity and commonplace portrayals
of feminine home endeavors, from ring toss to reclin-
ing on a daybed. White began an influential teaching
career in photography at Columbia University in 1906.
In 1912, White broke with Stieglitz after a feud and in
1914 founded the Clarence H. White School of Pho-
tography, which was instrumental in the development
of the next generation of photographers (see Chap-
ter 11). In 1916 White helped establish the Pictorial
Photographers of America, whose membership wanted
to continue to promote the pictorial ideas that Stieglitz
was abandoning. White's teaching, a monetary neces-
sity criticized by Stieglitz (who could afford not to mix
photography and business), reduced his artistic output
and development. White's situation exemplifies the
continuing dilemma facing artists of how to earn a liv-
ing in a society that offers little support to artists while
remaining artistically vital. He died while leading a
group of photography students in Mexico.

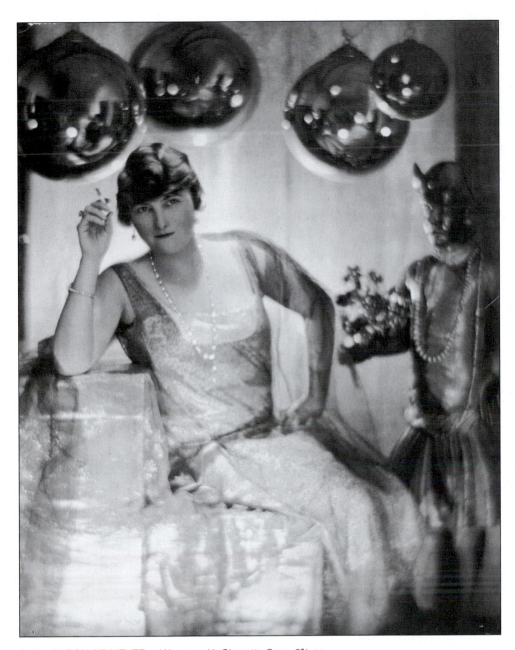

9.14 BARON DE MEYER. *Woman with Cigarette Case.* 9⁷⁄₁₆ ×
7½ inches. Platinum print.   Courtesy George Eastman House.

In November 1910, the Albright Art Gallery (now
the Albright-Knox) in Buffalo, NY, presented the *Inter-national Exhibition of Pictorial Photography,* orga-nized by Stieglitz to sum up pictorial photography. The
Albright's purchase of twelve prints linked the pictori-alists with the Pre-Raphaelites, who broke away from
the traditional avenues of aristocratic, church, and gov-ernment art patronage and actively framed the idea of
the modern gallery system, with its dealers, collectors,
and high prices for art works. These modern concep-tions about gallery sales, collections, and connoisseur-ship made up a key ingredient of the Western art scene
during the twentieth century. The Buffalo exhibition
marked the culmination of the pictorial movement by

"the most beautiful gallery in America." It was a recog-nition and sanctioning of photographers as artists and
photography's ability to compete with traditional art
mediums. Because the pictorialists changed the status
of their photographs through the investment of time in
their handwork, people were now willing to purchase
photographs for display on their walls instead of just in
their private albums. Pictorialist methods separated the
photographic process from the machine, elevating the
image and its maker to the plane of art and artist.

## The Decline of Pictorialism

The success of the pictorialists resulted in numerous
uninformed imitators interested only in achieving a
pictorial look and led to a tarring of the movement.

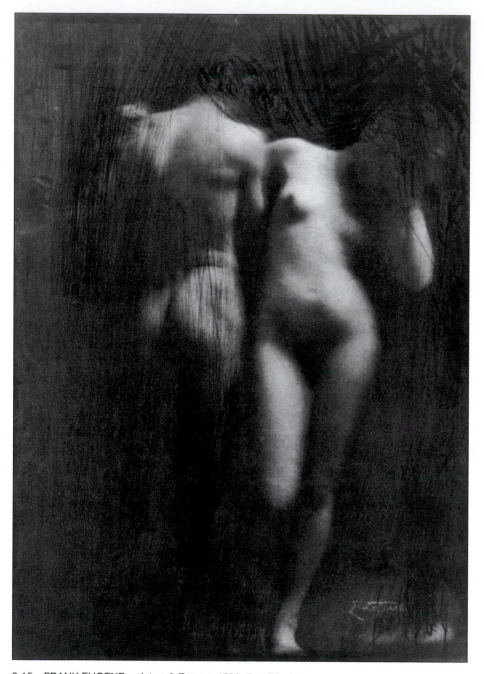

9.15   FRANK EUGENE.   *Adam & Eve,* ca. 1900. 7 × 5 inches.
Photogravure.   Courtesy George Eastman House.

Leading practitioners, such as Demachy, recognized that "many pictorialists will meddle with their prints in the fond belief that any alteration, however bungling, is the touchstone of art."[36] As pictorialism became a recognized style, others assumed the trappings without the context, resulting in pictures that appear affected. With the original impetus gone, the emulators' work became synonymous with vapid, strained, and worn-out formulae. Eventually, even images in *Camera Work* seemed overwrought because everyone, including Stieglitz, was struggling to discover where the bound-

aries of the practice lay. What is evident is that even gifted artists make bad art; their genuine ability is in not being afraid to take chances and risk failure. By the time of the Buffalo exhibition, the group Stieglitz had founded and the style it championed had ceased to interest him and was disintegrating. Stieglitz turned his attention to modern art which he began to present in *Camera Work,* and he presented only one photography show, of Paul Strand (1916), during the last four years of "291." Many excesses were committed in the name of pictorialism, but the Photo-Secession helped photography realize its place as an artistic medium.

As art is an evolutionary process, rooted in people's experiences, it is always in flux. The process of interchange and crossing boundaries confirms how "real-

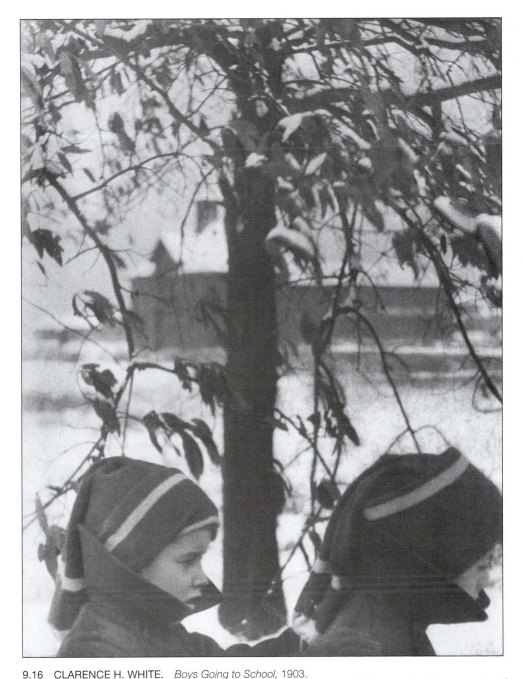

9.16 CLARENCE H. WHITE. *Boys Going to School,* 1903. 8 1/16 × 6 1/8 inches. Photogravure. Working as a bookkeeper taught White to concentrate on detail and planning. He favored the familiar, using the same subjects over again in the belief that it furthered his understanding of their inner emotions, creating compositions suggested by the subject. Formations, such as *Boys Going to School,* use ordering and limited depth of field to heighten the beauty of form and texture in everyday events.   Courtesy George Eastman House.

ism" is continually being reinvented. It verifies that reality in art is artificial and has to be recreated if the art is going to be more than an illustration. When a society agrees that something is real, it indicates that a comparison with reality has confirmed the observation.

When we look at a work of art and are moved by it, we do not make such a comparison because it is the power of the work, not its imitation, that speaks to us. This is what artists, including the pictorialists, traditionally strive to achieve. Photography released painters from their societal compact to make realistic representation, pointing artists toward the pursuit of personal and abstract concerns while supplying examples of a new, and previously unseen reality. Artists were influenced by the contemporary look and subject matter of the photographic image and photographic effects such as *halation.* Halation is the luminous halo, with a diffused outer edge, that occurs when an exposure is made into a bright source of light (backlighting). Early films were prone to halation and would exaggerate the effect.

Impressionists picked up on such effects and incorporated them into their visual vocabulary.

Aesthetically, pictorialism demonstrated that photography was an elastic medium and could be used to interpret life with the same aesthetic impulses used in making paintings. In turn, photography freed artists to expand the boundaries of representation, making impressionistic and other modern explorations possible. Theoretically, pictorialism established photography as an art by assimilating it to various styles and theories of art. Once photography was established as an interpretive medium, its own photographic art theory was free to emerge. The pictorial movement was a big stride in the direction of photographers investigating their own medium and establishing their place in the art world. With these changes underway, some of the foremost pictorialists, especially Stieglitz, reconsidered photography's position, not as it related to painting but on its own inherent characteristics.

## Endnotes

1  "Society Gossip," *Philadelphia Photographer,* vol. 17, no. 195 (March 1880), 98.

2  "Photographers' Association of America," *Philadelphia Photographer,* vol. 17, no. 201 (September 1880), 275.

3  Peter Henry Emerson, "Photography, A Pictorial Art," *The Amateur Photographer,* vol. 3, no. 76 (March 19, 1886), 138–39.

4  The photographs were influenced by Joseph Mallord William Turner (1775–1851), an English romantic landscape painter concerned with portraying the elemental forces of nature, James McNeill Whistler (1834–1903); and the French Impressionists.

5  Like all printing-out processes, platinum's self-masking abilities allow subtle highlight details to be retained without the shadow areas becoming "buried." The images have a matte surface and are permanent, as platinum is more stable than silver. The platinum process was patented in 1873 by William Willis (1841–1923), who marketed it in 1879 as the Platinotype. Its high cost caused it to disappear from the commercial market by 1937, though it reappeared again in the mid-1980s through alternative sources.

6  P. H. Emerson, *Naturalistic Photography for Students of the Arts* (London: Sampson Low, Marston, Searle and Rivington, 1889), 150.

7  Although trained as a physician, neither Emerson nor other photographers of the time grasped the potential creative mastery that the understanding of the H & D curve could provide. It was not until 1941, when Ansel Adams translated sensitometry into aesthetics through his Zone System, that photographers had a reliable method of accurately depicting tonal relationships as they "previsualized" them.

8  Peter Henry Emerson, *The Death of Naturalistic Photography* (privately published, 1890). Reprint edition (New York: Arno Press, 1973) from the back of *Naturalistic Photography,* 3rd ed. (New York: The Scovill and Adams Co., 1899).

9  Bromoil was introduced in 1907 and allowed the option of making an enlargement from a small negative. In the bromoil process a gelatin silver bromide print was bleached and redeveloped in pigment, allowing color, tonal effects, and the diffusion of detail to be controlled by hand. Multiple impressions could be made with different colored inks. Bromoil's latitude and painterly appearance gave it a following among expressive printmakers through the 1940s.

10  Emerson, *The Death of Naturalistic Photography* (privately published, 1890).

11  Joseph T. Keiley, "The Linked Ring," *Camera Notes,* vol. 5, no. 2 (October 1901), 113.

12  Catharine Weed Barnes, "Why Ladies Should be Admitted to Membership in Photographic Societies," *The American Amateur Photographer,* vol. 1, no. 6 (December 1889), 224. Catharine Weed Barnes was an American photographer and editor of *The American Amateur Photographer.* In the early 1890s she went to England, where she married photographic journalist H. Snowden Ward (1865–1911) and was subsequently known as Catharine Weed Ward. In post-mortem secondary literature she is often referred to as Catharine Weed Barnes Ward. For a reprint of this short piece and seven of her other essays see Peter E. Palmquist, *Catharine Weed Barnes Ward: Pioneer Advocate for Women in Photography* (Arcata, CA: Peter E. Palmquist, 1992), 35–83.

13  F. H. Evans, "Some Notes on Interior Work," *The Amateur Photographer,* May 12, 1904, 372.

14  Robert Demachy, "On the Straight Print," *Camera Work* 19 (July 1907), 21–24.

15  George Smith, "Lantern Slides," *British Journal of Photography,* vol. 33, no. 33 (1886), 20–21.

16  An energetic writer, Evans explained his ideas in articles for popular journals. He wrote a series of twelve instructional lessons for *The Photogram* in 1904 and was a regular contributor to *Camera Work,* becoming the first English photographer to gain recognition in America.

17  Alfred Stieglitz, "The Hand Camera—Its Present Importance," *The American Annual of Photography,* 1897, 18–27. This article contained fourteen "snapshots" by Stieglitz.

18  Ward Muir, *The Amateur Photographer,* October 2, 1902, 273.

19  Oil-pigment printing was a contact process in which a gelatin-coated paper sensitized with potassium bichromate could absorb hand-applied inks or pigments. Known for its limited granular resolution and broad, slightly uneven tonal effects, it was revived in 1904 by G. E. H. Rawlins and remained popular through World War I.

20   The Second Commandment, the Prophets' battles with idolatry, the teaching of the rabbis, and the cultural and economic traditions of the Jews militated against the visual arts. The only reference to painting in the Old Testament is in the context of lewdness and whoredom. *Ezekiel* 23:13-16.

21   For reproductions of all of *Camera Notes*'s images see Christian A. Peterson, *Alfred Stieglitz's Camera Notes* (Minneapolis: The Minneapolis Institute of Arts in association with W. W. Norton & Co., New York, 1993).

22   Alfred Stieglitz, *Camera Work* 6 (April 1904), 53.

23   See Simone Philippi, Ute Kieseyer, *Alfred Stieglitz Camera Work: The Complete Illustrations 1903–1917* (Köln: Benedikt Taschen Verlag GmbH, 1997).

24   Paul Rosenfeld, "The Boys in the Darkroom," *America and Alfred Stieglitz,* Waldo Frank, Lewis Mumford, Dorothy Norman, Paul Rosenfeld, Harold Rogg (eds.) (New York: Doubleday, Doran & Co., Inc., 1934), 82.

25   See Jonathan Green, *Camera Work: A Critical Anthology* (Millerton, NY: Aperture, 1973).

26   Ads, *Camera Work* 42–43 (April– July 1913), unp.

27   See James Crump, *F. Holland Day: Suffering the Ideal* (Santa Fe: Twin Palms Publishers, 1995), 23.

28   J. M. B. W., "A Note on some Open-Air Nude Studies," *The Amateur Photographer and Photographic News,* vol. 52, no. 1344 (July 5, 1910), 20–21.

29   The bas-relief effect is achieved by making a contact positive transparency from a negative, placing the two pieces of film together slightly out of register, and printing from the combination.

30   Catharine Weed Barnes, "Photography from a Woman's Standpoint" (paper read before the Society of Professional Women, December 10, 1889), *The American Amateur Photographer,* vol. 2 (January 1890), 10.

31   See Barbara L. Michaels, *Gertrude Käsebier: The Photographer and Her Photographs* (New York: Harry N. Abrams, 1992), 17–18.

32   Giles Edgerton [pseudo. of Mary Fanton Roberts], "Photography as an Emotional Art: A Study of the Work of Gertrude Käsebier," *The Craftsman,* vol. 12 (April–September 1907), 88.

33   Alice Boughton, "Photography, A Medium of Experience," *Camera Work* 26 (April 1909), 33–36.

34   This indicates how industrialization transformed women's roles in the economy of the northeast. In 1800, only one woman in twenty worked outside her home, but within a hundred years in cities such as Boston, one woman in three derived income outside the home. The work experience had a significant cultural effect, fostering new attitudes and relationships. Women who worked in mills, shoe manufacturing, domestic service, or teaching tended to stay in the city, marry urban men, and have fewer babies than their rural counterparts.

35   With a soft-focus lens, no correction is made for spherical aberration. The result is that no part of the image is sharp. Special soft-focus portrait lenses allow the degree of diffusion to be controlled. Images produced from soft-focus lenses possess an exaggerated degree of brilliance in the highlight areas.

36   Robert Demachy, "On the Straight Print," *Camera Work* 19 (July 1907), 21–24. Also reprinted in Peter E. Palmquist *Catharine Weed Barnes Ward: Pioneer Advocate for Women in Photography,* 39–42.

# Modernism's Innovations

## Industrial Beauty

An innovative set of Western artistic, cultural, and spiritual precepts evolved during the early modernistic period (1880–1920), based on the new urban, industrial, and secular order. Modernist artists abandoned historical subject matter and Renaissance *illusionism,* the convincing depiction of nature, in favor of portraying contemporary events and experimental representation. The decline of aristocratic, church, and state patronage in the nineteenth century meant artists were no longer beholden to these powers and their values. In the new fledgling capitalist art market, where the probability of sales was small, artists were freer to experiment with appearance and content, and even ridicule the ruling powers. *Aesthetic formalism,* emphasizing form over content, emerged in part from an ecumenical belief that pure forms could transcend differences implicit in content and become as important as subject matter. Modernists also believed that meaning is inherently placed in an art work by the artist and read by the viewer. The positivist belief in progress was applied to art and photography, as new styles were continually promoted on the heels of others. Without a rudder to steer art toward collective

societal goals, the modern artists and photographers distinguished themselves by being unique. There was a reward for being "first," as new and different became values unto themselves. During this period there was a growing sense of moral instability that was related to the apparent crumbling of religious belief. "Art for art's sake" described personal art without social or religious sanction. A touchstone of modernism was individual freedom over social authority. With it came the side effect of alienation, the separation and estrangement from the usual societal positions. Once an affliction, alienation became a prized accessory of art. Dissenting artists created an ambiguous environment of detachment and uncertainty, making them major themes of twentieth-century art that have continued to isolate artists and their art from mainstream society.

In addition to his economic theories, Karl Marx (1818–1883) believed that art is part of a shared social reality and must be integrated into daily life. As the social function of art shifted from the public to the private, Marxist critics assailed the presumption that the purpose of art was aesthetic and individualistic. Marxists contended that art should scrutinize political and social reality, getting behind appearance to elucidate social relationships. They also insisted that art must not divorce itself from the realities of everyday people, as this weakened its ability to pinpoint problems and bring about social change. For art to be vital, Marxists said, it must operate in society and reach a large and diverse audience—a goal for which photo-based processes were ideal. The divergence of capitalist and Marxist positions marked a split in Western cultural values: whether culture should express private beliefs or group values.

The increased speed at which technology changed fundamental societal guideposts about industry, religion, and science produced a corresponding loss in traditional cultural values. The machine revolutionized social experience by shifting the balance of population growth from rural to urban areas. The velocity at which culture reinvented itself through technology between 1875 to 1905 had been unthinkable a generation before, and many were optimistic that technology's benefits were endlessly bountiful.[1]

## Cubism

Rapid changes in the modern world stimulated and challenged artists to reflect the immense shifts in human consciousness caused by the new technological landscape, including photography. Inspired by the work of painter Paul Cézanne, the *cubists*—Pablo Picasso, Georges Braque, Fernand Léger, Juan Gris—attempted to parallel the dynamism of the machine age by means of Enlightenment ideals that extolled analysis and reason. Active in Paris from 1907 through the 1920s, the cubists abandoned the Renaissance system of one-point

perspective and its accompanying geometrical system for depicting reality. They developed their own analytical system in which three-dimensional subjects were fragmented and redefined from various points of view simultaneously. Cézanne was engrossed with the way visual relationships shifted every time he moved his head. This process of seeing, the making of choices, how each turn of our head offered up a new truth, was what Cézanne sought to paint. This way of seeing is often used to organize a photograph. Photographers can hold a camera to their eye, making exposures (choices) as the camera is moved with each turn of the head through the scene. Cézanne's use of broken outlines took viewers through a never-ending process of visual change. In cubist paintings the making of choices is relative to one's physical and mental position, making doubt a major subject of their work.

Cubism became an international movement, prevailing in the avant-garde art realm until World War I. During its first period, called the *analytic* phase (1907–1912), Picasso and Braque demonstrated their belief that knowledge of a subject is the physical sum of all possible points of view. They compressed their inspection, which takes time for a viewer to comprehend, into a single view to show that the multiplicity of a subject was the governing element of reality. Cubism was a fresh visual language, fragmented, simultaneously dissolving and re-forming. It can be seen as a visual analogue for Einstein's discoveries of the molecular interrelationship of space and time.[2] Picasso and Braque regarded their work as realistic, emotionally and intellectually true, and did not consider complete abstraction a viable way to visually communicate contemporaneous experience. Their work offered a new definition of what constituted "authentic" visual reality. Both artists paid attention to photography's ability to create unusual juxtapositions, flatten and equalize space, exaggerate proportions, alter scale, and disrupt time. Picasso made and manipulated his own photographs during his cubist period. Earlier, he was formally influenced by a group of postcards made between 1905 and 1906 by **Edmond Fortier** (1862–1928) (see Figure 10.1), a photographer based in Dakar in Senegal.[3] As the limits of analytic cubism were reached in muted oval canvases of almost indiscernible subject matter, Picasso and Braque vastly enriched their visual vocabulary with *synthetic cubism* (1912–1914). It featured vibrant color, and assemblage and collage techniques, such as stenciling in letters and physically incorporating pieces of newspaper type and sand into their paintings.

Society's acceptance of photographic veracity allowed painters to explore new boundaries of representation. If painters were no longer needed to create one-point Renaissance perspective views of their subjects because photography could do it more quickly and inexpensively, then they were free to make paintings that did not look like paintings of the past. With

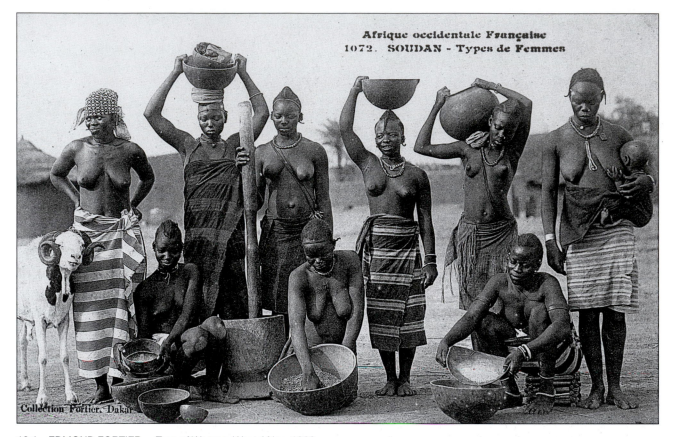

Afrique occidentale Française
1072. SOUDAN - Types de Femmes

Collection Fortier, Dakar

**10.1 EDMOND FORTIER.** *Type of Women, West Africa*, 1906. Collotype postcard. Pablo Picasso had a collection of some 40 colonial photographic postcards made by Edmond Fortier. The visual correlations between Fortier's "studies" and Picasso's paintings of 1906–1907, culminating in *Les Demoiselles d'Avignon* (1907), suggest that photographic African source material helped Picasso redefine his pictorial language and was a critical factor in the development of analytic cubism.   Courtesy Musée Picasso, Archives.

photography usurping art's traditional function as the mirror of nature, artists had to leave imitation behind and discover a new rationale for their profession. Art was forced to become smarter. This latitude in turn permitted photographers to consider how photography could address the same modernist concepts that had altered painting's sense of representation and ask: What was a photograph supposed to look like? Photographers no longer had to rely solely on the aesthetics of painting and could concentrate on the inherent qualities of the photographic process. A few photographers shed the romantic approach that had influenced the pictorialists of extolling emotion and idealism through spirituality. They explored modernism, steering photography back to its roots in the principles of the Enlightenment.

As analytic cubism emerged, **Alfred Stieglitz**, who was still championing pre-modernist pictorialism, underwent a transformation in his aesthetic thinking. In 1907, Stieglitz decided that for photography to grow it had to stop mimicking other mediums and return to its original "straight" foundation: the direct, minimally manipulated, camera-made view. With "purity of use" as a guide, the automatic and hence accurate recording of reality by a camera that placed a premium on clarity of detail would be essential points in judging the value of a photograph. By 1908, Stieglitz began to move away from pictorial photography; at "291" he showed the works of highly modernistic painters like Henri Matisse, Cézanne, Picasso, Braque, Constantin Brancusi, Jean Renoir, and unknown American painters such as John Marin, Arthur Dove, Marsden Hartley, and Max Weber. Stieglitz's change in visual thinking can be seen in his photograph *The Steerage* (Figure 10.2). With this image, he no longer waited for everything to arrange itself (as in *Winter on Fifth Avenue*) but acknowledged the hand camera's potential for instantaneously framing situations from life. The resulting negative was printed without cropping.[4] Using the full frame became a badge of honor, an announcement that the finished piece had been visualized before the shutter was released. The composition stood on its innate structure and did not rely on any postvisualization methods. The full frame said that a photograph should look like a photograph and not like an etching or a painting. It implied that the pictorialists' vision was weak, relying on artificial devices to construct an impure picture. These "straight" ideals would eventually dominate artistic photographic practice and become the dogmatic fetish of "proper technique."

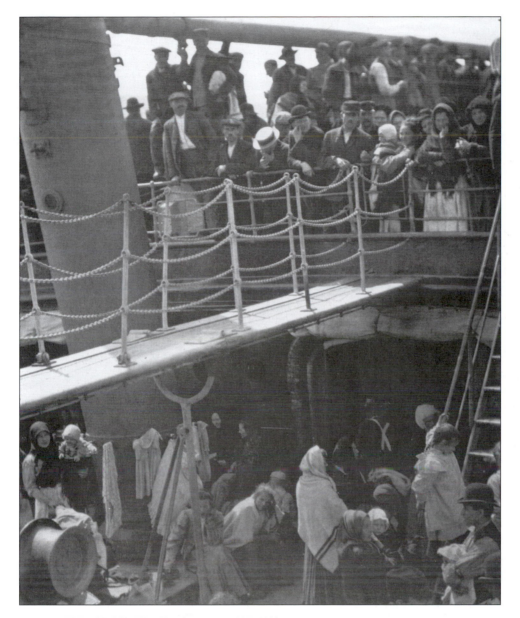

**10.2  ALFRED STIEGLITZ.**  *The Steerage,* 1907. 13⅛ ×
10⁷⁄₁₆ inches. Photogravure print. While walking the first-class deck
on a large steamer bound for Europe (not America), Stieglitz looked
down onto the lower level of the steerage and saw a young man in
a straw hat gazing over the rail at the group below. Stieglitz ran and
got his camera. The scene had not changed, and Stieglitz made
his photograph. He later told how: "I saw shapes related to one
another—a picture of shapes, and underlying it, a new vision that
held me."[5]   Courtesy George Eastman House.

In 1913, the newly organized Association of Ameri-
can Painters and Sculptors staged the *International
Exhibition of Modern Art* at the Armory of the 69th
Regiment in New York, introducing cubist, expression-
ist, and post-impressionist art, as well as photographs,
to a new audience. Stieglitz urged people to see the
Armory show and mounted an exhibition of his own
work at "291," the first in fourteen years, to see how
it compared with the work at the Armory. The Armory
show jolted American art from its provincial slumber
and left the public bewildered as the show's work dis-
mantled their visual gauges for measuring and respond-
ing to art. The public's confusion and interest can be
seen in the reaction to Marcel Duchamp's (1887–1968)
*Nude Descending a Staircase No. 2* (1912), a painting
about the idea of movement. Based on Marey's sequen-
tial photographs, Duchamp's figure in the continuous
action of coming down a staircase was lampooned as
"an explosion in a shingle factory," yet became a canoni-
cal image of modernism. People waited in line to get a
glimpse of this somber painting totally without prurient
interest. As author/art critic Calvin Tomkins has noted,
"the painting seemed to sum up everything that was
arbitrary, irrational, and incomprehensible in the new art
from Europe."[6] Initially, the exhibition's only effect was
the opening of a few new commercial galleries geared

toward investment collectors. Stieglitz was saddened that so little attention was paid to the American artists he admired, and he wondered how America could expect to produce first-rate creative figures without societal support.[7] Later Duchamp would comment that Stieglitz "abandoned the worldly conception of art. . . . He believed passionately that America should have its own artists. He felt his influence could force the issue."[8] During his career, Stieglitz's galleries would remain lonely outposts of modernism in an American society reluctant to fund contemporary arts. This lack of support assured the rise and dominance of self-sustaining popular culture throughout the twentieth century.[9]

## High and Low Art

As leisure time spread to the urban working class during the nineteenth century, demand rose for entertaining art forms that were more accessible than academic paintings, classical music, literature, opera, and traditional theater. These "high art" forms were considered elitist by the public: They had evolved in Europe for the aristocracy and required an education to be understood. Popular or "low" culture, often thought of as an American phenomenon, grew out of a multitude of everyday forms of communication—advertising, the comics, detective and romance novels, illustrated newspapers, popular music, nightclub scenes, and, later, movies and television.[10] During the first half of the twentieth century, an abyss stretched between high art and popular culture. As the lack of sales at the Armory show demonstrated, many modernist artists were considered revolutionary, making their work difficult to sell and uncoupling them from the capitalist engine of commerce. The makers of popular culture took a diametric stance, attempting to reach the broadest audience and defining success by business standards of profitability.

While the photogravures of Stieglitz's *Camera Work* reached only a few, albeit influential, readers, photographic reproduction in the form of the *real photo postcard* was accessible to all. Between 1905 and 1918, the "low art" form of the postcard was the major method for circulating photographs, thanks to three factors: The U.S. Post Office cut the cost of mailing postcards by half; in 1906, Kodak offered to print images on postcard stock at no extra charge; and reproducing photographs in newspapers continued to be difficult. Local professionals used real photo postcards, which are printed on sensitized paper rather than reproduced photomechanically like commercial postcards, to record regional fare such as local landmarks, county fairs, and disasters, and to make portraits; amateurs used them to mail their snapshots out into the world. Like tintypes and snapshots, the subject matter of the often anonymous postcards taught an appreciation of the vernacular and the beauty of the plain, straight-ahead stare.[11]

Stieglitz continued to photograph the expanding urban experience, with "high art" images of ferry boats, flying machines, railroad yards, and skyscrapers. He also turned inward by making portraits of the people close to him at "291," expecting his sitters to wait until the "living moment" revealed itself.[12] Konrad Cramer, a painter turned photographer, described a session with Stieglitz in 1911:

> He used an $8 \times 10$ view camera, its sagging bellows held up by pieces of string and adhesive tape. The lens was Steinheil, no shutter. The portraits were made in the smaller of the two rooms at "291" beneath a small skylight. He used Hammer plates with about three second exposures. During the exposure, Stieglitz manipulated a large white reflector to balance the overhead light. He made about nine such exposures and we then retired to the wash room which doubled as a darkroom. The plates were developed singly in a tray. From the two best negatives he made four platinum contact prints, exposing the frame on the fire escape. He would tend his prints with more care than a cook does her biscuits. The finished print finally received a coat of wax for added gloss and protection (the shift to a glossy surface, previously considered "unartistic," was a major change in Stieglitz's visual thinking).[13]

## Futurism

A few European artists reacted to technology's rapid changes to the urban scene with a manifesto on *futurism* in 1909.[14] Futurism was promoted by Milanese poet Filippo Tommaso Marinetti (1876–1944). Referring to himself as "the caffeine of Europe," Marinetti believed that every aspect of human behavior could be seen as art, making him the godfather of later happening and performance pieces that began with the dadaists after World War I. Marinetti was anti-historical and saw the past as an enemy to be destroyed.[15] In its place he wanted to use the power of the machine to create a new type of man. Futurism acclaimed a new modern industrial-age beauty: "the beauty of speed." The futurists used the vocabulary of cubism to show multiple and simultaneous points of view. Futurists were interested in Marey's photographic work showing the successive positions of a figure on a single plate because it introduced the notion of continuous time into a fixed space.

Influenced by futurism, the brothers Anton Giulio Bragaglia (1890–1960) and Arturo Bragaglia (1893–1962), made photographs of figures in motion that blurred the intermediate phases of the action by leaving the camera lens open as their subjects moved. The Bragaglias' blurry depictions connected the science of positivism with transcendental idealism, suggesting that beyond the visible lay a recordable dynamic of continuous movement at play. Their photographic tracings of physical gestures that normally happened too quickly to be observed expressed the energy of modernity and linked the Bragaglias with futurist painters such as Giacomo Balla, Umberto Boccioni, and Gino Severini. Despite this, the futurist painters maintained

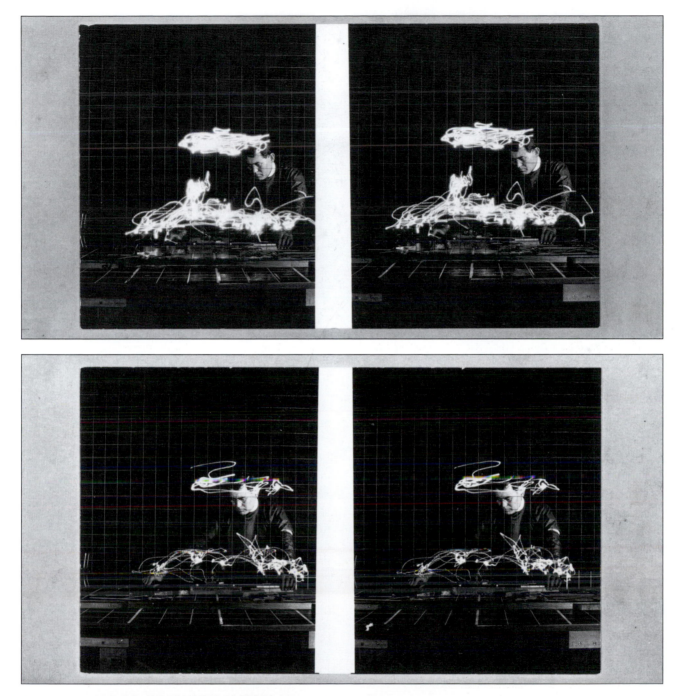

10.3 and 10.4   FRANK B. AND LILLIAN M. GILBRETH. *Photograph of inefficient work operation,* ca. 1935. 3¾₁₆ × 2½ inches each on 3½ × 7 inch mount. Gelatin silver stereograph (top). And *Photograph of efficient work operation,* ca. 1935. Gelatin silver stereograph (bottom). According to a letter written by Lillian Gilbreth to Beamont Newhall on July 9, 1957, these chronocyclegraphs were taken for the Eastman Kodak Company.   Courtesy George Eastman House.

the art hierarchy against photography and excluded the Bragaglias from being welcomed into their movement. Even so, the camera would become the definitive futurist tool, a machine proficient at catching the sensation of speed.

# Time, Movement, and the Machine

In the mechanized era of factory work, management searched for ways to make the worker fit the machine. Fredrick Winslow Taylor, a proponent of "scientific management," created a stir in labor relations by measuring the time it took the fastest worker to perform a task in order to show management how to increase productivity. Instead of a stopwatch, **Frank B. Gilbreth** (1868–1924) and **Lillian M. Gilbreth** (1878–1972) used a motion picture camera to examine job sites and uncover "the one best way to do work." Like the

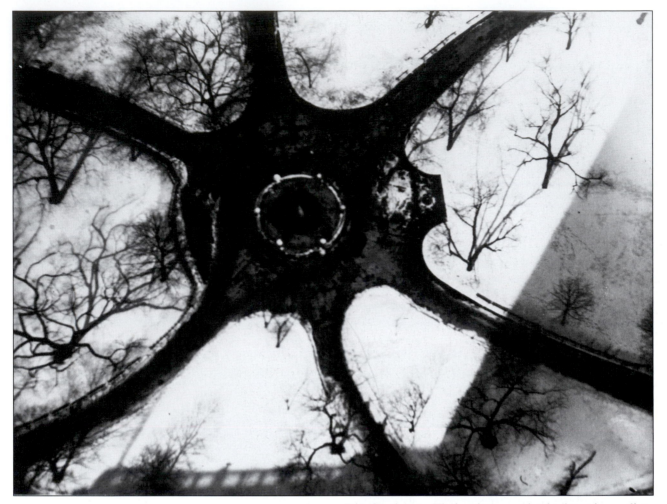

10.5   ALVIN LANGDON COBURN.   *The Octopus,* 1912 (direct overhead view, ca. 1957). 8 × 10½ inches. Gelatin silver print.

Courtesy George Eastman House.

futurists, the Gilbreths wanted to harness the power of the machine to formulate a new type of individual. Based on their visual findings, they would redesign job sites so that workers were in the right position to perform most efficiently. They discovered that stereo photographs delivered the most useful information and developed the "stereo chronocyclegraph," in which tiny lights attached to the subject gave a visual indication of the physical action.[16] The stereo effect made it easy to see which motions were essential to performing a task with the least amount of exertion (see Figures 10.3 and 10.4). Each task was photographed, and the chronocyclegraph analyzed to provide the pattern of maximum efficiency for each employee to follow.

The Gilbreths' work, like Étienne-Jules Marey's, alluded to the entire history of an action. The continuous light dashes in their chronocyclegraphs suggested the immediate past and future of the action, allowing for the action to be interpreted within the environment in which it was taking place. The Gilbreths' style seemed to present facts, but their interpretation favored

Big Business. Their photographs had an immediate financial and social effect: They helped businesses make their employees more machinelike, resulting in greater profitability. Although the Gilbreths claimed concern for a worker's "right to happiness," others saw their photographs as a vision of the corporate tyranny of continuous production, a loss of personal identity, and the standardization of life. It was science coupled to a process that brought with it a sense of alienation and psychological anxiety, as later satirized by Charlie Chaplin in his film *Modern Times* (1936).

## Toward a Modern Practice: Distilling Form

For **Alvin Langdon Coburn** pictorialism had run its course. He was ready to push his work forward by combining modern notions of personal freedom and futurist attitudes about the dynamic character of the early twentieth century to move towards abstraction. Coburn made pictures of New York skyscrapers by pointing his camera down at the subject and sometimes replacing the camera lens with various sized pinholes to modify sharpness. The aerial perspective of *The Octopus* (1912), made after a fresh, white snowfall, eliminated

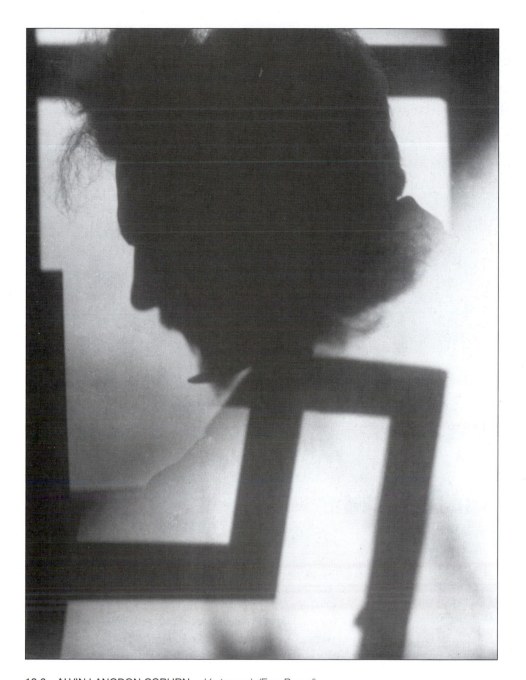

**10.6   ALVIN LANGDON COBURN.**  *Vortograph* (Ezra Pound), 1917. 8 × 6¹⁄₁₆ inches. Gelatin silver print. Is this dynamically composed, robotlike image a golem that protects its master, or does it portray the lost belief in the goodness of the machine? Even though the print is not sharp, this angular machine-age image seems to possess an inhuman sense of strength capable of uncircumspect destruction. Ezra Pound's head is disembodied and appears to be almost sticking on a pike. There is also a hint of a swastika foreshadowing Pound's later embrace of facism.   Courtesy George Eastman House.

unwanted detail and banished the familiar. Coburn abolished the horizon line, flattened perspective, and abstracted shapes, producing a startlingly different point of view. One exposure made from almost directly overhead was so abstract and therefore unfamiliar that Coburn did not print it for decades. His methods invited viewers to celebrate formalistic beauty rather than the photographic impulse to identify and name subjects. Such work attested to photographers' readiness to make pure form the content of their image. Technological wonders like the skyscraper dominated the urban experience, making the human form less significant. As moving pictures, telephones, and automobiles entered daily culture and altered the landscape as well as societal perceptions of time and space, artists began to make machines the subjects of their work.

Coburn vaulted toward abstraction in 1916 with his kaleidoscopic portraits of the poet Ezra Pound, called *vortographs* after Pound's *vorticism* movement

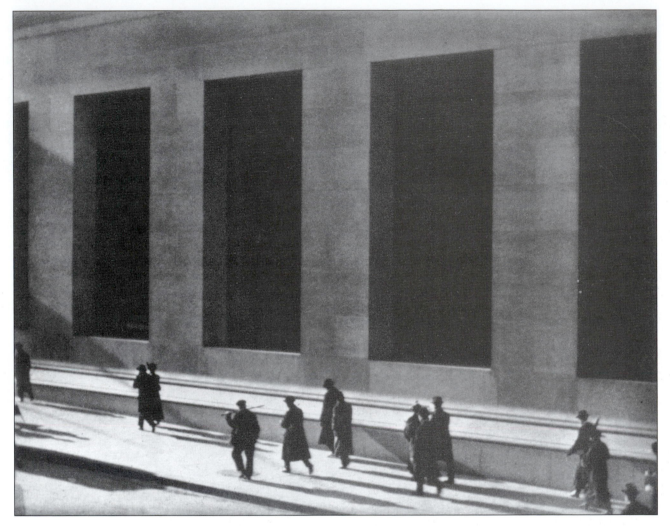

**10.7 PAUL STRAND.** *Wall Street,* 1915. From *Camera Work,* October 1916. 7⅛ × 4½ inches. Photogravure. Strand said: "I was trying to re-create the abstract movement of people moving in a city; what that kind of movement really feels like and is like. . . . They [the photographs] required a technique which could only be described as a snapshot . . . it is a snapshot when it becomes necessary to stop movement. . . . Thoreau said years ago, 'You can't say more than you see.' No matter what lens you use, no matter what the speed of the film is, no matter how you develop it, no matter how you print it, you cannot say more than you see."[17] Copyright © Aperature Foundation, Inc., Paul Strand Archive.

(1914–1915), a British offshoot of futurism. Vorticism rejected the cool placidity of cubism and emphasized abstraction and movement. Coburn used a prism in front of the lens to distort, flatten, multiply, and transform his subject into two-dimensional form. In Coburn's most radical work of this period, he arranged geometric objects on glass to achieve a cubistlike appearance that fractured the realism of subject content and single point perspective. The vortographs' rejection of nature as subject was received with such disapproval that Coburn abandoned his investigations. Nevertheless, the vortographs represented what critic De Zayas articulated as

photography's quest within the modernist movement to find a way of "being equally subjective and objective."

Visual experiments like Coburn's moved photographic practice towards the modernist concern with form. While Coburn was experimenting with abstraction, Marius de Zayas, a caricaturist and essayist on modern and African art, saw photography shifting from recording the outside world to penetrating the inner world. This shift reflected the modernist belief that rational scientific values, as understood by the process of distilling form, could be the new basis for life and culture. De Zayas saw a split opening between the objective and the subjective approaches as represented by Steichen and Stieglitz and wrote:

The work of Steichen brought to its highest expression the aim of the realistic painting of Form. In his photographs he has succeeded in expressing the perfect fusion of the subject and the object. He has carried to its highest point the expression of a system of representation: the realistic one. . . . Stieglitz has begun with the elimination of the subject in represented Form to search for the pure expression of the object. . . . one is the means by which man fuses his idea with the natural expression of Form, while the other is the means by which man tries to bring the natural expression of Form to the cognition of his mind.[18]

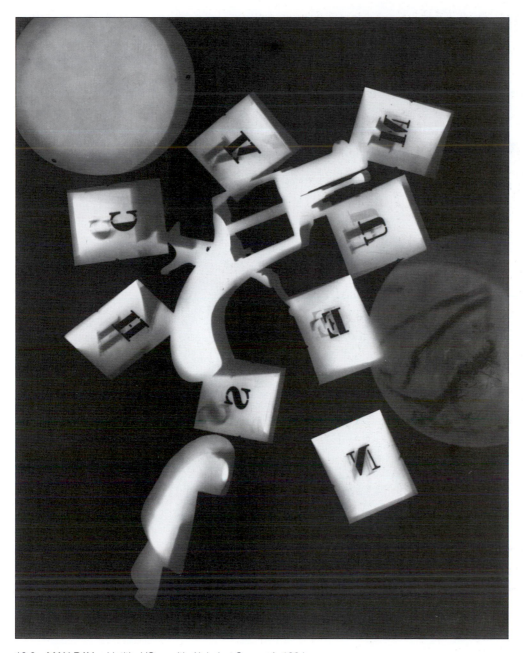

**10.8   MAN RAY.** *Untitled* (Gun with Alphabet Squares), 1924. 11⅝ × 9¼ inches. Gelatin silver print.   The J. Paul Getty Museum, Los Angeles.

This fundamental difference has continued to affect the practice of photography into the twenty-first century. One continues to be based on objective science and the other subjectively based on natural/spiritual ideals. This difference also caused a division between those who thought the purpose of photography was informational and those who wanted to push beyond the concerns of realism. In a 1913 issue of *Camera Work,* Stieglitz reproduced work by Steichen and displayed his own modernist stance with a boxed announcement:

Are you interested in the deeper meaning of Photography?

Are you interested in the evolution of Photography as a medium of expression?

Are you interested in the meaning of "Modern Art?"

Are you interested in the Development and Exposition of a living idea?

Are you interested in the Freedom of Thought and Freedom of Expression?

Camera Work is published for those who know or want to know.[19]

By 1917, Stieglitz and Paul Strand would become proponents of "straight" photography, whose essence and limitation lay in its unqualified objectivity and whose power was dependent on its purity of use. Others pursued "antiphotographic" pictorial strategies, but Stieglitz's views dominated the practice until the 1960s.

**Paul Strand** (1890–1976) became interested in photography at the Ethical Culture High School in New York, where he studied under the art critic Charles Caffin and took a photography course from Lewis W. Hine,

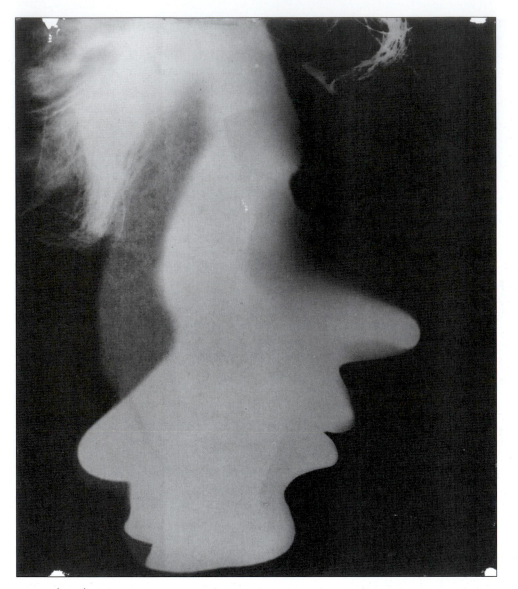

**10.9  LÁSZLÓ MOHOLY-NAGY.** *Untitled,* (Double portrait) 12¹⁄₁₆ × 10¾ inches. Gelatin silver print, Photogram. Moholy-Nagy stated: "The photogram . . . is the real key to photography. It allows us to capture the patterned interplay of light on a sheet of sensitized paper without recourse to any apparatus. The photogram opens up perspectives of a hitherto wholly unknown morphosis governed by optical laws peculiar to itself. It is the most completely dematerialized medium which the new vision commands."[20]  Victoria & Albert Museum, London.

who sent his class to Stieglitz's "291" gallery. After completing his studies and establishing himself as a commercial photographer, Strand was encouraged by Stieglitz to relinquish pictorial effects and experiment with the principles of cubism that led to his breakout images of 1916. The first of these hand camera images, *Wall Street* (Figure 10.7), showing the insect-sized human figure within the monumental concreteness of the metropolis, was reproduced in the October 1916 issue of *Camera Work.* In the final issue of *Camera*

*Work* (June 1917), Stieglitz presented a sequence of eleven Strand photogravures that moved from pictorialist notions into modernistic ideologies. Stieglitz's awareness of how the physical nature of a medium helps form the information the viewer receives led him to alter the way in which *Camera Work* was printed, eliminating his use of tissue proofs to make Strand's reproductions more effective. Stieglitz comments:

> These photographs are the direct expression of today. We have cut out the use of Japan tissue for these reproductions, not because of economy, but because the tissue proofs we made destroyed the directness of Mr. Strand's expression. In their presentation we have intentionally emphasized the spirit of their brutal directness.[21]

The powerfully edited series, which contained remnants of his earlier soft-focus style, presented emotionally charged images, such as *Man, Five Points Square, New York* (1916), an extreme close-up of a man's hopeless desperation. Another image, *New York,* moved towards abstraction with the tilted angle of the figures

and their shadows on the street. In 1916, images like *Abstraction* accentuated geometric form, sharper focus, and getting closer to the subject. By concentrating on important characteristics that could be understood in a concentrated structure, Strand informed viewers that these were not documents but abstract representations, making Strand not Stieglitz's protégé but one who was able to link modern art and photography.[22]

## Dada

At the beginning of the twentieth century many people looked to modern machine technology to make life easier and better. However, World War I unleashed an era of industrialized death that nullified most people's faith in the benevolence of technology and radically altered Western culture. The hand-held camera and faster emulsions allowed photographers to make such distressing images of World War I that governments often banned or censored frontline photographs. Many European artists were killed, fled to neutral cities, or emigrated to America. In New York Stieglitz offered artists, such as Francis Picabia (1879–1953), who helped establish a typographically emancipated arts journal, *291,* a cultural refuge. World War I marked the collapse of Europe as the center of Western civilization and the ascendancy of America as the driving cultural force of the twentieth century.

After World War I, a mass disillusion with a myth of the future based on the machine set in. Cosmopolitan European artists reacted to the war by launching an assault on the society that had unleashed such terror. Novels like James Joyce's *Ulysses* (1914–1921) ripped at the logic of language by destroying customary grammar and syntax. Visual artists dismantled what was left of Renaissance perspective and abandoned the precise rendition of heroic subjects in favor of works that relied on chance and irrationality. This collection of exiled artists called themselves *dadaists.*

Nobody knows who invented the name dada, but filmmaker Hans Richter believed it had a relation to the joyous Slavonic phrase, "Da, da" meaning "yes, yes" to life. Dada was never a style and did not have a didactic political or social agenda. Dada claimed the freedom to experiment, declaring play the preeminent human activity and using chance as its agent. Dadaists took art out of the studio and into the streets, creating early "happenings." Dadaist art was produced unconventionally and took unorthodox forms. Jean Arp dropped torn paper, "arranged according to the laws of chance," to form collages. Kurt Schwitters made collages out of garbage. Raoul Hausmann, Man Ray, and Morton Schamberg formed sinister assemblages out of everyday objects. Hannah Höch and John Heartfield reinvented photomontage. Their aggressive assault on bourgeois values, including the definition of what is art, enraged the public and led to dadaist works being labeled anti-art.

Marcel Duchamp, a member of the dada group, invented the idea of the *readymade,* common manufactured objects that he promoted to art by selecting and signing them. One readymade was a urinal entitled *Fountain* (1917). The point was to create "a new thought for that object," to demystify art by proclaiming that there were so many interesting things in the world there was no need to make more objects. Duchamp's approach was conceptual, making the mental act of choice, not the physical act of the hand, the center of creation. Readymades were Duchamp's antidote to what he called "retinal art," art that pleased the eye, because they put the idea before the visual manifestation. Duchamp also separated himself from the traditions of retinal art through his "assisted" readymade *LHOOQ* (1919), in which he added secondary male sexual characteristics— a black-penciled mustache and goatee—to a postcard of the "Mona Lisa." The uncouth French schoolboy title meant, for which *LHOOQ* was an abbreviation: "She's got a hot ass." This dada gesture satirized not only the cult of the masterpiece but the then forbidden subject of Leonardo's homosexuality and Duchamp's own curiosity and confusion concerning sexual roles. Along with Picabia, Duchamp influenced artists like Man Ray, who would bring dadaist concepts to photography. In view of the audience, the artistic stage was being struck of its traditional props and the reigning rules of beauty were being reformatted.

## Exploring Space and Time: The Return of the Photogram

Albert Einstein's (1879–1955) special theory of relativity (1905) changed the view of the universe more than any scientist since Isaac Newton. Artists were not mathematicians or philosophers, but their concerns were interwoven with those of an industrial world. Even without understanding the details of $E = mc^2$, some artists realized that the rules for ordering everyday life were faltering under the pressure of a multitude of new experiences and that innovative forms were needed to contain them.

Post–World War I artists reinvented the nineteenth-century *photogram* as a pictorial method of reinvestigating time and space. A photogram was made in a darkroom by placing an object on top of a photosensitive surface, exposing it to light, and processing it. A photogram could take an everyday object and transform it into something the human eye would not normally see, proving that human vision could not be trusted. Although photograms comply with optical laws and their processing can be controlled by normal methods, the results were unforeseeable and unique. Photographically faithful, yet liberated from Renaissance perspective, the photogram seemed able to instinctively express its own rules for representation. The photogram appeared

to be a "natural," automatic process, bypassing the pitfalls of representational systems.

**Man Ray** (Emmanuel Rudnitsky) (1890–1976), a painter and member of the New York dada group led by Duchamp and Picabia, had become acquainted with the modern art Stieglitz was presenting at "291" in 1910. In 1915, Man Ray learned photography in order to document his painting, but was soon experimenting with the machine motifs that fascinated his friends. Duchamp's cerebral skepticism about the emotional values of painting found an active, sensually poetic voice in Man Ray. Placing objects on white paper, Man Ray airbrushed paint around them, producing white forms on a colored ground similar in concept to the photogram (see Figure 10.8). Man Ray also "reinvented" the photogram in 1922. He later characterized his discovery as an unconscious, "automatic" darkroom happening that occurred in his tiny bathroom/darkroom when he "placed a small glass funnel, the graduate and the thermometer in the tray on the wetted paper and turned on the light."[23]

Immodestly, Ray called these cameraless images "rayographs." The enigmatic quality of the white shadows of the partially revealed everyday objects appealed to the dadaist love for the unexpected and pictorial belief in ordinary items. By moving his light source during the exposure and by shifting the objects in space above the paper, Ray extended the amount of time contained within the image and wreaked havoc with perspective. The technique also added depth and expanded the tonal range, making the work more gestural and dynamic. Ray continued these experiments for decades, selecting objects for their ability to invoke associations, feelings, and memories. The rayograph reopened the definition of a photograph by liberating it from the camera image, returning photography to its basic concept of creating an image through the agency of light.

A significant painter, sculptor, and filmmaker, Man Ray participated in the first international dada exhibition in Paris, joined the surrealist movement in 1924, and exhibited in the first surrealist show in Paris in 1925. He was an avid experimenter who combined diverse techniques, such as the Sabattier effect (or solarization) and the use of negative prints, to create "disturbing objects" that could extend awareness of the interior working of the mind (see Chapter 11). His ideas were also disseminated by his assistants, who included photographers Berenice Abbott, Bill Brandt, and Lee Miller. Arturo Schwarz wrote that "Man Ray never loved or felt admiration for the camera—to his students he would say, 'if you wish to make photographs throw your camera away!' Duchamp observed, 'It was his achievement to treat the camera as he treated the painter brush, as a mere instrument at the service of the mind.'"[24]

**László Moholy-Nagy** (1895–1946) was the third reinventor of the technique he called the *photogram*,[25] based on an analogy with the telegram. With Einstein working in Berlin and describing the world as a four-dimensional space-time continuum, it follows that the Berlin avant-garde would find new positions for observing the world. In Berlin, Moholy-Nagy sought to make images without transmitting the sentimental values of the hand and brush. In a search for a medium that retained its spiritual purity by "painting" itself, Moholy became interested in portraying the dynamics of light and space.

Moholy came from a constructivist background. *Constructivism* covered a period from 1913 through the 1920s during which Russian avant-garde artists rejected easel painting and the idea of "art for art's sake" in favor of utilitarian designs intended for mass production. Photography was an ideal constructivist medium: It was considered the antithesis of painting by many traditional artists and offered a way to make images in quantity. Moholy looked at photography as a means by which light, instead of paint, could sketch itself on a photosensitive surface. The obstacle in the direct link he sought was the camera lens. The photogram eliminated the lens, allowing pure light to directly picture itself as an organic element. The photogram permitted Moholy to retain the constructivist principle of "truth to materials" and reflect the constructivist celebration of scientific rationality and technology. Moholy's photogram of a face shows us an artist who uses his or her "head" to shape the constantly changing flow of light in time (during the photogram's production), space, and volume (see Figure 10.9). His later photograms moved away from identifiable objects to what Moholy referred to as "light modulators," allowing the experiments to concentrate on form and light as the source of content.

The photogram, as Talbot had first realized, was a "light paradox" that reversed the nineteenth century's trust in photographic description and narrative content. It inverted the values of the subject and produced a "negative" rendering with no narrative format. Without using mechanical darkroom equipment a photogram, unlike a normal photograph, revealed only what was blocked by the light, not what was illuminated by it. Like x-rays, photograms divulged unforeseen facets of reality. By banishing linear perspective, the photogram liberated photography from its role as the literal depictor of nature. These differences demonstrated the relativity of the viewing experience and even challenged the visually educated by denying viewers easy entry into the work. Moholy, who in 1929 called for "light studios to replace outdated painters' academies," situated the photogram as a fundamental photographic form capable of opening other doors of perception.

## Surrealism

Surrealism emerged after World War I from symbolism and dadaism. *Surrealism,* a term coined by the French poet and critic Guillaume Apollinaire (1880–1918) in

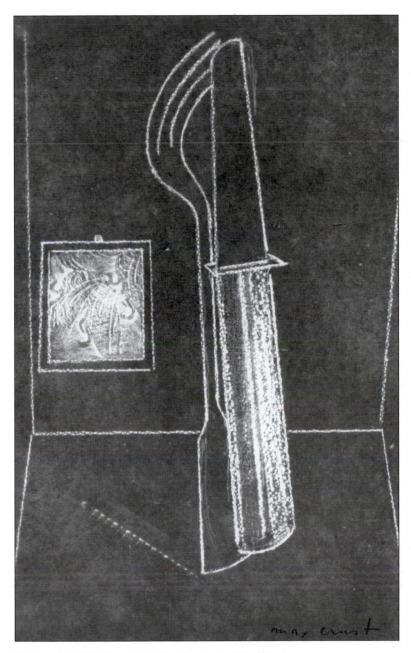

10.10    MAX ERNST.    *Mr. Knife, Miss Fork,* 1931. 9⁵⁄₁₆ ×
7½ inches. Cliché-verre.

is based on the belief in the superior reality of certain forms of previously neglected associations, in the omnipotence of dream, in the disinterested play of thought.[26]

Celebrating the dream as a method of problem solving, Breton looked towards "madness"—hallucination and illusions—as a pathway capable of freeing oneself from "the reign of logic." Breton described "the realistic attitude, inspired by positivism . . . [as] hostile to any intellectual or moral advancement . . . for it is made up of mediocrity, hate, and dull conceit . . . by flattering the lowest tastes."[27] People began to accept, in the 1930s, the notion that dreams could mirror repressed emotions and fantasies. Dream interpretation became in vogue, and photographers responded by devising images that evoked the prevailing look of the dream world.

## Collage

The collage works of **Max Ernst** (1891–1976) were an enigmatic group of fantasy images arranged in a dreamlike chance-encounter format. Based on readymade images, cut from catalogues and magazines, they offered up a dread-filled parallel universe that defied bourgeois explanation. Ernst's collage-novels took revenge on the late Victorian world of his youth by irrationally attacking and subverting its authoritarian underpinnings. Ernst wrested improbable meaning from images by using *frottage* (rubbing) and cliché-verre to illustrate books, such as *Mr. Knife, Miss Fork,* 1931.

Raoul Hausmann (1886–1971) was one of the Berlin dadaists who created avant-garde *photographic collages* out of cut-up photographs during the summer of 1918, based on a practice used in advertising since the nineteenth century. A photographic collage was produced when cut and/or torn pieces from one or more photographs were combined on a common support material. An expanded definition may include images from magazines and newspapers; combinations of colored papers, wallpaper, or fabric; natural materials such as flowers, leaves, and sand; and three-dimensional objects. There was no attempt to deny that the image was made up from a variety of source materials. It was not rephotographed and was itself presented as the final image.

Hausmann, along with German dadaists George Grosz, John Heartfield (see Chapter 14), and **Hannah Höch** (1889–1978), pushed the idea of using mass-printed source material by inventing the *photomontage*

1917, was a state of mind rather than a style. Begun as a European literary movement influenced by psychoanalytic thinking, surrealism helped to popularize Freudian notions about dreams, sex, the unconscious, and free association through methods, such as automatic writing, that liberated one from conscious reason and convention. The movement was defined by French poet André Breton (1896–1966) in his first "Manifesto of Surrealism" (1924) as:

> Psychic automatism in its pure state by which one proposes to express—verbally, by means of the written word, or in any other manner—the actual functioning of thought. Dictated by thought, in the absence of any control exercised by reason, exempt from any aesthetic or moral concern. . . . Surrealism

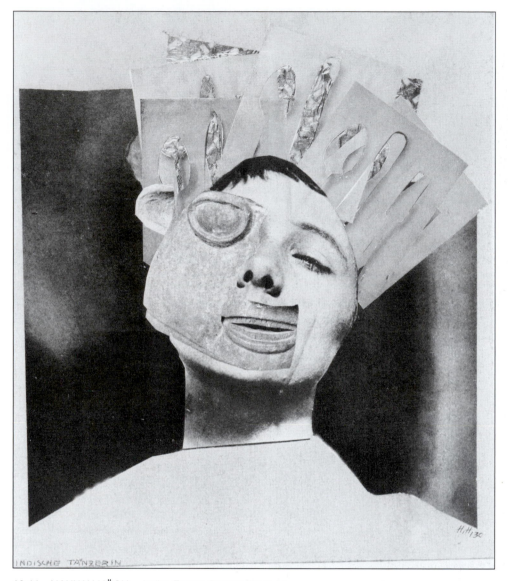

INDISCHE TÄNZERIN

**10.11   HANNAH HÖCH.**   *Indian Female Dancer (From an Ethnographic Museum),* 1930. 10⅛ × 8⅞ inches. Collage of cut and pasted papers and photographs on paper.   The Museum of Modern Art, New York.

in which pieces of photographs were combined into new compositions. A photographic montage follows the guidelines of collage, but the completed work is photographed so that the final image is converted back into a photographic print. This gives the option of using photographic methods to hide the sources of the work's various images and materials to create a new, seamless representation from which additional copies may be reproduced. Digital imaging tools have now eliminated intricate and laborious handwork.

They called their approach montage, meaning "assembly line," and termed the maker "monteur," or "engineer/mechanic," indicating that the picture was "engineered," not "created." World War I and the era's cultural and scientific revolutions affected the Ger-

man dadaists' syntax with the cut and torn refuse of urban life acting as a metaphor for the divided and fragmented society of the Weimar Republic. Combining found photographs and text enabled the dadaists to alter the original content and attack the bourgeois with images from their own publications. Höch's work offered insight into the *new woman,* the official redefinition of women's roles going on in German society. The increase in mass print media, Höch's raw material, supplied her with fresh images of women's changing identity—working, using appliances, and modeling in advertisements. Höch explored the intersection of avant-garde photomontage and the splintered experience of daily life in Weimar Germany. Her work deployed allegory, caricature, the grotesque, and irony, reflecting the dadaist concern with alienation (*Verfremdung*) and estrangement, taking the familiar and making it unfamiliar, and refashioning photo-based images into photomontages. Höch's disruptive, emotionally and sexually charged work played on tensions

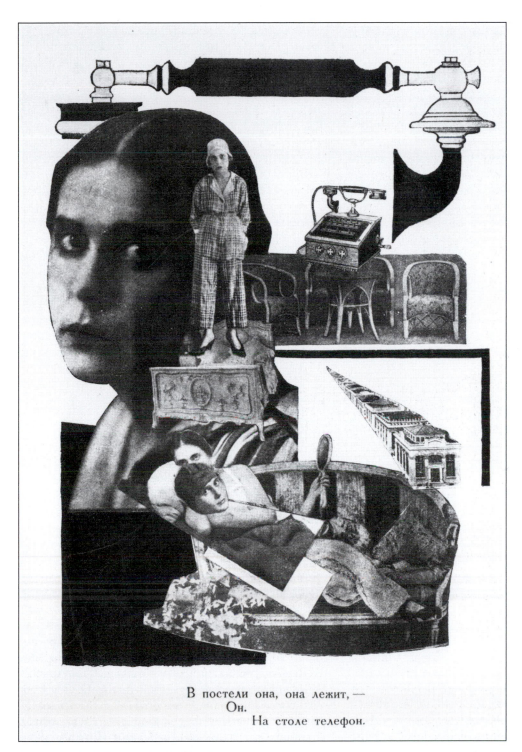

10.12 ALEKSANDR RODCHENKO. *She is on the bed, She's lying/He/The telephone is on the table,* 1923. From *Pro-Eto.* 6⅝ × 4⅞ inches. Offset lithograph. Rodchenko wrote: "In photography there is the old point of view, the angle of vision of a man who stands on the ground and looks straight ahead or, as I call it, makes "bellybutton" shots. . . . I fight this point of view, and will fight it, along with my colleagues in the new photography. The most interesting angle shots today are those "down from above" and "up from below," and their diagonals."[28]    Courtesy Howard Schickler Gallery, New York. Art © Estate of Aleksandr-Rodchenko/RAO, Moscow/VAGA, NY.

between anger/violence and pleasure/beauty to investigate issues of femininity and identity.[29] Some of Höch's other montages, like *Indian Female Dancer,* 1930 (see Figure 10.11), also fused Western and tribal imagery, thus dissolving the hierarchy that had defined their cultural relationship. Höch worked with montage throughout her life. Her cataloguing and reconfiguring of signs of modernism reflected the upheaval and uncertainty of the post–World War I Weimar period. Viewers saw the shattering and rearranging of traditional women's

roles, involving children, kitchen, and church, as one more frightening aspect of the change that led many to embrace national socialism.

In the 1920s and 1930s photomontage penetrated art and mass media in Germany, the Soviet Union, and the United States. It visualized common cultural themes in a new system of representation that ruptured the narrative format and Renaissance window frame. Montage broke out of "straight" photography's encasements and replaced it with reassembled images that conveyed a multifaceted sense of reality. It collapsed multiple points of views—discontinuous subjects, in different locations, and at various times—into a single, often unexpected, view. These newly created juxtapositions extended the concept of publicly acceptable reality by linking subjects that in turn formed new relationships that were not previously visible. This encouraged viewers to rethink their previous ideas about the subjects and formulate new opinions.

## Suprematism

**Aleksandr Rodchenko** (1891–1956) came from a *suprematism* background that gave artists permission to depart from the objective illustration of the world. Suprematism (1915–1923) was a Russian avant-garde movement to reduce painting to pure geometric abstraction by purging conspicuous allusions to the real world. It was the high-water mark for diverse artistic experiments affiliated with Russia's successful Bolshevik Revolution. Tracing its roots back to cubism and futurism, Kazimir Malevich defined the movement as "the supremacy of pure feeling." Suprematist ideas influenced constructivism and spread to the Bauhaus (see below) when they entered into the discourse of modern art.

A leader of the constructivists and a supporter of the Russian Revolution, Rodchenko viewed these new systems of seeing as a way to reshape society. In 1920, Rodchenko joined Inkhuk (the Institute of Artistic Culture), whose mission was to integrate art into everyday life. Abandoning painting for graphic design, Rodchenko designed some of the most original political posters in a Soviet culture where the poster was a primary form of mass communication. About 1923, Rodchenko came under the influence of El Lissitzky and Moholy-Nagy and commenced making photomontages (see Figure 10.12). El Lissitzky (Eliezer Markovich) (1890–1941), an innovative typographical designer, wed abstract form to social use. For Rodchenko photography was the ideal socialist medium: It was inexpensive, quick, and repeatable. Photography, according to Rodchenko, would furnish the monuments of the future: "What ought to remain of Lenin: an art bronze, oil portraits, etchings, watercolours, his secretary's diary, his friend's memoirs—or—a file of photographs taken of him at work and rest . . . ? I don't think there's a choice. Art has no place in modern life. . . . Every cultured modern man must wage war against art. . . . Photograph and be photographed!"[30]

By 1924, Rodchenko was using a small hand camera to make photographs of people and ordinary scenes that explored unconventional points of view. His pictures disturbed rules of composition and subject hierarchy, setting atypical priorities of visual importance. Seeing as the camera sees, Rodchenko developed an unusual grasp of space by tilting the camera and shooting from above or below the subject, using the instantaneous sense of the snapshot to create a sense of activity. These often diagonal compositions were reinforced by a rhythm of contrast between the highlight and shadow areas, delivering psychological retorts and factual information about the times. During an era when most Soviet photographers followed the party line and documented revolutionary acts by the customary means, Rodchenko defined a socially relevant photograph as a revolutionary act, one that destabilized an audience by portraying everyday scenes from unfamiliar angles.

## Art, Technology, and a New Faith

While some imagemakers were disassembling the narrative and looking for ways to visualize inner psychological experiences, others challenged the idea of content through their investigations of form based on the new technology. The most influential spot for these investigations was the *Bauhaus* school of art, craft, and design, founded in 1919 by architect Walter Gropius in the hyperinflationary economy of Weimar Germany. The Bauhaus, roughly meaning "building house," had its lineage in the socialist notions of the arts and crafts movement. Its curriculum was designed to synthesize architecture, painting, and sculpture into a single way of thinking and creating. In its effort to revitalize crafts, the Bauhaus, unlike the arts and crafts movement, sanctioned industrial technology. It sought to unite constructivist concern for modern materials with the emotional content of expressionism and the higher consciousness of spiritualism. Its faculty included Josef Albers, Herbert Bayer, Theo van Doesburg, Wassily Kandinsky, Paul Klee, El Lissitzky, and László Moholy-Nagy.

Under its credo, "Art and Technology, a new unity," the Bauhaus concentrated on functional craftsmanship as applied to the problems of mass production, producing revolutionary designs in tubular steel furniture, typography, and ceramics as well as experiments in abstract film, photography, dance, theater, and sculpture. Hitler closed the school in 1932, forcing most of the faculty to emigrate. Moholy-Nagy founded the New Bauhaus (now the Institute of Design, Illinois Institute

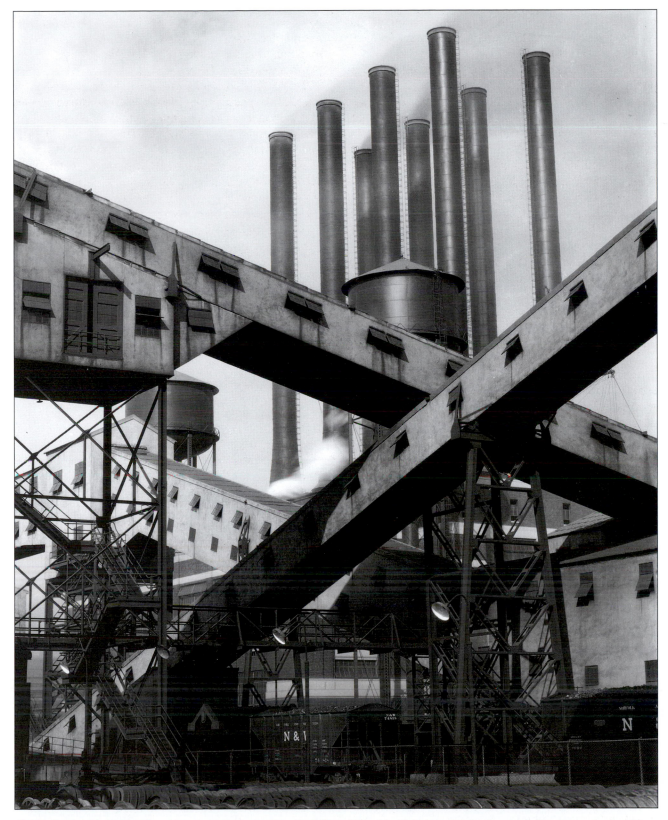

**10.13  CHARLES SHEELER.**  *Criss-Crossed Conveyors—Ford Plant,* 1927. 10 × 8 inches. Gelatin silver print. Sheeler summed up his analytical picturemaking method by stating: "I favor the picture that is planned and executed with the same consideration for its parts— within the complete design as is necessary in the building of a watch or an aeroplane."[31]     © The Lane Collection. Photograph courtesy Museum of Fine Arts, Boston.

**10.14  PAUL STRAND.**  *The Lathe,* 1923. 9¾ × 7½ inches.
Gelatin silver print.    Courtesy © Aperature Foundation, Inc., Paul Strand
Archive. Courtesy George Eastman House.

of Technology) in Chicago in 1937, which introduced new concepts about photographic process in the United States and established a precedent of teaching photography on the graduate level.

Philosopher Friedrich Nietzsche's proclamation about the death of God in 1882 was based on his observation that the rapid expansion of technology produced social change that caused traditional beliefs to crumble. Nietzsche wanted to create a new heroic morality, set in place by a breed of supermen whose "will to power" was needed to lead this new society. Others, out of this sense of anxiety, searched for this missing "essence" in nontraditional belief systems, from *theosophy,* a blend of

American transcendentalism and Hinduism, to *Swedenborgianism,* in which individual free will allows for profound communication with God. Scientific discoveries like Einstein's seemed to indicate that the world could not be trusted to be rational. For some, the pursuit of science offered hope of uncovering the essence of life.

In the heyday of American economic growth following World War I, American painters like Charles Demuth, Georgia O'Keeffe, Charles Scheeler, and Morton Schamberg took a more formalistic and highly materialistic approach to replacing their loss of faith and embraced the strong, self-evident precepts of *precisionism.* Precisionism (1918–1930) incorporated the streamlined design of cubism while retaining recognizable subject matter, reflecting American society's antagonism towards dematerialization and complete abstraction. Its spatially flattened formations celebrated

the down-to-earth, solid geometric forms of the technologically rooted industrial and architectural landscape of concrete and steel, such as factories, grain elevators, machines, and skyscrapers, with directness and simplicity.

The work of Morton Schamberg (1881–1918) and **Charles Sheeler** (1883–1965) exemplified what Strand considered to be "the very essence of photography," the camera's "absolute unqualified objectivity,"[32] to replace American faith in ephemeral spiritualism with something physical, an essence one could believe in regardless of what science discovered next. Schamberg's death in the flu epidemic of 1918 prematurely ended his work of placing abstracted machine parts into paintings and making cubist-derived, geometric urban photographs. In 1914, Sheeler initiated a series celebrating the "straight" American style of form and texture as found in Pennsylvania barns. Soon he was photographing the details of the unadorned interior of the stone farmhouse he shared with Schamberg, a house styled on necessity. This recognition of the plain design strength of line found its way into the modernist compositions that were fascinated with revealing the "soul" of machines. In 1923, Steichen hired Sheeler for *Vogue* and *Vanity Fair.* In 1927, Sheeler was commissioned to photograph the Ford Motor Works at River Rouge, site of Henry Ford's effort to manufacture a universal automobile through industrial standardization. Sheeler's concern for structure slimmed down the industrial compositions to a skeleton, delivering interacting, geometric forms without any trace of disorderly humanity. In his pictures, mechanical perfection reigned, allowing viewers to believe that the industrial landscape could lead to a logical utopia. These machine-based images served Sheeler as models for drawings and paintings that also celebrated the machine as heroic and stalwart subject matter (see Figure 10.13).

# Paul Strand and Straight Photography: Purity of Use

Writing in the final issue of *Camera Work,* Strand helped plot the course of "straight" photography for the next few generations:

> Photography . . . finds its raison d'être, like all media, in a complete uniqueness of means. This is an absolute unqualified objectivity. . . . The full potential power of every medium is dependent upon the purity of its use. . . . This means a real respect for the thing in front of him, expressed in terms of chiaroscuro. . . . The fullest realization of this accomplished without tricks of process or manipulation, through the use of straight photographic methods.[33]

After serving as an x-ray technician during World War I, Strand teamed up with Charles Sheeler to make a short film, *Mannahatta* (1921), combining confident, geometric visions of urban New York's skyscrapers with fragments of Walt Whitman's poems. In 1922, Strand purchased an Akeley motion picture camera and for the next seven years made his living doing film work.

In his article "Photography and the New God" (1922), Strand narrated the union of a fictional inventor and a scientist who created a "new Trinity: God the Machine, Materialistic Empiricism the Son, and Science the Holy Ghost." This fable aptly symbolized the new secular era whose deity was the machine. In a decade when Karel Câpek introduced the term "robot" in his play *R.U.R.* (1921) and the first American science fiction magazine, *Amazing Stories,* hit the stands (1926), Strand looked for ways to have his photographs embody this machine-conscious period (see Figure 10.14). Strand's formalistic and scientific outlook, on view in his machine images, opposed the emotional and irrational. These images would lay the groundwork for the mainline modernistic aesthetic values of photographic practice for nearly six decades, serving as visual indicators of a widening gulf between science and art.

# Endnotes

1   During this period the world witnessed the invention of the phonograph (1877), the incandescent filament lightbulb (1879), the recoil-operated machine gun (1882), synthetic fiber (1883), the steam turbine (1884), the electric motor and pneumatic tire (1888), the Diesel engine (1892), the Ford automobile, and the gramophone disk (1894). As the century drew to a close the pace became even more frenzied with the discovery of x-rays, the principles of rocket propulsion, and the publication of Freud's studies on hysteria (1895), and the opening of the Niagara Falls hydroelectric plant (1896). These were followed by the discovery of radium (1898), the magnetic recording of sound (1899), the first voice radio transmissions (1900), the Wright Brothers' first flight (1903), the digging of the Panama Canal (1904), and Albert Einstein's formulation of the *special theory of relativity* (1905), the photon theory of light (precursor of quantum theory), and his law of mass-energy equivalence, $E = mc^2$, the harbinger of the nuclear age.

2   Einstein discovered that as time expands, space contracts, annihilating Euclid's concept of space and time as separate phenomena. The popular understanding of this theory is expressed by the space traveler who comes back to earth almost unaged when compared to those who stayed on the planet.

3 See Anne Baldassari, *Picasso and Photography: The Dark Mirror* (Paris: Flammarion, 1997), 45–61.

4 It is not clear when Stieglitz first printed *The Steerage* as he didn't publish it until four years after making the negative. Some critics claim his account of taking *The Steerage,* which was written much later, acts as a self-serving retrospective effort to cover the fact that he didn't recognize the significance of the image until later. Nevertheless, *The Steerage* is emblematic of the new "straight" aesthetic.

5 Dorothy Norman, *Alfred Stieglitz: An American Seer* (New York: Random House, 1973), 76.

6 Calvin Tomkins, *Duchamp: A Biography* (New York: Henry Holt & Co., 1996), 117.

7 Norman, 76.

8 Ibid., 128.

9 Continued evidence of this lack of support can be witnessed in the funding of the National Endowment for the Arts, which was not established until 1965; its budget remains one of the smallest of any industrial nation.

10 See Kirk Varnedoe and Adam Gopnik, eds., *Modern Art and Popular Culture: Reading in High & Low* (New York: Harry N. Abrams and The Museum of Modern Art, 1990).

11 Robert Bogdan & Todd Weseloh, *Real Photo Postcard Guide: The People's Photography* (Syracuse, NY: Syracuse University Press, 2006).

12 Norman, 121.

13 Ibid., 212.

14 F. T. Marinetti, "The Founding and Manifesto of Futurism 1909"; reprinted in *Futurist Manifestos,* ed. Umbro Apol-lonio, The Documents of 20th Century Art (New York: Viking Press, 1973), 19–24.

15 Acting as an agent-provocateur for modern art, Marinetti called for the destruction of libraries and museums as "mausoleums" and glorified speed, violence, and war as "the world's only hygiene." The futurist worship of the machine and the belief that technology would allow humans to solve all their social ills, was supported by many of Europe's avant-garde. The futurists welcomed the start of World War I as the end of nineteenth-century civilization, but it had the side effect of killing some of the group's most talented members. After the war, the surviving futurists were assimilated into fascism.

16 During this procedure, tiny electric lights, blinking twenty times a second, were secured to a worker's wrists and a single sequence of the subject's motions were recorded in a darkened space called the "betterment room." The direction of the hand movements was easy to see as the photographic plate saw the light tracings as discrete, white, pearl-shaped increments. Distance was gauged through the use of a background grid. Time was measured by including a clock. The distance between the light fragments indicated pauses and variations in speed.

17 Paul Strand in *The Snapshot,* Jonathan Green, ed., *Aperture,* vol. 19, no. 1, 48–49, also as a book 1974.

18 Marius de Zayas. "Photography and Artistic-Photography," *Camera Work,* 42/43 (April/July 1913), 13–14.

19 *Camera Work* 42/43 (April/July 1913), unp.

20 Moholy-Nagy, "A New Instrument of Vision," *Telehor* (Brno, 1936); reprinted in Richard Kostelanetz, ed. *Moholy-Nagy* (New York: Praeger, 1970), 50.

21 Alfred Stieglitz, *Camera Work,* 49/50, (June 1917), 36.

22 See Maria Morris Hambourg, *Paul Strand Circa 1916* (New York: The Metropolitan Museum of Art, 1998).

23 See Arturo Schwarz, *Man Ray: The Rigour of Imagination* (New York: Rizzoli, 1977), 236.

24 Schwarz, 230.

25 Moholy-Nagy first introduced the term photogram in his *Malerei Fotografie Film* (Munich, 1925), Bauhaus Book no. 8.

26 Jean-Jacques Pauvert, ed., *André Breton: Manifestoes of Surrealism,* translated by Richard Seaver and Helen R. Lane (Ann Arbor: The University of Michigan Press, 1972), 26.

27 Ibid., 6.

28 Beaumont Newhall, *The History of Photography,* 1982, 201.

29 See Maud Lavin, *Cut with the Kitchen Knife: The Weimar Photomontages of Hannah Höch* (New Haven: Yale University Press, 1993).

30 Robert Hughes, *The Shock of the New,* (New York: Alfred A. Knopf, 1981) 95.

31 Archives of American Art, Charles Sheeler Papers, 4 pp., n.d., Reel NSH–1. Quoted in Merrill Schleier. *The Skyscraper in American Art,* 1890–1931 (New York: Da Capo Press, republication, 1986), 80.

32 Paul Strand, "Photography," *The Seven Arts,* vol. 2, no. 10 (August 1917), 524.

33 Paul Strand, "Photography," *Camera Work* nos. 49/50, (June 1917), 3.

# The New Culture of Light

## Teaching Modernism: The American Impulse

The chaos of post–World War I Europe gave America the opportunity to assume a leadership role as a global cultural center. Although another major war would be fought before the American art world did so persuasively, between the end of World War I in 1918 and the start of World War II in 1939, Americans took on an active role in shaping Western photographic practice. America did not have a tradition of cathedrals, frescoes, and monumental sculpture. It was precisely this lack of history that gave American photographers the freedom to turn to their own native cultural strengths—Puritan simplicity, mechanical ingenuity, and the building materials of an industrial society—for the basis of their approach. The adventurous left behind the moody, soft, moist air look of pictorialism in favor of a harder and more direct approach. It almost seemed as if the spiritual quality of light in the new world was cleaner, clearer, and sharper than the refined atmosphere of the old world. The American approach to light gave spiritual significance to the ordinary subjects of a material culture dedicated to finding better, faster, more affordable ways

11.1   PAUL OUTERBRIDGE.   *Chrankshaft Silhouetted Against Car,* 1923. 1⁷⁄₁₆ × 4¹⁄₁₆ inches. Platinum print. Inspired by Strand's Akeley movie camera series, Outerbridge photographed machine parts as if they were sculptures, converting the ordinary into the remarkable. His work unfolded from the belief that "to appreciate photography one must dissociate it from other forms of art expression. Instead of holding a preconceived idea of art, founded on painting, it must be considered as a distinct medium of expression—a medium capable of doing certain things which can be accomplished no other way."[1]   San Francisco Museum of Modern Art.

of performing tasks in order to make goods affordable to all. Instead of building another Chartres, Americans like Henry Ford built automobile assembly lines, manufacturing an entire culture around a mass-produced item that promised personal freedom.

In addition to the activities at "291," the Clarence H. White School of Photography (1914–1942), which offered classes in New York, Connecticut, and Maine was a site for the modernist aesthetic, especially through the design theories of Arthur Wesley Dow, who emphasized simplified geometric design as the basic structure of art.[2] While photography in Europe continued to be taught as a commercial craft in an apprenticeship system, the White School applied the artistic principles of modernism to training a generation of professionals, including Paul Outerbridge, Anton Bruehl (1900–1982), Ralph Steiner, Laura Gilpin, Margaret Bourke-White, Dorothea Lange, Karl Struss (1886–1981), and Doris Ulmann (1884–1934). The only school in the United States devoted exclusively to the instruction of art photography, it set a precedent for American leadership of photographic education in the twentieth century.

**Paul Outerbridge** (1896–1958), a White School alumnus, influenced the commercial field by combining the new "direct" aesthetic and the celebration of technologically derived objects, like an automotive camshaft, as heroic subject matter. Ralph Steiner's (1899–1986) close-up of typewriter keys, a machine for making words, used Arthur Dow's ideas about controlling highlights and shadows to accentuate the abstract

harmony within his vernacular subject matter, providing them with a spiritual base in fact. After completing her studies with White, Laura Gilpin (1891–1979) returned to the Southwest and opened a commercial portrait studio, but she continued to emphasize design and the unity of geometric pattern through her recording of indigenous American cultures that often integrated the native architectural forms within the landscape. **Margaret Bourke-White** (1904–1971), a student of White's at Columbia University, emerged in the late twenties with an industrial series on the Otis Steel Mills in Ohio, whose products went into the making of automobiles and skyscrapers (see Figure 11.2). This work, especially the active interior views, came to the notice of Henry Luce, who hired Bourke-White for his new publication, *Fortune* (1930), as her choice of subjects echoed the magazine's editorial interest in finance and technology.

## Stieglitz's "Equivalents"

After a decade of facilitating the work of others, **Alfred Stieglitz** returned to making images. In 1918, he embarked on a decade-long, cumulative psychological portrait series of his wife-to-be, painter Georgia O'Keeffe (1887–1986). The intimate-sized contact prints portray O'Keeffe abstractly, heroically, and personally. This extended portrait is a collaboration, an intellectual dialogue that challenged, enriched, and melded the ambitions, drives, and talents of both artists.

In 1922, Stieglitz continued to explore this inner psychological theme, but he returned one last time to nature and symbolist theory and isolated the sky as a surrogate heart. Excluding all traces of land, clouds became Stieglitz's abstract, metaphoric equations of his emotions and psychological states, a personal testament that the universe is a comprehensible component of the self. The "Equivalents" demonstrated Stieglitz's symbolic power to recast the everyday with spiritual significance in the midst of the post–World War I atmosphere of nihilism. His idea of an equivalent world

11.2  MARGARET BOURKE-WHITE.  *Hot Pigs,* Otis Steel Mills, Cleveland, 1928. 18¼ × 14⅟₁₆ inches. Gelatin silver print. Bourke-White's romantic admiration of functional architecture can be seen in her later pictures for *Fortune* and *Life* magazines. Bourke-White wrote: "To me . . . industrial forms were all the more beautiful because they were never designed to be beautiful. They had a simplicity of line that came from their direct application of purpose. Industry . . . had evolved an unconscious beauty—often a hidden beauty that was waiting to be discovered."³  © Margaret Bourke-White Estate.

that could extend an aesthetic sensibility to be applied to any subject, regardless of its external context and use in daily life. This not only freed his subject matter from literal interpretation, but it also released Stieglitz from the confines of his print's edges and allowed his images to take on a much larger mental stance that no longer relied on the physical attributes of the picture (see Figure 11.3).

During the 1920s, Stieglitz responded to the culture of the machine by making pictures from his Manhattan apartment window of the new steel skyscrapers arising amid the old brownstones (see Figure 11.4). The post–World War I building boom thrust the skyscraper into the American topography and psyche as its image proliferated throughout the arts. Stieglitz recognized the social price attached to the skyscraper mania, and his images juxtaposed symbols of progress with their accompanying alienation. Human scale lost its significance among the long black shadows cast by the shiny techno-mega-structures that crowded out the past. As he aged, Stieglitz lost interest in spreading his ideas via the graphic arts and was increasingly concerned with presenting his

11.3   ALFRED STIEGLITZ.   *Equivalent,* 1930. 6⅝ × 4⅝ inches. Gelatin silver print. For his "Equivalents," Stieglitz photographed around Lake George in upstate New York with a 4 × 5-inch Graflex camera and made only contact prints on gelatin silver paper. He presented his goals as a visual riddle: "My aim is increasingly to make my photographs look so much like photographs that unless one has eyes and sees, they won't be seen—and still everyone will never forget them having once looked at them."[4]   Courtesy George Eastman House.

cabalistic conclusions about modernistic art and photography in a majestic, patrician manner. To that end, he remained active as a New York City impresario, promoting modern painters and a few photographers at the Anderson Galleries (1917–1925), before operating the Intimate Gallery (1925–1929), and then An American Place until his death in 1946.

## Steichen Goes Commercial

In 1911, the year following the *International Exhibition of Pictorial Photography* in Buffalo, NY, **Edward Steichen** made his first fashion photographs, applying his artistic precepts to commercial photography. This led to his falling out with Stieglitz. Never having to earn a living through his photography, Stieglitz had complex and unrealistic attitudes about the activities that artists could do for money without selling their artistic souls to the devil. During World War I, Steichen was commander of the photographic division of the Army Expeditionary Forces, in charge of aerial photography. Discovering beauty in these high-definition pictures led Steichen to reject his soft-focus gum prints and burn his paintings. To reinvent himself, he devised visual

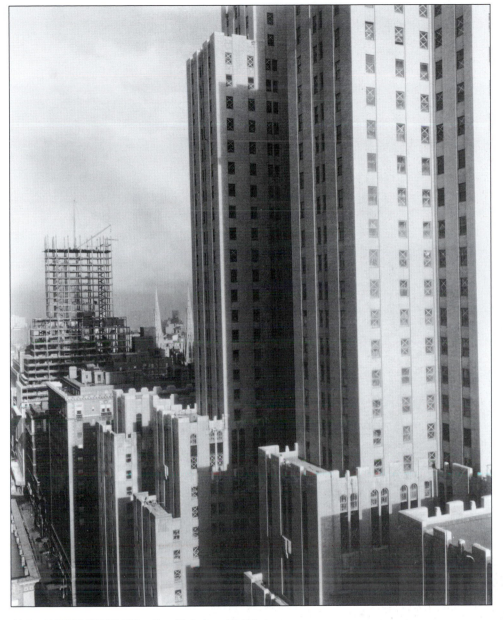

11.4 ALFRED STIEGLITZ. *New York, from My Window at the Shelton, West,* 1931. 7⅝ × 5¾ inches. Gelatin silver print.   Courtesy George Eastman House.

exercises, such as lighting and photographing a white tea cup on a black background a thousand different ways. Steichen became chief photographer for Condé Nast Publications in 1923, translating his newly learned visual data onto the printed pages of popular magazines (see Figure 11.5).

## Form as Essence

**Edward Henry Weston** (1886–1958) received his first camera in 1902 and by 1906 was working as a door-to-door photographer. After attending the Illinois College of Photography, Weston ran a successful portrait studio in Glendale, CA, from 1911 to 1922, where he was known for his soft-focus, pictorial style. During this period, under the influence of his studio partner, Margrethe Mather (1885–1952), and his apprentice and friend, Johan Hagemeyer (1884–1962), Weston awakened to the modernist directions in art and reevaluated his own work.

In 1922, Weston traveled to New York to meet the leaders of the modernist photography movement, Alfred Stieglitz, Paul Strand, Charles Sheeler, and Clarence White. On this journey Weston stopped in Ohio to photograph the American Rolling Mill (Armco) steelworks. These precise, straightforward images honor industrial architecture and technology while displaying Weston's ability to visually sort complex subjects into simplified semi-abstract form, marking a distinctive break with his pictorial origins.

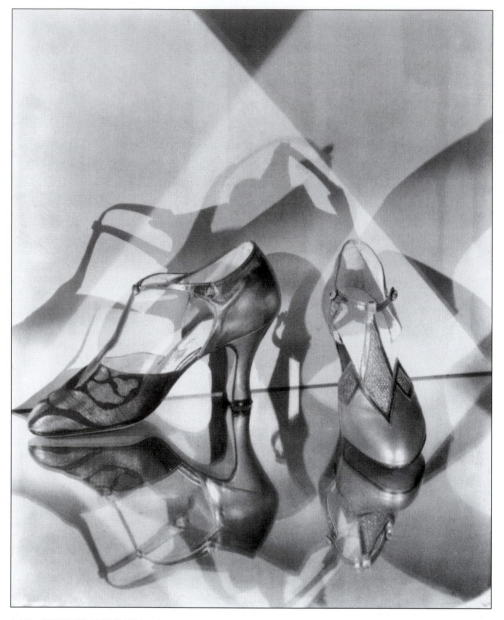

**11.5   EDWARD STEICHEN.**   *Shoes,* ca. 1929. 7⅞ × 7½ inches. Photogravure. Publishing regularly in *Vogue* and *Vanity Fair* for fifteen years, Steichen introduced the notion of modernism to a cosmopolitan audience interested in fashionably adorning itself. His product shots and his celebrity portraits of Charles Chaplin, Greta Garbo, and Gloria Swanson, among others, bring out the personality of each product or subject within the confines of a precisely designed and lit set.   Reprinted with permission of Joanna T. Steichen, Carousel Research.

In 1923, Weston moved to Mexico City and opened a studio with his lover and apprentice, Tina Modotti. Through Modotti, Weston became acquainted with members of the Mexican Renaissance, such as the mural painter Diego Rivera (1886–1957), whose dynamic social and political works was heroic in scope. During this period of self-analysis Weston began his *Daybooks,*[5] notebooks in which for the next twenty years he detailed his artistic struggles, emotional anxieties, and financial dilemmas. He wrote:

> the camera should be used for a recording of *life,* for rendering the very substance and quintessence of the *thing itself,* whether it be polished steel or palpitating flesh. . . . I feel definite in my belief that the approach to photography is through realism—and its most difficult approach.[6]

Weston's work was about what lies beyond the subject and its form. For Weston, "the thing itself" was not the recording of what was in front of the camera, but a search for what the popular philosopher Henri Bergson called "life force," the pure essence of existence.[7] Hence Weston wrote of the "seeing of parts—fragments—as universal symbols"[8] that are interchangeable. Through this transformative process of reducing the subject to its fundamental structure, Weston worked to reunite rational thought and subjective feeling. The

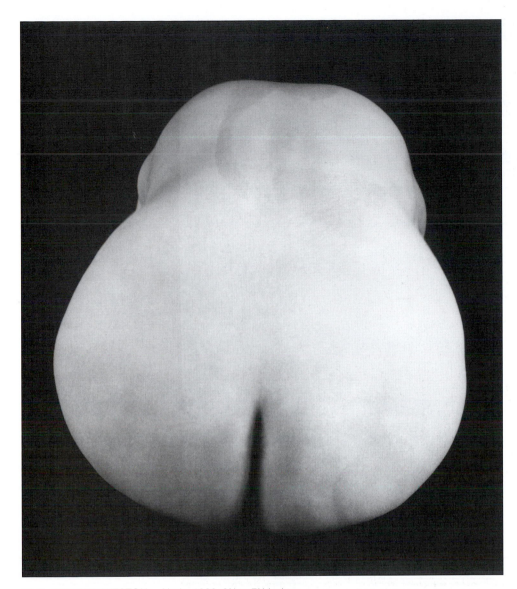

11.6 EDWARD WESTON. *Nude*, 1926. 8½ × 7½ inches. Gelatin silver print. Weston's sensual and sexual energy can be seen in over one hundred nude female studies made between 1918 and 1945. Unlike Stieglitz, Weston's approach was less romantic and more modern, not commemorating an individual but gazing at the female body with a coolness that eluded him in his private life. Weston's photographs acknowledge the beauty of the female body, and he later makes this appeal eternal by linking it with other organic life forms.   Collection Center for Creative Photography © 1981 Arizona Board of Regents.

ground glass became a site for harmonizing the technology and science of photography with a spiritual quest for knowledge of nature's most basic extract—the underlying unity of life forms. To obtain this Bergsonian vision, Weston changed his approach to make his method one with his aesthetic through his concept of *previsualization*, the ability to see one's finished print on the ground glass in all its desired qualities and values before exposure.[9]

To achieve explicitness of form, Weston put aside his soft-focus lens for a sharp focusing Rapid-Rectilinear. "The shutter stops down to 256 [the modern equivalent is f/64]; this should satisfy my craving for more depth of focus,"[10] he wrote. He began giving up the soft, subtle tonal range of the platinum paper for the sharper, more punchy tones of the gelatin silver paper. As Weston's compositions grew tighter, eliminating nonessentials, he repudiated the fashionable studio portrait to prove the unimportance of subject matter. He also simplified his darkroom, rejecting enlargements and using only a light bulb to make detail-packed contact prints. For two weeks Weston studied and photographed a toilet bowl, turning the modernist axiom of "form follows function" inside out by removing the form from its function and comparing it to a smooth-flowing, sensual shape.

In 1927, Weston moved to Carmel, CA, where he applied his lessons in abstraction to making close-up images of organic objects. Fruits and vegetables were isolated in a wash basin, photographed in natural light,

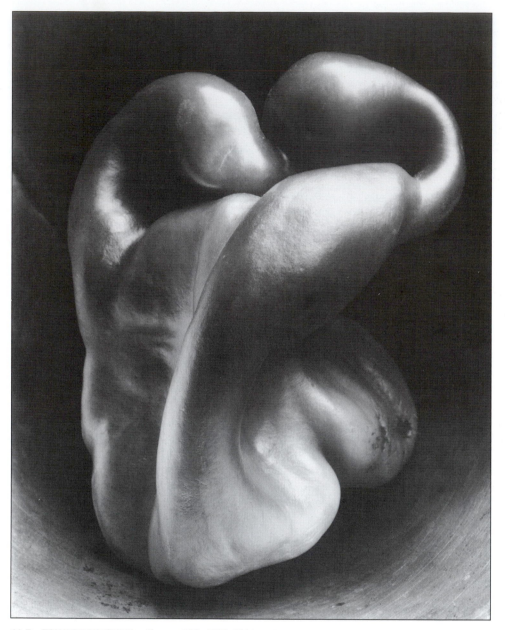

**11.7   EDWARD WESTON.**   *Pepper #30,* 1930. 9⅝ ×
7½ inches. Gelatin silver print. "Life is a coherent whole: rocks,
clouds, trees, shells, torsos, smokestacks, peppers, are interrelated,
interdependent parts of the whole. Rhythm from one become
symbols of all. The creative force in man feels and records these
rhythms, these forms, with the medium most suitable to him."[11]
Collection Center for Creative Photography © 1981 Arizona Board of Regents.

and then eaten, satisfying Weston's physical and meta-
physical hunger (see Figure 11.7). Later Weston applied
the same abstract approach within the landscape, alter-
ing and disguising scale so that organic matter turned
into architectural form. By the early 1940s, Weston was
reversing the process so that industrial sites could be
viewed as organic shapes.

In 1937 and again in 1938, Weston became the first
photographer to receive a John Guggenheim Memo-
rial Foundation Fellowship, easing his financial stress
and leading to the publication of *California and the
West* (1940).[12] The Guggenheim gave Weston freedom
and time to apply to the Western landscape what he
had learned about reducing a subject to its essential
form. The result can be seen in his meditative desert
sand dune images where the vastness of the landscape
overwhelms human scale and emptiness is everything.
The sensual, textural beauty of the dunes supplants the
human figure and the earth itself is presented as a nude.
The minimalism of the scene is accentuated to reveal
the spiritual essence within its apparent nothingness.
Often working with his son Brett Weston (1911–1993),
Weston's last Point Lobos, CA, images, made with
spare, pristine working methods, give concrete form to
his belief that "one must feel definitely, fully, before the
exposure [is made]."[13]

# Straight, Modernistic Photography

Group f/64 (1932–1935), founded in Oakland, CA, was a loose band of seven photographers—Edward Weston, Ansel Adams, Imogen Cunningham, Willard Van Dyke (1906–1986), Sonya Noskowiak (1900–1975), John Paul Edwards (1883–1968), and Henry Swift (1890–1960)—who promoted straight, modernistic photography. With their aesthetic stance based in precisionism, they named themselves after the smallest aperture on the camera lens, expressing their allegiance to sharply focused images printed on glossy gelatin silver papers without any signs of pictorial "handwork" and mounted on white board. Favoring natural forms and found objects, they offered an alternative to Stieglitz's disdainful urban bias against the naturalistic West Coast artists and the California pictorialist style.

In the 1920s, **Ansel Adams** (1902–1984) split his time between taking photographs for the Sierra Club and playing music, but after seeing some of Paul Strand's negatives he decided to devote himself to photography. The public came to see his images as the absolute pictorial testimony of the American Western landscape, a site of inspiration and redemptive power that must be preserved. Adams's visual understanding came from being in tune with the changing nature of light and how it moves within the landscape. To be able to record the visual sensations of a specific quality of light, at a precise location, and at an exact moment, Adams, with the help of Fred Archer (1889–1963), developed the *Zone System* in the late 1930s.

The Zone System takes the conceptual basis of Group f/64 and gives photographers a practical, yet scientifically grounded, method to implement their vision by controlling exposure, development, and printing, incisively translating detail, scale, texture, and tone into the final image. A *zone* represents the relationship of a subject's brightness to its density in the negative and the corresponding tone in the final print. Adams took the grayscale of a full-tone black-and-white print and refined it into eleven different zones, from Zone 0, maximum black, to Zone X, pure white. Adams identified the zones with Roman numerals to avoid confusion with other numerical combinations used in photography. Each zone is the equivalent to one f/stop difference in subject brightness and negative exposure. The zone system is designed to eliminate guesswork and give photographers repeatable control over their materials so that the outcome can be predicted (that is, previsualized).

Through Adams's writing, publications, and workshops, the Zone System became so popular with serious imagemakers for its ability to scientifically offer artistic control of the photographic process that it eclipsed other forms of printmaking. As with any method, the Zone System has been abused by the unthinking, who turned it into aesthetic dogma, which was never Adams's intent. Images like *Mono Lake Reflections, CA* (see Figure 11.8), reveal how Adams's interpretations fused seemingly competing concerns. The foreground and background are razor sharp and utterly still while the middleground moves. Dark shadows compete with bright highlights. The image uses the straight nature of photography not to report but to interpret and recite silvery poetry. It is accessible without pandering. The view is not overly dramatic or romantic but possesses subtleties that will be yielded on serious viewing. It is mythological, conveying a sense of optimism about the open Western space that says there are still uncovered possibilities in America and our society can push on into the future. These transcendental qualities allow the work to escape the "thingness" that can be so stifling and evoke a sense of essence about a place. By the 1960s, the accessibility of Adams's images, the respect for his technical brilliance, and the ability of his work to command higher prices gained photography entrance into a broader range of arenas, including mass media, galleries, and museums.

**Imogen Cunningham** (1883–1976) took up photography in 1901 after seeing the work of Gertrude Käsebier. By 1910 she had opened her own studio. As with the other members of Group f/64, Cunningham was a romantic pictorialist who took up modernism with the zeal of a convert. Cunningham's allegiance was clearly with Group f/64's credo that the "greatest aesthetic beauty, the fullest power of expression, the real worth of the medium lies in its pure form rather than in its superficial modifications."[14] The changes in Cunningham's work, from soft-focus pictorialism to sharply focused, geometric compositions (see Figure 11.9), parallel the economic collapse that led modernism into the documentary realism of the 1930s. As the fascination with technology was replaced by the immediate need to find solutions to Depression-era social problems, questions about the proper function of art and the correct use of materials replaced disputes over style, and abstraction gave way to straight descriptions of everyday culture.

The antithesis of Group f/64's philosophy can be seen in **William Mortensen's** (1897–1965) prolific output of melodramatic tableaux, instructional books, and classes. His work was so at odds with Group f/64's fundamental beliefs that Ansel Adams once referred to Mortensen as the "Antichrist." Mortensen's hand-manipulated work portrayed women under the control of male power, in male fantasies of domination (see Figure 11.10). His work rejected as mechanistic the doctrine of the straight print, seeing it as only one gateway for expression. Mortensen thought Group f/64's stance was hypocritical in allowing manipulation of tonality for "emotional" effect while labeling other forms of

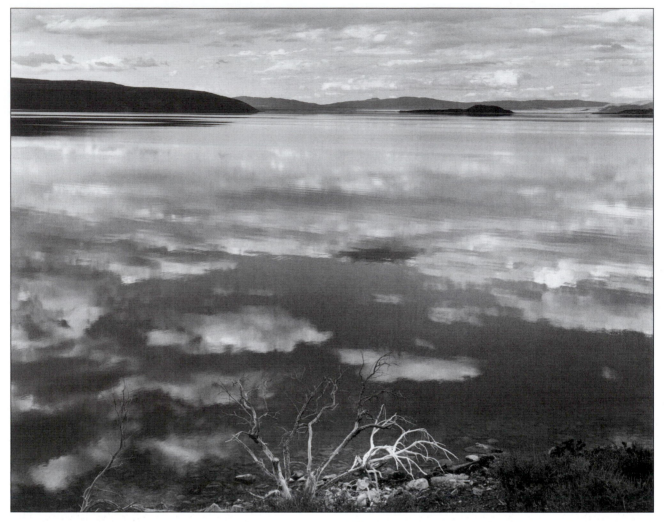

**11.8  ANSEL ADAMS.**  *Mono Lake Reflections, CA,* ca. 1947.
9⁵⁄₁₆ × 12 inches. Gelatin silver print. Adams believed that
photography was about interaction. He often compared the
negative to a musical score and the print to its performance. It
was Adams's view that: "The picture we make is never made for
us alone; it is, and should be a communication—to reach as many
people as possible without dilution of quality or intensity. . . . To the
complaint 'There are no people in these photographs,' I respond,
There are always two people, the photographer and the viewer."[15]
© Ansel Adams Publishing Rights Trust/Corbis.

manipulation unacceptable. As far as Mortensen was
concerned, "If tone is granted to be subject to control,
why not line, also, which has equal emotional signifi-
cance? And if line, why not shapes and forms? . . . And
if all these things are allowed, what becomes of the
'record of actuality?' . . . sunk without a trace."[16]

## Film und Foto
## and New Objectivity

Europeans continued to push the boundaries of the con-
ceptual practices of photography with projects like the
1929 international exhibition, *Film und Foto,* organized
in Stuttgart by the Deutscher Werkbund, a professional
organization of artists, craftspeople, and manufactur-
ers. At *Film und Foto,* the precisionist American and
the conceptually adventurous European ideas about
modern photography commingled. Weston selected
Cunningham's unromantic work along with the images
of Berenice Abbott, Paul Outerbridge, Edward Stei-
chen, Charles Sheeler, and his own for the exhibition.
Bauhaus master László Moholy-Nagy put together a
blend of advertising, artistic, journalistic, and scientific
images, disregarding their original context, to promote
photography as a flexible medium of communication.
To advance his ideas about light, geometric form, and
space, Moholy included his own works and those of
Albert Renger-Patzsch, Herbert Bayer, John Heartfield,
Florence Henri, André Kertész, El Lissitzky, Man Ray,
and Aleksandr Rodchenko. *Film und Foto* also linked
the most daring film and photography of the modern-
ist movement, screening Sergei Eisenstein's *Potemkin*
(1925), Dziga Vertov's *Man With a Movie Camera*
(1928), and Man Ray's *L'Etoile de Mer* (1928).

**Albert Renger-Patzsch's** (1897–1966) *Die Welt ist
schön (The World Is Beautiful),* 1928, exemplified the

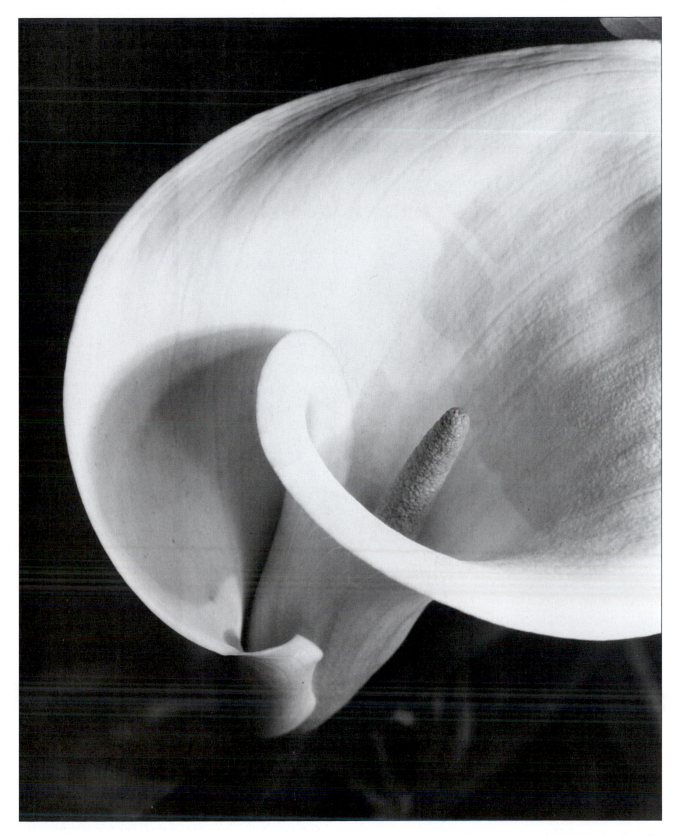

**11.9  IMOGEN CUNNINGHAM.**  *Calla,* ca. 1925. 11 ×
9½ inches. Gelatin silver print. While caring for her young children,
Cunningham condensed her domestic landscape into still life.
Her tightly rendered plant studies present nature with machine
precision or as sexual allusion, drawing sensual parallels to the
female form that she explored through her long career. Although
the picture is a faithful rendering of a plant, Cunningham's concern
was not the subject itself but what the subject could become
under special circumstances controlled by the photographer.
Courtesy Imogen Cunningham. © The Imogen Cunningham Trust.

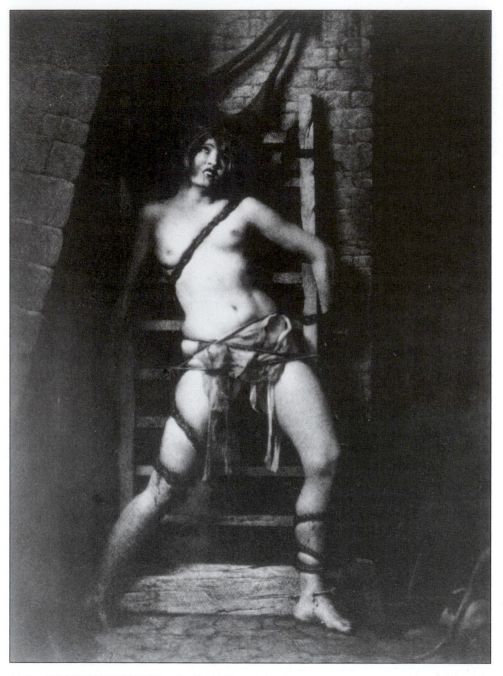

**11.10 WILLIAM MORTENSEN.** *The Spider Torture,* ca. 1934. 7⅝ × 5¾ inches. In his essay, "Fallacies of 'Pure Photography,'" Mortensen challenged the assumptions of Group f/64 by stating: "Purists and puritans alike have been marked by a crusading devotion to self-defined fundamentals, by a tendency to sweeping condemnation of all who over-step the boundaries they have set up, and by grim disapproval of the more pleasing and graceful things in life."[17] Courtesy George Eastman House.

concern for order in modernist German photography. The book alternated tight shots of animals, landscapes, and plants with factories and industrial equipment; there was no text on the picture pages. The concept showed the interrelationship between natural forms and machine-made objects, demonstrating the formal structure of all things. Renger-Patzsch relied on photography to classify and order subjects from the chaotic flow of the Weimar Republic. Whether the subject was industrial or natural, Renger-Patzsch applied a narrow clinical template of unyielding visual precision that removed and isolated the subject from its worldly context for viewer scrutiny. For instance, Renger-Patzsch chose a flower not for its softness or sensuality but for its sharp, repetitive features that did not invite intimacy or sentimentality (see Figure 11.11). For Renger-Patzsch, photography was a tool of natural science, encouraging viewers to ignore the individuality of the subject and see it analytically as a specimen to be cat-

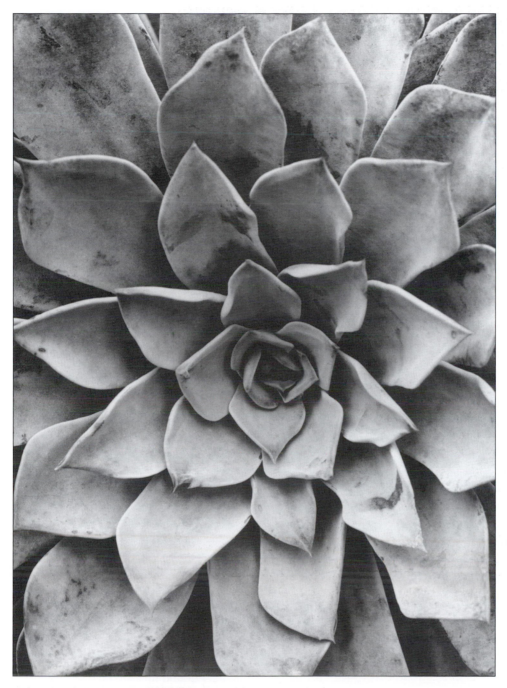

**11.11  ALBERT RENGER-PATZSCH.**  *Echeoeria,* 1922. 15 × 11 inches. Gelatin silver print.

egorized, labeled, and filed, and therefore known and safe to handle.

Renger-Patzsch's belief in "photographic photography," allowing "a fragment to symbolize the whole" and the "sharpness of photographic seeing [to] conjure up the fantastic in everyday nature,"[18] formed the underpinnings of *neue Sachlichkeit (New Objectivity),* as straight photography was known in Germany during the 1920s. The director of *Film und Foto,* Gustaf Stotz, observed the effect of this quest for structural order:

We see things differently now, without painterly intent in the impressionistic sense. Today things are important that earlier were hardly noticed: for example shoe lasts, gutters, spools of thread, fabrics, machine, etc. They interest us for their material substance, for the simple quality of the thing-in-itself; they interest us as means of creating space-form surfaces.[19]

The close-up became one of the main compositional devices in the New Objectivity. **Karl Blossfeldt's** (1865–1932) book *Urformen der Kunst* (*Art Forms in Nature,* 1928; English-language edition, 1932) used macro- and microscopic photography to present the "artistic" organizing patterns in nature. Such extreme views were intended to eliminate all atmospheric effects and personal reactions and to reveal a

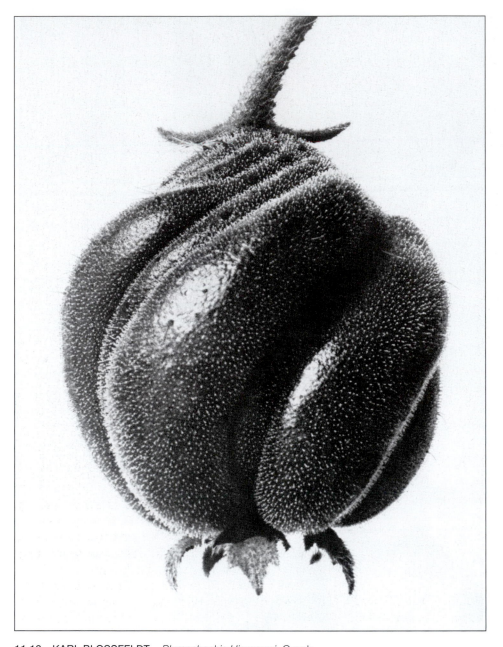

11.12    KARL BLOSSFELDT. *Blumenbachia Hieronymi*, Gesch-
lossene Samenkapsel, 18mml vergrössert, Nette Closed Seed
Capsule enlarged 14.94 times, 1900–1928, 10¼ × 8⅛ inches.
Gelatin silver print.    Courtesy Center for Creative Photography.

subject's basic design: "Nature is our best teacher,"[20]
said Blossfeldt. By enlarging discrete portions of a sub-
ject—the characteristics, details, patterns, and textures
that would otherwise go unobserved by human vision
or in normal-range photography—Blossfeldt made the
imperceptible perceptible.

The close-up has long been a source of essential
information in the medical, scientific, and technical
communities. Using the camera to enlarge and isolate
the subject has been the most logical and scientific
method. By eliminating all nonessentials and dispens-
ing with recreating a psychological mood or a social
relationship, the close-up seems to confirm that art and
nature are "intimately bound up as to be inseparable."[21]
In his images of plant forms, Blossfeldt believed that the
New Objectivity revealed the connection between natu-
ral form "governed by some fixed and eternal force"[22]
and art. Other imagemakers used the close-up as an
ingenious way of examining ordinary subject matter
and to interject private beliefs and emotions about what
was in front of their camera lens.

**Eugène Atget** (1857–1927) turned to photography at
age forty after working as a cabin boy, actor, and painter.
Atget undertook a methodical photographic survey
of the old quarters of Paris and its surrounding parks.
Working in the tradition of Charles Marville and the
*Monuments historiques* project, Atget spent thirty years
making over 10,000 photographs with an outmoded

11.13  EUGÈNE ATGET.  *Fête du Trône de Géant,* 1925. 7 ×
9 inches. Printing out paper, gold toned.   Courtesy George Eastman
House.

wooden view camera and tripod, often using a wide-angle lens that did not match the camera format. This produced *vignetting,* a darkening of the image towards the corners in the final print. Under his hand-lettered sign, "Documents pour artistes," Atget scratched out a living selling contact prints, made from his glass plate negatives on printing-out paper and toned with gold chloride. Seemingly resistant to change, Atget never professed belief in any artistic movement, nor was he given to technical experimentation. Atget's savant-like accumulation of empirical observations of a premodern Paris is as much about the psychological nature of time as it is an extended architectural study. His work went unnoticed until his neighbor, Man Ray, published some of his images without credit in the official surrealist journal, *La Révolution Surréaliste,* in 1926.[23] The surrealists, who gave themselves permission to find new meaning in a subject or discard the intended one, saw Atget as a primitive in touch with his unconscious self. For the surrealists, Atget's storefront pictures of man-

nequins, window reflections, and odd juxtapositions of objects could distort time, space, and scale so that they appeared to have emerged from a dream.

Atget's poised, commonplace scenes have a disturbing sense of apprehension and of being removed from the world, a combination enabling the photographs to transcend photography's competing views of documentation and self-expression. His body of work does not evoke a quaint sensation of the past, but provides the materials necessary to analyze the elusive attributes of time. An avid reader of nineteenth-century French literature, Atget wanted to preserve the Paris of the past by photographing buildings slated for demolition and recording in detail how the ironworks, stone, and vegetation evoked a spirit beyond their physical description. His catalogue of arcades, doorways, private gardens, public spaces, and ordinary people struggling to earn a living, shows a lyrical understanding of the street and a society on the verge of extinction. The seemingly simple images convey a sense of sorrow for an irreclaimable era. Atget vetoed Man Ray's proposal that he use a hand-held Rolleiflex camera, complaining to him that "le snapshot went faster than he could think. . . . Trop vite, enfin! Too fast."[24] He understood

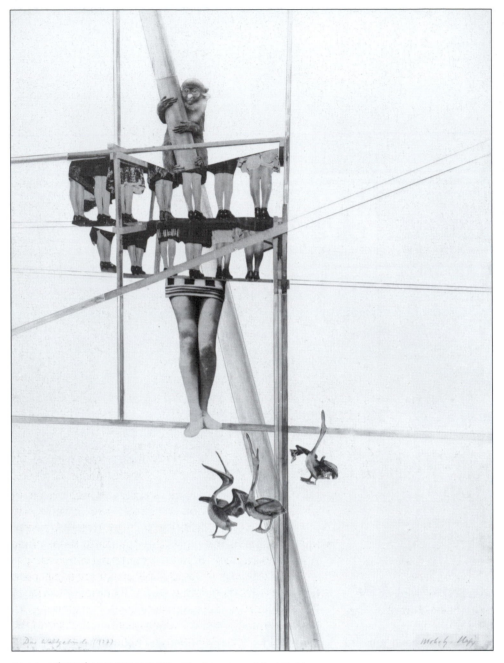

**11.14  LÁSZLÓ MOHOLY-NAGY.**  *The Structure of the World,*
1927. 25½ × 19⅝ inches. Photomechanical offset, rotogravure,
pencil.

that the element of time built into his antiquated style of
working allowed him to meditate on what was in front
of his camera. Atget's extended study prolonged the
photographic moment to reveal how time transforms
a subject.

## Experimentally Modern

The 1920s was a period of experimentation, and at the
forefront, dealing with the "realm of the fantastic," was
the Bauhaus master **László Moholy-Nagy**. Moholy-
Nagy sought a purely photographic approach indepen-
dent of all previous forms of representation. Moholy
urged investigation into "the new culture of light" so
that "the strongest visual experiences that could be
granted to man" could be made available through its
understanding and use. He wrote: "This century belongs
to light. Photography is the first means of giving tangi-
ble shape to light, though in a transposed and—perhaps
just for that reason—almost abstract form."[25] Unlike
the precisionists, Moholy-Nagy wanted to use photog-
raphy to show what the human eye alone could not see.
In "Production-Reproduction,"[26] he took the position
that mediums primarily used for reproduction, such as
photography and film, could be reduced to their most

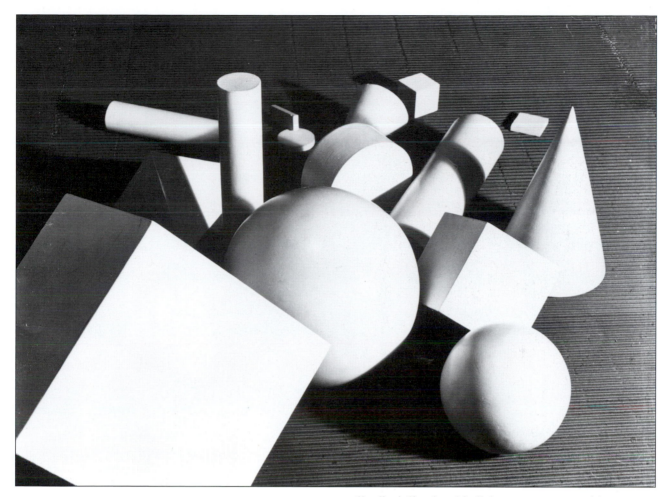

**11.15   HERBERT BAYER.** *Untitled,* geometric shapes on white corrugated cardboard, ca. 1930s. 9 × 12¹³⁄₁₆ inches. Gelatin silver print. Herbert Bayer (1900–1985) was a graphic designer, trained at the Bauhaus with Moholy, who incorporated photographs, rather than drawings and paintings, into his work. Bayer constructed highly geometric studio compositions with a deep sense of plastic (three-dimensional) space, rather than linear space, that relates to Moholy's idea of fotoplastik.    © Galleria Martini & Ronchetti, Genoa, Italy.

elemental level and then extended on a new, innovative course. For Moholy, "reproduction" stood for imitative or repetitive relationships. "Production" signified the new forms, such as his photograms, appropriate to the world of technology, that make "new, previously unknown relationships . . . between the known and as yet unknown optical."

Moholy and his wife, Lucia Moholy (1894–1989), who was his collaborator and darkroom technician as well as a teacher and the author of *A Hundred Years of Photography, 1839–1939,* experimented with these concepts in 1922 by making photograms and photomontages. Moholy's practice of montage, which he called *fotoplastik*,[27] was based on the surrealist method of recording the unconscious, but without the surrealist attachment to the irrational. He saw his approach as an experimen-

tally disciplined and judicious strategy to achieve an art form that struck a balance between reason and spirit, and between people and their culture. Moholy's photomontages relied on the graphic suprematist forms of the circle, cone, and spiral to create multiperspective compositions, a schema that disturbed Renaissance perspective and its companion formulas for acquiring knowledge through images. His photomontages juxtaposed contrasting imagery in open compositions, with much of the surrounding space left intentionally blank. The resulting interplay of movement between the fragmented images and the stillness of the unused space applied both optical and psychological pressure on viewers to recreate the same commotion and unstableness they experienced in modern daily life.

## New Vision

Much of what is called *New Vision* or Bauhaus photography, based on the aesthetic possibilities of geometric form, is discussed in Moholy's *Malerei, Fotografie, Film (Painting, Photography, Film),* 1925. New Vision reflected the aesthetic possibilities of geometric form as it related to architecture and the machine. In straight photography it was characterized by the use of geometric compositions, the close-up, the oblique points

11.16   FLORENCE HENRI.   *Composition No. 12,* ca. 1929. 9⁹⁄₁₆ × 14¾ inches. Gelatin silver print. *Composition No. 12* embodied what Moholy called a "new space, which was to be produced through the relations of the elemental material of visual expression—a new space created with light directly. . . . The surface becomes a part of the atmospheric background; it sucks up light phenomena produced outside of itself—a vivid contrast to the classical conception of the picture, the illusion of an open window . . . it represents the mastery of the surface, not for atmospheric, but for plastic spatial ends."[28]   Courtesy Galleria Martini & Ronchetti, Genoa, Italy.

of view, the inclusion of reflective surfaces to alter perspective, and the hand-held camera to cover sports events and produce action scenes. It permitted any type of optical manipulation of light, making the medium its own subject. Its underlying premise was that images must be made by photography and must look photographic. During the 1920s this mode of working, without its conceptual base, spread rapidly after being co-opted by German commercial advertising, marketing, and the popular press.

Moholy's straight photography favored non–eye-level points of view to duplicate the constructivist antiperspective, compositional structure. Moholy also incorporated Theo Van Doesburg's painting theory of "counter-composition," designed to relieve the abstract purity of *De Stijl*[29] compositions, such as those of Mondriàn, by rotating his camera and even making double exposures in order to secure a counter-composition that was less rigid and more active. He also made regular use of negative prints, and would juxtapose two images to create an energetic and varied reading of a subject.

After Hitler closed the Bauhaus in 1933, Moholy eventually settled in Chicago, where he became the director of the New Bauhaus in 1937. Founded by local businessmen and modeled on the principles of its namesake, the school opened that fall, in the midst of the Great Depression. It closed after only a year, but in February 1939 Moholy opened his own institution, the School of Design in Chicago, which was reorganized as the Institute of Design in 1944. Students of this institution were taught to adventurously investigate Moholy's idea that "a knowledge of photography is just as important as that of the alphabet" and "the illiterate of the future will be ignorant of the uses of camera and pen alike."[30] These beliefs disseminated through American photography as other educators, including Harry Callahan, Aaron Siskind, and their students, continued Moholy's teachings.

**Florence Henri** (1893–1982) studied with Moholy and the painter Fernand Léger and doubtless had seen Léger's film, *Les Ballets mécaniques* (1923–1924), which used light and mirrors to distort, fragment, and multiply images. Henri blended Moholy's and Léger's approaches to formulate a geometric, multiplaned, semi-abstract vision founded on the dematerialization of light. The overlapping space, utilizing reflections and refractions, became enigmatic and permitted meaning to be ambiguous and fluid. On the verso (backside) of *Composition No. 12,* a cataloguer positioned it as a

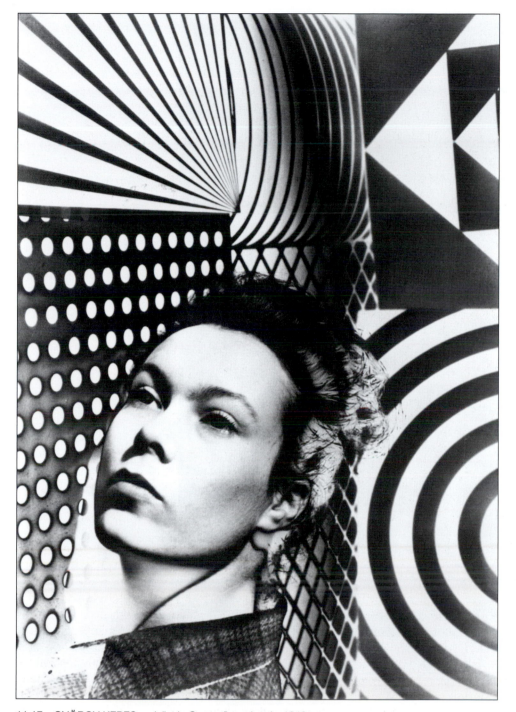

11.17  GYÖRGY KEPES.   *Juliet in Camouflage Jungle,* 1942.
7⅝ × 5⁷⁄₁₆ inches. Gelatin silver print.    © György Kepes Estate.
Courtesy George Eastman House.

vertical, though here in Figure 11.16, it is reproduced as a horizontal. Eastman House print archivist David Wooters acknowledged Henri's invitation to interpret the work's position with his comment: "Let the bottom find itself."[31]

**György Kepes** (1906–2001), a close associate of Moholy who became the head of the light department at the New Bauhaus, proclaimed he was not a photographer but an artist "committed to working with light."[32] An avid experimenter, Kepes juxtaposed fragmented light spaces with structured rhythmic patterns of geometric shapes to create visual opposition. This use of opposites, natural forms in a dreamlike field of geometric shapes, was a metaphor of alternating natural and technological realities. Kepes used "to read nature, to learn about nature, and to create patterns which reveal nature."[33] In response to the teaching of Kepes, Carlotta Corpron (1901–1988) embarked on a series of studies utilizing the properties of light, rather than the object, to produce images. Lotte Jacobi (1896–1990), known for

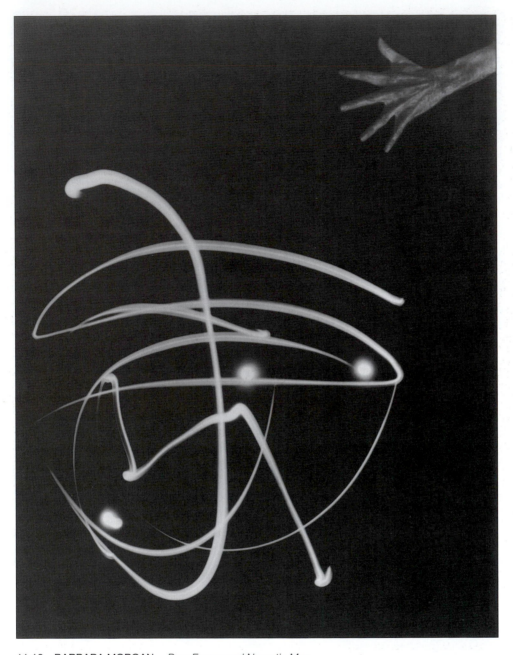

11.18   BARBARA MORGAN.   *Pure Energy and Neurotic Man,*
1941/71. 19¾ × 15¼ inches. Gelatin silver print.   © Barbara
Morgan, The Barbara Morgan Archive.

her stylized portraits, also combined light graphics with
camera imagery to produce what she called "photoge-
nic drawings."

## Pathways of Light: Time, Space, and Form

**Barbara Morgan** (1900–1992) combined camera and
cameraless images into the same composition, using
what Moholy referred to as "automatic photomontage."
Her multiple exposures conveyed the complexity of
energy, time, and human psychology. Against a black
vacuum of nothingness, as in *Pure Energy and Neurotic
Man,* Morgan presented an anxious hand, tentatively
frozen in the act of deciding whether to reach toward or
pull away from a light force.

Morgan's cinematic use of space and time may sym-
bolize an interior dream/thought process, permitting
what Moholy referred to as *mirroring,* sharpening the
"identification of the inside and outside penetrations, to
take place. With this instrument of thought many other
phenomena (dreams for example) can be explained as
space-time articulations. In dreams there is a charac-
teristic blending of independent events into a coher-
ent whole. Superimposition of photographs, as seen in
motion pictures, can be used as the visual representa-
tional form of dreams, and in this way, as a space-time
synonym."[34]

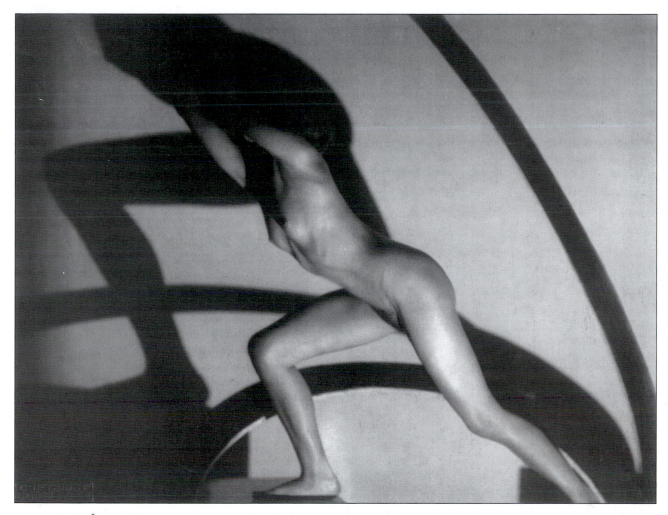

11.19  FRANTIŠEK DRTIKOL. *Composition,* 1929. 8⅝ × 11⁵⁄₁₆ inches. Pigment print.    © Ervina Bokôvá-Drtikolová. Courtesy Robert Koch Gallery, San Francisco.

**František Drtikol** (1883–1961) was a Czech pictorialist, grounded in the ideas of symbolism and *Jugendstil* (German art nouveau), who in the 1920s incorporated modernist ideas about geometric form, light, and space into studies of the female nude. In 1922, he developed the halftone photolithography process, a combination of oil printing and lithography.[35] In his Salome theme nudes, the female body is not individualized but is presented as form and space, integrating the settings and themes of art deco, symbolism, expressionism, and cubism. The expressionistic shadows become as important as the subject, offering visual depth, emotional weight, and sensuous mystery in a theatrical setting of fascination with the nude. In the early 1930s, before giving up photography, Drtikol replaced live models with plywood figures, marking a shift towards the abstract. His work and teaching influenced other Czech photographers including Josef Sudek (1896–1976) and Jaromír Funke (1896–1945), whose still-life compositions emphasize abstraction in concert with light and heavy shadow.

**Francis Joseph Bruguière** (1879–1945) studied photography with American pictorialist Frank Eugene and experimented with multiple exposures and printing techniques as early as 1912. Throughout the 1920s, Bruguière made formally abstract photographs, whose principal subject matter was light, by photographing cut and shaped paper designs. These "designs in abstract forms of light"[36] were his way of "apprehending light as an active symbol of consciousness."[37] In the early 1930s, Bruguière inserted elusive figurative components into these experiments, which can be seen in the book *Few Are Chosen* (1931). The intricate interplay of light and shadow produce a visual counterpoint to each other, giving the work kinetic and sculptural attributes. By moving his light source during the exposure to make overlapping shadows, Bruguière's tonally lavish prints take on surreal attributes: The viewer knows such shadows do not occur in nature but may exist in a dream. This sense of multidirectional light is also evident in clichés-verres he did during this period. In the later 1930s, Bruguière combined solarization, cut paper, and multiple exposure with a figurative element in a dynamic geometric composition, *Woman on the Phone* (ca. 1936–1940). The photograph has a sense of

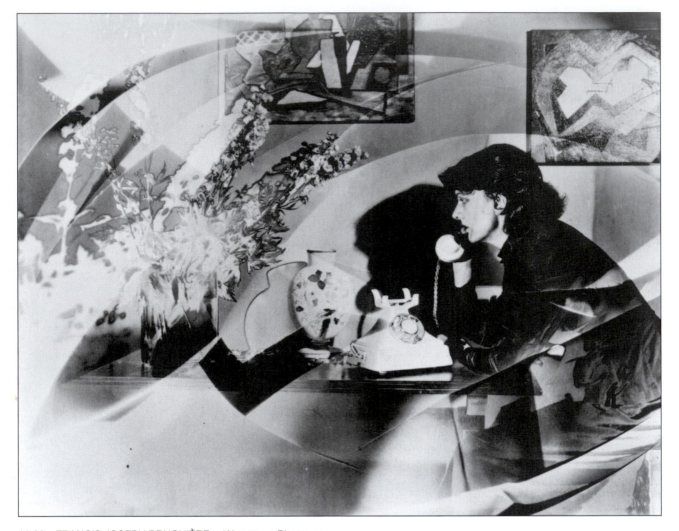

11.20 FRANCIS JOSEPH BRUGUIÈRE. *Woman on Phone,* ca. 1936/40. 7⁷⁄₁₆ × 9⁷⁄₁₆ inches. Gelatin silver print. Courtesy George Eastman House.

movement and a disquieting energy in a still situation. The solarization results in a surrealistic glimpse of both the exterior and interior realities of the subject. Multiple exposure lets objects take on a dual existence, making it appear as if viewers can look in and look out at the subject simultaneously, bridging the Bauhaus concern with the pathways of light and the surrealistic drive to connect the conscious and unconscious mind.

## Surrealistic Themes

During this same era, surrealist artists took yet another approach to defining modernism, announcing that anything could be art if it was observed as art. According to the surrealists, the definition of reality itself was the question that must be answered; photography confirmed that the world was not what it appeared to be. For the surrealists, photography was a witness that gave true but conflicting testimonies: One version adhered to

the external facts while the other was a construct of the mind based on a viewing of the facts.[38] In a surreal context, photographs could stop being quotations and could act as conduits for free association. From this belief the surrealist **Hans Bellmer** (1902–1975) used sexually taboo imagery to symbolize decaying German society. Dolls and mannequins became surrealist fetishes of male sexual desire. Bellmer fabricated a doll, the size of an adolescent girl, held together by ball joints so that its head, breasts, and limbs could be moved, and used it to make ambiguously erotic and jarring tableaux. The doll appeared in a variety of locations, wearing wigs and little attire, except for shoes, stockings, or a flimsy top, creating a pornographic environment. The doll appeared to have been physically abused, eliciting a sympathetic yet voyeuristic response that both attracts and repels. Bellmer hand-colored these photographs to bolster their menacing nature.

Later, Bellmer made a second doll with a central ball joint that enabled him to compose anatomically impossible configurations of doubled body halves, such as a torso with legs at both ends. Here the body was a prison of dissonance and futility, straining to break free from

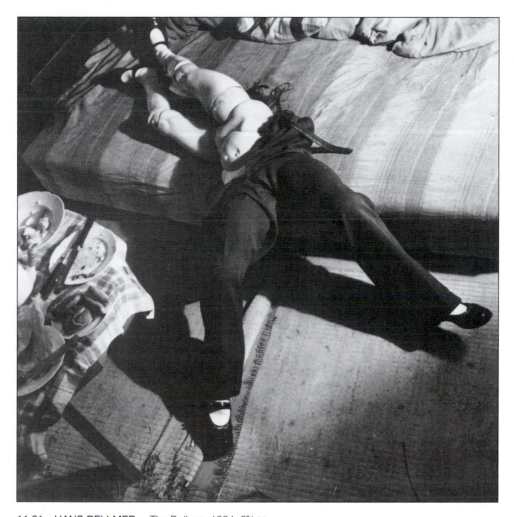

11.21  HANS BELLMER.  *The Doll,* ca. 1934. 5¾ ×
5⁷⁄₁₆ inches. Gelatin silver print with applied color. Bellmer's doll
images undermined the nostalgic Nazi vision of undisturbed
Aryan youth, faithful to family and nation. Bellmer's surrealistic
representation of an interior rather than an exterior view made
visible the internal terrors of human sexual obsessions and
proclivities normally beyond the scope of photographic vision.

its own human limits. Many of these synthetically col-
ored images were published in *Les Jeux de la poupée,*
*1935–1936,* his limited-edition *artist's book.*[39]

At the age of fourteen, Georges Hugnet (1906–1974)
met Jean Cocteau, Marcel Duchamp, Max Ernst, and
Pablo Picasso and began writing poetry and making art-
ists' books. His early work examines characteristic sur-
realist topics of sexual violence and unorthodox sexual
practices. He uses found images and text to evoke a
narrative sense, but maintains an air of mystery that
keeps viewers from obtaining enough clues to know
what is being conveyed. Hugnet's *La septième face du
dé, Poèmes—découpages* (1936) is a ninety-page offset
printing work of twenty chapters. Each unconventionally
laid-out page features poetry in a multitude of typefaces
with some small appropriated images, against a mon-
tage of found images and text. The merging of images
and text produces a suggestive serial narrative that
contemplates interior pathologies based on the photo-
graphic evidence. An erotic fantasy of male supremacy
is established through installments revolving around a
young girl's sexual life. Bare-breasted women appear in
enigmatic situations featuring sadomasochist activities
and positions of male conquest and control. Hugnet's
ordered montages contain an abundance of open white
space and have a shared ancestry with Moholy-Nagy's
fotoplastiks. The clarity of Hugnet's constructions can
be even more disconcerting than Moholy's, as what is
actually being described, the subconscious netherland
of dream and spirit, is not physically evident but comes
to fruition in the viewer's mind.

**Man Ray**, who Cocteau called "the poet of the dark-
room,"[40] was a deft experimenter whose compositions
contained unexpected juxtapositions based on dada and
surreal premises. Man Ray placed no credence in the
purity of practice, taking the position that "a certain
amount of contempt for the material employed to express
an idea is indispensable to the purest realization of this
idea."[41] This attitude led him to use the *Sabattier effect*
to question reality and disconnect the subject from the

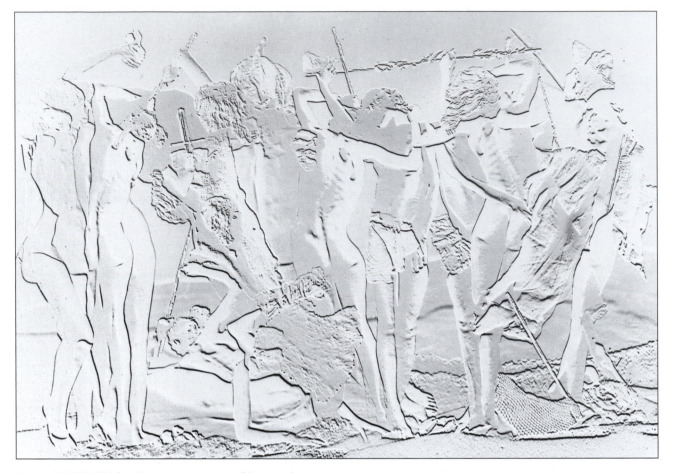

11.22    RAOUL UBAC.    *Maquette pour un mur/Maquette for a Wall,* 1938–1939. From the series *Le Combat des Penthésilées/Battle of Pentheseúa.* 6¾ × 9½ inches. Gelatin silver print.
San Francisco Museum of Modern Art.

photograph. The Sabattier effect, first documented by French scientist Armand Sabattier in 1862, is the partial reversal of an image caused by exposing it to light during development. Man Ray called it "solarization," and like the rayograph it was rediscovered in 1929 in his darkroom. Lee Miller, at the time Man Ray's assistant and lover, accidentally turned on the lights while developing film. Ray went with the chance occurrence and printed the negative, discovering that its partially reversed tones yielded a print that appeared both as a positive and a negative. It became a Man Ray signature technique, kept secret until about 1932 when his relationship with Miller ended.

Under Ray's influence, **Raoul Ubac** (1910–1985), an artist and a poet, found new combinations of photomontage, solarization, bas-relief, and *brûlage* (using direct heat to melt the photographic emulsion) to remove a subject from its original context and place it into a surrealistic dream. Finding Breton's *Surrealist Manifesto* "a revelation and a calling," Ubac sought to disintegrate form, often using the body as a site for these invasions of light that turn representation inside

out. In the series *Le Combat des Penthésilées (Battle of the Amazons,* 1938–1939), Ubac photographed a single female nude in a variety of positions and made prints from which he produced a collage. This image was rephotographed and solarized to embellish and reverse tonal relationships. Then the solarized images were photographed twice and the resulting negatives were sandwiched together, slightly out of register, to produce a *bas-relief* effect (see Figure 11.22). In conventional bas-relief printing an exact positive and negative image of the same scene are combined slightly out of register to create the illusion of relief. Ubac's double positive method produced a print whose sense of low sculptural relief is achieved with only glowing grays, instead of the dark contour lines of regular bas-relief. This allowed what surrealist writer Georges Bataille called *informe,* to take place; the "unthinking" (the undoing) of all categories, the removing of all boundaries and concepts (or proper forms) used to shape meaning. Informe does not transcend meaning; it transgresses meaning. A notion of formlessness emerges by means of collapse and defilement, allowing new forms and definitions to emerge. Ubac's methods invade the space of the body, destroying its normal boundaries, defying gravity, distorting perspective, and transforming the body into various psychic states from violent

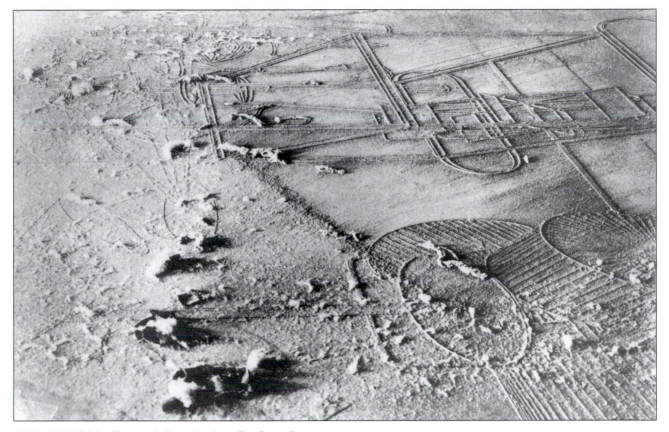

11.23  MAN RAY.  *Elevage de Poussiere* from *The Green Box,*
1934 aka *Dust Breeding* (on Duchamp's *Large Glass*), 1920. 7⅞ ×
10¼ inches. Gelatin silver print.    Philadelphia Museum of Art.

disintegration to ecstasy.

Man Ray's solid conceptual base allowed him to
find his voice in a variety of mediums, including films,
such as *Emak Bakia* (1926), that investigate the fourth
dimension through editing that collapsed and restruc-
tured time and space. Man Ray understood that pho-
tography's mooring in reality let him keep order even
in a surrealist squall. Ray did not think that truth could
be discovered in the "thing itself" because truth was
fluid and was constantly being transformed. Ray's pho-
tographing of Duchamp's dadaist work in progress, *The
Bride Stripped Bare by Her Bachelors, Even* (1915–
1923) is most often referred to as *The Large Glass,* a
big piece of glass that had been lying flat on sawhorses
collecting dust, demonstrates the celebration of ideas
over subject matter. At the time, Duchamp decided this
ephemeral act could only be made permanent through
photography and called the resulting document *Dust
Breeding* (1920).[42] Man Ray saw a different meaning
and published the same image as *View Taken from an
Airplane* (1922). These two interpretations of the same
image point out the elusive nature of photographic truth.
Although the photograph remains the same, it takes on
a new existence under different framers and dissimilar
interpretations. Conceptually the image discloses the
fluid and contradictory nature of the photograph and
how the interpretation of the image is dependent on
the circumstances of the viewer. Does the viewer see
the image as a literal document that is tethered only
to itself (the thing)? Or can the image have its own
separate identity (that of the mind) that shifts with its
surroundings? Both Duchamp and Ray saw artmaking
as a process that involved the artist, the art object, and
the viewer in an ongoing venture of reciprocal creation
and interpretation.

As the older Stieglitz and his progeny now relied
on straight photography to uncover eternal truth, dada-
ists and surrealists, such as Man Ray, steered a differ-
ent course. For Man Ray reality was a flux and, like
the name he gave himself, he did not settle for what
was already a given for most people, but searched for
new ways to visualize life's temporary and evanescent
nature. He stated: "Perhaps the final goal desired by the
artist is a confusion or merging of all the arts, as things
merge in real life."[43]

# Endnotes

1 *Paul Outerbridge: A Singular Aesthetic. Photographs and Drawings 1921–1941: A Catalogue Raisonné,* Elaine Dines, ed., in collaboration with Graham Howe (Laguna Beach, CA: Laguna Beach Museum of Art, 1981), 21.

2 See Bonnie Yochelson and Kathleen A. Erwin, *Pictorialism into Modernism: The Clarence H. White School of Photography* (New York: Rizzoli, 1996).

3 Margaret Bourke-White, *Portrait of Myself* (New York: Simon and Schuster, 1963), 49.

4 Alfred Stieglitz, "How I Came to Photograph Clouds," *The Amateur Photographer,* vol. 56, no. 1,819 (September 19, 1923), 255.

5 *The Daybooks of Edward Weston:* vol. 1, *Mexico and The Daybooks of Edward Weston:* vol. 2, *California,* Nancy Newhall, ed., (Millerton, NY: Aperture, 1973).

6 *The Daybooks of Edward Weston:* vol. 1, *Mexico,* Nancy Newhall, ed., (Millerton, NY: Aperture, 1973), 55.

7 French philosopher Henri Bergson postulated that the world is made up by two opposing tendencies, the life force and the resistance of matter against that force. Bergson believed that we know the material world through our intellect, but that it is by intuition that we perceive the life force and the reality of time, which is not a unit of measurement but a "duration" of "the persistence of the past in the present" that makes up life experience. These ideas were enthusiastically adopted by artists during the 1920s.

8 Edward Weston, "Photography," 1934, in Peter C. Bunnell, ed., *Edward Weston on Photography* (Salt Lake City: Peregrine Smith Books, 1983), 74.

9 Edward Weston to Frank Roy Fraprie, June 7, 1922, The Center for Creative Photography, University of Arizona, Tucson. Quoted in Newhall, *The History of Photography,* 1982, 188.

10 Nancy Newhall, ed., *The Daybooks of Edward Weston,* vol. 1, 80.

11 Nathan Lyons, "Weston on Photography," in Beaumont Newhall and Amy Conger, eds., *Edward Weston Omnibus* (Salt Lake City: Peregrine Smith Books, 1984), 170.

12 Edward Weston with Charis Wilson Weston, *California and the West* (New York: Duell, Sloan & Pearce, 1940).

13 Edward Weston, "Photography—Not Pictorial," Camera Craft, vol. 37, no. 7 (July 1930), 318. Also reprinted in Peter C. Bunnell, ed., Edward Weston On Photography (Salt Lake City: Gibbs M. Smith, 1983), 59.

14 John Paul Edwards, "Group f. 64," *Camera Craft,* vol. 42, no. 3, (March 1935), 107.

15 Ansel Adams, *Camera and Lens,* Book 1 of the Ansel Adams Basic Photo Series (Hastings-on-Hudson, NY: Morgan and Morgan, 1948), 23.

16 William Mortensen, "Fallacies of 'Pure Photography,'" *Camera Craft,* vol. 41 (June 1934), 257.

17 Mortensen, 260–61.

18 Carl Georg Heise, "Preface" to Albert Renger-Patzsch, *Die Welt ist schön,* (1928) trans. in "Photography and the Neue Sachlichkeit Movement," David Mellor, ed., *Germany: The New Photography, 1927–33* (London: Arts Council of Great Britain, 1978), 10.

19 Gustaf Stotz in *Das Kunstblatt* (May 1929), trans. in Van Deren Coke, "Introduction," *Avant-Garde Photography in Germany, 1919–1939* (San Francisco: San Francisco Museum of Modern Art, 1980), 18.

20 Karl Blossfeldt, *Art Forms in Nature,* Second Series (New York: E. Weyhe, 1932), Foreword, unp.

21 Karl Nierendorf, "Preface," *Urformen der Kunst,* 1928; trans. in David Mellor, ed., *Germany: The New Photography, 1927–33* (London, 1978), 17.

22 Ibid.

23 Atget's work might have been lost if not for Berenice Abbott, Man Ray's assistant at the time, who raised money to purchase Atget's prints and negatives. Abbott spent years crusading to bring Atget's images to the notice of photographers and collectors. The Museum of Modern Art purchased the collection in 1968 and began to exhibit and publish his work. See John Szarkowski and Maria Morris Hambourg, *The Work of Atget* in four volumes: vol. I, *Old France* (New York: The Museum of Modern Art, 1981); vol. II, *The Art of Old Paris,* 1982; vol. III, *The Ancient Regime,* 1984; and vol. IV, *Modern Times,* 1985.

24 Julien Levy, *Memory of an Art Gallery* (New York: G. P. Putnam's Sons, 1977), 91.

25 All quotes in this paragraph from László Moholy-Nagy, "Unprecedented Photography," 1927; reprinted in Christopher Phillips, *Photography in the Modern Era: European Documents and Critical Writings, 1913–1940* (New York: The Metropolitan Museum of Art and Aperture, 1989), 83–85.

26 László Moholy-Nagy, "Produktion-Reproduktion," *De Stijl* (Leiden) vol. 5 no. 7 (July 1922) as in Christopher Phillips, *Photography in the Modern Era: European Documents and Critical Writings, 1913–1940* (New York: The Metropolitan Museum of Art and Aperture, 1989), 79–82.

27 Fotoplastik was the term Moholy used to separate his photomontages from the montages of the dadaists. A completed fotoplastik was a finished collage that was photographed by Lucia Moholy and altered in the printing to produce a series of variant images, such as a negative print. The titles, also done with Lucia Moholy, were not intended to be descriptive and were often colloquialisms or made-up words that defy translation.

28 László Moholy-Nagy, *The New Vision* (1928), in *The New Vision and Abstract of an Artist,* trans. by Daphne M. Hoffman, (New York: George Wittenborn, Inc., 1947), 38–39.

29 De Stijl ("The Style"), based on the belief that absolute artistic purity is possible, was launched in the Netherlands by Theo van Doesburg and was active from 1917 to 1931. Entirely abstract and aiming towards a purity of vision, De Stijl permitted only the use of the straight line, the right angle, and the three primary colors (red, blue, and yellow), augmented by white, black, and gray.

30    László Moholy-Nagy, "From Pigment to Light," *Telehor,* vol. 1, no. 2, (1936), 32–36, translated and reprinted in Nathan Lyons, ed., *Photographers on Photography* (Englewood Cliffs, NJ: Prentice-Hall, 1966), 80.

31    David Wooters, George Eastman House Print Archivist in conversation with author about Florence Henri's *Composition No. 12,* June 29, 1994.

32    Telephone interview with Diana du Pont, October 24, 1984 in Van Deren Coke with Diana C. du Pont, *Photography: A Facet of Modernism* (New York: Hudson Hills Press in association with the San Francisco Museum of Modern Art, 1986), 58.

33    Ibid.

34    See László Moholy-Nagy, "Space-Time and the Photographer," *American Annual of Photography, 1943* (Boston: American Photographic Publishing, 1942), 7–14.

35    In Drtikol's method an oil print image is transferred onto a litho stone in order to divide tones into half- and quarter-tones, resulting in prints that possess more physical depth than a gelatin silver print and have the light texture of a lithograph. This technique was used to print his book *Les Nus de Drtikol* (1929).

36    Quoted in James Enyeart, *Bruguière: His Photographs and His Life* (New York: Alfred A. Knopf, 1977), 16.

37    Walter Chappell, "Francis Bruguière" *Art in America,* vol. 47, no. 3, (Fall 1959), 59.

38    See Rosalind Krauss et al., eds., *L'Amour fou: Photography and Surrealism* (New York: Abbeville Press, 1985).

39    Artists' books refer to works constructed in a book format, produced in limited editions, and usually only available in art bookstores, galleries, and museums. The term is attributed to Dianne Vanderlip, who arranged the exhibition *Artists Books* at Moore College of Art, Philadelphia, in 1973. Its precursor was work such as William Blake's *The Marriage of Heaven and Hell* (ca. 1790), which he wrote, illustrated, and published with the help of his wife.

40    Neil Baldwin, *Man Ray: American Artist* (Da Capa Press, unabridged republication by arrangement with Clarkson N. Potter, 1988), 139.

41    Arturo Schwarz, *Man Ray: The Rigour of Imagination* (New York: Rizzoli, 1977), 230.

42    After this photograph was made, Duchamp fixed the dust with varnish. *The Large Glass* eventually evolved into *The Bride Stripped Bare by Her Bachelors, Even* (1915–1923).

43    Man Ray, interview, 1951 as quoted in Neil Baldwin, *Man Ray: American Artist,* 11.1, unp.

# Social Documents

## An American Urge: Social Uplift

Millions of European immigrants came to America in the nineteenth century, looking for personal freedom and the opportunity to make a better life. Buffeted by a series of post–Civil War depressions, however, many were left jobless, hungry, and psychologically beaten down, barely existing in disease-plagued New York City tenements.[1] **Jacob A. Riis** (1849–1914), who came to New York from Denmark in 1870, suffered the degradations of spending nights in police lodging for the homeless, tramping the streets in search of work, doing chores for food, and even walking to Philadelphia to look for a job, before finding employment in 1873 with a New York news bureau. In 1877, Riis became a police reporter in Mulberry Bend, the East Side's worst slum district. Here more than a million people lived in 37,000 airless, dark, and unhygienic tenement buildings. Forty thousand people a year entered workhouses or asylums while thousands of homeless children scavenged for food until they were old enough to join criminal gangs.[2] Reporting on the scandalous conditions as a journalist was not enough for Riis, who wanted to bring about reform: windows in every tenement room, indoor plumbing, tenant rights. Realizing that words could not fully convey the horrid conditions, he turned to photography to document the

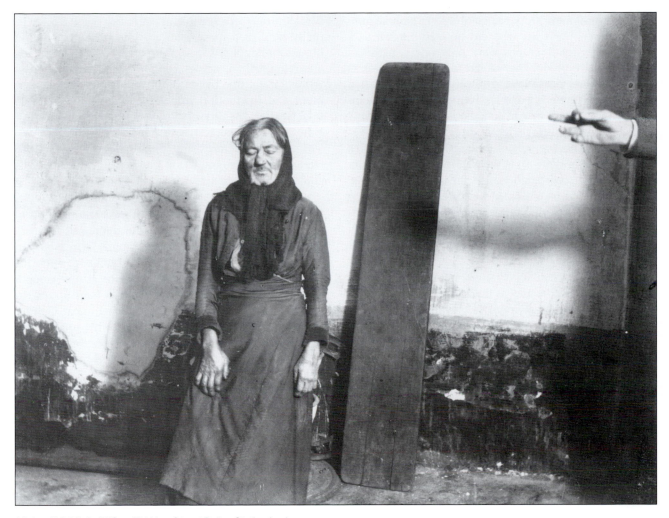

**12.1   JACOB A. RIIS.**   *Eldridge Street Police Station Lodger: An Ancient Lodger and the Plank on Which She Slept,* ca. 1888. Gelatin silver print.   Courtesy Jacob A. Riis Collection, © Museum of the City of New York.

evidence and used the photographs as weapons for social change. Riis's pioneering efforts at social reform would lead Theodore Roosevelt, then NYC police commissioner, to call him "the most useful citizen in New York." The exposing of political and social corruption that Riis and other reformers engaged in became known as *muckraking.*[3]

The hand camera enabled Riis to photograph in the tenements at night or in low light. He used dangerous flashlight powder to illuminate the horrid details of grim poverty: dirt, trash, peeling paint, and the starkness of having nothing. The flash cartridges were fired from a revolver whose explosive discharge would awaken sleepers. At times, Riis set places on fire, ignited his own clothes, and almost blinded himself. He described how he started one fire while photographing a group of blind beggars inside a tenement attic: "When the blinding effect of the flash had passed away. . . . I saw the flames creeping up the wall, and my first impulse was to bolt for the street and shout for help. The next was

to smother the fire myself, and I did, with a vast deal of trouble."[4] His article "Flashes from the Slums," which appeared in the February 12, 1888, edition of *The Sun* (New York) and was illustrated with wood engravings made from photographs, described how his subjects reacted to "the blinding flash . . . the patter of retreating footsteps and the mysterious visitors were gone before they could collect their scattered thoughts and try and find out what it was all about."[5] Riis's hit-and-run strategy can make his images seem dispassionate. After all, he was not concerned with individuals but with the collective problems of the group. Nevertheless, his images offered a first public glimpse into the unmerciful, claustrophobic life of destitution by someone who had been there too.

Riis was interested in obtaining photographs to illustrate his widely attended reformist lectures, in which he introduced the concept of "social uplift." He saw crime, ignorance, and vice as the effects rather than the causes of poverty, and felt people needed government and private programs to raise themselves out of poverty and to instill middle-class values. Social uplift has been disputed by some as patronizing and others as expensive and ineffective, yet the food stamp and

Medicaid programs are legacies of a long campaign to fight poverty. For Riis, who did not see himself as a photographer, photographs were only one component of his social crusade. He wanted to make his case as persuasively as possible and toward this end enlisted Richard Hoe Lawrence and Dr. Henry G. Piffard, members of the Society of Amateur Photographers of New York, to make pictures under his direction. This involvement of other photographers explains the varying styles of what became known as the Riis photographs, from the stark and confrontational to the near picturesque. In his lectures, Riis presented the shocking facts on the tenement problem: immigration figures, population density, police statistics, and death rates. He did not rely solely on the rational to achieve results, however, but crafted entertaining and emotional lectures, appealing to the heart and the hankie. Riis understood that a photograph's narrative content was fluid and could be directed to create meaning and symbols. By synthesizing music, lights, lantern slides, and ethnic humor, he played to his audience's family and religious values, even pausing for sacred singing. Near the end of the talk, he showed slides of both the burial trench at Potter's Field and Jesus Christ. Odd as Riis's lectures might seem to us, this blend of coarse humor and spirituality likely amplified the effectiveness of his images for his audiences. Not only did Riis make the unseen and ignored visible, but he also made his audiences feel their responsibility to act and help press for reforms such as razing the worst slums and constructing settlement houses, schools, and "pocket" neighborhood parks.

Although Riis claimed to be a clumsy photographer, uninterested in aesthetics or technique, the images produced under his direction have profoundly influenced social documentary practice. Riis did not idealize, sentimentalize, or arrange his subjects into pleasing compositions to explain the difficulties of industrial transformation. The pictures reveal the problems of explosive urban growth and increased ethnic diversity that were causing major societal upheavals, without calling attention to their construction. The randomness of the compositions lends authenticity while the chance recordings of the unexpected add authority. By juxtaposing sympathetic subjects with their dilapidated surroundings, Riis made a case for social response, insisting that "the other half" does not have to live like this.

His book, *How the Other Half Lives* (1890),[6] included seventeen halftone illustrations and nineteen line drawings based on photographs, along with text calling for action. As the halftone process for translating photographs into printer's ink had not been perfected, the photographs lacked detail and sharpness. Even so, the book is a landmark in American social reform.[7] Always a muckraking reformer who recognized the value of photographs as social documents,

Riis continued to lecture as well as write. He eventually published more than a dozen books, including his autobiography, *The Making of an American* (1901), and remained an indefatigable magic lantern lecturer. Although not free from prejudice, his blend of amusement and instruction impelled civic-minded people to act: After Theodore Roosevelt became governor of New York, he worked with Riis to institute reforms. Through his lectures and publications Riis demonstrated that photographs, in combination with words, could direct social activity.

As part of this American wave of social reform, **Lewis Wickes Hine** (1874–1940), a sociologist from Columbia University who became interested in artistic photography, began to photograph at Ellis Island in 1904, where 71 percent of all immigrants to America landed between 1892 and 1924.[8] Hine taught camera courses and took his students, such as Paul Strand, to Stieglitz's "291." As a teacher at the Ethical Culture School in New York, a vital setting for the progressive movement, Hine used photography to combat the rampant prejudice against the newly arrived peoples from eastern and southern Europe. Using a 5 × 7-inch camera, Hine revealed the potential of these individuals. Hine's subjects appear to be aware of the camera and cooperative in constructing an image whose structure and use of light is empowering. His sympathetic style challenged accusations that the "new" immigrants, unlike the "old" immigrants from England, Ireland, and northern Europe, were morally and socially depraved and responsible for crime, corruption, labor unrest, political radicalism, and the slums. Hine outlined the beliefs that made his photographs potent weapons for change:

> The picture is the language of all nationalities and all ages. . . . the average person believes implicitly that the photograph cannot falsify. . . . This unbounded faith in the integrity of the photograph is often rudely shaken, for, while photographs may not lie, liars may photograph. It becomes necessary, then, in our revelation of the truth, to see to it that the camera we depend upon contracts no bad habits.[9]

This outlook would separate Hine's work from earlier reportage and formulate his "documentary" style that combined objective fact with subjective emotion into what Cornell Capa would later call the attitude of the "concerned photographer" (see Chapter 14).

Between 1906 and 1918, Hine photographed for the National Child Labor Committee (NCLC). He was assigned to photograph for the *Pittsburgh Survey* (1909), whose massive six-volume report on the city's industrial conditions was a pivotal document of the reform movement. Here Hine learned the methods of case studies, statistics, and surveys that made up the budding discipline of sociology. The NCLC needed facts documenting abuses of children in the workplace to support the passage of protective legislation. Hine

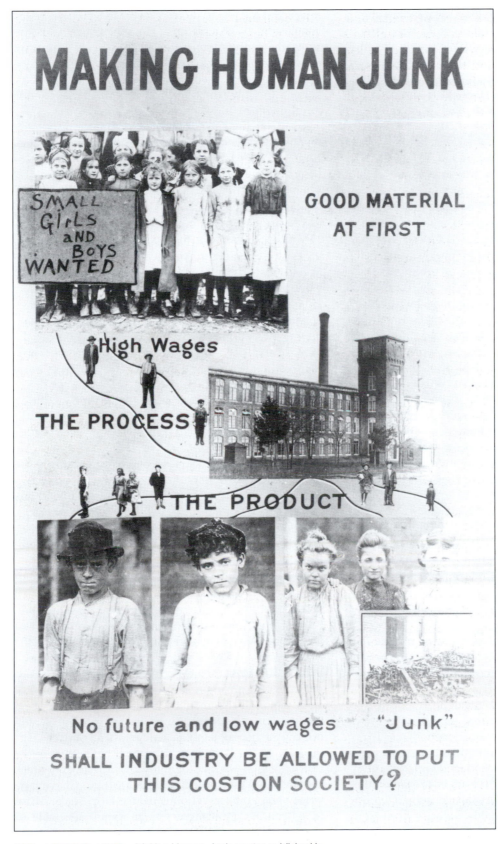

12.2   LEWIS W. HINE.   *Making Human Junk,* poster published in Hine's brochure, "The High Cost of Child Labor," 1915.   Library of Congress, Prints and Photographs Division.

collected information about the children he photographed, including each child's name, age, height, weight, nature of the child's work, how long the child had been on the job, and any work-related injuries, so as to "refute those who, either optimistically or hypocritically, spread the news that there is no child labor."[10] The act of naming people and placing them in time transformed Hine's images from the general to specific, making them appear genuine. Decades later, labor unions continued to make use of his images in their "before and after" campaigns to show how they had improved the lives of American children.

Hine, generally an unwanted visitor at industrial sites, developed ingenious ways to make his images, posing as a fire inspector, postcard vendor, Bible salesman, and as an industrial photographer who needed a child standing next to a machine to provide a sense of scale. Working quickly with available light, which necessitated large apertures and limited his depth-of-field, he relinquished fine art references, recording instead the dirty details of the industrial landscape and its small, forlorn, ill-clad inhabitants. With less artistic stratagem, Hine's pictures had a more immediate impact, a sense of being objective records.

Hine exposed the myth that everyone could pull themselves up by their bootstraps and succeed in America. Moralistic tales, such as Horatio Alger, Jr.'s *Ragged Dick,* encouraged the capitalist rags-to-riches fable that in a "free country poverty in early life is no bar to a man's advancement."[11] Destroying these fictions would discourage the rationalization of child labor as a training camp for junior capitalists. Hine made the process, not the product, of labor the focal point of his images. By picturing those who labored instead of what they made, he laid open the deception of consumerism, in which people enjoyed mass-produced products without considering their negative repercussions—the sweatshops, the dangerous working conditions, unemployment, and pollution.

Hine produced both visual and written material for exhibition and publication. As early as 1910, he was creating picture sequences, forerunners of the photo-essay, for *Survey* magazine. His cropped images have captions to contextualize the meaning of the image, instituting a narrative format that editors would refer to as the "photo story." Hine developed "Time Exposures," a series of photographs of the same subject, from different points of view, collaged with text, offering a descriptive and interpretive analysis that clarified a situation in need of change. He also designed didactic collages that portrayed a greedy industry converting healthy children into "Human Junk" (see Figure 12.2). Referring to himself as an "interruptive photographer," Hine understood the chameleonlike nature of the photograph and realized that a knowledgeable person did not have to stop at taking a picture, but could make an image and use text to direct viewers to a predetermined conclusion. "With a picture," Hine stated in 1909, "thus sympathetically interpreted, what a lever we have for the social uplift."[12] His work appeared in books, magazines, pamphlets, slide lectures, and traveling exhibits, helping to mobilize public concern to pass legislation reforming the child labor laws in the 1910s.

In 1930, Hine undertook his last major project: photographs of the men who were building the Empire State Building. Following the construction over 102 vertigo-inducing steel stories, the 56-year-old Hine had himself swung out in midair with his view camera to record the final rivet being installed on the pinnacle of the building. These dangerous efforts celebrate the mythological spirit of labor, not the building, a counterpoint to the growing feeling in American cities that people had become insignificant in the urban landscape. Unlike the work of those interested in the beauty of the machine, Hine's compositions juxtaposed human and machine characteristics (see Figure 12.3). Often emphasizing the faces of the workers, Hine stepped away from the massive and flawless authority of industry to show how humans fit into industrial progress. The resulting innovative photographic picture book, *Men at Work* (1932), contained full-bled pages and unadorned typography.

## Ethnological Approaches

During the nineteenth century, photography was placed in the service of numerous ethnological theories as a technically powerful means for imposing positivist classifications on nonindustrial cultures (see Figure 12.4). Photographers made images from their own view, as outsiders, and distributed them. In doing so they established and controlled another group's visual identity.

**Adam Clark Vroman** (1856–1916) was one photographer who took a less invasive approach. Between 1895 and 1904, he photographed Hopi, Navajo, Zuni, Laguna, and Acoma peoples to record a way of life that was rapidly vanishing, bringing the first reports of the Pueblo aesthetic back to cluttered, eastern Victorian homes. His modernistic portrayals have been considered honest and unpretentious. Vroman did not create a pictorialist, romantic "noble savage" or conceal nontraditional elements. He respected the dignity and privacy of his subjects at a time when tourists visiting holy Native American sites often blatantly ignored restrictions on the photography of sacred ceremonies and dances. Disrespectful and insensitive behavior by white photographers who treated the Hopi snake dance (a sixteen-day rain prayer) as an exotic spectacle of "otherness" eventually led the Hopi to first restrict and then ban all photographers from the dance in the early twentieth century (see Figure 12.5). Vroman spent time in the villages, obtained people's trust, and as a demonstration of good faith returned with prints for his sitters.

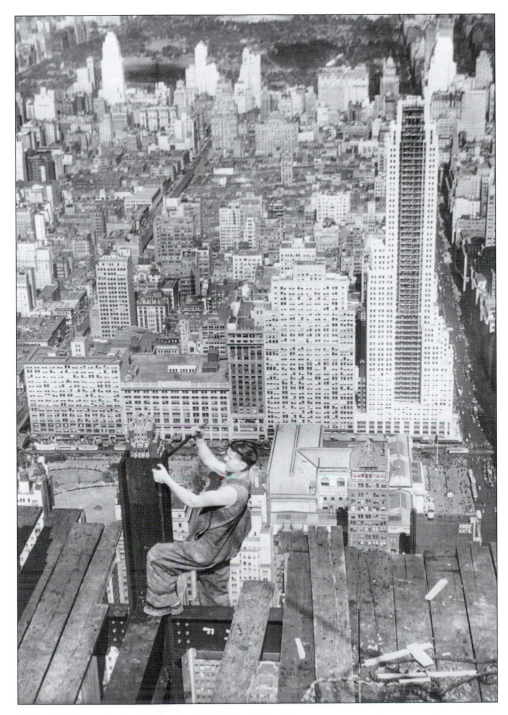

12.3   LEWIS W. HINE.   *Steelworker, 85 stories up. Looking north to Central Park,* ca. 1931. 6⅝ × 4⅝ inches. Gelatin silver print. In *Men at Work,* Hine summed up his position on the friction between humans and technology by writing: "Cities do not build themselves, machines cannot make machines. . . . We call this the Machine Age. But the more machines we use the more do we need real men to make and direct them. . . . I will take you into the heart of modern industry . . . where the character of the men is being put into the motors, the airplanes, the dynamos upon which the life and happiness of millions of us depend."[13]   Courtesy George Eastman House.

By giving slide lectures to white Americans, Vroman helped alter the distorted, stereotypical depiction of Native Americans as subhuman, bloodthirsty savages.

A photographer who made a career of photographing Native Americans was **Edward Sheriff Curtis** (1868–1952). As a teenager, Curtis built his own camera and taught himself photography, and in the early 1890s he opened a photography and photoengraving business in Seattle. Curtis learned ethnographic methods as the official photographer for the Harriman Expedition to Alaska (1899). Between 1900 and 1906, Curtis and his assistants photographed Native Americans of the

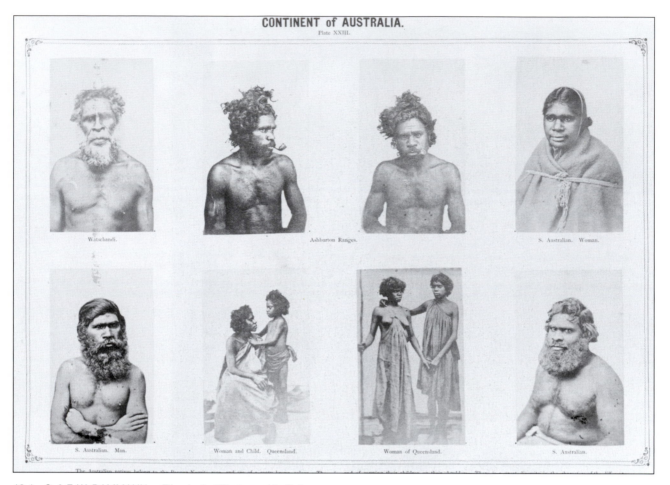

**12.4 C. & F. W. DAMMANN.** *Ethnological Photographic Gallery of the Various Races of Men,* Plate 23. 12⁷⁄₁₆ × 15¹⁵⁄₁₆ inches. C. & F. W. Dammann's *Ethnological Photographic Gallery of the Various Races of Men* typifies the British colonial attitude as it presents eight carte-sized plates of native people in the "Continent of Australia" section with this accompanying text: "There is a great diversity in the characters of the different tribes; many are intelligent and inoffensive, some are fierce and in a state of the rudest barbarism. There is no doubt that some of the tribes indulge in cannibalism." (Stoke's Australia).[14]   Courtesy George Eastman House.

Northwest, Southwest, and Great Plains. Curtis traveled and lived with Native Americans at a time when the Bureau of Indian Affairs was suppressing native religious ceremonies. In an era when respectable scientists considered native groups as an early phase of evolution and white domination a Darwinian triumph, many native people were willing to reenact scenes of traditional life for posterity.

Curtis was not an objective documentarian. His work applied a white European cultural filter to native life, combining romantic, soft-focus pictorial methods with the ethnological to manufacture a nostalgic view of the vanishing noble savage. Curtis suppressed evidence of assimilation and manipulated his images for emotional effect. Costumes, wigs, props, and backdrops were transported from one group to another for picturesque purposes. Sculptural lighting, silhouettes, touched-up highlights, and print burning and dodging were used to produce formal, dramatic, and dignified portraits (see Figure 12.6).

From 1900 to 1930, Curtis worked with about eighty native groups, producing some 40,000 images. He wrote four books, supervised sixteen others, made more than 10,000 recordings of native language and music, and recreated northwest coast native life on a set for his silent film, *In the Land of the Headhunters* (1910–1914). His monumental work, *The North American Indian* (1907–1930), contains almost 2,200 images, with twenty volumes of text, each of about 350 pages. Only 250 editions, printed in photogravure to achieve brilliant luminous effects and unusual depth, were published. The original plates were rediscovered in 1977 and their partial reprinting brought Curtis's work back into public attention.

Although it is criticized for its racist attitudes and romantic treatment of native people as exotica, Curtis's fabricated work continues to provide the only evidence of artifacts, costumes, ceremonies, dances, games, legends, and songs of many tribes' previous existence. There was no market for the realism of reservation despair, but with the Native Americans' complicity, Curtis used his narrative skills to recreate idealized

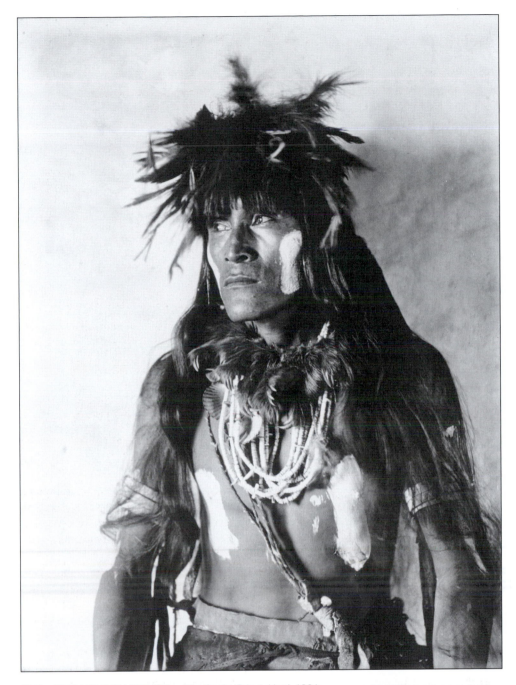

12.5  ADAM CLARK VROMAN.  *The Snake Priest, Hopi*, 1901.
8¼ × 6⁹⁄₁₆ inches. Gelatin silver print. Numerous native groups do
not believe in making permanent records of sacred events out of
reverence for the original. The legacy of outside groups, beginning
with the Spanish, suppressing native religious life and forcing them
to carry on their rites in secret, also made them suspicious of
whites who wanted to record their ceremonies, which they feared
could be used as evidence for additional repression.   Courtesy
George Eastman House.

symbols of a vanished time in the West. Made during an
era of unrestrained industrialization, Curtis's ennobling
treatments continue to represent the timeless myth of
the virtuous primitive.

Racial exploitation and idealistic myths were also
being perpetrated through photographic means in the
American East. **Frances Benjamin Johnston** (1864–
1952) received her first camera from George Eastman,
a family friend, and in the early 1890s opened a stu-
dio in Washington, DC. Johnston encouraged women
to consider careers in photography by writing articles
and arranging shows and publications to serve women
photographers. Through her friend Gertrude Käsebier,
Johnston experimented with pictorialism and in 1904
became an associate member of the Photo-Secession.
Johnston did commercial assignments around the theme
of the workplace. Her most widely known images were
for a Virginia school, the Hampton Institute, dedicated

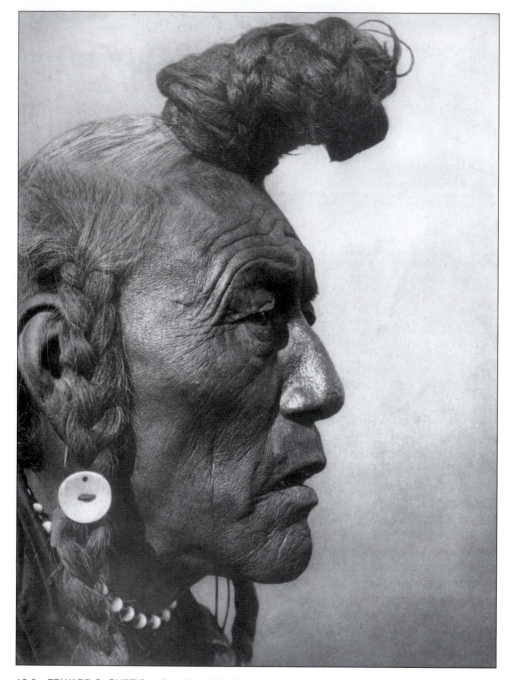

12.6   EDWARD S. CURTIS.   *Bear Bull—Blackfoot.* From *The North American Indian,* vol. 18, plate 640, ca. 1926. 15⅝ × 11⅞ inches. Photogravure. Curtis manipulated the contents of scenes for pictorial effect and removed or retouched all evidence of the modern world in an effort to recreate an authentic past that was in the process of slipping away.   Courtesy George Eastman House.

to the reformist ideal of industrial training to eliminate poverty among rural Native- and African-Americans. At the end of the nineteenth century, the "Hampton Idea," typified by its most famous graduate, Booker T. Washington (1856–1915),[15] was championed as a remedy for racial troubles by bringing the "light of civilization" to the nation's "darker races." Johnston's Hampton prints, originally produced for the Paris Exposition of 1900, were later numbered, captioned, and placed in a leather album. During the 1940s, the album was donated to the Museum of Modern Art, where it was eventually exhibited and published in an abridged version as the *Hampton Album* in 1966.

Johnston's tableaus offered a version of the white American Dream with faces of color. Her immaculately constructed, almost sculptural "friezes" dramatize the Hampton philosophy. Viewers get a privileged look at humble students learning the white man's ways. The captions stress that students are receiving a plain, utilitarian education. Images such as *Class in American History,* 1899, can be compared with Rejlander's *Two*

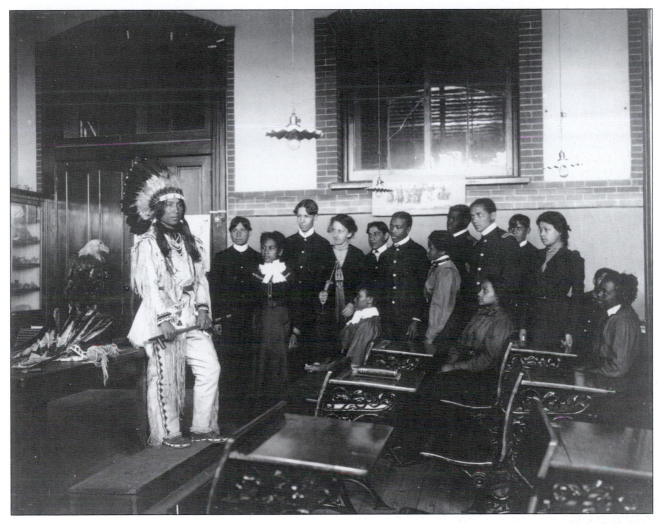

12.7   FRANCES BENJAMIN JOHNSTON.   *Class in American History, 1899.* From the *Hampton Album.* 7½ × 9½ inches. Platinum print.   The Museum of Modern Art, New York.

*Ways of Life,* where a person comes to a crossroads and must decide whether to take the hard route of righteousness or the lazy path of wickedness. In Johnston's allegory viewers observe the stereotypical Native American warrior as the embodiment of the old (bad) picturesque Wild West dramatically juxtaposed with the new (good) examples of Hampton's "specimens." The photographs offer proof that the Hampton program could train Native- and African-Americans to become productive members of civilized, white culture. The participants, including a symbolic stuffed American eagle sitting on a table, appear as a lifeless diorama, celebrating the conservative belief that sheer determination leads to a quick transformation. Nobody is out of position, implying that Hampton students follow orders and maintain discipline. Viewers are free to examine their space and give a blessing without having to participate.

The *Hampton Album* reminds us how difficult it is to critically examine the concepts that influence our thinking. Johnston shows how our beliefs influence how we see, make, and interpret images. Johnston's beguilingly formalistic images continue to deliver racist messages, just as Leni Reifenstahl's film *Triumph of the Will* (1935)[16] beautifies the ideals of Hitler's Third Reich. The reformist faith in the American Dream was so deep, however, that it never seemed wrong to impose it on others. By examining the original thought and context behind and the context of such documentary work and comparing it with contemporary beliefs, we can gain an understanding of the "truth" of those underlying ideologies that the photographer wanted to convey.

Photography offers its practitioners a social license to interact with other, nonmainstream people and situations that they may find disturbing, problematic, or unfamiliar, and share their impressions with the curious who wish to vicariously scrutinize these circumstances. **E. J. Bellocq** (1873–1949) was a New Orleans commercial photographer who used photography to explore the forbidden world of prostitutes. Not much is known about his surviving plates made in the Storyville red light district, except that they convey a sense of complicity between the male gaze and the female sitter.[17] Although the atmosphere is a mix of

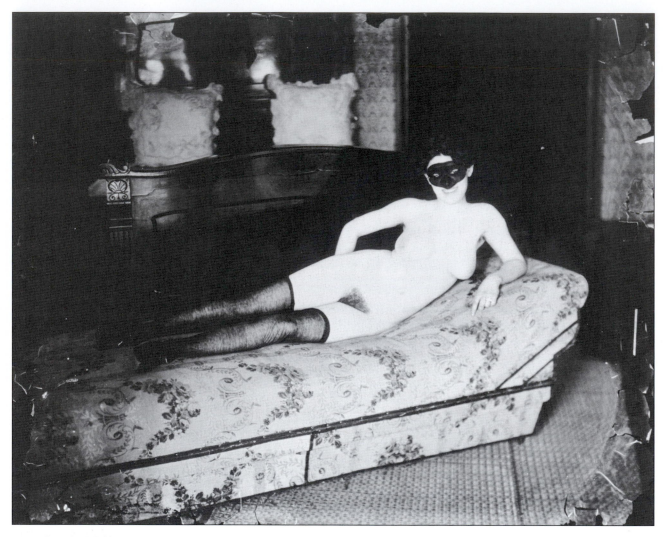

12.8  E. J. BELLOCQ.  *Storyville Portraits: Untitled, Plate 27
(Reclining Nude with a Mask),* ca. 1912. 8 × 10 inches. Gelatin
silver print.   © E. J. Bellocq. Courtesy Fraenkel Gallery, San Francisco.

lassitude, resignation, and sexuality, no sexual acts or
men are depicted, and some of the photographs offer
no clues that the women were prostitutes. Overall, the
images wrestle with penetrating the veil of languor and
suppressed desire in a way not possible before pho-
tography. Even the most explicit, where the woman is
presented in dark surroundings as a mysterious sexual
object, is countered by the fantasy of availability in
the woman's expression that hints at the pleasures to
be had once the masks between the observer and the
observed are lifted. Some recently published Bellocq
images show scratched-out women's faces, lending the
pictures a kind of licentiousness. The aggressive can-
cellation of their faces by an anonymous hand hints at
the vulnerable position of people who offer their bod-
ies for sale and, by proxy, shows how the making of a
photograph of any powerless *other* always places the
photographer in the judgment seat.

**Tina Modotti** (1896–1942) was indicative of a new
generation of socially involved artists who saw the
camera as a tool for cultural change, balancing formal-
ism with human content. From 1922 to 1930 she had an
intimate as well as a working relationship with Edward
Weston, whose photographs were not made for politi-
cal or social purpose. Modotti preferred flat light that
favored the linear qualities of the subject instead of the
hard, direct light that Weston used to emphasize mass
and texture. She was willing to challenge Weston's pur-
ist axioms and would crop or enlarge a negative to make
the final image. As a documentarian of Mexican work-
ers, Modotti merged her work into a "place in social pro-
duction" consistent with the symbols and doctrines of
communist *social realism* that favored didactic illustra-
tion of political subjects and forbade abstraction.[18] She
regarded her photography as the Mexican muralists did
their painting: as a democratic art. Unfortunately, this
led some of her later work, like *Mexican Sombrero with
Hammer and Sickle* (1927), and *Bandolier, Corn, Sickle*
(1927), which attempt to join art with propaganda, to
become preachy clichés. Eventually abandoning pho-
tography for overt political activism, Modotti stated "I

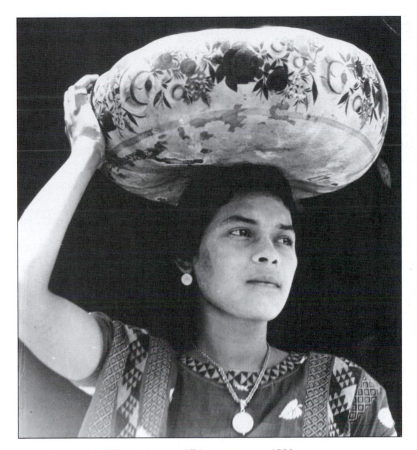

12.9   TINA MODOTTI. *Woman of Tehuantepec*, ca. 1929. 3¼ × 2¹⁵⁄₁₆ inches. Gelatin silver print. Modotti's strongest iconic images combined the pure formal clarity of Weston, the elegant composition of Vermeer, and the social/political concerns of the Mexicanidad movement into a geometric balance that emphasized the heroic qualities of Mexico's working class people.   Courtesy George Eastman House.

put too much art in my life—too much energy—and consequently I have not much left to give to art."[19] Her sympathetic treatment of Mexican working people can be seen as part of an embryonic awakening of a new type of ethnic/social consciousness that would change not only how photographs look, but who makes them.

## Emerging Ethnic Consciousness

During the first decades of the twentieth century, entrepreneurs of diverse ethnic backgrounds opened photographic businesses to make cultural records within their own communities. Minority photographers, like Native American Richard Throssel (1882–1933), faced the challenge of surviving in a commercial world that would not hire them.[20] Their circumstances rarely provided the financial freedom or leisure time to do personal work, and their personal interests had to be consolidated into their daily studio work.

**Horace Poolaw** (1906–1984) was a Kiowa who became one of the first Native American professional photographers. Poolaw used a straight style to present an insider's view of the difficult relationship between natives and non-natives. His best work juxtaposes the traditional and the modern, astutely representing the incongruities and underlying difficulties of forced cultural assimilation (see Figure 12.10). Poolaw's inclusion of "anachronisms," such as six-packs of soda, breaks down what critic Lucy Lippard refers to as "the time-honored distance between Them and Us, the illusion that They live in different times than We do. 'Anachronisms' may also be somewhat threatening to Our peace of mind, recalling how They got There (the Reservation), were put There, in a space that is separated from Us by the barbed wire of 'absentee colonialism.'"[21]

One of the best known studios serving the African-American community was run by **James VanDerZee** (1886–1983), who began an eighty-year career when he bought a mail-order camera and set up a darkroom in his bedroom closet as a teenager.[22] Opening his first Harlem studio in 1916, VanDerZee made portraits of members of the Harlem Renaissance of the 1920s, including religious leader Adam Clayton Powell, Sr., comedian Florence Mills, dancer/actor Bill "Bojangles" Robinson, and activist Marcus Garvey, founder of the Back-to-Africa movement. VanDerZee's romantic representations of the black middle and upper classes provided records of family and social events while testifying to the private achievement, aspiration, and elegance of a people beginning their struggle for racial equality. VanDerZee was expert at using light, composition, props, retouching, and montage to achieve a flattering, positive, sometimes sentimental ambiance of a life seldom seen by outsiders who were accustomed to viewing degrading images of black life (see Figure 12.11). Deborah Willis says his work defines "a people in the process of transformation and a culture in transition . . . VanDerZee presented in visual terms the growing sense of personal, and national identity of his sitters, underpinning this is the thoroughly modern sensibility with which he confronted the issue of race."[23]

Writer **Eudora Welty** (1909–2001) made "snapshots" from the position of an outsider who wanted to honestly represent another group. While working for the Works Progress Administration (WPA), she traveled through Mississippi, her home state and the nation's poorest, writing articles about the WPA Projects for local newspapers. On her own, Welty used a Kodak to

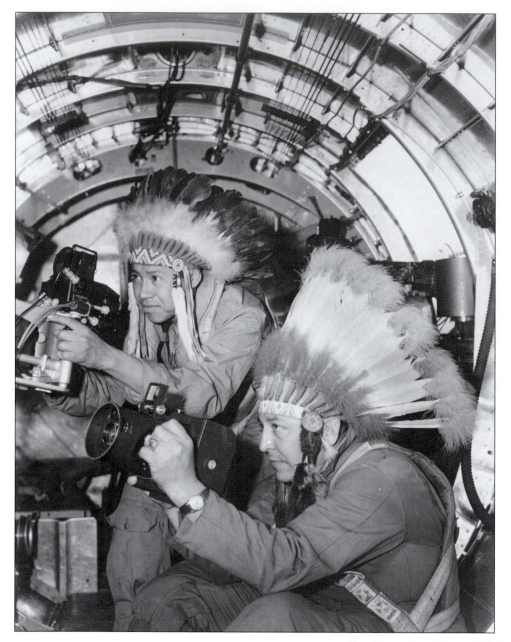

12.10  HORACE POOLAW.  *Horace Poolaw, Aerial Photographer, and Gus Palmer, Gunner, MacDill Air Base, Tampa, FL,* ca. 1944. 12¼ × 9⁹⁄₁₆ inches. Gelatin silver print. Poolaw's photographs often reveal the contradictions and irony of the Kiowa lifestyle as it underwent rapid transition during the first half of the twentieth century. After World War II broke out Poolaw enlisted in the Army Air Corps (the Kiowa's ancestral enemy) where he trained young men in aerial photography. "Because young Kiowa men were expected to become warriors, many of Poolaw's contemporaries joined the armed forces feeling that this was not only their patriotic duty as Americans, but an opportunity to fulfill traditional roles."[24]    Courtesy Stanford University. Horace Poolaw Photography Project. Courtesy Charles Junkerman.

picture the people she encountered and upon returning home made prints in her kitchen at night. The merit of Welty's work is in its human subject matter. Her book,

*One Time, One Place, Mississippi in the Depression: A Snapshot Album* (1971), is not an anthropological study but "a family album"[25] of individuals with whom she was "well positioned [to photograph], moving through the scene openly and yet invisibly because I was part of it, born into it, taken for granted."[26] Welty noted that many of the people she photographed had never had their picture taken before; by photographing them, she was "able to give something back" to her subjects. Pictures like those of the Bird Pageant (see Figure 12.12) "were made at the invitation, and under the direction, of its originator. . . . I would not have dared to interfere with the poses."[27] Welty was aware of the difficulties of photographing outside one's own group. She stated:

> In taking all these pictures, I was attended . . . by an angel—a presence of trust. In particular, the photographs of black persons by a white person may not testify soon again to such

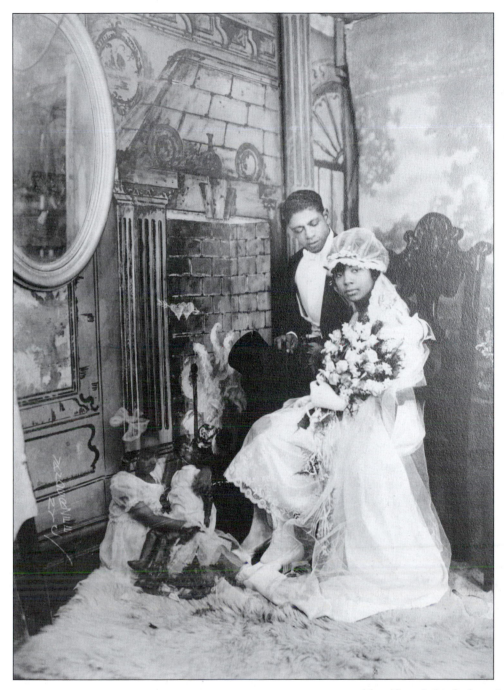

12.11   **JAMES VANDERZEE.**   *Future Expectations*, 1925. 8 ×
10 inches. Gelatin silver print.   Photo by James VanDerZee. © Donna
VanDerZee, New York.

intimacy. It is trust that dates the pictures now, more than
the vanished years. . . . I was too busy imagining myself into
their lives to be open to any generalities.[28]

## The Physiognomic Approach

From photography's earliest days, police had hired
daguerreotypists to record criminals' faces. By the 1870s,
police mug shots were used for visual identification and
in "wanted" posters. French police first used photographs

to identify rebels during the revolutionary Commune
of Paris uprising of 1871, leading Alphonse Bertillon
to standardize the practice and its accompanying data,
known as *bertillonage,* in 1872.[29] By the 1880s, Paris
police had 90,000 images on file, and the production of
photographs for court evidence was standard practice.[30]
Photographs were displayed in rogue's galleries and cir-
culated in albums such as **Thomas Byrnes's** *Professional
Criminals of America* (1886), which contained over 200
photographs of important and dangerous criminals along
with descriptions of their methods and records.

The use of photography and technology by gov-
ernment to guarantee its own authority and economic
interest by isolating and classifying individuals has

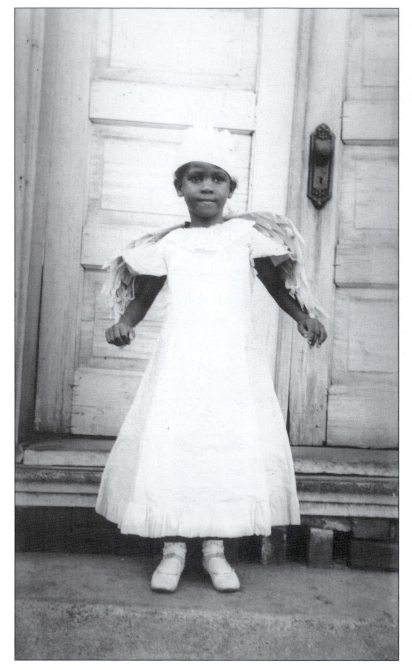

**12.12 EUDORA WELTY.** *Baby Bluebird, Bird Pageant, Jackson, MS.* Size varies. Gelatin silver print. Welty learned "a story-writer's truth: the thing to wait on, to reach there in time for, is the moment in which people reveal themselves. . . . Insight doesn't happen often on the click of the moment, like a lucky snapshot, but comes in its own time and more slowly and from nowhere but within. . . . My continuing passion, would be not to point the finger in judgment but to part a curtain, that invisible shadow that falls between people, the veil of indifference to each other's presence, each other's wonder, each other's human plight."[31]    Courtesy Eudora Welty Collection, Mississippi Department of Archives and History, Jackson, MS.

grown in importance during the twentieth century. Contemporary social critics Michel Foucault,[32] Allan Sekula, and John Tagg all expressed concern about photography's role in controlling people. Tagg linked the modern police force with industrial capitalism's need to protect the means of production—labor—from which it draws its profit. He believes police continue to use photography, from photographing speeders to mounting video cameras on lamp posts, to intimidate and pacify by using "observation-domination" techniques to compile "forms of conduct, attitudes, possibilities, suspicions: a permanent account of individual's behaviour."[33]

Control can also be exercised though more insidious means. For centuries, Europeans had been fascinated by the physiognomic approach that depicted society through hierarchies of function, position, and trade. Many still believe that body type and facial expression provide a window onto one's inner moral character and that photography offers a truthful method of revealing these facts. The Western belief in positivism went hand in hand with physiognomy. In 1912, **August Sander** (1876–1964) began a sociological study of the German people by making their portraits. He bicycled through the farming country with his view camera and tripod looking for new subjects, beginning a systematic approach to "collecting" people from German society. Sander's straightforward, unretouched portraits, generally made at eye-level, used a large lens aperture to convert the landscape into a neutral setting, similar to a seamless studio backdrop, placing attention on the subject (see Figure 12.14).

His concern for direct representation was shared by the practitioners of the *New Objectivity*, whose rationalist beliefs led them to probe beneath the surface in hopes of uncovering universal knowledge. Although World War I had annihilated the idea that civilization was advancing toward a new rational order, the survivors wanted proof that there was an intrinsic natural order waiting to be uncovered. Sander's tactics reflected these concerns as well as the institutionalized, medieval hierarchies that permeated German culture. Through precise attention to the details of dress, environment, expression, and pose, and a sense for the symbolic, Sander's "naturalistic" portraits respectfully represent a pictorial sociology of faces that reveal cultural and economic history and the struggle to accept the difference between social position and the

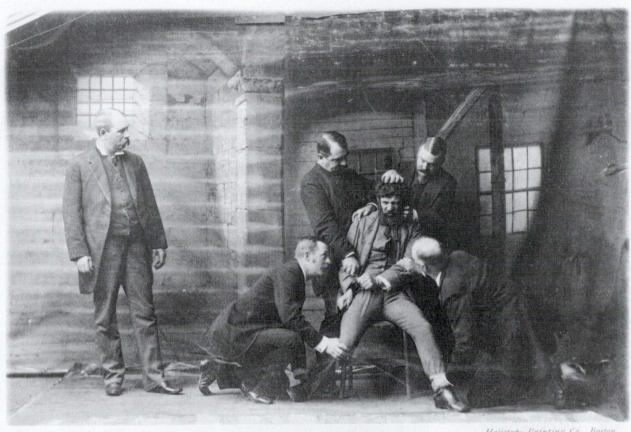

Copyright, 1884, by Thomas Byrnes.      Heliotype Printing Co., Boston.

THE INSPECTOR'S MODEL.

**12.13 THOMAS BYRNES.** *The Inspector's Model,* 1884. From *Professional Criminals of America,* 1886. Photomechanical reproduction. Offenders did not always want to cooperate with police. In *The Inspectors Model* (1884), four men struggle to hold a prisoner so that his picture can be taken as Byrnes, the inspector, looks on. Byrnes described the importance of photographing criminals: "Deception is their business [and] there are many—who carry no suggestion of their calling about them . . . men who lead double lives."[34] Yet Byrnes also comments: "Is physiognomy any guide? A very poor one. Judge for yourself. Look through the Rogue's Gallery and see how many rascals you find there who resemble the best people in the country."[35]

person who inhabits that position. Sander printed on glossy paper, normally reserved for architectural and technical illustration, after friends told him it simplified and reduced personal interpretation and made the image more objective.[36] Sander planned to publish a series of books covering his project, "Man in the Twentieth Century," but only the first volume, *Antlitz der Zeit (Face of Our Time),* appeared in 1929.[37] The Nazis, who used the same physiognomic approach to spread racial hatred, banned the book in 1934, destroyed the

printing plates, and seized the negatives, because it revealed a diversity of physical characteristics that did not match their genetic mythology. Sander then took up landscape and nature photography. He continued working after World War II, modeling an objective approach to a documentary style that viewed photography as an accurate notary with a humane duty to perform.

## The Great Depression: The Economics of Photography

In 1935, President Franklin Delano Roosevelt created the Resettlement Administration (RA), headed by former Columbia University economics professor and Undersecretary of Agriculture Rexford G. Tugwell. The RA's purpose was to aid poor, rural Americans who were uprooted from their tenant farms during the 1930s Depression and forced to move to urban areas and find industrial jobs. Tugwell appointed his former student and co-worker, Roy E. Stryker (1893–1975), as chief of the Historical Section. Stryker's job included implementing Tugwell's idea of using photography

**12.14 AUGUST SANDER.** *Prize-Winning Choral Club, Westerwald,* 1927. 11¾ × 8¼ inches. Gelatin silver print.
Die Photographische Sammlung, August Sander Archiv/SK Stiftung Kultur, Cologne.

to showcase the RA's work and American rural life in general. The goal was to show urban America a desperate situation and enlist popular support for Roosevelt's new programs of grants, loans, and resettlement money to displaced farmers. Influenced by Lewis Hine, whom he knew from using his photographs to illustrate Tugwell's textbook, *American Economic Life* (1925),

Stryker hired photographers such as Walker Evans, Dorothea Lange, Carl Mydans (1907–2004), and Arthur Rothstein for the project. Depending on funding levels, many other photographers, including Ben Shahn, Russell Lee, Jack Delano (1914–1997), Marion Post, John Vachon (1914–1975), John Collier, Jr., Gordon Parks, and Theo Jung (1906–1996), also worked on the project. While the group is generally referred to as the Farm Security Administration (FSA) project, the FSA was not officially organized until 1937, when the Resettlement Administration was absorbed into the Department of Agriculture.[38]

To carry out the mission, Stryker held briefings, gave reading assignments, conducted critiques, and developed shooting scripts for the field assignments, formulating an official FSA documentary style. Stryker established a network of publishing contacts to ensure that the images would reach their intended audiences. In the field, photographers developed their film, wrote captions, and sent materials back to Washington for editing, printing, and publication. Stryker was an unrivaled producer, who maintained the balanced distance between photographers, bureaucrats, media, and public necessary to implement Tugwell's idea: "We introduced Americans to Americans."[39] Stryker summed up what he saw as the difference between his strategy and that of the print media:

> Newspictures are the noun and verb; our kind of photography is the adjective and adverb. The newspicture is a single frame; ours a subject viewed in series. The newspicture is dramatic, all subject and action. Ours show what's back of the action.[40]

The middle-class audience at which these pictures were aimed was not aware of the stylized approach and considered the images accurate documents. The term "documentary" has been consistently and mistakenly applied to informational images, such as identification, legal, police, and scientific pictures, whose purposes are to be neutrally objective by authenticating the existence of specific subjects at a precise place and time. Stryker's intent was to dramatize real subjects in their actual settings, linking them to specific cultural messages so that viewers would formulate a favorable response to the new government programs. His agenda was to be positive and portray rural people working to improve their predicament. Humor and irony appeared, but the bizarre and the grotesque were circumvented. Camera angles and distance tended to follow the normal eye-level standards, giving a sense of cooperation and social equality, underlining the idea that these were good people experiencing hard times. Overall, the images are respectful of their subjects, providing a visual counterweight to the negative stereotypes of the mass media, such as Erskine Caldwell's *Tobacco Road* (1932) and *God's Little Acre* (1933), which gave the impression that the rural workers were misfits, loafers, and sex fiends.

**Dorothea Lange's** (1895–1965) FSA photographs epitomized the human cost of the Depression. Lange studied photography with Clarence White at Columbia University before opening a portrait studio in San Francisco in 1916. The Depression awakened Lange's social consciousness and she began photographing unemployed laborers. A childhood bout with polio left Lange with a permanent limp, possibly increasing her sympathy for circumstances that dramatically alter people's lives over which they have no control. By 1933, Lange had quit her commercial work to make photographs of the "forgotten man," in labor strikes and street demonstrations. A quotation by English philosopher and essayist Francis Bacon, tacked to her darkroom door, was her credo: "The contemplation of things as they are, without substitution or imposture, without error or confusion, is in itself a nobler thing than a whole harvest of invention."[41] Willard Van Dyke, of Group f/64, exhibited her early socially driven work in his Oakland, CA, gallery. They were seen by economics professor Paul Taylor, who hired Lange to illustrate a report recommending sanitary camps be built to provide migrant farm families with decent temporary housing. Taylor credited Lange's emotionally compelling photographs with convincing officials to set up the first camps. After seeing the report, Stryker hired Lange for the RA/FSA project, where she made what many considered the quintessential FSA image: *Migrant Mother*, 1936. Echoing the Madonna and child theme, Lange's archetypal image communicates the essence of a situation and its human relationship to history.

Lange took the photograph almost by chance. Speeding home one rainy late winter day, after a cold month of photographing migrant workers, Lange drove past a crude sign saying "PEA-PICKERS CAMP." "I didn't want to stop and didn't,"[42] she later said. Twenty miles later she made a U-turn and returned to the camp. Lange wrote:

> I was following instinct, not reason. . . . I saw and approached the hungry and desperate mother, as if drawn by a magnet . . . she asked no questions . . . . She said they had been living on frozen vegetables from the surrounding fields, and from birds that the children killed. She . . . seemed to know my pictures might help her, and so she helped me. There was sort of equality about it. . . . I knew I had recorded the essence of my assignment.[43]

Lange took these pictures to a newspaper editor who contacted United Press (UP), which informed the government authorities, who then took action to help. The headline of the March 10, 1936, edition of the *San Francisco News* proclaimed: "FOOD RUSHED TO STARVING FARM COLONY." The article contained two of Lange's images, but not *Migrant Mother*. Within a short time, however, the initially overlooked *Migrant Mother* took on a life of its own, and was reprinted and exhibited to such an extent that Lange later complained that it was making her a one-picture photographer.[44]

After leaving the FSA in 1940, Lange continued to photograph desperate social conditions. While she worked for the War Relocation Authority, Lange created her sympathetic series on the Japanese-Americans of the Pacific coast who, in the post–Pearl Harbor hysteria that catapulted America into World War II, were interned in camps by the Federal government. Her series reveals a person willing to take on unpopular causes. Although poor health prevented Lange from working for a number of years, she photographed several stories for *Life* in the 1950s. Lange's compassionate concern to make politically and socially driven work ran into

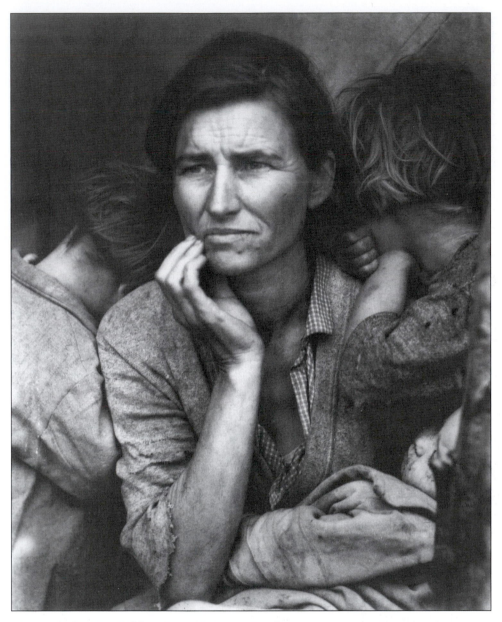

12.15 DOROTHEA LANGE. *Migrant Mother, Nipomo, Cal.,*
*1936.* Gelatin silver print. Stryker called *Migrant Mother:* "the picture
of Farm Security. . . . She has all the suffering of mankind in her but
all the perseverance too. A restraint and a strange courage. You can
see anything you want to in her. She is immortal."[45] The success
of this image overshadowed Lange's other accomplishments,
especially her humanizing of compositional formalism in a
documentary style that was used in other projects with Paul
Taylor such as *An American Exodus: A Road of Human Erosion*
*(1939).*   Library of Congress Prints and Photographs Division.

difficulty in the narrowness of the photojournalism
market of the 1950s, and some of her projects for *Life,*
such as *The Public Defender* (1956–1957) and *The Last*
*Valley* (1957) essays, were either not used or were dis-
torted by the editors. From 1958 to 1965, Lange contin-
ued freelancing, often with Paul Taylor, whom she had
married, making vital work that presented the relation-

ship of people to their culture and their connection to
the earth.

The FSA photographer whose work most profoundly
influenced the field of photography was **Walker Evans**
(1903–1975). Evans's dislike for the materialism of
the affluent 1920s led him to cultivate an economy of
practice that can be seen in his 1930s series of Victorian
and vernacular architecture. His deceptively transparent
approach—that this is exactly what the viewer would
have been drawn to had he been there himself—uncov-
ers the essence of a place and allows the unexpected
beauty of the everyday to reveal itself. In the fall of
1935, Stryker hired Evans for his RA/FSA project. Dis-
appearing into the South for weeks, Evans, the only FSA
photographer consistently using an 8 × 10-inch view
camera, returned with unheroic, clinical recordings of
ignored scenes from a fading regional American culture.
The images, unveiled by sentimentality, are possessed by

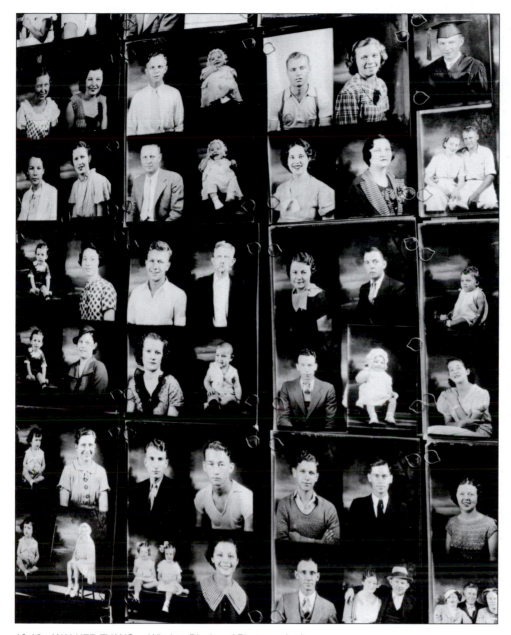

12.16   WALKER EVANS.   *Window Display of Photographer's Studio, Birmingham, AL,* 1936. 9½ × 7½ inches. Gelatin silver print. Evans's style builds on the force of specific, familiar details, transforming them into a universally recognized pattern of facts. Evans could see beneath the surface of the ordinary and uncover the extraordinary without commentary, footnotes, or statistics. His deceptively laconic head-on presentation of the facts, just before what feels like a looming collapse, have influenced how imagemakers view vernacular architecture and the American Main Street scene of signs and gas stations.   © Walker Evans Archive, The Metropolitan Museum of Art.

the photographer's puritanical objectivity mixed with an edge of pessimism. The works' understatement offered a testimony of facts, making viewers believe in the power of the plain photograph. We look at how Evans constructed a scene and nod in agreement: "Yes, this is how it is." Evans's self-effacing style made the relevance of the ordinary undeniable. Evans could ordain a moment from the present with a historical perspective, showing the present as if it was the past.

In the summer of 1936, Evans collaborated with his writer friend James Agee (1909–1955) on an article about three tenant cotton farmers in Hale County, AL, for *Fortune.* This unlikely New York journalistic duo spent most of August with one of the families, who under the cotton tenantry system did not own the land, the house, or the mule, and paid the landlord half of the crop. The two defied accepted working methods, each taking his own approach to the story. Evans rejected fairy tales of the rural South and worked with his subjects to directly represent their dignity in the face of hardship. The resulting images are a bare-bones inspection of the inner resources that enabled these people

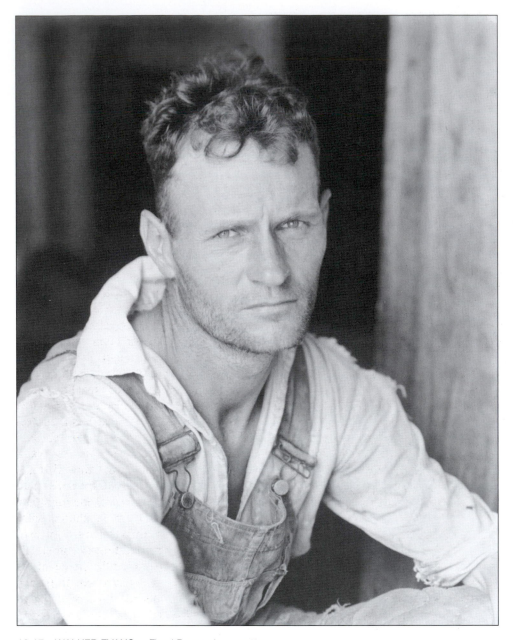

12.17   WALKER EVANS.   *Floyd Burroughs, a cotton sharecropper Hale County, AL,* 1936. 9½ × 7½ inches. Gelatin silver print.   © Walker Evans Archive, The Metropolitan Museum of Art.

to survive. The compositional economy of the images makes the truth of the situation self-evident (see Figure 12.17).

*Fortune* rejected the piece. A vastly expanded version was published as *Let Us Now Praise Famous Men* (1941). The book design was remarkable: The first thing a reader encountered was not text but a portfolio of Evans's photographs. Also highly unusual was that the photographs were not illustrations; as Agee said, the images and words were "coequal, mutually independent, and fully collaborative."[46] The critical and public response was indifferent at best; first year sales totaled less than 600 copies.

In the late 1930s, Evans made a series of anonymous New York subway riders, using a hidden camera, which was eventually published as *Many Are Called* (1966). These portraits dispense with the smiling face, revealing each person to be suspended within his or her own universe. The sequencing of the repeating images replaces the individuality of each person with a sense of exhaustion, similar to the monotonous effect of a subway car rumbling along the track station after station. In 1945, Evans joined the staff of *Fortune,* where he became an associate editor before retiring in 1965. His relationship with *Fortune* was ironic and sad. It marked the end of Evans's willingness to reveal the view from his privileged position. The view had shaped the information influential businesspeople used to make decisions of enormous social impact.

One of the FSA's most controversial photographers was **Arthur Rothstein** (1915–1985), who studied under

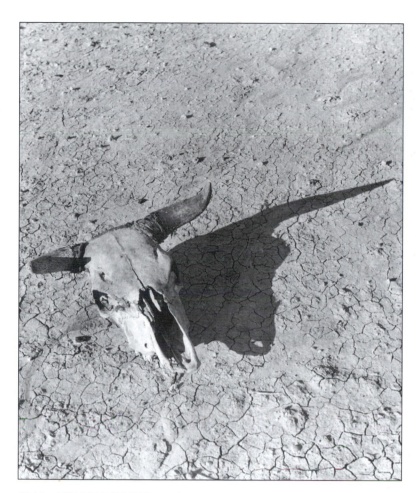

12.18   ARTHUR ROTHSTEIN.  *Steer Skull, Badlands, SD,* 1936.
12⅝ × 10⁵⁄₁₆ inches. Gelatin silver print.   Courtesy George Eastman House.

Stryker at Columbia University and joined the RA/FSA staff from 1935 to 1940. Rothstein's *Dust Storm, Cimarron County, OK,* 1936, an image of a farmer and his two young sons walking against the wind across a field that is buried to the top of fence posts with drifting dirt, became the consummate theatrical interpretation of the Dust Bowl—the prairie states' loss of unprotected topsoil due to winds and improper farming procedures. Unlike Lange's, some of Rothstein's best work was not "found" but was constructed on-site to make a point. In May of 1936, while driving through the South Dakota Badlands, Rothstein spotted a steer skull, a victim of the natural forces responsible for the severe weather, lying on the dry, cracked earth. Rothstein made some exposures and then he moved the skull about ten feet and made another exposure. He processed the film and returned it to Washington to be printed. An Associated Press editor used one of Rothstein's skull pictures as a symbol for the drought of 1936. The image, with the editor's caption, "skull of a drought-stricken steer," received national syndication. Spotting an opportunity to discredit Roosevelt's farm policies, a North Dakota

newspaper ran Rothstein's skull image with the headline, "It's A Fake."[47] The story, that Rothstein fabricated the scene, received national coverage. Roosevelt's opponents latched onto the image as proof that the RA program tricked people into accepting socialist experiments. Cartoons appeared showing a photographer (Rothstein) wandering the West with a skull under his arm. Stryker was left with the task of convincing people that the RA did not make a practice of "faking" photographs. Although Stryker encouraged his photographers to find the most compelling way to present their message, the public had different expectations. Newspaper readers expected photographers to act only as objective witnesses in their stead—their job was to report, not interpret, events. They accepted Lange's images but rejected Rothstein's staging as the violation of an implied journalistic trust, even though his intent was not to "fake" a *news* photograph of a specific drought but to characterize the overall conditions.[48] The difficulty arose when text was added to an image made as a general statement, thus converting it into a particular instance, as in the case of the steer skull (after all, how would we know that the steer died of drought?). Rothstein's skull image demonstrates the slipperiness of photographic meaning and how original intent can be shifted without the audience's awareness through the use of text, cropping, and placement within a different context. His other "straight" images corroborating the effects of the drought conditions were never questioned. Rothstein went on to help found the American Society of Magazine Photographers in 1941 and spent his life as a working photojournalist for *Look* and *Parade* magazines and as a journalism teacher.

To overcome public relations fiascoes like the steer skull incident, Stryker wanted to present "New Deal" communalism that was beyond the scare tactics of the administration's foes. Stryker found it in Pie Town, NM, an isolated alternative community of about 250 hardworking Dust Bowl homesteaders who cooperated to survive. Russell Lee (1903–1986) sought to detail the intimacy of Pie Town as a frontier experience of church dinners and square dances, a town patterned on a belief in the "American character" of family, church, and enterprise. To record the wealth of natural detail and expression inside people's homes, Lee used direct flash. This harsh, unnatural light produced artless images, thus striking a cord of incorruptibility and honesty that visually emphasized the primary subject of the photograph. But even as Lee was constructing this

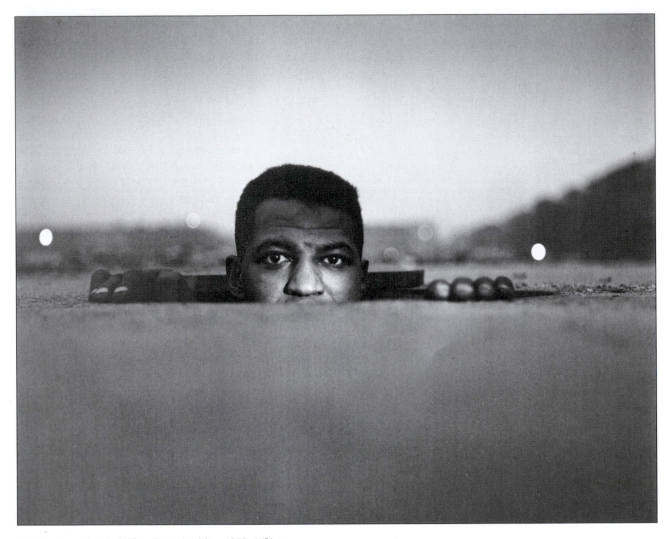

12.19 GORDON PARKS. *Emerging Man*, 1952. 14⅞ × 19⅛ inches. Gelatin silver print. *Emerging Man* visualizes the continuing identity crisis that has affected generations of African-American men. The image is based on Ralph Ellison's novel, *Invisible Man* (1952), that chronicles the story of a nameless African-American man who lives alone in an underground room as he searches to find himself in a society that does not want to acknowledge his existence and insists that he remain unseen and powerless. This image and three others were published as "A Man Becomes Invisible," in *Life* (August 25, 1952), 9–11. The article states that with Ellison's help Parks re-created scenes from the novel "to show the loneliness, the horror and the disillusionment of a man who has lost faith in himself and the world." © Gordon Parks. Courtesy Gordon Parks Foundation.

series, he was aware that Pie Town was a fading cultural vestige of pioneer ingenuity and cooperation soon to be overrun by "progress." In his notes, Lee wondered how long these values would last after electricity came and replaced community sings with radios, and burros and horses with tractors.[49] In 1941, Lee spent several weeks with his wife, Jean, photographing the environment of urban African-Americans in Chicago as part of an FSA project with the writer Richard Wright, author of *Native Son* (1940). The project resulted in *Twelve Million Black Voices* (1941), illustrated with numerous Lee and other FSA images of black ghetto life.

Ben Shahn (1898–1969) brought the viewpoint of a nonphotographer to the FSA project. An artist who had used others' photographs as models for figures in his works of social protest in the 1920s, Shahn learned to use a Leica from his former roommate Walker Evans in the early 1930s. At first, Shahn photographed the growing social disruption that was breaking down societal behaviors on the streets of New York. In 1935, however, he went to work as an artist for the Special Skills Department of the RA and was soon loaned out as a photographer to the Historical Section. His strong opinions on dramatizing social issues helped formulate Stryker's belief that the RA/FSA images needed to go beyond visual artifacts and convey empathetic statements informed by a class, economic, racial, and religious awareness. Shahn's casual approach produced nontraditional, asymmetrical compositions with an emphasis on form, and encouraged other RA/FSA photographers to consider the ephemeral genuineness of the *candid* approach. In candid work the subject is supposed to be represented naturally, without

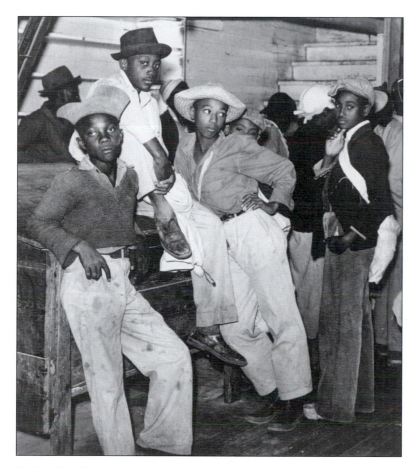

12.20   MARION POST WOLCOTT.   *Young Boys Waiting in the Plantation Store to be Paid off for Picking Cotton, Marcella Plantation, Mileston, MS,* ca. 1939. Gelatin silver print.

With the approach of World War II, Stryker shifted the strategy and themes of the FSA to assert the country's sense of physical and spiritual plenty. These transformations are exemplified by the work of **Marion Post** (1910–1990), who became Marion Post Wolcott when she married in 1941. Post's photographs of the interaction of nature and society consoled viewers who were tired of seeing people out of work with scenes where traditional work values were being practiced. This trend of sweeping aside troubling news and concentrating on affirmation would become the hallmark of the 1940s.

War reversed the hardships of the Great Depression. Suddenly, people who might have been in migrant labor camps were in the military, working in war factories, or back on the farm. The FSA expired in 1943, and its photographic activities were absorbed into the Office of War Information, leaving behind an exhaustive public archive. Between 1935 and 1943, some 80,000 prints and 200,000 unprinted negatives were produced and made available to editors and publishers at little or no cost, creating a legacy that has determined the country's vision of the Depression.[51]

## The FAP Project: Changing New York

interference from the photographer. Shahn cultivated the unposed mode by equipping his camera with a 90-degree right-angle viewfinder so that he could make "snapshots" without the subject's consciousness of the camera affecting the outcome. He also practiced *post-visualization,* cropping his negative to arrive at a satisfactory composition.

At a time when segregation rather than integration was the social norm, Stryker hired African-American **Gordon Parks** (1912–2006) as a photographer for the FSA project (1942–1943). Stryker employed Parks again for his Standard Oil Company of New Jersey Project in 1945–1948,[50] during which time Parks made some of his most unusual images of white corporate culture. Parks's ability to function in a multitude of social situations led to his hiring as the first black staff photographer for *Life* in 1949. His photoessays on the black fight for equality brought issues and leaders from a cross-section of the African-American community including Martin Luther King, Jr., the Black Muslims, the Black Panthers, Eldridge Cleaver, and Muhammad Ali into white middle-class living rooms (see Figure 12.19). His film, *Shaft* (1971), crossed over racial differences and influenced Hollywood and American culture.

During the 1930s, the documentary approach was the predominant mode for serious American photographers. After working as Man Ray's assistant and securing Atget's photographic estate, **Berenice Abbott** (1898–1991) returned to New York and opened a studio in 1929. Affected by Atget's unadorned realism, Abbott embarked on a photographic record of New York City. She supported this project through magazine work and teaching until 1935 when she gained funding from the Federal Arts Project (FAP) of the Works Progress Administration. Abbott sustained one of the few government-sponsored urban documentary projects over four years by fusing the earnestness of Atget with the playfulness of her Parisian modernist experience. Abbott deployed her 8 × 10-inch camera from a multitude of viewpoints, and cropped prints in her effort to manifest the chaotic and complex relationships between people and a great city. Her book, *Changing New York* (1939),[52] astringently and humorously contrasts the relationship of beauty and decay within an urban environment (see Figure 12.21). Abbott also promoted the documentary stance by championing the work of Atget and helping to arrange a retrospective of Hine's work.

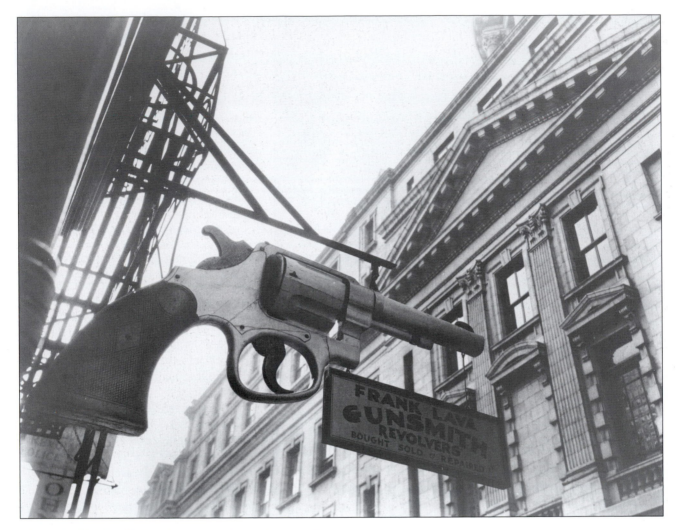

12.21   BERENICE ABBOTT.   *Gunsmith and Police Department,*
*6 Centre Market Place,* February 4, 1937. 8 × 10 inches. Gelatin
silver print.   © Museum of the City of New York, Federal Arts Project,
"Changing New York." Bernice Abbott/Commerce Graphics, NYC.

During the 1930s, other photographers such as **Roman Vishniac** (1897–1990) made a visual record of Jewish life in the ghettos of Eastern Europe between 1936 and 1939, which were systematically destroyed by the Nazis (see Figure 12.22). To make his photographs, Vishniac used a hidden camera, both to avoid charges of spying and because many Orthodox Jews would not have their picture taken. Vishniac managed to preserve about 2,000 of these photographs, hidden by himself and his family and smuggled into America by way of Cuba, which finally resulted in his book *A Vanished World* (1983). He also made significant scientific contributions to the fields of photomicrography and time-lapse photography.

## The Photo Booth: Self-Portraits for All

Until the late 1920s, people were accustomed to getting dressed-up and going to a photography studio to have a "directed" picture made. In the pursuit of increased speed and profitability, inventors worked to engineer a machine that would permit people to make their portraits on their own terms. The first automated photography apparatus was patented in 1889 by Mathew Stiffens and that same year Monsieur Enjalbert demonstrated a similar contraption at the Exposition Universelle in Paris, France. Neither was dependable enough to be self-sufficient. The breakthrough came in the fall of 1926, when a Jewish inventor from Siberia named Anatol Josepho (shortened from Josephewitz) (1894–1980) opened the first successful "dip 'n' dunk" wet-process photo booth concession in New York's Times Square. Known as the Photomaton, it was an instant hit and quickly called "Broadway's greatest quarter-snatcher." For 25 cents everyone from New York Governor "Al" Smith to the butcher, the baker, and the light bulb maker took their turn in the Broadway shop. In April 1927, *Time* magazine reported that 280,000 customers had posed and waited the eight minutes it took to process a strip of eight small photos.

The Photomaton spread to arcades, amusement parks, bus depots, fairs, and five-and-ten cent stores across the country. It was such a marvel that by

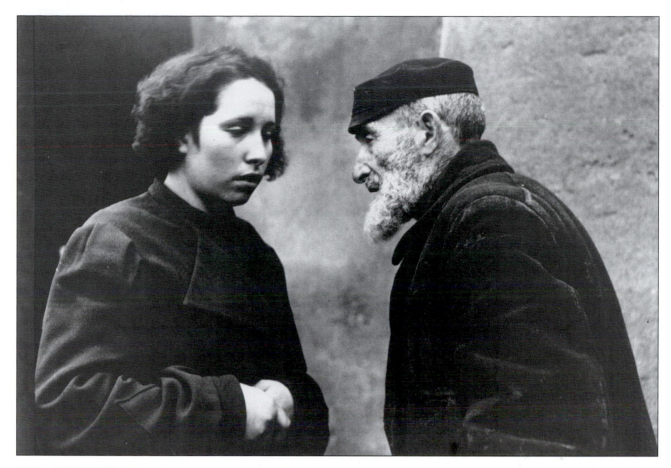

**12.22 ROMAN VISHNIAC.** *Granddaughter and Grandfather, Warsaw,* 1937. 16 × 20 inches. Gelatin silver print. The Nazis' rise to power and the accompanying anti-Semitism prompted Roman Vishniac to document the Jewish ghettos of Eastern Europe on the eve of the Holocaust. The surviving 2,000 candid images provide evidence of people, places, and traditions that were forcibly erased. Vishniac managed to get out of a French concentration camp and make his way to America in 1941, where he continued his scientific work with his photomicrography and time-lapse cinemamicrography of small animals, insects, and plants.   The Museum of Modern Art, New York. © Mara Vishniac Kohn.

March 1927 a business consortium paid Mr. Josepho $1 million for the American rights to his invention. The following year, the European rights were sold. Very quickly Surrealists André Breton, Luis Buñuel, and Salvador Dalí all posed for photo booth portraits with their eyes closed, reflecting Breton's belief that dreams were the conduit to the unconscious.

Competition in the "personal photography" market was immediate. Initially attendants in white smocks and gloves took patrons' money, suggested poses, cut the strips into individual photos, and sold extras including color tinting and frames. Curtains were added later, which invited immediate self-portraiture because once the curtain is drawn, one is removed from the rest of the world. The photo booth became an intimate, private studio in a public place where people feel free to act out their quixotic fantasies, make funny faces, and occasionally indulge in risqué poses. Beyond its amusement value, the machine became a source of portraits for chauffeurs' licenses, passports, and other forms of identification.[53]

Photo booths reached their height of popularity during World War II when American military men heading overseas and their girlfriends made likenesses to exchange as forget-me-nots. In the 1960s, Andy Warhol utilized photo booths to take portraits, including his own, which were enlarged and incorporated into his art. Since then, numerous artists have practiced "photoboothery" to make work, with many shows and books written about the practice.

Currently, digital photo booths make it possible to Photoshop your face onto the body of a cartoon character and send the results to a mobile phone, as well as produce variants like photo stickers and postcards.

## Mass-Observation

Another unique project undertaken during the Depression years was carried out by Mass-Observation and incorporated documentary photography, anthropology, socialism, and surrealism. Mass-Observation was founded in 1936 by journalist and poet Charles Madge (1912–1996) to study British society from real life in order to learn its true feeling about issues, such as the

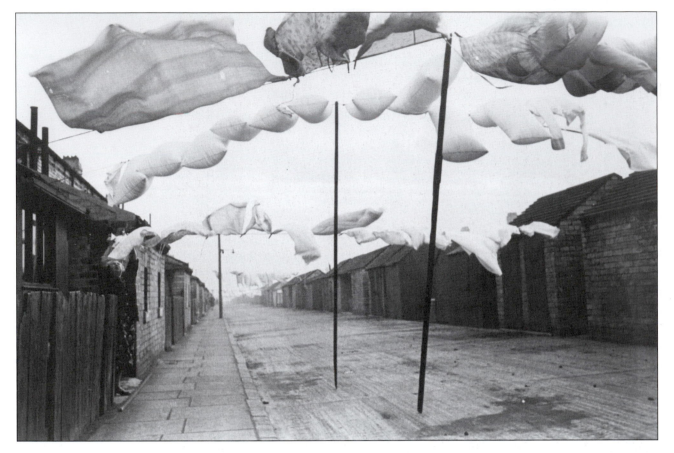

**12.23 HUMPHREY SPENDER.** *Wash on the Lines, Bolton,* 1937. 9¼ × 13½ inches. Gelatin silver print. Unlike the Farm Security Administration project, Mass-Observation was not interested in putting an affirmative face on things. Tom Harrisson thought it was important to include unobserved photography in his methodology because he "distrusted the value of mere words."[54] Humphrey Spender had difficulty with this style because it eliminated human interaction between the photographer and the subject. Courtesy Bolton Metro Museums and Art Gallery, Bolton, England.

Abdication Crisis of 1936 when Edward III gave up his kingship to marry American divorcée Wallis Simpson, he felt had been repressed. He was joined by filmmaker Humphrey Jennings (1907–1950) and by ornithologist and anthropologist Tom Harrisson (1911–1976), who had studied cannibals in Borneo and wanted to show comparisons between their culture and his own. Among other things, the group was interested in chance occurrences, how the juxtaposition of different types of events could disturb the status quo and how individuals interpreted the same event differently. By the end of 1937 their ethnographic undertaking involved more than 500 people keeping detailed diaries of everything they did on the twelfth day of each month throughout the year. Other volunteers acted as living "subjective cameras," doing "continuous observation" to collect a mass of data for future studies that science would use to "build new hypotheses and theories." They also asked participants to make snapshots of their daily lives and send them in with their written diaries. The theme of these activities was a search for identity during the time of the crumbling British Empire in which everyday people reported what society looked like to them.

In 1937 photojournalist **Humphrey Spender** (1910–2005) joined the group to photograph the working-class cotton mill town of Bolton, England (referred to as Worktown), where Harrisson had moved and disguised himself as a worker in order to become an inside observer. Harrisson loosely directed Spender to use hidden 35mm cameras, making him an "unobserved observer," to make secret pictures of people in public places carrying out various activities so that things could "speak for themselves": housing conditions, industry, and leisure, political, religious and social activities. With the outbreak of World War II, Mass-Observation supplied information on home-front morale to the Ministry of Information and eventually became a for-profit research center.

## The Film and Photo League

The Film and Photo League was originally part of the cultural propaganda wing of Workers' International Relief, a leftist strikers' aid group in Berlin that supported Workers' Camera Leagues in European and American cities. By 1934, the American group had

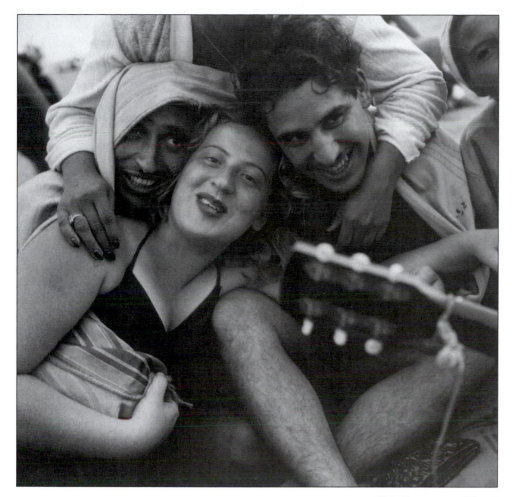

12.24  SID GROSSMAN. *Coney Island,* ca. 1947–1948. Gelatin silver print.  © Miriam Grossman Cohen. Courtesy Howard Greenberg Gallery, NYC.

evolved into the New York Film and Photo League, known for its propaganda films on social injustice and its documentary film classes. In 1936, the organization's filmmakers split over aesthetic and social issues. The still photographers regrouped under the leadership of **Sidney Grossman** (1913–1955) and Sol Libsohn (1914–2001) to form a self-supporting Photo League as a meeting place, gallery, and education site. The Photo League promoted the sanctity of the straight image and the belief that photography needed to serve a social-political purpose. During the 1930s, under the direction of Aaron Siskind (1903–1991), members of the Photo League's Feature Group spent three years covering New York's vibrant black community, producing the *Harlem Document* (1938–1940). Disputes with League members over his growing interest in formal aesthetics led to Siskind's leaving the organization in 1941. He continued his contemplative work and eventually joined the Abstract Expressionist movement (see Chapter 15).

The driving force between 1938 and 1949 for the ideals of the politically conscious Photo League, where the officers, teachers, and speakers donated their time,

was Sid Grossman. The League was the site for photography exhibitions at a time when few art museums would show photography. In December 1947, the United States Attorney General's office included the Photo League on its list of "Totalitarian, Fascist, Communist, and Subversive Organizations." Grossman, a member of the Communist Party, was blacklisted. In an effort to save the League, Grossman resigned from the organization. Ironically, by the late 1940s the League was attracting photographic talents without Marxist agendas, including Ansel Adams, Beaumont and Nancy Newhall, Barbara Morgan, Edward Weston, and Richard Avedon. But the blacklist's threat of lost livelihood and the growing public hysteria that accompanied Senator Joseph McCarthy's Communist witch hunts led to the League's collapse in 1951, leaving a spiritual black hole for those who wanted to unite photography and social change. Faced with the repression of intellectual freedom under McCarthyism in the 1950s, many American photographers shifted their position from work that called for social action to a more inner, highly personal approach. The Photo League's social activism would not manifest itself again in the photographic community until the civil rights struggles of the 1960s.

The conclusion of World War II with the dropping of two atomic bombs on Japan, the immediate

transformation of the U.S.S.R. from an ally to a foe that started the Cold War, and the explosive growth of the postwar economy shifted American concerns from the social issues of the Great Depression to those of materialism and nationalism. With this realignment, the socially conscious documentary practice supported by government funding was replaced by corporate models like *Life* magazine, which tempered cultural needs with its own commercial interests (see Chapter 14).

## Endnotes

1   Tenements appeared in New York when old houses were subdivided into small rooms and rented to immigrants. During Riis's time they evolved into four- to six-story apartment houses with tiny, often unventilated, dark rooms. Typically four families occupied a floor, each having one or two dark bedrooms about $6\frac{1}{2} \times 7$ feet, a $10 \times 12$-foot living area, and a communal kitchen, hall, and stairway.

2   Charles A. Mason, Preface to the Dover Reprint Edition, Jacob A. Riis, *How The Other Half Lives: Studies Among the Tenements of New York* (New York: Dover, 1971), vi.

3   The term muckrake comes from John Bunyan's *Pilgrims Progress* (1678–1684) and was used in a speech by President Theodore Roosevelt in 1906. The name muckraker was applied to American critics, journalists, and novelists who exposed corruption in business and politics at the turn of the twentieth century and called for social reform. They included Sinclair Lewis, Lincoln Steffens, and Ida M. Tarbell.

4   Jacob A. Riis, *How the Other Half Lives: Studies Among the Tenements of New York,* reprint (New York: Dover Publications, 1971), 30.

5   "Flashes from the Slums: Pictures Taken in Dark Places by the Lightning Process," *The Sun* (New York), February 12, 1888. Reprinted in Beaumont Newhall ed., *Photography: Essays and Images,* 1980, 155–57.

6   Jacob A. Riis, *How the Other Half Lives: Studies Among the Tenements of New York* (New York: Charles Scribner's Sons, 1890).

7   The halftones did not do justice to the photographs, causing the work to be neglected until the original plates were rescued by Alexander Allard who made new prints and began exhibiting them in 1947.

8   Pamela Reeves, *Ellis Island: Gateway to the American Dream* (New York: Dorset Press, 1991), 134.

9   Lewis Hine, "Social Photography, How the Camera May Help in the Social Uplift." *Proceedings, National Conference of Charities and Corrections* (June 1909), in Alan Trachtenberg, ed., *Classic Essays on Photography* (New Haven: Leet's Island Books, 1980), 111.

10   Alan Trachtenberg, "Ever—the Human Document," *America and Lewis Hine: Photographs 1904–1940* (Millerton, NY: Aperture, 1977), 133.

11   Horatio Alger, Jr., *Ragged Dick,* 203, quoted in James Guimond, "Lewis Hine and American Industrialism," *American Photography and the American Dream* (Chapel Hill: The University of North Carolina Press, 1991), 74.

12   Hine, 111.

13   Lewis Hine, "The Spirit of Industry," Introduction to *Men at Work* (New York: The Macmillan Co., 1932), unp.

14   C. and F. W. Dammann's *Ethnological Photographic Gallery of the Various Races of Men* (London: Trubner, n.d.), unp.

15   Booker T. Washington was the organizer and director of the Tuskegee Institute (1881), an early black educational institution, and author of *Up from Slavery* (1901).

16   Most of Germany's film community was forced to flee when Hitler was elected chancellor in 1933. Riefenstahl remained and was given carte blanche by Hitler to make a motion picture of the 1934 Nuremberg Party Convention. The result was her brilliant and inflammatory propaganda film, *Triumph of the Will* (1935), banned by the Allies even after the end of World War II.

17   For a discussion about the Storyville work, see John Szarkowski, ed., *E. J. Bellocq: Storyville Portraits: Photographs from the New Orleans Red-Light District,* ca. 1912 (New York: Museum of Modern Art, 1970). Also see revised edition with introduction by Susan Sontag (New York: Random House, 1996) and Janet Malcom, "The Real Thing," *The New Yorker,* vol. XLIV, no. 1 (January 9, 1997), 12, 14–16.

18   Drawn into a cultural movement known as *Mexicanidad,* which realigned Mexico's national identity with its ancient and indigenous cultural rather than its more recent colonial past, Modotti engaged in revolutionary political activities in the early 1920s, joined the Mexican Communist Party in 1927, was deported in 1930, and later went to the Soviet Union.

19   Letter to Weston, July 7, 1925; cited in Amy Stark, ed., *The Letters from Tina Modotti to Edward Weston* (Tucson: Center for Creative Photography, 1986), 39–40.

20   See Peggy Albright, *Crow Indian Photographer: The Work of Richard Throssel* (Albuquerque: University of New Mexico Press, 1997).

21   Linda Poolaw, *War Bonnets, Tin Lizzies, and Patent Leather Pumps: Kiowa Culture in Transition, 1925–1955. The Photographs of Horace Poolaw, October 5–December 14, 1990.* (Stanford: Stanford University, 1990), 13.

22   Telephone conversation between Donna VanDerZee and author, February 2, 1999.

23   Deborah Willis-Braithwaite, *James VanDerZee, Photographer 1886–1983* (New York: Harry Abrams in association with The National Portrait Gallery, Smithsonian Institution, 1993), 10.

24   Lucy R. Lippard, ed., *Partial Recall: Photographs of Native North Americans* (New York: The New Press, 1992), Introduction, 27.

25   Eudora Welty, *One Time, One Place, Mississippi in the Depression: A Snapshot Album* (New York: Random House, 1971).

26   Ibid., 4.

27   Ibid.

28   Ibid., 6.

29   For additional information on the taxonomic uses of photography, see Allan Sekula, "The Body and the Archive," in *The Contest of Meaning: Critical Histories of Photography,* Richard Bolton, ed. (Cambridge: The MIT Press, 1989), 342–89.

30   Heinz K. Henisch and Bridget A. Henisch, *The Photographic Experience 1839–1914: Images and Attitudes* (University Park: The Pennsylvania State University Press, 1994), 300–3.

31   Welty, 7–8.

32   See Michel Foucault, *Discipline and Punish: Birth of the Prison,* trans. A. Sheridan (Allen Lane: London, 1977).

33   John Tagg, *The Burden of Representation,* "A Means of Surveillance," (Minneapolis: University of Minnesota Press, 1993), 74.

34   Thomas Byrnes, *Professional Criminals of America* (New York: Cassell and Company, 1886), 54.

35   Ibid., 55.

36   Robert Kramer, *August Sander, Photographs of an Epoch, 1904–1959* (Millerton, NY: Aperture, 1980), 23. The author tells that Sander's use of glossy paper may have occurred when he ran out of his normal portrait stock, but his friend painter Wilhelm "Seiwert was quick to point out that he had in fact made an important aesthetic break-through and encouraged Sander to continue with the technique."

37   The complete work was envisioned as forty-five portfolios containing twelve photographs each. Sander wanted to present mankind as a cycle, with a moralistic hierarchy, centering on the roles men and women played in society.

38   For a history of the FSA, see F. Jack Hurley, *Portrait of a Decade, Roy Stryker and the Development of Documentary Photography in the Thirties* (Baton Rouge: Louisiana State University Press, 1972).

39   Roy Emerson Stryker and Nancy Wood, 73.

40   Ibid., 8.

41   Lange first used the Bacon quote on a change of address announcement and later on a Christmas card. Quoted in David Travis, "Ephemeral Truths," *On the Art of Fixing a Shadow: One Hundred and Fifty Years of Photography,* Sarah Greenough, et al. (Washington, DC: National Gallery of Art, 1989), 248.

42   Dorothea Lange, "The Assignment I'll Never Forget," *Popular Photography,* vol. 46, no. 2 (February 1960), 42, 126. Also reprinted in Newhall, *Photography: Essays and Images* (1980), 262–65 with all six exposures.

43   Ibid.

44   For a chronicle of this image see Vicki Goldberg, *The Power of Photography: How Photographs Changed Our Lives* (New York: Abbeville Press, 1991), 136–42.

45   Roy Emerson Stryker and Nancy Wood, *In This Proud Land: America 1935–1943 as Seen in the FSA Photographs* (Greenwich, CT: New York Graphic Society, 1973), 73.

46   James Agee and Walker Evans, *Let Us Now Praise Famous Men: Three Tenant Families.* Reprint with new introduction by John Hershey (Boston: Houghton Mifflin Company, 1988), Preface x1vii.

47   *Fargo Forum* (August 27, 1936) quoted in F. Jack Hurley, *Portrait of a Decade, Roy Stryker and the Development of Documentary Photography in the Thirties* (Baton Rouge: Louisiana State University Press, 1972), 88.

48   Conversations between Arthur Rothstein and the author, January 26–28, 1979.

49   As referred to in James Guimond, *American Photography and the American Dream,* 132. These notes are located in Library of Congress, microfilm lot 639M, item no. 36715D.

50   For background information about this project see Steven W. Plattner, *Roy Stryker: USA, 1943–1950: The Standard Oil (New Jersey) Photography Project* (Austin, TX: University of Texas Press, 1983).

51   All the FSA work is owned by the government and inexpensive prints can be ordered from the Library of Congress. Many images are available on their website.

52   For a comparison of then and now, see Douglas Levere, et al. *New York Changing: Revisiting Berenice Abbott's New York.* (Princeton, NJ: Princeton Architectural Press, 2004).

53   Näkki Goranin, *American Photobooth* (New York: W. W. Norton & Co., 2008).

54   As quoted in Deborah Frizzell, *Humphrey Spender's Humanist Landscapes: Photo-Documents, 1932–1942* (New Haven: Yale Center for British Art, 1997), 26.

# Nabbing Time

## Anticipating the Moment

For most of the nineteenth century photographers had worked with extended time exposures that required forethought and the cooperation of the subject. As film sensitivity increased, a shutter capable of isolating units of time in fractions of a second was invented to control brief exposure. By the close of the nineteenth century, changes in artistic, philosophical, and scientific thinking about how time was measured and portrayed, along with technology-based, mass-production methods, made it possible to gauge, see, and think about time in ways that were formerly unimaginable. The actualization of Herschel's notion of the snapshot,[1] by the hand-held camera, allowed all photographers to define previously undetectable moments of life. This change enhanced the democratic nature of the hand camera by further expanding the range of vernacular subject matter, from loved ones to streetcars, that thoughtful photographers like Stieglitz began to incorporate into their visual thinking. The hand camera cemented the most popularly cherished concept of twentieth-century practice: nabbing a precise instant from the flow of time. This ability to rapidly distill complicated activities would define the majority of practice throughout the twentieth century.

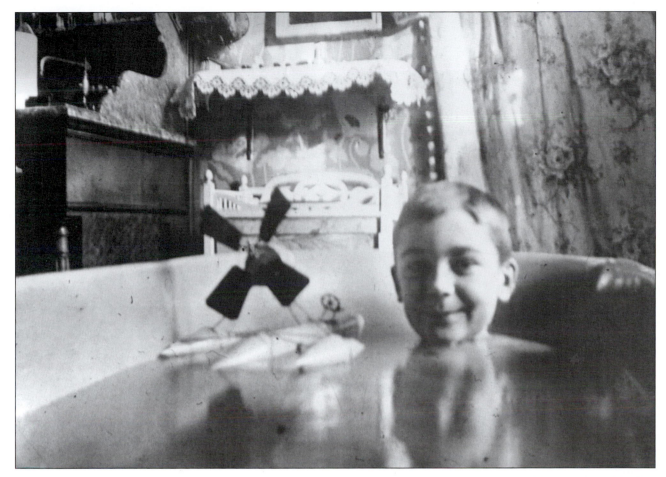

13.1  JACQUES-HENRI LARTIGUE.  *My Hydroglider with Propeller,* 1904. 5¼ × 6¹¹⁄₁₆ inches. Gelatin silver print.   Photograph by Jacques-Henri Lartigue. © Ministère de la Culture-France/Association des Amis de J.H. Lartigue, Paris.

By the start of the twentieth century, the technology for taking time prisoner was so easy that even a child like **Jacques-Henri Lartigue** (1894–1986) could use it to offer his version of life. Lartigue was an affluent amateur, one with the freedom to observe without concern for posterity or the public, who now had the means to record life's commonplace details from a personal point of view. His instinctively ebullient images capture his enchanted childhood, which was a testing ground for new inventions, including automobiles, bicycles, and airplanes, and show how new technology quickly altered that existence.

Beginning with a view camera at age seven, Lartigue soon convinced his father to get him a hand camera so he could naturally pursue his child's point of view, like putting the camera on the floor to record his toy racing cars. Hand cameras made it easier and less financially risky to make conscious experimental decisions, as when Lartigue balanced his camera on a plank of wood extended over a bathtub to picture himself and his toy water glider. For Lartigue, photography's new simplicity made it part of childhood play, "a magic thing with all sorts of mysterious smells, a bit strange and frightening,"[2] an arena of visual pleasure. During France's cultural renaissance, "La Belle Époque," young Lartigue's snapshots collected the amusements and fragile beauties available to the well-to-do just before this well-bred world disappeared into the abyss of World War I.

Lartigue's albums chronicle a fascination with the motion and speed that was transforming the world and providing new aesthetics. The ease of the hand-held camera allowed anybody to embrace the physical act of seeing subjects as they moved through time. Lartigue took his camera everywhere, eventually deforming his shoulder from carrying it. His intuitive images reveal and confirm what serious photographers struggled to discover and master: the expertise of anticipation. He was obsessed with capturing the peak moment of action where critical timing was achieved through observation and calculation. His most advanced Block Note camera had a top shutter speed of 1/300th of a second, making his decision when to release the shutter crucial. Pushing the shutter at the moment the image was seen was too late, due to the mechanical and physiological delay between seeing and exposing. Lartigue compared it to playing tennis—one had to foresee the exact moment beforehand and have the ability and training to act without consciously thinking. As a child Lartigue

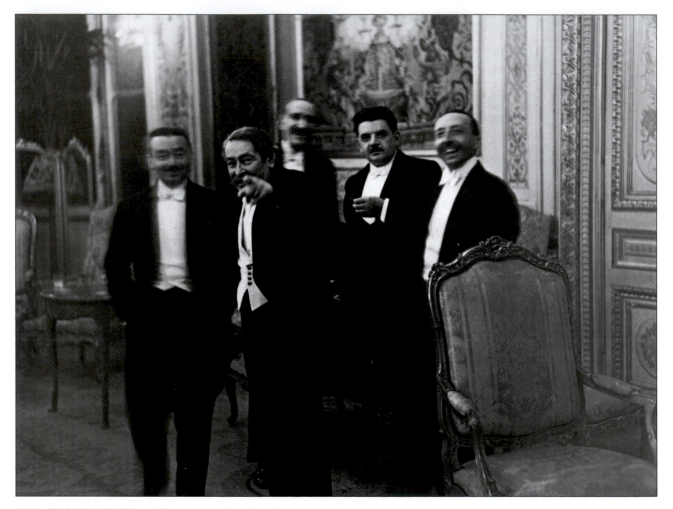

13.2   ERICH SALOMON.   *5 Diplomats*. Variable dimensions.
Gelatin silver print.   Berlinische Galerie, Berlin, Germany.

was an unthreatening spectator, able to glide into situations and uncover unguarded instances of highly complex, fleeting human interrelations. Although he never received any photography training, through practice Lartigue was able to use the camera to organize the random attributes of life with coherent clarity. Lartigue's work did not influence the practice of his time, remaining unknown to the public until it was presented at the Museum of Modern Art in 1963.

During the early decades of the twentieth century, gradually improving films and better lenses allowed the camera to evolve into a truly miniature machine. Technological breakthroughs in camera design placed an image-making system at the fingertips of any photographer who wanted to take part in the expanded uses and markets of the medium. By eliminating technical obstacles, the hand camera permitted photographers to be in the flow of events as they unfolded, trapping moments in time, instead of being outside and having to forge happenings for the sake of the camera. The adoption of miniature cameras was slow, but in 1924 the Ernox (later Ermanox) made clear the future of hand cameras.

Claiming "What you Can See, You Can Photograph," it had shutter speeds up to 1/1000 of a second and a fast f/2 lens, and made small exposures on either individual dry plates or sheets of film.

For those who favored miniature cameras, the most desirable models used 35mm roll film, which was standard stock in movie studios. By the mid-1910s, a few still cameras, notably the Simplex, used 35mm film, but the most famous remains the Leica. Although invented about 1913 by Oskar Barnack (1879–1936) of the E. Leitz Optical Works in Wetzlar, Germany, the Leica was not marketed until 1925. Utilizing a 24 × 36mm film frame, it was smaller and lighter than folding hand cameras and let photographers rapidly and unobtrusively make up to forty exposures without reloading. Faster, high-definition, and interchangeable lenses followed. So did the built-in *coupled rangefinder*. Introduced in 19216 on a Kodak camera that made postcard-sized images, the coupled rangefinder allowed photographers to quickly align overlapping images into a single image, ensuring sharper images by eliminating the need to guess the focusing distance. In 1932, *it* first became a built-in feature of 35mm cameras, appearing on both the original Zeiss Ikon Contax and the Leica II.

Other evolutionary attributes, such as single-lens-reflex (SLR) viewing at eye level, were marketed after World War II, but did not gain traction until the early 1960s. Built-in meters became more common to hand cameras at this same time; autofocus followed in the 1980s. The march toward miniaturization continued with the 1996 introduction of the Advanced Photo System (APS), which uses a film cartridge about a third smaller than a conventional 35mm cassette. The domination of digital imaging has since led the major manufacturers to stop supporting the system, leaving it to die a slow death. The miniature camera's ability to allow repeated exposures, stop action with fast shutter speeds, perform in low-light situations, avoid attracting attention, and produce sharp, enlargeable images, drastically altered how photographs were conceived, executed, seen, and interpreted.

The miniature camera leveled long-standing societal rules about what was private and what was public, disregarding social position and thereby making everyone more or less equal. In 1927, **Erich Salomon** (1886–1944) used a concealed camera to make pictures of a murder trial inside a courtroom in which photography was forbidden. These images aroused enough notice that Salomon quit his job and began to make unposed, available light photographs of celebrities, diplomats, politicians, social gatherings, concerts, and theater presentations with a miniature camera. By 1929, an editor for *The London Graphic* coined the phrase *candid camera/photograph,* in reference to Salomon's ability to capture unguarded moments. Referring to himself as a "historian with a camera,"[3] Salomon brought the camera into social realms where it had been prohibited (see Figure 13.2). By means of silent shutters and cable releases, Salomon's camera (he switched to a Leica in 1932), hidden in his hat, a valise, or a potted plant, informed the general public of cultural events and ways in which the powerful carried out their business beyond public scrutiny. Salomon commented on the adrenaline rush of making such images: "The work of a photojournalist is a constant battle, a battle for the picture, and as in hunting, he gets his game only if he has an obsession for the chase."[4]

A collection of Salomon's candid photographs was published as *Berühmte Zeitgenossen in unbewachte Augenblicken* (*Celebrated Contemporaries in Unguarded Moments*), 1931. The public demand for these "extraordinary" pictures would, through repetition, lead them to become ordinary. During a period when Germany was newly experiencing democracy, what was striking was how unremarkable these people who made important decisions looked. The small camera showed the human connection between the statesman and the citizen.

The practice of making images without a subject's consent was epitomized by the flash attack style of Italy's paparazzi, as portrayed in Federico Fellini's film *La Dolce Vita* (1960), who aggressively "stole" people's images. This strategy of interjecting a camera into strangers' lives during moments of extreme stress has become the staple of numerous television docudramas, and continues to blur the line between the public's right to be informed and an individual's right to privacy. The death of British Princess Diana in 1997 while being chased by the tabloid press produced cries for legislation to restrict photographers' freedom to photograph a person anyplace, anytime. In 1998 a law was passed in Quebec, Canada, forbidding photographers to take pictures of people in public situations without their written permission.

Salomon's images continue to be of historical interest but their capacity to excite has faded with the loss of novelty and social context. Designed to inhabit a print environment that provided supplemental information through a caption, when seen today, removed from the circumstances of time and page, many appear mundane and point to the transient nature of photographic meaning. The photograph's chameleon-like ability to possess numerous interpretations, instead of a single fixed one, led critic Walter Benjamin to observe:

> The camera will become smaller and smaller, more and more prepared to grasp fleeting, secret images whose shock will bring the mechanism of association in the viewer to a complete halt. At this point captions must begin to function, captions which understand the photography which turns all the relations of life into literature, and without which all photographic construction must remain bound in coincidences. . . . Will not captions become the essential component of pictures?[5]

In 1933 Salomon fled Nazi Germany and settled in the Netherlands, where he worked with a miniature camera to present a behind-the-scenes look at social activities that were not overtly political. As his interest in celebrities and news value gave way to photographing ordinary people involved with everyday tasks, the subject and caption were no longer crucial, allowing Salomon's photographs to be interpreted in an open manner. Salomon was later betrayed to the Nazis as a Jew and sent to the Auschwitz extermination camp, where he perished. His images survive because he had buried his negatives, which his son recovered after World War II. Salomon's small camera methods were slow to be adopted by the American photographic establishment. It would be well into the 1950s before most magazines would routinely allow their photographers to use the miniature camera for many of their assignments.

By the late 1910s, **André Kertész** (1894–1985) was demonstrating the visual language of modernism with asymmetrical compositions, close-ups, distortions, reflections, and unusual points of view. Grainy compositions, involving the bodies of swimmers seen through the refraction of water, indicated Kertész's willingness to reshape reality. Ducos du Hauron had produced a series of distorted images in 1888 and in the 1930s Kertész returned to this theme by using a mirror to

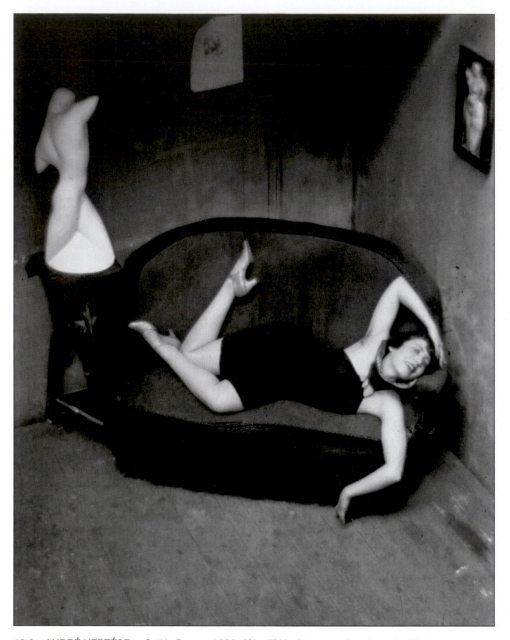

13.3 ANDRÉ KERTÉSZ. *Satiric Dancer,* 1926. 9¾ x 7¾ inches. Gelatin silver print. The J. Paul Getty Museum, Los Angeles. © Estate of André Kertész. © RMN.

transform the female body in a manner similar to Picasso's. Kertész's modernist/surrealist spirit led him to Paris in 1925. Here he used his Leica to geometrically order the unexpected moments of everyday life, like children playing in the park or the corner of Piet Mondrian's studio, in a life-affirming, lyrical, sometimes sentimental fashion. He joined a small cadre of photographers making their living as photojournalists in the growing market of the European picture press (see Chapter 14).

Kertész haunted the streets of Paris in a state of expectation, waiting to examine the unforeseen. Like the surrealists, he believed the mask of reality could be decoded by a spontaneous vision that was possible through accidents in time. Writer Pierre Mac Orlan referred to the work of these freelance photojournalists as "révélateurs" (developing agents), who by observing life could apprehend the "right moment," reflecting the idea that a photograph taken in one moment becomes history in the next. Mac Orlan wrote:

> The greatest field of [documentary] photography . . . consists . . . in its latent power to create . . . death for a single second. Any thing or person is, at will, made to die for a moment of time so immeasurably small that the return to life is effected without consciousness of the great adventure.[6]

Kertész's joyous "Leica spirit," the new small camera mentality, combined the formal design elements of De Stijl and the Dutch painter Piet Mondrian (1872–1944) with a natural intuition to extract poetic "rest-stops" from the flow of time that alter expectations

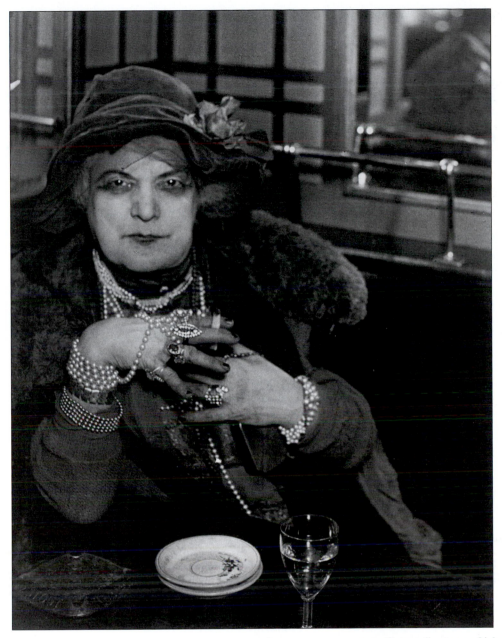

13.4  BRASSAÏ (GYULA HALASZ).  *"Bijou" of Montmartre,* ca.
1932. 11⅞ × 9⅛ inches. Gelatin silver print.   David H. McAlpin Fund.
The Museum of Modern Art, New York. © Estate Brassaï-RMN.

about common occurrences and objects. His work was inspirational to numerous photojournalists, including Brassaï, Henri Cartier-Bresson, and Robert Capa. In 1936 Kertész moved to New York, but the American picture press did not appreciate his distinctive form that they felt "talked too much." Their lack of support contributed to Kertész's growing sense of disillusionment, and his later work, relying on urban architecture as a major theme, was more formal and remote. In 1930 Kertész wrote:

> I am an amateur and intend to remain one my whole life long. I attribute to photography the task of recording the real nature of things, their interior life. The photographer's art is a continuous discovery which requires patience and time. A photograph draws its beauty from the truth with which it is marked.[7]

Not all the new candid work was seized from the ever-moving stream of time. Some photographers constructed images around the notion of suggesting a situation. The relativistic attitude of Einstein's theories, in which the truth of any situation is determined by one's position in time and space, was a stance adopted by many photographers. Although a photograph may not represent absolute truth, what it did report was something difficult to judge as true or false.

Since its invention, the photograph has acted as an eyewitness, but the rise of the illustrated press demanded more unusual subject matter, leading photographers, such as **Brassaï** (1899–1984), to photograph situations considered forbidden topics for public discourse.

Brassaï (Gyula Halász), who took his name from his hometown of Brasso, Transylvania, was an artist motivated by Kertész's work to portray the night life of Paris. A compatriot of the Paris surrealists and of Picasso, Brassaï contrived stylized tableaus in brothels, cafes, and on the streets of this fringe culture that Mac Orlan referred to as the subconscious "social fantastic," where the erotic and dangerous lay outside of mainstream society. Brassaï had his subjects act out their concealed activities as he set up his small plate camera on a tripod, opened the shutter, and fired his flash, recording a theatrical version of a candid moment that demystified and humanized the people from the world of night. Sixty-two identified plates from this series (one photograph per page), minus the most risqué, were published as *Paris de nuit* (*Paris by Night*) in 1933. Brassaï blended reality and fantasy to get beneath the surface, presenting a voyeuristic suggestion of shrouded taboos that only come out in the dark. Brassaï explained:

> For me the photograph must suggest rather than insist or explain; just as a novelist offers his readers only part of his creation—in leaving certain aspects unexpressed—so I think the photograph shouldn't provide superfluous explanations of its subject.[8]

Brassaï's philosophy of suggestion can also be observed in his series of clichés-verre, *Transmutations,* (see Figure 13.4) for which Brassaï wrote: "I compelled myself here to reveal the hidden figure which lay in each mental picture. . . . The dislocated parts of the photographs reorganized themselves into new combinations. . . . I cut their flesh as one carves a block to break loose the figure which it conceals. . . . The photograph is now and then volatilized. At times some debris has survived: a piece of quivering breast, a foreshortened face, a leg, an arm. Enshrined in graphism this debris gives to our obsessions, to our dreams the flash of the instant, the breath of reality."[9]

The small camera allowed photographers like **Henri Cartier-Bresson** (1908–2004) to blend into situations. Like an alert detective with a camera, Cartier-Bresson did not intrude, but waited for the scene to arrange itself before him. He was a consummate surrealist[10] who studied cubist painting and spent a year traveling in Africa before acquiring a Leica in 1932. Cartier-Bresson's photography manifests a form of visual alliteration and rhyme by patiently waiting for the right juxtapositions of coincidence and disparity to occur in real-life situations. The split second that he called the *decisive moment* is not the height of action, but rather that instant when the formal spatial relationships of the subjects reveal their essential meaning. Cartier-Bresson saw that moment as "the simultaneous recognition, in a fraction of a second, of the significance of an event as well as a precise organization of forms which gave that event its proper expression."[11]

Although he worked for numerous publications, Cartier-Bresson was not a journalist interested in reporting the news, but was concerned with capturing significant moments that had the audacity to surprise us with their own meaning. Such an image is his *Gestapo Informer Accused, Dessau, Germany, 1945* (see Figure 13.5) in which an enraged, puffed-up woman reaches over and seemingly deflates another woman with her indictment.

Cartier-Bresson's belief in the revelatory moment and his antipathy for prestaged situations defined and shaped the modernist, small-camera aesthetic of intuitively anticipating when a component of life opens and defines itself for an instant. Often utilizing limited depth-of-field, Cartier-Bresson created a shallow stage for his subjects to reveal themselves within. This construct made it simpler to forecast and follow action, removed subjects from their normal environment, and transformed them into portable collage material for surrealistic theater. His *full-frame* aesthetic, a scene completely visualized at the time of exposure, separated the mental act of seeing from the physical craft of photography. Typical of French photographers of the era, Cartier-Bresson did not express himself by making sensitive prints, preferring to employ professional labs to do his processing and printing. His stripped-down photographic grammar shunned fine print adages in favor of a direct application of materials and process. This was ideal for photographers like Cartier-Bresson who traveled and made their living by having their work reproduced in magazines and newspapers and not by selling individual photographs as aesthetic objects. To have more control over his images, after World War II Cartier-Bresson and a small group of like-minded photographers formed *Magnum Photos,* the first cooperative photographic agency (see Chapter 14).

The types of moments that a camera can report are only limited by the visual resources of the photographer. **Bill Brandt** (Hermann Wilhelm Brandt) (1904–1983) was influenced by the surrealists when he left London to go to Paris in 1929 and became Man Ray's assistant. Returning to London in 1931, Brandt distinctly saw and characterized British types in their cultural context. In this first phase of his career he pictured the divisions of social class in England during the Depression. Using family members and their household servants, Brandt recreated scenarios he had witnessed in the upper-class milieus and in working-class mining towns. These docudramas, published in *The English at Home* (1936), *A Night in London* (1938), and *Camera in London* (1948), are expressionistic interpretations rather than reportage. His compositions, based on German Jugendstil/Art Nouveau posters, are graphic, sober and contain an undertow of foreboding. His grainy images are printed *down* (dark), sacrificing shadow detail and mid-tone separation, emphasizing a brooding and ominous psychological state. In the introduction of *The English at Home,*

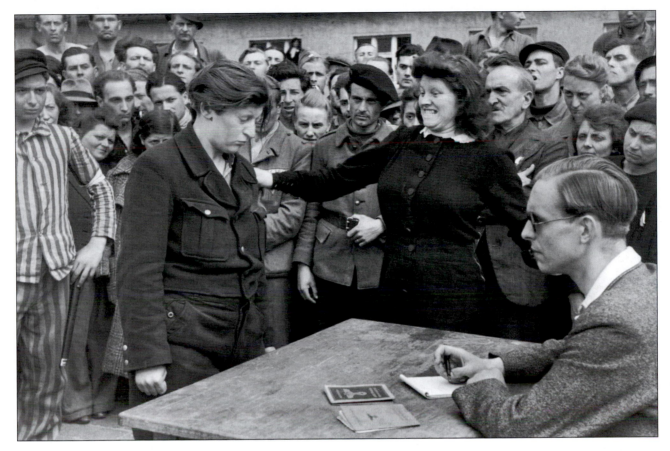

13.5   HENRI CARTIER-BRESSON.   *Accused Gestapo Informer,*
*Dessau, Germany, 1945.* Variable dimensions. Gelatin silver print.
In discussing his ideas about composition, Cartier-Bresson stated:
"We look at and perceive a photograph . . . all in one glance.
In a photograph, composition is the result of a simultaneous
coalition, the organic coordination of elements seen by the eye.
Composition must have its own inevitability about it . . . at the
moment of shooting it can only come from our intuition. . . . If you
start cutting or cropping a good photograph, it means death to the
geometrically correct interplay of proportions."[12]

Raymond Mortimer refers to Brandt as an anthropologist
who had the "detached curiosity of a man investigating
the customs of some remote and unfamiliar tribe."[13]

Brandt's later Cold War work deals with literary
figures, landscape, and the female nude. Influenced by
Gregg Toland's wide-angle cinematography in *Citizen
Kane* (1940), Brandt used a pinhole camera to exagger-
ate perspective, making statuesque female nudes remi-
niscent of El Greco that stretch and extend in space while
remaining uncomfortably close. The distortion of scale
and the displacement of objects produce puzzling opti-
cal illusions that free subjects from their surroundings,
which encourage viewers to explore nonrational mean-
ings. This lack of definitive meaning, the atmosphere of
a troubled dream, presents a mysterious and imposing
sense of femininity. Working in isolation, Brandt crafted

formal, strangely lit, high-contrast prints of figures that
glow with an unknown power (see Figures 13.6 and
13.7). These images offer a reflective, inscrutable vision
in opposition to the factual, and poetically explore the
anxiety of the atomic era (see Chapter 15). In his 1948
book, *Camera in London,* Brandt stated that:

> It is part of the photographer's job to *see* more intensely than
> most people do. He must have and keep in him something
> of the receptiveness of the child who looks at the world
> for the first time or of the traveler who enters a strange
> country. . . . We are most of us too busy, too worried, too
> intent on proving ourselves right, too obsessed with ideas to
> stand and stare. . . . Very rarely are we able to free our minds
> of thoughts and emotions and just see for the simple pleasure
> of seeing. And so long as we fail to do this, so long will the
> essence of things be hidden from us."[14]

The surreal moment of fantasy as it collided with
social conventions of the day was explored by **Man-
uel Alvarez Bravo** (1902–2002). Alvarez Bravo, the
son and grandson of Mexican painters and photogra-
phers, was encouraged by Tina Modotti and Edward
Weston to pursue photography. After meeting André
Breton in 1938, his work took a decidedly surreal turn
to include Mexican societal customs and Catholic reli-
gious beliefs, featuring peasant life, death, and dreams.
In response to Breton's request for a cover image for
the *International Surrealist Exhibition* (1940), Alva-
rez Bravo photographed a female nude on a rooftop
in strong sunlight. A doctor bandaged the model's feet

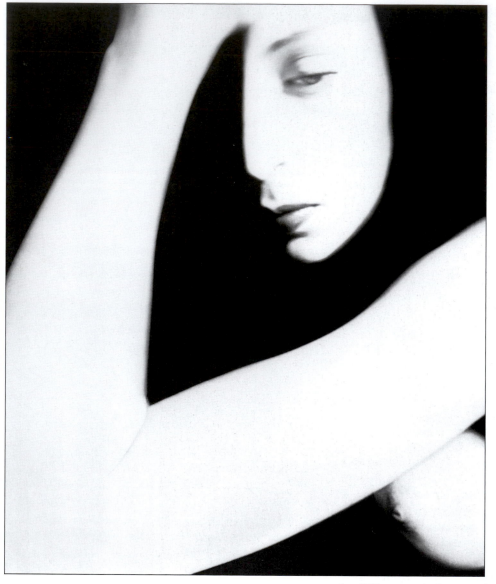

13.6  BILL BRANDT.  *Untitled*, 1961. Variable dimensions.
Gelatin silver print.   Bill Brandt © Bill Brandt Archive Ltd.

and hips, leaving the model's pubis exposed as she lay on a rough blanket against an adobe wall next to four pieces of thorny cacti. *La buena fama durmiendo* (*Good Reputation Sleeping*), 1939, creates surrealistic sexual tension by contrasting concealment and display with the psychological interaction of seduction, threat, and humor. The enigmatic tableau blends the reality and fantasy of a woman alone, asleep, and vulnerable, with what is private now public. The model appears unconcerned as the cacti stand guard, protecting her against the perils of desire. Due to international censorship forbidding the display of pubic hair, this image was not used on the cover. Bravo constructed images, such as *El Sistema Nerviso del Gran Simpatico* (see Figure 13.8) that take on mythological dimensions as the male and female figures become one. Surrealist sentiments about alteration and confinement are juxtaposed with the differences in how society values men and women, as the man is viewed from within (the intellect) and the woman from without (physical beauty).

Alvarez Bravo photographed numerous types of surreal moments as part of his belief that "Philosophy is something that is not as delineated as you might think; it's as ephemeral as life itself. The different chapters in life are influenced by the age in which they are formed. The individual goes on developing without being aware—until the circumstances have passed—that changes have happened to you, that you no longer resemble the individual you once were."[15]

Another surrealist who found the day-to-day points of reality stranger and more compelling than imagined situations was **Lisette Model** (1901–1983). Trained as a musician and painter in Austria, Model took up photography to earn money during the Nazi rise of the 1930s. After serving a brief apprenticeship with Florence Henri, Model emigrated to New York in 1938. While she was looking for work as a darkroom assistant at the *PM*

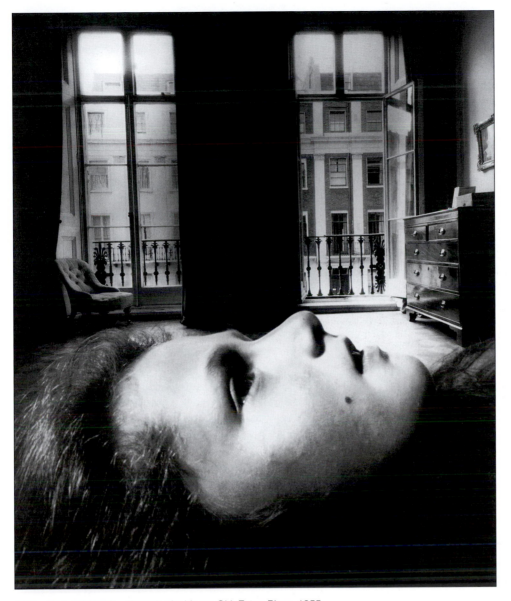

13.7   BILL BRANDT.   *Portrait of a Young Girl, Eaton Place,* 1955. Variable dimensions. Gelatin silver print.   Bill Brandt © Bill Brandt Archive Ltd.

newspaper, editor Ralph Steiner saw her prints of the wealthy French on the Riviera and the street people of Nice. Changing their original context, he featured them in the paper's Sunday magazine with the cover shot and six full-page reproductions.[16] The headline read, "Why France Fell," and each image was accompanied by only a single-word caption: Weariness, Boredom, Underprivileged, Greed, Cynicism, Self-Satisfaction.[17]

The *PM* portfolio intrigued Alexey Brodovitch, art director of *Harper's Bazaar,* who hired Model to photograph for the magazine. Model combined her appreciation of the immediacy of the snapshot and her need to orient herself in a new country by reordering the vitality of New York City into a fresh and challenging vision (see Figure 13.9). She never showed interest

in conventional beauty, but pursued the collecting of the deadly sins. Their expressive impact derived from Model's confrontational and intrusive style of treating her human subjects on a grand and monumental scale. Her use of unfamiliar perspectives created the sensation of people bulging forward out of the frame, becoming landscapes, massive and heroic shapes that take on roles of exaggerated sardonic allegory. Beginning around 1950, after Berenice Abbott encouraged her to teach photography at the New School for Social Research in New York, Model taught small workshops for the rest of her life, influencing developing photographers such as Diane Arbus (see Chapter 16).

With the city as her motif, **Helen Levitt** (b. 1913) looked for direct photographic expressions of her feelings by anticipating moments from life as seen from the street. She was inspired by Cartier-Bresson to photograph children in Harlem in 1936, and followed that theme throughout her career. In 1938 Levitt met Walker

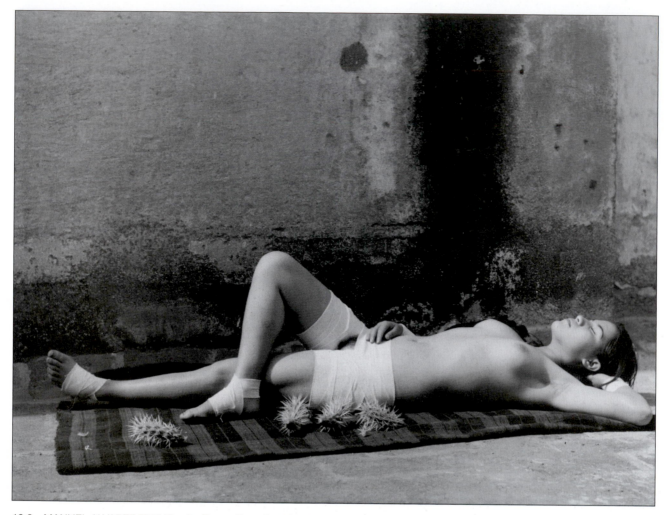

13.8   MANUEL ALVAREZ BRAVO.   *La Buena Fama Durmiendo (Good Reputation Sleeping),* 1938–1939. Variable dimensions. Gelatin silver print.   International Center of Photography. © Colette Urbajtel.

Evans, who became her mentor and friend, and James Agee. Her collaborations with Agee included two films, *The Quiet One* (1949) and *In the Street* (1952), and a book, *A Way of Seeing,* done in 1946 but not released until 1965.[18] Agee romanticized the work, but the corners of Levitt's spontaneous renderings of New York's neighborhood children engaged in games of fantasy are filled with eerie allusions to an explosive underclass (see Figure 13.10). Working with a Leica and a right-angle prism allowed her to point the camera in one direction while photographing in another, as her friend Ben Shahn had done for his FSA work. Seeing the streets of New York as a stage and its people as performers, Levitt made visual memorials, capturing the fleeting confluence of chance from the episodic flow of real life. She does not offer a structure of rhetoric, like that of the FSA or Photo League, to contextualize her images. In spite of urban poverty and violence, her photographs are not about despair, and their lack of verbal mooring lets them retain a transitory sense of the fantastic. Levitt's state-

ment: "All I can say about the work I try to do, is that the aesthetic is in reality itself,"[19] keeps intellectualization to a minimum and explains nothing about her mysterious aesthetic decisions except to say that this is how she saw life. Her open approach encourages people to imprint their own attitudes as the photographer shapes, summarizes, reflects, and allows her experiences to resonate against our own. In the late 1950s, Levitt investigated the potential of color to expand, intensify, and transform the emotional and psychological content while continuing to work the same themes.

Sometimes it takes a person skilled with both pictures and words to create a collection of moments to describe a place. In *The Inhabitants* (1946) and *The Home Place* (1948), **Wright Morris** (1910–1998) examined rural, small-town midwestern life during the 1930s and 1940s by placing text on one page and an image on the facing page. For Wright there was no single moment but a woven tapestry of what he called "photo-texts." In contrast to his novels, the bright Nebraska sun does not illuminate the skin of people but only the surfaces of their surrounding artifacts and structures; the people are nowhere to be seen (see Figure 13.11). They have vanished and the reader/viewer is confronted with

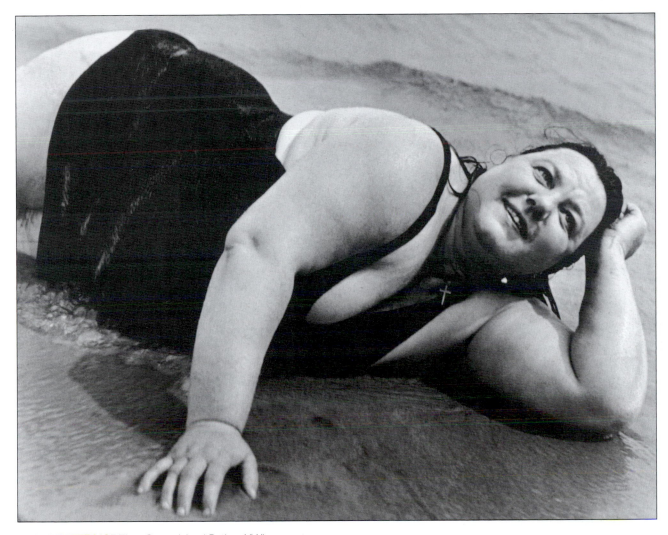

13.9  LISETTE MODEL.  *Coney Island Bather, NY* (Large woman on the beach), ca. 1942. 15½ × 19½ inches. Gelatin silver print. Berenice Abbott stated: "She [Model] uses the camera with her entire body as an extension of the eye itself . . . to look at life unblinkingly. . . . Lisette said: 'Don't shoot 'till the subject hits you in the pit of your stomach.'"[20]  Photo © National Gallery of Canada, Ottawa. © Estate Lisette Model.

their relics. The lives of the visually absent people are described in his fictional text, a blend of accounts and impressions that act in concert to present a community of people and their environs. This strategy extends the moment as a reader travels back and forth between the visual and the verbal, salvaging from the ruins of the Depression a distilled, affectionate, but unnostalgic collection of a time, place, and people now vanished. Morris's melding of words and pictures provided a model for future imagemakers, such as Robert Frank, who thought that a collection of moments was needed to fully describe a subject. Morris commented on his multiple presentation and its effect:

> How are we to distinguish between the real and the imitation? Few things observed from one point of view only can be considered *seen*. The multifaceted aspect of reality has been a commonplace since cubism, but we continue to see what we will, rather than what is there. Image-making is our preference for what we imagine, to what is there to be seen.[21]

**Harold E. Edgerton** (1903–1990) had no interest in moments from urban or rural life. Edgerton did share some of the same concerns as Hans Felix Siegismund Baumann, aka Felix H. Man (1893–1985), who used a miniature camera on a tripod to arrest the peak gestures of musicians and conductors, providing a record and a physical sense of their performance. Edgerton wanted to visualize such climactic and unseen instances under laboratory conditions. An electrical engineer, he devised the modern stroboscope, using light-emitting gas discharge tubes triggered by high-voltage pulses, in the process of solving a scientific problem in the early 1930s. His discovery, that tubes filled with xenon gas greatly increased light output, provided the foundation for manufacturing electronic flash units a decade later. Edgerton used these findings to make two types of motion studies. One involved a series of repeating flashes, with a predetermined interval of time between them, to make multiple-exposure and motion pictures of subjects as they moved through time in a manner

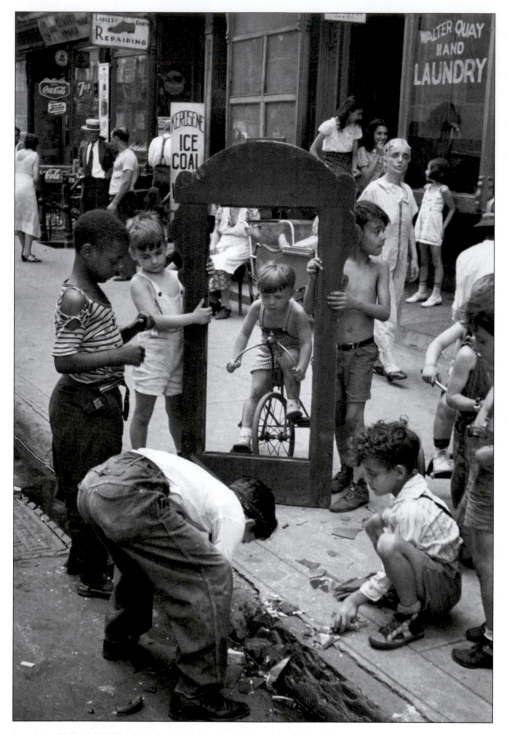

13.10  **HELEN LEVITT.**  *New York, New York,* ca. 1945. Variable
dimensions. Gelatin silver print. © Helen Levitt, Courtesy Laurence Miller
Gallery, New York.

similar to the one pioneered by Marey. The other used
only one flash of extremely short duration, as brief as
1/1,000,000 of a second, to make single images that
made visible what had been an empty, unseeable, hence
unknowable moment in time (see Figure 13.12). Edg-
erton adapted ordinary cameras, replacing the shutters
with electrical illumination that substituted brief flashes

of light for the opening and closing of a shutter. He uti-
lized technology to identify and incorporate previously
unobserved instances of time into visual vocabulary and
public consciousness. His visual evidence, like Atget's,
provides data and artistic revelation. James R. Killian,
Jr., wrote: "Edgerton is primarily interested in analyses
and hitherto undiscovered information. . . . He does not
seek a style charged with mystical inner meaning, meta-
phor, or emotion. . . . Throughout his career he invented
new photographic systems as tools to solve problems.
In this work his photography is sometimes secondary

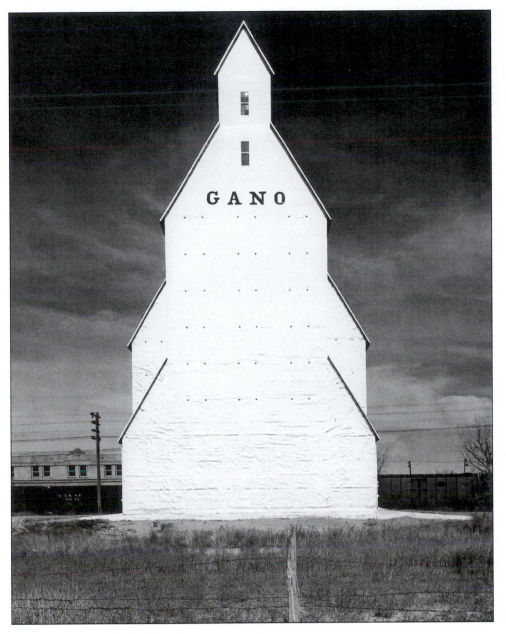

13.11   **WRIGHT MORRIS.**   *Gano Grain Elevator, Western Kansas,* 1940. Variable dimensions. Gelatin silver print. Morris said: "If there is a common photographic dilemma, it lies in the fact that so much has been seen, so much has been 'taken,' there appears to be less to find. The visible world, vast as it is, through overexposure has been devalued. The planet looks better from space than in a close-up. The photographer feels he must search for, or invent, what was once obvious. This may take the form of photographs free of all pictorial associations. This neutralizing of the visible has the effect of rendering it invisible. In these examples photographic revelation has come full circle, the photograph exposing a reality we no longer see."[22]  Collection Center for Creative Photography, University of Arizona © 2003 Arizona Board of Regents.

to the information he seeks."[23] As the world entered the atomic age, Edgerton was there with his camera to record an early above-ground atomic explosion.[24]

Even though a moment may have been captured by a camera, its meaning is never fixed. Today such a moment as Edgerton's atomic blast can be read as a signal marking the end of America's idealistic transcendental myths and the beginning of an embrace of European existential angst. As photographers became aware of the difficulty of holding on to a single meaning, they moved away from the notion that meaning must be controlled by the maker, as in *Life* magazine, in order for the image to be accessible. The atomic age unleashed a new generation of artists who made images not only directly from their lives but also by recycling previous moments. The images' meaning was intentionally left open to encourage viewers to participate in the process by ascribing their own set of beliefs to the picture.

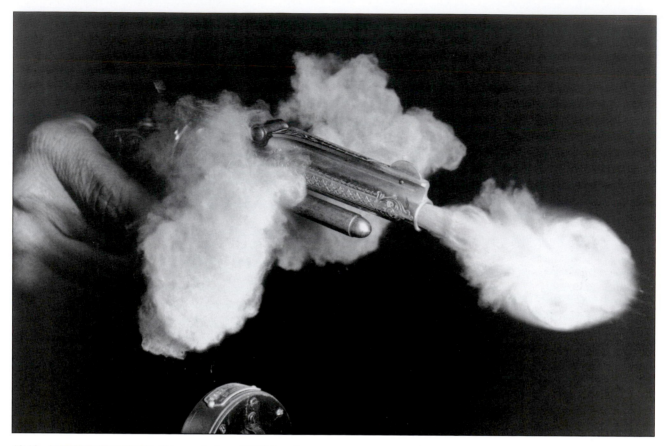

**13.12 HAROLD EDGERTON.** *Firing an Antique (1878) Revolver,* 1936. Variable dimensions. Gelatin silver print. Scientific value aside, Edgerton's photographs possess an element of the fantastic not only because they depict a formerly vacant space, but because of their ability to prolong the childhood pleasure of objects violently exploding and breaking—firing pistols, bursting glass, bullets impacting, and bucking horses. © Harold & Esther Edgerton Foundation, 2009. Courtesy Palm Press, Inc.

## Endnotes

1  Sir John Herschel anticipated the concept and mechanism of snapshooting in 1860 stating: "I take for granted nothing more than the possibility of taking a photograph, as it were, by a snap-shot—of securing a picture in a tenth of a second of time; and . . . that a mechanism is possible . . . by which a prepared plate may be presented, focused, impressed, displaced, numbered, secured in the dark, and replaced by another within two or three tenths of a second." Sir J. F. W. Herschel, "Instantaneous Photography," *Photographic News,* vol. 4, no. 88 (May 11, 1860), 13.

2  Richard Avedon, ed., *J. H. Lartigue: Diary of a Century* (New York: Viking Press, 1970), unp., 1901 diary entry.

3  Peter Hunter (Salomon), *Erich Salomon* (Millerton: Aperture, 1978), 5.

4  Erich Salomon, *Berühmte Zeitgenossen in unbewachten Augenblicken/Celebrated Contemporaries in Unguarded Moments* (Stuttgart: J. Engelhorns Nachf, 1931). Quoted in Beaumont and Nancy Newhall, *Masters of Photography* (New York: Castle Books, 1958), 134.

5  Walter Benjamin, "A Short History of Photography," 1931, in Alan Trachtenberg, ed., *Classic Essays on Photography* (New Haven: Leete's Island Books, 1980), 215.

6  Pierre Mac Orlan, "La photographie et le fantastique social," *Les Annales* (1 November 1928), 414. Quoted Travis, "Ephemeral Truths" in Sarah Greenough, et al., *On the Art of Fixing a Shadow: One Hundred and Fifty Years of Photography* (Boston: Bulfinch Press, 1989).

7  Cited in Anna Fárová, ed., *André Kertész,* adapted by Robert Sagalyn (New York: Grossman Publishers, 1966), 7–8.

8   Ibid., 12.

9   Brassaï, introduction to *Transmutations,* 1934–1935, unp., an album of twelve cliché-verre prints.

10   For information on André Breton's influence, see Peter Galassi, *Henri Cartier-Bresson: The Early Work* (New York: Museum of Modern Art, 1987), 12.

11   Henri Cartier-Bresson, *The Decisive Moment* (New York: Simon & Schuster, 1952), unp.

12   Henri Cartier-Bresson, *Ibid,* unp.

13   Raymond Mortimer, Intro. to Bill Brandt, *The English at Home* (London: B. T. Batsford, 1936), 4.

14   Bill Brandt, *Camera in London* (London and New York: Focal Press, 1948), 14–15.

15   Manuel Alvarez Bravo, *Revelaciones: The Art of Manuel Alvarez Bravo,* an interview conducted by Isaac Artenstein in MoPA members publication #13 (1990) (Balboa Park, CA: The Museum of Photographic Arts), 6.

16   For Model's account of the *PM* story and her relationship with Brodovitch, see James McQuaid and David Tait, unpublished transcript, "Interview with Lisette Model," January 28–30, 1977 (1978) located at the Richard and Ronay Menschel Library, George Eastman House., RB TR 140 M52 M26.

17   Lisette Model, "Why France Fell," *PM's Weekly,* Sunday Edition, Section Two, January 19, 1941, cover and 34–39.

18   *A Way of Seeing: Photographs of New York by Helen Levitt,* essay by James Agee (New York: Viking Press, 1965). The book has been reissued in revised forms in 1981 and 1989 with resequencing, recropping, and the addition and subtraction of images. For discussion see Katherine Dieckmann, "Mean Streets," *Art in America* (May 1990), 223–29, 263.

19   Helen Levitt in Brooks Johnson ed., *Photography Speaks: 66 Photographers on Their Art* (New York: Aperture/The Chrysler Museum, 1989), 64.

20   Berenice Abbott, Preface, *Lisette Model* (Millerton, NY: Aperture, 1979), 8–9.

21   Wright Morris, "In Our Image," *The Massachusetts Review,* vol. 19, no. 4 (1978). Reprinted in Vicki Goldberg, ed., *Photography in Print* (1988), 536.

22   Morris, 542.

23   Harold E. Edgerton and James R. Killian Jr., *Moments of Vision: The Stroboscopic Revolution in Photography* (Cambridge, MA: The MIT Press, 1979), 10.

24   This series of nonstrobe photographs is in keeping with Edgerton's passion for finding a way to present the unseen. Edgerton made them from atop a seventy-five foot tower, seven miles from the blast site, using a ten-foot focal length telescope and a magneto-optic shutter for split-second imaging of the explosion.

# From Halftones to Bytes

## Pictures and Printer's Ink

The initial success of the daguerreotype was based on its ability to fulfill an underlying human desire for graphic representation, as expressed during ancient Roman times in Pliny's myth about a young woman who outlines the shadow of her paramour on a wall as a mechanism of remembrance. The daguerreotype's failure was due to its inability to reproduce itself. People not only wanted an automatic way of directly capturing nature, they also wanted an easy and inexpensive method for sharing their remembrances with as many people as they pleased. It was this human characteristic, the desire to share something of personal importance with others, that led Niépce to first experiment with light to make images that could be printed in multiples by a press in ink.[1]

As England and France expanded basic public education laws during the 1830s, publishing grew to meet the needs of a newly literate industrial society. The rapid growth of cities that accompanied industrialization increased the demand for newspapers, illustrated books, and magazines. In 1842, *The Illustrated London News* became the first weekly magazine to favor images over text. It contained numerous full-page

illustrations, including two-page bleeds; becoming a model other publishers would follow. The biggest technical obstacle such publications faced was how to use ink to print pictures and text at the same time. Neither Daguerre's nor Talbot's processes could make high-quality, reproducible, and permanent images to compete with the economy of production and permanence of ink-based lithographs and wood engravings in this thriving picture market.

*Intaglio* printing methods for reproducing images, such as aquatint, etching, line engraving, and mezzotint, used recessed printing areas and were therefore incompatible with moveable type, which relies on relief printing, in which the raised areas are inked. *Lithography,* a planographic process in which an image is drawn on a flat surface, was also unsuitable for use with moveable type. Illustrations made from either of these two methods had to be printed separately and hand-pasted (tipped in) into a publication, making them costly and time consuming. What was needed was a process that would allow both text and pictures to be printed simultaneously using the same equipment, materials, and skills.

In 1842 the search for a process that would bring photography into the arena of publishing led Hippolyte Fizeau to devise a method for making prints from etched daguerreotypes, but it was impractical. The real breakthrough was in the work Talbot did for what would come to be known as the *halftone process.* The halftone process permits a continuous tone image, such as a photograph, to be printed simultaneously with text. The halftone principle utilizes an optical illusion in which tones are represented by numerous small dots of different sizes having equal optical density and equal spacing between their centers. In printing, the halftone screen divides an image into tiny dots that deposit ink on paper in proportion to the density of the original image tones in the areas they represent. In 1858, Talbot published an article describing how he devised a way for images and text to be printed at the same time through relief methods, by making exposures through a fabric screen to break the image up into tiny sections that when etched would make tolerable prints. By 1856, improvements in Talbot's method, which he called photoglyphic engraving, contained all the data that Karl Klic would need to invent his intaglio *photogravure process* in 1879. Refinements in the halftone process, such as Frederic E. Ives's cross-line screen, which generated images made of dots of varying size and distribution just as we see them in today's newspapers and magazines, and the high-speed relief (letterpress) press, made it economically feasible to print text and images together, ending the era of photographers acting as small independent publishers.

By the 1890s, monochromatic pictures could cheaply and easily be reproduced alongside type, but photography did not immediately replace the previous conventions of newspaper and magazine illustration. Editors were reluctant to change the "artistic" engravings and woodcuts accepted as *pictorial illusion,* the understanding between the viewer's reaction to an image and the reality it represents. People were accustomed to specific styles of depiction and reluctant to accept anything different. As photography was a new medium, there was no backlog of historical photographs for publishers to call upon and use in their illustrations. Photographers had to be present at events to record them; draftsmen could produce pictures of events they had never observed without their credibility being questioned. As photomechanical reproduction improved, however, picture magazines used more photographs for illustration and advertising and their sales rose. The expansion of the audience for photographs changed the subject matter depicted. Previously, photographers could make a living selling postcards of local scenes and people. Now, to reap the economic advantages of the new technology, publishers needed subjects that interested large audiences, leading to the glamorization of people and places from Babe Ruth to the Grand Canyon.

Photomechanical reproduction made pictures ubiquitous and altered concepts of art while raising issues of control and censorship. In "The Work of Art in the Age of Mechanical Reproduction" (1936),[2] Walter Benjamin (1892–1940) stated that even the best reproduction has an imperfect presence, therefore it lacks a unique existence, an authenticity, a state of being and authority he called *aura.* Benjamin wrote that reproduction eliminates aura, shatters tradition, and emancipates a work of art from its dependence on ritual, reducing the distance between artists and viewers and making the work more accessible. The breakdown of aura and its replacement of reality with reproduction smashed conventions, but the loss of contact with the authentic (original) left a spiritual vacuum of "second-hand" experiences. As photographically-based reproduction became routine during the twentieth century, the authentic individuality of an art work and, in turn, the personal self suffered from a mounting sense of alienation due to a loss of belief in the power of nature and its replacement by technology. By the close of World War II, American artists who previously portrayed the beauty of the natural world joined their European counterparts in turning inward to find subjective responses to their existential woes. Ironically, as inky reproductions age they become "antique images" with a patina of nostalgia and our culture then reassigns an aura, based on the romantic sentiments about the passage of time. This liberates the reproductions from their primary function, converting them into new ways of seeing the past based on the present.

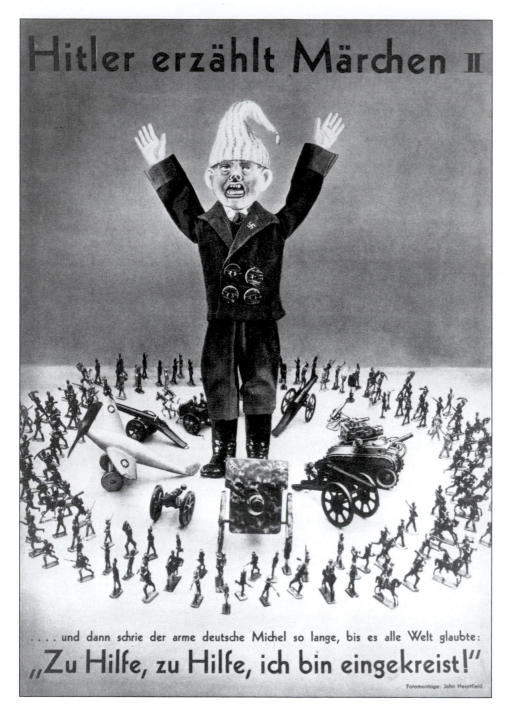

Hitler erzählt Märchen II

.... und dann schrie der arme deutsche Michel so lange, bis es alle Welt glaubte:

„Zu Hilfe, zu Hilfe, ich bin eingekreist!"

Fotomontage: John Heartfield

**14.1   JOHN HEARTFIELD.** *Hitler erzählt Märchen II (Hitler Tells Fairytales II).* From *AIZ* (March 5, 1936). 14¾ × 10⁷⁄₁₆ inches. Photogravure print. John Heartfield, one of the creators of photomontage in the 1920s and 1930s, operated under the motto: "Use Photography as a Weapon" to challenge the images and words. He realized the power of photographs comes not only from their ability to reproduce reality, but also to alter reality. Photographs can be used to warn us about the dangers of impending war or to draw us into a conflict.   Courtesy George Eastman House.

## The Photo Magazine

A twentieth-century newspaper's dynamic combination of graphic systems, drawing, photography, and type anchored a photograph's free-floating meaning to an instructive mode not chosen by the photographer but by an editor, editorial committee, or paying client. In a technologically based culture that depended on precise definitions, a multiple reading of a news photograph was not considered desirable. The control of meaning for commercial, editorial, and political purposes was refined by German illustrated magazines, such as *Berliner Illustrierte Zeitung (Berlin Illustrated Newspaper),* founded in 1890; *Münchner Illustrierte Press (Munich Illustrated Press),* begun in 1923; and *AIZ,* or *Arbeiter Illustrierte Zeitung (Workers' Illustrated Newspaper),* started in 1921. Their illustrated lessons

about how to manipulate meaning were quickly conveyed throughout the world.

The passionate, political photomontages of **John Heartfield** (1891–1968), who anglicized his name from Helmut Herzfeld as a protest against a German anti-British campaign in 1916, were specially constructed for ink reproduction. According to fellow dadaist George Grosz (1893–1959), he and Heartfield "[re]invented the photomontage in his studio at five o'clock on a May morning in 1916."[3] Both were probably familiar with the cutting and pasting of images done by soldiers on the Western front to get reports of the slaughter of World War I past the censors. Heartfield most often appropriated images that he then metaphorically reassembled, especially pictures dealing with Nazis, dramatically subverting their original intent to make scathing social commentary. The photographic nature of montage lends it credibility. Its photographic exactness makes printed advertisements successful, and observers are convinced of its message before they have time to analyze how they have been persuaded.

Hitler's rise to power ended the flowering period of European photojournalism. In 1933 Hitler suppressed all photography-based publications that questioned his authority. Heartfield and his fellow montagemaker Karl Vanek fled to Prague, where *AIZ* continued to publish, and then to England in 1940, where Heartfield stayed until 1950 when he returned to what had become communist East Germany. Even now, with the specific propaganda message of the work gone, Heartfield's montages continue to cry against greed and oppression.

Editors Karl Korff and Kurt Safranski of the *Berliner Illustrierte* and many photographers escaped to America. Stefan Lorant of the *Münchner Illustrierte* went to London, where he founded *Lilliput* (1934) and *Picture Post* (1938) and edited the *Weekly Illustrated*, before emigrating to the U.S. All these publications were headed by strong editors who took completed photographic assignments and contextualized them through page layout selections and text. Since photographers still did their own processing and printing, they could exercise limited editorial direction through the choice of images they submitted.

The concepts of these exiled pioneers of photojournalism and of Lucien Vogel, editor of the French picture magazine *Vu (Seen),* made their way to America. Many pictures Erich Salomon took during his visit to America in 1929 impressed publisher Henry R. Luce (1898–1967), who had them reproduced in *Time* (founded 1923) and *Fortune* (founded 1930). Luce, the child of Christian missionaries in China, adopted the conservative, paternalistic position that objective reporting was not desirable or even possible. In 1934, Luce envisaged a magazine whose managers would "edit pictures into a coherent story [and] harness the main stream of optical consciousness" with the "mind-guided camera."[4] The first issue of *Life* hit the stands on November 23, 1936,

with a cover story about the construction workers on the Fort Peck, MT, dam project by *Fortune* photographer Margaret Bourke-White. Writing in a style reminiscent of nineteenth-century stereo-view advertisements, Luce declared *Life's* mission:

> To see life; to see the world; to witness great events . . . to take pleasure in seeing; to see and be amazed; to see and be instructed; thus to see, and to be shown, is now the will and new expectancy of half mankind.[5]

*Life* was a runaway newsstand hit (*Look,* its competitor, appeared in 1937). Following a corporate model, photographers were expected to be disciplined members of a bureaucratic division of labor (see Figure 14.2). Teams of specialists pieced together a magazine that was overseen and directed by men with definite political and social agendas. *Life* became a fixture in middle-class American living rooms, its weekly circulation peaking at 8.5 million copies with an estimated readership of 24 million. Over half the U.S. population read at least one or more issues in any three-month period.[6] *Life* spawned similar magazines like *Ebony* (1945) that catered to the African-American community. Through photo-essays, like Ernst Haas's (1921–1986) 24-page *Magic Images of New York* (1953), the interpretive and poetic possibilities of color photography were integrated into daily viewing habits. *Life* preached mainline American values throughout the 1950s, but by the late 1960s the effects of rising costs, a shift in societal beliefs away from a homogeneous viewpoint, and television's ability to instantly reach larger audiences with news bites contributed to the magazine's decline. After 1,864 consecutive issues, *Life* ceased weekly publication in 1972. It was restructured to a smaller monthly format in 1978 until it finally ceased regular publication in 2000.

A powerful, popular photographic press, similar in substance to the mass-circulation magazine phenomenon, also emerged in the 1930s. *Popular Photography* (1937) quickly became the leading photographic journal in America. Two other popular magazines also began at this time: *Minicam* (1937), later called *Modern Photography,* and *U.S. Camera* (1938). Unlike older publications designed for salon photographers, these new magazines concentrated on amateurs who favored small, hand-held cameras. The editors relied on democratic appeal, a fascination with technology, and a bit of cheesecake to "spread the cheerful gospel that photography is a lot of fun."[7] Supported by the photographic industry, they encouraged amateurs to buy expensive equipment with the promise that their easy, how-to-do-it articles would instruct and technically empower them with the means of self-expression. As quality rose and production expenses dropped, more illustrated magazines targeted specific audiences. Professional photography organizations, such as the American Society of Magazine Photographers (ASMP) and the Professional Photographers of America (PPA), started their own journals (*Infinity* and *Professional Photographer*).

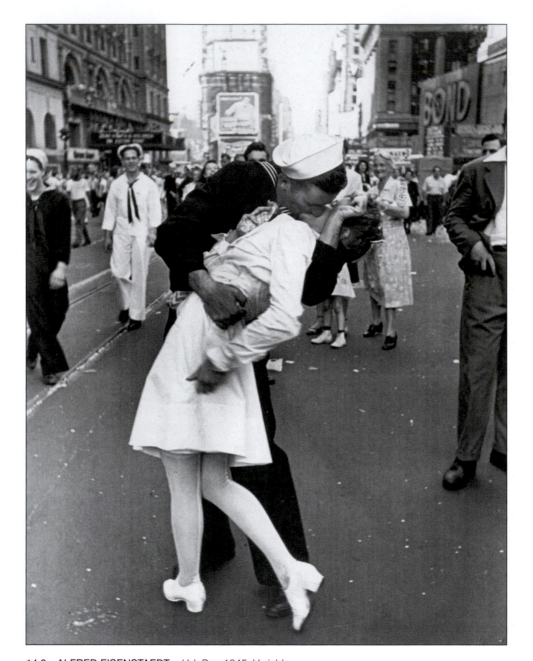

14.2 ALFRED EISENSTAEDT. *V.J. Day,* 1945. Variable dimensions. Gelatin silver print. One of the original *Life* staff photographers, **Alfred Eisenstaedt** (1898–1995) pioneered the use of the 35mm camera for photo-reportage in Germany while cementing his reputation as a photographer capable of making printable images in almost any time-based, assignment-driven situation. He produced over 2,000 people-oriented news assignments during his forty years with *Life.*   Photo by Alfred Eisenstaedt/Time & Life Pictures/Getty Images

*National Geographic,* designed to educate its audience about the world, first appeared as a monthly scientific journal in 1888. Not available by subscription, but as a benefit of membership in the National Geographic Society, the journal started using photography to "illustrate" its stories in 1906, becoming one of the first magazines to regularly reproduce autochromes.[8] Autochrome was the first practical color photography system, invented by Auguste and Louis Lumière in 1903 and manufactured beginning in 1907. In this additive screen process, a glass plate was dusted with microscopic grains of potato starch that were dyed with orange, green, and blue-violet. A fine powder of carbon black was used to fill in spaces between the grains. A panchromatic emulsion was applied to the plate and the exposure was made through the back of the plate, so that the dyed potato starch acted as tiny filters. This was developed into a positive transparency and viewed from the emulsion side by light that was colored as it passed through the screen.

*National Geographic's* impact on photographic practice has not been as extensive as *Life's* because until the 1970s its editors continued to rely on extensive text as the story dynamic, utilizing photographs as

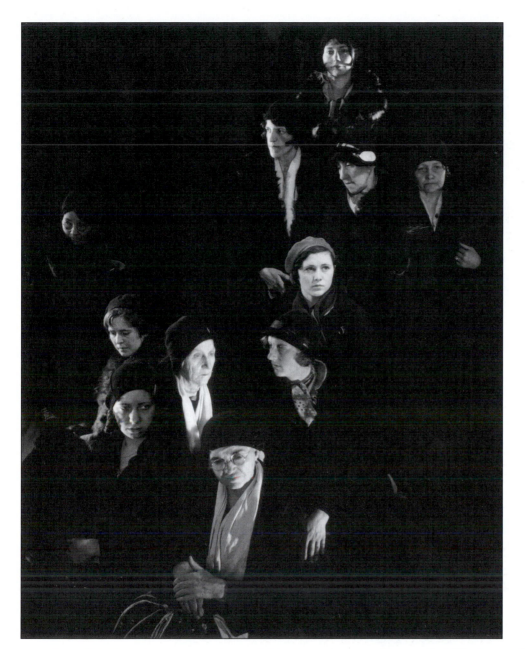

14.3 EDWARD STEICHEN. *Homeless Women,* 1932. 13⅝ × 10⅝ inches. Gelatin silver print. Steichen described how he made this image: "Then there was the story of the homeless women in New York lodging houses during the Depression. It seemed that many women, old and young, jobless or too old to work and contribute to the food supply, left home and came to New York. When the Travelers Aid Society found such people, they put them up in lodging houses for the night. We were to do a brochure for the Travelers Aid Society, and I suggested that the agency bring up the first twenty women who came out of the lodging house in the morning. There was to be no selection. Each woman was to be given ten dollars. . . . To get the rudderless feeling of their story, I instructed each woman to look in a different direction."[9] Reprinted with permission of Joanna T. Steichen, Carousel Research.

supplements that illustrate rather than drive the narrative. Nevertheless, by the mid-1950s *Geographic* was the reigning exotic picture book for armchair travelers. From its inception in an age of European imperial expansion, *National Geographic* was a *Wunderkammer* (wonder cabinet) of curiosities, collecting, ordering, and summing up knowledge for the pleasure and instruction of educated, middle-class Americans— expanding the territory of the conceivable. Under the guise of scientific pursuit, photography allowed readers to vicariously observe "primitive" customs of *the Other* (see Chapter 7). For young people, *National Geographic* permitted the forbidden viewing of bare-breasted, "native" women. *National Geographic* never aspired to "advocacy journalism," always steering away from hard, unpleasant truths. In commenting about the editorial obsession for "balanced" coverage, a *National*

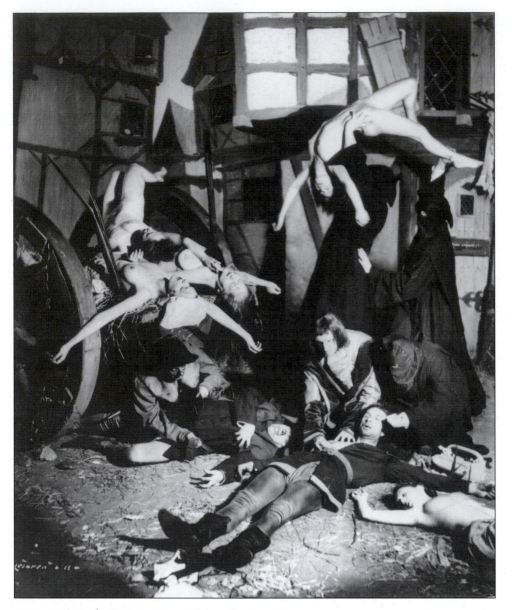

14.4  LEJAREN À HILLER.  *Etienne Gourmelen,* from the series *Surgery Through the Ages* ca. 1933. 18 × 14¾ inches. Gelatin silver print.   Visual Studies Workshop, Rochester, NY.

---

*Geographic* photographer once joked that "in a story on volcanoes . . . you should balance their destruction with something good about volcanoes."[10] Even critics who question *National Geographic*'s disengagement from its Victorian roots of racial differences, class attributes, and sexual imperatives acknowledge it has nowadays begun to pay attention to the cultural boundaries it depicts for a readership estimated at 40 million.[11]

## The Separation of Art and Commerce: Advertising and Fashion

During the nineteenth century, wealthy amateurs discriminated between photographs made for art and those made for commerce; individuals whose livelihood depended on photography seldom made these distinctions. Champions of modernism, such as Stieglitz, required photographers to be commercially untainted, widening the separation between artistic and commercial practice. During the twentieth century, commercial photographers seeking artistic validation led schizophrenic existences. The arts community demanded they create a body of work distinctly different from their commercial activities, reinforcing the notion that making a living through commercial photography and producing art were incompatible and perpetuating the myth of the idealistic, starving artist. Regardless of what the art elite thought, however, commercial photography infiltrated Western consciousness as low-cost and high-quality offset printed images became the major source of visual representation. By the 1960s, a tidal wave of printed color images was eroding the boundaries between these areas.

14.5  NICKOLAS MURAY.  *Hand and X-Ray Machine,* ca. 1962. 10½ × 11¼ inches. Carbro print.    Photo by Nickolas Muray, © Nickolas Muray Photo Archives. Courtesy George Eastman House.

Fashion magazines were among the first to regularly use editorial photographs. Baron Adolph de Meyer's elegant pictorial displays of fashion through light and texture began to appear in *Vogue* in 1913. Ten years later, **Edward Steichen** replaced de Meyer as chief photographer for the Condé Nast publications *Vogue* and *Vanity Fair.* Steichen formulated modernistic styles inspired by cubism and art deco for advertising, celebrity, and fashion photography by mastering a new tool in the photographic vocabulary: incandescent light. Steichen's command of artificial lighting enabled him to emphasize or invent the glamour in whatever was before his lens. He stressed the formal aspects of his subject. Relying on a strategy based on class and romance, Steichen helped persuade advertising agencies that photog-

raphy was more effective than hand-drawn illustration in reaching the growing market of female consumers.[12] He created bold and dynamic compositions that communicated clearly on a printed page, even if the image lost detail or suffered from contrast problems during the printing process. The resulting reproductions appeared more elegant than in reality. Steichen's design sense got him commissions, and he made money not from the direct sale of his prints but through reproduction rights. Photographers like Steichen who worked with publication in mind gave up the trappings of fine art for those of journalism, whose end product is not a photographic print but the printed page. Steichen applied the principle of mechanical repetition to his own seeing, using multiple exposure or repeating shapes to construct images such as his *Homeless Women* (see Figure 14.3), for the Travelers Aid Society. Unlike the FSA photographers who went directly to their subjects, Steichen brought

14.6  HORST P. HORST.  *From Paris—Corset with Back Lacing,*
1939. 9¹⁰⁄₁₆ × 7¹³⁄₁₆ inches. Gelatin silver print. The printed ad copy
links the city of romance, bondage, and art with the expectations
of nighttime pleasures: "Paris puts you back in laced corsets—and
here they are. Detolle made the extreme, back-lacing corset . . . to
bind you in for the Velasquez silhouette. This corset is specifically
for evening."¹³

subjects to him and altered their circumstances accord-
ing to his aesthetic will, raising issues of exploitation
that continue to surround the practices of the fashion
industry. Advertisers of that time considered it a dar-
ing strategy to take a more "naturalistic" approach that
associated "real" people, instead of professional mod-
els, with their products.

An early successful artistic ad campaign, now con-
sidered sexist, was **Lejaren à Hiller's** (1880–1969)
*Surgery Through the Ages,* done for Davis & Geck, Inc.,

makers of surgical sutures. Between 1927 and 1933,
Hiller concocted a historic series of over 200 great
moments in medical history that appeared in medical
journals and hung in hospitals and physicians' offices
throughout the country. His tableaux, *Etienne Gour-
melen* (see Figure 14.4), depicts the sixteenth-century
doctor renowned for his heroic treatment of bubonic
plague victims. All the men are clothed, while young,
beautiful, naked women die helplessly in sexually sug-
gestive positions.

Because advertising fueled profits, advertisers and
publishers looked for ways to stimulate sales. Their
alchemic formula was to visually represent a dream,
spin this dream into desire, and forge the desire into
a salable product. Color photography got a big boost
as advertisers discovered its added "realism" spurred
sales. In 1931, the *Ladies' Home Journal* ran the first
full-color reproduction of a carbro process print by

14.7    MARTIN MUNKACSI.    *Lucille Brokaw,* from *Harper's Bazaar,* December, 1934. Variable dimensions. Gelatin silver print.    © Joan Munkacsi. Courtesy Howard Greenberg Gallery, NYC.

**Nickolas Muray** (1892–1965). The *carbro process,* patented in 1855 by Alphonse Poitevin, was designed to make prints from photographic negatives and positives by using an emulsion containing particles of carbon or colored, nonsilver pigment to form an image. Considered the most versatile of the carbon processes, the name carbro was given to an improved version to signify that carbon tissue was used in conjunction with a bromide print (car/bro). Muray's pre–World War II celebrity glamour portraits and color advertisements helped formulate an artificial style that communicated not only the needs of the advertiser, but the attitudes and preoccupations of American society as well, ranging from sex to invisible electromagnetic radiation (see Figure 14.5). By the mid-1930s, American photographer Harold Haliday Costain reported that advertisers were embracing color:

> The most noticeable recent change in advertising tendencies is the widespread use of color photography for all types of illustrations. The American advertisers, realising that over 75 per cent. [sic] of all purchases were made by our women, set about to further appeal to them by means of colour, and the great increase in its general use proves beyond doubt its claim to success.[14]

The desire to convert dreams into dollars was realized on the inky pages of fashion magazines like *Vogue, Harper's Bazaar,* and *Vanity Fair.* The art directors and photographers of these publications absorbed aesthetic trends into their approach that showcased celebrities

and juxtaposed fashionable clothing within contemporary settings such as skyscrapers, sports themes, and abstract paintings. Sir Cecil Walter Hardy Beaton (1904–1980) was a leading fashion photographer of the 1930s, first for *Vogue* and later for *Harper's Bazaar*. He was one of the first to use actresses as fashion models, importing their fairy-tale mystique to whatever he was photographing. Beaton relied on his flair, wit, and irony to stay in tune with his celebrity and royal subjects, keeping him close to his real interest, fashionability—the manner of being fashionable. He shifted styles to accommodate and reflect those who prided themselves on their ability to outwardly express their inner originality and to serve as public tastemakers. People in the fashion business, just like Hollywood moviemakers, learned to visualize American dreams, as in Frank Capra's *It Happened One Night* (1934) and *Mr. Deeds Goes to Town* (1936), and make and distribute these fantasies of idealistic individuals by means of mechanical reproduction at a universally affordable price.

**Horst P. Horst's** (1906–1999) fashion career, spanning almost sixty years with Condé Nast, got underway as a model and assistant for George Hoyningen-Huene (1900–1968), who brought the functionalism of the New Objectivity into the studio assignments he did for *Vogue* and *Harper's Bazaar* between 1925 and 1945. Horst's mastery of light and use of props are demonstrated in his 1939 *Vogue* corset ad image (see Figure 14.6). Here a faceless corseted torso conveys sexual tension through an object of repression and self-inflicted discomfort, walking the obscure boundary lines of pleasure, pain, eros, and cruelty.

**Martin Munkacsi** (1896–1963), originally a painter and sportswriter, used the small, hand-held camera with the split-second sensitivity to give a dynamic sense of action to his fashion and sports photographs. Beginning in 1933, Munkacsi adopted the candid technique with athletic models, outside, in natural light, for *Harper's Bazaar*. His spontaneous approach established the second major fashion magazine working style: naturalism.

In the 1950s Alexey Brodovitch (1894–1971), the art director of *Harper's Bazaar* from 1934–1958, released fashion from its past genres by devising a new compositional structure for the printed page and challenging photographers to produce daring images for this format. Brodovitch envisioned his layouts as single rectangles that spread over two pages instead of the narrow vertical column of a single page. He experimented with type, illustrations, white space, bleed photographs, and montage to expand and control the visual pacing of time. Brodovitch's work as a designer and teacher, coupled with his recognition of the abilities of immigrant photographers to find new forms for interpreting the culture of the New World, affected the styles of photographers such as Lisette Model, Irving Penn, Rich-

ard Avedon, Louise Dahl-Wolfe (1895–1989), Hiro, and Robert Frank. In addition, Brodovitch influenced people in the business who saw his ideas in ink each month on the pages of *Harper's Bazaar* and began to imitate them.

Irving Penn (b. 1917), a student of Alexey Brodovitch, devised an austerely sophisticated graphic form of fashion photography. Working with Alexander Liberman (1912–1999), the art director of *Vogue* for over forty years, Penn dispensed with naturalism and spontaneity in favor of formal studio control, doing away with the cluttered paraphernalia and theatrical lighting of the previous generation of fashion photographers. Whether photographing Peruvian Indians, New Guinea tribesmen, or Hell's Angels, Penn set up a "luminous tent,"[15] a makeshift studio containing a gray or white seamless paper backdrop and artificial lights, to pose his subjects in a blank space. Penn's strategy removed sitters from their normal surrounding, treating all subjects to the same structured composition and elegant lighting fashion models and socialites received. Liberman observed that Penn invented "his space [to give] an immediate reading of character."[16] Fashion photographers universally adopted Penn's method.

During the 1950s, Penn saw no incongruity between art and commerce, stating: "The fashion magazine is one of the few contemporary media in which commerce success and the highest esthetic standards are not incompatible."[17] Critic Milton Brown disagreed, claiming that countless fashion photographs eroded thoughtful aesthetic explorations and were no more than vacant pastiches of "superficial tricks and attitudes which gives to their pictures an air of sophistication and modernity."[18] By the 1980s, Penn, tired of the printed page, redirected his attention to making editioned, platinum-palladium prints of urban detritus, such as cigarette butts, and still lifes of bones and skulls. Regardless of subject matter, Penn's preoccupation with perfection in refined balance and tonal subtlety prunes away the inconsequential, smoothes over established hierarchy, and keeps his subject emotionally detached for contemplation. A believer in the "less is more" theory, Penn said:

> If you had two apples to photograph and could dispense with one, you would have more apple in the remaining one. I know this in terms of communication, though not necessarily in terms of esthetics.[19]

Richard Avedon (1923–2004) studied with Brodovitch after spending World War II making thousands of ID photos for the merchant marine. Under Brodovitch's mentoring eye, and later with art director Marvin Israel (1924–1984), Avedon's work for the printed page was instrumental in casting the look of fashionable post–World War II women. His control of pose and facial expression depicted women as astute, resourceful,

14.8  PHILIPPE HALSMAN.  *Vice President Richard Nixon,* White House, 1955. Variable dimensions. Gelatin silver print.   Photo by Philippe Halsman. © Philippe Halsman.

amused, and entertaining. For twenty years Avedon's personality portraits, appearing in *Harper's Bazaar,* shaped how America saw public figures from President Eisenhower to Marilyn Monroe.

Although the fine art world continued to reject dual art director/photographer visions for being commercial team operations, photographers often acted as producers whose assistants carried out their plans. This production strategy, common in fashion photography, creates a hierarchical system of patronage for advancement. Hiro (Wakabayashi Yasuhiro) (b. 1930), a protégé of Avedon, worked his way through this structure and

gained recognition by isolating the glamorous details of fashion and actively using color in a mix that served up material icons to its followers. Such an atelier/studio approach runs contrary to the modernistic sentiment of a single genius whose hand touches every phase of the masterpiece, yet is consistent with the practice of studio photography since the days of the daguerreotype. In seeking the prestige of the "high" culture, photographers run the risk of losing the broader impact that the "low" culture of the printed page affords.

Avedon actively promoted his work as crossing the imaginary boundaries of the commercial and art worlds. His large format studio practice of isolating people from their environment embraced the detail of facts over idealization. Avedon's visual mapping can be traced to his reading of French novelist Marcel Proust (1871–1922) for insight into societal behavior,

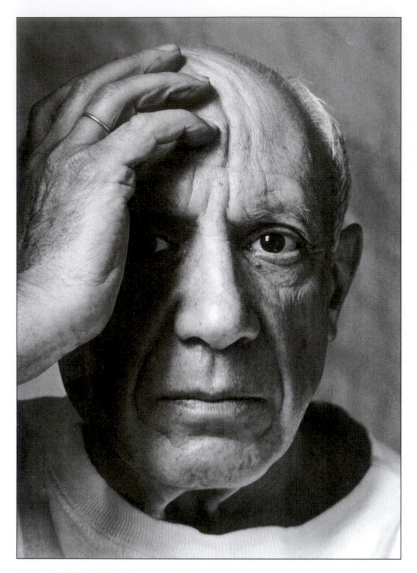

**14.9 ARNOLD NEWMAN.** *Pablo Picasso,* Vallauris, France, 1954. 12³⁄₁₆ × 12⁵⁄₁₆ inches. Gelatin silver print collage. Photo by Arnold Newman/Getty Images.

manners, and social structure, pursuing a theme that linked external events and internal reality to show how time influences memory.[20] This led Avedon off the printed page and onto the gallery wall where his productions, such as *In the American West* (1985), used enormous prints that read more like topographic maps than portraits.[21] Avedon, like Proust, was socially resourceful, yet he viewed individuals as isolated, society as deceptive and governed by snobbery, and artistic enterprise as a theological calling.[22] He delineated and magnified the smallest detail until it took on an unsettling sense of importance, existentially isolating and separating people from their surroundings. Whereas Proust was an active participant within the environment he described, Avedon acted as an outside constructionist who located his subjects, removed them from their surroundings, and brought them to the neutral, floating,

white backdrop of his "style" studio. He maintained representational power during these fleeting relationships, shaping the outcome that abstracts subjects from their natural environment. Avedon succeeded in crossing the borders of art and commerce by sequestering and presenting that which made his subjects exceptional, as in his sequence of his dying father that incorporated personal subject matter with formal studio strategies.[23]

Photography broke down the doors of privacy. Compared with cartes de visite and lithographs, the halftone and the printed page provided a means to address and expand the public's yearning for celebrity portraits. The public's thirst for images of the famous, as surrogates for their own mingling in a Proustian society for which they had no calling card, encouraged editors to eagerly translate them into ink.

George Hurrell's (1904–1992) studio portraits of Hollywood stars presented the dream of glamour and perfection that provided a fantasy relief from the images of the Great Depression as portrayed by the FSA photographers. Hurrell created beauty and dra-

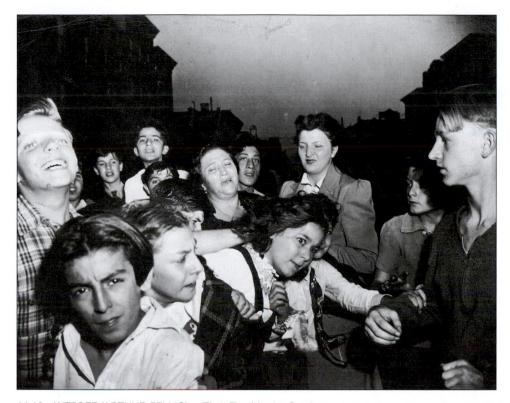

14.10   WEEGEE (ARTHUR FELLIG).   *Their First Murder*, October 9, 1941. Variable dimensions. Gelatin silver print.   International Center of Photography, New York.

matic emotional intensity through his expert lighting and retouching, and his images, distributed by Hollywood fan clubs and magazines, were gobbled up by the public.

The publishing world's desire to promote and capitalize on the notion of fame can be seen in **Philippe Halsman's** (1906–1979) incisive portraits that appeared on over 100 covers of *Life* as well as in magazines such as *Saturday Evening Post* and *Paris Match*. Halsman believed the portraitist's most important tools were conversation and psychology, not technique. A self-taught photographer, Halsman claimed his greatest influences were the Russian masters of literary psychology Fyodor Dostoyevsky (1821–1881) and Leo Tolstoy (1828–1910). Halsman utilized playful methods, like jumping in the air, to unmask his subjects and divulge their essence. This concept, published as *Philippe Halsman's Jump Book* (1959), expanded his working repertoire to include multifaceted views designed to simultaneously reveal different aspects of a celebrity's personality.

For over half a century, Canadian Yousuf Karsh (1908–2002) made formal environmental portraits for numerous publications. Though his subjects were not merely famous but world achievers, it was not their stature but Karsh's heroic application of incandescent lighting, rendering dramatic highlights and shadows with clarity and textural richness that appealed to audiences of the printed page. Regardless of a subject's

social position, Karsh's lighting fused personality with ability. When applied to a commercial product, his lighting conveyed a sense of competence, making the product appear well-made and worthy of purchase.

By means of symbols and arrangement of the figure within the space of his composition, **Arnold Newman** (1918–2006) visually orchestrated the interior concerns of his sitters. Newman's favorite procedure was to bring his studio to his subjects, integrating their personalities with their surroundings, thereby affirming the subject's position, occupation, and status to an audience unfamiliar with the subject. At times the photographer's explorations of the essence of his subject led him to adopt unconventional means. Newman's collage portrait of pioneer kinetic artist Agam (Rishon Letzion) broke up the edges of the frame and destroyed Renaissance perspective, actively portraying a sense of the artist's work in which the view metamorphoses as a spectator walks by sculptural works constructed with air, light, and water.

Michelangelo Antonioni's film *Blow-Up* (1966), modeled on photographer David Bailey, personified the pop culture values of "swinging London" during the 1960s and set the fashion photographer up as an unparalleled figure whose self-appointed job was to experience and photograph every new trend. This made being a photographer very appealing to the counterculture generation, who began to take photography and filmmaking courses in record numbers.

By the 1970s fashion was not only covering almost any topical event but was also representing women in new ways on the printed page. Helmut Newton's

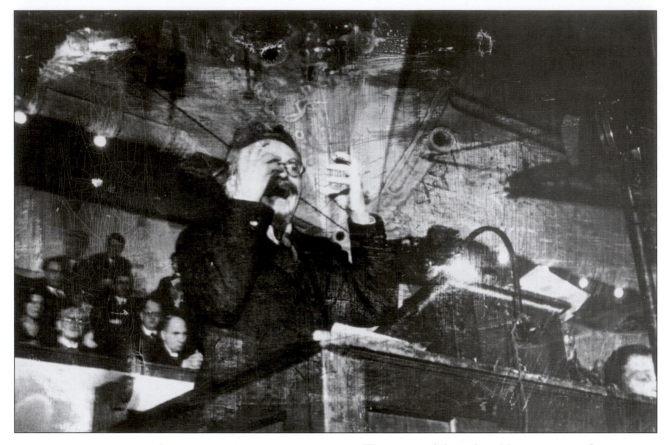

14.11  ROBERT CAPA.  *Leon Trotsky, Copenhagen,* 1931.
8⅞ × 13⁷⁄₁₆ inches. Gelatin silver print.

(1920–2004) highly interpretive images, as in *White Women* (1976), depict women as aggressive and sexual but also dangerous and unavailable to intimacy. His stylish, sadomasochistic portrayals have entered the mainstream through advertising and fashion, promoting what James G. Ballard, author of *Crash* (1973), calls the "normalization of the psychopathic."[24] In this process the media acts as a buffer between viewers and images, allowing previously aberrant behavior to be tolerated as long as it is consensual.

The work of more women photographers began to regularly appear in ink. The ethereal color work of Sarah Moon (b. 1940), Joyce Tenneson (b. 1945), and Deborah Turbeville (b. 1937) is subdued, offering a softer sensation of the social and sexual circumstances of women. Their commercial approach downplays the hard sell in favor of a subliminal tack, establishing a relationship between a product and the promise of achieving the experience depicted in the advertisement. Rather than portraying a product's virtues, for instance, a photograph might show two people embracing, suggesting that the product would also deliver extra effects like fulfillment, happiness, and love. A side effect of this type of repetitive message has been the public's ability to make connections from less literal renditions.

The pace quickened and became more fragmentary during the 1980s, influenced by the rapid and more spontaneous-looking media productions pioneered by MTV. People's awareness of how fashion photography can influence culture has also increased. Ironically, in 1997 President Bill Clinton criticized the fashion industry for exalting the drug culture with its "heroin chic" pictures of emaciated young women and tattooed men.

## Newspapers

Newspapers were slower than magazines to incorporate photographs. It took time to discover how photography could best report the news. Until *telephotography,* which is the transmission of images via the telephone, became reliable in the mid-1930s, the delays in getting photographs back to the home office translated into a loss of newsworthiness. On a daily basis, editors learned that photographs could be a visual shorthand, surpassing words when conveying concrete, everyday incidents such as fires, staged ceremonies, and action-oriented sporting events. News photographs succeeded by letting viewers examine penetrating moments of human behavior at their kitchen tables with coffee cup in hand. Regularly covered events, like meetings, that looked boring when photographed as news could be spiced up with a caption supplied by a reporter.

The golden period of American news photography began in the 1920s and continued through the late

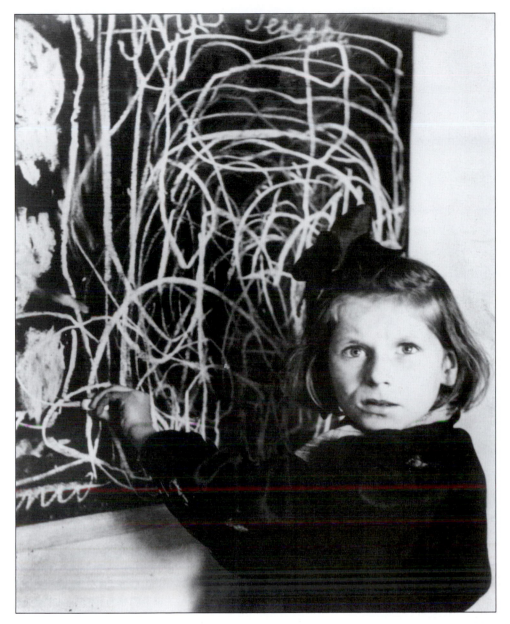

14.12 DAVID SEYMOUR. *Tereska, a Polish child in a home for disturbed children,* 1949. 12½ × 10 inches. Gelatin silver print. "Terezka, a disturbed child in an orphanage. When asked to draw a picture of her home, she produced these scrawls on the blackboard."

1950s when it was displaced by television news. Newspapers organized their own local staffs and labs and established reliable sources for nonlocal events, as new methods of reproduction convinced management that images and text could be readily printed together. By providing the same format 365 days a year, newspapers create a routine that smoothes over individual stylistic differences among photographers and provides a comforting rhythm of dependability and sameness that people accept as representing the way things are.

Practical and affordable, the synchronized flashlight expanded the subject possibilities of the photojournal-

ist, not only providing illumination but also delineating a spry sense of visual space. The glaring white light froze the subjects, revealed secrets, and brought them forward out of the darkness to be scrutinized. Whatever a flashlight image lacked in naturalness it made up for in its forceful, graphic simplification, creating a sense of melodrama that was effective in the tabloid press.

**Weegee** (Arthur Fellig) (1899–1968) represents a resourceful use of flash as a news-gathering tool from this golden period. Weegee, like other notable photojournalists and street photographers, had the gift of "prophecy," a sixth sense enabling him to stay ahead of an unfolding event and know exactly when to release his blazing flash. Named after Ouija, a board game that claims to predict the future, Weegee scooped the competition by monitoring police and fire radio dispatches, sleeping in his clothes, and having a car outfitted with a makeshift office and darkroom in the trunk. Weegee's

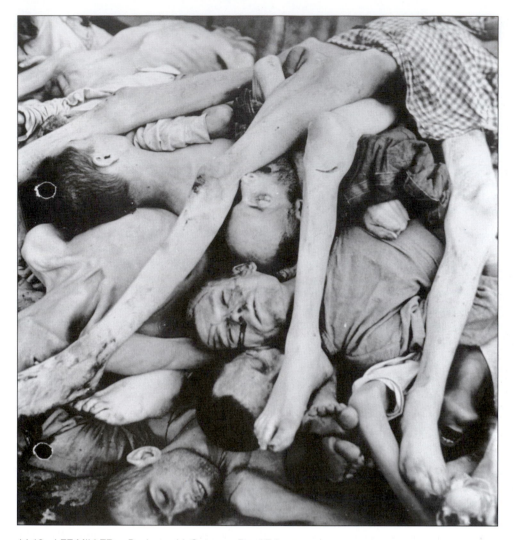

14.13  LEE MILLER.  *Buchenwald, Germany: Dead Prisoners,*
April 30, 1945. Gelatin silver print. Images of concentration camp
victims, made by Miller and reproduced in *Life*, provided conclusive
evidence that Germany had engaged in the extermination of
Jews, gypsies, homosexuals, and other so-called undesirables
who they demonized as unalterably dangerous, evil, and
unredeemable.[25]   © Lee Miller Archives, England 2009. All rights reserved.
www.leemiller.co.uk.

direct-frontal, synchronized flash assault produced
unrefined and titillating images that broke through
society's veneer, presenting a raw, spontaneous, pes-
simistic, and primeval view of humanity.

Dressed in a trench coat, wearing a fedora, smoking
a cigar, carrying a 4 × 5-inch Speed Graphic with a
flashgun, and making sarcastic remarks, Weegee could
have been keeping company with the literary charac-
ters, Sam Spade and Mike Hammer. His pictures, like
those in *Naked City* (1945), speak in the same blunt,
uninvolved, and unrefined tone as a Dashiell Hammett
or a Mickey Spillane *noir* pulp detective novel. Wee-
gee's working style was classic "f/8 and be there." No
fancy techniques, just an instinctive response to the sit-

uation, with structure later imposed through darkroom
cropping or a picture editor. This intuitive method was
ideal for tabloid picture news, giving the look and feel
of an event the reader was not present to see. The task
of interpretation was left to a caption editor, who gave
each image an appropriate moral, political, or social
accompaniment. Removed from its journalistic bonds,
Weegee's work can transcend its news time and take on
the distressingly symbolic form of a morality tale by a
fabulist whose aggressiveness and antagonism towards
his subjects gives his caricatures piercing believability.

## War Reportage

As World War II loomed, news gathering organizations
and publications shifted their emphasis from features to
hard news of the war fronts. As America went to war,
so did many of its photographers, including Captain
Edward Steichen, who served as Director of Navy Com-
bat Photography. *Life* sent photographers to the fronts
and ran a school for army photographers. The country
began to rely on picture magazines to stay abreast of
events, even before September 1943 when government

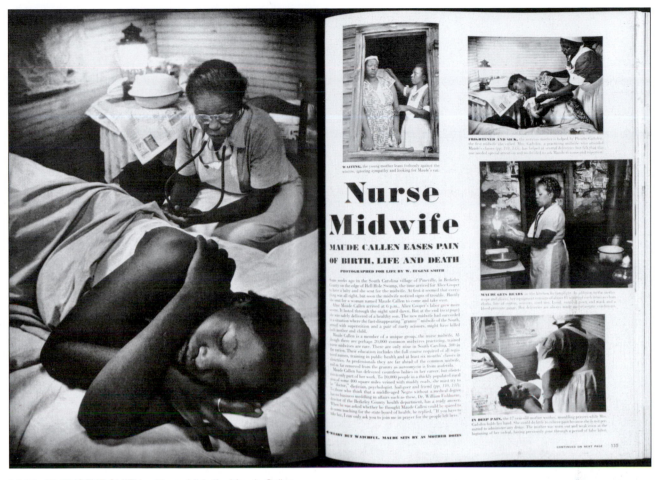

**14.14   W. EUGENE SMITH.** *Nurse Midwife: Maude Callen Eases Pain of Birth, Life and Death* (*Life,* December 3, 1951). 13⅝ × 10¹⁄₁₆ inches. *Nurse Midwife* was the first serious essay in a mainline American publication to feature an African-American in a professional context. Smith said: "I was fighting racism without ever making racism the point. I had long crusaded against racism, not by hitting people over the head with a hammer, but by compassionate understanding, presenting something that people could learn from, so they could make up their own minds."[26]   Estate of N.E. Smith/Black Star: Courtesy George Eastman House. © Heirs of W. Eugene Smith.

censorship had prevented the publication of pictures showing Allied "dirty work" or American dead.

Reportage-style photography continued to be reshaped by the wars of the twentieth century. Smaller cameras and faster films encouraged war correspondents to risk their lives by getting into the thick of the action and recording what they saw. This new generation was not as concerned with reporting the official story and delivered images that were less inhibited by censorship and the need to make propaganda.

**Robert Capa's** (André Friedmann) (1913–1954) explosively damaged picture of Russian revolutionary Leon Trotsky ushered in his flamboyant career of covering political movements and war. His image of

"a Spanish soldier the instant he is dropped by a bullet through the head"[27] while his shadow still appears to be standing freezes a moment of death.[28] His terse approach, analogous to his writer friend Ernest Hemingway's (1889–1961) war novels, such as *A Farewell to Arms* (1929) and *For Whom the Bell Tolls* (1940), put him actively into the fray. Whether it was China, the beaches of Normandy, Israel, or finally Vietnam, where he was killed by a landmine, Capa's working dictum was: "If your pictures are not good enough, you aren't close enough."[29] A self-declared "gambler," Capa went in on the first wave of the 1944 D-Day invasion, only to have all but eight of his exposures ruined by an excited darkroom assistant, who turned on too much heat while drying the negatives and melted the emulsions before the eyes of the London office.[30] Capa was so animated he often made exposures more rapidly than his camera's fastest shutter speed. These blurry and grainy images give the sense that Capa was capable of recording events that occurred even too quickly for a camera. Capa was instrumental in forming Magnum Photos (1946),[31] the first cooperative photographic agency managed by photographers.

**David Seymour** (David Szymin) (1911–1956), nicknamed "Chim," shared a darkroom with Robert Capa and Cartier-Bresson in Paris. He was a combat

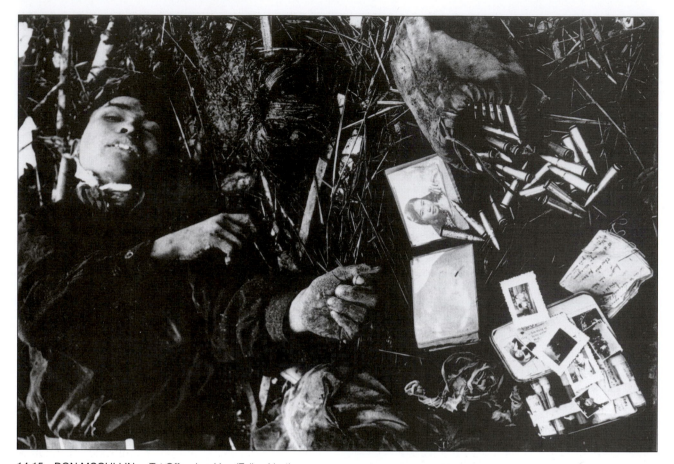

14.15 DON MCCULLIN. *Tet Offensive, Hue (Fallen North Vietnamese soldier, his personal effects scattered by body-plundering soldiers)*, 1968. 16½ × 11¾ inches. Gelatin silver print. English spy novelist John Le Carré considers the effect of existential angst on photographers and viewers: "The dead and nearly dead, like the mad, are free, but their freedom is no use to them. I expect that McCullin has committed suicide through his camera many times. . . . If it is possible—as Albert Camus insists that it is,—to feel, without romanticism, nostalgia for lost poverty, then perhaps it is also possible to feel nostalgia for physical suffering as a form of human nobility from which our good luck too frequently withholds us."[32]   © Don McCullin/Contact Press Images.

photographer whose documentation of the effects of war in Europe on children for UNESCO resulted in *Children of Europe* (1949) (see Figure 14.12). Cartier-Bresson said: "Chim picked up his camera the way a doctor takes a stethoscope out of this bag, applying his diagnosis to the condition of the heart; his own heart was vulnerable."[33] Chim became president of Magnum upon Capa's death but was killed a few years later by an Egyptian machine-gunner, four days after the Armistice at Suez.

World War II was the first conflict in which photographers expressed empathy with the daily life of the soldiers and the victims of war. The images of Margaret Bourke-White, **Lee Miller** (1907–1977), and George Rodger (1908–1995) depicting widespread devastation and concentration camp victims were visual evidence of the Nazis' indescribable war crimes against civilians (see Figure 14.13). As the death camps were considered to be a state secret and photography of daily events was forbidden, their publication denied the executioners their wish to erase their acts of barbarism and the millions of people they murdered from human memory. Additionally, such depictions of a lack of moral compass reveal the disappearance of God as a living presence in European civilization.[34] David Douglas Duncan's (b. 1916) Korean War coverage in *Life* and his book, *This Is War* (1951), showed that war was not full of glory but of the crying and dying of young American soldiers.

**William Eugene Smith** (1918–1978) was a war correspondent for *Life* who after being seriously wounded at Okinawa in 1945 committed himself to "try and take what voice I have and give it to those who don't have one at all."[35] After recuperating, Smith produced three dramatically heroic photo-essays for the magazine: *Country Doctor* (September 20, 1948), *The Spanish Village* (April 9, 1951), and *Nurse Midwife* (December 3, 1951).[36]

Smith constantly fought against picture stories put together by an editor, believing that the "photo-essay has to be thought out, with each picture in relationship to the others, the same way you would write an essay."[37] In *Country Doctor* his photographs convey a

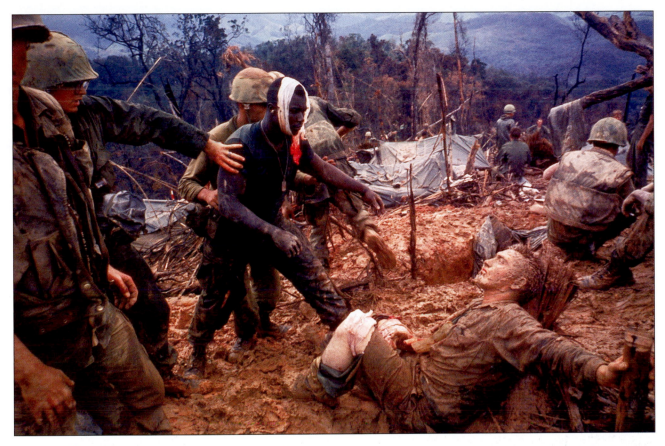

14.16 LARRY BURROWS. *Reaching Out (during the aftermath of taking hill 484, South Vietnam),* 1966. Variable dimensions. Dye imbibition print.

sense of who this doctor is, without any editorializing text. Smith's way of working propelled the photo-essay away from *Life*'s imposed format, which led viewers through stories, and toward an interpretive explanation discovered by the photographer. He claimed to have learned how to do this by listening to Beethoven.[38]

Smith also went against accepted journalistic practice by setting up photographs and manipulating his prints to clarify the feeling he wanted to present. The metrical *Spanish Village* was pivotal because it made the entire village, rather than an individual, the champion of the story. Smith's humanitarian concerns are manifested in his last and most extended work, *Minamata* (1975), about the effects of industrial pollution on a Japanese fishing village. The waters of Minamata Bay were being poisoned by industrial mercury discharge, resulting in birth defects across a generation of children. While making these photographs Smith received a terrible beating from company goons that may have shortened his life. Smith's position was to affirm that photography can help bring about social change by stressing that "to cause awareness is our only strength."[39]

In 1966, Cornell Capa (1918–2008), Robert Capa's brother and a Magnum photojournalist whose work appeared extensively in *Life,* established the International Fund for Concerned Photography at a time when picture magazines were being displaced by electronic media (video) images. In 1968 Capa stated that "the production demands and controls exercised by the mass communications media on the photographer today are endangering our artistic, ethical, and professional standards and tend to obliterate the individuality of the witness-artist."[40] Initially the fund exhibited and published the work of Werner Bischof (1916–1954), Robert Capa, David Seymour, André Kertész, Leonard Freed (1929–2006), and Dan Weiner (1919–1959). Known as *The Concerned Photographer,* this project linked their images with the "humanitarian-with-a-camera" work of Lewis Hine that "demands personal commitment and concern for mankind."[41]

Cornell Capa wrote: "The role of the photographer is to witness and to be involved with his subject. The role of the Fund is to encourage and assist such involvement, to preserve and to stress the value of conservation."[42] Cornell Capa widened the activities of this group to include its own gallery, archive, and teaching facility. In 1974, Capa opened the International Center of Photography (ICP) in New York, serving as its director until 1994. During Capa's tenure ICP exhibited many photographers who practiced his brand of "humanist photography."

Beginning with Shomei Tomatsu's (b. 1930) and Hiromi Tsuchida's (b. 1939) documentation that draws

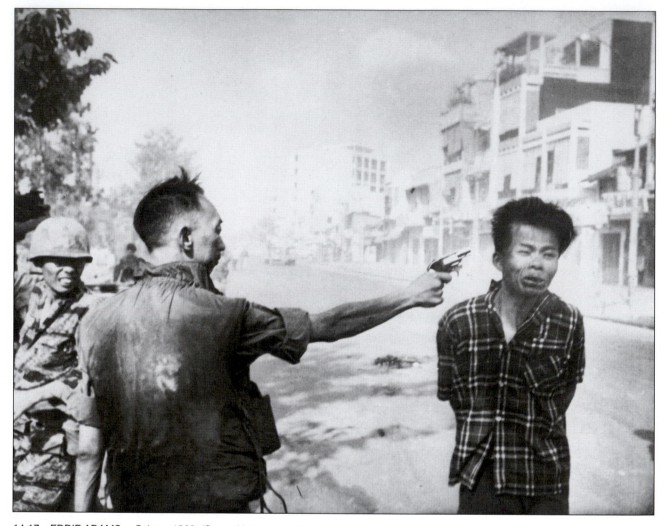

14.17 EDDIE ADAMS. *Saigon,* 1968. (General Loan executing prisoner). 10⅝ × 13⅝ inches. Gelatin silver print.

on the long-term aftermath of the bombing of Hiroshima and Nagasaki, and on through the Vietnam War, photographers had an almost continuous series of global war tragedies to chronicle.[43] The common denominator many of these photographers shared was an optimistic belief in a humanistic universalism that celebrated the existence of an eternal human essence, dignified the individuals photographed, saw the suffering of one as the suffering of all, and viewed photography as a universal language.

**Don McCullin's** (b. 1935) horrific images of the atrocities in the Congo, Northern Ireland, Vietnam, Biafra, and Lebanon were published as *Hearts of Darkness* (1981), a book that presents its deathly verdict through the images' accumulated effect. The combining of imagery from around the world presents suffering as a universal experience. The danger for both the photographer and viewer of such an approach is that over time each individual crisis loses its identity, taking on similar attributes that numb the public to all such

situations. As a habituated traveler into the realm of human anguish, McCullin challenges those who want to remain uninformed about the world and seek shelter in imaginative cinematic/video violence that takes visual pleasure in apocalypses (see Figure 14.15).

**Henry Frank Leslie "Larry" Burrows** (1926–1971) spent nine years covering the Vietnam War before being killed when his helicopter was shot down over Laos. Burrows's groundbreaking serial use of color for *Life* was part of the wave of appalling images that invaded America's living rooms. For most people color added a layer of compelling reality. Unlike in previous wars, journalists in Vietnam had almost unrestricted access to the action. Debate erupted around whether such images caused people to question America's right to be fighting this faraway war and fueled the ranks of protesters demonstrating to end the conflict. Politicians blamed the media for undermining their authority, but photojournalist Philip Jones Griffiths (1936–2008), who did *Vietnam, Inc.* (1971), gives a different account:

I would say 99 percent of all journalists in Vietnam approved of the war and 85 percent approved of the way the war was being fought. . . . So, the popular conception—*misconcep-*

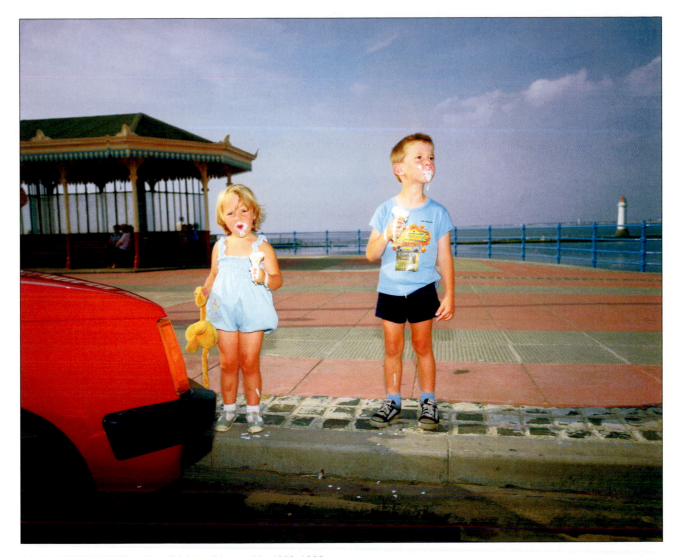

14.18    MARTIN PARR.  *New Brighton, Merseyside,* 1983–1986.
Chromogenic color print.

tion—by the public at large and the Reagan administration, that allowing all the press into Vietnam caused us to lose the war [is incorrect]. In fact, for the most part, the press in those early years was instrumental in making the war continue because most of what was recorded by the press was very, very pro the military intervention there.[44]

Most wars are summed up in public memory by a few images. From Vietnam, two photographs have especially held the public's attention: The first is Huynh Cong "Nick" Ut's (b. 1951) wrenching image, *Terror of War* (1972), picturing a hysterical girl who has ripped off her burning clothes, fleeing down the road after an accidental aerial napalm attack;[45] and **Edward (Eddie) T. Adams's** (1933–2004) photograph of a South Vietnamese general and chief of police firing a bullet into a suspected Vietcong prisoner's head, without a trial (see Figure 14.17).

Adams's photograph has taken on mythical proportions. With his hands tied behind his back, the victim's contorted face at the instant of death transforms the

event and has become a symbol of the bitter Vietnam legacy. The picture made Adams famous at the expense of his other work, making him a one-image photographer. Adams wrote about the remorse he felt as his image took on a barbaric meaning that was shaped by people's disgust for the war: "In taking that picture, I had destroyed his [the South Vietnamese general's] life. For General Loan had become a man condemned both in his country and in America because he had killed an enemy in war. People do this all the time in war, but rarely is a photographer there to record the act."[46] After his story appeared, the picture took on a different meaning when Adams received letters from U.S. military officers stating that the victim was a known Vietcong lieutenant who had murdered a South Vietnamese major, his wife, and their children.[47]

The question of whether the people at home get an accurate representation of events during wars or misleading dramatic highlights surfaced during the 1994 American invasion of Haiti. David Unger of *The New York Times* wrote: "Perhaps photojournalism operates on some variant of the Heisenberg uncertainty

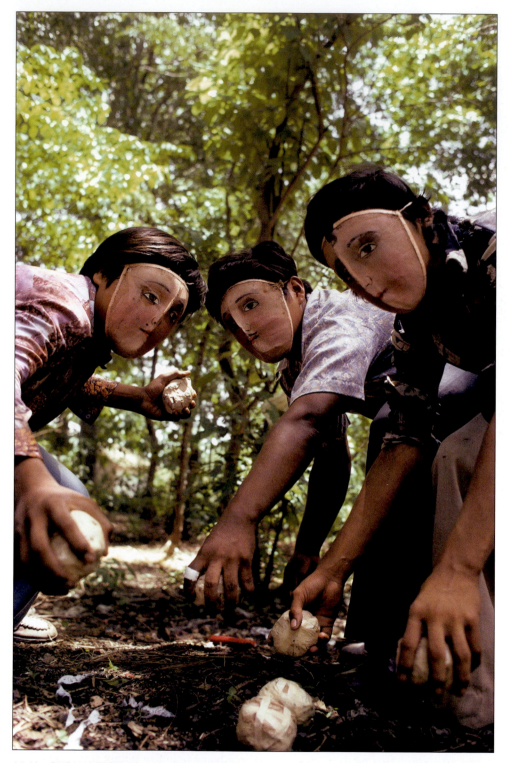

14.19  SUSAN MEISELAS.  *Youths Practice Throwing Contact Bombs in Forest Surrounding Monimbo,* 1978. Variable dimensions. Dye destruction print. Susan Meiselas's work is an example of how life can become art: The hero in Peter Weir's film *The Year of Living Dangerously* (1982) was loosely based on Meiselas's Nicaraguan experiences.

principle, which holds that efforts to measure some things may alter phenomenon they're part of. That is, taking a picture can change the Big Picture."[48]

Can a picture change the outcome of an event? Images can affect viewers in different ways, indicating people often see what they want to see when looking at a picture. In the Rodney King case (1991) four white police officers stopped a black man for driving drunk and then beat him for resisting their commands. The incident was captured on videotape, which led to indictments of those officers who carried out the violence. Many were convinced that the video evidence guaranteed a conviction. When a jury didn't see it that

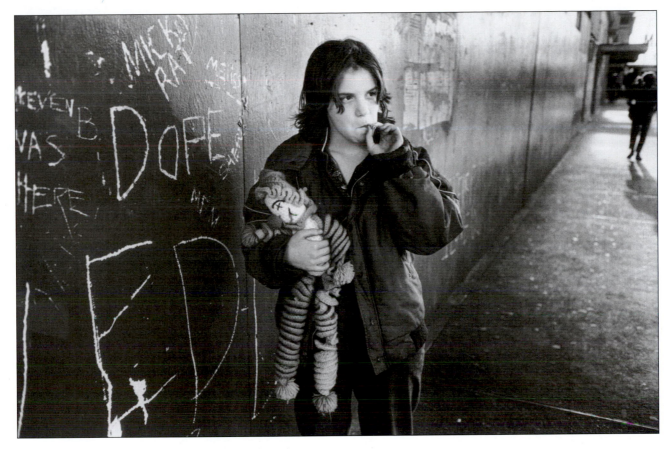

14.20   MARY ELLEN MARK.   *Lillie, Seattle,* from the series *Streetwise,* 1983. 9 × 13⅞₆ inches. Gelatin silver print. Mark says: "I'm interested in the guy that doesn't have all the breaks in life and people who live on the edge. . . . I photograph them because they have a certain passion and humanity that really interests me. I would like my pictures to be a voice for them. Photography is about seeing the world in your own peculiar and personal way."[49]   Courtesy George Eastman House. © Mary Ellen Mark.

way and refused to convict, rioting broke out. Others believe that intense television coverage surrounding sensational court cases where all the participants play to the truth of the camera, like the O. J. Simpson murder trial (1995) and President Bill Clinton's impeachment (1998–1999), can alter the outcome.

The seeming truthfulness of photography overpowers even an adroit viewing public watching CNN cable news. This is important because live television coverage has supplanted photographic coverage. During the 1991 Persian Gulf War CNN featured a video clip (provided by the U.S. military) of a "smart bomb" going down a chimney and blowing up a targeted building. This video clip was replayed over and over until it symbolized the entire sanitized military operation in which death was not pictured. Unger believes that "until viewers come to understand that seeing is not necessarily believing, that *caveat emptor* (let the buyer beware) applies to news as well as commerce."[50]

## The New Subjective Journalism

Beginning with the assassination of President John F. Kennedy in 1963 and throughout the civil rights struggle and the Vietnam War of the 1960s, television progressively became the dominant news source for most Americans. To compete, photographers often adopted more subjective, stylized, or satiric approaches like the new British style of reporting associated with **Martin Parr's** (b. 1952) work such as *The Last Resort: Photographs of New Brighton* (1986), which reveals the disconnect between expectations and reality in vibrant colors instead of traditional shades of gray (see Figure 14.18). When *Life's* editorially driven style of photojournalism collapsed in the early 1970s, alternatives developed that were more receptive to new voices, including women and minorities. Publishers began to market books of captioned photographs with condensed text. The new format offered documentary photographers, such as Jill Krementz (b. 1940), the first female staff photographer for the *New York Herald-Tribune* and author of over a dozen books, and **Susan Meiselas** (b. 1948), best known for her books *The Carnival Strippers* (1976) and *Nicaragua* (1981), the opportunity to edit their own images (see Figure 14.19). This arrangement enabled photographers to have more control over the presentation and perception of an event, putting their work before

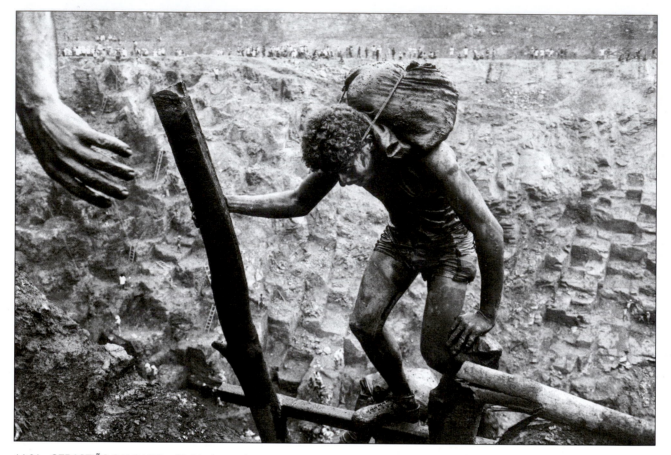

14.21 SEBASTIÃO SALGADO. [Gold mine worker on ladder carrying sack on his back], from his book *Workers*, Gold, Serra Pelada, Brazil, pages 312–313. Variable dimensions. Gelatin silver print. © Sebastiao Salgado/Contact Press Images.

the public for longer periods of time than a disposable magazine, thereby increasing its potential influence.

As the distinction between what the press considered news and what the museums thought was art blurred, artist-trained photographers, such as **Mary Ellen Mark** (b. 1940), broke the strict confines of journalistic practice to seek a more in-depth and personal interpretation of a subject. Mark's approach, like Avedon's and Newton's, raised the issue of how to delineate between photographic documents and photographic art. Mark not only worked for magazines but also received funding from not-for-profit groups for projects that were exhibited in museums and published as books. Her working style did not fit the superficial, drive-by treatment that deadline-driven journalists work against. Mark's treatment required time to develop a relationship between the photographer and the subject, as seen in her books, *Ward 81* (1979), *Falkland Road: Prostitutes of Bombay* (1981), *Streetwise* (1988) (see Figure 14.20), and *Indian Circus* (1993). Counterculture magazines like *Rolling Stone* also hired women photographers such as Annie Leibovitz (b. 1949), to make self-aware, theatrical celebrity portraits that have helped define stardom in a star-struck era.

**Sebastião Ribeiro Salgado** (b. 1944) first made photographs to supplement his written reports while working as an economic adviser in Africa in 1970. His images, like an endless morality play whose heroic character's suffering knows no end, portray his subjects in the midst of dirty manual work; he presents them simultaneously as themselves and as archetypes of themselves. Salgado's personalized approach, like Avedon's and Mark's, challenges assumptions about the photographic document and art photography. His project, *Workers: An Archaeology of the Industrial Age* (1993), formally interprets the end of large-scale manual labor in mining and other industries due to mechanization. To make his point that the production of goods is global, Salgado has photographed workers using their bodies as machines in Bangladesh, Brazil, Cuba, India, Poland, the Ukraine, and Venezuela. Salgado sees no hierarchy in manual labor, as physical demands equalize workers and give them common ground. Salgado states:

> The form of these pictures must represent the problem, the reality, the basis of what is happening. What I really want to do with these pictures is to produce a kind of homage to the working class and the old ways of producing that are disappearing. . . . I want to portray them as a group. . . . When I put them all together I want to have a family of workers.[51]

Western publishers, who have reaped the benefits of these people's labor while ignoring the effects of the accompanying cultural genocide, have been reluctant to publish Salgado's images. Fred Ritchin, Salgado's col-

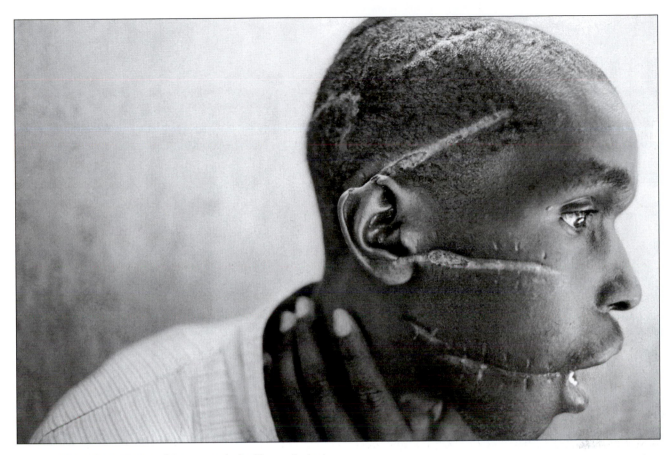

14.22  JAMES NACHTWEY.  [Hutu man who had been attacked with machetes], from *Inferno*, pages 256–257. Rwanda, 1994. Variable dimensions. Gelatin silver print.    © James Nachtwey. Courtesy VII Photo Agency.

laborator, curator, and editor, complained that magazine editors found his pictures "too disturbing" to use; after five years, Salgado's pictures have only received a fair showing in a museum retrospective of a "famous" photographer. Ritchin describes this as an example of "an unfortunate tendency to elevate the messenger while denying the message."[52] At a time when computer imaging is threatening the trustworthiness of documentary practice, due to what Ritchin calls the "decline of the aura of believability,"[53] Salgado's approach, in which the body of *the Other* becomes a collective manifestation of the human spirit, tries to resuscitate the social-documentary tradition.

Highly influenced by images from the American Civil Rights movement and the Vietnam War, **James Nachtwey's** (b. 1948) close-up, wide-angle style of working places him directly into hellacious conflicts from the slaughter of Tutsis by the Hutus in Rwanda to the famine and genocide in Darfur. Nachtwey's images, like Salgado's, have been reproached by academic critics who contend that journalistic photographs should not make their subjects artistically pleasing as this contaminates the so-called "real" with visual pleasure, thus beautifying grief and pain to achieve viewer satisfaction.[54] This tactic labels such images as being

detrimental to constructive social engagement.[55] It does not recognize that such images might awaken one's compassion, or that such an acknowledgment could be a first step toward social justice. Advocates of this photography argue it is necessary to recognize that picture making involves applying aesthetic principles to a subject, but more important, it is judicious to realize the ability of exceptional photographers to transform their subjects and transmit a subject's sensibility to others. One can recognize there are limits on what photography can represent, and any emotional attachment to an image is unstable and subject to manipulation, and yet maintain it is necessary to feel and acknowledge the suffering of others before we can act to alleviate it. They recognize that humans seem overwhelmed and powerless when confronted with the suffering of individuals other than ourselves, but think photographers can help us overcome this condition by becoming aware of the anguish of others in their pictures. Such images, as in Nachtwey's *Inferno* (1999), can make one conscious of the complexity of the process of representation in an active and inquiring way. Thus stifling such images curtails intellectual, emotional or social engagement. As Nachtwey says, "I have been a witness, and these pictures are my testimony. The events I have recorded should not be forgotten and must not be repeated."[56]

The images generated by the events of September 11, 2001, such as the exhibition and later book *Here Is New*

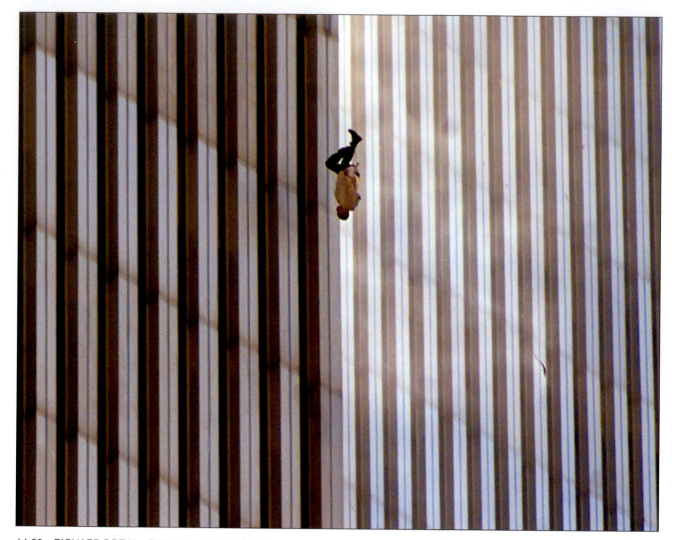

14.23   RICHARD DREW.   *Falling Man* (2001). Variable dimensions. A man falls from the north tower of New York's World Trade Center on Sept. 11, 2001, after terrorists crashed two hijacked airliners into the WTC twin towers. In the immediate aftermath of the September 11 attacks, this photograph provoked feelings of anger. It ran only once in many American newspapers after they received irate letters from readers who felt the image was disrespectful, manipulative, and voyeuristic. This led to the media's self-censorship of the photograph, preferring to print photographs of acts of sacrifice and valor. Drew had this to say: "This is how it affected people's lives at that time, and I think that is why it's an important picture. I didn't capture this person's death. I captured part of his life. This is what he decided to do, and I think I preserved that."[57]

*York: A Democracy of Photographs* (2002) that anonymously presented photographs about 9/11 by anyone who submitted them,[58] was the turning point that caused many critics to revisit their previous stance about the power of photographs to represent deprivation, humiliation, and suffering in a constructive manner. Perhaps they realized that pictures are more accessible and visceral than words. Since people are not intimidated by photographs they see privately in books, magazines, television, or on the Internet, it promotes an immediate response in which individuals can question what these photographs show them. Shocking photographs, such as **Richard Drew's** *Falling Man* (2001) (see Figure 14.23), which has been largely suppressed,[59] can provide an entry into deeper feeling and thinking by allowing viewers to identify with the suffering of the person being pictured and substitute our image for their image.

Commentators acknowledge that photography often keeps company with death, and images are not always used as a force for good. Terrorists recognize this power and purposely create and distribute abominable images, such as the brutal beheading of *Wall Street Journal* reporter Daniel Pearl in 2002, for the purpose of intimidation, hoping to make people afraid to act; however, most images generate more complex responses to their subjects. For instance, the defining image of the Iraq invasion in 2003 has shifted over time from the official United States media moment of the toppling of a statue of Saddam Hussein to the sadistic amateur snapshots made in Abu Ghraib Prison by U.S. military person-

can assert ideas and perceptions that we recognize as our own, but could not have given concrete form to without first having seen those images. Riveting images can bear witness in time, which may raise our consciousness, and inspire action to bring about social change.

## Bytes of News

Rising production costs, shrinking readership, and a shifting of resources to electronic media has made the future relationship between photography and the halftone murky at best. People can read nonphysical publications made up of bytes instead of atoms, from *The New York Times* to *The Wall Street Journal,* on the Internet. Companies like Bill Gates's Corbis (pro .corbis.com) have been trying to recast how people think about cultural institutions and the resources they contain. By acquiring the Bettmann Archive[62] in 1995, and by making deals to digitize worldwide museum collections, such projects have streamlined the process of marketing electronic reproductions to communications professionals, made the collections more accessible, while trying to turn a profit. Yet the popularity of the Internet, where Getty Images (www .gettyimages.com) was a pioneer as the first distributor to license images online, has eroded that demand. The financial problems of print publications and a related drop in demand for higher-resolution pictures that command premium prices have hurt profitability. Newer Internet-based rivals, such as www .istockphoto.com, offer images as low in quality as those taken by cellphone cameras and sell them for a dollar or even less. In terms of serious research, digitizing collections removes the power of the place and emphasizes the transaction between the viewer and the object in a new way. Dr. Anthony Bannon, director of the George Eastman House, stated: "Instead of museums declaring 'we have the collection and we'll wait for you to come to use them, we'll wait for you to come to us, and you will, when you need us,' we are now engaging in a reciprocally correcting conversation loop, trying to understand what audiences need, preparing and sending our messages in that format whenever we can, and listening to be sure that our messages were understood."[63]

The demand to access still and moving pictures on the screens of computers, mobile devices and other portable electronics has fueled a matching pressure to produce more image content, which is often met by amateurs who make their efforts available at no cost. As news gathering organizations encourage viewers to instantly send images of breaking stories via their cell phone cameras, anyone can be a reporter without the prerequisite technical or ethical education. This phenomenon is quite different from reading a professionally-produced newspaper, where readers

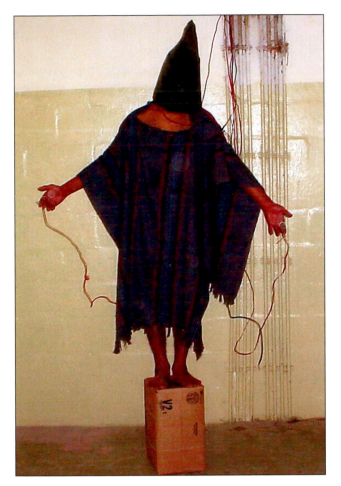

**14.24 UNKNOWN PHOTOGRAPHER.** *Abu Ghraib Prison,* 2003. Variable dimensions. Digital file. Now, digital imaging allows soldiers themselves to document and tell their uncensored stories of war. The grainy, amateur snapshots made of prisoners being abused by the guards in Abu Ghraib prison in Iraq, distributed by email and eventually on the Internet, were deemed so powerfully disturbing and shameful that the U.S. government tried to suppress them. Changes in who is making and circulating pictures are evolving with the widespread use of web logs (blogs) and alternative news and open reference websites. The character of imagemaking and its distribution is challenging old journalistic approaches creating new and diverse ways of seeing, understanding, and knowing our world. These images also demonstrate the veracity of digital images can be authenticated within the structure of reliable journalistic process.[60]

nel (see Figure 14.24)[61] to videos of roadside bombings posted by insurgents on the Internet. The result of such pictures has been a mixture of protective indifference, an inculcation of compassion, and a call to action. This may be because an image's authority is determined as much by imagination and memory as it is by its indexical relationship to the real. Engaging such tough images acknowledges the intricacy of life through their capacity to sensitize and stimulate peoples' latent exploratory senses that generate empathy. Hard-hitting photographs

have some assurance of journalistic standards and can recognize certain biases of reporters and editorial committees. The ability of the World Wide Web to deliver perfect digital copies of false data and propaganda, known as *fauxtography*,[64] whether by politicians, paramilitary groups, or part-time stringers/reporters with personal agendas, makes it vital for the audience to be capable of critically examining the information it is receiving so it does not fall prey to the unquestioning, "we read/see/hear it, so it must be true" syndrome.

As commissions for new professional journalistic work continue to fall, more analysts have been questioning the notion of photographic objectivity. This, combined with the digital revolution, has produced an ethical and existential identity crisis that has forced journalistic photographers to acknowledge their own subjectivity in reporting the news and helping to define history. The outward illustrative approach has declined in favor of a more inward, exploratory style of photojournalism. Photographers may take a more open and active stance to discovering things they did not already know and convey that from an editorial point of view. But, most important, at the beginning of the twenty-first century the majority of Americans know their world primarily through reproductive media. First, we see the world through a television, computer, or PDA (personal digital assistant); later, the world confirms what we have seen on the screen (see Chapter 18, The Digital Future Is Now).

# Endnotes

1   For a history about making multiple copies of a single image, see: Richard Benson, *The Printed Picture* (New York: The Museum of Modern Art, 2008).

2   Walter Benjamin, "The Work of Art in the Age of Mechanical Reproduction," in Walter Benjamin, *Illuminations,* Hannah Arendt, ed., English translation, (New York: Harcourt, Brace, and World, 1968), 219–53. Although published in 1936, this essay did not widely enter into academic discussions of photography until the late 1980s and early 1990s.

3   George Grosz, "Randzeichnungen zum Thema," *Blätter der Piscatorbühne* (Berlin, 1928); trans. in Peter Selz, "John Heartfield's Photomontages," *The Massachusetts Review,* vol. 4, no. 2 (Winter 1963), unp.

4   From "A Prospectus for a New Magazine," 1934, New York, Time Inc. Archives.

5   Henry Luce in Philip B. Kunhardt Jr., ed., *Life: The First Fifty Years, 1936–1986* (Boston: Little Brown and Co., 1986), 5.

6   Time Inc. Audit Bureau for circulation figures, New York, NY.

7   "We Look Back on a Great Era," *Popular Photography,* vol. 30 (May 1952), 39.

8   Jane Livingston, *Odyssey: The Art of Photography at National Geographic* (Charlottesville, VA: Thomasson-Grant, 1988), p. 27.

9   Edward Steichen, *A Life in Photography* (Garden City, NY: Doubleday and Co., 1981), unp., located in Chapter 9, "Introducing Naturalism into Advertising."

10   Catherine A. Lutz and Jane L. Collins, *Reading National Geographic* (Chicago: University of Chicago Press, 1993), 66.

11   Ibid.

12   See Patricia Johnson, *Real Fantasies: Edward Steichen's Advertising Photography* (Berkeley: University of California Press, 1997).

13   *Vogue* (September 15, 1939), 76; cited in Nancy Hall-Duncan, *The History of Fashion Photography* (New York: Alpine, 1979), 64.

14   Harold Haliday Costain, "Photography," *Modern Publicity 1935–36* (London, 1936), 20; cited in Robert Sobieszek, *The Art of Persuasion* (New York: Harry Abrams, 1988), 71.

15   Alexander Liberman, introduction to Irving Penn, *Passage: A Work Record* (New York: Callaway/Knopf, 1991), 5.

16   Ibid., 6.

17   Jonathan Tichenor, "Irving Penn," *Graphis* vol. 6, no. 33 (1950), 396.

18   Milton Brown, "Badly Out of Focus," *Photo Notes,* (January 1948), 5–6.

19   Vicki Goldberg, "Irving Penn Is Difficult. Can't You Tell?" *The New York Times,* November 24, 1991, Section 2, 40. No Penn image appears as he claimed he would only grant permission for monographs of his work.

20   Jamie James, "Transcending," *ARTnews,* vol. 93, no. 3 (March 1994), 105.

21   For a critique of this project see Richard Bolton, "In the American East: Richard Avedon Incorporated" in Richard Bolton, ed., *The Contest of Meaning: Critical Histories of Photography* (Cambridge: The MIT Press, 1989), 261–282.

22   Based on an extended conversation between Avedon and the author at Toad Hall, the ranch home of Stanley Marsh III, Amarillo, TX, November 1984, while Avedon was photographing *In the American West*. The project was sponsored by the Amon Carter Museum, Fort Worth, TX.

23   A clash between critical thought and commerce has prevented an Avedon image from being reproduced in this project. In a series of telephone calls and faxes during December 1998 and January 1999, Avedon's studio manager, Norma Stevens, requested text and sample designs. Stevens then asked that changes be made to correct "inaccuracies." After this was done, she refused permission to reproduce an Avedon image because she did not like the "tone" of the piece. For the Avedon studio machine all aspects of photographic practice appear to be commodities subject to control, negotiation, and manipulation.

24   "Body Work: Andrew Hultkrans talks with J. G. Ballard and David Cronenberg," *Artforum,* vol. XXXVI, no. 7, (March 1997), 117.

25   See Daniel Jonah Goldhagen, *Hitler's Willing Executioners: Ordinary Germans and the Holocaust* (New York: Alfred A. Knopf, 1996).

26   Henri Cartier-Bresson, in *The Concerned Photographer,* unp., 265.

27   Robert Capa, "Death in Spain," 1936. Caption from *Life,* July 12, 1937, vol. 3, no. 2, 19. This image is better known as *Death of a Loyalist Soldier.*

28   Controversy surrounding "The Falling Soldier" may be resolved with the surfacing of thousands of Capa's Spanish Civil War images. See: Randy Kennedy, "The Capa Cache," *The New York Times,* Sunday, January 27, 2008, AR 1 & 31. This discovery also contains the negatives of Gerda (Pohorylles) Taro (1910–1937), a pioneering female photojournalist whose brief career consisted mainly of dramatic photographs from the front lines of the Spanish Civil War. Taro, whose partnership with Capa was both professional and personal, was struck by a tank and killed. See: *Gerda Taro* (London & NY: Steidl/ICP, 2007).

29   Quoted in Cornell Capa, ed. *The Concerned Photographer* (New York: Grossman, 1968), unp.

30   Robert Capa, *Images of War* (New York: Grossman Publishers, 1964), 110.

31   Magnum Photos was founded in Paris in 1946 by Henri Cartier-Bresson, Robert Capa, David (Chim) Seymour, George Rodger, and Bill Vandivert. The photographers were motivated by exasperation with magazines like *Life* that determined a photographer's assignment, controlled the use of the images, and retained ownership of the negatives. At Magnum, the photographers select the editors and staff and set policy on how work is represented and sold. Profits are shared in proportion to the sales of the work. Nowadays, younger photographers can become Magnum associates and have their work represented on a commission basis. A New York office was established in 1947.

32   John Le Carré, intro. to Don McCullin, *Hearts of Darkness* (New York: Alfred A. Knopf, 1981), 19.

33   Cartier-Bresson, 265.

34   See Bernard Wasserstein, *Barbarism and Civilization: A History in Our Time* (New York: Oxford University Press, 2007).

35   Paul Hill and Thomas Cooper, "W. Eugene Smith," *Dialogue with Photography* (New York: Farrar, Straus and Giroux, 1979), 280.

36   See Glenn G. Willumson, *W. Eugene Smith and the Photographic Essay* (Cambridge: Cambridge Press, 1992).

37   Op. cit., 266.

38   Ibid., 264.

39   W. Eugene Smith and Aileen M. Smith, *Minamata* (New York: Holt, Rinehart and Winston, 1975), 8.

40   Cornell Capa, Introduction, *The Concerned Photographer,* unp.

41   Ibid.

42   Ibid.

43   Photographs of the aftermath of the bombing of Hiroshima and Nagasaki, especially of people, rarely have been published in the West. For an overview see Ryuichi Kaneko et al., *The Half-Life of Awareness: Photographs of Hiroshima and Nagasaki* (Tokyo: Tokyo Metropolitan Museum of Photography, 1995).

44   Marianne Fulton, *Eyes of Time: Photojournalism in America* (Boston: Little Brown, 1988), 208.

45   After making the picture, the 22-year-old Ut drove the girl to a hospital, saving her life. At this writing, the woman in the picture is married, has a child, and lives in Toronto, Canada.

46   Eddie Adams, "The Pictures That Burn in My Memory," *Parade Magazine,* May 15, 1983, 9.

47   Eddie Adams telephone interview with Vicki Goldberg in Vicki Goldberg, *The Power of Photography,* 229.

48   David C. Unger, "Taking Haiti," with photographs by Alex Webb, *The New York Times Magazine* (October 23, 1994/Section 6), 53–54.

49   Mark Edward Harris, "The C & D Interview: Mary Ellen Mark," *Camera and Darkroom* (October 1993), 22–31.

50   Unger, 55.

51   John Bloom, "An Interview with Sebastião Salgado," October 5, 1990, San Francisco in John Bloom, *Photography at Bay: Interviews, Essays, and Reviews* (Albuquerque: University of New Mexico Press, 1993), 151–165.

52   Cited in David Levi Strauss, "Epiphany of the Other," *Artforum* (February 1991), 99.

53   See Fred Ritchin, *In Our Own Image: The Coming Revolution in Photography/How Computer Technology Is Changing Our View of the World* (New York: Aperture, 1990).

54   See Susan Sontag, *Regarding the Pain of Others* (New York: Picador, 2004).

55   Martha Rosler, "In, Around and Afterthoughts (on Documentary Photography)," *3 Works,* Halifax NS: Press of the Nova Scotia College of Art & Design, 1981. In reaction to this argument, more photographers began to create and photograph staged scenes.

56   www.jamesnachtwey.com.

57 Peter Howe, "Richard Drew," *The Digital Journalist,* 2001. www.digital journalist.org/issue0110/drew.htm.

58 See Giles Peress, et al., *Here Is New York: A Democracy of Photographs* (Zurich: Scalo Publishers, 2002).

59 See www.esquire.com/features/ ESQ0903-SEP_FALLINGMAN.

60 See André Gunthert. "Digital Imaging Goes to War," *Photographies,* 2008, 1:1, 103–112.

61 To learn about the details surrounding the making of the Abu Ghraib photographs, see Philip Gourevitch and Errol Morris, "Exposure: The Woman Behind the Camera at Abu Ghraib," *The New Yorker,* March 24, 2008, 44–57.

62 The Bettmann Archive was founded in 1930 by Otto Bettmann, known as "The Picture Man," and contains over 16 million images, making it one of the world's largest and most important photographic archives. Bettmann is considered the father of the image resource business.

63 Dr. Anthony Bannon, "The Geography of the Collection," a lecture delivered April 27, 1997, for CEPA Gallery at the Anderson Gallery, Buffalo, NY.

64 Charles Foster Johnson coined the term *fauxtography* on his weblog, Little Green Footballs, do describe publishing of manipulated photographs by new services such as Reuters and the Associated Press during the 2006 Israel–Lebanon conflict.

# The Atomic Age

## *New Light/Fresh Methods*

The 1945 decision by President Harry S. Truman (1884–1972) to drop atomic bombs on the Japanese cities of Hiroshima and Nagasaki ended World War II and began the Atomic Age. Despite the forming of the United Nations Charter (1945), world peace was elusive. Initial postwar exhilaration rapidly gave way to apprehension and tension as the Soviet Union exploded its first atomic weapon (1949). Americans realized that "the bomb" could now be used against them. As test blasts escalated, the arms race of the Cold War commenced. The physical and psychological fallout from these scientific events altered the American transcendental belief in nature. The incredible economic benefits scientists promised from the "Atoms for Peace" program, such as plutonium nuclear reactors that would generate not bomb material but electric power so inexpensive that meters would be unnecessary, never materialized. Instead, technology seemed on the verge of overwhelming nature, bringing with it a loss of firm moral ground and the possibility of outright extermination. Even Robert Oppenheimer, the head of the Manhattan Project that developed America's first atomic weapon at the Los Alamos laboratory, had so many doubts about what they had unleashed upon the world that he resigned his position.[1] The atomic bomb changed the world, and post–World War II

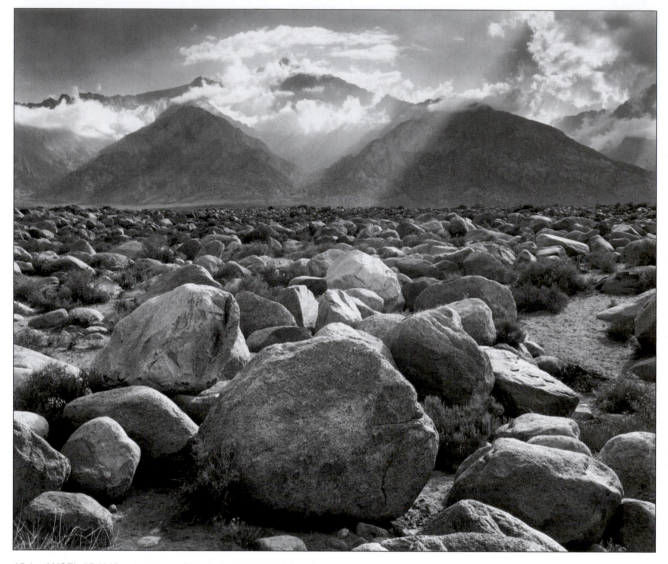

**15.1    ANSEL ADAMS.**    *Mount Williamson, Sierra Nevada, from Manzanar, California—Clearing Storm,* 1945. Variable dimensions. Gelatin silver print.    Ansel Adams Publishing Rights Trust/Corbis.

artists started to reflect its destabilizing consequences. A small group of American photographers shifted their modern and naturalistic outlook to a more abstract, surreal, and existential stance.

Until World War II the modernist concept of the naturalistic/documentary photograph, the previsualized, full-frame aesthetic of the individual photographer, reigned supreme. Magazines, such as *Popular Photography* and *U.S. Camera,* reinforced it and gave national exposure to work produced by the FSA and the Photo League. The modernist agenda was advanced by Beaumont Newhall (1908–1993), the curator of the recently established Department of Photography at the Museum of Modern Art (1940), the first at a major art museum. Newhall's *The History of Photography: 1839 to the Present Day,* originally published as a catalogue accompanying the MoMA exhibition of the same name in 1937, defined the modernist approach and intro-

duced its artists to the public.[2] Another watershed event was the establishment of the George Eastman House Museum of Photography, which opened in 1949, and the appointment of Newhall as its first curator and, later, its director (1958–1971). From these positions Newhall, often assisted by his wife, Nancy Parker Newhall (1908–1974),[3] championed a select group of photographers, many of whom were personal friends, through exhibitions, publications, and lectures.

Before the atomic bomb **Ansel Adams** made images, such as *Mount Williamson (1945),* that embodied Newhall's modern, naturalistic vision. Adams's compositions visualized the essence of nineteenth-century American transcendentalism: ethereal light illuminating the solid enduring earth. Here the sharp focus of reason co-existed with the timeless beauty of nature. Not far from Mount Williamson, Adams also photographed the human landscape at Manzanar War Relocation Center, a California internment camp where more than 10,000 West Coast Japanese-Americans were imprisoned by the U.S. government during World War II (the resulting images were published as *Born Free and Equal,* 1944).

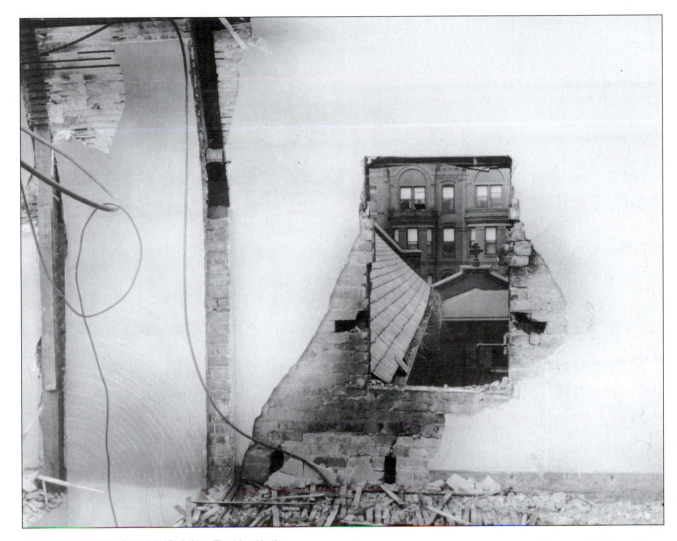

15.2  CLARENCE JOHN LAUGHLIN.  *The Head in the Wall,* 1945. 11 × 14 inches. Gelatin silver print. Laughlin wrote: "This broken opening in a shattered building, by a process of natural magic, becomes the head of Havoc, the horrible head of devastation itself symbolizing the ruin which faces a society which cannot control its own destructive impulses—which cannot control war. Visually, space becomes reversed, the opening becoming more solid than the wall itself."[4]  The Historic New Orleans Collection.

Although removed from the battlefields, Adams made shrewd images that encouraged people to scrutinize the mountains and heavens for a higher moral authority to replace the one that seemed to be crumbling.

After the detonation of the first test bomb at Trinity Site on July 16, 1945, the earth and the heavens no longer seemed to possess the same degree of lasting spiritual strength that Adams's photographs personified. Even the light was different now. I. I. Rabi, a Nobel laureate physicist who observed the explosion, reported it was "the brightest light I have ever seen or that I think anyone has ever seen. It blasted; it pounced; it bored its way right through you. It was a vision which was seen with more than the eye. It was seen to last forever. You would wish it would stop; altogether it lasted about two seconds."[5] This new world could not be contained by the old transcendental ways that saw the camera as the eye of nature. This new light demanded fresh methods of representing the visions of the world that went beyond what the eye could see.

The increase in war-enforced emigration of artists gave European cultural and intellectual theories wider currency in America and provided photographers with alternative approaches to Newhall's modernist program. The American painters Arshile Gorky (1904–1948) and Adolph Gottlieb (1903–1974) adopted the surrealist ideas of Max Ernst and André Breton into paintings devoid of rational intent or utilitarian representation, forming the basis of *Abstract Expressionism.* Representative of an attitude of intense allegiance to psychic self-expression, abstract expressionism paralleled post–World War II's atomic existential philosophy's belief in individual action as the key to salvation. Surrealism also gave expressionist photographers who did not fit the modernist mode the means to rebel against the empirical, realistic outlook that dominated American practice. The infusion of new ideas helped break the domination of the assignment-driven photoreportage of the literal moment, allowing photographers

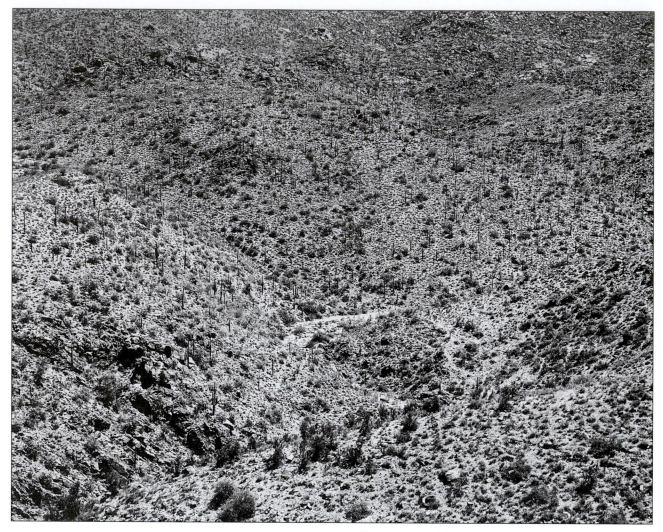

15.3   FREDERICK SOMMER. *Arizona Landscape,* 1943. 7⅝ × 9⁹⁄₁₆ inches. Gelatin silver print. "For years I looked at the Arizona landscape and it seemed almost a hopeless task. . . . There wasn't anything worth featuring, nothing worth making a to-do about. All those plants were dry and dead and dying. And, if they weren't, you could take them as a whole, in their totality. . . . What was the difference between the top of the picture and the bottom of it? It was all the same. But there was a difference. The only thing is that it was more subtle . . . there's a great deal going on. Maybe this helped me to realize that I was looking at details. These were enormous areas, but still there were no details. . . . There's nothing happening in the sky and I decided, 'No skies for me.' Finally there was no foreground, there was no middle distance, there was nothing. And there was very little distinction between the plants and the rocks. Even the rocks were struggling."[6]   Courtesy Frederick & Frances Sommer Foundation.

to make more timeless and intangible representations of the allegorical, the psychological, and the spiritual.

Commercial magazines did not believe that private symbolic imagery was suitable for a popular audience, leaving expressive practitioners to face solitary lives of offering images to tiny audiences with little hope of financial compensation. Still, some found straight

realism too restrictive and wanted more mental space for cerebral interpretation and personal enlightenment. The search to find alternatives to *social realism,* representational images with a social purpose, was underway. Photographers sought to extend their practice beyond the commercial and functional to explore internal intellectual and philosophical quests. Their search for a new form of spiritualism in an atomic age shifted from the modernistic approach that favored strongly defined, tangible subject matter and the structuring role of light, to compositions that embraced the subjectivity of inner self-expression, the metaphor, and the manipulation of materials and processes. In a world now controlled by invisible atoms, there was a growing interest by photographers in psychoanalytic theory and surrealist dream imagery that promoted nonrational aspects of being.

## The Surrealistic Metaphor

The use of photographic metaphor—a photograph that intends to transcend its exterior appearance—seemed at odds with the presumably objective nature of photography, which is secured to such appearances. Yet it

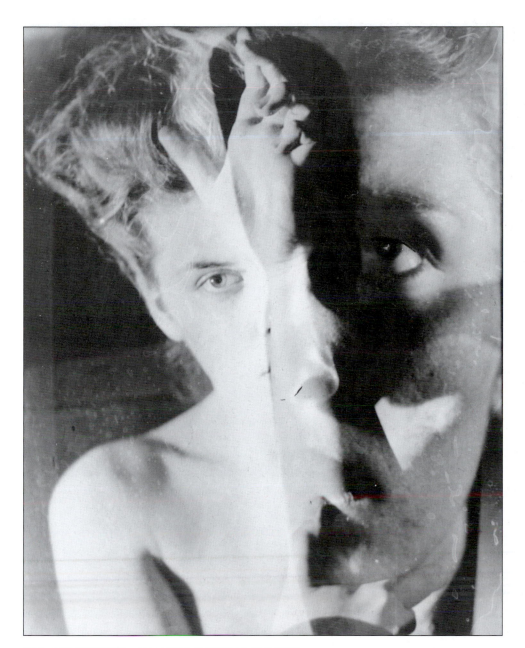

15.4  VAL TELBERG.  *Unmasking at Midnight,* circa 1948.
11⅛ × 9⅝ inches. Gelatin silver print. "What interests me most is
not what one can see, but what goes on unseen in one's mind,"
Telberg said.[7] And "I try and invent a completely unreal world, new,
free and truthful, so that the real world can be seen in perspective
and in comparison."[8]    Courtesy Los Angeles County Museum of Art,
Ralph M. Parsons Fund. (M.87.81.2). © Estate Val Telberg, Courtesy
Laurence Miller Gallery, New York.

was this metaphorical approach, combined with sur-
realism, which allowed photographers like **Clarence
John Laughlin** (1905–1985) to suggest connections
and create new analogies about time and place.

Laughlin was a self-taught New Orleans photogra-
pher with no sphere of like-minded artists, who by the
late 1930s was using surrealist strategies, such as blur-
ring, double exposure, light manipulation, and coded
poses, to disrupt photographic realism. A devotee of the

French symbolist poets Charles Baudelaire and Arthur
Rimbaud, Laughlin depended on enigma and fantasy
to evoke a disturbing dreamlike quality rich in mys-
terious allegories and melancholic sexual undertones.
His romantic images, filled with the sultry legends of a
pretechnological South that wanted to ignore the com-
ing atomic age, incorporate, and yet move in a direction
different from, the modernist aesthetic of Weston and
Adams. Laughlin was not interested in representing an
outer object as a-thing-in-itself but in its "psychic [con-
tent] in terms of inner perceptions and compulsions, in
terms of intuition and symbolism (the treating of the
object as a-thing-beyond-itself)."[9] His work protested
a rational and technical society that denied emotions.
Laughlin was after a spiritual resurrection, uniting body
and intellect, instinct and reason, poetry and utility. His
series, *Poems of the Inner World,* wrestles with the psy-
chology of anxiety, confusion, desire, death, fear, guilt,

**15.5  MINOR WHITE.** *Columbus Avenue, San Francisco,* 1949. 7⅝ × 9⅞ inches. Gelatin silver print. The wall statement for a White exhibition curated for the George Eastman House by Walter Chappell said: "This photographer releases the shutter while looking at things for what else they are, and later reflects on the photographic image for what else it is. Why? Because this is the way to use camera work to mirror inner life. This is the way of what Alfred Stieglitz called *Equivalents*. Because this is the liberating discipline by which photographs become turning points between man and nature and looking glasses that can be walked into. Only half the story is given in photographs and words. The other half, as 11th century Chinese painters believed, is given by the viewer as he completes the images in his mind. What he remembers later is his own. . . . In payment of promises made to Walt Whitman and acknowledgments of invoices from Donne, Emily Dickinson and Blake; Freud, Ansel Adams, Edward Weston and *I Ching*."[10]   Reproduced with permission of the Minor White Archive, Princeton University Art Museum. Copyright © Trustees of Princeton University.

and renewal. Laughlin's studies of Southern antebellum architecture, published as *Ghosts Along the Mississippi* (1948), concentrate on what he referred to as their "psycho-physical environment." Laughlin said:

> "It is a strange fusion of psychological factors with physical factors that most excites me. . . . All buildings, all cities that have been greatly lived, that have been greatly dreamed on, and that extend far through time—have this secret life."[11]

This combination of cultural and physical ingredients, topography, and *Zeitgeist* (spirit of the time) share similar preoccupations with the Southern gothic literature of William Faulkner, Carson McCullers, and Flannery O'Connor. Laughlin's titles, like *We Reached for Our Lost Hearts* and *The Eye that Never Sleeps,* made a verbal-visual link, encouraging a metaphorical/poetic interpretation that foils the authority of a photograph to act as a literal representation of what it depicts. Laughlin's theatrically staged scenes stymie realism

with montage and multiple exposure, destroying the accepted continuum of time. Laughlin's belief that "the limitations of photography are nothing more than the limitations of photographers"[12] informs a generation of magical Southern photographic thinking in the work of Jerry Uelsmann, Van Deren Coke (1921–2004), Robert W. Fichter, and Ralph Eugene Meatyard.

**Frederick Sommer** (1905–1999), raised in Brazil and trained as a landscape architect, seriously pursued photography after meeting with Stieglitz in 1935. Charles Sheeler and Max Ernst encouraged his systematic explorations with "the sensitized surface, rather than photography itself" that included camera-less negatives, clichés-verre, smoke-on-glass, paint-on-cellophane, cut-paper images, and musical notation as art. Although Sommer cared for the accurate illustration of how things are and studies their shapes in the manner of a Renaissance anatomist, surrealist underpinnings add a phantasmagoric quality to his imagery. Sommer's early photographs step into a realm of the grotesque and nightmarish to question temporal existence while functioning as metaphors for war and foreshadowing the mass destruction that would leave Europe in ruin. Images like *Eight Young Roosters* (1938) demonstrate an awareness of positivistic typology, the scientific recording of specific genres that uses repetition to encourage viewers to ponder the essence of the subject. Sommer applied his typological thinking, stressing the relationship between similar subjects, to his landscapes.

Sommer struggled with how to depict the landscape of the American West. Finding the Arizona desert immune to traditional rendition, Sommer looked at nature to suggest its own order. By eliminating the sky and the foreground, Sommer made images that defy gravity and occupy their own dreamlike space. The harsh landscape seems to float in its own endless and enigmatic space. The lack of classical associations for measurement and placement in the Arizona desert give his pictures a disorienting sense of being in a foreign world where one's position in time and space is uncertain. Its topography reflects Sommer's conclusion that the landscape "exists for itself." Sommer's detailed, horizonless views in the 1940s shaped his topological response to the desert landscape and anticipated the more obscure imagery he would make twenty years later using smoke on cellophane. Jam-packed, edge-to-edge, they express and foreshadow the same set of concerns as Jackson Pollock's (1912–1956) skein painting. Sommer's observation—"What is the importance of Duchamp, if not to tell us that the things that go on in painting can be done without painting"[13]—reveals his desire to push the envelope of photography.

The desire for a metaphoric resonance can be seen in the work of **Val Telberg** (1910–1995), who became interested in surrealism and experimental filmmaking while studying painting at the Art Students League in New York. He learned photography in order to support himself by making "quickie" photos of nightclub patrons. Impressed by the films of Maya Deren and Frances Lee, Telberg adapted cinematic techniques, such as the dissolve and jump cut, to still photography, distorting its narrative content. Telberg challenged "previsualization" by using the darkroom as a workshop for his imagination. Working on a light table, Telberg arranged negatives, often hand-altering them, into mental images that were sandwiched between glass and printed. As in a dream narrative, the action jump cuts from one element to another. The overlapping negatives can offer the illusion that the viewer is watching a cinematic projection that flattens space, shifts scale, and compresses time. Telberg's mental cross-cutting of these reality fragments provides a hallucinatory, time-based stream-of-consciousness, offering a multivisual forum for exploring the normally unseeable relationships among his fantasies, feelings, and memories, often with tragic undertones.

## The Photograph as Spirit

Upon his return from active military duty in the Philippines during World War II, **Minor White** (1908–1976) sought visual metaphors in order to access the hidden mythical nature within reality. His first attempt was a portfolio, *Amputations* (1947), of portraits of soldiers juxtaposed with images of nature and with verse:

> *If battle gives me time*
> *It is my will*
> *To cut away all dear insanities*
> *I get in War*
> *Or if I live*
> *To amputate the pain*
> *I've seen endured*

For decades, White continued to reedit and alter this metaphoric sequence of images, reaching back before Nazism, Stalinism, the Holocaust, and the atomic bomb to find an aesthetic order that made sense. During the politically oppressive Cold War era of communist witch hunts and blacklists, artists and intellectuals turned away from activist social encounters. They searched for an inward path of myth and transcendence from suffering that would lead to personal contentment and wholeness. White returned to Stieglitz's *Equivalents* of the 1920s, photographs that function metaphorically by subordinating their literal subject matter, not to explore photography but himself. He would later state: "I photograph not that which is, but that which I AM."[14] During World War II White converted to Catholicism. The unshakable existential angst instilled by the war led him to study aesthetics with modernist art historian Meyer Schapiro (1946) and explore mysticism,

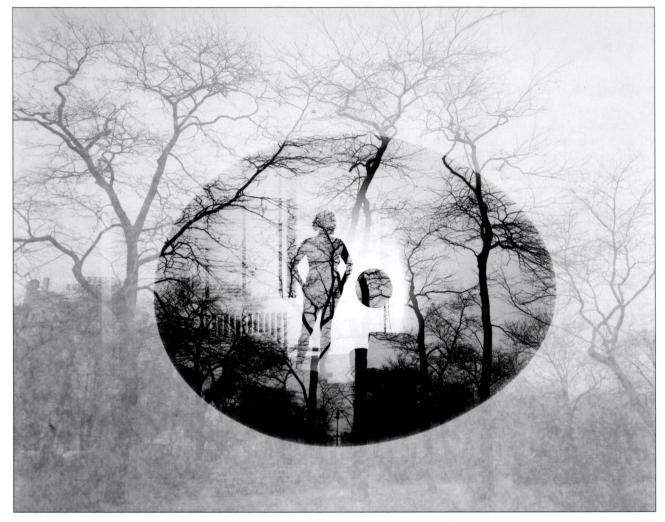

**15.6    HARRY CALLAHAN.** *Eleanor, Chicago,* ca. 1953. 17.2 × 16.5 cm. Gelatin silver print.    © The Estate of Harry Callahan. Courtesy Pace/MacGill Gallery, New York. Image courtesy Center for Creative Photography.

Zen Buddhism, Gestalt psychology, and the teachings of George Ivanovitch Gurdjieff (ca. 1877–1949). White achieved the same sense of mystical naturalism that abstract painters, such as Mark Tobey, sought, not by inventing subjects to be photographed but by editing and sequencing reality-based images into a framework that liberated them from their original meaning. Once the photographic image was freed from its burden of representation, White believed that viewers could subjectively "read" an image for personal meaning. In a process referred to as *mirroring,* White postulated that we "invent a subject . . . out of the stuff and substance of ourselves . . . [and] turn the photo into a mirror of some part of ourselves."[15] By the 1960s, White was convinced that photographs do not contain their own meaning, that a photograph may contain numerous meanings, and that viewers are the source of these meanings. Thus "the audience can be as creative as the photographer . . ."[16]

White's major contribution to photography was his ability to share his ideas with the field. White taught at the California School of Fine Arts (1946–1953) with Ansel Adams, at the Rochester Institute of Technology (1955–1965), and at Massachusetts Institute of Technology (1965–1974); conducted workshops throughout the country; and was the assistant curator of exhibitions and editor of *Image* at the George Eastman House (1953–1957). White's *Zone System Manual* (1953) helped introduce and expand Adams's concepts. His biggest impact on the fine art of photography was helping found *Aperture* magazine in 1952 and acting as editor from 1952 until 1975. *Aperture,* with roots in the San Francisco renaissance of Eastern philosophy and religion, manifested its photographers' concerns for the contemplative, the intuitive, the mystical, and the universal. White used *Aperture* to champion his reinterpretation of Stieglitz's photographic equivalents as a form of Zen meditation "akin to the mystic and to ecstasy. . . . One feels, one sees on the ground glass into a world beyond surfaces. The square becomes like the words of a prayer or a poem, like fingers or rockets into two infinities—one into the subconscious and the other into the visual-tactile universe."[17]

15.7   AARON SISKIND. *New York, No. 6,* 1951. Variable dimensions. Gelatin silver print.   © Aaron Siskind Foundation, Courtesy Silverstein Photography. Image courtesy Center for Creative Photography.

# Photo Education as Self-Expression

America, left economically and physically whole after World War II, became the world leader of visual culture. President Truman's GI Bill provided federal funding to educate some 8 million returning veterans. To take advantage of thriving enrollments, college and university art departments offered photography courses stressing personal expression. Despite the death of Moholy-Nagy in 1946, his new Bauhaus, the former School of Design in Chicago, became a center for "New Vision." Renamed the Institute of Design in 1944, the school encouraged students to think of photography's foundation in terms of light instead of equipment, to work with unconventional methods, and to cross boundaries by mixing media. Self-expression and experimentation, rather than documentation, became the photographic destination. These concepts informed a generation of teachers who would oversee the explosive growth of photographic education beginning in the late 1960s and running through the early 1980s. Two of the most influential photographers/educators associated with the Institute of Design were Harry Callahan and Aaron Siskind.

**Harry Callahan** (1912–1999), with Arthur Siegel (1913–1978) and Aaron Siskind, developed the expressive photography program at the Institute of Design

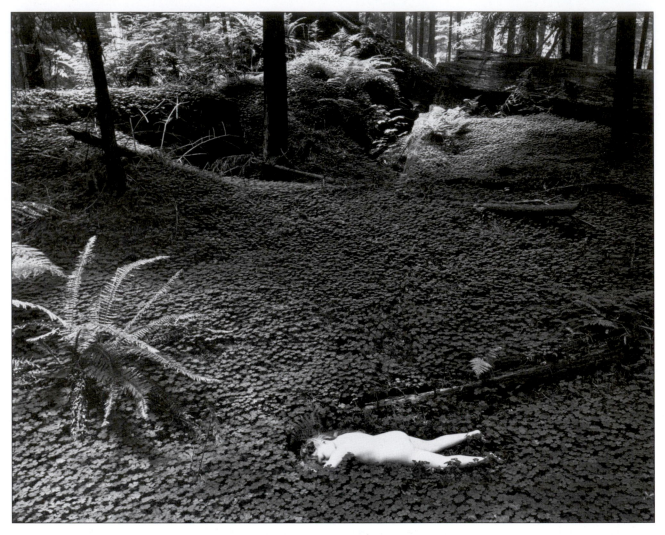

**15.8 WYNN BULLOCK.** *Child in Forest,* 1951. 7⁷⁄₁₆ × 9⁷⁄₁₆ inches. Gelatin silver print. Bullock said: "I think everything is mysterious. . . . To me everything in art is a symbol, it's never the thing. . . . I believe that symbols are more important than the people. They have more power to influence the world than the people who create the symbols. Why is it that all the great philosophers, scientists, painters, and so forth still have this great influence? It's because of the symbols they've left us."[18]

(which in 1950 became part of the Illinois Institute of Technology), where he taught from 1946–1961. In 1961, he moved to the Rhode Island School of Design (RISD) to head its photography department and taught there until 1977. Callahan saw photography not in terms of a camera but as a process through which one could see the self. Photography was about learning to control the visual *gestalt* of the picture, the photographer's mental organization that determines the image's construction and cognitive meaning. Callahan wrote: "I am interested in relating the problems that affect me to some set of values that I am trying to discover and establish as being my life. I want to discover and establish

them through photography. . . . This reason, whether it be good or bad, is the only reason I can give for these photographs."[19]

Using a thematic approach that can be arranged under the headings of Eleanor (Eleanor Knapp, Callahan's wife), the City, and Landscape, Callahan worked intuitively to infuse his pictures with feeling and selfhood. Spare, highly abstracted winter scenes, such as *Detroit,* 1948, hearken back to Moholy's prenuclear reductionist impulses in which nature is seen as design and form. In one series, Callahan diminishes nature by projecting outdoor scenes onto Eleanor's bare back. The image suggests that simply reproducing the natural world will not answer existential questions and that such knowledge can only be found by examining one's private emotions and thoughts. The expression of this detached consciousness, the desire to withdraw into the self, became an early nuclear motif: the artist as an island. The confusion, disorientation, and growing isolation of the early nuclear era can be seen in Callahan's early street images, in which he uses a telephoto lens to fill the frame with heads of isolated people, cut away from their environment, alienated in their own inner reality.

Callahan's experiments with double exposure and collage are visual signs of the fragmenting self and the lost spiritual values that were rapidly being replaced by a booming consumer economy. As Akira Kurosawa's postnuclear film, *Rashomon* (1950), affirmed in its tale of rape and murder told from four different perspectives, a uniform approach to life and history is not possible. Truth is a patchwork resulting from a multitude of personal inquiries and positions.

Callahan was an archetypal modernist who saw form as a path to the spirit. His vision of an artist was patterned after Somerset Maugham's *The Moon and Sixpence* (1919), a fictionalized account of Paul Gauguin (1848–1903), in which the artist is a solitary hero with a sacred calling, beyond the comprehension of his fellow mortals.[20] Callahan, known for being tongue-tied when discussing his work, stated: "Photography seems so simple to me that there doesn't seem to be much to say."[21] After an almost complete 25-year silence concerning the meaning of his work, Callahan wrote a short statement about what was important for him and his struggle to keep working:

> It's the subject matter that counts. I'm interested in revealing the subject in a new way to intensify it. A photo is able to capture a moment that people can't always see. Wanting to see more makes you grow as a person and growing makes you want to show more of life around you. I photograph continuously, often without a good idea or strong feelings. During this time the photos are nearly all poor but I believe they develop my seeing and help later on in other photos. I do believe strongly in photography and hope by following it intuitively that when the photographs are looked at they will touch the spirit in people.[22]

The other major figure to come from the Institute of Design was **Aaron Siskind** (1903–1991). After producing documentary projects, such as the *Harlem Document* and *The Most Crowded Block in the World,* during the late 1930s, Siskind dropped the Film and Photo League's social documentary stance to pursue the abstract and personal. Siskind's aesthetic switch led him to become friends with painter Franz Kline and his coterie during the emergence of abstract expressionism.

Siskind brought the concepts of abstract expressionism to photography by using the straight photographic style (no unusual manipulation of materials) to make a visual analogy that transcended the literalness of the subject and promoted a subjective interpretation. Through controlling the tension between representation and the independent image, Siskind balanced photography's descriptive capacity with allusion, converting direct photographic observations into visual metaphors. In 1951, after meeting Callahan at Black Mountain College, Siskind accepted an invitation to teach at the Institute of Design, and in 1971 he rejoined Callahan at RISD.

Siskind's sharp, highly detailed, large-format abstract images of dripped paint, graffiti, and peeling walls symbolize the disintegration of old-fashioned lifestyles in a nuclear era and the search for a self-centered spiritual core that does not compromise reality. His ordered work is difficult, as he does not rely on the literal, sexual, or spiritual devices of his contemporaries to delve into the symbolic character of communication. Bypassing the photo-essay's interchangeability of words and pictures, Siskind's calligraphic/hieroglyphic images converge at the juncture where pictures and words become one (see Figure 15.7). Through a process of renewal and self-discovery, similar in concept to Stieglitz's *Equivalents,* Siskind not only internalized photography but also liberated his thinking from pictorial subject matter. Siskind assembled an experience by transforming the outer wrapper of a subject into an inner reality through the camera's ability to isolate and alter scale, generating drama by disclosing the relationship of one object to another.

The desire to invent fresh forms that expressed the new psychological needs of the atomic era could also be seen in the work of the German group *fotoform.* Founded in 1949, members of fotoform wanted to explore photographic abstraction and to challenge the belief that photography was objective. Their effect on mainstream German photography at the time was said to have been like "an atomic bomb in the compost heap." One of the group's members, Otto Steinert (1915–1978), promoted *Subjektive Fotografie* (subjective photography), a new international movement designed to encompass "all domains of personal photography" that advanced "conscious subjectivism."

## Family of Man

Introducing this metaphorical style to the public was a curatorial challenge. When organizing *The Family of Man,* an exhibition that celebrated universal humanism at the Museum of Modern Art, Edward Steichen thought **Wynn Bullock's** (1902–1975) image, *Child in Forest* (see Figure 15.8), symbolized the mythical first woman and chose it as the show's opening piece. Steichen selected Bullock because he believed the photographer's visual language joined the natural environment with the abstract symbolism of the inner world in an accessible manner. Although the composition of Bullock's work is highly structured, the authority of his images lies in their ambiguous temperament that expresses his belief that reality is constructed through personal experience.

*The Family of Man* exhibition and book was the major American photographic event of the 1950s.[23] Organized by Steichen, the director of the Department of Photography at MoMA (1947–1962), "as a mirror of the essential oneness of mankind,"[24] it was enthusiastically received in 1955. Working on the premise that photography was a universal language, Steichen

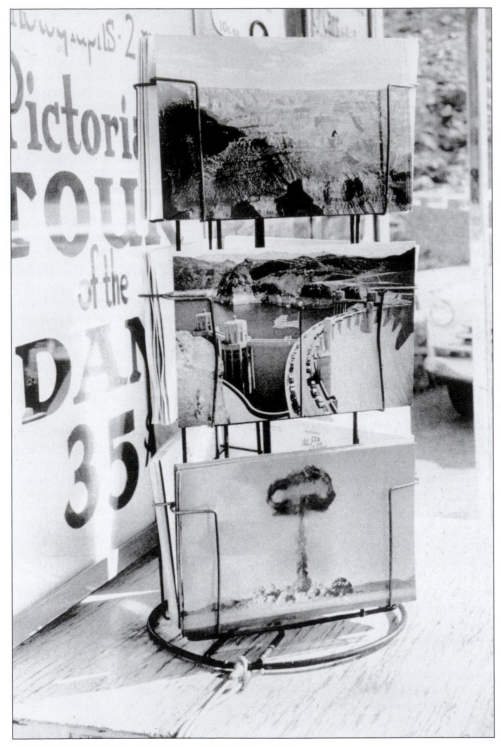

**15.9 ROBERT FRANK.** *Hoover Dam,* 1955. 18⁹⁄₁₆ × 12⁹⁄₁₆ inches. Gelatin silver print. Under a blazing Nevada sun, Robert Frank's amalgam of pictures brought together the natural, rough, wild canyons of the Colorado River, the smooth, artificial, restraining container of the Hoover Dam, and the terror of an atomic mushroom cloud, producing a 1950s allegory of the past, present, and future. Frank's vision of the atomic era can be understood in the statement: "Black and white is the vision of hope and despair. This is what I want in my photographs."[25]  © Robert Frank.

assembled 508 images, from 68 countries, by 273 photographers, into a giant three-dimensional magazine layout. To match its democratic premise that people were the same, Steichen did not treat the photographs as individual works but as pieces of a larger tapestry. Just as in magazine practice, photographers gave up control over image quality, size, placement, and context. Jacob Deschin, the photography critic for *The New York Times,* called it "essentially a pictured story to support a

concept . . . an editorial achievement [for Steichen] rather than an exhibition of photography."[26] The public, weary of the Korean War and Senator Joseph McCarthy's House Un-American Activities Committee investigations, was ready to affirm the goodness of humankind. The show traveled for years, to over thirty countries, and was seen by a reported nine million people. Despite its unquestioned commercial success, the show had little impact on furthering the thinking of American photographers because it ignored the changes and traumas that the first nuclear decade had brought about. But the silent 1950s heard no public outcry from photographers rejecting Steichen's controlled, sentimental approach. The real problem was the lack of exhibition and publication alternatives that might offer a different viewpoint. Photographers who did not share Steichen's rosy outlook and believed humanity was staring into an atomic void, who wanted to address issues that threatened their artistic and intellectual freedom, found reaching the public extremely difficult.

## Photography and Alienation

During the same year *The Family of Man* opened, **Robert Frank** (b. 1924), an émigré photographer who was included in the show, used his Guggenheim fellowship[27] to undertake what has become America's most photographically influential and mimicked cross-country road trip. Frank came from Switzerland to New York in 1947, where he met Alexey Brodovitch, a conduit of European photographers into the U.S. scene, and worked briefly as a fashion photographer for *Harper's Bazaar*. By 1953, Frank was in contact with the poet Allen Ginsberg (1926–1997) and the writer Jack Kerouac (1922–1969). Frank's intensely personal vision of the culture of the Eisenhower years was not an optimistic Steichenist celebration of togetherness; instead it reflected the alienation, loneliness, and spiritual desolation he felt while reading Jean-Paul Sartre's trilogy, *Four Roads to Freedom*.[28] By exposing some 800 rolls of 35mm film during his meandering journey that crisscrossed the United States, Frank was actively searching for a new structure with which to comprehend the nuclear world. Frank intuitively used a small 35mm Leica in available light situations as an extension of his body, disregarding the photojournalistic standards of construction and content matter. His stealthful, disjointed form, and use of the blur, grain, movement, and off-kilter compositions, became the emotional, unpicturesque, and gestural carrier of what would be the new 35mm message: the freedom to discover new content and formal methods of making photographs. Frank said: "I was very free with the camera. I didn't think of what would be the correct thing to do; I did what I felt good doing. I was like an action painter."[29]

Frank absorbed and transformed the aesthetics of abstract expressionism into his photographs, creating a constant tension within his picture frame. He applied a type of photographic description to his driving odyssey that was not interested in salable public images. These were nervous, private, unglamorous images that did not always deliver a clear, single narrative message, or give way to social or visual clichés. Frank responded to the American cultural landscape as seen from an automobile elliptically, like the existential authors and philosophers who stated that everything was tentative and relative, giving his images of the American road an unstable sense of ambivalence and ennui. It was a way out of the prewar contemplative aesthetics of his close supporter Walker Evans, providing no sense of security, no decisive moments, and no independent masterpieces. Standard practice taught photographers to discard all exposures except "The One." Frank's accomplishment was in using the succession of 35mm images to arrange sequences that have a completeness and makeup that no single image possessed.

To make *The Americans,* Frank assembled the results of his road trip into a symbolic montage in which the camera discovers its own way of telling. He photographed people in states of boredom and emptiness, while the incidental details convey themes of power, privilege, race, and religion, generating meaning by a complex layering of relationships between images. Frank avoided signs of the "good life" and newsworthy topics. He hated "Those god-damned [*Life*] stories with a beginning and an end."[30] He concentrated on marginalized groups that the media often left out: African-Americans, senior citizens, and teenagers. Frank's portrayal of businessmen, cowboys, movie stars, and politicians simultaneously invoked and critiqued familiar American myths. In *The Americans* meaning is built up from each preceding image, like a jazz piece, where even the blank soundless spaces are necessary for flow and interpretation. The visual motifs that hold *The Americans* together—automobiles, diners, flags, jukeboxes, televisions—created a new iconography for "the road." In his introduction to *The Americans,* Jack Kerouac, author of *On the Road* (1957), recognized Frank as a modern Ulysses who critically conveyed the paradoxical feelings of stimulation and isolation that accompany a voyage through popular culture:

> Anybody doesnt like these pitchers dont like potry, see? Anybody dont like potry go home see Television shots of big hatted cowboys being tolerated by kind horses . . . Robert Frank, Swiss unobtrusive, nice, with that little camera that he raises and snaps with one hand he sucked a sad poem right out of America onto film, taking rank among the tragic poets of the world [sic].[31]

Frank was unable to find a U.S. publisher and *The Americans* was first released in France in 1958. The

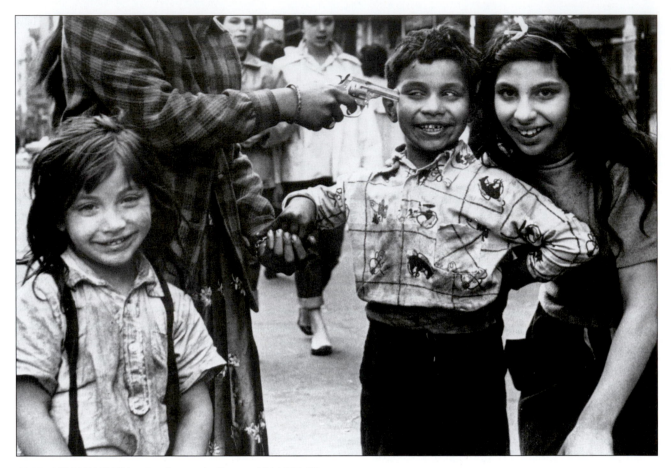

**15.10  WILLIAM KLEIN.**  *Gun 2, near the Bowery, NY,* 1955. 9³⁄₁₆ × 13⅝ inches. Gelatin silver print. Klein recalled that he was "very consciously trying to do the opposite of what Cartier-Bresson was doing. . . . I wanted to be visible in the biggest way possible. My aesthetics was the New York Daily News. I saw the book I wanted to do as a tabloid gone berserk, gross, grainy, over-inked, with a brutal layout, bull-horn headlines. This is what New York deserved and would get."³² © William Klein. Courtesy Howard Greenberg Gallery, NYC.

initial responses to the American 1959 Grove Press edition were negative. The editors of *Popular Photography* took the unusual step of collectively reviewing it. Almost without exception, they condemned Frank's approach: It showed "contempt for any standards of quality or discipline in technique." His point of view was "an attack on the United States" and "a sad poem for sick people."³³ Frank knew that because his photographs did not embrace the values of the family of man, violated the canons of documentary methods and techniques, and bypassed the country's natural beauty, technological achievements, and virtues of hard work, they would be controversial. He believed "that life for a photographer cannot be a matter of indifference and it is important to see what is invisible to others." But the criticisms of *The Americans* increased Frank's disgust with the state of professional practice. He wrote:

Photography is a solitary journey. That is the only course open to the creative photographer. There is no compromise: Only a few photographers accept this fact. That is probably the reason why we have only a few really great photographers. In recent years camera journalism has become many people's definition of good photography. For me camera journalism means taste dictated by the magazines.³⁴

By the early 1960s, Frank's talent for sequencing images led him into filmmaking, and he made *Pull My Daisy* (1959–1960), *Me and My Brother* (1965–1968), the infamous *Cocksucker Blues* (1972) (which was suppressed by Mick Jagger of the Rolling Stones), and a video, *Home Improvements* (1985). His film editing experience suggested and led to his later inclusion of words with his still pictures, which appeared in *The Lines of My Hand* (1972). Frank also experimented with mixed media—glue, tape, and nails—and still photographs to demonstrate the impossibility of "securing" a fixed meaning. Frank's most accessible and forceful still and motion picture work created a structure that portrayed its subjects without the hierarchy of a master narrative, directly from life's ordinary nonevents that nobody had bothered to depict. The disjunctions between the figures and objects express a sense of urgency about mundane things while retaining a sly sense of humor. These unidealized commonplace pleasures purposely abandon the merchandising context of commercial publishing and the constraints

of photojournalistic time. Instead, they are pictures of existential doubt that make observers examine their own values. Frank's fusion of the documentary mode with the subjective metaphor, along with his resistance to established structure, his demand for authorial control, and his willingness to learn how to present what the camera sees, are his strongest attributes.

The union of moody subjectivity and the documentary style was also being perfected by **William Klein** (b. 1928), an expatriate American fashion photographer, filmmaker, designer, and painter, who left New York to make Paris his home. While recognized in Europe, his nonfashion work was largely ignored in the United States during the 1950s because his images did not fit into the social realist working mode.[35] Klein enlarged the syntax of photography by combining the in-your-face action approach of Weegee with the sensibility of a satirical Sartre. Using a Leica with a wide-angle lens to satisfy what he called "a gluttonous rage . . . to see all the contradictions and confusion"[36] of big cities like New York, Rome, and Tokyo, Klein courted accident, blur, contrast, distortion, cockeyed framing, graininess, and movement. He encouraged chance by making long exposures in dim light and shooting without looking into the viewfinder. Klein rebelled against the 1950s notions of the decisive moment, which included not intervening into a scene, making good compositions, and producing normal looking prints. His images are not those of a detached observer but those of a provocateur. Klein referred to his *Life Is Good for You in New York—William Klein Trance Witness Revels* (1956) as "a crash course in what was not to be done in photography."[37] His dynamically unconventional framing and printing techniques, which wooed the luminous light-scattering qualities of photographic halation (or lens flare), emphasize the vaporization of preatomic values and a rising sense of anarchy, chaos, and dread that most people wished to ignore. His use of black tones challenged traditional photographic print values and accentuated the sense of the city as théâtre noir. According to Klein, "everyone I showed them to said, 'Ech! This isn't New York—too ugly, too seedy, too one-sided.' They said, 'This isn't photography. This is shit!'"[38]

The direct eye contact between subject and photographer often found in Klein's compositions clues viewers that Klein's presence has caused a response. Despite his confrontational strategy, which captures or elicits overt social hostility, Klein's attitude toward his subjects remains ambiguous. His practice of getting too close and violating the conventions of proximal space flew in the face of the modernist reliance on formal pictorial organization that deemphasized and distanced photographers from their subjects. Klein's city books, *Rome* (1958), *Moscow,* and *Tokyo* (1964), revolve around aggression. Regardless of the culture,

polite values are nonexistent. What Klein pictures is a subject's animosity toward the whole process: the camera, the photographer, and the viewer. His catalogue of irreverent "mistakes" as masterstrokes helped codify a new way of seeing. Klein's incorporation of text, billboards, and signs, along with his book's aggressive layout, assaults viewers with innovative montage that combines images and words to recreate the same sense of action that he and other filmgoers experienced in Paris's Cinemathèque.

Between 1955 and 1965, Klein worked with Alexander Liberman at *Vogue,* taking models out of the studio and into the street, pioneering a new use of space with his wide-angle and telephoto lenses. In 1958, Klein took up filmmaking. Among his works are a problematic trilogy on African-Americans: *Eldridge Cleaver, Black Panther* (1970); *Muhammad Ali: The Greatest* (1964–1974); and *The Little Richard Story* (1979). The films address the role of language: who controls it in the media and how words and images are used to formulate identity.[39] His later fashion work, *In and Out of Fashion: William Klein* (1994), reflects Klein's interest in motion and time. Some prints from this body of work appear to have been made directly from a grease-pencil-marked 35mm contact sheet.[40] Here the enlarged image contains a central frame that has been circled along with parts of the preceding and following frames. When exhibited, the images look like pieces of movie film stock and are read chronologically from left to right. Klein also presents contact sheets in his exhibitions to provide a visual record of how he sees his way through situations.

Klein's audacious framing and image cropping combined with radical darkroom techniques represent the spirit to transcend the traditions of the media that were also displayed by **Mario Giacomelli** (1925–2000). Giacomelli was a landscape painter who operated a typography shop in his agricultural village of Senigallia, Italy, before taking up poetry and then photography. The *neo-realist* films of Vittorio DeSica, Roberto Rossellini, and Luchino Visconti, frankly depicting the loss of direction facing war-ravaged Italy, made Giacomelli aware of the camera image's power. This aesthetic is characterized in Rossellini's film *Open City* (1945). Shot on newsreel stock, and made on location with available light with mainly nonprofessional actors, the film conveys a sense of authenticity and journalistic immediacy. Its structure was a series of episodic vignettes that did not idealize the characters, but showed ordinary people in heroic moments. Rossellini stated the neo-realist motto after his film opened: "This is the way things are."

Working with these values, Giacomelli dealt with his community's partnership with the land. He photographed the same piece of earth, from the same vantage point, throughout the year, usually altering the perspective by excluding the horizon line to deprive onlookers

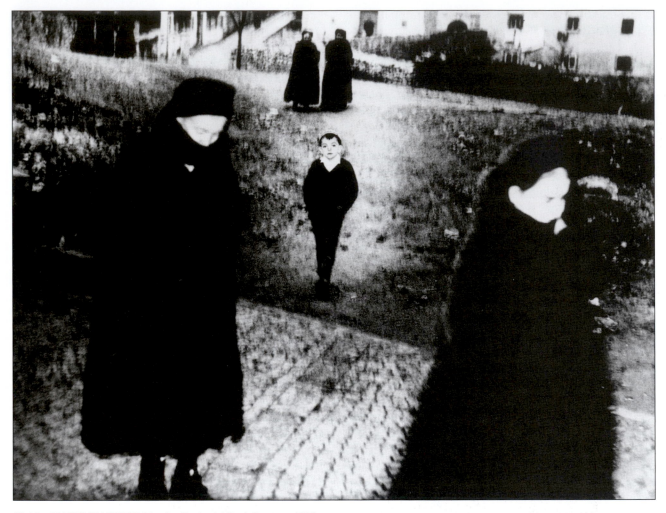

**15.11   MARIO GIACOMELLI.** *La Gente del Sud: Scanno,* 1959. 11 × 14⁷/₁₆ inches. Gelatin silver print.   Courtesy George Eastman House. © Mario Giacomelli

of any visual anchor. Giacomelli foreshortened space by stacking up forms as if they were on a vertical plane. In 1956, Giacomelli wrote:

> I have taken from the conscience of nature; the work of man, the marks, the ground, and here the chance instants of recording before the losses are gone for the relative duration of time.[41]

That same year Giacomelli embarked on a long-term project based on the title of a poem, "Death will come and it will have your eyes," about old age. The series has been called bleak and pessimistic, but it accurately conveys the passionate sense of enclosing darkness that his elderly subjects were experiencing. He distorted some of his prints by letting one corner of the paper curl up and float while it was being exposed under the enlarger. This project was followed by others on butchered animals, gypsies, and war victims at Lourdes. Giacomelli's dynamic urgency and lack of concern for proper use of materials found a following in the United States during the 1960s and can also be seen in the work of Robert

Frank and Josef Koudelka (b. 1938), whose deep, dark print tones portray the mental and physical conundrums and world-weariness of being a refugee.

By 1960, Giacomelli's response to his sense that humans had overrun nature was to cut patterns into the landscape with a tractor. In 1970, he was photographing the plowed fields from the air. The sensation of violent upheaval can be seen in the physical appearance of Giacomelli's work. People were agitated by his high-contrast prints, which often had only three tones, a departure from the fine-print aesthetic. Giacomelli did not see a negative as a fixed, sacred entity but as a flexible starting place for inner expression. He executed darkroom techniques to intensify and/or eliminate information. Not content to stick with what the camera delivered, Giacomelli was determined to shape the medium to his vision.

## Making a Big Jump

The ideas of Moholy-Nagy and the images of Francis Bruguière, Lotte Jacobi, and Frederick Sommer opened the doors of subjective realities to the abstract experiments of **Henry Holmes Smith** (1909–1986) of the

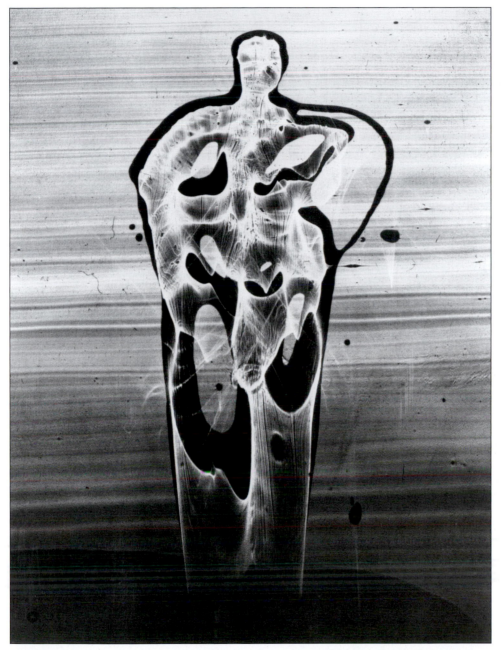

15.12  HENRY HOLMES SMITH.  *Giant,* 1949. 11⅞ ×
9¹⁄₁₆ inches. Gelatin silver print.    Courtesy Smith Family Trust.

late 1940s.[42] Smith supported the metaphorical mode
while working to establish art photography in academia
using a scientific model, and in "XI Zero in Photogra-
phy" (the title refers to the name of an atomic particle)
wrote that photographers should follow the example of
nuclear physicists and create their own community to
control photographic discourse without concern for pop-
ular opinion. His semiscientific position is indicative of
the confusion during the early atomic era, when science
appeared to have flattened all natural avenues for con-
necting with life forces. Not interested in pursuing the
seen world of facts but in searching for ways to visualize

myth, Smith was absorbed in how light formed images.
He wrote: "Photographers know something special about
light: the photographic mark of light is dark, the brightest
light makes the blackest mark."[43] Smith demonstrated his
ideas using Karo corn syrup in place of a lens. "As the
syrup runs down the sheet of glass it causes light falling
on it to refract making marks that celebrate light itself."[44]
Behind the glass, a sheet of enlarging paper was exposed
to the light from a 50-year-old, 100-watt theater spotlight
with a clear lens, set up fifteen to twenty feet away and
controlled with a foot switch. "The shapes . . . tell me
things. . . how a child might imagine a giant in a horrid
ancient tale, the mystery of all that I shall never see and
the wonder of a good many things I shall never under-
stand. There may be more than I know in the pictures and
I am content to know that."[45]

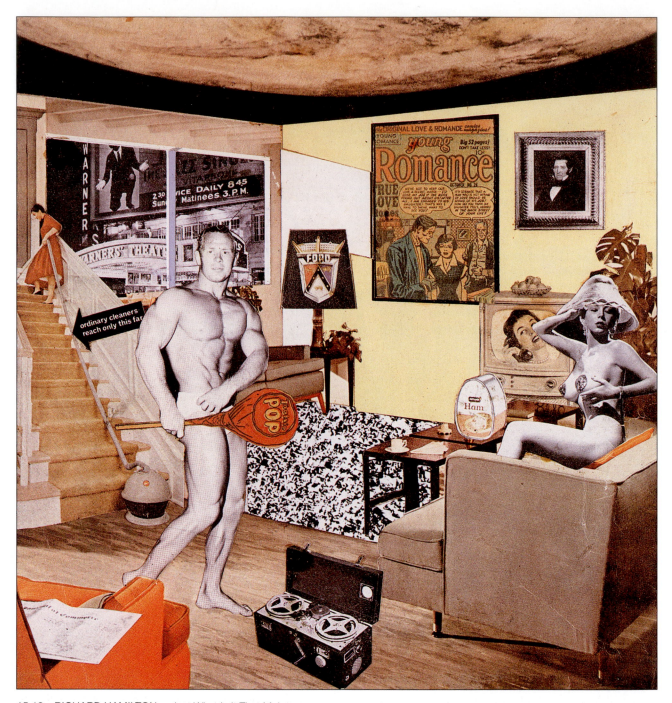

**15.13   RICHARD HAMILTON.** *Just What Is It That Makes Today's Homes So Different, So Appealing?* 1956. 10¼ × 9¾ inches. Collage.   © Kunsthalle, Tübingen, Germany.

This process of combining cliché-verre with the photogram used drawing and painting methods to create symbolic images that Smith claimed allowed "intangible characters from the ancient mythological world" to appear (see Figure 15.12). The technique was an "automatic" photographic process of poetic picturemaking similar to the gestural methods of abstract expressionists. Smith's color experiments, begun in 1936, followed a similar course of not being limited by the rules of color representation that relied on filters or colored lights to achieve their color balances. Smith dismissed the relationship of the subject's color to his results by picking monochromatic subjects and introducing color through a color printing process.[46] Such experiments in printmaking methods set the stage to the investigation of alternatives to straight photography that would characterize the 1960s. At the invitation of Moholy-Nagy, Smith taught at the New Bauhaus for the year of its existence, 1937–1938. Between 1947 and 1977, Smith taught at Indiana University, where he developed one of the first college-level courses in the history of photography.

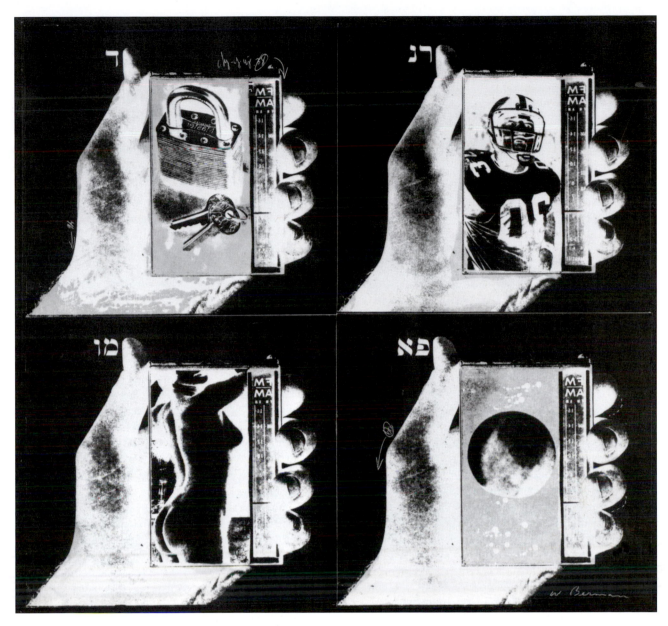

15.14  WALLACE BERMAN.  *Untitled.* 12³⁄₁₆ × 13⅛ inches.
Verifax matrix prints.    Courtesy Wallace Berman Estate.

A hallmark of the atomic age was the knowledge that science could change things irrevocably in a flash. Edwin H. Land's (1909–1991) Polaroid process satisfied the desire to make one's own images in a moment. Land got the idea while taking snapshots of his daughter, who wanted to know why she could not see the pictures instantly. The result was the 1948 Christmastime introduction of a self-contained camera system that delivered a browntone print in one minute. This led to the development of a range of Polaroid products, including color film, that were routinely used by amateurs and professionals. Polaroid encouraged artistic exploration of these unique images by employing Ansel Adams as a consultant from 1948 until his death in 1984. The company also had a unique policy of collecting images for exhibition and publication by artists working with Polaroid materials.[47] Land refined and speeded up Eastman's underlying concept that one did not have to be a photographer to make photographs. Polaroid products and the Kodak Instamatic camera (1963) continued to democratize the practice, encouraging people who knew nothing about photography to become their own photomakers. Digital imagemaking increasingly made Polaroid products outmoded, to the point that the company announced it would cease film production in 2008.

The smashing of atoms to produce nuclear fission produced transformations in other aspects of society that had been taken for granted. The phenomenon of a camera-free photographer taking preexisting photo-based images, removing them from their original circumstances, and through juxtaposition giving them new meaning, is indicative of how picturemaking criteria

were changing in the nuclear age. **Richard Hamilton's** (b. 1922) collage, *Just What Is It That Makes Today's Homes So Different, So Appealing?*, in which the word "Pop" makes its artistic debut, contains the key visual ingredients of *pop art*. Writing about what he called a "landscape of secondary, filtered material," Hamilton stated that "Pop should be: Popular (designed for a mass audience), Transient (short-term solution), Expendable (easily forgotten), Low-cost, Mass-produced, Young (aimed at youth), Witty, Sexy, Gimmicky, Glamorous, Big Business. . . ."[48] In an era when television and radio were replacing books and painting as the social carriers of culture, Lawrence Alloway, the English critic who in 1958 coined the term "pop art," had this to say:

> Mass production techniques, applied to accurately repeatable words, pictures, and music, have resulted in an expendable multitude of signs and symbols. To approach this exploding field with Renaissance-based ideas of the uniqueness of art is crippling. Acceptance of the mass media entails a shift in our notion of what culture is. Instead of reserving the word for the highest artifacts and the noblest thoughts of history's top ten, it needs to be used more widely as a description of "what society does."[49]

Under an ironic guise, pop art took hold in America, celebrating the postwar-nuclear era—mass consumer theater of desire and illusion, while rejecting the heroic personal, spiritual stance and psychological content of the abstract expressionists. It provided the foundation for the silk-screened celebrities of Andy Warhol, the comic strip look of Roy Lichtenstein's (1923–1997) paintings, and the transformation of commonplace objects into monumental sculpture by Claes Oldenburg (b. 1929). This technically-rooted work asserted that American culture was about the multiple—the assembly line that made identical products that everyone could buy.

As the nuclear age challenged the belief in nature as the source of creation, artists turned to the inventive possibilities of the machine for inspiration. In 1957, California assemblage artist **Wallace Berman** (1926–1976) made collages with a new technology—the Verifax machine.[50] Using a constant motif, such as a hand holding a transistor radio, he replaced the radio with commonplace images, like a football player or a Master lock, to form a repeating cinematic structure. Hebrew letters were featured in many images as Berman strived to incorporate sociological and spiritual meaning through the mysticism of the Cabala.[51] He often turned the process itself around by using the negative matrices as the images (see Figure 15.14). This reversal simplifies a subject and heightens the emblematic power of an image by removing it from the documentary arena. These dark, gritty, and streaked prints were generally presented in a grid series, suggesting a cosmic oracle or force (atomic) that transforms energy into visible symbols.

Berman is characteristic of those nonphotographers, knowing nothing of photographic convention, who burst onto the scene in the 1960s. These artists used copying machines, not to duplicate text-based documents but to record a new set of materialistic values drawn from popular mass-media sources, to make new works. These isolated experiments, made during an era that would only accept the "straight" documentary approach, displayed the ease by which any image could be appropriated and made a part of another work. One now had a quick method of being a cameraless photographer, making compositions of the pyramids on a copy-machine glass instead of on a camera's ground glass and using the newfound technology to push a button and instantaneously print the results.

## The Subjective Documentary

During the early years of the atomic age, most Americans did not see new photography through the work of cloistered artists but experienced it through a humanistic reporting style brought over by exiled European practitioners. This subjective-documentary approach gained popularity in the late 1940s and was typified in the lyrical photography of Marc Riboud (b. 1923) and the sympathetic authenticity of Robert Doisneau (1912–1994). The popularity of Doisneau's bistro and street scenes hinged on nostalgia, presenting a disappearing lifestyle that appealed to an American idea of old Europe and was a respite from nuclear angst. Doisneau's image, *Le Baiser de l'Hotel de Ville,* 1950, aka *The Kiss,* became a poster icon of street photography and young love. The photograph appears to have "caught" a woman and a man spontaneously kissing in front of an outdoor café on a busy Parisian street. The man's right hand on the woman's right shoulder draws her to his lips and they kiss, all in perfect view of the camera. Shortly before Doisneau's death a French couple, claiming to be the kissers, who unsuccessfully sued for royalties, raised troubling questions surrounding this image. Doisneau's lawyers disproved their claim by producing contact sheets of the couple in the photograph in locations around Paris and contracts showing that they had been hired for a project commissioned by *Life*. The text accompanying the original piece in *Life* said the photographs were "unposed," a claim Doisneau never denied. In an interview Doisneau stated: "Photography is not a document on which a report can be made. It is a 'subjective' document. Photography is a false witness, a lie. People want to prove the universe is there. It is a physical image that contains a certain amount of documentation, which is fine, but it isn't evidence, a testimony upon which a general philosophy can be based."[52]

These revelations broke an unspoken contract governing what viewers call reality. The strength and weakness of documentary photography is based on the collective trust between the photographer and the viewer. By accepting Doisneau's "unposed" picture his audience agreed to believe they were witnessing a

scene from "real" life. Instead they were taken in by a docudrama.

Doisneau's work is emblematic of the changing ground rules of the 1950s that revealed the contradictions and incongruities in prenuclear assumptions. Relativism, what conservatives would call the great disease of modernity, reshaped relationships. Agreements between photographers and viewers were called off as the age of viewing innocence ended. The concept of a photograph as a nonfictional transcription of reality had to be rethought and seen instead as constructed fiction. A new public viewing motto could have been: "Seeing is not believing." During a time when artists were questioning the idea of proof and reality, people still wanted pictures that confirmed their ideas about the universe, widening the gap between public expectation and how artists were now presenting the world. The process of renegotiating what constituted reality in the atomic age was underway.

The atomic age broke the stranglehold of the "big" picture magazines. Readership diminished as a generation brought up on the immediacy of television and airplane travel found the photo essay an inadequate and worn-out experience. This loss of purpose and vitality plus rising production costs led to the folding of *Collier's* in 1957, followed by *Coronet* in 1961, *The American Weekly* in 1963, *Look* in 1971, and *Life* in 1972.[53]

A transition in viewing habits began as a small audience developed an interest in photographer-artists. In New York, Helen Gee (1915–2004) opened Limelight, a gallery devoted to photography that was supported by profits from its coffeehouse. Between 1954 and 1961, Limelight presented 61 exhibitions, including the work of Robert Frank and Lisette Model.[54] Coffeehouses became sites for Beat poets, folk singers, jazz musicians, and the counterculture of social protest. Allen Ginsberg's "hydrogen jukebox" attack on American values, *Howl* (1956) expressed the sentiments of the era: "I saw the best minds of my generation, destroyed by madness starving, mystical, naked, who dragged themselves thru the angry streets at dawn looking for a negro fix . . ." His poem stirred up so much anger that it was seized.[55] During the same year, African-American photographer Roy DeCarava opened A Photographer's Gallery (1955–1957) in New York, where artists like Harry Callahan and Minor White could be seen by appointment.[56] However, aside from small irregularly operating galleries, MoMA was the only regular source of photography exhibitions in New York.

The atomic era fissures open in the area of race relations in America. In 1947 Jackie Robinson (1919–1972) became the first black man to play modern major league baseball, part of a larger trend that would eventually lead the Supreme Court to strike down "Jim Crow" segregation laws that controlled how and where blacks could interact with white society.[57] The desire to show these changing parameters of the atomic world can be seen in the work of Roy DeCarava (b. 1919), for which he became the first African-American to receive a Guggenheim fellowship. DeCarava's work expressed a fundamental paradox that African-Americans faced in the materialistically expanding nuclear culture of the 1950s; being surrounded by white dreams that blacks were often denied the means to attain. DeCarava came into the public eye for collaborating on a book about life in Harlem, *The Sweet Flypaper of Life* (1955), with writer Langston Hughes. His moody prints, often dark and with a glowing area of light, whether of jazz musicians or urban street life, show the competing dynamism of darkness and light. His wife, art historian Sherry Turner DeCarava, wrote:

> Such forces in DeCarava's pictures are both visible and invisible; they may manifest themselves as a psychological valent of terror or fear, as a social valent of abandonment or as a human form. Yet there is no "nature morte" in the images. The pictures display an atomic life-energy as both positive and negative elements occur in relation to each other; an interpenetration and exchange of vital forces occurs on all levels. In the midst of these illusions, however, the photographs express not struggle but a sense of stillness.[58]

While African-American life and culture are central to DeCarava, his most resolute work transcends the literalness of situations and penetrates their binary meaning. In *Hallway New York* (1953), a claustrophobic tenement hallway, illuminated by a dim overhead light, whose walls seem almost a mirror reflection of each other, propel the viewer to a barely visible doorway.[59] DeCarava's psychological involvement, traveling down the hallway of the present to the door (escape) of the future, transforms the subject into a metaphor. Although DeCarava emphatically states that his "work is about beauty and caring,"[60] this interaction of reality and illusion and its accompanying contradictions provides context, tension, and shared ground for meaning within a moment of stillness, revealing that racism has excluded the majority of African-Americans from the post-nuclear boom. This adoption of an autobiographical approach, the incorporating of oneself into the visual structure, widely filtered into the practice of the 1960s. As the demand for photographic education increased, DeCarava ran the Kamoinge Workshop for young black photographers (1963–1966) and later taught at New York's Hunter College.

Running on a parallel track of opposite aesthetics was **Eliot Porter** (1901–1990), a Harvard Medical School graduate, teacher and researcher in bacteriology and biochemistry, and amateur photographer, who was profoundly impressed by Ansel Adams's work. After Stieglitz showed Porter's images at An American Place in 1938–1939, Porter devoted himself to photography, developing new methods for photographing wild animals, birds, and insects by using telephoto lenses, flash,

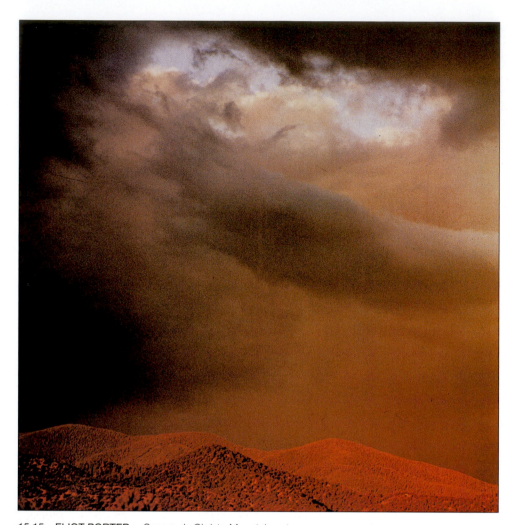

**15.15  ELIOT PORTER.** *Sangre de Christo Mountains at Sunset, Tesuque, New Mexico,* July 1958. 8⅝ × 8⁷⁄₁₆ inches. Dye imbibition print (Kodak dye transfer). Porter believed that "to put the world, and yourself at the same time, in a valid perspective you must remove yourself from the demands of both. The world's demands fade the faster, but nonetheless surely your own will shrink to acceptable proportions and cannot sally forth to attack you. In the wilderness of Glen Canyon you do not assail yourself. You glide on into the day unpursued, living, as all good river travelers should, in the present."[61]  © 1990 Amon Carter Museum, Fort Worth, Texas, Gift of the artist, 1989.19.104.

and special shutters. To Porter, nature was "an undiluted source of pleasure and a reservoir of mysteries" about life, and he wanted to use science to understand and protect it. In 1940, Porter started making his *dye transfer process* prints in order to achieve more accurate and permanent colors. The dye transfer process was a subtractive *imbibition* assembly method that relied on the selective absorption of dyes for making color prints from color negatives or positives. Gelatin relief matrices were produced from three separation negatives made through red, green, and blue filters, soaked in yellow, magenta, and cyan dyes, and transferred in register to a support (paper). The system can be traced back to 1875 and remained commercially accessible until Kodak discontinued it in 1993. The process was complex and demanding, but offered incredible latitude in manipulating a print and was much more stable than a chromogenic color print of that era.

Porter became well-known through his publications, such as *The Place No One Knew: Glen Canyon on the Colorado* (1963), showing what was lost when the damming of the Colorado River for the generation of electricity meant flooding Glen Canyon to create Lake Powell. This was a belated lesson for the Sierra Club as it discovered the effectiveness of harnessing *beauty,* that which makes the content of art powerful to the beholder,[62] to promote environmental causes. Porter's "beautiful" color images helped awaken consciousness about ecological issues and the dangers of uncontrolled technology. They assisted the newly forming environmental movement by getting people to join the Sierra Club and had the added benefit of helping color photography gain entry into the art world. In the foreword of *The Place No One Knew,* editor David Brower asked:

But where will the chance to know wildness be a generation from now? How much of the magic of this, the American earth, will have been dozed and paved into oblivion by the great feats of engineering that seem to come so much more readily to hand than the knack of saving something for what it is? . . . Again and again the challenge to explore has been met, handled, and relished by one generation—and precluded to any other.[63]

But as much as artists like Porter and Paul Caponigro (b. 1932), a student of Minor White, continued to celebrate Thoreau's "tonic of wildness," the world was pushing the limits of nature. Some of Caponigro's early east coast work incorporated urban distress, but his move to the southwest, allowing him to stay within his internal universe, typified the division in photographic practice between these two philosophies. Most of Caponigro's high modernist work deals with uniting people's relationship to nature, revealing "the landscape behind the landscape."[64] But there was a division forming between the artists born in pre-atomic and post-atomic times, as it became harder to believe in past truths in the face of the atomic reality. Those capable of maintaining a pre-atomic outlook kept their faith in the mysteries of nature; those who dissented against the scientific atomic outlook became existentialists.

## The Terror of Riches

The automobile, as Robert Frank had observed, symbolized a machine of personal power. The American love affair with the automobile was demonstrated by President Eisenhower's Federal-Aid Highway Act of 1956, authorizing the construction of over 40,000 miles of interstate superhighways without much thought to carnage, congestion, destruction of core city neighborhoods, suburban sprawl, or petroleum dependence. The 1950s saw the American family's disposable income rise by 49 percent. A baby boom began in the United States after World War II; more babies were born between 1948 and 1953 than in all the previous thirty years. But what was the price of this new affluence? Between 1940 and 1964, the number of psychiatrists increased almost sixfold. Americans believed they needed the Bomb to protect their newfound material wealth, and test bombs were regularly set off. H-bomb tests annihilated atolls in the South Pacific; A-bombs charred the Nevada desert. Cold War East–West relations deteriorated with the Soviet downing of an American U-2 spy plane in 1960. The politics of brinkmanship was brought to a climax by President John F. Kennedy (1917–1963) and Soviet Premier Nikita Khrushchev (1894–1971) during the 1962 Cuban missile crisis that took the world to the edge of nuclear destruction.[65] Beneath the material riches lay terror. Social activist/critic Todd Gitlin wrote:

We grew up taking cover in school drills—the first American generation compelled from infancy to fear not only war but the end of days. Every so often, out of the blue, a teacher would pause in the middle of class and call out, "Take cover!". . . . Under the desks and crouched in the hallways, terrors were ignited, existentialists were made. . . . Several observers have reported what my own impressions and interviews confirm: Children who grew up in the Fifties often dreamed, vividly, terrifyingly, about nuclear war.[66]

While middle-class Americans indulged in the contradictory aspirations of creativity and security, painting pictures by numbers with John Negy on TV, a fringe subculture of alienated antiheroes began to rebel against what J. D. Salinger's Holden Caulfield called "phoniness" in *Catcher in the Rye* (1951). For this affluent and educated minority, who felt caught in a restrictive world, science had failed. The reliance and expense of the Bomb meant there was no future as resources for cities, infrastructure, and schools were drained on a secretive natural-security state.[67] "Alternative" directions and solutions were necessary if humankind was to continue to evolve.

## Endnotes

1   See Richard Rhodes, *Dark Sun: The Making of the Hydrogen Bomb* (New York: Simon & Schuster, 1995), 203–5.

2   Newhall rewrote the catalogue as a book in 1949. Its narrative strategy was planned with the assistance of a storyteller, Hollywood scriptwriter and novelist Ferdinand Reyher. See Paul Hill and Thomas Cooper, *Dialogue with Photography* (New York: Farrar, Straus, and Giroux, 1979), 407–8.

3   Nancy Newhall was a writer and worked with Ansel Adams on eight books, including *This Is the American Earth* (1960) and her biography of Adams, *The Eloquent Light,* 1963. While Beaumont was in the military service she was acting photography curator at MoMA. She wrote the poetic text for Paul Strand's *Time in New England* (1950), edited *The Daybooks of Edward Weston* (1957 and 1961), and authored *P. H. Emerson: The Fight for Photography as a Fine Art* (1975).

4   *Clarence John Laughlin* in Jonathan Williams, Introduction, *Clarence John Laughlin: The Personal Eye* (Millerton: Aperture, 1973), 13.

5   See Rhodes, 175.

6   Frederick Sommer, "Extemporaneous Talk," *Aperture* (1971), unp., cited in Leland Rice, "Introduction," in *Frederick Sommer at Seventy-Five: A Retrospective* (Long Beach: The Art Museum and Galleries, California State University, 1980), 13.

7   "Art and the Subconscious: The Multi-Negative Photography of Vladimir Telberg-von-Teleheim," *American Artist,* vol. 13, no. 1 (January 1949), 60.

8   "Composite Photography by Val Telberg," *American Artist,* vol. 18, no. 2 (February 1954), 47.

9   Clarence John Laughlin, "Beyond Documentation and Purism," text accompanying slide set distributed by Light Impressions, Rochester, NY, "Clarence John Laughlin," produced by Focal Point Press, 1977, 1.

10   Wall label from *Sequence 13—Return to the Bud,* curated by Walter Chappell during the spring of 1959 at George Eastman House, Minor White Archive, George Eastman House, Rochester, NY.

11   Clarence John Laughlin, *Lost Louisiana: An Essay in the Poetry of Remembrance,* unpublished manuscript, begun ca. 1973, 27. Manuscripts Division, The Historic New Orleans Collection. Quoted in Nancy C. Barrett, "Brick and Wood and Spirit: The Architectural Photographs of Clarence John Laughlin," in Keith F. Davis, *Clarence John Laughlin: Visionary Photographer* (Kansas City: Hallmark Cards, Inc., 1990), 36.

12   Laughlin in Williams, Introduction, 12.

13   Sommer, 13.

14   Minor White, *Mirrors, Messages, Manifestations* (Millerton, NY: Aperture, 1969), 186.

15   Minor White, "Equivalence: The Perennial Trend," [1963], *Photographers on Photography,* Nathan Lyons, ed. (Englewood Cliffs, NJ: Prentice Hall, Inc., 1966), 173.

16   Minor White, "Extended Perception through Photography and Suggestion," *Ways of Growth,* Herbert Otto and John Mann, eds. (New York: Grossman, 1968), 35.

17   Minor White, "The Camera Mind and Eye," (1952) *Photographers on Photography,* 166.

18   Interview with Wynn Bullock, in Paul Hill and Thomas Cooper, *Dialogue with Photography,* 331.

19   Harry Callahan, "An Adventure in Photography," *Minicam Photography,* vol. 9, no. 6, 28–29. Reprinted in *Photographers on Photography,* Nathan Lyons, ed., (Englewood Cliffs, NJ: Prentice Hall, Inc., 1966), 40–41.

20   From a taped conversation between Callahan and John Szarkowski (April 1975, Providence). Tapes are in MoMA's Department of Photography. Cited in John Szarkowski, *Callahan* (Millerton: Aperture, 1976). 16–17.

21   Letter from Harry Callahan to Ann Armstrong (February 19, 1947). Files of the Department of Photography, MoMA. Cited in ibid., 17.

22   Harry Callahan, statement on *Photographs: Harry Callahan* (Santa Barbara: El Mochuelo Gallery, 1964).

23   *The Family of Man* created by Edward Steichen, prologue by Carl Sandburg (New York, The Museum of Modern Art, 1955). Steichen claimed that he, Wayne Miller (photographer), and Paul Rudolph (architect) looked at more than two million images before designing the exhibition.

24   Ibid. Edward Steichen, introduction, 4.

25   Robert Frank quoted in Sarah Greenough, Philip Brookman, et al., *Robert Frank: Moving Out* (Washington, D.C.: National Gallery of Art, 1994), 54.

26   Jacob Deschin, "Panoramic Show at The Museum of Modern Art," *The New York Times,* January 30, 1955. Cited in John Szarkowski, *Mirrors and Windows: American Photography since 1960* (New York: The Museum of Modern Art, 1978), 16.

27   Steichen, along with Walker Evans, Alexey Brodovitch, Alexander Liberman of Condé Nast, and art historian, Meyer Shapiro: all were listed on his application as supporting his project.

28   Jean-Paul Sartre, *The Age of Reason* (1945), *The Reprieve* (1945), and *Troubled Sleep* (1949). Frank said: "I read all the early books by Sartre, the

*Roads to Freedom* novels. It helped me, it strengthened my determination." In William S. Johnson, "The Pictures Are a Necessity: Robert Frank in Rochester, NY, November 1988," *Rochester Film & Photo Consortium Occasional Papers, No. 2,* January 1989 (Rochester, NY: George Eastman House), 27.

29   Ibid., 30.

30   Janis and MacNeil, 56.

31   Jack Kerouac, "Introduction," *The Americans: Photographs by Robert Frank* (New York: Grove Press, 1959), unp.

32   William Klein, in Jane Livingston, *The New York School Photographs 1936–1963* (New York: Stewart, Tabori & Chang, 1992), 314.

33   "An Off-Beat View of the U.S.A.," *Popular Photography,* vol. 46, no. 5 (May 1960), 104–6.

34   *Du,* vol. 22, no. 1 (January 1962), unp.

35   A jury at *photokina 1963,* an international photographic exhibition and trade fair held about every two years in Cologne, Germany, voted Klein one of the 30 most important photographers in the medium's history, yet he was not even listed in the index of Newhall's final edition of *The History of Photography.*

36   Klein, in Livingston, *The New York School,* 314.

37   Cited in Jerry Mason, ed., *The International Center of Photography Encyclopedia of Photography* (New York: Crown Publishers, 1984), 282.

38   Cited by Jonathan Green, *American Photography: A Critical History 1945 to the Present* (New York: Harry Abrams Publishers, 1984), 216.

39   For more information on these and other Klein films, see Katherine Dieckmann, "Raging Bill," *Art in America* (December 1990), 71, 73, 75, 77, 79.

40   See William Klein, *In and Out of Fashion: William Klein* (New York: Random House, 1994).

41   Cited by Stephen Brigidi and Claire V. C. Peeps, Introduction, "Mario Giacomelli," *Untitled 32* (Carmel, CA: The Friends of Photography, 1983), 9.

42   See Henry Holmes Smith interview in Hill & Cooper, *Dialogue with Photography,* 132–59.

43   Henry Holmes Smith, *Portfolio #2, Henry Holmes Smith* (Louisville, KY: Center for Photographic Studies, 1972), unp.

44   Ibid.

45   Ibid.

46   See Henry Holmes Smith interview in John Bloom, *Photography At Bay,* 207–8.

47   For additional information about how artists use Polaroid materials see Robert Hirsch, *Exploring Color Photography,* 3rd ed. (New York, McGraw-Hill, 1997).

48   Richard Hamilton, 1957, cited Robert Hughes, *The Shock of the New* (New York: Alfred A. Knopf, 1981), 344.

49   Cited ibid., 342.

50   Verifax was a wet-print process developed at Kodak during the 1940s. A disposable paper negative formed a matrix from which a print was made on a specially treated paper. See Marilyn McCray, *Electroworks* (Rochester: George Eastman House, 1979), for information about these machine processes.

51   Cabala is based on the belief that every accent, letter, number, and word of the Scriptures contains mysteries. Cabalistic signs and writing are used as amulets and in magical practice.

52   Robert Doisneau in Hill & Cooper, *Dialogue with Photography,* 108. Also note that *The Kiss* does not appear in this book because the Doisneau estate, concerned that this image was being overexposed, raised its reproduction fee well beyond the means of this project.

53   *Life* appeared as a weekly until 1972, then as an intermittent "special" until 1978; a monthly from 1978 to 2000; and a weekly newspaper supplement from 2004 to 2007 before ceasing once again with the issue dated April 20, 2007. It continues as a brand name on the Internet.

54   See Helen Gee, *Limelight: A Greenwich Village Photography Gallery and Coffeehouse in the Fifties* (Albuquerque: University of New Mexico Press, 1997).

55   In 1956, poet/publisher Lawrence Ferlinghetti's City Lights Bookstore in San Francisco was raided and Allen Ginsberg's *Howl* was seized and declared obscene. A trial exonerated *Howl* and its accompanying publicity gave the Beat writers national attention, resulting in the publication of Jack Kerouac's *On the Road.* For details, see Barry Miles, *Ginsberg: A Biography* (New York: Simon & Schuster, 1989).

56   See Peter Galassi, *Roy DeCarava: A Retrospective* (New York: The Museum of Modern Art, 1996), 22–23, 269–70.

57   In *Brown v. Board of Education of Topeka, Kansas* (1954) Chief Justice Earl Warren moved to protect the rights of minorities by outlawing public school segregation.

58   Sherry Turner DeCarava, Introduction, *Roy DeCarava: Photographs,* James Alinder, ed., *Untitled 27* (Carmel: The Friends of Photography, 1981), 7.

59   In a telephone conversation with the author on March 4, 1999, DeCarava denied permission to reproduce this work. He stated: "I want to control the context of my work. . . . I keep it from getting abused."

60   Ibid.

61   Eliot Porter, *The Place No One Knew: Glen Canyon on the Colorado,* abridged, David Brower (ed.) (San Francisco: Sierra Club and New York: Ballantine Books, 1968), 14.

62   See Dave Hickey, *The Invisible Dragon: Four Essays on Beauty* (Los Angeles: Art Issues Press, 1993).

63   Porter, 8.

64   Paul Caponigro, *Landscape* (New York: McGraw-Hill, 1975), unp.

65   Time has given Nikita Khrushchev's famous provocation to the West, "We will bury you," a previously unimaginable twist to history as his son and cold war scholar, Sergei N. Khrushchev, became a United States citizen in 1999.

66   Todd Gitlin, *The Sixties: Years of Hope, Days of Rage* (New York: Bantam Doubleday Dell Publishing, 1987), 22–23.

67   Richard Rhodes, *Arsenals of Folly: The Making of the Nuclear Arms Race* (New York: Knopf, 2007).

# New Frontiers

*Expanding Boundaries*

## Structuralism: Reading a Photograph

The 1960s was a decade of cultural, economic, and political upheaval that challenged American societal values. At age 43, John F. Kennedy was the youngest president ever, and he invited artists and poets to White House events. After Eisenhower, Kennedy brought a new sense of vitality to the nation as he declared a "New Frontier" of social reform that included aid to education, medical care for the aged, the extension of civil rights, the formation of the Peace Corps, and a physical fitness program. This progressive social agenda was juxtaposed with an aggressive foreign policy that included the abortive Bay of Pigs invasion of Cuba in 1961, the Cuban Missile Crisis of 1962 that brought the United States and the former Soviet Union to the brink of nuclear war, and an increased number of U.S. military advisors in South Vietnam. When astronaut Neil Armstrong walked on the moon (1969), there were those who claimed that the entire event was staged by NASA in a secret airplane hangar in Houston. The bottom line was: Surface appearances could not be trusted.

In the arts people were discarding the idea that photographs were direct pictures of the world and replacing it with the concept that photography had its own morphology that

intervened between reality and the viewer. In the 1950s, French semiotician and structuralist (see Structuralism below) Roland Barthes (1915–1980) decoded the formal relations of signs to one another (syntax) and the symbolic logic of photography for the purpose of cultural analysis. Based on the work of American philosopher Charles Sanders Peirce (1839–1914) and Swiss linguist Ferdinand de Saussure (1857–1913), semiotics is the study of how meaning is constructed and understood. Semioticians maintain that the relation of words to things is not natural but assigned by society, and language is basically a self-contained system of signs made up of two components, the "signifier" and the "signified." The signifier is the word itself that people use to define the material world around them. The signified represents the mental associations we have with that word, which may or may not be conscious and which are affected by our culture. Semioticians analyze these mental associations to understand how a society creates meaning and to find hidden meaning(s). Semioticians do not limit their practice to language and stress that any aspect of a culture, such as a photograph, can communicate meaning and thus function and be analyzed as a sign. Semiotics has provided the historical foundation for modern structuralism.

Barthes wrote "photography crushes all other images by its tyranny."[1] In the United States, he wrote, "everything is transformed into images: Only images exist and are produced and consumed . . . and [this] de-realizes the human world of conflicts and desires under cover of illustrating it."[2] This was a revelation compared to Vance Packard's *Hidden Persuaders* (1957), an exposé about concealed advertising practices, which never discussed the persuasive role of photography in a consumer society. Surveying the scene, Henry Holmes Smith wrote: "Before I can make any estimate of photography's present state and future prospects, I need to know what a photograph should look like and I am not at all certain that I do."[3] What had been sanctioned was now under scrutiny. Against a Stieglitzian framework of straight photographers canonized by Newhall in his *The History of Photography,* debate opened over craftsmanship (the fine-print aesthetic and proper use of materials), formal concerns (compositional construction), social duty (the depiction of beautiful and spiritually ennobling subjects), and just what a photograph could mean. Was a photograph a witness to history or an equivalent to inner vision? Was its meaning determined by its maker, or by an editor, or was it free floating? And lastly, could two individuals read the same photograph and ascribe different meanings to it based on their own life experiences?

The notion that one could read a photograph was given currency by Henry Holmes Smith and Robert Forth and endorsed by Minor White. Its foundations can be traced to Ferdinand de Saussure, who estab-lished a structural study of language that emphasized the arbitrary relationship of the linguistic sign or code to what it signifies and how meaning is determined. In academia *Structuralism* explores the relationships between language, literature, and images on which linguistic, mental, and cultural "structural networks" are fabricated. Structuralists contend such networks are what produce meaning within a particular person, organization, or culture that in turn frames and motivates the actions of individuals and groups. It analyzes society by looking at such cultural phenomena as signs that have hidden underlying meaning(s) that can be decoded. These signs can be compared to the basic grammatical components of language that together create linguistic meaning, or the essential elements of myths that reveal how a society creates a framework for understanding the world. Structuralism states that no single element has meaning in itself but must be understood as an integrated part of a society's fundamental organization. Structuralists think that meaning is derived by seeing how one sign relates to another. For structuralists, photographs do not exist in isolation but are a part of a complex cultural structure of signs, filled with hidden messages, which must be analyzed for their meaning based on the experiences of the photographer and the viewer. Structural theory gave hope for understanding a seemingly chaotic atomic world that saw Newton's unified mechanical universe crumble into the physics of Einstein's invisible particles. Coupled with existentialism, Structuralism offered tactics for refitting the pieces of the world and making it whole again.

In the late 1950s, Noam Chomsky (b. 1928), an American linguist, revolutionized the study of language with his theory that innate structures, not sounds, are the basis for speech. This idea that inherent, unconscious structures might serve as the foundation of understanding started philosophers and artists searching for the hidden structures that shaped meaning. In photography, such doctrines questioned the trustworthiness of the singular, modernist construct of the "thing itself." Photographers began to pay attention to the overall context of their work. The result was a loss of belief in the approach of Karl Blossfeldt and Edward Weston that isolated subjects from their surroundings.

During the 1960s, Chomsky accused the media of conspiring to suppress information vital to the understanding of the Vietnam War and massage it into a misleading and consumable format. Chomsky believed in the ideal of an informed, democratic society freely arriving at decisions, and he pointed out that images are not neutral containers and thus people must actively ferret out their meaning. If the thing itself could no longer be trusted to supply an accurate and complete meaning, then photographers had to devise new ways of making images that offered insight into the world. In turn, viewers were asked not to passively accept any

image or statement about it on face value, but to take responsibility for extrapolating their own meaning.

Throughout the 1950s, exhibitions like Steichen's *The Family of Man* (see Chapter 15) reinforced the general belief that photography was exempt from these "hidden persuaders" that shaped meaning. By the early 1960s photographers began to question whether photography was a universal language, or whether outside influences, like its surrounding context and viewer subjectivity, determined reality and hence photographic meaning. Then George Eastman House curator Nathan Lyons wrote:

> If we are to confront the meaning of contemporary photographic expression . . . then let us establish a working premise by asking: Was a pepper to Edward Weston or a photogram to Moholy-Nagy less real than a breadline to Dorothea Lange? . . . Our discourse concerning this matter has fragmented the photographic community into reverently biased schools of thought, and by doing so has retarded a much needed dialogue concerning ideas which are essential to an understanding of photographic expression.[4]

## The Found Image: The Beginnings of Postmodernism

Walter Benjamin observed that one consequence of photomechanical reproduction was the disturbance of authenticity and originality, which diminished the aura of an original work. As a result of the growing domination of the photographic image, many modernistic twentieth-century artists expanded the definitions of their media. The new definition toppled the established importance of the subject matter itself and the "correct" use of materials for making pictures. Although artists like Picasso often were silent concerning their direct use of photographs, both the detailed information and the way it was "automatically given" by photography was now invading the artistic vocabulary.[5]

In 1955, **Robert Rauschenberg** (1925–2008) began to exhibit "combines" of painting and sculpture that incorporated seemingly discordant and incompatible items, such as stuffed animals, photographs, and photomechanical reproductions. In what the critic Lawrence Alloway labeled "an aesthetic of heterogeneity,"[6] Rauschenberg constructed work of dissimilar parts, excerpted directly from popular culture and filled with contradictions that left the origins of his source materials open and available for public inspection.

Rauschenberg had been making photographs since his student days at the Bauhaus-émigré outpost of Black Mountain College in North Carolina, where he worked with color abstractionist Josef Albers (1888–1976) and chance operations composer John Cage (1912–1992).[7] By the early 1960s, Rauschenberg had abandoned abstract expressionism and was using transfer processes to overlap found images and/or his own photographs onto his canvases, which also united lithography and silkscreen. This new use of materials and subject matter reflected his belief that "Painting relates to both art and life. Neither can be made. (I try to act in that gap between the two)."[8]

Rauschenberg, like Robert Frank, used ready-made vernacular sources, like tires and diners from the automobile culture, to create motifs and push the content of high art to include mass communication, politics, and technology. Rauschenberg's embrace of the photographic sensibility, in terms of content, style, and technique, and as a photographer, meant his painting had to be reconsidered in terms of printing. The critic Douglas Crimp wrote:

> Rauschenberg had moved definitively from techniques of production (combines, assemblages) to techniques of reproduction (silkscreens, transfer drawings). And it is this move that requires us to think of Rauschenberg's art as postmodernist. Through reproductive technology postmodernist art dispenses with aura. The fantasy of the created subject gives way to the frank confiscation, quotation, excerptation, accumulation, and repetition of already existing images. Notions of originality, authenticity, and presence, essential to the ordered discourse of the museum are undermined.[9]

This way of working was antithetical to the accepted definition of photography as the supplier of an ordered, unbroken view of reality, one comprised of single moments. Rauschenberg saw the world as a camera saw it, selecting, extracting, and assembling the visual information that was already there. This method of thinking exemplified Duchamp's belief that creation is about decision making, that a photographer is not simply one who makes photographs but is one who thinks and works with photographs.

## The Rise of Pop Art

During the 1960s, assemblage, conceptual art, environmental art, minimalism, op art, pop art, and photorealism explored form, syntax, and style, demonstrating the struggle in the art world between the painterly and the photographic. The ubiquitous nature of photography and its ability to deliver fresh forms of representation provoked new attitudes, forms, iconographies, and strategies that affected aesthetics. Artists incorporated photographic mannerisms and processes into their projects, and they directly placed photographs into their work. Pop art rejected the conventions of painting and turned to photography for its images and process. Artists like Andy Warhol, James Rosenquist, and Tom Wesselmann used consumer-based images, including advertising photographs, pictures of celebrities, news photos, and postcards, to destroy artists' handwork and make recognizable subject matter from soup cans to comic strips supreme.

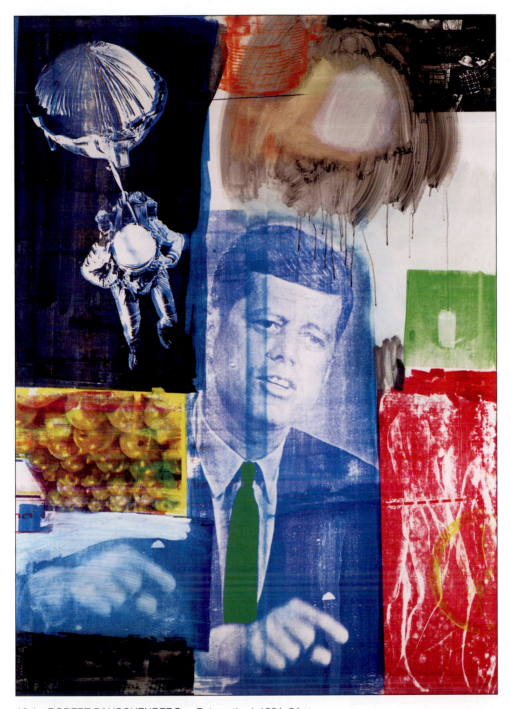

16.1  ROBERT RAUSCHENBERG.  *Retroactive I,* 1964. 84 × 60 inches. Silkscreen print with oil on canvas.   Wadsworth Atheneum Museum of Art, Hartford, CT. Gift of Susan Morse Hilles. Art © Robert Rauschenberg Estate/Licensed by VAGA, NY.

The rage produced by race riots, the Vietnam War, and the assassinations of John F. Kennedy (1963), Malcolm X (1965), Martin Luther King, Jr. (1968), and Robert F. Kennedy (1968) resurrected the myth of the doomed outsider. Yet within the alternative community there remained a sense that anything was possible. At the suggestion of the British-Canadian artist Brion

Gysin (1916–1986), the experimental beat writer William S. Burroughs (1914–1997), whose *Naked Lunch* (1959/65) was ruled obscene in Massachusetts for its open depiction of homosexuality and drugs, applied dadaist montage methods to his writings. In *The Ticket That Exploded* (1962), Burroughs cut-up and rearranged texts to free his work from cognitive processes and linear time. Cut-ups allowed Burroughs to fantasize a hallucinatory universe made up of a mosaic of voices in which society's familiar rules no longer applied, a universe in which anything could happen because "Nothing is True" and "Everything is Permitted."[10]

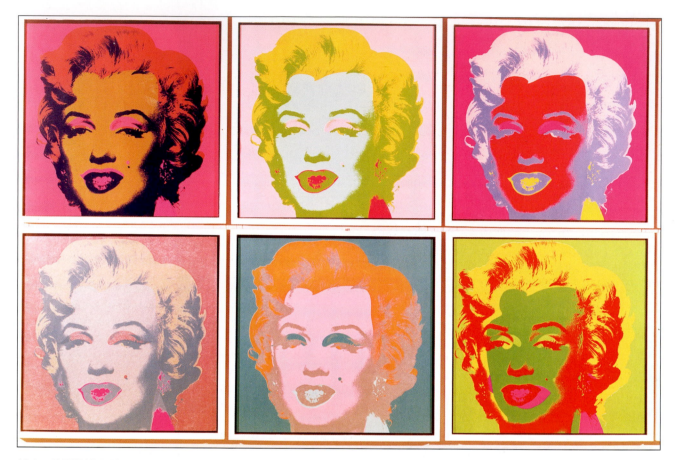

16.2 ANDY WARHOL. *Marilyn, left hand side,* 1964. Silkscreen.
© Private Collection/Alinari/The Bridgeman Art Library.

Around 1965, Burroughs and Gysin collaborated on collages of hieroglyphs and photographs placed over an irregular grid, presenting their view that reality was not singular or holistic but a dynamic system of local, interdependent perceptions.[11] The duo defied the narrative construct by overloading the page with text and images that multiplied to the margins of the irrational. This procedure of intentional discombobulation also acknowledges that once an image gets into circulation it takes on a life of its own, whose course cannot be commanded or foretold.

**Andy Warhol's** (1928–1987) acceptance and use of commodity images from advertising, magazines, and newspapers came to symbolize pop art. Warhol's *Campbell's Soup Cans* (1962) was hand-painted, but by the end of 1962 he had switched to photo-silkscreen. His *Disaster Paintings* (1963), covering tragedies like a plane crash and President Kennedy's assassination, offered an alternative to the romantic modernism of abstract expressionism, aligning Warhol with photography by appropriating sensational news photos, enlarging them, repeating them, and adding flat fields of color.[12] Warhol destroyed the photographs' original context and distanced viewers from any sense of loss or horror, leaving them uninvolved spectators. The technique reflects on psychiatrist R. D.

Laing's observations in *The Divided Self* (1959) in which he portrayed the schizophrenic (the "mad" person) as an outsider, estranged from himself, in a society that he or she could not accept as real. As Charlie Chaplin had done in *Modern Times* (1936), Warhol announced that he wanted "to be a machine," declared his own estrangement from society, and proceeded to use photography to extract repetitious images from popular culture. Whether it was soup cans, a car crash, or the electric chair, Warhol was devoted, like an intensely neurotic person who repeats an act over and over, to the static sameness and banality of a mass-produced commodity, and his work sparked debate on the effects of technology on society. His early plotless, single-action films—such as *Sleep* and *Empire* (1963)—were interminable exercises in camera passivity. In *Sleep* the camera remained fixed on a sleeping man for eight hours, while *Empire* consisted of a seemingly endless shot of the Empire State Building. Warhol's studio, aptly named The Factory, did not create fine art in the tradition that stretches back to Renaissance Florence as much as it manufactured products. Warhol celebrated capitalism and commerce, making fashion and promotion the means to their own ends, granting greater importance to perception than to the means of artistic production. Art was commerce and the artist a businessman who, with the right spin, could sell anything. The avant-garde stance of the new was replaced with a stance based on fickle popular culture. Every person, every work of

art, would be "famous for fifteen minutes," in Warhol's words. A Warhol piece could be glanced at like a television screen, as authenticity was replaced by artifice. Second-handedness became a virtue. Warhol treated Mao Tse-tung, Marilyn Monroe, and Mickey Mouse with the same reverence, demonstrating how meaning can reside in the eyes of the beholder. Such restless trend-surfing was evidence that the cultural scales balancing the past and present, guided by what T. S. Eliot called the "presence of the past," had shifted, making the past only a burden to be rid of rather than a provider of cultural context. The avant-garde prophecy that tradition would kill the conventional subjects and materials of fine highbrow art making and viewing became self-fulfilling in a way quite different than the avant-gardists had intended. Warhol's use of photographic repetition reinforced his position of not placing himself above his audience. He stated:

> "What's great about America is that it started the tradition where the richest consumers buy essentially the same things as the poorest. You can be watching TV and see Coca-Cola, and you know that the president drinks Coke, Liz Taylor drinks Coke, and just think, you can drink Coke, too. A Coke is Coke and no amount of money is going to get you a better Coke than the one the bum on the corner is drinking. All the Cokes are the same and all the Cokes are good. Liz Taylor knows it, the president knows it, the bum knows it, and you know it."[13]

Canadian media analyst Marshall McLuhan (1911–1980) provided a philosophical base for discussing the pivotal themes facing photography in the 1960s with his book, *Understanding Media* (1964). In a chapter called "The Medium Is the Message," McLuhan stressed that new technology gradually creates a dynamic environment grounded in process. He wrote:

> The electric light is pure information. It is a medium without a message. . . . This fact, characteristic of all media, means that the "content" of any medium is always another medium. The content of writing is speech, just as the written word is the content of print, and print the content of the telegraph . . . the message of any medium or technology is the change of scale or pace or pattern it introduces into human affairs. . . . Whether the light is being used for brain surgery or night baseball is a matter of indifference . . . "the medium is the message" because it controls the scale and form of human association and action.[14]

McLuhan noted that "camera[s] tend to turn people into things, and the photograph extends and multiplies the human image to the proportions of mass-produced merchandise."[15] The quantity (repetition) of information being delivered became more important than its quality. The contemplation of this overload of electric information was replacing creativity. The pop artists, mesmerization with this sensibility sent a message to the public that art and artists no longer shared any responsibility for explaining the incomprehensible, for unmasking frauds, or for acting as a gyroscope for morals or taste, because it made no difference what art

said. Numerous artists and critics felt that understanding could only be achieved through verbal narration. McLuhan did not share this view.

> Education is ideally civil defense against media fall-out. Yet Western man has had, so far, no education or equipment for meeting any of the new media on their own terms. Literate man is not only numb and vague in the presence of film or photo, but he intensifies his ineptness by a defensive arrogance and condescension to "pop kulch" and "mass entertainment". . . But the logic of the photograph is neither verbal nor syntactical, a condition which renders literary culture quite helpless to cope with the photograph.[16]

Rather than evaluating a photograph by a literary standard, McLuhan wanted a photograph to be understood on its own characteristics. McLuhan recognized the fundamental confrontations between literary and visual culture and the flaws inherent in imposing a verbal and/or ideological framework on visual information. Cultural critics, whether political or religious, often project their "correct" views of an image, denying the possibility of understanding an image on other levels. Such critical filters tend to distrust photography's democracy and assume positions that value a work in terms of ideology and language, placing a literary model above a visual one. This removes the prospect of the average person formulating his or her own understanding without guidance from the experts. It also denies the pleasure of approximation, even though it may result in a failure to comprehend the maker's original intent.

## Challenging the Code

In the 1960s photographers began to contest the code of direct optical and chemical imaging. Art Sinsabaugh (1924–1983), a graduate of Chicago's Institute of Design, did a series in the early 1960s using a 12 × 20-inch banquet camera to make long horizontal landscapes. Although he still relied on an archeological approach, making highly detailed, exquisitely seen, frieze-like compositions, Sinsabaugh discovered a somber way of looking at the landscape.

As a boy, Sinsabaugh had photographed with an 8mm movie camera, and his later panoramic images retain a cinematic sense of extending time and the field of view. The empty spaces in many of these unsentimental compositions foreshadow the "new topographics" landscape photography of the 1970s and 1980s, as we will see. Sinsabaugh's detached and unromantic images describe the low ground of the American prairie, revealing its sparseness and the severity of its beauty. They also reveal an abrupt and discordant human presence against an empty sky and endless horizon. As a teacher on the cusp of a shift in photographic practice, Sinsabaugh foreshadowed the coming changes: "Today can and should be the time for those interested in the visual images possible through photography to advance

**16.3  SYL LABROT.**  *Untitled,* from the Portfolio: *Ten Synthetic Landscapes,* 1972. 18⁹⁄₁₆ × 22⁵⁄₁₆ inches. Color serigraph.

© Syl Labrot Estate. Courtesy Visual Studies Workshop, Rochester, NY.

the quality of this imagery by turning back to the techniques of the past. . . . I appeal for a critical reevaluation of the discarded techniques of photography to enhance the images of the future."[17]

**Syl Labrot** (1929–1977) investigated ways of cracking the codes of representation at the crossroads of painting, printmaking, and photography to uncover opportunities for joining these three media. Labrot's purpose was to explore subjects in a manner that would not be possible with photography alone. He was interested in picturing a subjective, inner world of emotional states as opposed to replicating the exterior world. His immersion in abstract expressionism and *color field* painting, whose large, abstract areas of unmodulated color rejected illusions of visual depth and expressive gestural brushwork, led Labrot to investigate the dye transfer process in the late 1950s. These experiments reveal the inclination of photographers to expand

the monochromatic palette and break color free from its pejorative commercial associations. Labrot used the graphic qualities of printmaking to transform his images. His method of extracting details, simplifying a subject down to just color and texture, and layering striking hues that do not resemble the effects of the paintbrush, demonstrates how photography can also address an inner spirit. The sensuous, colored, photo-based surface of Labrot's fictionalized *Synthetic Landscape* series, as seen in his artist's book *Pleasure Beach* (1976), visually evokes territory similar, metaphysically, to that of the Argentine writer Jorge Luis Borges (1899–1986), whose work intrigued the artist. Labrot's imaginary landscapes blend fantasy, myth, and symbolism to question destiny and time. If Labrot saw life as a Borgesian labyrinth, he also, unlike Warhol, saw art as his way of overcoming the chaos of life.

## The Social Landscape

By the late 1950s, many photographers felt a passionate discontent with a variety of sources. There still lingered a generally unspoken spiritual void, a vast unexplain-

able emptiness, caused by the Holocaust/Shoah. The aftershocks of this event, even on those not affected directly, would cause a group of photographers with Jewish cultural backgrounds to question the rules that make society function. Other artists began to examine what economist John Kenneth Galbraith labeled the *Affluent Society* (1958), an atomic culture where "wealth is the relentless enemy of understanding."[18] This questioning led to a rejection of many photographic conventions, including the medium's aesthetics, definitions, and subject matter, as well as the role of the photographer. The rising interest in popular culture vis-à-vis the snapshot encouraged imagemakers to work with vernacular subjects found in family albums, magazines, and newspapers, and stylistically extend them, as Robert Frank had done, into new aesthetic and communicative purposes.

In 1960 and 1961, a lecture series in Rochester, NY, "Photography and the Picture Experience," opened a discussion on the influence of the snapshot on the syntax of photography that would continue throughout the 1960s. At a George Eastman House conference in 1964, John Szarkowski (1925–2007), director of MoMA's department of photography from 1962 to 1991, made a presentation on vernacular imagery. It was informed by John A. Kouwenhoven's *Made in America* (1948), which examines the conflict between the "cultivated" effect of European art and the "vernacular" style of American technological design. Nathan Lyons made a presentation on the role of the snapshot in contemporary imagemaking.[19] The conference resulted in three important exhibitions, Lyons's *Toward A Social Landscape* (1966) at George Eastman House, Szarkowski's *New Documents* (1967) at MoMA, and *12 Photographers of the American Social Landscape,* curated by Thomas H. Garver, with assistance from Szarkowski, at Brandeis University. These shows introduced a number of imagemakers who were repudiating formal, modernistic expectations about how the photograph should look and what it should picture. This disavowal of formal qualities helped launch a movement based on the casual and unconventional vocabulary of the snapshot, as seen in the early work of Lee Friedlander, Garry Winogrand, Danny Lyon, Duane Michals, and Bruce Davidson.

Such photographers were refining a gut-level response to their subjects that would clarify, but not define, life as they found it. Their approach, to work out new "authentic photographic forms,"[20] based on the snapshot, incorporated the diverse traditions of art and documentary photography. Coined the *snapshot aesthetic,* it referenced the *cinema vérité,* or direct cinema, filmmaking method that dispensed with directorial control and previsualization techniques. Many photographers considered the label a contradiction in terms: since snapshooters generally ignore artistic conventions, it meant an aesthetic of nonaesthetics.

For most photographers the preferred designation was *social landscape,* which referred to scenes based on the instantaneity and interconnectedness of people to their environment. In his introduction to *Toward A Social Landscape,* Lyons wondered if photographs of natural landscapes should be more highly prized, aesthetically, than man-made landscapes. He suggested that our classical notions of landscape should be reevaluated and expanded to include a greater "interrelatedness" with the environment, forming "the context of a more total landscape."

A photographer whose work radically redefined the social landscape was **Garry Winogrand** (1928–1984). Too young to fight the Nazis, Winogrand, a gruff New York Jew, worked out of a manic desire to purge himself of trauma by balancing chaos and impending disaster. He accomplished this by challenging assumptions of order, sorting out relationships through the act of photographing. Winogrand used a 35mm camera and a wide-angle lens not to show more of a subject but to get closer and more involved in the forces propelling a situation. His statement, "I photograph to find out what something will look like photographed"[21] blasts the system of previsualization. He turned familiar incidental occurrences into complex and unsettling environments capable of subverting suppositions about his subjects. Winogrand's tilted framing was a radical reimaging of the straight aesthetic that destroyed a viewer's sense of order. His subjects often appeared to be on the verge of falling out of the frame, infuriating people who accused him of not being able to hold his camera steady. According to Szarkowski, Winogrand "discovered that he could compose his pictures with a freedom that he had not utilized before, and that the tilted frame could not only maintain a kind of discipline over the flamboyant tendencies of the wide-angle lens, but could also intensify his intuitive sense of his picture's meanings."[22]

Winogrand's compulsive machine-gun, cinematic approach, always on the verge of anarchy, was a way of discovering what the subject actually was. Between 1978 and 1984, Szarkowski estimated that Winogrand made more than 300,000 exposures he never looked at.[23] Szarkowski speculated that Winogrand "photographed whether or not he had anything to photograph, and that he photographed most when he had no subject, in the hope that the act of photographing might lead him to one."[24] This is consistent with Winogrand's conviction that "there was no special way a photograph should look," that the compositional components of any photograph were forged by framing a point of view that best described the photographer's sense of a subject.

Szarkowski championed Winogrand's images as demonstrating his own belief that photography's power laid in its descriptive and formal characteristics and not in its cerebral reasoning possibilities. In *The Photographer's*

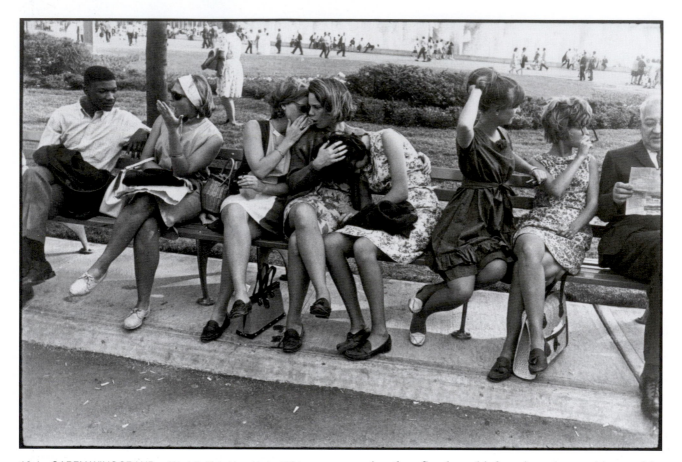

**16.4 GARRY WINOGRAND.** *World's Fair, New York,* 1964. 8¹³⁄₁₆ × 13⅛ inches. Gelatin silver print. Winogrand positioned himself not as a critic looking for closure but as an artist who was actively discovering life forces that transform situations. In his *Women Are Beautiful Portfolio* he stated: "I suspect that I respond to their energies, how they stand and move their bodies and faces. In the end, the photographs are descriptions of poses or attitudes that give an idea, a hint of their energies."[25]  © Garry Winogrand. Courtesy Fraenkel Gallery, San Francisco.

*Eye* (1966), Szarkowski named five elements that form a vocabulary and a critical perspective for photography: "The Thing Itself (the actual world), The Detail, The Frame, Time, and Vantage Point."[26] His theoretical construct provided a system for reevaluating photography. Through his MoMA bully pulpit of curating, collecting, and writing, Szarkowski functioned as tastemaker for a movement of photographers and educators including William Eggleston, Nicholas Nixon, Stephen Shore, Lewis Baltz, Tod Papageorge, and Robert Adams. He favored work that emphasized topographical description and had a minimum of emotional attachment. For Szarkowski, a consummate modernist, form rather than historical context made pictures intriguing. Szarkowski's influence was felt for three decades, creating a methodic and sanitary mechanistic climate of straight camera vision that insisted that order and meaning could be imposed on the messiness and unpredictability of life.

Another Szarkowski favorite who could superbly organize and convey the visual chaos and complexity of the urban environment was **Lee Friedlander** (b. 1934). Working to privatize public subjects, Friedlander pushed the narrative dialogue into a discussion of description and observation. His spiritual explorations questioned God's silence during the Holocaust and led him to favor individual redemption through personal grace and hard work. Friedlander constructed an interior world that was not apparent until it was organized through his camera. The discontinuous urban landscape became raw material for a hybrid, formalized, and personalized aesthetic that reshaped American street photography.[27] With sardonic humor, Friedlander ordered fragmented chaos to define not society but his place within society. Like jazz musicians John Coltrane, Miles Davis, Bill Evans, and Thelonius Monk, who used their music to help forge new identities for themselves, Friedlander's solipsism, his belief that the self is the only object of verifiable knowledge, became the benchmark for photographers examining the inner landscape. Friedlander's inquiry is summed up in his introduction to the first of his numerous books, *Self Portrait* (1970):

> I suspect it is for one's self-interest that one looks at one's surroundings and one's self. This search is personally born and is indeed my reason and motive for making photographs. The camera is not merely a reflecting pool and the photographs are not exactly the mirror, mirror on the wall that speaks with a twisted tongue. . . . The mind-finger presses the release on

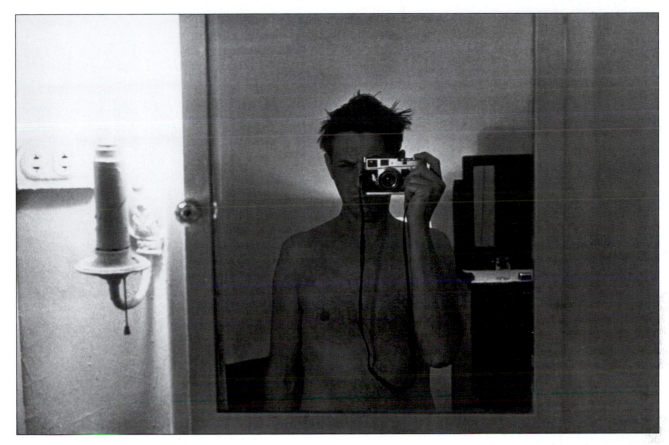

16.5   LEE FRIEDLANDER.  *Philadelphia,* 1965. 7⁵⁄₁₆ ×
11⅛ inches. Gelatin silver print.   © Lee Friedlander, Courtesy Fraenkel
Gallery, San Francisco.

the silly machine and it stops time and holds what its jaw can
encompass and what the light will stain. That moment when
the landscape speaks to the observer.[28]

The urban landscape, as in *Lee Friedlander: Pho-
tographs Frederick Law Olmsted Landscapes* (2008),
becomes a framing device, like the camera, that sets the
stage for an investigation of the human presence within
its enclosures, juxtapositions, and overlapping reali-
ties. The conceptual basis for Friedlander's metropo-
lis can be linked to Duchamp as his visual radar leads
him to readymade sites that contain images of images.
Friedlander's structuralist approach involves an often
extremely complex piecing together, a reading of all the
interconnected parts and signs to determine meaning.
Friedlander uses the reproducibility of the photograph
to dismantle the conventional documentary mode of
labeling the specifics. People are no longer individuals
but are metamorphosed into reproducible forms. Favor-
ing the ordinary, Friedlander does away with hierar-
chical ordering and makes objects, people, places, and
time interchangeable. He forces viewers to search for
a lone, human presence, often Friedlander's shadow,
which could be anyone's shadow, in a isolated land-
scape from which God is nowhere to be found.

The people and ideas that aroused the intense curios-
ity of Diane Arbus (1923–1971) were not to be found
in *The Family of Man* but on the outer fringe of soci-
ety that tyrants like Hitler wanted to eradicate. Arbus,
who grew up in an upper-middle-class Jewish family in
New York and was educated at the progressive Ethical
Culture School, did advertising photographs with her
husband, Allan Arbus, for her father's store. This led
to the couple being hired to take fashion pictures for
*Harper's Bazaar.* Between 1955 and 1957 Arbus stud-
ied privately with Lisette Model, who stressed that "the
most mysterious thing is a fact clearly stated."[29]

An emerging feminist awareness in the 1960s
expanded opportunities for women photographers.[30]
Arbus's interest shifted from the studio fashion work
to a challenging style that relied on frontal light, often
a flash, to sharply depict people who seemed willing to
reveal their hidden selves for the camera. What Arbus
pictured often seemed sensational because she unre-
lentingly broke down public personas. Arbus unblink-
ingly pictured people in the margins of society so that
their images were no longer about them as individuals
but about them as archetypes of human circumstances.
People found her work, like *Triplets in Their Bedroom,
N.J.* (1963), the cover shot of the *New Documents* cata-
log, distressing because the subjects did not fit into the
American dream, even if they were outwardly trying
to do so. For Arbus, living one's private life was not
enough. A public morality was needed to avoid ending

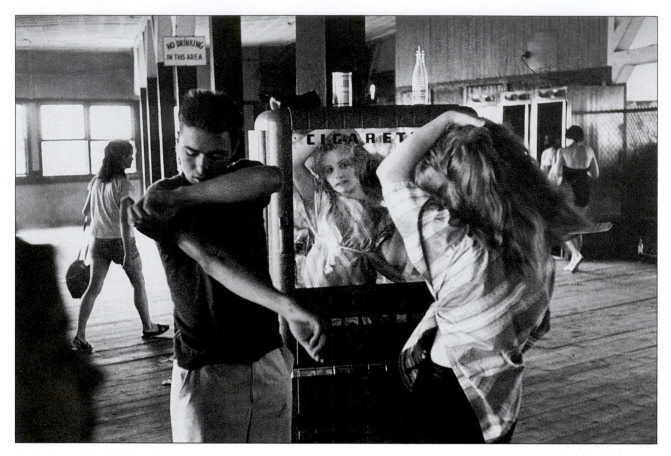

**16.6   BRUCE DAVIDSON.**   *Two Youths, Coney Island,* 1959.
Variable dimensions. Gelatin silver print.

up like those "good Germans" who had made a clear distinction between who was acceptable and who was not. Arbus pushed the boundaries of what was permissible by heroically visualizing her subjects and then recording them within a snapshot framework. After her suicide in 1971, Arbus's work developed a cult following, though some critics, such as Allan Sekula, said that her "fetishistic cultivation" of freaks had cruelly sacrificed their humanity.

However, such critiques miss the force of her work, which is underscored by Arbus's favorite Goethe quote: "Every form correctly seen is beautiful."[31] Arbus was known to wear her camera everywhere: "I never take it off."[32] For Arbus the process of photographing was the paramount experience and through it she expressed the ambiguities and contradictions of herself and life. Arbus often got to know her subjects, such as Eddie Carmel, the 495-pound, eight-foot tall "Jewish Giant," who she photographed for years before making the images she was after.

Arbus believed that "a photograph is a secret about a secret. The more it tells you the less you know."[33] She said that "photographing is not about being comfortable, either for the photographer or the subject" and that "you've got to learn not to be careful."[34] Her portraits are the result of her process of collecting and exchanging secrets that nobody wanted to share. Arbus knew that people did not want to look at what they perceived as a horror, barely covered by a thin layer of human skin. She understood that "Most people go through life dreading they'll have a traumatic experience. Freaks were born with their trauma. They've passed their test in life. They're aristocrats."[35]

Arbus's final series dealt with retardates, whose being and identity take us to an edge of human experience. These images challenge the definition of self and confront viewers with the secret fact that nobody is "normal." The pathos in Arbus's photographs is not that of her subjects but that of the viewer. Arbus's pictures are not about types of freaks but a cataloging of that communal secret of wanting to be "normal" and wanting to be accepted for who we are. The pain that makes viewers avert their eyes is due to the internal violence Arbus pictures between the void of our inner self-perception and that of outer public reality.[36]

## New Journalism

Arbus's photographs, which often appeared in *Esquire*,[37] were part of a trend towards personal journalism that used the guise of reportage to present a highly subjective view of the world. **Bruce Davidson's** (b. 1933) images, like the "New Journalism" of Tom Wolfe, Hunter Thompson,

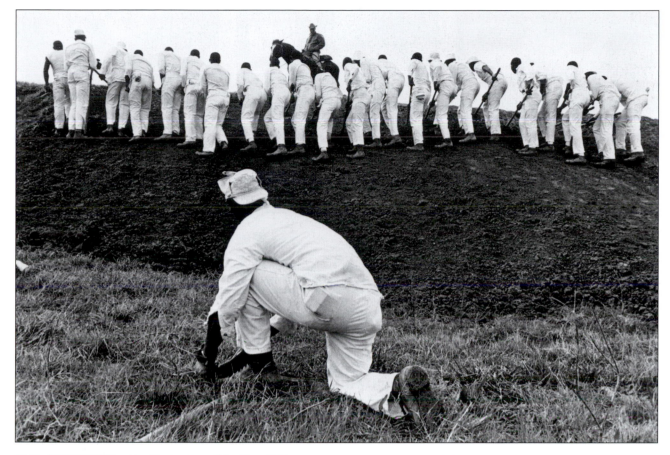

16.7  DANNY LYON.  *Hoe Sharpener and the Line,* 1969.
7⅝ × 11⁷⁄₁₆ inches. Gelatin silver print.  Courtesy George Eastman
House.

and Norman Mailer, contain authentic details of people and their situations. Davidson's early photo essays about an old French widow and a circus midget are indicative of his sympathetic representations of those who are not part of mainstream culture. During 1958, Davidson photographed a New York City gang and their rituals—hanging out under the boardwalk, drinking beer, dancing, or combing their hair in the mirror of a cigarette machine. He recalled:

> I took the finished photographs to the editors at *Life* who looked at them and gave them back to me. . . . I became more aware of the photographs of Robert Frank, who had just published *The Americans.* In it I saw an America that diminished the dream and replaced it with a piercing truth. It was hard for me to endure those bitter, beautiful photographs, for I had still within me the dream of hope and sympathy. . . .[38]

Davidson's personal involvement with gangs drove him in 1974 to look for the girl he had photographed combing her hair in the Coney Island mirror, to see what had happened to her dream since 1958. Davidson wrote:

> She had married the gang leader. . . . Their daughter was fifteen, the same age she was then. She said: "We all had a dream, but we lost it. Most of the kids we knew are on drugs,

in crime, or dead. You meant a lot to us because you were someone from the outside who had a camera and was taking pictures of us." I told her that her picture was hanging in museums around the world. When her teenage daughter came into the room, she turned to her daughter and said, "Look, this is a picture of your momma when she was your age." Then she turned to me and smiled. "Maybe my dream isn't quite lost."[39]

Davidson's photo essays, whether of the Los Angeles ghettos (1966), or of Spanish Harlem (*East 100th Street,* 1970), and of the *Garden Cafeteria* (1976), where many of his subjects were Holocaust survivors, are about perseverance and holding on to dreams. They are the result of an extended involvement that depends on the complicity and trust of his subjects. Like Walker Evans's sharecropper images, Davidson shows the face of human dignity in the midst of tribulation. But unlike Evans, Davidson's empathy with many of his subjects provides an intimate sense of what it takes to endure in a hostile world. His photographs are not radical in form, but they are compelling in their social conscience. In the humanitarian spirit of the 1960s, in an era before many subcultures were publicly pursuing self-representation, Davidson gave photographic validation to the everyday effects of disenfranchisement and loneliness within the urban landscape. Davidson has been criticized as an outsider exploiting marginalized people, but his full tonal range, view-camera prints convey a sense that he honestly respects his subjects and amidst despair seeks to affirm the

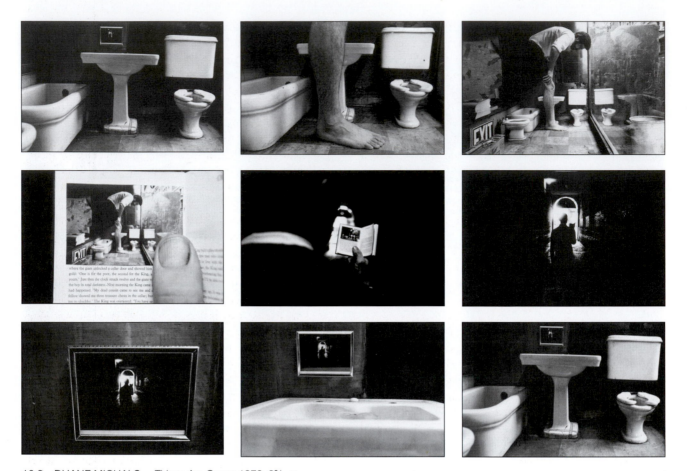

**16.8   DUANE MICHALS.** *Things Are Queer,* 1973. 3⁵⁄₁₆ × 5¹⁄₁₆-inches (each image). Gelatin silver prints. Michals believes that diversity of practice is essential, as "... everything is a subject for photography including your own fantasies, your own truth, your own desires, your own fears. That's where you live. You don't live on the streets looking at people's faces or looking at sunsets. You live in your mind. And you know your fears more intimately. What I want from you is your secrets. That's the only thing you can give me: your secrets."[40]   © Duane Michals. Courtesy Pace/MacGill Gallery, New York.

diversity of life. The activities of photographers like Davidson demonstrate that the lives of ordinary people are worthy of preservation. They provide an opportunity for an initial dialogue, bridging the gap between Them and Us, and they foretell the fact that numerous cultural groups would actively begin to represent their own identities in the closing decades of the twentieth century.

In the early 1960s the active desire to directly change the world led to political actions like the Freedom Rides, marches, and sit-ins to end segregation. **Danny Lyon** (b. 1942) was one of the new journalism photographers in the 1960s who rebelled against the status quo, the values of measured material success, and the passive role of the documentary photographer. Lyon was radicalized by the civil rights movement of the early 1960s and became an official photographer for the Student

Nonviolent Coordinating Committee. In 1965, half of Americans over 65 still had no medical insurance; one-third of Americans lived below the poverty line; more than 90 percent of the black adults in many southern counties were not registered to vote; nationwide, only 200 blacks held elected office; and only a third of 3- to 5-year-old children attended nursery school or kindergarten.[41] Believing they could change the world, photographers like Lyon did not heed psychedelic guru Dr. Timothy Leary's call to "tune in, turn-on, and drop-out" but instead gave up being observers and actively immersed themselves within the situations they were photographing. Their viewpoint shifted from outsider to adopted guest member of a community. They were granted the privilege of making images from a vantage point in which the traditional subject/photographer relationship was jettisoned in favor of a more personal approach. Such relationships set the groundwork for imagemakers from within the groups themselves to take over the task of self-representation that would be the hallmark of politically motivated photography in the 1980s and 1990s.

Lyon's photographs of the early civil rights confrontations and marches resulted in *The Movement* (1964). Some of the conditions Lyon photographed were improved by President Lyndon B. Johnson's "Great Society" laws dealing with Medicaid benefits, the Voting Rights Act, and Federal aid to education.

Lyon continued to be a participatory photographer who saw his function as giving form to a subject's own story. Lyon's next experience was as "staff photographer" for the Chicago Outlaws motorcycle gang, where he provided form to the subject's own story that concluded with the publication of *Bikeriders* (1968). The authenticity of the photographs was evidenced by over 40 text pages of the bikers telling their own stories. This active immersion methodology climaxed in *Conversations with the Dead: Photographs of Prison Life with the Letters and Drawing of Billy McCune # 122054* (1971), the result of fourteen months spent photographing inside six Texas prisons (see Figure 16.7). The book focused on one prisoner's story, incorporating his letters and drawings "to explain to the free world what life in prison is like."[42]

## Multiple Points of View

By the mid-1960s people in many levels of society were exploring options to the "business as usual, we have done it this way for years, why change now?" approach to life. Consumer activist Ralph Nader's (b. 1934) exposé of General Motors, *Unsafe at Any Speed* (1965), had shown that what was good for GM was not necessarily good for America. Nader's citizen action groups lobbied for consumer, financial, and legal rights, and demonstrated that there were alternatives to established practices. At the same time, photographers challenged the cherished notions of photographic veracity and time by using the blur, double exposures, high-contrast print tonal values, and multiple images (sequences).

During the mid-1960s, **Duane Michals** (b. 1932) shifted from photographing single enigmatic moments, as in his unpeopled sites of *Empty New York,* to invented sequential images that wrestle with inner dramas. His evolution reflects a shift from public to private concerns as well as a changed view of photographic time. The theatrical, time-lapse reality of Michals's images, informed by the work of surrealistic artists René Magritte and Georgio de Chirico, the visionary poet William Blake, and the magical realist Borges, represents another way of knowing the world. Where Minor White used photographic sequencing metaphorically, Michals's photo-fables and passion plays are narrative.

Initially working with a simple 35 mm Argus C-3 camera and natural light, Michals's cinematic mise-en-scène sequences, the arrangement of visual forms and movement within a given space, blend the implausible with the mundane. Inherently photographic means, including lens flare, multiple exposures, and the snapshot, are used to suggest an unseen, ethereal spirit world. Michals said: "What I cannot see is infinitely more important than what I can see."[43] In 1974, he added handwritten text, sometimes in the first person and other times from an omniscient point of view, to direct the viewer's response while maintaining a balance and distinction between the words and images he tethered to make a distinct impression. By the early 1980s, Michals was painting directly onto his prints. His blending of mediums and methods enabled Michals to make visible what would have been invisible in a straight photograph. These experiments in photography, language, and painting allowed him to expand his investigations and their metaphysical themes of the psychic, spiritual, and sexual, exemplifying his own dictum: "Either you are defined by your medium or you must redefine it."[44] Even when he deals with his homosexuality, as in *Salute, Walt Whitman* (1996), his characterization remains the universal exploration and discovery of the self.

The transformation in Michals's work was denotative of the mood of the 1960s: questioning how things were done, trying new procedures, and eliciting fresh outcomes. The accuracy of what the American government was telling people was being disputed on numerous fronts. Many people were convinced that, despite issuing more than two dozen volumes, the Warren Commission's investigation of President Kennedy's assassination was a cover-up that purposely ignored alternate explanations of the event. Visually, the same concern for seeking alternative viewpoints rather than a single fixed perspective was expressed in the 1966 exhibition, *The Persistence of Vision.* The show, featuring the work of Donald Blumberg (b. 1935), Charles Gill (b. 1933), Robert Heinecken, Ray K. Metzker, Jerry N. Uelsmann, and John Wood (b. 1922), challenged the assumption that a photograph's worth should be based on its ability to convey knowledge directly from nature. Wood's cross-disciplinary approach influenced artists such as Nathan Lyons, Robert Heinecken, Robert Fichter, Thomas Barrow, and Betty Hahn to jump in and break down conditioned barriers between mediums and what constituted an appropriate photograph. Collectively their approach asked: might not multiple or sequential imagery be as perceptually natural as a single photograph?

Nathan Lyons's (b. 1930) practice centers on the concept that meaning has no archetypal arrangement, and that photographers do not find meaning but have to construct it through a combination of verbal and visual thinking. This method of working posits that meaning arises from a group of images and that the ordering of a group does not have to have an apparent rational or thematic foundation. In *Notations in Passing* (1974) and *Riding First Class on the Titanic* (2000), Lyons's sequential ordering suggests that what is significantly communicated is determined by what he calls the "combinatory play" among the images. Such a strategy relies on the space and time between the images to bring out viewer associations. Artists who follow this practice tend to be distrustful of translating images into words, insisting that the way to deal with the content of nonliteral photographs is to experience the images.

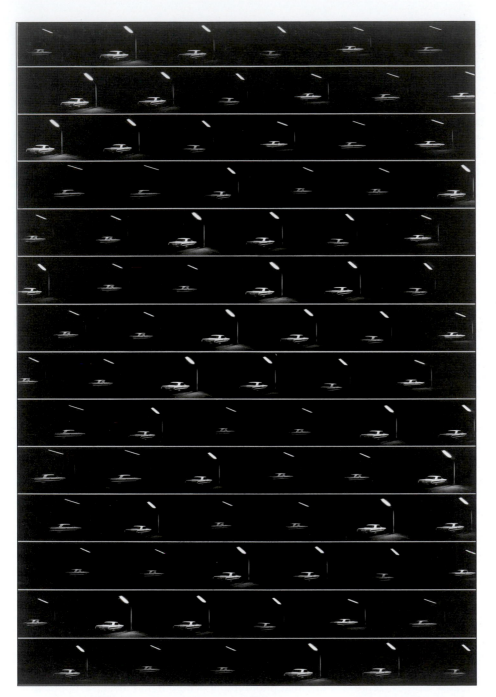

**16.9  RAY K. METZKER.**  *Car and Streetlamp,* 1966. 30 × 22 inches. 14 Gelatin silver prints. Metzker wrote: "Discontented with the single, fixed frame image . . . my work has moved into something of the composite, of collected and related moments. . . . I employ methods of combination, repetition and superimposition. Where photography has been primarily a process of selection and extraction, I wish to investigate the possibilities of synthesis."[45]  © Ray K. Metzker. Courtesy Laurence Miller Gallery, New York.

**Ray K. Metzker's** (b. 1931) sequential, multi-frame, mosaic images bring the New Bauhaus design approach, learned through his studies with Callahan and Siskind at the Institute of Design, to bear on the integrity of the photographic process. Metzker presents the idea of a contact sheet, with its multiple views and tonal variations in the prints, as a way to understand a subject rather than a means of distilling the one answer. He utilizes a calligraphic tension, a visual script that weaves the black photographic frame line into a rhythm that produces a gridlike ordering of the subject. Using individual visual units, representing time and space, and light and dark pictorial values, as building blocks, Metzker constructs meaning when he arranges them into a formal visual matrix that gives his subject the impression of interruption, a sense of being simultaneously whole and fractured. His composites of many

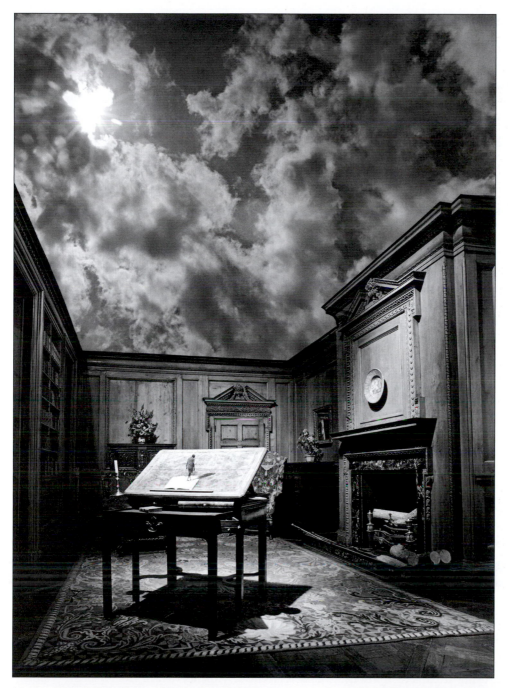

16.10   JERRY UELSMANN.   *Man on Desk,* 1976. 20 ×
16 inches. Gelatin silver print.   © Jerry Uelsmann.

small images depart from the usual photographs made for reproduction in book form, functioning instead as a large single image to be displayed on a gallery wall. The composites work well both from a distance, as scenes take on rhythmic, abstract qualities, and close up, where attentive viewers can see the crisp photographic particulars.

During the 1960s photographers explored the strain between the belief in the fundamental realism of the photograph and the subjectivity of the artist's vision.

**Jerry Uelsmann** (b. 1934) does this by making complex multi-image allegories with sophisticated multiple-printing techniques. Uelsmann, who studied with Minor White and Henry Holmes Smith in the late 1950s, was the first of a new breed of university-trained image-makers whose support comes from teaching and grants. Thus freed from commercial restraints, Uelsmann challenges the mindset that photography's place is to deal with the rational, and that printing a negative is a rote process. Reintroducing Oscar Rejlander's idea that a single camera image does not have to yield up the final image but can act as part of a larger, constructed representation, Uelsmann collects and combines components directly from his own experience to realize a formal

pictorial configuration whose meaning lies outside of the everyday world. Unlike Rejlander, Uelsmann does not tell narrative stories but uses his virtuosic combination printing technique to confront the incomprehensible. The process itself was synonymous with the alternative culture's interest in interactive performance that is evident in the music of Jimi Hendrix (*Purple Haze*), the Beatles (*Sgt. Pepper's Lonely Hearts Club Band*), the Paul Butterfield Blues Band (*East/West*) and The Doors (*Light My Fire*), for discovering what lies beyond the logical, offering evidence of the independence of the imagination.

Uelsmann's seamless multi-image productions are like dreams freed from the anchors of reason. In the predigital age, they offered objective optical records of impossible situations—trees floating in air, faces coming out of rocks, radical contrasts in scale, positive and negative imagery—expanding photographic discourse and ambiguous enough to contain both multiple meanings and no meaning. His iconography paradoxically combines popular culture with playfully fabricated mythological settings, often using humor. His intuitive methods can communicate complex emotions and contain ingredients similar to the romantic Southern magical realism of John Laughlin. Uelsmann's fantastical juxtapositions of the seemingly unrelated form seamless "psychic landscapes," becoming so wondrously believable as to question the supposedly self-evident empirical nature of photographs. It is a transcendental approach that synthesizes discordant parts to reconcile the suitable and inappropriate, the natural and the artificial, the physical and the spiritual.[46]

In response to the social upheavals of the 1960s, photographers like **Robert Heinecken** (1931–2006) searched for new artistic and technical options that not only relied on multiple images but saw any photographically based activity as source material for picturemaking. In the anything-can-go spirit of the *happening*,[47] where the audience became part of the event and was responsible for its interpretation, Heinecken suggested how the boundaries of photographic content and form could be expanded. Rarely using a camera himself, Heinecken worked with direct processes, such as the photogram. Using a printed magazine page as a negative, he foiled the conventions of previsualization in favor of chance and free association. These reformulated combinations of images an d sometimes text can generate new meanings from the original materials by destroying their original context. Heinecken experimented with photographic emulsion on canvas, metal, and plastic, and presented his work in the form of pictures on cubes, picture puzzles, and stacked blocks.

Trained as a printmaker, Heinecken made work that departed from the customary appearance and form of photographs. His interest in photography was not as a means of taking pictures but for its ability to reproduce images. As far as he was concerned, the world already had all the images he needed. Any image was raw information containing the "residual of actuality," a fragment of truth that could be synthesized to show the culture that produced it. Heinecken's methods visualize Marshall McLuhan's ideas of how advertising and news photographs seduce consumer/viewers by generating a false reality whose foundation is based on clichés and stereotypes. Using a magazine page as a contact negative and printing both sides of the page together, as in his *Are You Rea* series, confirms how meaning can be buried inside the image and must be excavated. Former George Eastman House curator William Jenkins observed: "Fashion, sports, home decorating and sex inexplicably melt into a consistent magma of contemporary culture."[48]

Heinecken used offset printing to alter pornographic and war atrocity images and rebound his altered materials into existing magazines, which were then replaced at newsstands. In the same way that comedian Lenny Bruce's sardonic social critiques surfaced via the media and were borrowed by other comedians, Heinecken's fusion of popular and pornographic magazines confronted the similarities rather than the differences between the two. Photographer/historian Carl Chiarenza explains:

> Indeed, one is hard put to name anything that has not been replaced by a photographically derived image. His recycling of these images makes this astounding point before making any other. Heinecken knows the photograph is not real. He also knows that most of us still believe it is. Photography can be the perfect voyeur for a mechanical age. The camera eye is lusty and insatiable, a perfect match for Heinecken's eye.[49]

This lusty match has meant Heinecken's work has been attacked by those who object to the sexual subject matter and others who feel it represents women in a subservient manner. His work is often a humorous disrupter of the notions about how things are, who incorporates cultural images to examine issues concerning gender, imaging, power, sex, and violence from a male point of view (see Figure 16.11). It also reflects the undercurrent of violence—race riots and the Vietnam War—that the media brought nightly into people's living rooms. Like the nameless photographer in Michelangelo Antonioni's film *Blow-Up* (1966), Heinecken uses the reproducibility of photographic processes, as opposed to the camera itself, to question and reveal the subsurface truths that the photograph delivers and the culture that has produced them. Interested in a media-oriented approach to photography that could offer a critical process for collecting, reorienting, and transforming images and their meaning from popular culture, Heinecken's working methods of montage and mixed media pointed out ways to extend the expressive possibilities of the medium.

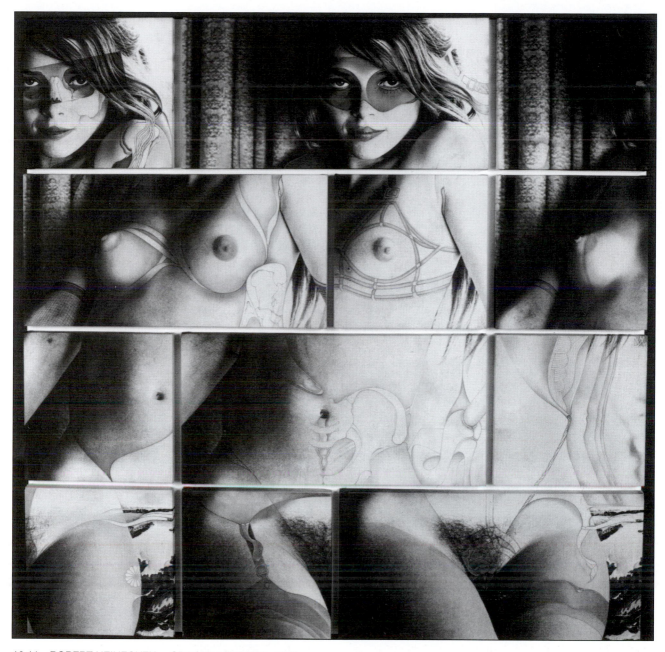

16.11 ROBERT HEINECKEN. *Cliché Vary/Fetishism,* 1974.
42 × 42 inches. Photographic emulsion on canvas, pastel chalk.
Courtesy George Eastman House. © Robert Heinecken. Courtesy Pace/
MacGill Gallery, New York.

## The Rapid Growth of Photographic Education

The forces driving social change in the 1960s affected how photographic issues were analyzed. The growing interest in photographic education shifted the dialogue from the professional sector and the pages of *Popular Photography* to the university. In 1962, an invitational teaching conference at George Eastman House[50] sparked the founding of the Society for Photographic Education (SPE)[51] whose purpose was to foster a forum for people involved in the teaching of photography. In Rochester, NY, Nathan Lyons left the George Eastman House and founded the Visual Studies Workshop (VSW) there in 1969. A model of the new interdisciplinary approach to photography and visual culture, VSW influenced the next generation of photographers just as schools like the Institute of Design had done previously. Photography, now based in art departments, received a pronounced injection of academic aesthetic discourse through the influence of SPE. This growth burst open during the 1970s, offering teaching, gallery, and museum jobs for graduates who came out of the

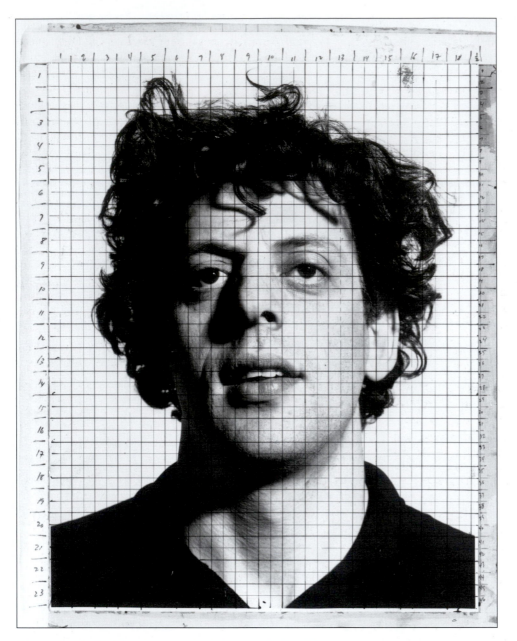

**16.12   CHUCK CLOSE.** *Working grid photograph of Phil,* 1969. 13¾ × 10¾ inches. Gelatin silver print with ink and masking tape. Some art critics considered Chuck Close an artistic Antichrist because he worked from photographs instead of directly from life. Close admired the camera's ability to level hierarchy, to see all of a subject equally and not to place more importance on one area than another. Close took that lack of hierarchy, as used by Abstract Expressionistic painters like Frank Stella, and applied it to representational painting so that every square inch was made the same way and had the same visual attitude. Close stated: "I wanted to make something that was impersonal and personal, arm's-length and intimate, minimal and maximal, using the least amount of paint possible but providing the greatest amount of information. . . . I always thought the best art was extreme whatever it was."[52]   © Chuck Close. Courtesy Pace/MacGill Gallery, New York.

university photography programs that had sprung up across the United States. The mixing of photography with other visual mediums had an invigorating, cross-pollinating effect on the visual arts.

During the mid-1960s, painters like **Chuck Close** (b. 1940), Robert Cottingham, Richard Estes, Audrey Flack, and Ralph Going developed *photorealism,* whose subject matter was how the objective and descriptive qualities of photographic vision affected the interpretation of reality. The photorealists were entranced by the lenticular and spectral effects of photographs—background blurring, depth of field, perspective distortion, selective focus, spatial flattening. Their skillfully executed paintings were conceived from photographs rather than directly from life, and in Close's methodology the photograph acted as a small-scale grid template for his descriptive painting that converted the

human face into unfamiliar landscape. Ironically, in spite of their reliance on photographic appearances, most of the photorealists rejected the direct photograph as an inferior art. Only Close, who used the large-format Polaroid studio camera to make bigger-than-life, multi-image portraits, welcomed photographic syntax in its fundamental form. More recently, he has made daguerreotype portraits. Less as a photorealist than an artist concerned with using photographic detail as a building block, Close utilizes photographic vision to take what appears to be a chaotic system and show how it can make sense out of disorder.[53]

The 1960s did not see a single stylistic approach like Group f/64 or an individual like Stieglitz dominating the medium but rather a loose democratic assemblage whose experiments, rebellions, and social critiques expanded the ranks of people involved with photography. Technical innovations like the introduction of the Nikon F in 1959, which ushered in high-quality, fully interchangeable, 35mm single-lens-reflex camera systems, and the Kodak Instamatic in 1963, with its drop-in film cartridge, made it easier for both professionals and amateurs to make photographs, including color. The teaching of photography at the university started to swell the ranks of practitioners and introduced fresh ideas to developing imagemakers, broadening the practice, breaking away from standardized mass-produced materials, and widening its critical audience. The new and different ways that people used photographs ignored the tradition of the fine print and spiritually elevating subjects. The desire for reform actively affected people's social and artistic lives. A tiny, dynamic group of imagemakers rethought the definitions of content and the nature of the photograph, and applied their counterculture ideas to revamp concepts of what a photograph was supposed to look like; who a photographer was; what a photographer did; and how viewers might respond. This discussion soon extended to a larger audience, one concerned with how photographs could be conceived conceptually and technically, viewed, and evaluated. In this expansive framework of individualism, photography did not have to confine itself to scenes of the external world but could fabricate a new aesthetic that interacted with other media, explore subjective inner realities, and transcend its previous limits.

## Endnotes

1   Roland Barthes, *Camera Lucida: Reflections on Photography*, translated by Richard Howard (New York: Hill and Wang, 1981), 118.

2   Ibid., 118.

3   Henry Holmes Smith, "Photography in Our Time: A Note on Some Prospects for the Seventh Decade," *Henry Holmes Smith: Collected Writing, 1935–1985* (Tucson: Center for Creative Photography, 1986), 68.

4   Nathan Lyons, *Toward A Social Landscape* (New York: Horizon Press, 1966), 5.

5   See Van Deren Coke, *The Painter and the Photograph, from Delacroix to Warhol* (Albuquerque: University of New Mexico Press, 1964). Revised and enlarged edition, 1972.

6   Lawrence Alloway, Introduction, *Robert Rauschenberg* (Washington, DC: Smithsonian Institution, 1976), 5.

7   During the 1940s, artist Joseph Cornell (1903–1972) began using photographic images in combination with found objects in his theatrical box constructions, but these were not widely seen and had little immediate impact on other artists' working methods.

8   In Lucy R. Lippard, *Pop Art* (New York: Frederick A. Praeger, 1966), 6.

9   Douglas Crimp, "Appropriating Appropriation," *Image Scavengers* (Philadelphia: Institute of Contemporary Art, 1983), 33.

10   William S. Burroughs, *Nova Express* (New York: Grove Press, Evergreen Edition, 1992), 147–49.

11   For details about their collaborations, see Robert A. Sobieszek, *Ports of Entry: William S. Burroughs and the Arts* (Los Angeles County Museum of Art, 1996).

12   Warhol's appropriation of such materials has raised legal and ethical issues surrounding copyright violation. In 1996, Time Inc. and photographer Henri Dauman sued his estate, claiming Warhol had used a *Life* magazine photo of Jacqueline Kennedy at her husband's funeral to make silkscreen prints without getting permission, paying, or crediting Dauman or Time/Life. See "Warhol Estate Sued for Using Kennedy Photo," *The New York Times,* Sunday, December 8, 1996, 52.

13   Kynaston McShine, *Andy Warhol: A Retrospective* (New York: Museum of Modern Art, 1989), 458.

14   Marshall McLuhan, *Understanding Media: The Extensions of Man* (New York: McGraw-Hill, 1964), 8–9.

15   Ibid., 189.

16   Ibid., 195 and 197.

17   Art Sinsabaugh, *Six Photographers* (Urbana: University of Illinois, 1963), unp.

18   John Kenneth Galbraith, *The Affluent Society* (Boston: Houghton Mifflin, 1958), 1.

19   For details on these events see Robert Hirsch, "Nathan Lyons on the Snapshot," *CEPA Journal,* Winter 1992–1993, 6–7.

20   All quotes in this paragraph from: Nathan Lyons, Introduction, *Towards A Social Landscape,* 6–7.

21   Quoted by Janet Malcolm, "Photography: Certainties and Possibilities," *The New Yorker,* vol. 51, no. 24 (August 4, 1975), 56–59.

22   John Szarkowski, *Winogrand: Figments From the Real World* (New York: Museum of Modern Art, 1988), 23.

23   Ibid., 36.

24   Ibid., 39.

25   Garry Winogrand, "Women Are Beautiful Portfolio," (Austin, TX: RFG Publishing, 1981), unp.

26   John Szarkowski, *The Photographer's Eye* (New York: Museum of Modern Art, 1966), 8.

27   For information about street photography see Colin Westerbeck & Joel Meyerowitz, *Bystander: A History of Street Photography* (Boston: Little Brown, 1994).

28   Lee Friedlander, Introduction, *Self Portrait* (New York: Haywire Press, 1970).

29   Quoted in Patricia Bosworth, *Diane Arbus: A Biography* (New York: Alfred A. Knopf, 1984), 187.

30   During this time social reformers like Betty Friedan (1921–2006), author of *The Feminine Mystique* (1963) and founder of the National Organization for Women (1966), questioned the notion that a woman could only achieve fulfillment by being a wife, having children, and managing the home.

31   Bosworth, 41.

32   Ibid., 132.

33   Ibid., Preface, xi.

34   Ibid., 249 and 303.

35   Ibid., 177.

36   Why is there no Arbus photograph? Initially, the lawyer for the Arbus Estate, John Pelosi, said: "Sorry to disappoint you but your request is denied." Eventually he forwarded the text to Doon Arbus. On April 26, 1999, Mr. Pelosi called the author's permission editor and said, "She didn't understand the points the author was making and failed to see a reason why a photo was needed."

37   See *Diane Arbus: Magazine Work,* Doon Arbus and Marvin Israel, (eds.) (Millerton, NY: Aperture, 1984).

38   Bruce Davidson, Introduction, *Bruce Davidson Photographs* (New York: Agrinde Publications Ltd., 1978), 10.

39   Ibid., 14.

40   Quoted in A. D. Coleman, "Duane Michals," *Camera & Darkroom,* vol. 15, no. 11, (November 1993), 30.

41   Cited by David E. Rosenbaum, "Time Wrap: Republicans Like Both Previews and Reruns," *The New York Times,* Sunday, December 11, 1994, Section 4, 16.

42   Danny Lyon, *Conversations with the Dead: Photographs of Prison Life with the Letters and Drawing of Billy McCune # 122054* (Holt, Rinehart and Winston, 1971), 13.

43   Quoted in Shelley Rice, "Duane Michals's 'Real Dreams,'" *Afterimage,* vol. 4 (December 1976), 6.

44   Coleman, 27.

45   Ray K. Metzker, [Statement], *Aperture,* vol. XIII, no. 2 (1967), unp.

46   See: Robert Hirsch, "Maker of Photographs: Jerry Uelsmann," *Photovision,* September/October, 2002, 18–27.

47   A Happening was part of the 1960s Pop Art scene. Its name derived from Allan Kaprow's 1959 New York show *18 Happenings in 6 Parts,* in which a rehearsed, multimedia event unfolded. The audience moved on cue from room to room, becoming part of the performance, and it was their job to unravel the disjointed events. Kaprow said a happening was an "assemblage of events performed or perceived in more than one time and place."

48   William Jenkins, "Introduction," James Enyeart, ed., *Heinecken* (Carmel, CA: Friends of Photography, 1980), 15.

49   Carl Chiarenza, from an unpublished article, September, 1976 in *Heinecken,* 29.

50   See "Invitational Teaching Conference at the George Eastman House 1962," (Rochester: George Eastman House, 1963).

51   The group was formalized in Chicago in 1963 with Nathan Lyons as SPE's first president; Aaron Siskind, Art Sinsabaugh, Henry Holmes Smith, Clarence White, Jr., and Minor White were installed as members of the first board of directors.

52   Robert Shorr, et al., *Chuck Close* (New York: The Museum of Modern Art, 1998), 89.

53   See Chuck Close, et al. *A Couple of Ways of Doing Something* (New York: Aperture, 2006).

# Changing Realities

## *Alternative Visions*

The Vietnam War (1946–1975) ended with a cease-fire agreement in 1973 and American troops withdrew. Before divisions in the country could heal, the Watergate affair caused many people to abandon the notion of government integrity and forced Richard M. Nixon to resign in 1974, the first U.S. president to do so. People were worn out from a decade of internal dissension and were looking toward quieter and more peaceful times. The raw, screaming guitars of the 1960s gave way to the canned disco sounds of the Bee Gees. This distinctive split could be seen in photography. The first half of the decade saw a settling of the emotionally charged frontiers of the 1960s, while the second half was a dry, formal, cooling-down period. Photographic practice, like the conservative "Silent Majority" that ushered in the "Reagan Revolution" of the 1980s, moved from the idealistic, community-based search for open form experiments to the restrained stance of the straight gelatin silver print and a pessimistic philosophy of diminished possibilities that questioned the foundations of originality and quality.

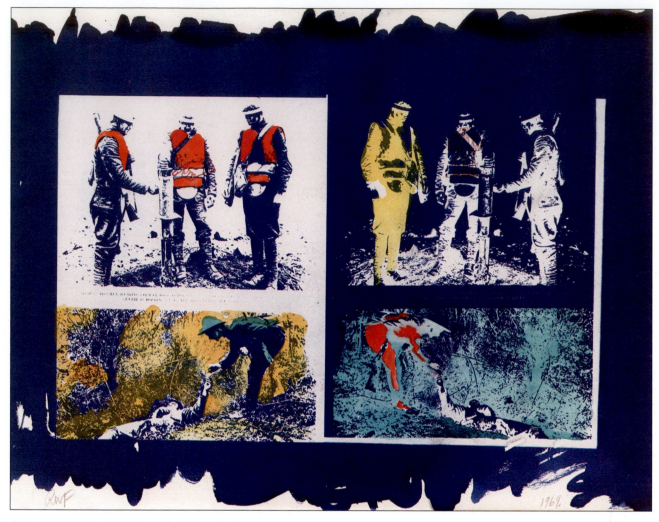

**17.1** ROBERT W. FICHTER. *World War I Soldiers*, 1970. 14 × 18 inches. Cyanotype with watercolor. © Robert Fichter. Image courtesy Jerry Uelsmann Collection.

## New Approaches

In the 1960s the democratic-based social movements—which extended into photographic practice—had their basis in doubt. Many believed that any problem-solving process had to allow for the possibility that one might not get it precisely right. The American appreciation of uncertainty finds its lineage in the thinking that created the U.S. Constitution, whereby new ideas, in the form of Amendments, could be developed, implemented, and discarded—providing a structure open to change.

During the 1960s, photographers pursued a path of dissent by challenging accepted chemical and optical methods of photographic presentation. The philosophies of Cartier-Bresson's "decisive moment" and Szarkowski's "photographer's eye" were put in the backseat by a new group of discontented imagemakers. **Robert W. Fichter** (b. 1939) pushed the boundaries of conventional practice in his explorations of the

Sabattier effect (aka, solarization) and by exposing the same roll of film numerous times in a cheap plastic toy *Diana* camera. Fichter, a painter and printmaker who studied with Jerry Uelsmann and Henry Holmes Smith, experimented with alternative imagemaking methods, including collage, cyanotype, gum bichromate, hand-coloring, and an old Verifax copy machine. Fichter's work and especially his teaching, at UCLA (where Heinecken taught) and later at Florida State University, gave students the support to conduct their own investigations into the expressive form and the symbolic content of the photographic image.

As the 1970s opened, photographers were seriously examining their medium's roots. Universities added courses in photographic and film history to their curriculums. Photographers reexamined anonymous vernacular images, such as snapshots and postcards, which gave legitimacy to collecting photography and fueled its acceptance in art galleries, museums, and publishing houses. As part of a movement that was rediscovering historical processes, photoeducators like Betty Hahn, (b. 1940) who also studied with H. H. Smith, used the cyanotype and gum processes to make loose, roughly

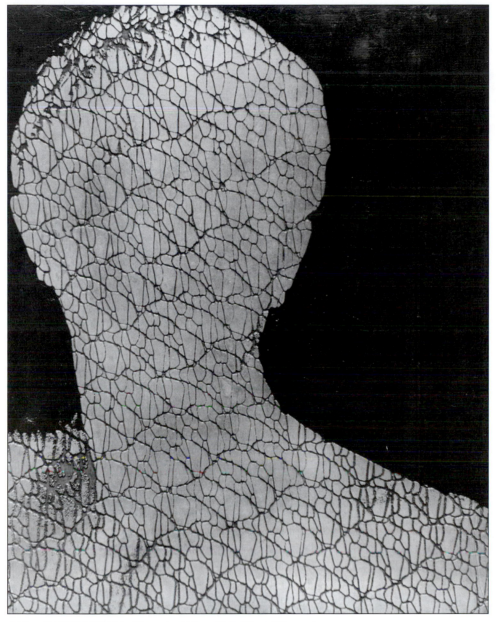

17.2   NAOMI SAVAGE. *Enmeshed Man*, 1972. 70 × 55½
inches. Paint and tempera on copper-plated magnesium.   © Naomi
Savage Estate. Courtesy Francis M. Naumann Fine Art, New York.

detailed, impressionistic images, with flat fields of color
that disputed the ideals and content of the glossy print.
Hahn and photoeducator Bea Nettles (b. 1946) looked
into the sculptural properties of scale, space, and vol-
ume by making images on fabric and then stuffing and
stitching them. Nettles then spread the concepts in her
alternative process book, *Breaking the Rules* (1977), and
in artists' books, such as *Flamingo in the Dark* (1979).

In curating *Photography into Sculpture* (1970) for
MoMA, photo-historian Peter C. Bunnell (b. 1937) gave
credibility to twenty artists, including Ellen Brooks
(b. 1946), Darryl Curran (b. 1935), Robert Heinecken,
Bea Nettles, and Doug Prince (b. 1943), who were

broadening the flat photographic playing field into the
third dimension. Prince's small Plexiglas boxes house
a series of transparent images, one in front of the other,
whose multilayering and sense of depth resist the opac-
ity of the photographic image by allowing a solitary
viewer to look through time and space. **Naomi Savage**
(1927–2005), who had worked with Man Ray, com-
bined photographic methods such as multiple exposure,
negative printing, and toning with collage, engraving,
and intaglio. Her most intriguing work involved metal
photographic etchings in which the plate itself becomes
the final object rather than a part of the process, trans-
forming her subject's appearance and a viewer's
expectations.

Interest in how imagery could be formulated got a
boost from photographs produced for scientific pur-
poses. NASA's intricate composite photographs taken

17.3   THOMAS BARROW. *Caulked Construction—Teepees,*
1979. 18 × 19 inches (irregular). Reconstructed gelatin silver print
with caulking, staples, and spray paint.   Washington Art Consortium:
Henry Art Gallery, University of Washington, Seattle; Museum of Art,
Washington State University, Pullman; Northwest Museum of Arts and
Culture, Spokane; Seattle Art Museum; Tacoma Art Museum; Western Gallery,
Western Washington University, Bellingham; Whatcom Museum of History and
Art, Bellingham. American Photographs: 1970–1980; gift of the Virginia Wright.
© Thomas F. Barrow, 1979. Courtesy Laurence Miller Gallery, New York.

by the Surveyor moon landing craft in 1966 and 1968
were of interest to artists and the public. Uses of such
technology encouraged photographers to explore the
possibilities of new imaging systems like the photo-
copy machine. Sonia Landy Sheridan (b. 1925) oper-
ated the copy machine as a camera. Often using her
own body as source material, Sheridan's electro-
static prints demonstrated the immediacy of the pro-
cess and the interactive connection that was possible
between artist and machine. This concept was furthered
by Ellen Land-Weber (b. 1943), who placed three-
dimensional objects on the copy machine's docu-
ment glass and printed the resulting images on Arches
watercolor paper, which produced a soft, muted,

lithograph-like rendering. Sheridan founded the Gen-
erative Systems Department at the School of the Art
Institute of Chicago in 1970 to offer a forum for artists
and scientists to investigate new methods of image pro-
duction, including copiers, video, and computer-gener-
ated images.

**Thomas Barrow** (b. 1938), who studied at the Insti-
tute of Design, experimented with found mass-media
sources on an outmoded Verifax photocopier to cre-
ate quick, densely packed montages that comment on
America's intense level of consumerism. The direct,
cameraless images led Barrow to his Man Ray–like
spray-painted photograms of the late 1970s and early
1980s. Here he investigated concepts concerning
abstraction, language, representation, and the cultural
thinking process that ties them together. For Barrow,
photographic data is a jumping-off spot, as the immac-
ulate print is discarded in the conviction that artistic
response lies beyond the pictorial vision of the lens.

Barrow continued to work with these issues in his
*Cancellation* series (1974–1978), bridging the two seem-
ingly incompatible photographic trends of the 1970s—of
highly charged personal experimentation and emotionally
minimal formalism. Barrow photographed the southwest-

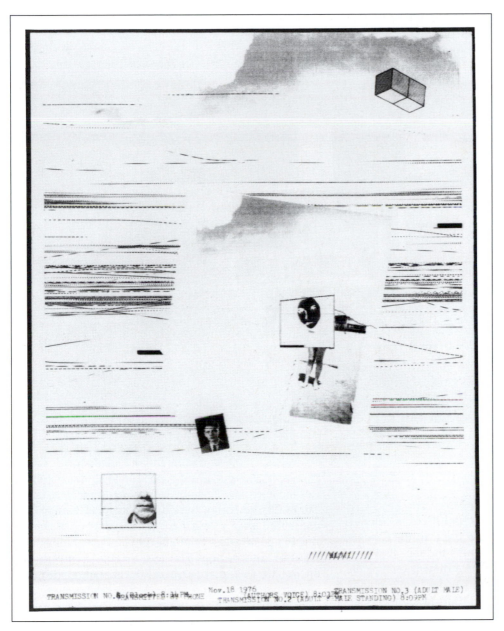

17.4  **WILLIAM LARSON.** *Transmission 0035,* 1974. 11 × 8½ inches. Electro-carbon print. Larson states: "The early fax technology, although slow in transmitting (6 minutes per 8½ × 11 inch paper) produced relatively high resolution for reproduction of visual materials. Since it translated everything into an audio signal to be sent via telephone, it read everything from images to classical music as a simple digital code, which was then converted into corresponding voltage levels to literally burn the image(s) into their special paper at the receiving end. It was also possible to manipulate the image, while it was printing, by simply moving the stylus as it burned the image into paper."[1]   © William Larson. Courtesy George Eastman House.

ern, social landscape in the literal, deadpan style known as New Topographics that had become popular with photographers in the West. Barrow breaks the neutrality of the images with an explosive hand gesture, slashing an "X" onto the hallowed surface of the negative. This physical alteration separates the subject from its image, demanding that we recognize that the picture is a facsimile of reality. It also, according to curator Kathy McCarthy Gauss, lodges a protest against the inhumanity, insensitivity, and unaesthetic nature of the landscape:

> The obvious marking, the attempted destruction of the negative carries a veiled humorous allusion to the historical tension between craft and machine. The mechanically derived landscapes are highly rational and formal, rendered with a dispassionate approach that contrasts with the slash marks. The primitive defacing introduces an element of intellectual discord aimed against the refined mechanistic photographic image. The marks are akin to graffiti and suggest repudiation, a tweaking of the subject that recalls Marcel Duchamp's alteration of the Mona Lisa.[2]

**17.5 KENNETH JOSEPHSON.** *Postcard Visit, Buffalo,* 1970, 10.2 × 16 cm. Collage (color postcard collage) The Art Institute of Chicago. Photography © The Art Institute of Chicago. © Kenneth Josephson.

At the end of the 1970s Barrow took his *Cancellations* a step further by vandalizing the print. In the *Caulked Reconstructions* Barrow dismantles the flat, fine print and then reassembles it into a three-dimensional patchwork that is joined together with silicone caulk, staples, and spray paint (see Figure 17.3). Barrow's direct intervention signals his dissatisfaction with the straight print and the machinelike, spiritual detachment of the photographic process. By extending his physical presence into the picturemaking process, Barrow asks viewers to spend more time with the work than they would with a conventionally made camera image. This recycling of imagery and materials, with references to contemporary culture and art history, into concentrated multilayered formats reminds viewers about the complexity of modern existence and how difficult it can be to decipher what is really happening in any image.

**William Larson** (b. 1942), who also attended the Institute of Design, was interested in the interactive nature of the photographic process and in finding methods to transcend the limitations of the modernist print aesthetic. Working with a Graphic Sciences Teleprinter that converted an image into audio signals that were transmitted via telephone and reassembled to produce a facsimile, Larson built up an image over time through multiple transmissions. The collaged data, based on snapshots, snippets of text, and marks made by sounds, suggested ambiguous messages and the kinds of memories that are experienced when trying to recall a dream. These electro-carbon renditions, made between 1970 and 1976, were called *Fireflies* because of the recurring image of a firefly and the allusion to the ephemeral flight of information. The low-resolution images use open space to impart a sense of the alienation, distance, and uncertainty that surrounds new technology (see Figure 17.4).

## Turning the Straight Photograph on Itself

Other photographers turned the straight photograph inside-out to remind viewers that photography is simultaneously a trace of the real and an inherent abstraction. **Kenneth Josephson** (b. 1932), who studied at Rochester Institute of Technology and the Institute of Design, investigated the truthfulness of the silver print. Josephson's approach is conceptual, de-emphasizing subject matter and stressing the relationship between a photograph of a subject and the subject itself. Josephson makes photographs about photographs that reveal "the process of creating pictures as ideas rather than as representations."[3] In one series, Josephson holds a postcard of each scene into his photographic frame, playfully interjecting himself as a performer who is

**17.6    ROBBERT FLICK.**    *SV# 035/81, Near Live Oak I,* Joshua Tree National Monument, CA, 1981. 20 × 24 inches. Gelatin silver prints. Flick's *Sequential Views* combines the characteristic photographic trends of the 1970s. Relying on the verisimilitude of the gelatin silver print, Flick creates a formal repetitious structure that is paradoxical to what the images appear to conceptually divulge. His continuum of views, merging into one, challenges presumptions about photographic process, space, and time. By shifting location, extending or negating forms through perspective, or using different focal length lenses, Flick disrupts the borders between indexical documentary practice that offers a cataloging of subjects and artistic interpretation. Besides questioning the physical makeup of any place and the notion of the single photograph, these views provide alternative explanations to the difference(s) between appearance and reality.    © Robbert Flick. Courtesy Robert Mann Gallery, NY.

formally distorting reality while mocking the idea of photographic duplication, demonstrating the absurdity of attempting to reoccupy the same space (see Figure 17.5). In some cases Josephson goes beyond the issues of how the photographic frame functions and gets into what the frame includes and excludes and how the photograph conveys data. In *Honolulu* (1968), Josephson printed the image of three people so dark that its specific informational value was lost; you knew they were people but could not identify them as individuals. He then printed the same image with the details present, tore away parts of the images he didn't want, and collaged the remaining pieces on top of the full dark image so you could now see their faces and know who they were. Through collage methods that create intersections between black-and-white and color, Josephson examines what takes place along the borders of photographic reality. His work stresses the ambiguity of representation and the effect of time on the realization of the subject. Josephson reshapes the photograph to discover a new vantage point that disrupts Renaissance concepts of how the world is and what a picture is supposed to look like.

The notion of photographic veracity was likewise examined by Joseph Jachna (b. 1935), who also went to the Institute of Design. Jachna constructed formal landscapes around hand-held mirrors he introduced into his frame to make his audience aware of the differences between natural and photographic space.

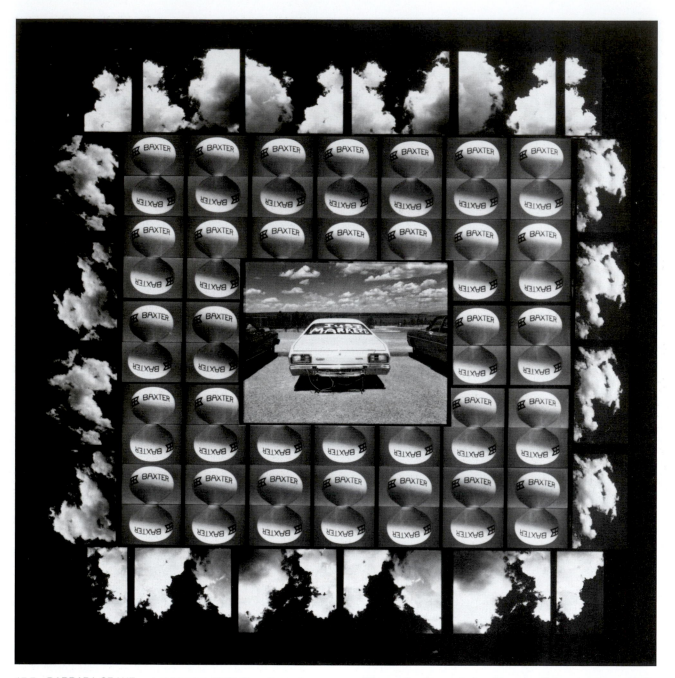

17.7   BARBARA CRANE.   *Just Married,* 1975. From the series *Baxter/Travenol Laboratories.* 16 × 20 inches; mural size 9 × 7 feet. Gelatin silver prints.   © Barbara Crane.

Self-consciously revealing the image and the procedures of its creation, Jachna held up the manipulative power of the photograph for examination. By layering a number of images into a single photograph Jachna fooled the viewer's sense of time and space. The intensely printed blacks and glowing highlights lend a spiritual quality and reverence to an ambiguous space that has been distorted and flattened by the mirrored reflections. These personal mediations disturb the boundaries between optical fact and optical illusion.

The authority and dominance of the single, straight gelatin silver print aesthetic was questioned through other innovative approaches that encouraged individual expression. The concept, championed by Szarkowski, that the frame was singular and all-inclusive was questioned by artists such as Barbara Blondeau (1938–1974), Barbara Crane, and **Robbert Flick** (b. 1939) (see Figure 17.6), who worked with multiple, extended framing and serial repetition. Paradoxically, they used the straight print to challenge its own aesthetic and accompanying assumptions about time and how it relates to picturemaking and viewing. **Barbara Crane** (b. 1928) examined these ideas often on a large scale, building up temporal relationships between objects that cannot be comprehended all at once but

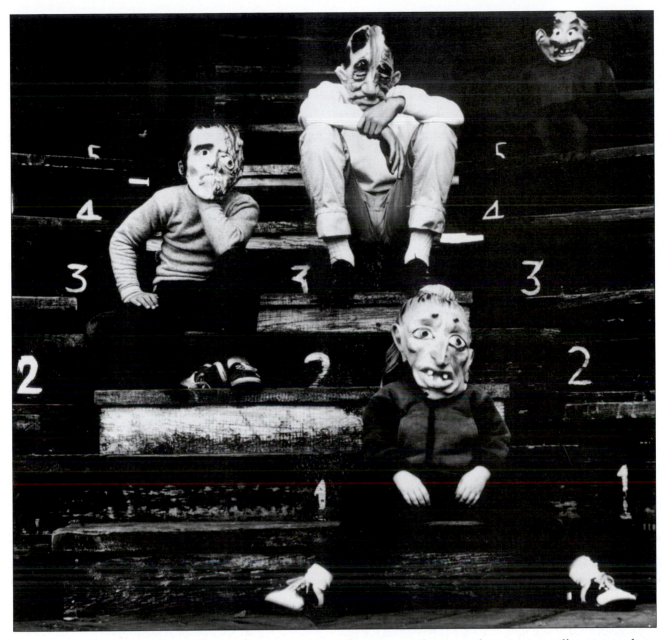

17.8   RALPH EUGENE MEATYARD.   *Romance (N) from Ambrose Bierce, No. 3,* 1962. 7 × 7⁵⁄₁₆ inches. Gelatin silver print.

© Ralph Eugene Meatyard Estate. Courtesy Fraenkel Gallery, San Francisco.

disclose themselves over time. It is this "extra" time that allows complex interrelationships to be discovered (see Figure 17.7).

## Personal Accounts: Documentary Fiction

The attention Diane Arbus's work received in the 1960s encouraged other photographers to personalize photographs made as social documents. Beginning in the 1960s, some photographers like Ralph Eugene Meatyard, Les Krims, Arthur Tress (b. 1940), and Lucas

Samaras used a narrative, neosurrealist approach to map interior landscapes. They dealt with the irrational by ordering an environment they could control. These fictions, made up of ordinary objects and set in commonplace environments, were intentionally organized to reveal underlying psychological conditions in a documentary style. The effect of this direct intervention by artists with their subjects was to stimulate tension between the fundamental formalism of the photograph and the subjectivity of the artist's personal vision, creating a hybrid form—documentary fiction.

**Ralph Eugene Meatyard** (1925–1972), who studied with photographic curator/historian Van Deren Coke, was an optician from Lexington, KY. Working in the Southern Gothic tradition, Meatyard used family and friends as models to generate enigmatic, hauntingly impenetrable dramas filled with surprise and fear. In his

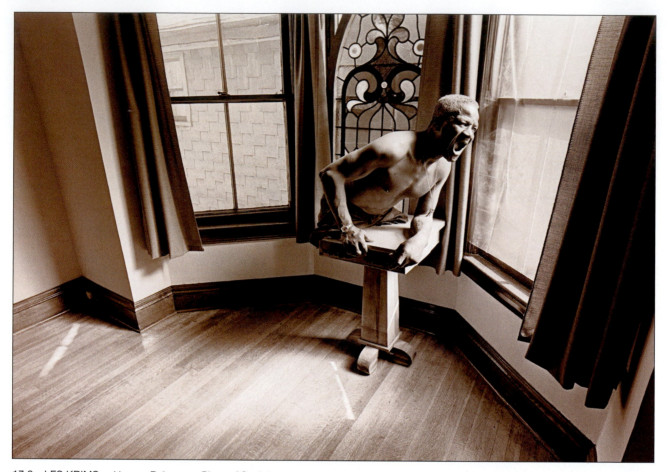

17.9 LES KRIMS. *Human Being as a Piece of Sculpture* (*Screaming Man Fiction*), Buffalo, New York, 1970. 4⅝ × 6⅞ inches. Gelatin silver (Kodalith) print.    © 1970 Les Krims.

series of surreal "Romances," Meatyard had his models wear cheap Halloween masks as a symbolic device for diving below the surface of outer reality (see Figure 17.8). Meatyard turned the regular confines of his square 2¼-inch camera format askew, portraying the precarious voyage of life. His often darkly printed and sometimes ghostly blurred images reinforced the idea of the world as frightening, unseeable, and unknowable. Like Clarence John Laughlin before him, Meatyard's combination of real environments and phantasmal effects created ambiguous documents about identity, remembrance, and the continuance of time. Although Meatyard worked throughout the 1960s, his images did not receive attention until the posthumous publication of *The Family Album of Lucybelle Crater* (1974), which used the family snapshot genre to present the dark side of Steichen's *Family of Man*. It was built around a fictional character based on a Gertrude Stein story.[4]

**Les Krims** (b. 1943) staged preposterous situations from his internal theater of the absurd and grotesque that were calculated to disturb and shock Main Street's sense of decency and propriety.[5] His images from the late 1960s and early 1970s were printed on Kodak Kodalith paper, a graphic arts material not intended for pictorial use, to deliver high-contrast, dramatically grainy, brown-toned effects that defied conventions of print quality. Provocative, self-published, boxed folios on dwarfs, deer hunters, murder scenes of nude young women, and his topless mother making chicken soup, received wide notice, encouraging young photographers to visualize their inner fictions and explore forbidden subjects. There is no neutrality or compassion in Krims's intent; the absurd is given full rein. His vexing image of a screaming, legless man on a pedestal leaves viewers no place to go except to confront the affliction (see Figure 17.9). When his photographs were shown in Memphis, TN, an enraged viewer kidnapped the son of the gallery director and held him hostage, demanding that Krims's pictures be removed.

At his best, Krims was a trickster who tested viewers' tolerance by photographing taboo subjects. But critics condemned Krims's aggressive attitude as condescending. They said the harsh flashlight and wide-angle lens he used to photograph dwarfs in *The Little People of America* (1972) sensationalized their differences in a sardonic manner. Others considered his work such as *Making Chicken Soup* (1972) that mocks Jewish mothers and family albums, to be unenlightened buffoonery. His book of manipulated Polaroid SX-70 charades, *Fictcryptokrimsographs* (1975), contained

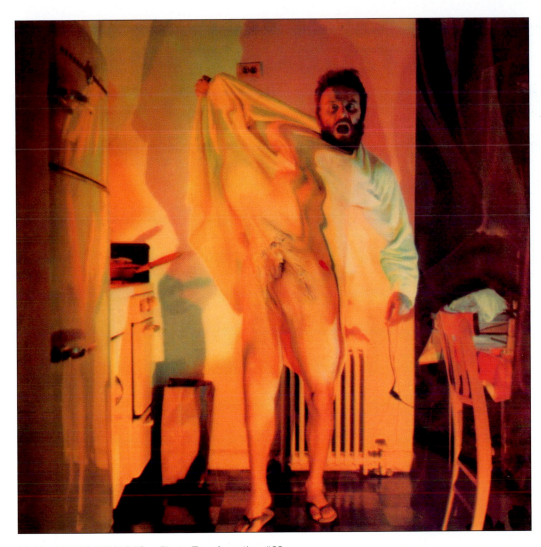

17.10  LUCAS SAMARAS.  *Photo-Transformation, #39.*
June 13, 1974. 3⅛ × 3¹/₁₆ inches. Diffusion-transfer print.
© Lucas Samaras. Courtesy Pace/MacGill Gallery, New York.

women whose distorted nude bodies were under attack by bananas, meat grinders, and toy airplanes. During a time of rising feminist consciousness and the era of the Vietnam War, it was considered a prime example of adolescent, machismo misogyny. These attacks led Krims to withdraw from the U.S. photography scene, though he has continued to exhibit new work in countries such as Germany and Japan.

The interaction between art and photography can be seen in the fictional creations of **Lucas Samaras** (b. 1936). Samaras is a painter, sculptor, and performance artist who in the late 1960s did a series called *Auto-Polaroids* in which he manipulated his face and body, altering his appearance to visualize a psychological autobiography. In 1973, Samaras started his *Photo-Transformations,* a body of work in which he photographed himself with colored lights and a Polaroid SX-70 camera to confront the theme of the modern self that Samaras sees as being open to constant rein-

vention. Designed as the definitive snapshot system, the SX-70, introduced in 1972, was ideal for experimentation because it did not have an established aesthetic, the unique results were immediate and private, and it freed makers from having to know anything about photographic process. Vernacular imagemakers, such as Walker Evans, took up the SX-70 for its ability to directly collect and present data. Unhappy with the confines of the gelatin silver print, Samaras used the SX-70 to relocate his manipulative impulses directly into the medium. Samaras interacted with the process by using a stylus to move the dye layers of the film before they hardened, achieving the same raw, gestural effect and extravagant, unnatural color within the rococo motif he favored in his painting and sculptures. Within the mundane setting of a cramped New York City apartment, Samaras's body erupts, spreads, and stretches, as if possessed by demonic forces, revealing a hidden monster lurking below the surface. Samaras's self-obsessed, surreal tableaux dispense with romantic and sentimental ideals of the self, and like a psychedelic drug experience, they engage the viewer in a dynamic hallucinatory state of psychic transformation

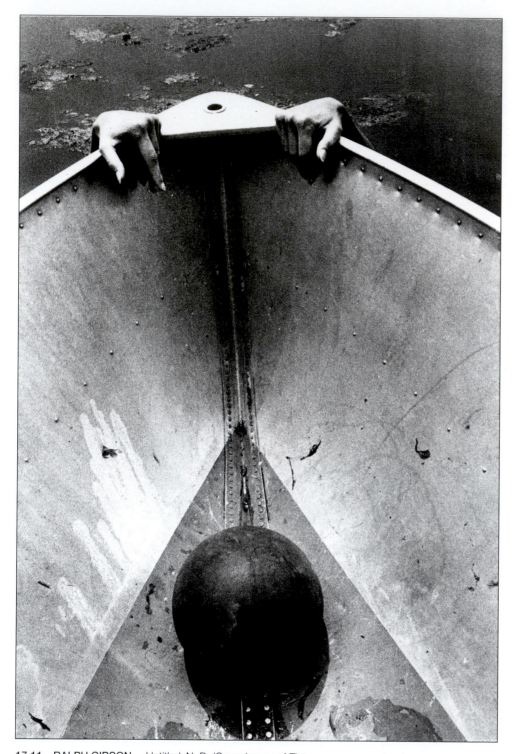

**17.11 RALPH GIBSON.** *Untitled*, N. D. (Cover image of *The Somnambulist*, 1970.) Size varies. Gelatin silver print.

© Ralph Gibson.

(see Figure 17.10). The instant Polaroid print, having no negative to be tinkered with, lends a sense of authenticity to his visions. As befits someone who critic Peter Schjeldahl called "the artist laureate of narcissism,"[6] Samaras's favorite subject is himself. By showing viewers how multinatured the self can be, he continues an artistic tradition that would become celebrated and much imitated in the role-playing work of Cindy Sherman (see Chapter 18). Samaras stated, "When I say 'I,' more than one person stands up to be counted."[7]

The counterculture of the 1960s developed its own brand of American existentialism, stressing that there were no single answers and that people were free to discover their own self(s) and meaning of life. This led numerous artists to pursue their understanding of the world through the filter of the self and track their

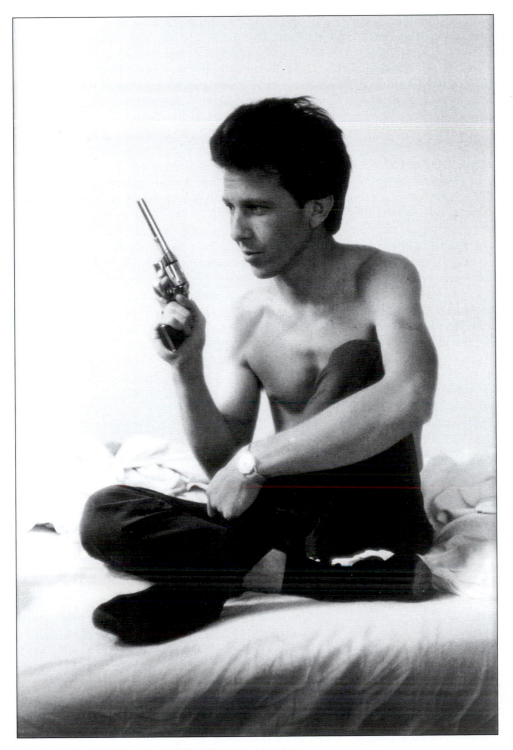

17.12 **LARRY CLARK.** *Dead 1970*, 1968. 14 × 11 inches. Gelatin silver print. Inside the book this image appears with text that reads: "dead 1970" and on the opposite page text that reads: "death is more perfect than life."    *Courtesy the artist and Luhring Augustine, New York.*

observations through a personal journal. For photographers, this diaristic impulse, the desire to make a visual record about a subject based on one's own experiences, reached its widest audience in book form. The financial nonviability of publishing controversial material for small audiences forced photographers to return to self-publishing. The content and form of these biographical narratives were often a personal mix of images and text, having roots in the snapshot and the family album. This flexible form allowed for individual freedom, self-definition, and the expression of alternative lifestyles. The format departed from the style of the *Life* photo essay, giving a sense of looking at an anecdotal scrapbook. These young photographers were working with

the one subject they knew best: their own lives. The books they made did not rely on single decisive moments but spun their tales through a collage of sequences that often alternated between black-and-white and color images, contact sheets, film clips, found images, newspaper stories, handwritten notes, drawings, paintings, and informally written accounts (see Artists' Book section later in this chapter).

This biographical approach formed the basis for the publishing experiments of **Ralph Gibson** (b. 1939). In 1969 the former assistant to Dorothea Lange and Robert Frank founded Lustrum Press, which during the 1970s published an unconventional collection of books featuring his and others' photographs.[8] Gibson's own high-contrast 35mm work is tightly composed and reflects the *minimalist* impulse to eliminate extraneous detail. It gets right down to the essentials of producing a nonliteral, but visually complex, symbolic system that evokes an oracular, dreamlike state. Gibson's use of the close-up, visually editing-out the details of the world, strengthens the fleeting, transient quality of his enigmatic settings (see Figure 17.11). Gibson demonstrates that the gelatin silver print is capable of revealing a separate and distinct realm beyond empirical thinking, as his introduction to The *Somnambulist* states: "Clarity is all any man seeks, this somnambulist merely finds his on the Other Side."[9]

The publication of **Larry Clark's** (b. 1943) *Tulsa* (1971) was an insider's look into the nether world of drugs, guns, and sex without excuses or righteous statements (see Figure 17.12). Working from his personal observation that "once the needle goes in it never comes out,"[10] Clark indulges a viewer's appetite for rebellion and voyeurism. Dispensing with conventional artifice and interjecting his own presence, Clark visually steers people through the ritualized but abjectly unromantic working-class underside of the permissive 1960s' "Free Love Generation." Clark continued to use photography as a form of erotic and metaphysical rescue from the chilling brutality and hopelessness of the low-life drug and gun world, making the book *Teenage Lust* (1983) and films such as *Kids* (1996) and *Wassup Rockers* (2006). These proclivities are evident in Clark's MySpace page (www.myspace.com/larryclark) in which the self-proclaimed "punk Picasso" would like to meet "women, punks, rebels, rockers, skaters, troublemakers." In a 1992 interview Clark discussed how he came to his autobiographical approach: "I know a story that no one's ever told, never seen, and I've lived it. I would go back to Oklahoma and start photographing my friends. That's when it snapped—I wanted to be a storyteller, tell a story. Which I hate even to admit to now, because I hate photojournalism so badly."[11] *Vagabond* (1975), a self-published book by Gaylord Oscar Herron (b.

1942), also from Tulsa, expanded the autobiographical form by presenting the artist as an outsider in search of metaphysical understanding.

Michael Lesy (b. 1945) revealed the subjective nature of historical investigations by showing viewers how historians are montagemakers who assemble, edit, and juxtapose images and text to impose order and meaning on the chaos of human and natural events. The extension of this line of reasoning denies that the facts of any photo-essay can been seen as the Truth. Lesy appropriated turn-of-the-nineteenth-century images of small town America by a Wisconsin photographer, Charles J. Van Schaick (1852–1946), and combined them with bizarre news items from a local weekly newspaper of the period to create *Wisconsin Death Trip* (1973). Lesy's montage, which received an enthusiastic reading, was structured entirely of quotations, unconcerned with the logic of observation, description, systematic analysis, or original intent. At a time when myth killing was a growing academic preoccupation in American Studies, Lesy fashioned a surrealistic psychohistory of a Midwestern American Dream revolving around pathological patterns of death, fear, and decline. Dwelling in the underworld of mental breakdowns, murder, sex, and suicide, Lesy undermined the notion that small-town America was an ideal, anxiety-free place.

At times the demarcation point between what is documentary and what is fiction can be difficult to distinguish. Eugene Richards (b. 1944), a former Vista worker, made the photographs for his book *Dorchester Days* (1978) throughout the 1970s. They are a dark, fragmented, diaristic chronicling of a poverty-stricken Boston neighborhood, whose residents show the consequences of being out of reach of the American dream. His documentary approach measured authenticity by how deeply he felt about the subjects he was involved with and photographed. Richards's *Knife and Gun Club: Scenes from an Emergency Room* (1989) led to accusations that he was a ghastly voyeur hooked on misery. In *Cocaine True Cocaine Blue* (1993) Richards coupled his images with the narrative voices of addicts and their families to provide a chilling account of how addiction has scorched their lives. Brent Staples, author of *Parallel Time: Growing Up in Black and White* (1994), accused Richards of prolonging myths of "black depravity," asking "why are nearly all of the people in these photographs black? [when] The vast majority of drug addicts in America are white."[12] Staples raises the larger issue of the inherent inequality between subjects and photographers in such undertakings. He makes the point that "When the culture focuses on black addiction alone, we miss the breadth of the danger and confine the problem to 'those people' over there."[13] This can be one of the difficulties of personal journalism, fueled as it is by the obsessions of even the most socially con-

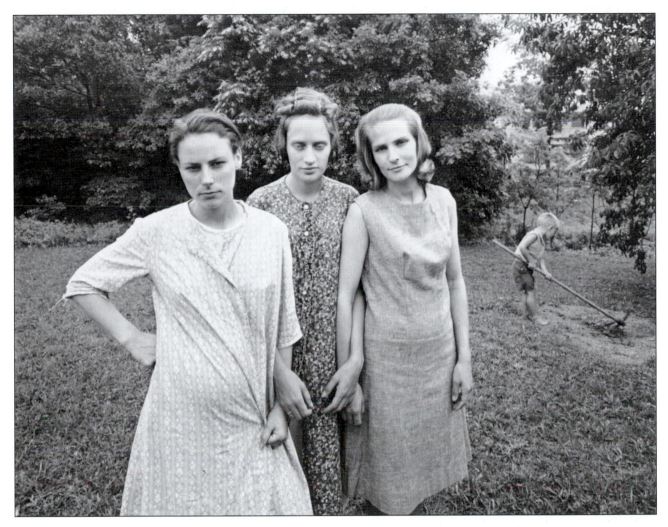

17.13  EMMET GOWIN.  *Edith, Ruth and Mae, Danville, VA,*
1971. 5¹¹⁄₁₆ × 7¼ inches. Gelatin silver print. Gowin says: "My
pictures are made as part of everyday life . . . with a camera on a
tripod. In this situation, both the sitter and photographer become
part of the picture. Sometimes my photographs resemble home
snapshots, . . . but I always want to make a picture that is more
than a family record. I feel that the clearest pictures were at first
strange to me; yet whatever picture an artist makes, it is in part a
picture of himself—a matter of identity."[14]  © Emmet Gowin. Courtesy
Pace/MacGill Gallery, New York.

scious photographers who bring their private concerns
and prejudices to a project. When asked by reporter
Lisa Redd if people of color are too often used to dem-
onstrate pathology in the media, Richards countered:

> If you are going to go out and do something about the way
> drugs are hurting people, you've got to say how it's hurting
> people. If you're going to do a book on the worst drug addic-
> tion, then you go to areas not unlike the ones I went to. The
> drugs are coming in and devastating these communities. You
> asked me if I understood the pain people are feeling from
> looking at those pictures? Of course I do. But you have to
> look at what the book is about. If I had done a book represent-
> ing black America, then I should have been shot. . . . Journal-

ism isn't journalism by consensus; it is by a person doing the
best he or she can to find the truth."[15]

## The Snapshot

Many photographers thought the experiments of the
1960s had taken photography away from its vernacular
roots and wanted to reassess photography's democratic
nature as manifested in the snapshot. The attraction
was the snapshot's artless ability to directly commu-
nicate the vitality of our ordinary, personal, and com-
munal affairs. A snapshot is not a manufactured episode
but a record that can reveal the essence of a situation.
Through a series of articles, interviews, and portfolios,
Jonathan Green's *The Snapshot* (1974) examines the
nature of the snapshot and its relationship to contempo-
rary photographic practice.[16] Green declared:

> The word snapshot is the most ambiguous, controversial
> word in photography since the word art. It has been bandied
> about as both praise and condemnation. It has been discussed
> as both process and product. A snapshot may imply the hur-
> ried, passing glimpse or the treasured keepsake; its purpose
> may be casual observation or deliberate preservation. The
> snapshot may look forward in time to a chaotic, radically

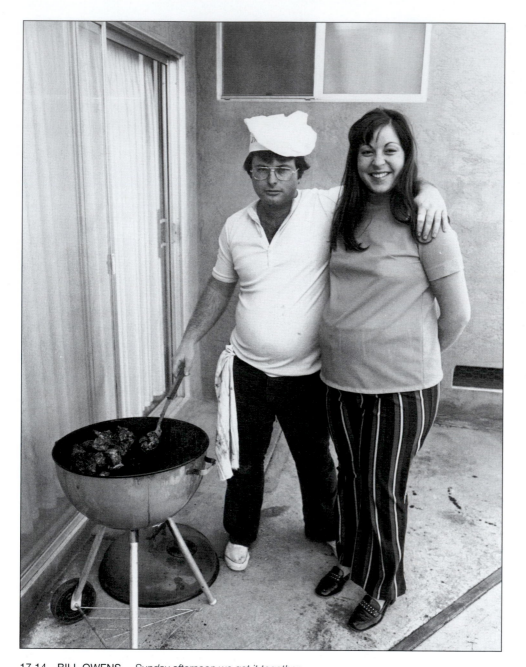

17.14  BILL OWENS.  *Sunday afternoon we get it together.
I cook the steaks and my wife makes the salad,* ca. 1970.
14 × 11 inches. Gelatin silver print. Owens wrote of his suburban
experience: "The people I met enjoy the lifestyle of the suburbs.
They have realized the American Dream. They are proud to be
home owners and to have achieved material success. To me
nothing seemed familiar, yet everything was very, very familiar. At
first I suffered from culture shock."[17]   © Bill Owens, Courtesy Robert
Koch Gallery, San Francisco.

photographic structure, the appropriate equivalent of modern
experience; or it may look backward to the frontal formal
family portrait of a bygone age.[18]

**Emmet Gowin** (b. 1941), one of the photographers
featured in *The Snapshot,* consciously incorporated the

personal iconography of his life in the rural South with
the "snapshot aesthetic." Gowin concentrated on his
immediate family and surroundings, doing extended
portraits of his subjects, especially his wife in allegori-
cal roles, like Madonna, mother, odalisque, prankster,
and Venus, and tableaus of family groups (see Figure
17.13). The actions of daily life take on a quixotic iden-
tity, while the injection of sensuality helps avoid senti-
mentality. Gowin considered this work, influenced by
Cartier-Bresson and Robert Frank, to be his apprentice-
ship, a necessary preparation that would help him find
his own photographic voice documenting the dramatic
contest between the powers of nature and culture.[19] His
search to "discover the inherent value that's hidden in
things that you haven't yet seen"[20] led Gowin into aerial
landscapes that seek a balance between the real and the

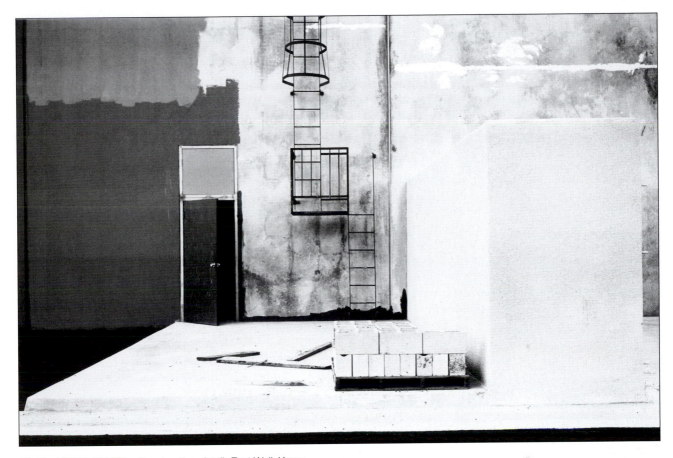

**17.15  LEWIS BALTZ.**  Construction detail, *East Wall, Xerox, 1821 Dyer Road, Santa Ana,* from Series Title "New Industrial Parks," 1974. 15.1 × 22.8 cm. Gelatin silver print.  Courtesy George Eastman House. © Lewis Baltz.

surreal, to reestablish his spiritual connectedness with nature.

Judy Dater (b. 1941) combined the intimacy of the snapshot with the formal structure of large-format interpretive portraiture. Her involvement in the developing women's movement manifested itself in a group of theatrical, urban portraits whose premise was that a woman, rather than a man, looking at women would bring fresh insights and display a different range of attitudes and styles. Dater's work rebelled against fashion's exploitation of women through expensive, superficial accessories that encourage unrealistic standards of appearance. Her nudes did not exploit women's sexuality but presented the women as being more at ease with their bodies. Often photographing her subjects in their own surroundings, Dater gave them leeway in determining the choice of costume and pose. In her work women were not defined by their outfits but by the strength of their physical presence.

One element of the snapshot, often lacking in serious imagemaking, is the recording of humorous events.[21] The acceptance of life's spontaneity and its ordinary subject matter into the 35mm aesthetic paved the way for humor-based photographers like Elliott Erwitt (b. 1928) and Burk Uzzle (b. 1938) to express their visual wit as a legitimate component of thoughtful imagemaking. **Bill Owens's** (b. 1938) *Suburbia* (1973), based on his work as a newspaper photographer for the Livermore, CA, *Independent,* satirizes the suburban experience of abundance. Owens's environmental portraits of Livermore residents (Owens lived there, too) were allegedly neutral, but his process of selection and the juxtaposing of these images with comments on "what the people feel about themselves"[22] deliver a devastating examination of a place lacking a collective focus and a historic identity (see Figure 17.14).

## Post-Structuralism/ New Topographics

*Post-structuralism,* based on the work of three French structural theorists, Jacques Derrida, Jacques Lacan, and Michel Foucault, formed the minimal and conceptual art movements of the 1970s. It posited that people are shaped by linguistic, psychological, and sociological structures over which we have no control, but which could be discovered by using the theory's methods of investigation. The premise was that texts, whether words or images, are unstable and cannot be trusted, and that everything is a momentary construction without a fixed

meaning or truth. Post-structuralism's elitist, jargon-filled writings countered the personal, emotion-filled work of the 1960s and rejected Western values as pointlessly transparent. It also served notice to historians and researchers that they must become aware of how their strategies affect the outcome of their research, even though it is impossible to move outside of a situation to do an objective study. Post-structuralists favored work that was emotionally detached and concerned with illusion and constructed reality. The approach of the "new topographics" would bring some of these concerns to photographic practice.

*New topographics* refers to the human-altered landscape that became a theme for photographers who sought a return to the landscape aesthetic without the romantic notions of the picturesque or the sublime. These photographers saw the once abundant landscape as physically and spiritually depleted, with only finite potentialities left.[23] To portray the drastic changes that had occurred to the landscape since the end of World War II, and to dispute the monumental myths of the enduring and lyrical American landscape, these image-makers photographed the intersection where nature and culture collided, such as the development of subdivisions near the mountains in Park City, UT. Their strategy was to take the direct nineteenth century view and use it to conduct a clinically detached examination of an uncomfortable subject. They looked for banal, little, minimal things along the road, avoiding the dramatic, heroic, and transcendental displays of Ansel Adams, to convey a sense of loss. They rebuked the sublime as an insupportable ghost of the past and embraced the ordinary iconography of urban modernity. New topographics practitioner Robert Adams (not related to Ansel) explained his position:

> To the extent that life is a process in which everything seems to be taken away, minimal landscapes are inevitably more, I think, than playgrounds for aesthetics. They are one of the extreme places where we live out with greater than usual awareness our search for an exception, for what is not taken away.[24]

The new topographics' ambivalent, highly structured, masculine approach also distanced their work from the poetic, pictorial expressionism of the 1960s. The viewers, like jurors in a courtroom, were expected to review the evidence and pass judgment.[25] The difficulty was that ordinary onlookers did not necessarily understand the premises informing the work. The minimalist stance of the new topographics photographers made many images interchangeable with commercial commissions, further confusing the public. The exhibition *New Topographics: Photographs of a Man-altered Landscape,* curated by William Jenkins at George Eastman House in 1975, featured Robert Adams, Lewis Baltz, Bernd and Hilla Becher, Joe Deal, Frank Gohlke, Nicholas Nixon, John Schott, Stephen Shore, and Henry

Wessel, Jr. (b. 1942). Jenkins linked their "stylistic anonymity" to conceptual artist Edward Ruscha's (b. 1937) sardonic, stripped-down, topographic books, such as *Twenty-Six Gasoline Stations* (1962), *Some Los Angeles Apartments* (1965), and *Every Building on the Sunset Strip* (1966), that shun beauty, emotion, Mother Nature, and sentiment. As John Schott (b. 1944), who did a series conceptually linked to Ruscha entitled *Route 66 Motels,* said: "They are not statements about the world through art, they are statements about art through the world."[26] This subtle approach pictures the inconspicuous nuances of the human constructions within the natural landscape, maintaining what Frank Gohlke (b. 1942) refers to as a "passive frame," where "there is a sense of the frame having been laid on an existing scene without interpreting it very much."[27]

**Lewis Baltz's** (b. 1945) project *The New Industrial Parks near Irvine, California* (1974) is a dispassionate, minimalist social critique of the desolate sites of the new urban/suburban landscape. Baltz claimed, "The ideal photographic document would appear to be without author or art."[28] Through the act of precise "Flaubertian" description, of finding just the right vantage point, Baltz used the discipline of formalism to order and repossess a bland, desolate subject. His sophisticated and unemotional disinterest symbolically presented the dehumanized, anywhere corporate warehouse space of the late twentieth century.

**Robert Adams** (b. 1937), a former English professor, takes a literary approach to the "New West," as site of diverse interaction between nature and culture. This approach was based on the personalized New Journalistic critiques of American society, such as Truman Capote's *In Cold Blood* (1966) and Norman Mailer's *The Executioner's Song* (1979), where tales of heroic deeds were replaced with a senseless lack of respect for life. In *The New West* (1974) Adams recognizes that the grace, beauty, and order of the open American West has been obscured by the confusing commercial upheaval of freeways, strip malls, tract and trailer homes (see Figure 17.16), and road signs. Adams uses a Western roadside scene as an analogy to explain what he is after:

> By Interstate 70: a dog skeleton, a vacuum cleaner, TV dinners, a doll, a pie, rolls of carpet. . . . Later, next to the South Platte River: algae, broken concrete, jet contrails, the smell of crude oil. . . . What I hope to document, though not at the expense of surface detail, is the Form that underlies this apparent chaos.[29]

Eastman House curator William Jenkins claimed that the purpose of his *New Topographics* exhibition was "not to validate one category of pictures to the exclusion of others,"[30] but the ease with which the style could be feigned brought out an army of imitators. *New Topographics* also neatly dovetailed with John Szarkowski's opinions about what a photograph should do and how a photograph was supposed to look, which he summed up

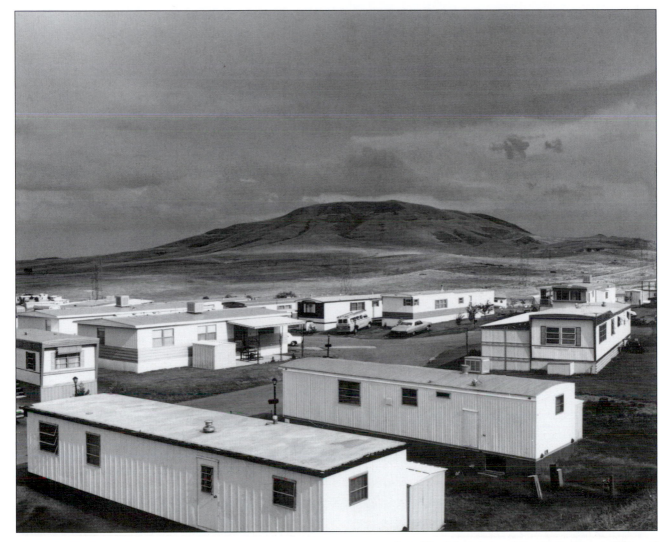

17.16   ROBERT ADAMS.   *Mobile homes, Jefferson County,
Colorado,* 1973. 5¹⁵⁄₁₆ × 7½ inches. Gelatin silver print.    © Robert
Adams. Courtesy Fraenkel Gallery, San Francisco.

in *Mirrors and Windows: American Photography since
1960* (1978). Szarkowski acknowledged "a fundamen-
tal dichotomy between those who think of photography
as a means of private, self-expression and those who
think of it as a method of exploration relating to public
concerns."[31] Szarkowski's allegiance was with the lat-
ter who acted "as a trustworthy interpreter of events
and issues he was privileged to witness."[32]

## The Rephotographic Survey Project/Time Changes

Between 1977 and 1979, the Rephotographic Sur-
vey Project (RSP), formed by **Mark Klett** (b. 1952),
Ellen Manchester, JoAnn Verburg (b. 1950), **Gordon
Bushaw** (b. 1947), and Rick Dingus (b. 1951), pre-
cisely rephotographed 122 nineteenth-century Western

survey sites, like Mountain of the Holy Cross, CO, and
Canyon de Chelly, AZ, that had been pictured a cen-
tury before by Western photographers. After the cool-
ness of the New Topographics, the RSP contrasted how
nineteenth-century photographers saw the landscape
with the unfolding interaction of human development
and natural transformations over time. The project's
act of pairing old and new images showed how photo-
graphs can display and measure time (see Figures 17.17
and 17.18). This method established a dualistic mean-
ing of time and space, putting spectators into a time
machine that permits them to glance between then and
now. The group effort of doing "a survey of a survey"
led RSP participant Verburg to reflect:

> Our representation of the West is less the result of what we
> noticed or preferred then [sic] of what we found—changed
> or not,—at predetermined vantage points. So, ironically our
> survey did what theirs [the original survey photographers]
> purported to do: to show the West without shaping it to our
> own artistic purposes.[33]

The RSP was indicative of a larger cultural interest in
reseeing and reassessing American values. Other pho-
tographers during this time took a different approach to

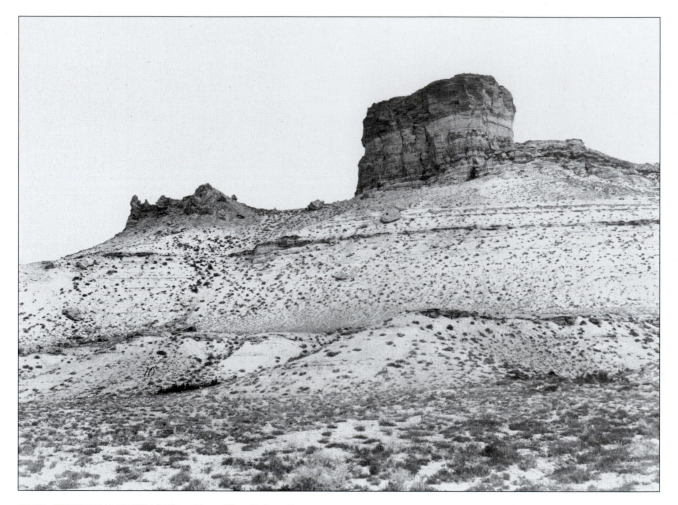

17.17 TIMOTHY H. O'SULLIVAN. *Green River Buttes, Green River WY,* 1872. 6¼ × 8½ inches. (plate 130) Albumen silver print. U.S. Geological Survey. Print courtesy Mark Klett. Harry Ransom Humanities Research Center, The University of Texas at Austin.

re-entering the past. Bill Ganzel (b. 1949) did not replicate FSA pictures in his *Dust Bowl Descent* (1984), but he revisited many of the same people and scenes that had been photographed during the original project, examining cultural changes and ways in which meaning is transformed by new contexts. Nicholas Nixon's (b. 1947) yearly ritual of taking the same pose of his wife and her sisters, allows small physical changes to take on larger psychological importance. This serial approach to time elevates private subjects into symbols of aging and change. In the early 1970s, **Milton Rogovin** (b. 1909) made a series of working-class people's portraits near his neighborhood in Buffalo, NY. He returned to photograph the same people in the early 1980s and again in the 1990s. The results were published as *Triptychs: Buffalo's Lower West Side Revisited* (1994) so that viewers could compare the photographs to see how the people aged, changed, and endured over time (see Figure 17.19). More recently, Douglas Levere's (b. 1966) *New York Changing* (2004) painstakingly rep-

licates the images in Berenice Abbott's *Changing New York* (1939), illuminating the only constant is change itself.

## Color Rising

The experimental characteristic of the 1960s and 1970s saw the emergence of color from the commercial world into the realm of art. Previously only a few photographers, such as Ernst Haas, Helen Levitt, Eliot Porter, and Arthur Siegel, could claim significant bodies of work in color. Associated with the garish and decorative ways of advertising, color had been deemed inappropriate for art photographers. As magazines ran more color and as color materials became less expensive, easier to use, and more permanent, an increasing number of photographers ignored the commercial stigma and ventured into this sphere.

A cadre of photographers had built a fine art aesthetic of photography around black-and-white images. After World War II Kodak tried to encourage the artistic use of color materials by giving boxes of 8 × 10-inch Kodachrome to some of these photographers like Edward Weston and Walker Evans who were extremely suspicious of color; they believed it exagger-

17.18   MARK KLETT AND GORDON BUSHAW. *Castle Rock, Green River, WY*, 1979. 6¼ × 8½ inches. Gelatin silver print.
© 1979 Mark Klett and Gordon Bushaw for the Rephotographic Survey Project. Harry Ransom Humanities Research Center, The University of Texas at Austin.

ated realism while diminishing expressiveness. Most remained unconvinced. As late as 1969 Walker Evans said: "These are four simple words which must be whispered: color photography is vulgar."[34]

By 1965 color, through movies and television, was omnipresent in American life, and for the first time both amateur and commercial photographers bought more color film than black-and-white. Color's former drawbacks now became sought-after characteristics. In the spirit of the 1960s, color was seen as shattering photography's traditions and meshing with the here and now on its own terms. The 1966 MoMA exhibition of 4 × 5-inch Polaroid images by Marie Cosindas (b. 1925) signaled Szarkowski's willingness to unlock the door of high art to color.

In 1976 Szarkowski mounted a major exhibition of **William Eggleston's** (b. 1939) work at MoMA that touched off arguments over color photography's status in the art world. In the catalogue, *William Eggleston's*

*Guide* (1976), Szarkowski claimed the works were "perfect: irreducible surrogates"[35] of understated, vernacular views about the social landscape of the New South. Often verging on the trivial, the enlarging of Eggleston's personal "snapshots" into lush dye-transfer prints, making them valuable art objects, exaggerated the mundane and confronted onlookers with the insipid emptiness of the contemporary American environment (see Figure 17.20). Eggleston's openness to the most insignificant subject matter, like a dog lapping water from a puddle or an inside view of a home oven, gave the idea that anything could be photographed. His unpretentious approach that found intriguing images in what others ignore was criticized as one of diminishing expectations, an epiphany of the banal, a declaration that there was nothing left to photograph. Many viewers were unwilling to elevate a mundane color snapshot to High Art. Art critic Hilton Kramer responded to Szarkowski's claims by writing, "Perfect? Perfectly banal, perhaps. Perfectly boring, certainly."[36]

In the afterword of *The Democratic Forest* (1989), Eggleston laments that the public only looks at his subject matter and not at how he has "seen" it. Critics raise the point that people might not care for such nihilistic work because it affirms nothing but one individual's idiosyncratic way of seeing. Photographers tend to

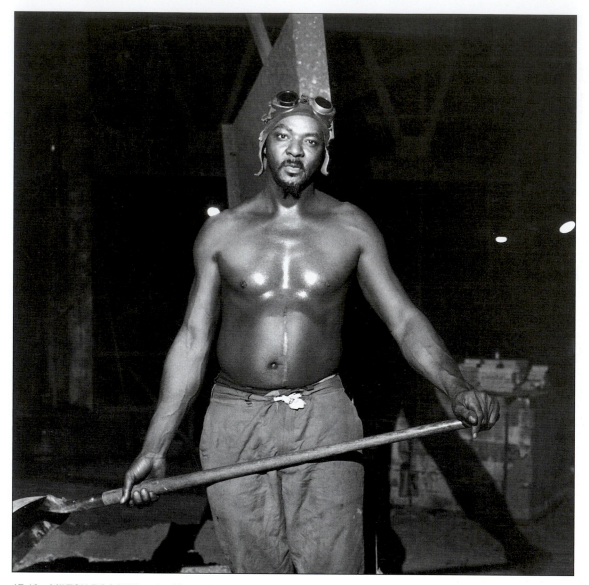

17.19  MILTON ROGOVIN.  *Joe Kemp,* from the series *Working People,* 1976. Gelatin silver print.    Courtesy the Rogovin Collection.

conclude that such shortcomings of understanding are those of the audience and not the makers. Indirectly, Eggleston raises questions about the interpretation and response to images. Are these issues strictly problems for viewers or are they a shared concern, an interaction between makers and viewers, and what, if any, responsibility do photographers have for educating their audience? The controversy surrounding Eggleston's work became part of a full-scale discussion about color practice and its dramatic emergence in the 1970s as an acceptable artistic form.

The Eggleston exhibition officially welcomed other photographers, like **Stephen Shore** (b. 1947), whose color work was also shown at MoMA in 1976. Shore's 8 × 10-inch color view camera images, which he began

making in 1974, formally described familiar but peopleless scenes within the human-altered landscape of the new topographics style. His passive yet circumspect work found acceptance in Szarkowski's schema by setting up a distilled atmosphere and spatial arrangement for contemplating this secular world with the utmost clarity and detail. Shore's deadpan restraint, as seen in *Uncommon Places* (1982), subdues the easy, sensuous nature of the color palette and concentrates on the nuance of natural light and color upon the artifacts of street life without human presence.

The rethinking of color as a viable option for serious photography is evident in the work of **Joel Meyerowitz** (b. 1938). After watching Robert Frank work and realizing the gestural potential of the small camera, Meyerowitz left his career in advertising to become a black-and-white style street photographer. By the late 1960s he used color for its additional descriptive qualities. In 1976 Meyerowitz began to photograph with

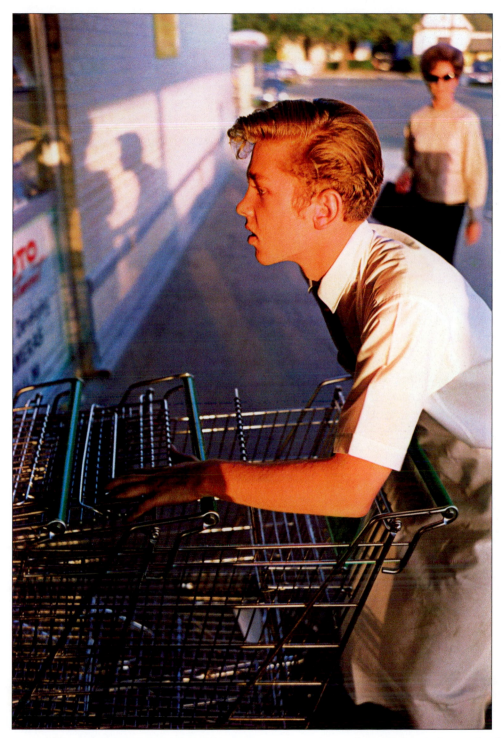

17.20  WILLIAM EGGLESTON.  *Untitled [Supermarket Boy with Carts]* from the *Los Alamos Portfolio*, 1965–1974. Variable dimensions. Dye-transfer print.    © 2009 Eggleston Artistic Trust. Courtesy Cheim & Reid Gallery, New York.

an 8 × 10-inch view camera around Cape Cod, MA, concerning himself with the polymorphous aspects of sand, sky, and water. The publication of his popular *Cape Light* (1978) announced the shift from the split-second, jazzy black-and-white improvisations of 35mm street photography to the formal, contemplative, and descriptive qualities of a view camera and an orchestral color palette that viewers could readily understand. Meyerowitz now lingered around a scene, waiting to record the subtle passages of light and time that slowly transformed the subject (see Figure 17.22). His color prints stress a slower, more distant, romantic, sensuous response to luminous effect, the pure beauty of light, rather than the close, edgy, instantaneous reaction of the black-and-white street moment. Meyerowitz recalled

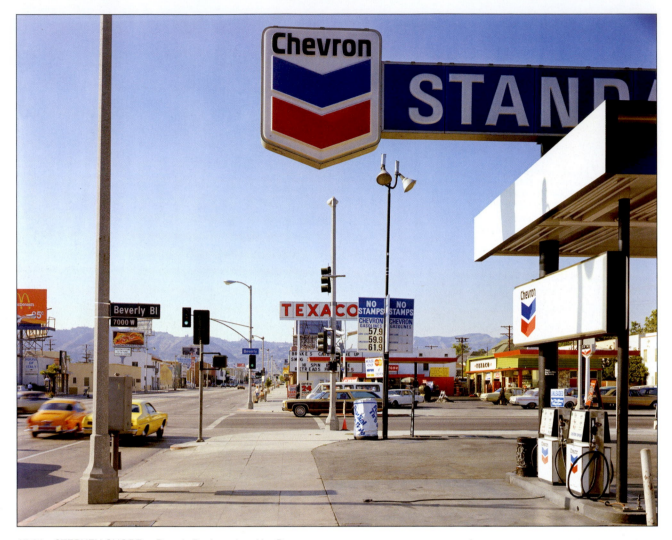

17.21  STEPHEN SHORE.  *Beverly Boulevard and La Brea Avenue, Los Angeles, CA,* June 21, 1975. 20 × 24 inches. Chromagenic color print.    Courtesy 303 Gallery 303, New York.

the descriptive and suggestive qualities that led him to pursue color photography:

> When I committed myself to color exclusively, it was a response to a greater need for description . . . color plays itself out along a richer band of feeling—more wavelengths, more radiance, more sensation. . . . Color suggests more things to look at [and] it tells us more. There's more content [and] the form for the content is more complex.[37]

Of late, Meyerowitz's *Aftermath* (2006) provides a color archive of the ruins of Ground Zero and those who assisted in the clean-up process after the attacks on the World Trade Center on September 11, 2001.

Following her dictum that "formalism is everything,"[38] Jan Groover's (b. 1943) still-life arrangements proved popular with institutions, such as MoMA, that held on to formalism because it was familiar and understandable to their audiences and staffs. In reaction to the societal looseness of the 1960s, Groover

empirically exercised control over color, form, light, and space in her studio. "For me, the rules are how things go together,"[39] she stated. The isolated spatial readability of the large format enabled her to create perceptual illusions that suspend normal photographic time. Groover's precisely arranged still-lifes impart an impression of being in the present rather than in the past. Through her use of reflection and transparency, Groover fabricates a sensation of spatial ambiguity in which depth becomes inaccessible and observers experience a disruption of *figure-ground,* the relationship between the subject and the background. The enlarging process further distorts reality by making commonplace objects, like kitchenware, slightly larger than life, giving them a sculptural personality that makes viewers reconsider the prosaic.

**John Pfahl's** (b. 1939) *Altered Landscapes: The Photographs of John Pfahl* (1981), playfully uses the cyclopean vision of a view camera to reveal the synthetic nature of Renaissance pictorial theories of distance, perspective, and scale. Pfahl maintains an intellectual distance by combining the picturesque, nineteenth-century landscape with his own formal manipulation

17.22    JOEL MEYEROWITZ.    *Bay/Sky, Provincetown*, 1977.
16 × 20 inches. Chromogenic color print. (Cat #66 from book
*Cape Light*.)    © Joel Meyerowitz.

of scenes, from the exact vantage point of the camera, delivering a conflicting message in a single image. Pfahl gives ironic colorful evidence of that which we believe cannot be so, humorously informing onlookers that all facts are conceptual and that visual truth is a matter of consensual agreement (see Figure 17.23).

**Joel Sternfeld's** (b. 1944) cross-country pilgrimages in a Volkswagen camper are about reconciling issues of appearance and myth with the landscape. As seen in *American Prospects* (1987), Sternfeld uses a 8 × 10-inch camera to load his color documents with a tension caused by the intrusion of mundane human objects and the invasiveness of technology on the beautiful and sublime landscape. Sternfeld often relies on humor to confront intriguing contradictions and incongruities that unmask the superficial and call attention to ordinary life (see Figure 17.24).

The aggressive, close-up, flash 35mm images of Mark Cohen's (b. 1943) extend the formal sense of how

a color photograph can look. Cohen's physical intrusiveness violates society's comfortable proximal distance to document private portions of a subject's personal space. His "grab shot" images of the goings on within an inner city neighborhood deliver undefended views that disrupt the rules about how photographs are made and how they appear. Cohen is not looking for detached observations but active, in-your-face engagements with strangers that are brazenly uncivil and can produce social embarrassment and confrontation. These forced encroachments get to the crux of the struggle, which began with the small hand-held camera, between photographers who pursue images without permission and the subject's right to privacy and ability to respond to an intrusion. Cohen's incursions are about the power to control visual representation, the photographer's ability to stealthily make pictures by surprise and capture the subject's response.

## Artists' Books

At the same time the formal physical concerns of photographic practice were being addressed by many photographers, other artists were examining photography's

**17.23   JOHN PFAHL.**   *Great Salt Lake Angles, Great Salt Lake, Utah,* October, 1977. 8 × 10 inches. Chromogenic color print.
© John Pfahl.

cultural context. Lew Thomas's *Photography and Language* (1976) used the work of over 30 artists to investigate the interrelationships of images and text. During the 1960s, members of the Fluxus group worked to break down the barriers between art and the public. Their activities can be linked with a new interest in the book format. During the 1970s, artists' books became a way for imagemakers to control production and costs, deliver their work to an audience in context, and express concepts too complex for a single image. Artists' books used autobiography, narrative, and humor to deal with the new pluralistic concerns of women and minorities that surfaced in the 1960s.[40]

Artists set up independent presses, like Joan Lyons's (b. 1937) Visual Studies Workshop Press in Rochester, NY, to publish works by other artists.[41] Keith Smith (b. 1938), who studied at the Institute of Design and made work at VSW, produced over a hundred artists' books, featuring an interactive use of materials that took the medium beyond its factual realm. Scott Hyde (b. 1926) worked directly from color separations so that every image in his offset, photolithograph books and journals was an "original." Canadian Michael Snow's

(b. 1929) *Cover to Cover* (1975) investigated the nature of the book, the concept of the sequence, the act of picturing, and the process of perception.

In a world that has witnessed a steady decline in the role of animals, Peter H. Beard's (b. 1938) *African Diaries* (1978) juxtaposed a tapestry of collaged newspaper clippings, Polaroid SX-70s, snake skins, and handprints made from his own blood with images of fashion, "primitive" culture, and wild animals to tell "secrets" about his adopted home in Kenya. Beard's foot-high memento scrapbooks reveal the diversity of the book form in terms of object, image, and its ability to transform the personal into a shared experience that reminds us of the important connections between the animal and human kingdoms. Combined with his earlier photo essay, *The End of the Game* (1965), Beard's work helped replace the high-powered firearms safaris with high-tech camera safaris to the world's wildlife meccas.

## Reconfiguring Information

Nancy Rexroth's (b. 1946) non-linear memory book, *Iowa* (1977), made with a Diana camera,[42] and Eric Renner's (b. 1941) use of pinhole cameras dispute the modernist presumption that equates image sharpness with quality of information. The toy Diana camera

17.24   JOEL STERNFELD. *McLean, Virginia, December 4, 1978*, 18 × 22 inches. Chromogenic color print.   Courtesy the artist and Luhring Augustine, New York.

achieved cult status among photographers for being noncommercial and nonconformist. Its cheap plastic construction made it notorious for producing light leaks and guaranteed low image resolution. *The Less Than Sharp Show* (1977) demonstrated how variety of practice could "relax the veracity issue of a photographic image." The exhibition featured an array of eccentric approaches that disassembled image clarity, including Gary Hallman's (b. 1940) use of flash during long exposures, Bea Nettles's Kodak Instamatic camera work, and Linda Connor's (b. 1944) old 8 × 10-inch view camera with a soft-focus lens. Curator Howard Kaplan wrote:

> The less than sharp image facilitates the viewing of the photograph for its intrinsic value as a photograph, as opposed to a document of what once existed. . . . Being spared much of the hard edge content associations, the viewer can now focus on other aspects of the photographic image. . . . The *new* content may now be quite *loaded* so as to provoke quite different associations/experiences from it.[43]

**Ruth Thorne-Thomsen's** (b. 1943) poetic *Expeditions* combine collage aesthetic expectations based on nineteenth-century travel pictures and pinhole images to construct false historical landscapes. The softness of the pinhole distorts one's perception of time and scale, allowing viewers to become dreamlike voyagers into the personal archetypes of their subconscious (see Figure 17.25).

Photographers taking camera equipment into the night also overturned historic landscape traditions. Roger Mertin (1942–2001) and Richard Misrach applied flash to distort and prolong time. Steve Fitch's (b. 1949) night images in *Diesels and Dinosaurs* (1976) string together a progression of nocturnal illuminations, adding mystery to banal American road culture. Robert Hirsch's (b. 1949) outdoor, nighttime flashes, printed on non-conventional materials including Kodalith, disturbed conventional print values and expanded the sense of the 35mm frame by adding time and movement during the printing process. This was part of a *haptic,* or kinesthetic, approach that actively incorporated the photographer into the entire picturemaking process. Such approaches, encompassing numerous alternative methods like hand-coloring, enlarger move-

17.25 RUTH THORNE-THOMSEN. *Head with Plane, IL,* 1979.
4 × 5 inches. Toned gelatin silver print. © Ruth Thorne-Thomsen.
Courtesy Laurence Miller Gallery, New York.

ment, appropriated images, and toning, destabilized the orthodox photographic rendition of the landscape and often injected a feeling of estrangement and separation from nature.

**David Levinthal** (b. 1949) and cartoonist Garry Trudeau collaborated to produce *Hitler Moves East: A Graphic Chronicle, 1941–43* (1977), rerepresenting World War II battle scenes from the eastern front using miniature studio sets and selected archival materials, which were also printed on graphic arts paper (Kodalith) not intended for pictorial purposes. These small atmospheric tableaux, based on actual visual models, utilize the historical illusionism of documentary war images to narrate and make the past accessible (see Figure 17.26). Levinthal has continued to mine these fabricated tabletop landscapes in books that examined *Modern Romance,* (1985), *The Wild West,* (1993), and *Mein Kampf,* (1996). The images strike at the genuineness of photographic meaning while remaining believable, enabling viewers to criss-cross between their imagination and reality. Levinthal said that his tiny scenes "were mirrors of society's image of itself, much like Norman Rockwell paintings for the *Saturday Evening Post.* Playsets reinforced the popular culture and beliefs and stereotypes of America."[44]

## Expanding Markets

Government funding from the National Endowment for the Arts (NEA) sparked artistic growth in the 1970s. Created in 1965 as a tiny part of President Johnson's Great Society program, the NEA made its first grant to an individual photographer, Bruce Davidson, in 1968. The agency set up a special category for Photographer's Fellowships in 1971 (discontinued in 1996), giving recognition to photography as an independent art form, and in 1972 began its Workshop Program to fund the first generation of "artist-run" spaces, which led to the founding of other not-for-profit spaces. The following year, the NEA established grant categories for Photography Exhibitions and Publications, enabling museums and alternative spaces to produce their own projects and literature.

NEA funding encouraged the formation of state art councils and the giving of private matching donations, which helped artist-run spaces expand and achieve a limited degree of stability.[45] Artist-run spaces are creation and presentation sites for new artists and their ideas that

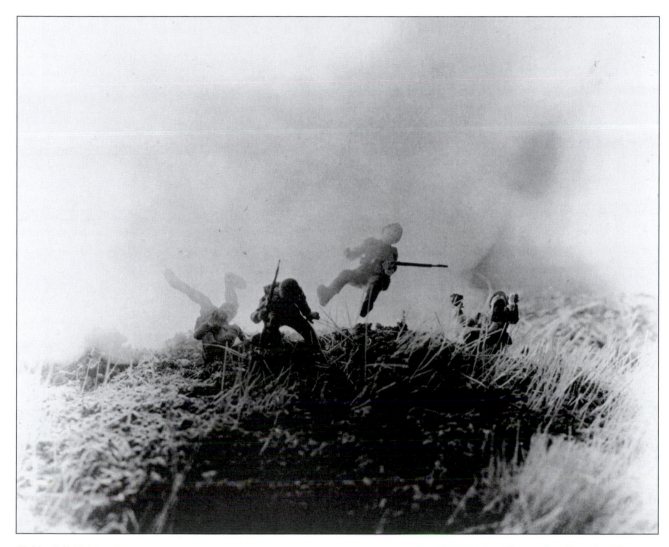

17.26   DAVID LEVINTHAL.   *Untitled*, from *Hitler Moves East*, 1976. 8 × 10 inches. Gelatin silver (Kodalith) print.   Courtesy David Levinthal.

continue to play a pivotal role in maintaining the vital and experimental outlook of American photographic practice, providing a flexible and meaningful alternative to the more rigid framework of commercial galleries and large museums. These spaces provide outlets that champion diversity and broaden the scope of artistic and critical practice. The success of such initiatives can be seen along Interstate 90 in central and western New York, an essential photographic corridor that has been a focus of alternative activities and currently is home to Light Work in Syracuse (founded 1973), Visual Studies Workshop in Rochester (1969), and CEPA (Center for Exploratory and Perceptual Art) in Buffalo (1974).[46]

The expansion of photographic practice in the early 1970s resulted in the establishment of a new generation of commercial galleries, such as Lee D. Witkin's Witkin Gallery (1969–1999) and Light Gallery (1971) in New York, and museum programs, including the California Museum of Photography (1973), the International Center of Photography (1974), the Center for Creative Photography (1975), and the Chicago Center for Contemporary Photography (1976), succeeded by the Museum of Contemporary Photography (1984), all dispensing photography to a wider audience. High school, college, and university photography courses continued to expand, giving rise to record numbers of people earning Master of Fine Arts degrees in photography. The university scene connected photography to the art gallery world, enabling a few imagemakers to support themselves by selling their work. New York gallery interest led photography into the art auction market, which intensely raised the price of historical photographs. While the recession of 1979–1982 drastically cooled down the market, prices for both historical and contemporary photographs would expand beyond the economic gains of the early twenty-first century and photography now has fully established a place in the commercial side of the art world.

## Critical Writing

The 1970s witnessed a wave of republished works, such as *The Literature of Photography: An Arno Press*

*Collection* (1973), which included 62 classic volumes on aesthetic, historical, scientific, and technical aspects of photography. Barbara London and John Upton's *Photography* (1976), based on the *Life Library of Photography* (1970–1972), provided an opportunity for teachers to break out of the mechanic, manual mentality of instruction by linking ideas to technique and providing readers with stimulating visual examples. The 1970s saw a widening of photography's intellectual base with the founding of publications such as Visual Studies Workshop's *Afterimage* (1972) and Friends of Photography's *Untitled* quarterly series (1972) and the evolution of SPE's *exposure* into a critical journal (ca. 1973). The editorial policies of *Afterimage* and *exposure* gave voice to feminist and lesbian theorists, such as Catherine Lord, Jan Zita Grover, and Deborah Bright.[47] A. D. Coleman began to write serious photography reviews for the general public in the *Village Voice* (1968–1973) and *The New York Times* (1970–1974).[48] Additional voices included Marxist critic John Berger's *Ways of Seeing* (1972), which critiqued Western capitalist art as a symbol of ownership and a demonstration of male power. Allan Sekula and Martha Rosler also wrote Marxist and feminist political critiques for *Artforum*[49] and *exposure*.[50]

The 1973 publication by the *New York Review of Books* of Susan Sontag's (1933–2004) critical essay about the nature of photography, later expanded and revised as *On Photography* (1977), initiated a serious intellectual dialogue from within the practice and the community of arts and letters. In spite of her sharp critique of the medium, Sontag related how viewing photographs of Nazi concentration camps changed her own life:

> Nothing I have seen—in photographs or in real life—ever cut me as sharply, instantaneously. Indeed, it seems plausible to me to divide my life into two parts, before I saw those photographs (I was twelve) and after . . . something broke. . . . I felt irrevocably grieved, wounded, but a part of my feelings started to tighten; something went dead; something is still crying.[51]

The experience shaped her belief that the "camera is sold as a predatory weapon. . . . To photograph people is to violate them, by seeing them as they never see themselves, by having knowledge of them they can never have; it turns people into objects that can be symbolically possessed. Just as the camera is a sublimation of the gun, to photograph someone is a sublimated murder—a soft murder."[52] Sontag's distressed response to these horrific images led her to later argue that photography desensitizes its audience. Although numerous photographers and critics were upset with Sontag's claims, based on an educated sensibility from outside the field rather than a research methodology from within the practice, her writing raised fundamental philosophical questions facing the medium. Ultimately, many of Sontag's assertions were refuted, even by the author herself in *On the Pain of Others* (2003). No other book about photography has been so hotly analyzed and discussed from so many competing standpoints.

There was renewed interest in the writing of Walter Benjamin, to whom Sontag paid homage in the last chapter of *On Photography,* and to Barthes's and Derrida's concept of *deconstruction,* that is, the recognition and understanding of the underlying and generally unspoken and implicit assumptions, concepts, and frameworks, which form one's thoughts and beliefs. As we shall see, this exposing and tearing down of any arbitrary construction of reality began to appear in a photographic context in works by John Baldessari, Sherrie Levine, and Richard Prince (see Chapter 18). These writings forecast the rise of *postmodern criticism,* the rejection of the notion of originality in a society that ceaselessly recycles ideas and images, as espoused by Craig Owens and Douglas Crimp in the late 1970s in the journal *October.* The collective effect of these endeavors was a broadening of the practice to include a greater diversity of approaches and voices, particularly those of women, gay, and minority imagemakers, or *the Other,* challenging power relationships between photographers and subjects and how viewers see and understand these associations.

## Endnotes

1   William Larson, letter to author, February 12, 1999.

2   Kathleen McCarthy Gauss, *Inventories and Transformations: The Photographs of Thomas Barrow* (Albuquerque: University of New Mexico Press, 1986), 120.

3   Carl Chiarenza, "Eye and Mind: The Seriousness of Wit," in Lynne Warren, *Kenneth Josephson* (Chicago: Museum of Contemporary Art, 1983), 7.

4   Ralph Eugene Meatyard, with texts by Jonathan Greene, et al., *The Family Album of Lucybelle Crater* (Millerton, NY: Jargon Society, 1974), 73.

5   See A. D. Coleman, *The Grotesque in Photography* (New York: Ridge Press/Summit Books, 1975).

6   Peter Schjeldahl, "The Wizard in the Tower," in *Lucas Samaras* (New York: Pace/MacGill Gallery, 1991), unp.

7   Lucas Samaras, *Samaras Album* (New York: Whitney Museum/Pace Editions, 1971), 9.

8   The Lustrum line featured Danny Seymour's *A Loud Song* (1971), Robert Frank's *The Lines of My Hand* (1972),

Larry Clark's *Tulsa* (1971), as well as instructional books such as *Darkroom, Darkroom II, SX-70, Contact Theory, Landscape Theory,* and *Nude: Theory.* In addition, Lustrum published Gibson's dreamlike trilogy of photo-novels *The Somnambulist* (1970), *Deja-Vu* (1973), and *Days at Sea* (1974).

9    Ralph Gibson, *The Somnambulist* (New York: Lustrum Press, 1970), unp.

10    Larry Clark, preface, *Tulsa* (New York: Lustrum Press, 1971), unp.

11    Larry Clark, *Flash Art,* May/June 1992, quoted in Brooks Johnson, *Photography Speaks II* (New York: Aperture/The Chrysler Museum of Art, 1995), 106.

12    Brent Staples, "Coke Wars," *The New York Times Book Review,* Sunday, February 6, 1994, 11–12.

13    Ibid.

14    Emmet Gowin, *Emmet Gowin: Photographs* (New York: Alfred A. Knopf, 1976), 100.

15    Eugene Richards, *ReView,* vol. 17, no. 3 (May/June 1994), 13. Unhappy with the context of how his work was being discussed, Richards declined to give permission to reproduce an image.

16    *The Snapshot* included work by Emmet Gowin, Henry Wessel, Jr., Tod Papageorge, Joel Meyerowitz, Nancy Rexroth, Garry Winogrand, Lee Friedlander, and Robert Frank.

17    Bill Owens, *Suburbia* (San Francisco: Straight Arrow Books, 1973), unp.

18    Jonathan Green, Introduction, *The Snapshot* (Millerton, NY: Aperture, 1974), 3.

19    See Sally Gall, "Emmet Gowin," *Bomb 58,* Winter, 1997, 21.

20    Ibid.

21    For an early history of this genre see Heinz K. Henisch and Bridget A. Henisch, *Positive Pleasures: Early Photography and Humor* (University Park: The Pennsylvania State University Press, 1998).

22    Owens, unp.

23    The photographers of the "New Topographics" were working in the same arena as eclectic postmodern architect Robert Venturi, whose book *Learning from Las Vegas* (1972) emphasizes the validity of American roadside strip building and advertising.

24    Robert Adams, "In the Nineteenth-Century West," in *Why People Photograph* (New York: Aperture, 1994), 148–49.

25    In terms of popular culture, the New Topographics mission can be summed up by the *Dragnet* TV character, Joe Friday, played by the deadpan Jack Webb, who was always instructing witnesses to deliver "just the facts."

26    John Schott quoted by William Jenkins, Introduction, *New Topographics: Photographs of a Man-altered Landscape* (Rochester, NY: George Eastman House, 1975), 5.

27    William Jenkins, *New Topographics,* 5.

28    Lewis Baltz quoted in *New Topographics,* p. 6, from review of *The New West* by Robert Adams, in *Art in America,* vol. 63, no. 2 (March/April 1975), 41.

29    Robert Adams, *New Topographics,* 7.

30    William Jenkins, *New Topographics,* 7.

31    John Szarkowski, *Mirrors and Windows: American Photography since 1960* (New York: The Museum of Modern Art, 1978), 11.

32    Ibid.

33    JoAnn Verburg, "Between Exposures," Mark Klett, et al., *Second View: The Rephotographic Survey Project* (Albuquerque: University of New Mexico Press, 1984), 10.

34    Quoted in Louis Kronenberger, *Quality: Its Image in the Arts* (New York: Atheneum, 1969), 208.

35    John Szarkowski, *William Eggleston's Guide* (New York: The Museum of Modern Art, 1976), 14.

36    Hilton Kramer, "Art: Focus on Photo Shows," *The New York Times* (May 28, 1976) Section C, 18.

37    Joel Meyerowitz, *Cape Light: Color Photographs by Joel Meyerowitz* (Boston: New York Graphic Society, 1978), unp.

38    Jan Groover, Renato Danese, ed., *American Images* (New York: McGraw-Hill, 1979), 140.

39    Jan Groover, *Outside the City Limits: Landscape by New York City Artists,* exhibition catalogue (Sparkill, NY: Thorpe Intermedia Gallery, 1977), 22.

40    Pluralists oppose the notion of having a single mainstream of thought in favor of a multitude of approaches that present diverse points of view.

41    See Joan Lyons, ed., *Artists' Books: A Critical Anthology and Sourcebook* (Rochester: Visual Studies Workshop, 1985).

42    See David Featherstone, *The Diana Show: Pictures Through a Plastic Lens, Untitled 21,* (Carmel, CA: Friends of Photography, 1980).

43    Howard N. Kaplan, *The Less Than Sharp Show* (Chicago: The Chicago Photographic Gallery of Columbia College, 1977), 4.

44    David Levinthal, *Small Wonder: Worlds in a Box* (Washington: National Museum of American Art, 1996). Front interior dustjacket.

45    For a critical article about the NEA and artist-spaces, see Grant Kester, "Rhetorical Questions: The Alternative Arts Sector and the Imaginary Public," *Afterimage* (January 1993), 10–16.

46    Some of the other important alternative photographic spaces that continue to operate include The Light Factory (Charlotte, NC); San Francisco Camerawork (San Francisco, CA); Photographic Resource Center (Boston, MA); Houston Center for Photography (Houston, TX); The Center for Photography at Woodstock (Woodstock, NY); Blue Sky Gallery (Portland, OR) and Minnesota Center for Photography (Minneapolis, MN). The NEA ended general operating support to all of these organizations in 1996. In 1998 the Supreme Court ruled that "decency" standards could be considered in awarding federal art grants. Information about each of these organizations can be found by visiting its website.

47   See Deborah Bright, ed., *The Passionate Camera: Photography and Bodies of Desire* (London and New York: Routledge, 1998).

48   See A. D. Coleman, *Light Readings: A Photography Critic's Writing, 1968–1978* (New York: Oxford University Press, 1979).

49   See Allan Sekula, "On the Invention of Photographic Meaning," *Artforum*, vol. 13 (January 1975), 36–45; "The Instrumental Image: Steichen at War," *Artforum*, vol. 14 (December 1975), 26–35.

50   See Martha Rosler, "Lookers, Buyers, Dealers, and Makers: Thoughts on Audience," *exposure*, vol. 17, no. 1 (1979), 10–25.

51   Susan Sontag, *On Photography* (New York: Farrar, Straus and Giroux, 1977), 20.

52   Ibid., 14–15.

# Thinking About Photography

## Conceptual Art: The Act of Choosing

During the socially turbulent 1960s, artists rethought the roles of photographers, photographs, and viewers. Photographic practice shifted from modernistic formalism that emphasized compositional and tonal elements of the straight print to a conceptual approach in which ideas took precedence over how subjects were depicted. *Conceptual art* offered a way to circumvent commercialization and formalism and supply a concrete framework for cerebral works of art. Conceptual artists adopted photographs, undervalued by the art establishment, as organizing mechanisms for transmitting cultural messages. Applying aspects of semiotics, feminism, and popular culture, conceptual artists used the camera as an alleged neutral recording device. They made deadpan prints that appeared to be aesthetically artless and that bore little resemblance to traditional fine art objects.

Conceptual artistic collaborations and networks like Fluxus, which included Joseph Beuys (1921–1986), **Nam June Paik** (1932–2006), and Yoko Ono (b. 1933), upset bourgeois expectations by choosing intangible intellectual/social concerns over discernible aesthetic/visual ones. Although

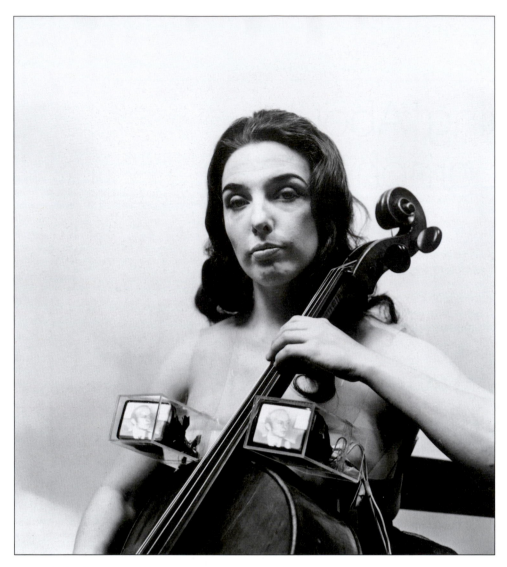

**18.1    NAM JUNE PAIK.** *TV Bra for Living Sculpture,* 1969.
Television sets and cello (worn by cellist Charlotte Moorman).
Gelatin silver print.    © Estate Nam June Paik. Photo by Peter Moore
© Estate of Peter Moore/ VAGA, New York, NY.

Fluxus had a foothold in mainstream culture, their agenda was to revamp it. Mixed media events, such as the Charlotte Moorman and Nam June Paik collaboration featuring Moorman playing her cello while wearing miniature television sets fashioned into a brassiere, were their forte. Mail art and rubber stamp art were other nonconformist, low-cost Fluxus activities. In mail art the pieces were addressed, stamped, and mailed to the exhibition site. Shows were often loosely organized around a theme and all work that was received was displayed. In rubber stamp art an image and/or text was made into inexpensive rubber stamps to be quickly reproduced endlessly, anytime, anywhere. Both were open democratic approaches that did not require high levels of technical skill. These approaches rejected the notions that expert curatorial judgment was necessary to organize a show and that art was something original, precious, and irreplaceable.

Along with the practitioners of pop art, artists and critics explored *semiotics,* the study of the signs that make up the basis for all forms of communication (see Chapter 17).[1] During the 1970s, certain artists used the analytical tools of semiotics to examine clichés, myths, and stereotypes about gender and power that were communicated and reinforced through mass-media sign systems. They used semiotics-based analysis to try and reveal the multitude of possible meanings produced by the variations between the apparent, professed content of a work of art (that semioticians call the "text") and the cultural assumptions of the viewer. This approach disclosed the social context for the production, reception, and dissemination of images and how this shapes the underlying message of all representations.

**John Baldessari's** (b. 1931) work of the late 1960s reconstituted the text from his readings of John Barthes onto canvas to invest Barthes's ideas about images and

18.2   JOHN BALDESSARI.   *An Eight-Sided Tale,* detail from the Artist's Book *Close-Cropped Tales,* 1980. 3⅝ × 6 inches (irregular shape). Photo offset.   © John Baldessari. Courtesy CEPA Gallery, Buffalo, NY.

mythologies with new meaning. In 1968, as a means to break with technique and embrace the maxim that Art is truly in the idea (see Chapter 10), Baldessari burned all his paintings. Such judgments, which are at the core of the Conceptual Art Movement, led Baldessari to playfully commingle mediums to court ambiguity and the dualities of chaos and order and to free himself from doing what artists had previously been expected to do: Organize the world and give it a defined, narrative meaning. During the 1970s, Baldessari asked himself "why photographers do one thing and painters another." Baldessari stated:

> The real reason I got deeply interested in photography was my sense of dissatisfaction with what I was seeing. I wanted to break down the rules of photography—the conventions. I began to say photographs are simply nothing but silver deposit on paper and paintings are nothing more than paint deposited on canvas, so what's the big deal? Why should there be a separate kind of imagery for each?[2]

Baldessari appropriated images from popular culture, especially Hollywood film stills, taking the existential position that choice making is what makes both your life and art authentic. His work is not grounded in formal issues but "is about the moment of decision and about fate intervening and chance eroding and disrupting our powers to make a decision."[3] In *Close Crop*

*Tales* (1981), Baldessari rejected the rectangular picture format and broke away from formalistic confines of the edge by cutting his content-loaded images (film and publicity stills) into dynamic shapes with between three to eight sides.[4] The book tells six "tales," from "A Three-Sided Tale" to "An Eight-Sided Tale." Baldessari explained: "All the images are the different sides dictated by the internal composition, so there was a three-sided shape triangle, then there's something in there that dictates those three sides. . . . All of the framing is dictated by what is inside."[5]

Today Baldessari employs assistants to help create his works, with mural-size printing and framing "jobbed out" elsewhere. He sums up this outlook by stating, "It's delegation. An architect is a classic example. He doesn't have to build a house. A composer doesn't always have to conduct his work so why should an artist?"[6]

In *Blasted Allegories* (1978), Baldessari invited friends to ascribe a single word to black-and-white images randomly taken from television, which were then arbitrarily colored or shaded with a hue whose first letter started with the same first letter of the chosen word. Algebraic messages were then added to the pieces to form verbal and visual "sentences." This mutual exchange of visual and verbal groupings encouraged an open, multiple "reading" of the work. The dense, layered meaning of allegory replaced the homogeneity of the metaphoric modernist approach.

*Allegory,* the reliance on symbols to represent meanings other than those indicated on the surface, was resurrected in the late 1950s by the French *situationists.*

The situationists, characterized by Guy Debord's (1931–1994) theories in *Society of the Spectacle* (1967) about commodity fetishism and mass media, proposed that transient experiences, like taking on the role of flâneur and strolling through a city, furnished fleeting sights and sounds that were themselves art. Their stance implied an end to art objects, but it was based on a society so attuned to the aesthetic qualities of its everyday surroundings that the people no longer required art. Allegory permits artists to deal with appropriation, fragmentation, transience, the disintegration of tangible means of measurement, and the uncertainty of meaning and time, while emphasizing content over pictorial concerns. Questioning a work's source, purpose, context, audience, and meaning disturbs the importance typically given to an artist as a shaman who can see and explain the world, suggesting a more equal and open-ended exchange between artists and audiences.

As approaches to photography became more cerebral, photographers searched for fresh models. Conceptual work dispensed with the modernist physical standards of the fine print—the thoughtful use of light, material, process, and technique—dismissing the bedrock upon which photography had gained its artistic acceptance. Sharing the character and outlook of Marcel Duchamp's readymades, conceptual images blatantly ignore past aesthetics and heroic subject matter in favor of blandly describing mundane facts. Unlike documentary artists, conceptual artists recorded arranged events with a minimalist severity that abolished any visual components included solely for the sake of beauty. This reductionist outlook shaved subjects down to fundamental abstract ideas, often too complex to be understood within the confines of a single photograph, further challenging the reportorial mode of photography. Artists not absorbed in the observation of outer reality or their own personal lives abandoned the photographic method of making selections from the external world. These artists gave up acting as spectators and editors and instead took directorial responsibility for constructing images in their studios and darkrooms. The studio, instead of the street, became a creation site, recasting the nineteenth-century compositional syntax of Oscar G. Rejlander and Henry Peach Robinson, which had been exiled by modernism. This way of thinking put photographers on equal footing with other artists who had the authority to fashion images based on their internal directives. No longer was a photographer limited to picturing only what was visible, to being a presenter of physical evidence, a reliable witness of outer reality, a reporter subject to the whims of available light. Ironically freed of the task from which photography had liberated painting, a photographer could now take the privileged position of creating what had formerly been considered an "unphotographable" internal event.

# Performance Art

The conceptual artist **Bruce Nauman** (b. 1941) used the supposed objectivity of the photograph to give a documentary look to his contrived situations, known as *performance art*. This term has been retroactively applied to early live-art forms, such as body art and happenings. The progressive disintegration of conventional artist materials and presentation forms led to the engagement of the real body as a forum for cultural critiques as seen in work of artists such as Vito Acconci, Chris Burden, Yves Klein, and Carolee Schneemann. Performance art is an open-ended classification for art activities that include elements of dance, music, poetry, theater, and video, presented before a live audience and usually "saved" by photographic methods and shown to larger audiences. One of its purposes is to provide a more interactive experience between artists and audiences.

Robert Smithson's (1938–1973) constructed Earth Work projects, like *Spiral Jetty* (1970), a 1,500-foot long spiral of earth and rock that jutted out into Great Salt Lake, and Christo's (Vladimirov Javacheff) (b. 1935) temporary projects, such as wrapping a building, or his *Running Fence* (1976), a 24½-mile fence of fabric, rely on photography to reach larger audiences. Initially, many conceptual artists resisted being documented, claiming that photographs would convert their art into marketable objects, violating their basic concept that such work was supposed to be experienced in person. But soon, Smithson was exhibiting his photographs and Christo and his partner Jeanne-Claude (Denat de Guillebon) (b. 1935) were selling theirs to help fund new projects such as *The Gates* (2005) in New York City's Central Park. Artists like Smithson, who created transitory situations that he extracted from nature or left for nature to decompose, fixed his work with photography, stating: "Photography makes nature obsolete."[7] Such strategies helped to dissolve the boundaries that divided photography from other media.

Austrian artist **Arnulf Rainer's** (b. 1929) body became an innovative site for merging the historical pain of World War II with the fierce gestural marking or defacing of the print surface, violating modernist tenets about the separation of art and photography to expressionistically explore the "internal" human being, the soul, the power of instincts, and the subconscious (see Figure 18.4). **Anselm Kiefer** (b. 1945), whose thickly painted canvases dealing with the seductive and violent German mythos of "blood and soil" often contain a mural-sized photograph beneath the paint, confronted the historical reality of German militarist authoritarianism.[8] Kiefer's enormous paintings, based on photographs of architectural subject matter, meditate on the linkage of history, time, and memory. What appears to

**18.3 BRUCE NAUMAN.** *Portrait of the Artist as a Fountain,* 1966. 19⅞ × 23¾ inches. Chromogenic color print. In *Portrait of the Artist as a Fountain,* the half-naked Bruce Nauman first elevated his body to the status of a traditional sculptural motif (this work references Marcel Duchamp's *Fountain* (1917), a urinal signed and exhibited as art). By spewing liquid, Nauman mimics ejaculation and urination, demoting the functions of his mouth from the intellectual process of speech to the physical process of elimination.

be a landscape painting of a pyramid is actually a creation based on a photograph Kiefer made in India of a building where bricks are hand-made (see Figure 18.5). Kiefer utilizes photography to transform an obscured image of the world based on the debris of history that emphasizes the ambiguity and paradoxes of reality and the intrinsic suffering that is an inescapable component of human affairs. Considering Kiefer's absorption with Nazi Germany, is it mere chance that these brick factories are in essence ovens that echo the crematoria of the Nazi death camps where millions perished?

Since 1964 **Gerhard Richter** (b. 1932) has amassed found and self-produced photographic documentation, including newspaper reproductions, prints, and snapshots, which he preserves on panels. This endeavor, called *Atlas* (1964 to present), now includes thousands of photographic images on hundreds of panels, and serves as a way to "get a handle on the flood of pictures by creating order since there are no individual pictures at all anymore."[9] Richter's penchant to build onto and produce new layers of meaning is visible in the components of his photo-paintings. *Onkel Rudi* (1965) is modeled on a photograph, taken twenty-five years earlier, of the artist's Nazi uncle proudly dressed in his SS uniform (see Figure 18.6). Richter severely disrupts the photorealism that dominates "we will conquer the world attitude" by using a squeegee to blur the carefully applied layers of paint, thereby calling into question the reality within the portrait. The irony of Onkel Rudi's existence in the former Communist East Germany emerges through Richter's act of blurring, which

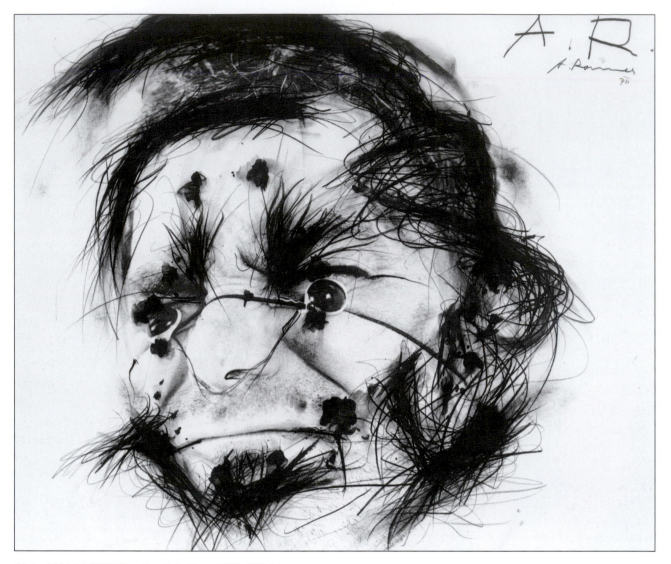

**18.4  ARNULF RAINER.**  *Bundle in Face,* 1974. 20¹⁄₁₆ ×
23¹³⁄₁₆ inches. Gelatin silver print with ink and oil crayon. Arnulf
Rainer photographed himself grimacing to access a preverbal
body language, but he felt the resulting images did not capture the
psychic reality of his self-transformation. By uniting his photography
and drawing Rainer created a tension between the comic and the
tragic in which "all sorts of new personages suddenly appeared to
me who, all being ME, were not capable of manifesting themselves
solely by the movement of my muscles."¹⁰   San Francisco Museum of
Modern Art. © Arnulf Rainer.

"pierces the skin of photographic representation, making us aware that the camera does not record reality in a total or unproblematic way."¹¹

Some say only those who have directly experienced the Holocaust have the ability to truly represent it. Others disagree, claiming that the aftershocks of this calumnious event, and by extension other such occurrences, continue to vibrate so intensely that anyone who feels its effects has the right to try and find

new ways of representing and understanding such trauma. Such conceptual interpretations can be seen in Art Spiegelman's comic books *Maus: A Survivor's Tale: My Father Bleeds History* (1986) and *Maus II: A Survivors Tale: And Here My Troubles Began* (1991) and in the work of **Christian Boltanski** (b. 1944). Through the first-hand presentation of a historical event that does not rely on the traditional documentary formula of being an on-the-spot witness, narrator, or photographer, each artist demonstrates what Ernst van Alphen calls the "Holocaust effect."¹² Forgoing irony, Boltanski uses postmodern methods to engage the past through indirect references about the unknown dead of the Holocaust that enlist its signifiers like archival boxes, deteriorated snapshots, light bulbs, and piles of clothes (see Figure 18.7). These items establish a theatrical environment that rescues and transforms the existence of ordinary people from the oblivion of war and time. His unsentimental process encourages viewers to reflect on how this tragic event continues to haunt

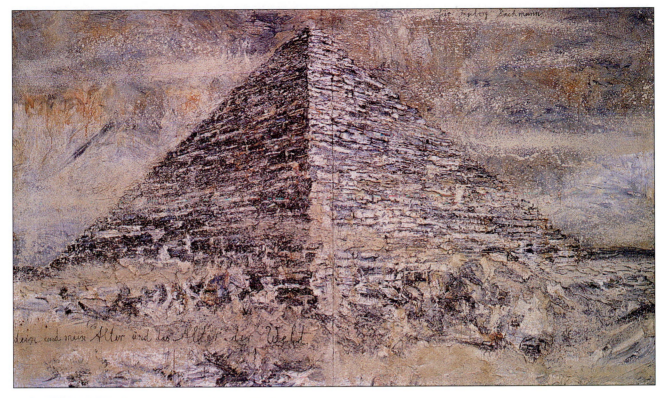

18.5   ANSELM KIEFER.   *Your Age and Mine and the Age of the World,* 1997. 129⅞ × 220½ inches. Emulsion, acrylic, shellac, burnt clay, and sand on canvas.   © Anselm Kiefer.

Western culture and its political policies throughout the world, and reminds us to be on guard against what Holocaust survivor and author of *Night* (1958) Elie Wiesel calls the "Perils of Indifference."

Former performance artists **Gilbert and George** (Gilbert Proesch, b. 1943, and George Passmore, b. 1942), who played on their sense of photographic time as they posed for hours as living sculpture, manipulated themselves as the content in their series of photographs presented in a grid formation. Adopting the slogan "Art for All," photography became their vehicle for suspending movement and memorializing their daily lives. Their brightly-colored monumental photomontages, having much in common with sculpture, confronted an audience with "modern fears" involving British social attitudes and homosexuality. Appearing in their work as respectable, contemporary dandies, their persnickety, conservative sartorial style conceals their irreverent examination of issues from religious fundamentalism to sex advertisements, which often include nudity and depictions of sexual acts (see Figure 18.8).

**William Wegman** (b. 1943) wittily incorporated his dog, Man Ray (1970–1982), into real-time videos that built on repetition to observe and record numerous staged situations. In 1978, Wegman shifted his modus operandi from these spare studio video performances (a stream of moments) to the large-format Polaroid camera (a formalized controlled moment). This transformed the way Wegman worked and led to *Man's Best Friend* (1982), the first of numerous publishing ventures in which his dogs appeared (see Figure 18.9).

Wegman's dogs (Fay Ray followed Man Ray and Wegman now works with her offspring) became "blackboards of living art materials" that Wegman nursed "into engagements not of their own thinking that are disturbing and funny . . . [while] being careful not to make them ridiculous."[13] By combining body and performance art, substituting a canine for familiar people and situations, Wegman systematically explored the metamorphosis of a single subject. Mixing detachment and love, Wegman cultivated his fantasies with a patient, "neutral" companion that takes all the transformations seriously.

## A Return to Typologies

**Bernd** (1931–2007) and **Hilla** (b. 1934) **Becher** began collaborating in the late 1950s to document industrial structures as *archetypes,* the paradigm of a class of subjects that represents the essential elements shared by all varieties of that class. Their dispassionate scrutiny favored a centered, frontal confrontation, utilizing a high point of view. Backgrounds were minimized, eliminating the surroundings and diminishing perspective. The light was direct, flat, and lacking in luminosity. With no shadows, clouds, or traces of other human

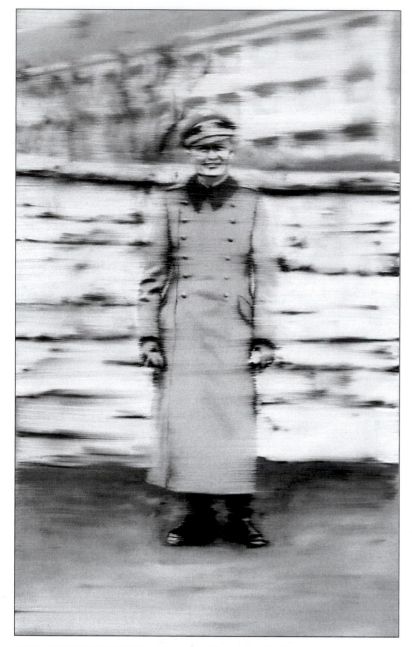

18.6    GERHARD RICHTER. *Uncle Rudi (Onkel Rudi)*, 1965.
34¼ × 19¹¹⁄₁₆ inches. Oil on canvas.    The Czech Museum of Fine Arts,
Prague, Czech Republic. Marian Goodman Gallery. © Gerhard Richter.

The Bechers' methodology renews the positivist, encyclopedic compulsion to catalog the world in the belief that to know something is to subdivide, quantify, and recombine it. Their work asks the "how" question without getting entangled in the thorny thicket of "why?" It disregards the issue of whether compiling more information always leads to a greater understanding of a subject. What is important lies in observing, measuring, and making conclusions based on the data, even if the subject of the data-gathering cannot be explained. It is a way of distancing oneself through the act of presenting nature as an abstraction, moving observers towards the Elizabethan philosopher Francis Bacon's proclaimed goal of science: mastery over the natural world. Bacon's Cartesian model equates truth with utility and the intentional manipulation of the environment. It considers the *neoplatonist* outlook that sees the universe as a holistic, living, interconnected organism, as mystical fluff, and directs a course towards the domination of nature through a rational, technologically based thought process.[15] This level of detachment may prompt viewers to examine the relationship of these photographs to the amoral historical events of World War II that affected artists of the Bechers' generation. Does the Bechers' stance come from a minimalist disposition or is it indicative of a larger consciousness defined by its refusal to examine its own authoritarian history?

The Bechers' highly controlled photographs are generally presented in a grid format (often about 3 × 3 feet), where the image clarity allows the nuances of these functionalist sculptural compositions, which are about to be destroyed as obsolete, to be comprehended and appreciated. By objectively "naming" the subjects, the Bechers hope to convey their historical condition within an industrialized culture.

As a teacher, Bernd Becher's conceptual approach, treading between order and disorder, shaped the work of his students, including Andreas Gursky, Candida Höfer (b. 1944), Thomas Ruff (b. 1958), and Thomas Struth (b. 1954). Höfer's large-format photographs of empty interiors and social spaces are designed to capture the "psychology of social architecture." Ruff and Struth's images emphasize an empirical formula of amassing facts to study in a judicious and systematic fashion. Ruff's larger-than-life-size, emotionally expressionless headshots serve as archetypes, presenting a human head

activity, absolute stillness prevailed. These artifacts, which the Bechers referred to as "anonymous sculpture," were based on an industrial archeology whose topology can be studied in a new setting without nostalgia and in whose configuration lies the microcosm of the ideal universe (see Figure 18.10). The Bechers' stated purpose is "to collect the information in the simplest form, to disregard unimportant differences and to give a clearer understanding of the structures."[14] Their images are a form of comparative anatomy, which they claimed provides a system of understanding the world that cannot be achieved in a natural setting.

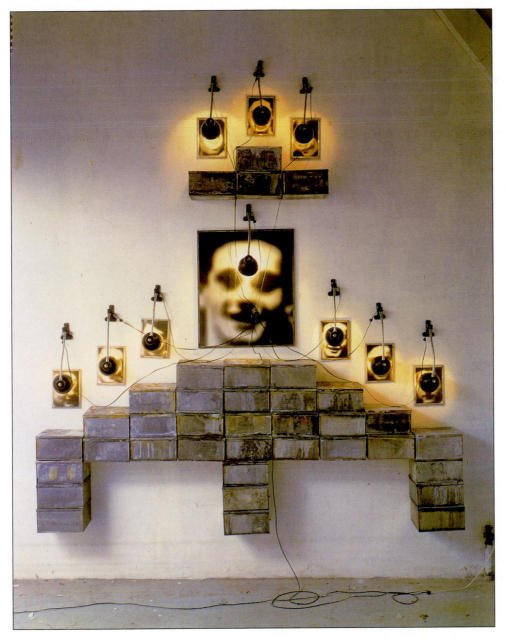

18.7 CHRISTIAN BOLTANSKI. *Autel Chases (Altar to the Chases high school)*, 1987. "Lessons of Darkness," installation view.  Courtesy Marian Goodman Gallery.

as a summary of the universe. His more recent building portraits are likewise serial and reclusive in nature, and have been edited digitally to remove obstructing details, giving the images a standardized appearance. Struth's desire to reduce his visual vocabulary to its simplest premise—to look, to see, and to reflect—can be seen in his 12 × 16 foot *Video Portraits* (1996–2002). Here Struth shows with restraint the heads and shoulders of people calmly gazing into the camera, and by extension, at us. Except for occasional blinks, and small, involuntary muscular movements and other initially imperceptible occurrences, the steady and unmoving

portraits combine the contemplative stasis of painting with photography's grasp of the ephemerality of everyday occurrences.

**Robert Cumming's** (b. 1943) analytical photographs come out of scientific procedures for gathering evidence that stress objective measurement, controlled procedure, and technological methods. Cumming's images run contrary to fine art expectations of personal expression and seem to rely on the photographic process to gather, organize, and document data into logical information. However, his work does not really do this. The images are pseudo-events, astutely staged, droll fictions that distort assumptions surrounding photographic veracity. Cumming's meticulous "anti-documents" parody scientific correctness. Their purpose is not to dupe people—Cumming provides clues—but to challenge observers to find the defects in the visual logic.

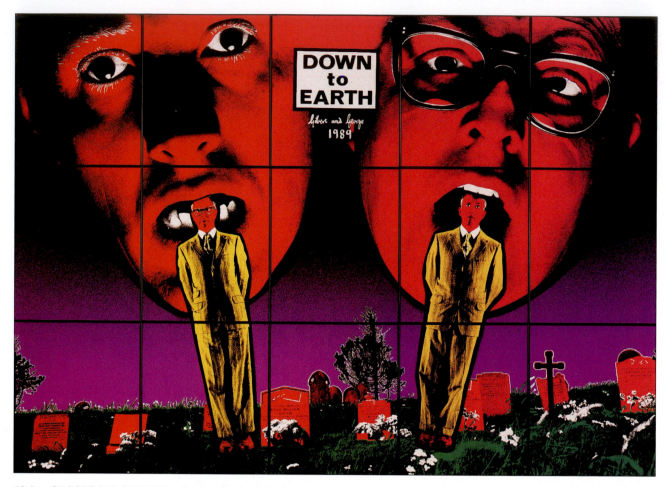

**18.8** GILBERT AND GEORGE. *Down to Earth*, 1989. 88½ × 125 inches. Chromogenic color print. Courtesy Sonnabend Gallery, New York.

In the series *Three Sides of a Small House, the Fourth Being Obscured by a Low Wall and Some Foliage* (see Figure 18.11), an attentive onlooker will notice that the side walls of the house are identical. Cumming's visual record of this event is so minimal that it steers viewers into considering the ideas that constitute the event; in this case, the fictional nature of the subject becomes apparent, revealing how a photographer can contrive information. As he points out how the act of observation alters what is being observed, Cumming also questions photography's impartiality and the role of the camera as a recorder and formulator of reality. His tableaux, reflecting his interest in Hollywood movie-making, caution us to beware of messages delivered on a screen, whether TV, film, or computer.

The obsession with cataloging pushes its conceptual limits with Douglas Huebler's (1924–1997) proposal to photograph "the existence of everyone alive in order to produce the most authentic and inclusive representation of the human species. . ."[16] Instead of aesthetically pleasing objects, Huebler used the objective repeatability of photography as a thinking aid to call attention to his larger conceptual goals. In this case Huebler wanted to show the notion of impossibility. The purpose of his utterly banal images was to challenge the idea that a single picture could explain any subject, and therefore deny the significance of visual documents, which in turn pointed out the deceptive rationalism that went into the making of an archive.

## Postmodernism

*Postmodernism* refers to the dissolution of traditional boundaries between art, architecture, popular culture, and the media that has been accomplished by an open-ended process of borrowing and mixing ideas, art forms, and representations from the past and the present. As differences between mediums become less distinct, their unique concepts and processes commingle. This has led to the formation of ambiguous and contrary hybrids that pay no attention to the modernist concept of achieving "pure" articulated ways of thinking, making, and understanding the arts. Postmodernist theoreticians draw heavily from structuralist and post-structuralist theory. They believe meaning cannot be determined by surface appearances since everything from a photograph to a television program is a text that must be decoded.[17] The act of deciphering the "text"

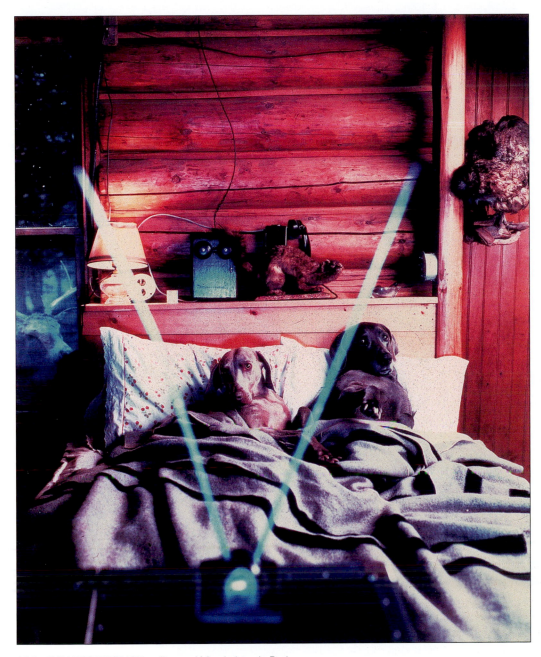

18.9   WILLIAM WEGMAN.   *Ray and Mrs. Lubner in Bed Watching TV (second version)*, 1981. 24 × 20 inches. Diffusion transfer print.   © 1981 William Wegman. Courtesy Pace/MacGill Gallery, New York.

and unveiling the hidden assumptions behind it is what Jacques Derrida (1930–2004) called *deconstruction.* However, Derrida believed that all meaning is fluid and temporary and there is no such thing as an absolute meaning. He and other poststructuralists conclude that finding true meaning is like trying to find your true reflection in a hall of mirrors. Everything is distorted. The notion that there is not a single truth of experience is at the core of postmodern thinking. This is in direct opposition to the modernist view of trying to discover the "essence" or essential meaning in the world. Post-

modernism has disallowed the notion of artistic intention, reference, and meaning and has led some critics to say it has cut off art from its political and social moorings. It has also encouraged artists to explore divergent ways of representing reality and reintroduced issues from the 1960s like feminism, racism, and sexual orientation, and brought them to the forefront.

For postmodern thinkers photography is not the stimulus for theory but the consequence of it. Jean Baudrillard (1929–2007) wrote that we are a media-saturated society of the *simulacrum,* a "copy" of which there is no original. From his viewpoint, we are a culture not just of the image, but one in which the image has replaced that which it was supposed to represent. These phantom images, or *simulacra,* supplant reality

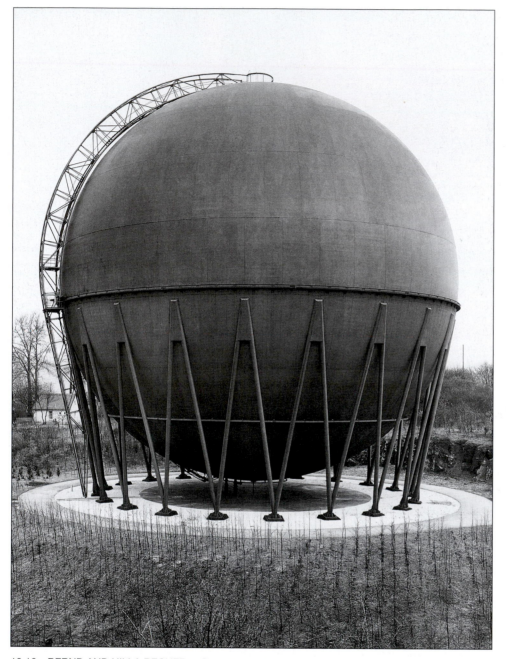

18.10  BERND AND HILLA BECHER.  *Gasometer, Wuppertal, Germany,* 1963. Gelatin silver print.  Courtesy Sonnabend Gallery.

and curtail our ability to make genuine responses to life.[18] Originality, a building block of modernism, is no longer viable, since everyone in the industrialized West is contaminated by mass culture. Its indiscriminate effects render us incapable of originality, making recycled, secondhand imagery the clear choice.

Bart Parker (b. 1934) used photographs and text to examine the separation between reality and the image of that reality. Parker asserted the primacy of the image by showing how a subject can be confused with its representation. Parker's *Tomatoe Picture* (1977) evokes

semiotic theory by directly comparing a subject with its sign: Two images, one made of an actual tomato and the second taken from a color photograph of a tomato, seem identical. However, the captions tell us that one image is of a "real" tomato while the other is a flat representation, making visible the postmodernist belief that representation misconstrues the original.

Over the course of a year, Paul Berger (b. 1948) photographed diagrams and formulas on classroom blackboards, only partially advancing the film after each exposure. The developed film was cut into thirds and contact printed, and the continuously overlapping sequence of image strips was made into an abstracted progressive grid. The repetition of chalk lines in this series, *Mathematics,* takes on calligraphic flow, using photographic

**18.11 ROBERT CUMMING.** *Three Sides of a Small House, the Fourth Being Obscured by a Low Wall and Some Foliage,* 1974. 6¼ × 8 inches each. Gelatin silver prints. Cumming sums up the underlying themes of his images as "out-and-out illusionism and magic tricks, satires, on the misreading of natural phenomena, and sardonic commentaries on the history or art and photography."[19]
Art © Robert Cumming/Licensed by VAGA, New York, NY.

accuracy to transform scientific information into a study about photographic representation, scale, space, and time. The fact that Berger spent a year making photographs of chalk lines reveals the growing artistic disenchantment with "the subject." If one accepts the postmodern notion that there is no "original," it is easy to believe that the subject of one's work is of little consequence. This acceptance of secondhand experience that denies the possibility of an original parallels the ideas in Barthes's essay "Death of the Author" and scholar Frederic Jameson's pronouncements about the "death of the subject." Poststructuralists would say that this position is an indication that the construct of the self never has existed and never can exist.[20] Berger's *Seattle Subtext* (1984) draws on these semiotic studies, using electronically transmitted imagery to comment on the mechanisms from which we obtain knowledge by reading photographs. Berger examines the collision between reality and illusion that occurs in viewer expectations when the changeable, electronic, digital mentality confronts that of the fixed, mechanical Gutenberg press. Berger wrote:

> *Seattle Subtext* is an imaginary and reordered magazine, a hypothetical alteration of the context and composition of all the "information" that pours into ones [sic] home. By drawing on the conventions of "layout," it becomes possible to construct relationships among still photographs and television imagery, typeset captions and computer text. These relationships posit a personalized environment of great density and simultaneity in a format usually thought of as fixed when received—the magazine.[21]

In *Driftworks* (1984), postmodern philosopher Jean-François Lyotard pursues the position of "active nihil-

ism"— "pushing decadence [of capitalist society] to destroy the belief in truth under all its forms"—where the artist hopes for nothing and admits art is insignificant and powerless to change anything. Ronald Jones, deconstructionist artist and critic, says:

> Instead of creating anything new, we move into slow motion where nothing seems to change. We create a "hover" culture. . . . Throwing things into neutral becomes the most radically charged gesture of the moment.[22]

In this position an artist forsakes an activist approach to fulfilling heroic cultural ideals, conceding that an individual no longer possesses the ability to rectify much that is wrong with reality. Instead the artist "hovers" over existing cultural models, in a paradoxically passive approach, hoping that the act of "hovering" will somehow fatigue the structure and cause it to fail. Such a belief implies that we are victims of our preconceived thoughts; an artist's work and a viewer's response can only affirm these predispositions. The assertion concludes that a source of single truth is impossible, as meaning depends upon its context. Opposing critics say that such an embrace of "received ideas" accepts a dangerous and tyrannical form of mental conformity, the type that gives rise to totalitarianism.

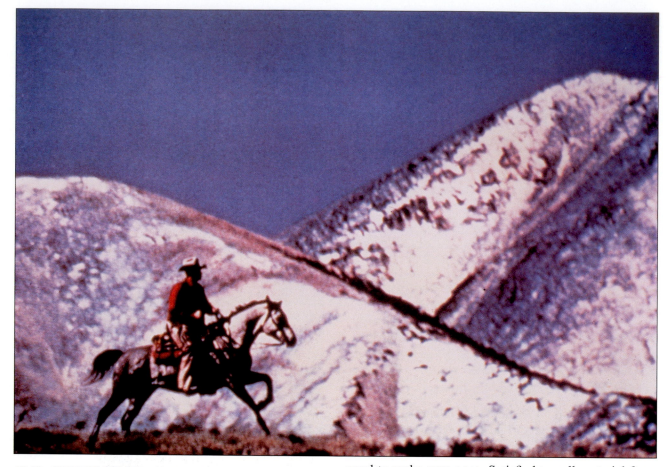

18.12 RICHARD PRINCE. *Untitled*, 1987. 27 × 40 inches. Chromogenic color print. Courtesy Regen Projects, Los Angeles.

The artistic collaboration known as MANUAL was formed in 1974 by Suzanne Bloom (b. 1943) and Ed Hill (b. 1935). Their choice of name implies a guiding handbook as well as the sense of touch, reflecting their concerns about the *phenomenological* aspects of artmaking: observable facts and occurrences. MANUAL was an early adopter of electronic imaging to merge pictures/identities of the past with those of the present, atomizing time and space, leaving its audience with only the now. Their digital strategy implies that originality is a myth and that there can be no divine architect of creativity or true self because everything inside a person's mind has been imprinted by culture and language, inescapably making all images and texts reworkings of existing works; not even a photographer can reveal anything truly new.[23]

## Deconstructing Myths

**Richard Prince** (b. 1949) claims to be unmasking the schema of advertising imagery by rephotographing and cropping found magazine images (see Figure 18.12). Prince's position is one of exhaustion: The world has all the photographs it requires, he says, and there is no need to make new ones. Satisfied to cull material from the existing stockpile, Prince makes it clear that "These pictures are more than available, and unless you've been living in an alley, inside an ash-can, wrapped up in a trash liner (with the cover closed), chances are better than even, you've seen them too."[24] The postmodernists call this practice of using existing images *appropriation;* critics refer to it as pirating. Prince describes the postmodern condition in his writing, which features nameless characters (who serve as surrogates for the artist):

Magazines, movies, TV, and records. . . . It wasn't everybody's condition but to him it sometimes seemed like it was, and if it really wasn't, that was alright, but it was going to be hard for him to connect with someone who passed themselves off as an example or a version of a life put together from reasonable matter. . . . His own desires had very little to do with what came from himself because what he put out (at least in part) had already been out. His way to make it new was *make it again,* and making it again was enough for him and certainly, personally speaking, *almost* him.[25]

Prince's postmodern stance is that most people only know the world through secondhand experience, through copies. Prince says:

The photographs of [Jackson] Pollock were what they [the media and through them the public] thought Pollock was about. And this kind of take wasn't as much a position as an attitude, a feeling that an abstract expressionist, a TV star, a Hollywood celebrity, a president of a country, a baseball great, could easily mix and associate together.[26]

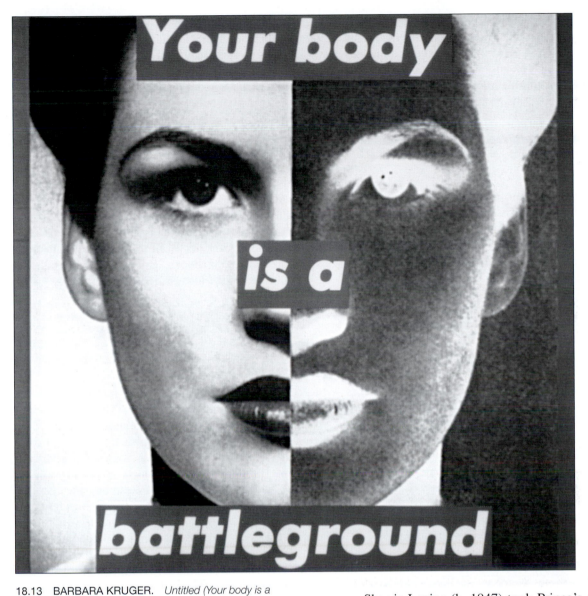

**18.13   BARBARA KRUGER.** *Untitled (Your body is a battleground)*, 1989. 112 × 112 inches. Photographic silkscreen on vinyl. Kruger said: "The thing that's happening with photography today vis-à-vis computer imaging, vis-à-vis alteration, is that it no longer needs to be based on the real at all. I don't want to get into jargon—let's just say that photography to me no longer pertains to the rhetoric of realism; it pertains more perhaps to the rhetoric of the unreal rather than the real or of course the hyperreal."[27]   The Broad Art Foundation, Santa Monica. © Barbara Kruger. Courtesy Mary Boone Gallery, New York.

As the original disappears so does its mythic value, emphasizing the act of choosing as the artistic feat. Prince asks: "What measurements or speculations that used to separate their value could now be done away with?"[28] His radical cropping and enlargement of detail provide an avenue of inquiry into the media's presentation of gender through posing and stereotype, although Prince never comes out and condemns such practices.

Sherrie Levine (b. 1947) took Prince's concept further by rephotographing a reproduction of Edward Weston's *Torso of Neil* and exhibiting it as her own work, *Untitled (After Edward Weston)*, in 1979. Levine did the same with Walker Evans's photographs and later with reproductions of well-known paintings. Her action bluntly condemns what she and other feminist artists consider a competitive, male-dominated, capitalist culture's insistence on the importance of originality—on who did it first. After doing commercial art earlier in her career, Levine states she "was really interested in how they [the commercial art field] dealt with the idea of originality. If they wanted an image, they'd just take it. It was never an issue of morality; it was always an issue of utility."[29] Others argue that culture cannot be divorced from morality, that culture is selective, and that selection involves choice; these choices form the basics of our ethics. Levine's renouncing of the traditional meaning of authorship, creativity, and originality was a rejection of the modernist belief

in progressive change, which infuriated most viewers and foreshadowed ethical issues surrounding the digital appropriation of work. Her copies of copies, functioning as stand-ins for the originals without the original artists' agreement, amplify the inherent defects of the mechanical reproductions process. Levine says:

> The pictures I make are really ghosts of ghosts; their relationship to the original images is tertiary, i.e., three or four times removed. . . . I wanted to make a picture which contradicted itself.[30]

Levine's "ghosts" reinforce Baudrillard's position that power can be exercised through control of the means of representation. By understanding the code in which the originals support cultural assumptions and stereotype, and reusing the images critically, one can deplete their power.

The team of **Mike Mandel** (b. 1950) and Larry Sultan (b. 1946) satirized and deconstructed expectations surrounding the American myth of fame. Their photo-offset series, *Baseball Photographer Trading Cards* (1975), took a group of "photo stars" like Ansel Adams, dressed them up like baseball players, and anointed them with the visual status accorded to sports idols whose images are collected as bubble gum trading cards. While normal baseball cards give a player's batting statistics, these cards listed items like the photographer's favorite film and developer. These "clubby" cards pay ironic homage to a photo-elite unknown to the public at large. Indirectly they ask why top artists do not receive the same status and financial rewards as celebrity sports figures, pointing out the lack of respect, understanding, and value placed on artmaking.

**Barbara Kruger** (b. 1945) spent ten years working as a graphic designer for various women's magazines that extolled beauty, fashion, and heterosexual relationships before she began to produce photomontages, resembling billboards, with text that questioned capitalism's relationship to patriarchal oppression and the role consumption plays within this social structure (see Figure 18.13). In *Remote Control: Power, Culture, and the World of Appearance* (1994), Kruger deconstructs consumerism, the power of the media, and stereotypes of women to show how images and words manipulate and obscure meaning. Kruger says: "I work with pictures and words because they have the ability to determine who we are, what we want to be, and what we become."[31] Her work concisely asks: Who speaks? Who is silent? Who is seen? Kruger visualizes what Roland Barthes called "the rhetoric of the image," showing viewers the tactics by which photographs impose their messages, revealing the hidden ideological agendas of power. She sees stereotypes of women as instruments of social power, determining who is in and who is out. Her curt phrases—"Who is bought and sold?" "Your manias become science," "Your gaze hits the side of

my face"—go to the core of male demonstrations of financial, physical, and sexual power.

Drawing on the seductive strategies of advertising, Kruger reuses anonymous commercial, studio-type images of purposely orchestrated movements. Like Prince, Kruger is not interested in action per se but in "the stereotype's transformation of action into gesture."[32] Her selective use of personal pronouns—I/my, you/your—builds attraction, emphasis, and significance by simultaneously connecting the addressee and the speaker. Since first- and second-person pronouns do not carry gender, they allow observers to enter into Kruger's work and illuminate the mechanisms of involuntary subjection. Kruger also recognizes the changing usage and reality of a photographic message and designs her work to function in numerous situations, including books, gallery walls, installation environments, and billboards. Kruger states:

> But to me the real power of photography is based in death: The fact that somehow it can enliven that which is not there in a kind of stultifyingly frightened way, because it seems to me that part of one's life is made up of a constant confrontation with one's own death. And I think that photography has really met its viewers with that reminder.[33]

Victor Burgin's (b. 1941) work takes on the photographically fragmented nature of the postmodern environment that deals with all events and images as being equally encoded with meaning, readable, and woven into one seamless reality. Along with conceptual artist Hans Haacke (b. 1936), Burgin created forums to address political consciousness designed to upset the modernist position of making aesthetic considerations a priority. In *The End of Art Theory* (1986), Burgin places the visual arts in the context of contemporary cultural theory that embraces language and socio-economic issues. Burgin's combinations of images and text cut across advertising, film, painting, and photography to deconstruct the modes and means of symbolic representation.

## Gender Matters

The tableau became a locale where artists deconstructed the underlying assumptions that define the practice of photography. **Judith Golden's** (b. 1934) work represents the burgeoning feminist expression of the 1970s movement that rejected modernism's values of ideal beauty. Golden's decade-long investigation of female personas and roles examines the ways photography can transform a subject. By humorously hand-manipulating the picture surface, Golden disregards traditional aesthetic values and emotional responses. Her approach was part of a penchant among artists who used handwork and appropriation to blur the distinction between the beautiful chemically produced image and the image that was graphically generated. Golden assumes authority and control over her public represen-

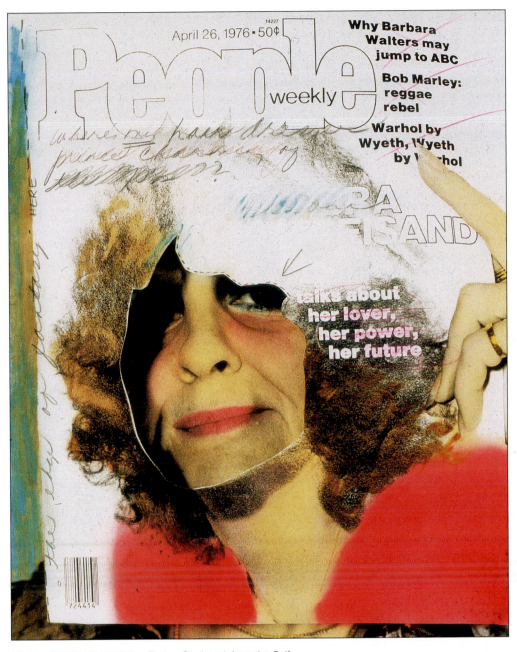

18.14   JUDITH GOLDEN.   *Barbra Streisand*, from the *Self-Portrait Series*, 1976–1978. 14 × 11 inches. Gelatin silver print with oil paint.   Courtesy Judith Golden.

tation, creating a groundwork that other artists, such as Cindy Sherman, would build upon. Her incorporation and subversion of pictures of women from popular magazines questions the media's presentation of women and reveals how a magazine cover acts as a facade to conceal the real individual; she encourages viewers to look beneath the surface of an image to see what is really occurring (see Figure 18.14).

In *Untitled Film Stills* (1978–1979) **Cindy Sherman** (b. 1954) appropriates the 1950s black-and-white movie publicity format, assuming female roles that unmask the Hollywood conventions of *film noir* and its objec-

tification of women (Figure 18.15). Technically self-portraits, but equally akin to performance art, Sherman's photographs question the stereotypical representation of all female "types" in the media and raise issues about personal and social identity for both sexes. The veracity of the photograph is turned upon itself in compositions that call attention to the duality that exists between the performance and the artist. Sherman's equivocal images do not show a single true self but a series of discontinuous representations, fictionalized copies of the self that blend artifice and authenticity. This amalgam of mutable self-identities, without an original, created by bouncing off of cultural portrayals is representative of Douglas Crimp's theories on what would later be called post-modernism. According to Crimp:

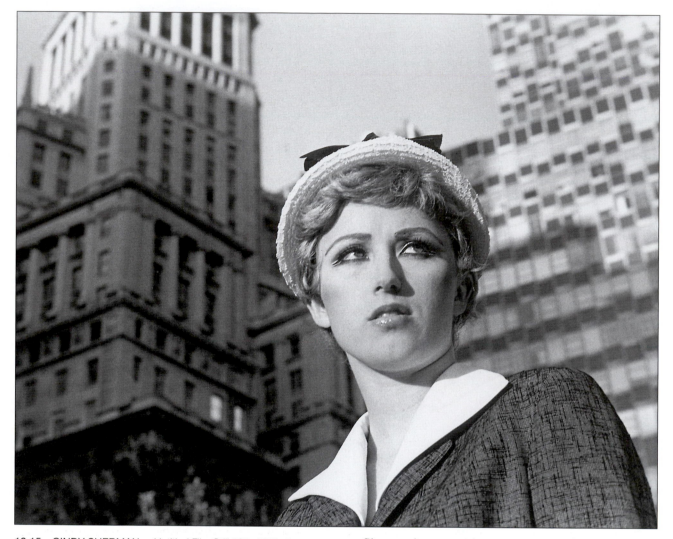

**18.15   CINDY SHERMAN.** *Untitled Film Still #21*, 1978. 8 × 10 inches. Gelatin silver print.   Courtesy the Artist and Metro Pictures.

We only experience reality through the pictures we make of it. To an even greater extent our experience is governed by pictures, pictures in newspapers and magazines, on television and in the cinema. Next to these pictures, firsthand experience begins to retreat, to seem more and more trivial. While it once seemed that pictures had the function of interpreting reality, it now seems that they have usurped it.[34]

Even though Sherman made her own images, Crimp considered her a postmodernist, because her pictures duplicate existing representations of women whose authorship is our cultural consciousness. Meaning is achieved not by what is represented, but in relation to already available images within our society. Sherman agrees:

I didn't actually lift the image. . . . I would rehash it and spit it out, which was a different sort of process. Watching a lot of movies, looking at a lot of movie books, I absorbed as much information about the "look" of movies as possible. No one had ever literally seen any of my images until they were produced, and yet one felt the gnawing of recognition upon viewing them.[35]

Sherman's next project was to create large-scale tableaux of distracted women, played by herself, in ambiguous, often angst-ridden situations, utilizing color to maintain a sensual edge. Her self-conscious work possesses the qualities of formal composition, control of light, and sense of play that deliver aesthetic pleasure, an element that has been either discredited or denied by other postmodernists. Sherman's psychological images of the masking of self-identity and her subsequent movement into the realm of myth and fairy tale, through reenacting well-known paintings and sometimes changing the gender of the protagonist from male to female, were popular because audiences understood the work and did not view her as an ideologue. When asked if she agreed with Crimp's analysis of her work, Sherman replied:

The only way it makes sense to me now is because you've paraphrased the core of what was in those articles. Even though I read them at the time and understood the general concept, I couldn't have repeated it to someone else if my life depended on it. I've only been interested in making the work and leaving the analysis to the critics, I could agree with many different theories in terms of their formal concepts but none of it really had any basis in my motivation for making the work.[36]

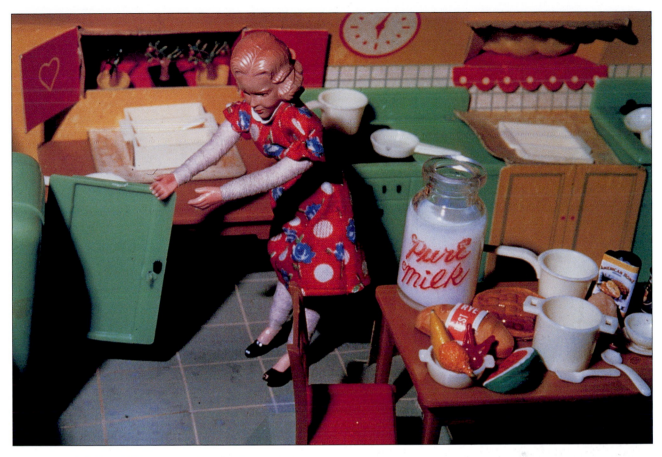

18.16 LAURIE SIMMONS. *Woman Opening Refrigerator/Milk in the Middle,* 1979. 6⅛ × 9½ inches. Chromogenic color print. © Laurie Simmons. Courtesy Sperone Westwater Gallery, NY.

By the late 1980s Sherman had reduced the female body to vulgar, fragmented by-products: menstrual blood, internal organs, vomit. In the early 1990s, she armored herself with plastic prostheses. Masked by these fabricated body parts her physical self disappeared, a comment on the disintegration of her corporeal being that also stridently attacked the fetishism of the male gaze. By the close of the 1990s, Sherman had returned to making small black-and-white prints that tightly depict dolls from popular culture whose mangled appearance convey a sense of sexual rage with an undercurrent of revenge.

Artists such as Eileen Cowin (b. 1947) examined the unstable dynamics of the postmodern family instead of the individual. Cowin's *Family Docudramas* came out of television soap operas and characterize the anxiety and tension within the American family structure. The lack of text makes these stylized scenes elusive. The gestures of participants tell onlookers that a dramatic confrontation is taking place, but the details remain purposely vague so that viewers can fill in their own particulars. Cowin used herself, her family, and often her twin sister as players in these tableaux. When the Cowin twins appeared in the same scene, viewers could

get the strange sensation that there was only one woman instead of two. This combination entity could simultaneously take on the roles of participant and observer, allowing viewers to indulge their voyeuristic impulses without having to admit to them. By breaching the conventions of familial representation and displacing their normal cultural context, Cowin both unveils and deconstructs the differences between how we think we act and how others see us.

**Laurie Simmons** (b. 1949) stages miniature figures and environments as stand-ins for suburban middle-class cultural models. Her strategy, surrounding *In and Around the House* (1983),[37] often included the use of a dollhouse, symbolizing the loss of childhood innocence, where small-scale figures reenact scenes of how society teaches women to behave. The toy figures provide the necessary distancing for Simmons to scrutinize and disclose the patriarchal customs that express and teach her cultural behavior models (see Figure 18.16). Dealing with similar themes, Ellen Brooks's (b. 1946) tableaux also use miniature substitutes that displace the sentimental nostalgia of the dollhouse with a disquieting and trenchant milieu of sexual anxiety.

## Fabrication

Instead of reusing existing images, James Welling (b. 1951) photographically converts household items into

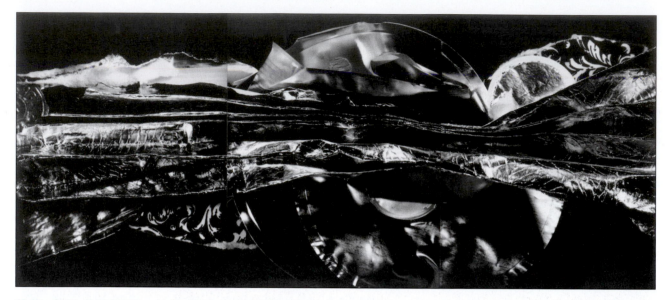

18.17   CARL CHIARENZA. *Untitled Triptych, 56/55/54,* 1996.
5 × 11 feet. Gelatin silver prints.   © Carl Chiarenza. Courtesy the artist.

familiar, archetypal images: Crumpled aluminum foil becomes an apparent abstract landscape. Yet, expectations related to what viewers think they have seen and felt are left unfulfilled, setting up a contradictory mental state that promises emotion and insight but reveals only the materials from which the scene was manufactured. Welling's synthetic landscapes personify the circumstances of postmodern representation: They simultaneously are about something particular, everything in general, and nothing whatsoever. In a process of circular meaning, the work embodies the postmodern concept that all representations refer only to other representations.

Working in his studio, **Carl Chiarenza** (b. 1935) uses scrap materials to make collages specifically to be photographed. The collages are means to an end which is the photograph. In the tradition of Alfred Stieglitz, Minor White, and Aaron Siskind, Chiarenza's pensive symbols formulate a connection between the mind and nature that elicits inner emotional states. This work, that often references the landscape, deconstructs the formal media boundary lines and allows photography to merge with sculpture, graphic design, and painting. For Chiarenza photography is a process of transformation and as such he utilizes photography's illusional qualities to remind viewers about the difference between a photograph and reality and that they are looking at a picture and not a concrete reality. Chiarenza states: "The problem is to get the viewer to release the commonly but falsely held belief in the photograph as a window; to get the viewer to go through the window in a state of openness to a new experience, not a representation of one that has already occurred."[38]

Artists such as Sarah Charlesworth (b. 1947) and **James Casebere** (b. 1953) manufacture stylized "signs" to present archetypal situations. Casebere's *In*

*The Second Half of the Twentieth Century*[39] deploys his handcrafted miniatures along with text to examine the way society uses toys to encode cultural messages to children. The practice of building and photographing models allows artists to contemplate subjects for longer periods of time than would be possible working directly from an actual subject. The models serve as abstract stand-ins for previous ways of representing the subject, prompting viewers to question how images are loaded with intentions and how this affects their own thoughts about the subject. Synthetic archetypes also permit artists to combine or use subjects that do not physically exist, as in Casebere's moody recreation of the prison of the Bastille (see Figure 18.18). Such recreations play with notions of traditional photographic time by permitting pre-photography subject matter to be fixed in photographic form.

**Sandy Skoglund** (b. 1946) makes room-sized installations in supersaturated, contrasting colors and impossible situations, often portraying adult anxieties in childlike models and surreal confrontations between nature and culture, and then she photographs them (see Figure 18.20). They are both temporary installations and permanent photographs. Her crossing of sculpture and photography humorously expresses the continuing need artists have to be physically involved in the process of making objects. "Instead of taking everything out, like Minimalism did, I turned around and started to put everything back in,"[40] said Skoglund. The emphasis remains on controlling the subject while creating juxtapositions that reveal the tension between the internal and external worlds that is normally unseen in nature. Utilizing photography as a unifying container of meaning, Skoglund does not want to be caught up in making things look "natural" for the camera. She does not see fabrication as being cynical or out of touch with reality but as a place where "the world of ideas and the world of appearances come together"[41] so that viewers may contemplate the connection between the natural and the man-made environments.

18.18 JAMES CASEBERE. *Panopticon Prison #3*, 1993. 22¾ × 25¾ inches. Waterless lithograph.   © James Casebere. Courtesy the Artist and Sean Kelly Gallery, NY.

Olivia Parker's (b. 1941) enigmatic still-life assemblages, featuring organic (as in flowers) and inorganic (as in maps) subject matter, rely on a process of recontextualization to achieve their "human implications." Her juxtapositions, based on the legacy of cubism and constructivism, describe a realm of interior spaces and inner states. Parker elegantly suggests themes, such as death, sensuality, and physical and spiritual travel, but she does not provide definitive meanings. A major focus of her work has been on how our understanding of the world has shifted and reshifted from alchemy and magic, to an empirical mechanical model, to a realm of theoretical mathematics (or chaos theory).[42] Parker believes that part of being creative is the ability to dive off into the unknown. She says: "It's not just the willingness to go off the edge; it's the ability to move and act without knowing exactly what's going to happen."[43]

The studio tableaux is combined with the legacy of surrealism in the work of **Joel-Peter Witkin** (b. 1939) to upset photography's associations with the real. Witkin blends the erotic and the macabre to examine areas that are considered off-limits by society. His morbid Hieronymus Bosch–like scenes, replete with corpses, fetuses, and hermaphrodites, suggest that hell is a current state of being. Witkin compares his work with the last trial of St. Francis of Assisi, who confronted the demise of his own flesh by kissing a leper's pus-filled lips and saw the leper turn into Christ. As with the writings of the Marquis de

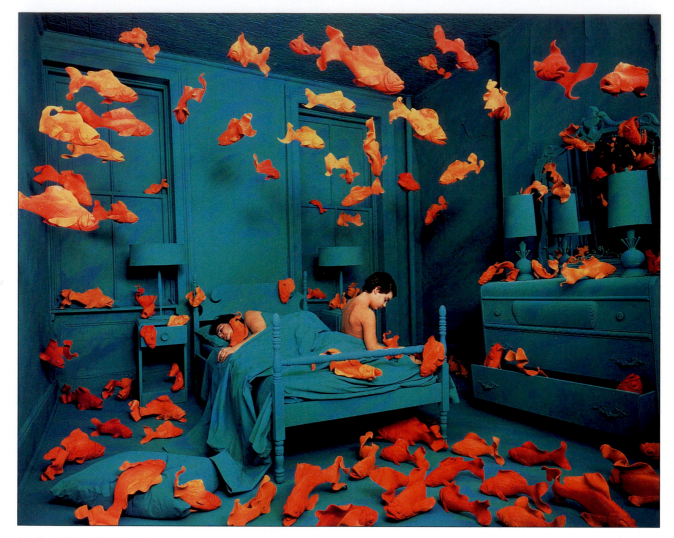

**18.19** SANDY SKOGLUND. *Revenge of the Goldfish,* 1981.
30 × 40 inches. Dye-destruction print.    © 1981 Sandy Skoglund.

Sade, Witkin's grotesque permutations of bestiality, crucifixion, and sadomasochism have a commanding physical appearance that allows us to see that beauty and evil are not mutually exclusive. Witkin tells us:

> The Grotesque derives from grotto, the caverns and subterranean darkness. Saints loved the darkness because that's where you go to bring out the people who are drowning. When I, as an individual, continue my journey into perception and better realities, I have to engage the person in darkness because I'm in darkness. . . . We all have to make a decision as to what we're basically serving. If your life and work are about despair, there's no resolution, no redemption.[44]

Witkin uses the darkroom to tamper with expectations about the imagery a photograph delivers and how a photograph looks. He often reinforces the brutality of his scenes by scratching the negative and staining and vignetting the print, giving us the feeling that his prints "were to be punished for the vision they carried."[45] Witkin also exposes areas of the print through tissue—flat, wrinkled, wet, or dry—for a selective visual softening and uses toners to produce a warm effect. These nonconformist methods, which some consider heretical for their unorthodox craftsmanship, build in an atmosphere of age, giving his prints the authority and believability of daguerreotypes. Within the studio, Witkin conjures up artifice and reality, using historical art references to speculate on allegorical, conceptual, religious, and sexual potentialities (see Figure 18.20).

Fabricating environments for the camera allowed the team of **Patrick Nagatani** (b. 1945) and **Andrée Tracey** (b. 1948) to densely pack symbols from popular culture into a controlled situation. The influence of movie special effects is evident in their extensive sets and painted backdrops, which also recall Nagatani's work as a Hollywood set painter. Their images contradict our expectations as the outer logic of photographic truth commingles with modern anxieties, allowing an interior landscape to come into view (see Figure 18.22). Nagatani's book *Nuclear Enchantment* (1991) employs similar strategies to metaphorically examine the history and social issues surrounding America's nuclear culture and the events that have shaped it, such as the internment of Japanese-Americans during World War II.

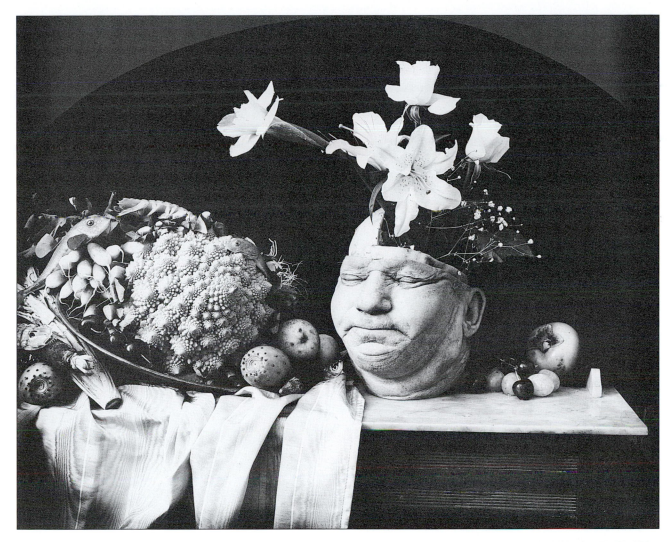

18.20　JOEL-PETER WITKIN, *Still Life, Marseilles,* 1992. 26 × 32 inches. Toned gelatin silver print. Witkin says that: "When I'm working with a severed head, I'm engaged in very direct spiritual dialogue. . . . My job, given the opportunity, is to put flowers into the remainder of his brain, as if it were the well of *my existence*."[46]
© Joel-Peter Witkin.

Philip-Lorca diCorcia (b. 1953) and **Jeff Wall** (b. 1946) take a similar conceptual approach to scripting out their photographs. In staging his images for the camera, diCorcia has models perform familiar domestic scenes, like a man staring into an open refrigerator at night, to convey existential dread. Wall deals with metaphysical panic by digitally orchestrating elaborate and obsessive scenes, like *Dead Troops Talk* (Figure 18.23), which meditates on anxiety, fear, and violence. Such images challenge assumptions by asking: Is a constructed image innately less truthful than a *decisive moment*, and can an assembled picture reveal previously unseen truths? Both assemble ambiguous facts and fictions camouflaged as truth to describe real situations that defy the traditional photographic approach of grabbing the scene out of the flow of real time. By skating the edge between life and theater these imagemakers reveal certain veiled stories, mythic forms, and perplexing situations in what we call life.

## Altering Time and Space

Imagemakers like Jan Dibbets (b. 1941), Eve Sonneman (b. 1946), and Lew Thomas (b. 1932) investigated the cultural functions of photography as it was influenced by the sequential nature of film, by serial forms of minimal art, and by the use of language in conceptual art. Working with multiple images that often used the stability of the grid to ground their compositions, they expressed conceptualist concerns with real time, information systems, and theories of knowledge and process, and challenged the notion that there was a singular, stable existence. Thomas would expose thirty-six frames of black-and-white 35mm film of a mundane subject, making only slight compositional changes in each frame. The result was ordered into large grids, which further diminished the subject and forced a viewer's attention to issues of time and space to examine the underlying structure of how an

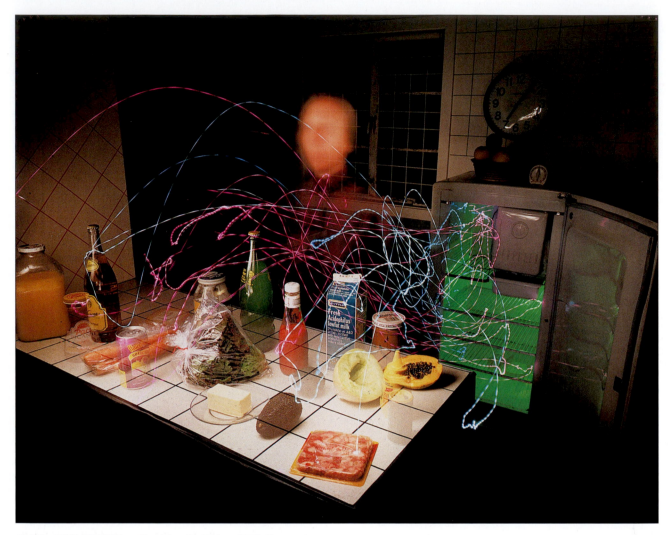

**18.21 MIKE MANDEL.** *Emptying the Fridge,* 1985. From *Making Good Time,* 1989. 20 × 24 inches. Dye-destruction print.

image is experienced. The structuralist filmmaker **Hollis Frampton** (1936–1984) and **Marion Faller** (b. 1941) utilized adjoining 35mm frames to humorously explore real-time activity and pay homage to Eadweard Muybridge.[47] In their *Vegetable Locomotion* series (see Figure 18.24) the grid is deployed to lend the appearance of empirical science. Artist Chuck Close adopted a modified grid to assemble extreme close-ups and highly detailed photographic sections into intensely intimate canvas-sized portraits (see Chapter 17). Mike Mandel carries on a satirical critique in *Making Good Time* (1989), applying early twentieth-century beliefs about how to scientifically manage time/space reality to the domestic middle-class culture of southern California. Mandel's tableaux, based on the Gilbreths' work (see Chapter 10), reveal the limited nature of photographically portrayed time and deconstruct the supposed model of reality that it assembles. Although their approaches were diverse, these artists shared the desire to transform and expand the photo-

graphic experience predicated on the supremacy of the single image of a moment in time. Their efforts at reimaging time and space helped to widen the discussion concerning the nature of photography.

Barbara Kasten's (b. 1936) constructivist studio assemblages formally intermix color, line, perspective, texture, and volume to deconstruct hypothetically designed spaces into separate sectors. Her work was so in tune with postmodern architecture that Kasten left her studio to use actual buildings as sites to "reorganize the visual environment."[48] Her large-scale productions were indicative of an era where photographers became scene builders, managing skilled crews to handle the lights and mirrors, to alter perception by disorienting our customary sense of how things appear. By recording everything in a single moment, with no multiple exposures or postcamera manipulations, Kasten asserts that there is an unexplored realm beyond the familiar photographic reality.

The sanctity of the individual image was assailed by artist **David Hockney** (b. 1937) as he explored multifaceted representations of a subject. Dissatisfied with the way photography rendered depth and represented

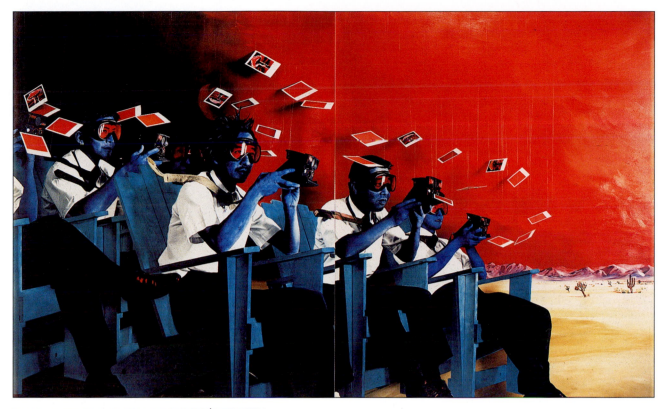

18.22   PATRICK NAGATANI AND ANDRÉE TRACEY.
*Alamogordo Blues,* 1986. 20 × 31 inches. Diffusion transfer print.

time and space, Hockney believed that people gave conventional photographs only a brief look because they lack "lived time." "Life is precisely what they don't have . . . photography is all right if you don't mind looking at the world from the point of view of a paralyzed cyclops   *for a split second.*"[49] Hockney expresses philosopher Henri Bergson's idea that matter is in constant movement. One way to convey this reality is through a synthetic view of a subjective experience, an artist's projection of self-awareness onto the external world. Hockney did this by making numerous photographs of a scene and arranging the resulting prints into a cubist-like collage. His canvas-sized visions bring together an expanded collection of components observed over time and fabricated into a grand, extended, constantly changing entirety. By interrupting space and displacing time, Hockney breaks the perspective of the Renaissance window, carrying his swaying synthetic images beyond the edges of the frame, dissolving the rectangle (see Figure 18.25). Joyce Neimanas (b. 1944) did similar work, arranging Polaroid SX-70 prints, not to reproduce the scene as the camera sees it, but according to her own internal rules of perspective.

**Michael Spano** (b. 1949) used a Graph-Check sequence camera to make a two-tiered grid of eight separate exposures on a single piece of 4 × 5-inch film as he actively moved the camera into and through a scene (see Figure 18.26). The motion in his work

dynamically visualizes the chaotic and frenzied nature of postmodern city life: Subjects appear, disappear, reappear, and move about within a scene; Renaissance time and space collapses; ordinary transactions dissolve into uncommon incidents. The juxtaposing of images invites viewers to make fresh associations. As the narrative format dematerializes, a new perception comes into being, presenting the world in a state of multiplicity.

**Holly Roberts** (b. 1951) lived in the Zuni Pueblo during the 1980s where she found that the Zuni belief in multiple realities—such as a person might be transposed into an animal—reinforced her own intuitive beliefs. Roberts obliterates the mechanical photographic image with paint, opening a path that treads a line between mystery and realism and allowing visceral feeling to dominate subject matter. Real world time is left behind as observers are engaged by the visual presence of an altered dreamlike state and the physicality of the pictures themselves, which meditate on cultural history, human emotions, the landscape, and interpersonal relationships. This permits her to use the authenticity of the photographic rendition of reality to oppose or parallel it with her painting. In addition to single images, Roberts also cut out portions of her photographs and mounted them on canvas, permitting her to work on a larger scale, combine parts of different images, and obtain a richer intricacy of surface quality and texture. Roberts says, "My unconscious intelligence directs my hands to tell the materials where to go. It allows the emotional/spiritual channels to open up. This does not

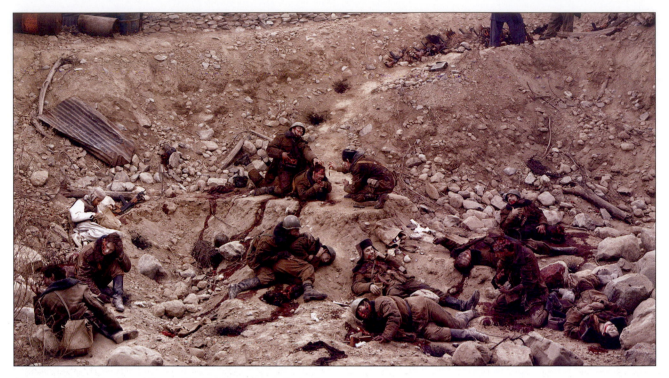

18.23 JEFF WALL. *Dead Troops Talk (A Vision after an Ambush of a Red Army Patrol, near Moqor, Afghanistan, Winter 1986)*, 1992. 7' 6⅝" × 13' 8⅜". Transparency in light box. © Jeff Wall.

happen because we think about, explain it, or conceptualize it. It occurs because we put our hands in it and that act takes us somewhere else."[50]

**Doug** and **Mike Starn** (b. 1961), the Starn Twins, have cultivated ideas of replication and the possibility of identical doubles. Often basing their work on self-conscious, historical paintings, the Starns were noticed in the 1987 Whitney Museum of American Art Biennial, a notable exhibition of contemporary art, for their brusqueness of surface and inconsistencies of scale and space created by splattering chemicals, tearing prints, and putting pictures together with transparent tape. A pseudo-antique patina of cracked emulsions, creases, and torn edges gives their images a sense of time and decay, making their often familiar content seem like a retelling of Western history. Their hand-based studio method, embracing the fluidity of time, is not so much a postmodern deconstruction as it is a romantic reconstruction, recalling the building of Western civilization. The borrowing of figures and compositional schema from past artistic movements places them in these earlier traditions while hinting how the past can easily invade the present. Their complex sculptural approach, relying on glass, Plexiglas, wood, silicone, and pipe-clamps, yields seductive, fetishist objects that mock the efforts of collectors and curators to preserve original works. The Starns, rather than neutralizing the physical carrier of the photographic message, make the carrier as aesthetically consequential as the image (see Figure 18.28).

Against the widening backdrop of digital technology, artists like Adam Fuss (b. 1961) and **Abelardo Morell** (b. 1948) alter conventional photographic notions of time and space by returning to the most direct and fundamental principles of photography. Fuss dispenses with the camera to produce large color photograms that remove the mechanical obstacles between himself and his subjects. Fuss says "I like the idea of things being as they are. A photogram can be two things at the same time. It's light passing through the egg yolk [referencing one of his photograms that incorporates egg yolk]; the fact that it looks like the sun is wonderful, but it *is* an egg yolk. It's the perfect metaphor."[51]

Morell was a street photographer who now converts rooms into pinhole cameras obscura. He then uses a view camera to make extended (eight hours and longer) exposures that record the composite image produced by the pinhole projection of what is outside the space upon what is in the room itself (see Figure 18.29). This dualistic engagement transforms the subjects into alternative visions of themselves.

## Investigating the Body

During the late 1980s, a conservative reluctance to fund contemporary art caused avenues of governmental support to drop. At first funding leveled off and then diminished, slowing photography's explosive growth and forcing a consolidation and downsizing in the field. Galleries and alternative spaces closed; auction prices dropped; student enrollments and full-time academic teaching appointments declined. As traditional public

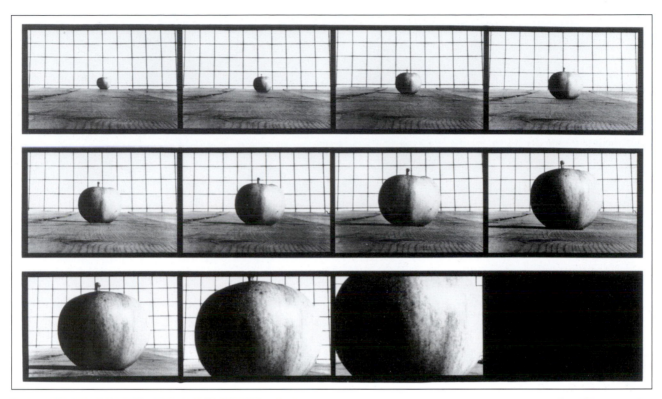

18.24  HOLLIS FRAMPTON AND MARION FALLER.  *Apple Advancing* from the series *Sixteen Studies from Vegetable Locomotion,* 1975. 11 × 14 inches. Gelatin silver print.  © Marion Faller.

funding sources became more scarce, imagemakers turned from introspective self-portraits to more public and often raw confrontations of cultural, sexual, spiritual, and social identity, visually portraying a cultural divide.

**Andres Serrano** (b. 1950) integrates spiritual aspirations and the human body into his art-making. His tableau, *Piss Christ* (see Figure 18.30), became a cause célèbre when it was attacked by U.S. congressmen and religious leaders.[52] Intended not to malign religion but to return sacred concerns to the creative process, Serrano's work is informed by "unresolved feeling about [his] own Catholic upbringing which helped [him] redefine and personalize [his] relationship with God. For [Serrano], art is a moral and spiritual obligation that cuts across all manner of pretense and speaks directly to the soul."[53] Serrano titles his work so that viewers will know the bodily source of his materials: blood, milk, menses, semen, urine. His large-scale photographs of bodily fluids open a discourse around society's anxiety surrounding the drug- and sex-related situations by which the HIV virus is transmitted. The use of text to alter a viewer's perception also becomes a way for Serrano to connect the corporeality of his body with the spiritual nature of Christ. In naming *Piss Christ,* he recasts a solemn cultural symbol—a crucifix—into a representation of rebellion.

Serrano's work is postmodern; he disrupts the pleasure one expects to receive from an icon of spiritual solace. Some multicultural critics have stated that North American artists of color, like Serrano, are forced to learn the ways of the dominant culture alongside their own, often mixed, cultures and live perilously between the two. Only these outsiders, like Serrano, are capable of provoking real change in how encoded cultural messages are read. Critic Lucy Lippard stated that "Serrano's work is part of the polyphonous discourse many Third World scholars have been calling for; he challenges the boundaries formed by class and race, and between abstraction and representation, photography and painting, belief and disbelief."[54] Whether photographing Ku Klux Klan members in full regalia, bodies in a morgue, or a rap music star, Serrano attempts to "take a formal tradition and subvert it by inverting the images, abstracting that which we take for granted, in an attempt to question not only photography, but [his] own experience and social reality."[55]

In the politically conservative 1980s, the Christian right wing started a culture war as a conspicuous way for people to express their political beliefs concerning the type of society America should be.[56] **Robert Mapplethorpe's** (1946–1989) homoerotic and sadomasochistic images became a flash point for conservative members of Congress, who found these explicit images so disturbing that they called for their censorship.[57] Mapplethorpe's flawlessly ordered and crafted images are built, like our own society, on conflict and contradiction. Filmmaker/author Michael Gill calls them

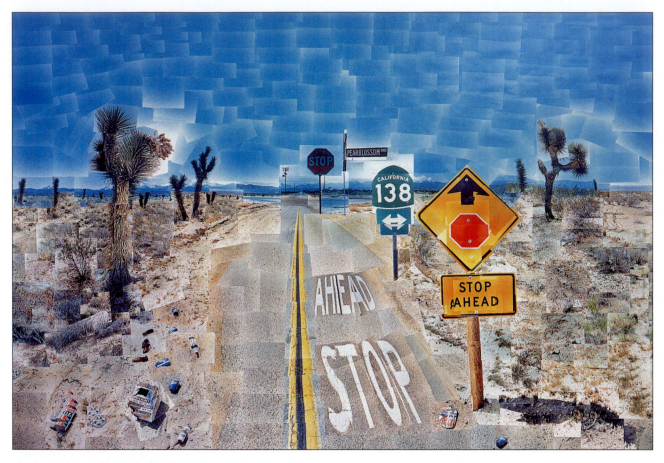

**18.25**    DAVID HOCKNEY. *Pearblossom Hwy., April 11–18, 1986 (2nd version).* 72 × 107 inches. Chromogenic color prints. Courtesy David Hockney No. 1 U.S. Trust, Santa Monica. © David Hockney.

"calculating and intense; cold and intimate; abstract and erotic; cruel and witty; classical and pornographic; clinical yet human."[58] Mapplethorpe's highly formalized yet intimate portraits push taboo areas of sexuality, especially male homosexuality in the time of AIDS, into the mainstream gaze. Erotic work of women, like bodybuilder Lisa Lyon, and of male African Americans straddle a line between formal beauty and sexual objectification. Mapplethorpe's classically inspired, often headless pictures feature close looks at genitalia, representing the postmodern condition that has broken everything down into fragments of specialized interest and signifies a cultural split between emotion and reason. *Man in Polyester Suit* (1980) is a close-up of a black man's penis sticking out of his pants. Mapplethorpe said: "I zero in on the part that I consider the perfect part in that particular model."[59] Critics labeled the image racially obscene, presenting an African American man as civilized on the outside while reinforcing the stereotype that underneath it all he is a wild sexual monster. By presenting highly sexualized imagery without the normal contextual framework of advertising or art, Mapplethorpe defied the constraints upon which the use of sex in the media

depends, opening a national discourse on the boundaries of art, pornography, and censorship. Mapplethorpe's most haunting works are metaphors of his life and death (he died of AIDS) that present the beckoning illusion of physical beauty and its erotic power, like a pristine poisonous apple that invites one to take a bite and die a horrible death (see Figure 18.31).

During an era when the privileged cultural position of straight white men continued to be assailed by women and minority groups, **John Coplans** (1920–2003), a former writer and editor of *Artforum,* broke another taboo. When he was sixty-four, Coplans started a 15-year project that depicted details of his own aging body—hands, feet, back, thighs—in a direct, unflatteringly monumental manner. His formal, faceless close-ups are unrelenting and unsentimental reminders of diminishing capacity and mortality, visualizing unidealized conventions that a media-driven "youth culture" has repressed (see Figure 18.32). These looming, highly detailed images, in which a universal body becomes landscape, possess a sculptural quality and point out how the male body has been largely excluded from the modernist aesthetic. In forming this series Coplans asked himself:

Why are you doing what everyone else does? Why don't you go back to that moment when you began to photograph . . . and see what happens? That's when I took my

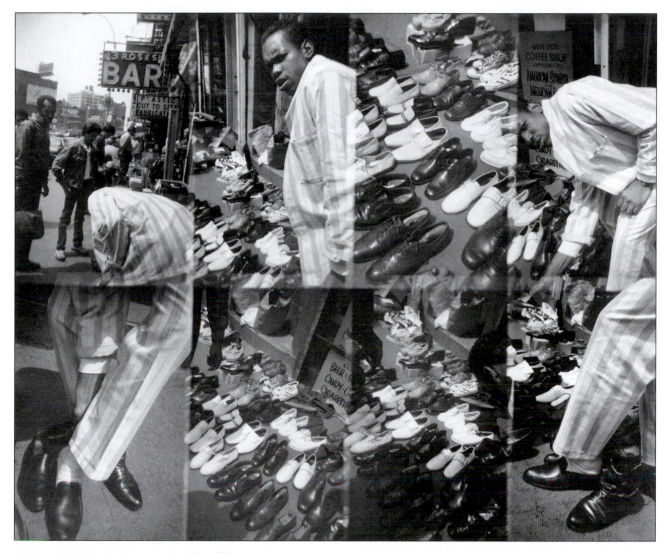

**18.26  MICHAEL SPANO.** *Untitled* (*Used Shoes*), 1984.
46 × 55 inches. Gelatin silver print. Spano builds postmodern
associations by juxtaposing his subject(s) in space and time. The
sequence camera allows Spano to physically move through a
scene as each of the eight lenses exposes a different section of
the film, creating an interval of time that is longer than a single
instantaneous moment.

clothes off and asked my assistant to photograph me. And
I was simply entranced with the process. The result was me
there, but it wasn't me, it was some archaic figure, I didn't
have any icongraphy, because it was all done intuitively.[60]

**Nan Goldin's** (b. 1953) garish, vérité-style slide
and music diary, *The Ballad of Sexual Dependency*
(published as a book in 1986), used 700 to 800 images
and popular songs to spin a tale of abuse, drugs, and
sex. Her images have been criticized as voyeuristic,
but Goldin is a member of the group she photographs.
For Goldin her camera and photographs become part
of her intimate relationships, recording her subjective
internal feelings rather than objective external experi-
ences. The camera joins and clarifies what is going on

between Goldin and her subjects (see Figure 18.33).
Goldin explores how sexual addiction is a motivating
factor in coupling, maintaining that certain people are
unable to leave destructive relationships because they
are addicted to the physical gratification of sex. She
believes that the estrangement people bring to their
relationships derives from society's expectations about
gender roles. Her images are intended to confront view-
ers with behaviors society has wanted to keep unseen.

While postmodernism has offered photographers
more self-conscious and taboo-breaking ways of depict-
ing the body, the depiction of nude children remains a
very controversial topic. The child's age and the sur-
rounding circumstances—whether a child has the ability
to decide whether or not to be photographed nude—
has been a contentious issue. Jock Sturges's (b. 1947)
nude portraits of prepubescent teenage girls led to the
confiscation of his equipment and photographs by the
FBI and $100,000 in legal fees (a grand jury refused
to indict him).[61] Images of nude children have shifted
from Gertrude Käsebier's late nineteenth-century sym-
bols of optimism and ideal beauty to metaphors for adult

**18.27   HOLLY ROBERTS.**   *Mud Truck*, 2006. 30 × 80 inches. Mixed media.

desires. The issue is complicated by a societal debate on how children should be educated and how much freedom an individual can have in a pluralistic society.

Sally Mann's (b. 1951) chronicle of her children's growing up in *Immediate Family* (1992) raised questions concerning the boundaries of art and the responsibilities of being a parent: Can young children truly give informed consent to be in sensual pictures made by their parent? Do these sensual images spring from the children, or are they shaped by an adult? What are the private boundaries of a child's body? Is it courageous or exploitive to confront what others have turned away from? Mann's finely crafted, self-conscious tableaux, which she asserts were made with her children's cooperation, create a web of confessional documentary and contrived fiction. Their power depends on photography's descriptive ability to evoke forgotten and/or repressed childhood feelings and memories of innocence and sexuality. Mann said that she would have stopped making these images if she thought they would hurt her children, and defended her position by stating:

> I'm responding with the only vocabulary I have to ordinary and extraordinary situations that I see around me. . . . But the more I look at the life of the children, the more enigmatic and fraught with danger and loss their lives become. That's what taking any picture is about. At some point, you just weigh the risks.[62]

Lauren Greenfield (b. 1966) chronicles the sociological aspects of the role of the body in youth culture. *Girl Culture* (2002) examines the secret world in which girls use their bodies as projects to fashion their identity. *Fast Forward* (2004) looks at how the materialistic trappings of image and celebrity affect Los Angeles youth, from the gangs of South Central and East L.A. to the affluent of the Hollywood show-business world. *Thin* (2006) explores how external appearances can clash with self-perceptions to produce eating disorders. Greenfield states:

> I have been interested in documenting the pathological in the everyday . . . in the tyranny of the popular and thin girls over the ones who don't fit that mold . . . in the competition suffered by the popular girls, and their sense that popularity is not as satisfying as it appears . . . in the time-consuming grooming and beauty rituals that are an integral part of daily life . . . in the fact that to fall outside the ideal body type is to be a modern-day pariah . . . in how girls' feelings of frustration, anger, and sadness are expressed in physical and self-destructive ways: controlling their food intake, cutting their bodies, being sexually promiscuous . . . in the way that the female body has become a palimpsest on which many of our culture's conflicting messages about femininity are written and rewritten . . . [and most of all] in the element of performance and exhibitionism that seems to define the contemporary experience of being a girl.[63]

## Multiculturalism: Exploring Identity & History

For most of the twentieth century, America maintained the optimistic belief that it was a pluralistic culture, a "melting pot" that assimilated each arriving new group into a singular larger society. In the last decades of the twentieth century, numerous cultural communities came to consider assimilation a bogus ethnocentric concept and have sought to replace it with *multiculturalism*. This concept has its roots in the pragmatism movement at the end of the nineteenth century that developed a premise of cultural pluralism, which was viewed as essential to build a more egalitarian society. Multiculturalism emphasizes group identity and building self-esteem through learning about the achievements of one's own group. It decries the elevation of European cultural traditions over those of Asia, Africa, and the indigenous nonwhite populations of the Americas, and rejects the social and economic exploitations of colonialism and its tendency to view "other" cultures as primitive or exotic. It demands that the non-European notions of art, family, and concepts of time be considered on their own terms.

**18.28  DOUG AND MIKE STARN.**  *Sphere of Influence,* 1990–1992. 23 × 14 × 14 feet. Toned gelatin silver film, silicone, tar, steel, Plexiglas, pipe clamps.   Courtesy Mike and Doug Starn.

Artists became aware of how society-at-large constructs concepts of identity and reacted by making portraits of their group that countered this often stereotypical view. Imagemakers from specific cultural groups provide readings from an internal point of view to reveal how each group sees itself. They bring with them an understanding of their own cultural group's social rituals that allows them to deliver intimate, first-hand accounts of their group's values. They offer a view from within, rather than a gaze from without. For example, **Dinh Q. Lê's** (b. 1968) woven color images from his series *Portraying White God* fabricates a new interconnected reality and are indicative of work by artists from subcultures struggling to establish their identity in relation to the predominant culture (see Figure 18.35). Dawoud Bey's (b. 1953) large-scale portrait series of

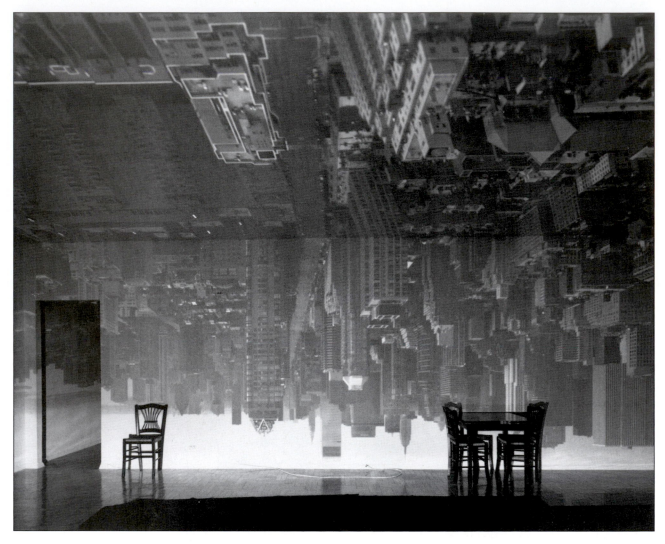

18.29    ABELARDO MORELL.    *Camera Obscura Image of Manhattan View Looking South in Large Room,* 1996. 20 × 24 inches. Gelatin silver print.    © Abelardo Morell, courtesy Bonni Benrubi Gallery, New York, NY.

teenagers, entitled *Class Pictures* (2007), combines image and text to expand the notion of the photographic portrait, and shows the genre can be a surprising amalgamation of opposite characteristics capable of breaking down stereotypical representations of American youth across the ethnic and social spectrum. In a fashion similar to television documentaries like the BBC's *Up* series (since 1964), PBS's *An American Family* (1971), and WE's *High School Confidential* (2007), where the subjects are aware of the camera, Bey's work discloses intimate details about the characters while raising the questions: Can we trust what we see? What is sincere? What is a self-conscious construction for the camera?

Stephen Marc's (b. 1954) *Underground Railroad* project utilizes digital montage to combine the past and the present to make a historical movement involving African-American identity accessible. The Guerrilla Girls (formed 1985), an anonymous, feminist collab-

orative that protects its members' identities with gorilla masks, have used photo-based images and processes in the production of street posters that criticize racism and sexism.[64] Through protests and educational activities, the Guerrilla Girls scrutinize the traditional role of women within visual culture as objects, rather than as makers of art. Also working collaboratively, Jo Spence (1934–1992) and Terry Dennett (b. 1938) did a series, *Remodeling Photo-History* (1982), juxtaposing the unidealized female body with mundane landscapes featuring power transmission lines to call attention to contradictions and myths about women and nature. After Spence was diagnosed with breast cancer in 1982, the two investigated the significance society has given to women's breasts. In 1986 Spence and Rosy Martin did *Photo Therapy,* in which Spence, a former wedding photographer, explored issues surrounding women including beauty, marriage, and powerlessness. Fazal Sheikh (b. 1965) makes sustained portraits of displaced communities around the world, which address their traditions, as well as their political and economic problems. By establishing a context of respect and understanding, his photographs ask viewers to learn more about the

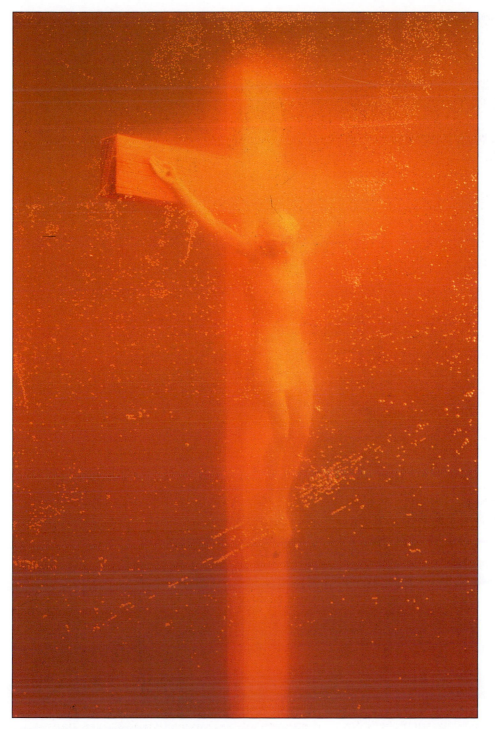

18.30  ANDRES SERRANO.  *Piss Christ,* 1987. 60 × 40 inches. Dye-destruction print. Serrano walks the line between the sacred and the sensational in images such as *Piss Christ* and his recent *The History of Sex.* Serrano has stated that: "I think God created the body for a reason and we were meant to exploit it."[65]  © Andres Serrano. Courtesy Yvon Lambert New York, Paris.

people in them and about the circumstances and human rights issues that affect their lives.

Multiculturalism has increased access to education for women of color, who have been able to combine ethnic and feminist concerns in their work. Tuscarora Native American Jolene Rickard (b. 1956) uses photography to empower one of the oldest continually surviving aboriginal communities with a knowledge of its symbols and relationships. Rickard allows the photograph to function as a survival strategy, just as traditional storytelling or bead work was used to propagate and extend cultural meaning to the next generation. For Rickard the photograph serves to merge the material and spiritual worlds while also pointing out the lack of harmony in these worlds.

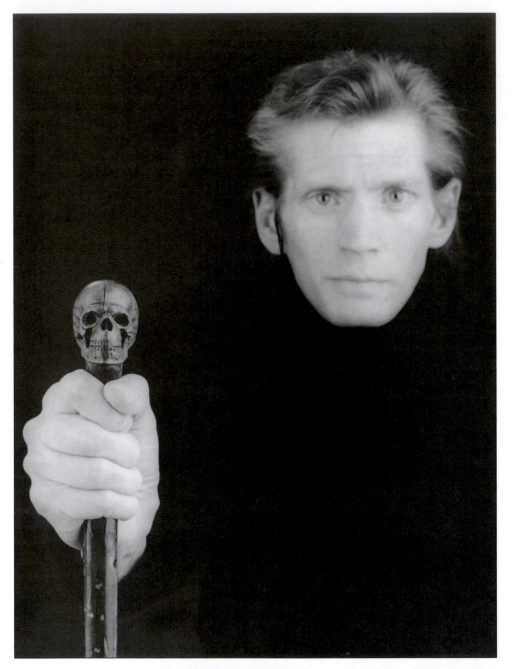

18.31 ROBERT MAPPLETHORPE. *Self-Portrait,* 1988. 20 × 24 inches. Gelatin silver print. © Copyright The Robert Mapplethorpe Foundation. Courtesy Art + Commerce.

Family stories have been the basis of the work of many people of color, especially women.[66] Family therapist Alan D. Entin believes snapshots can reveal the power structure of family existence. Entin discusses how the "background [of a photograph] can be read as information about social-cultural values, traditions, and ideals [of the family]. Photographs tell not only about what is photographed but about who is doing the photographing. Photographs are biographical as well as autobiographical."[67]

**Clarissa T. Sligh** (b. 1939) reexamines her past by looking at family snapshots to discover the differ-ences between the pictures and her memories. Joining together the African-American storytelling tradition with a postmodern strategy of combining family snap-shots with collage, cyanotype, Vandyke brownprint process, and handwritten text, Sligh underscores how difficult it can be to obtain the information one needs (see Figure 18.36). Sligh's visual connections empower her to explore the factors that have made up her African-American identity and move her beyond the character-izations that society has tagged her with. Sligh adopted an autobiographical image, Skookie, in her reworking of the universal reading primer, *Dick and Jane,* to con-front class values and racial exclusions.

Holding advanced degrees in folklore and art, **Carrie Mae Weems** (b. 1953) examines the narrative systems,

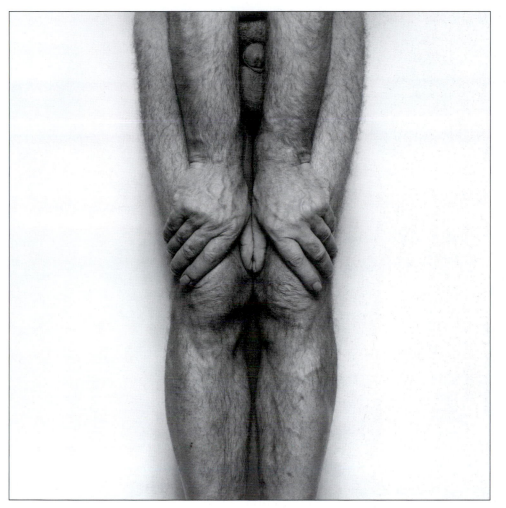

18.32   JOHN COPLANS.   *Self-Portrait (Legs, Hands and Thumbs Together)*, 1985. Gelatin silver print.   © John Coplans.

steeped in myth and religion, that make up a variety of African-American voices based on the historic catastrophe of slavery. In *Then What? Photographs and Folklore* (1990), Weems uses a photo-narrative of staged events and text to perform a cultural analysis and meditation on the issues surrounding power. She does this by showing the development and collapse of a romantic relationship around a kitchen table and the emergence of a sense of self that transcends the individual and speaks as a collective autobiography (see Figure 18.37). Her methodology has a persistent political resonance without being didactic. Weems's work focuses on the shared theme of what society has deemed normal by addressing issues of race, gender, class inequities, and stereotypes from her perspective as an African-American woman. In her *Africa* series, Weems explores the mythic quest for origins by subversively retelling the Adam and Eve story in an African Garden of Eden. Her work demonstrates that beauty and the pursuit for change are not necessarily antithetical. She states: "I want to make things that are

beautiful, seductive, formally challenging and culturally meaningful. I'm also committed to radical social change. . . . Any form of human injustice moves me deeply . . . the battle against all forms of oppression keeps me going and keeps me focused."[68] Weems's image and sound installation, *Ritual and Revolution* (1998), gave voice to numerous failed revolutions of the past 200 years, and aroused more than difficult thoughts when it was vandalized while on display in a museum.[69]

Lorna Simpson (b. 1960) is another African-American artist whose postmodern sectioned constructions, combining image and text, give evidence that relates to falsehoods about class, gender, and race. Her faceless portraits are generic emblems; they resist racist conjectures about black physicality by defying the power of a photographer to capture and impose a context on an image. They are part of Simpson's strategy of "not giving up everything, not giving up your face, completely who you are and everything to the camera."[70] By shifting the power of the gaze, Simpson disrupts the voyeuristic relationship of the observer and the observed, asserting her identity rather than having it imposed on her.

**Kara Walker** (b. 1969) employs the Victorian medium of cut-out silhouettes to investigate the

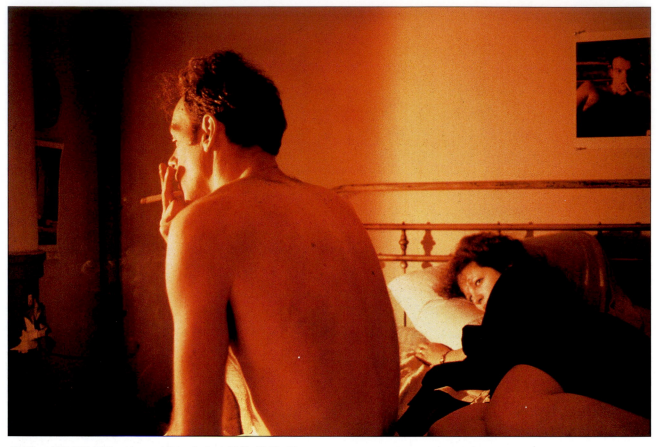

18.33  NAN GOLDIN.  *Nan and Brian in Bed, NYC*, 1983. 20 ×
24 inches. Dye-destruction print.    © Nan Goldin.

ignorant absurdity of racism and sexism. Her unruly
silhouette characters, who fornicate and mete out vio-
lence, exaggerate stereotypical roles often based on
pre–Civil War, Southern types, and reflect the dangers
of physiognomic methods, which rely on facial features
to determine one's character and/or ethnic origin. Her
theatrical use of colored light projection, as in *Darky-
town Rebellion* (2001), "tricks" people into walking
into her installation about our sinister side (see Figure
18.38). Here each viewer's silhouette joins the myth-
ological composition and thus actively commingles
with the historic realism of slavery and the fantasy of a
romance novel like Margaret Mitchell's *Gone with the
Wind* (1936), simultaneously seducing and implicating
each participant. Such a design provides audiences the
possibility of reassessing history, and their role in race
and gender relations.

The form of public address empowers and gives
space for others to tell their stories. Artist and industrial
designer **Krzysztof Wodiczko** (b. 1943) believes art
and design should engender postmodern debate. As an
exile from Poland, Wodiczko identifies with the voice-
less *Other* in a strange land who feels boxed in by pre-
conceived categories. Wodiczko dramatizes political and
social dilemmas, including colonialism, consumerism,

homelessness, and slavery, through slide projections on
the facades of public buildings (see Figure 18.39). Using
on-site trucks armed with projectors and generators,
Wodiczko's guerrillalike critiques take control of pub-
lic places away from the dominating class and its ideol-
ogy. His actions convert public spaces into theaters that
confront problems many people wish to ignore.[71] In a
variation of this process, Shimon Attie (b. 1957) projects
archive photographs, picturing subjects of Jewish life in
Berlin before the Holocaust, onto the walls of contempo-
rary buildings. The resulting composites merge the past
and the present to make vanished histories reappear.

W. G. (Winfred Georg Maximilian) Sebald (1944–
2001) was a German writer living in England who drew
on collective and personal memory to reconcile him-
self with the traumatic history of World War II and the
Holocaust. His works, such as *The Emigrants* (1992)
and *The Rings of Saturn* (1995), approach these subjects
obliquely, inventing a hybrid novel format that is part
memoir and part travelogue. They are notable for their
unpredictable mixture of fact (or seeming fact), recol-
lection, and imaginary tale, interspersed with redolent
black-and-white photographs, obscuring the borders of
veracity and fiction. Sebald, a devoted photographer,
favored found objects, postcards, and old newspapers,
which appear without captions and acquire meaning
from the surrounding text. These enigmatic images nei-
ther illustrate nor document the story, rather they create

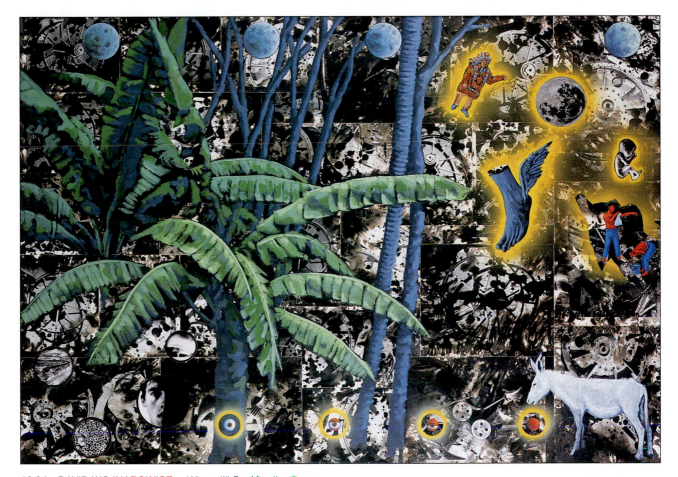

**18.34    DAVID WOJNAROWICZ.** *Where I'll Go After I'm Gone,* 1988–1989. 45 × 64 inches. Gelatin silver prints, acrylic, spray paint, and collage on Masonite. **David Wojnarowicz** (1954–1992), who died of AIDS in 1992, interwove his life and work to wrestle with issues of identity, sexuality, and the fragility of life. In opposition to Mapplethorpe, Wojnarowicz delivered a dark vision of physical decline and death. Entirely self-taught, Wojnarowicz relied on collage, paint, and text to challenge what he called the "pre-invented existence" that discriminates and imposes a power structure on people based on ethnicity, gender, race, and sexual preference.    Courtesy the artist's estate and P.P.O.W. Gallery, New York.

evocative counterpoints to the narrative that suggest a paradoxical and/or sardonic point of view.

China's swiftly rising economy has generated a corresponding creative re-awakening of Chinese art, as seen in the work of Hai Bo (b. 1962), Cao Fei (b. 1978), Xiao Lu (b. 1962), Rong Rong (b. 1968), Wang Qingsong (b. 1966), and **Liu Zheng** (b. 1969).[72] Liu typifies the dramatic shift in Chinese photography. Rejecting his early experiences constructing photographic "untruths" for Communist propaganda purposes, Liu changed direction in the mid-1990s and began investigating and documenting the diverse temperaments that collectively make up what he sees as the Chinese outlook and spirit. Working in a manner rooted in the practice of August Sander and Diane Arbus, his ongoing series *The Chi-*

*nese* (since 1994) depicts laborers, monks, performers, and homeless children to raise awareness about how China's breakneck modernization is transforming its national character (see Figure 18.40).

Photography's adaptability and instantaneous nature make it synonymous with the swiftly changing economic and social environment in Asia. Photo-based work, including installations and videos, from China and other Asian countries, such as South Korea and Japan, is now being given wider attention in Western venues.[73] This globalization of the arts offers Western audiences the opportunity to see how artists around the world perceive themselves and their communities on a personal, regional, national, and global level. What the long-term effects will be on Western practice remains to be seen, especially since Chinese artists operate within boundaries controlled by government authorities. Mao's legacy is full of twists and turns, and the Cultural Revolution remains a taboo topic, along with the three T's: Tibet, Tiananmen Square, and Taiwan. Living under cultural conditions where the forces of tradition still retain enormous power is not the model most artists favor, but it can challenge them to devise original and creative modes of expressing their concerns, resulting in new pathways of expression.

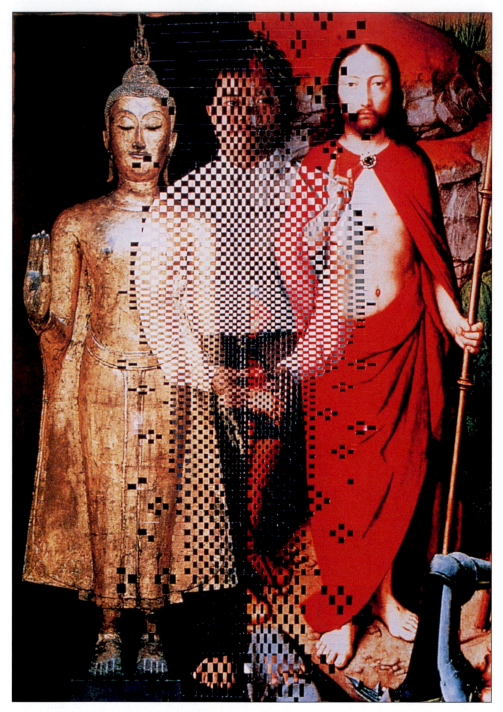

**18.35   DINH Q. LÊ.**   *Between,* 1994. 65 × 40 inches.
Chromogenic color prints with tape. Lê says: "As a Vietnamese
living in a western society, educated in western institutions
and surrounded by western popular culture, I am a product of
both East and West. Through my work, I explore the exchange
and interweaving of cultures and identities from a bicultural
perspective."[74]   Courtesy the artist and P.P.O.W. Gallery, New York.

## A Personal Cultural Landscape

Although much activity has been focused on power
issues relating to gender, identity, and sexuality,
imagemakers have been re-examining how socioeco-
nomic forces shape and define the landscape. During
the nineteenth century the vast majority of landscape
photographs were made by commercial photographers
whose content and style were dictated by the mar-
ketplace. In the last part of the twentieth century, the
lens of environmental organizations, whose mission
was to preserve the wilderness, informed people's
perception of nature. These groups often visually
established the boundaries of nature through roman-
tic color reproductions of pristine wilderness, which
gave people the misleading idea that anything not

HERE WE ARE WAITING FOR DADDY TO TAKE OUR PICTURE IN FRONT OF GRANDMA'S BACK PORCH. IT LOSES THE WELL FROM WHICH WE DRAW WATER. OUR WATER IS ALWAYS CO LD SUM EVEN IN N T MER WHE S C HE SNAIL LIVE OME TO AN INSIDE. CON ICEBOX, FOOD TAINING THE R SITS IN NER. EAR COR GET WHEN IT REAL TO BE THE Y HOT, BRI ICEMAN NGS A BIG BLOCK OF ICE EVERYDAY – SOME TIMES, WE MAKE ICE CREAM. I AM A VERY HAPPY KID. IN THIS HOUSE, GRANDMA IS IN CHARGE.

GRANDMA'S HOUSE
MA MA
THIS IS CARL. HE IS 8 YEARS.
SKOOKIE 2 YEARS.
HE IS 10 YEARS OLD. THIS IS JUNIOR.

C. T. SLIGH 1987

Clarissa T. Sligh    1987

**18.36   CLARISSA T. SLIGH.** *Waiting for Daddy,* 1987. 14 × 11 inches. Vandyke print. Jeffrey Hoone, director of Light Work, observed: "Sligh invites us to look closer at the posed facades and readymade ideals in the pictures that make up the memories of our lives. Her work tells us that we often see who we are told to see, feel what we are told to feel, and know what we are told to know. She also tells us that when we are told these things often enough, we become convinced that they are true. In this process of false fulfillment the substance of our memories is disengaged and we are restricted by the images we are forced to accept."[75]   Light Work.

wild is not natural. The current generation of progressive landscape photographers has moved away from this point of view. Their position is that the landscape is a more complex artificial perception: A human construct that blends the artifice of civilization with natural forms. Working from the premise that anything that can be photographed can be a landscape, these photographers have personalized the ingredients of their landscapes to reflect a broader range of societal issues. This has allowed them to bring forward environmental issues, such as pollution and climate change, which have been produced through the collision of culture and nature. Their work announces that there is "trouble in paradise" and that we can no longer afford an attitude that segregates nature into a discrete category of wilderness. By adopting a strategy of publishing the results of their inquiries, they are able to reach a broader audience than would see such work in a gallery setting.

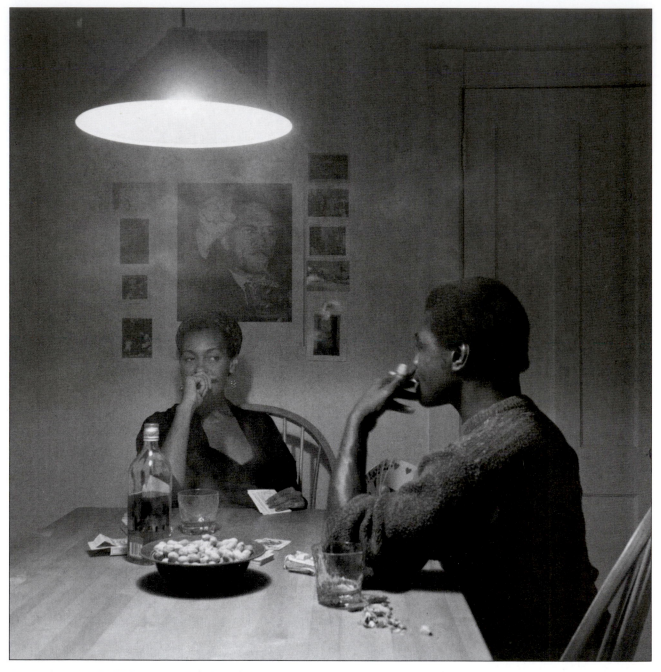

18.37    CARRIE MAE WEEMS.    *Untitled,* 1990. 28¼ ×
28¼ inches. Gelatin silver print.

In his book, *Waste Land: Meditations on a Ravaged Landscape* (1997), David T. Hanson (b. 1948) presents beautiful yet disturbing color images (many of them aerial views) of an American topography wounded by the assault of industrial and military economic forces. Hanson's images also remind us that the notion of landscape is never fixed, but is a creation of human perception and boundaries that is constantly shifting.

**Richard Misrach** (b. 1949) brought together 20 years of categorizing and probing society's relationship to the desert in *Crimes and Splendors: The Desert Cantos of Richard Misrach* (1996). His use of an

8 × 10-inch view camera allows him to create formal, lush, color prints of the mythical Western terrain that visually delight viewers. However, Misrach fashions a jarring duality by juxtaposing these photographs with others that show the presence of human occupation of the desert with its accompanying fires, gas-powered vehicles, man-made floods, dead animal pits, and remnants of violent and radioactive military activity (see Figure 18.41).

In *Farewell, Promised Land: Waking From the California Dream* (1999), photographer Robert Dawson (b. 1950) and writer Gray Brechin present their five-year study of the historic and social forces that have altered this legendary region. Although they present an often tragic

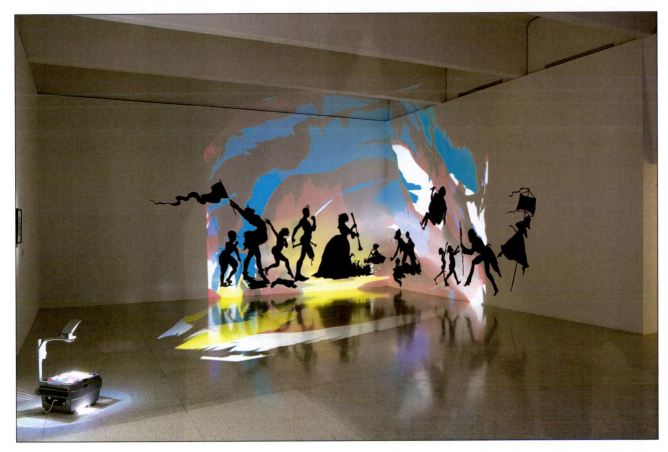

18.38   KARA WALKER.   *Darkytown Rebellion,* 2001. 15 × 33 feet. Cut paper and projection on wall. Installation view at The Walker Art Center, Minneapolis/photo by Gene Pittman/Walker Art Center.   © Kara Walker Image courtesy Sikkema Jenkins & Co.

view of how the land has been cynically developed, they also look to the future by representing those committed to safeguarding the state from its course of exploitation.

Exploring the connection between nature and industry, **Edward Burtynsky** (b. 1955) pictures places where human activity has reshaped the surface of the land. His startling large-scale color photographs, as seen in *Manufacturer Landscapes: The Photographs of Edward Burtynsky* (2003), of mining, oil refining, quarrying, rail-cutting, recycling, and shipbreaking uncover both the bleak and sublime beauty in the remains of industrial progress. The implied environmental and social turmoil that lie beneath these images picture the downside of western ideals of material fulfillment and happiness (see Figure 18.42).

The collaboration of **Robert & Shana ParkeHarrison** (b. 1968 & 1964) combines photography, painting, sculpture, and theater to address the human relationship to the land. In the series published as *The Architect's Brother* (2000) a character in a black suit (played by Robert) attempts to save or rejuvenate nature with Rube Goldberg-like machines that have been constructed from flotsam and jetsam (see Figure 18.43). Despite the sense

of futility and irony in their mythologically staged images, Robert ParkeHarrison says: "I attempt to represent the archetype of the modern man and draw the viewer into the scene without dictating a message or the outcome of the myth presented."[76]

What these artists share is an outlook that calls for action by challenging viewers to think about the human impact on the natural world, to learn more about their relationship to their environment, and to consider changes that could offer hope for the coming generations. Their point is that we make the landscape and it is therefore our responsibility to craft its future. Robert Dawson sums up this attitude with his statement that:

It quickly became clear to us that depicting only devastation would invite cynicism and detachment. I felt it was essential to go beyond showing our failures by calling attention to individual and collective efforts to restore and sustain our home. People involved in preserving California are engaged in a struggle that agriculturist Wes Jackson once described as "becoming native" to a place. Jackson argues that our culture has settled on the American landscape but that we have yet to become native to that place we call home. That process of becoming native motivates many of the people and organizations in our book. In undertaking this project, we too were searching for a way to come home.[77]

## The Digital Future Is Now

Photography's fundamental concept has been about light imprinting an image at a specific juncture in space

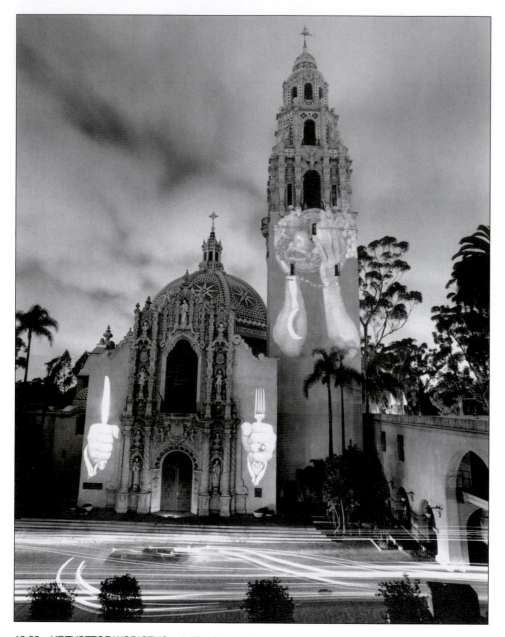

**18.39  KRZYSZTOF WODICZKO.** *In The Border Projection* (part one), *San Diego Museum of Man,* 1988. Installation view.  © Krzysztof Wodiczko. Courtesy Galerie Lelong, New York.

and time. Digital imaging breaks the customary prescription by giving imagemakers the ability to not only determine place and time, but to control space and time. This is possible because images are formed into a binary numerical code that is electronically stored and available for future retrieval. The seamless ease with which digital technology allows photographs to be combined and manipulated suggests that for the immediate future photography will be a hybrid of mixed media based not only on the observable reality of actual events, but also on the inner workings of imagination. This shift not only alters notions about the nature of photography but also conceptions about art and reality. Digital imaging has made

the geography of the world smaller. Like fairy tales and structuralism, it offers the ability to visually ruminate about ourselves. Since the advent of the personal computer, ambitious people who once dreamed of presiding over a physical domain now fantasize about controlling virtual space. Those people who are not able or willing to keep up with these rapid changes are becoming a technological underclass. As digital techonology becomes an everyday component in Western society, any creative individual who does not have an online presence virtually ceases to exist.

In the past, philosophers like Immanuel Kant (1724–1804) devised categorical imperatives, which acted as preconditions for prognosticating the ultimate reality—the causes and principles that make up Western thinking. Now images define behavior, shape identities, set fashions, and permeate our memories. Photo-based

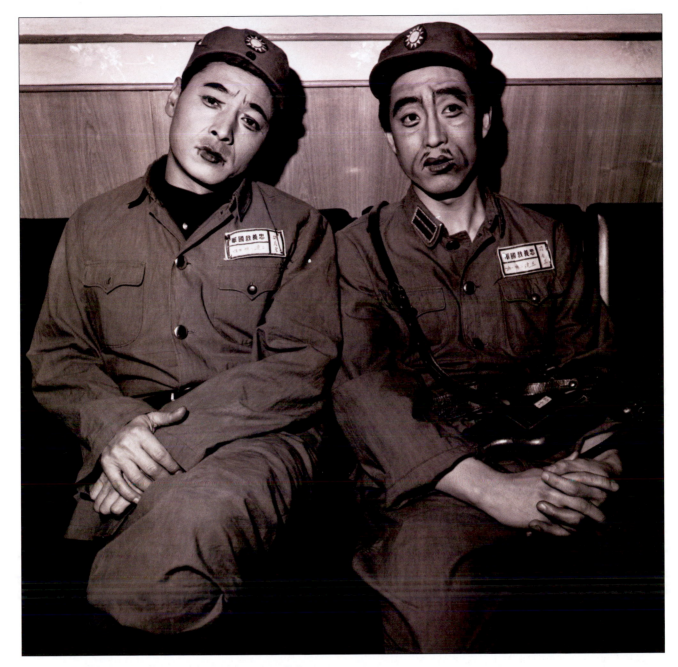

18.40  LIU ZHENG.  *Revolutionary Opera Performers, Beijing, 1998.* Gelatin silver print. Here Liu explores the influence of traditional Chinese history on contemporary Chinese society as well as the level of performance involved in the processes of depicting and constructing Chinese identity. Liu's assertion, "my compatriots are not only the subject of my work, but also the rightful owners and audiences for my work,"[78] makes clear his intention for *The Chinese* to function as a tool for collective identity reconstruction.   © Liu Zheng, Courtesy Yossi Milo Gallery, New York.

images are so interwoven into daily existence that life has become a collection of images, generating confusion between the artifice and the real.[79] As a result, entertainment and mass media are the primary frames of reference through which we filter experience. So-called reality TV shows, such as *Survivor,* graphically demonstrate how the authority of images frame reality, blurring the lines between truth and illusion, and news and entertainment.

Digitization gives new meaning to Kant's belief that we should behave as if the maxims on which we act and define society become, through our will, universal laws. Digitizing converts the static into the dynamic, turning completed, unalterable ideas and works into things of the past by permitting the process to be part of the product. Professions like photojournalism, rooted in the authenticity of photographic appearance and their circulation via the halftone process, have been radically retailored by the digital age (see Chapter 14). As media

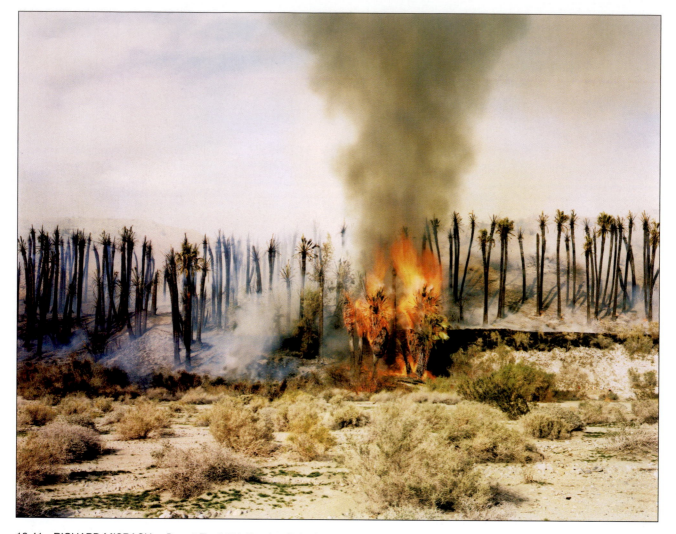

**18.41   RICHARD MISRACH.**   *Desert Fire #001 (Burning Palms),* 1983. 20 × 24 inches. Chromogenic color print.   Illustration Desert Cantos, cover and p. 47; Chronologies, pl. 14. © Richard Misrach, courtesy Fraenkel Gallery, San Francisco, Marc Selwyn Fine Art, Los Angeles and Pace/MacGill Gallery, New York.

sources rely more on freelance and citizen journalists, a public that is increasingly aware of the impossibility to separate "legitimate" images from those that have been manipulated may come to regard news pictures as little more than advertisements, illustrations, and/or propaganda. No longer are images known primarily through the screen of halftone dots that is print media. Instead, more and more images are experienced through the universe of electronic pixels on television, computer, and cell phone screens.[80] Western society's compact with the photograph as an empirical catalog of the real is being appropriated. The photograph's metamorphosis into fiction marks the end of an era that has dominated photographic history to date. In a Darwinian twist of Natural Selection, digital imaging has placed the traditional photograph in the same position that the invention of photography put painting.

A truism in the nonlinear path of progress is that gain seldom comes without loss. As schools and professional photographers replace their darkrooms with computers, there has been a reaction to the loss of the physical nature of darkroom work where "the dimly glowing light, the sound of trickling water, and the acrid smells of acetic acid and fixer rising from the sink create an otherworldly environment that alters customary space and time, spurring the senses to circumvent the confines of familiarity and predictability."[81] In past photographic practice, artists encouraged the material act of darkroom work to guide the outcome. Today, the manual production of photographic prints by contemporary artists can be seen not as nostalgia but as an intentional act of rebellion against the importance many academics place on theories of practice and content, where photographs often are prized more as illustrations for intellectual arguments than as objects of beauty and wonder. The great disparities among the working procedures of handmade, digital, and theoretical images has led to the suggestion that they should be regarded as separate ways of working, even if the final results are similar. All arguments aside, more artists are

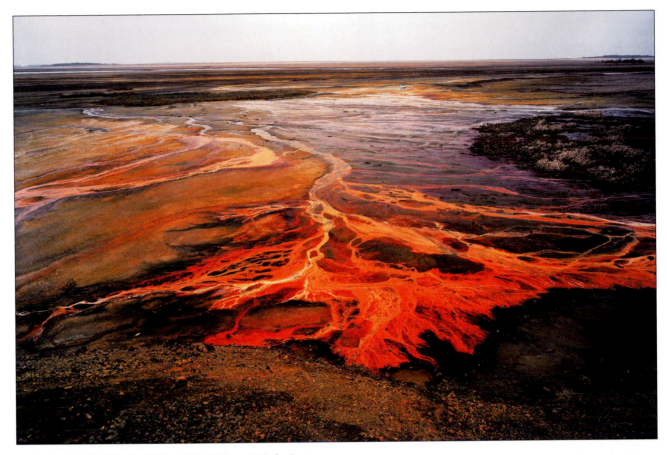

18.42 EDWARD BURTYNSKY. *Nickel Tailings, #30, Sudbury Ontario*, 1996. 40 × 60 inches. Chromogenic color print. "For 25 years I have created images about the various man-made transformations our civilization has imposed upon nature. And in the course of the evolution of my work, I became anxiously aware of the consequences our actions are having upon the world. As a husband and father, as an entrepreneur and provider, with a deep gratitude for his birthright in a peace loving and bountiful nation, I feel an urgency to make people aware of important things at stake. What we give to the future are the choices we make today."[82]

experimenting with hand processes now, from pinhole to wet-plate photography, than in any time since the late 1980s. Equally important, more commercial galleries and museums are including non-traditional forms of photography in their exhibitions and collections.

Also missing in action is the concept of a permanent master negative. As the storage disks in electronic cameras are designed to be erased and reused, a busy photographer might delete images of an event before publication. With the departure of originals, a complete record is lost. If any of the remaining photographs are altered before publication, there would be no root image for comparison. This retreat from the documentary model and the unwritten compact between photographers and audiences means that seeing is no longer believing. Confidence in the accuracy of photographs has eroded as news providers modify photographs without informing their readers. The descent began in 1982 when *National Geographic* editors "moved" the Egyptian Great Pyramids at Giza closer together to accommodate the vertical composition of their cover. On the other side of the editorial desk, unethical photojournalists have lost their jobs because they were caught "Photoshopping" images before transmitting them to their editors.[83] The intentional mishandling of such undetectable changes has contributed to audience skepticism about the accuracy of all photographs.

This increasing decline in the traditional acceptance of the veracity of the photographic original is part of a larger questioning of the meaning of truth, which leaves the meaning of cultural history, political events, and even personal memories uncertain. The topic of an ever-shifting authenticity has received much cultural attention on television, particularly by political satirist Stephen Colbert, who has popularized such buzzwords as *truthiness*, meaning "truth unencumbered by the facts," and *Wikiality*, derived from the open-source Wikipedia information website and meaning "reality as determined by majority vote." Citing how astronomers voted Pluto off their list of planets, Colbert points out that in user-created realities, such as Wiki websites, anything can become "true" if enough people say it is. This apprehension of losing the original has surfaced in scientific debates surrounding the ethics of genetic cloning.

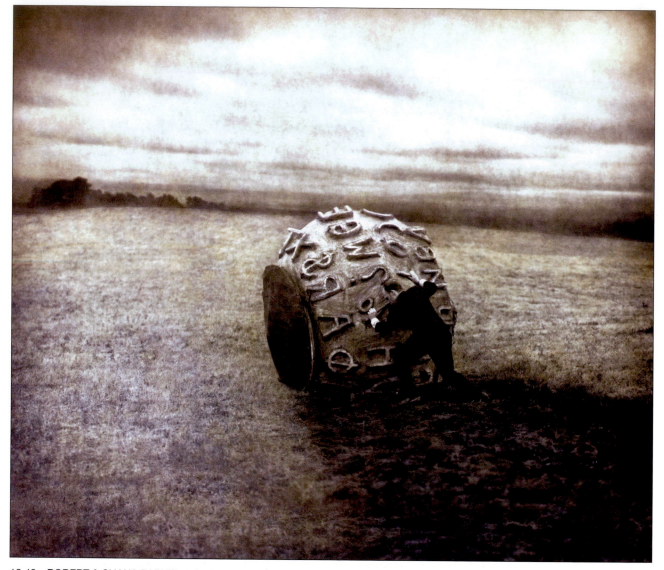

18.43   ROBERT & SHANA PARKEHARRISON.   *Earth Elegies,*
from the series *Kono, Promiseland.* 2000. Gelatin silver print with
mixed media.    Courtesy Robert and Shana ParkeHarrison.

Even in a postmodern society, where the camera is an integral part of life and many people assume multiple identities, there is an apprehension that a more advanced form of photographic cloning might steal our selves—that we would cease being individuals.[84]

**Andreas Gursky's** (b. 1955) premeditated gigantic spectacles of color and pattern combine large-format film capture with imaging software to generate a hybrid zeitgeist of industrial culture that appears more real than reality itself. His seductively colorful, super formalistic, and hyper-detailed fusion compositions synthesize the fast-paced, high-tech, expensive phenomena of globalization. His images, so perfectly beautiful and sublime that they hang in both museums and corporate boardrooms, evoke an anonymous postmodern sense of indifference that make individuals aware they are an inconsequential, just one among billions (see Fig-

ure 18.44). Gursky's supersized prints, based on an art world language that confuses the boundaries between fact and fiction, are indicative of the rise of market-driven production values. High-end Chelsea galleries in New York encourage artists to produce monumental works that successfully compete for wall space once reserved for paintings. Such works generate astronomical prices, leading some to say money is the new art criticism and has replaced serious curatorship in deciding what major museums exhibit.[85]

On the personal level, digital technology has transformed the traditional snapshot and the family album. In 1999 Kodak introduced its Picture CD service that "gives you everything you need: your full roll of pictures, organized and safely stored, plus fun interactive software [that] makes it easy to email a picture, even share a whole roll with family and friends around the world and [Kodak PictureDisk] lets you view your pictures on screen and more."[86] Now numerous such services, from Flickr to YouTube ("Broadcast Yourself"), allow people to post and view endless amounts of visual information.

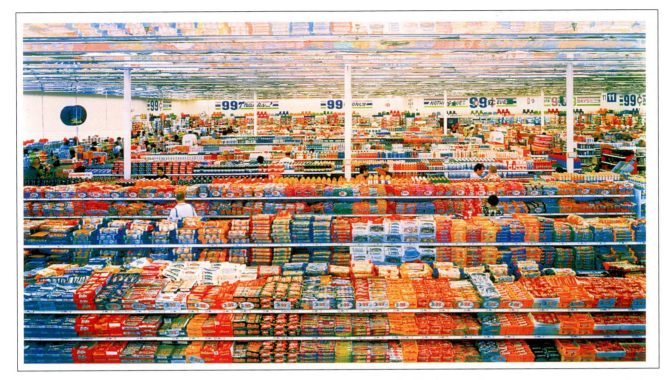

18.44  ANDREAS GURSKY.  *99 Cent,* 1999. 81½ × 132⅝ inches. Chromogenic color print.  Courtesy Matthew Marks Gallery.

Ultimately, the meaning of images depends on what viewers decide to believe about them. By disputing the medium's claims of objectivity through the use of photographic strategies that embrace artifice and simulation, conceptual and postmodern artists anticipated the digital message that photographs are not neutral containers of reality. Digital imaging tools make it possible to easily improvise the content of reality, spawning artists who are accustomed to inventing worlds rather than presenting them, and viewers who are willing to accept such inventions. At the beginning of the twenty-first century, artists are taking advantage of this expanded ability to express what makes up the "truth" of our world, and the signs that once were meant to refer to reality now point to individualized versions of that reality. Digital imaging allows truth to consist of whatever people deem to be important and whatever they choose to subvert. Digitizing permits artists to convey the sensational and emotional weight of a subject without being bound by its physical conventions, giving image-makers new ways to represent the multifaceted levels that make up splendor and veracity.

**Nancy Burson** (b. 1948) was one of the first to utilize computer power to alter and challenge cultural concepts of race. In *Mankind* (1983–1985) she applied digital morphing technology to create images of people who never existed, such as a composite person made up of Caucasian, Negroid, and Asian features weighted according to current population statistics (see Figure 18.45). Such pictures have no original physical being and exist only as digital data, showing us how unreliable images can be. These images are emblematic of a media-based society where the image (the perception of reality) is more important than reality itself. Burson has also used these tools to age-enhance human faces, allowing law enforcement officials to locate missing children and adults. Her *Human Race Machine* permits people to view themselves as a different race, allowing us to see that race is not a genetically but socially based concept. Like a magician, Burson shows us that appearances are illusory and highly deceptive.

**Barry Frydlender's** (b. 1954) images, which tackle the political, social, and religious complexities of life in Israel, are indicative of how digital imaging has altered the definition of photographic truth by mimicking and therefore undermining traditional photojournalistic methods. Although images, such as *Last Peace Demonstration,* 2004 (see Figure 18.46), appear to be a seamless representation of an event, they are actually the antithesis of "cyclopean" photography. Such a picture is a result of numerous images that Frydlender assembled into a single, time-compressed cinemascopic frame, which delivers a synthesis of the event based on many different vantage points and moments in time. "It's not one instant, it's many instants put together, and there's a hidden history in every image."[87] This methodology results in an imagemaker who no longer passively experiences and edits the world, but is an active participant who creates a realm and then photographically enlivens it. By inference, any kind of digital information —including audio and moving images—can become real. This means that digital truthiness, truth without

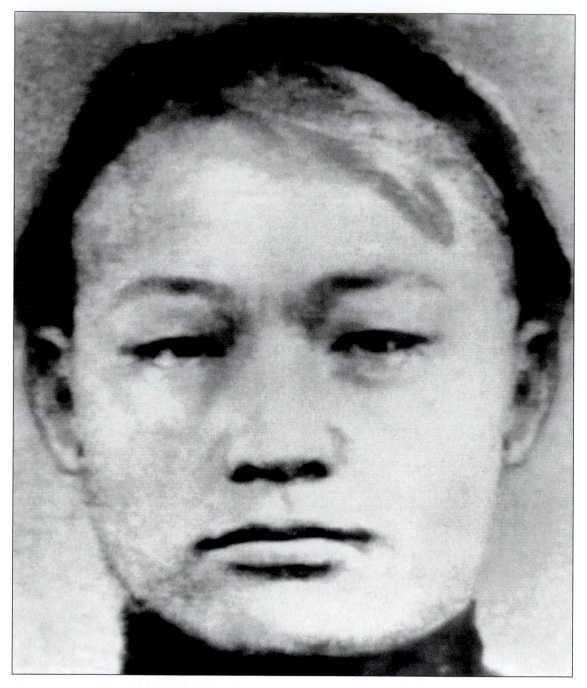

18.45   NANCY BURSON WITH RICHARD CARLING AND
DAVID KRAMLICH.    *Mankind,* 1983–1985. 7¾ × 7½ inches.
Gelatin silver print.

the authority of the original, can be used to visualize playful fantasies or dangerous fallacies. Since people like to "improve" upon the past, the ubiquity of digital practice raises questions about how these new abilities might change the future and affect our cultural and private memories: Will we in our technical sophistication delete people and events that fall out of favor?[88] Will we convincingly rewrite a memory to alter the outcome of an event or exaggerate our strengths and play down our weaknesses?

Along similar lines, **Gregory Crewdson** (b. 1962) uses elaborate Hollywood production methods, involving crews of technicians, to stage condensed cinematic stills that explore the tension between domesticity and nature in suburban life, often with a Freudian twist (see Figure 18.47).[89] As an artist and teacher, Crewdson has propagated the use of intricate theatrical elements and digital manipulation to fabricate self-enclosed scenes that resemble museum dioramas and impart a sense of voyeurism, as in an omnipotent observer, illustrating the malleability of photographic information in the digital age.

The marketing of digital image manipulation programs like Photoshop, introduced in 1989, coupled

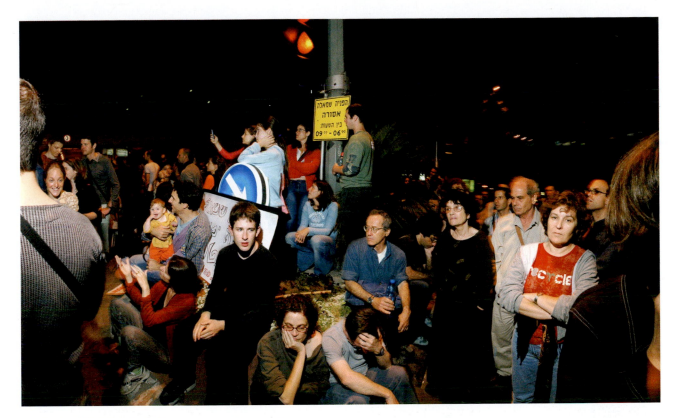

18.46  BARRY FRYDLENDER.  *Last Peace Demonstration,*
2004. 50 × 6 feet 6¾ inches. Chromogenic color print.

with new delivery formats—CD-ROMs, DVDs, Blue-Ray, and the Internet—have given digitalmakers cheaper, easier, faster, and more reliable methods of making and distributing their work. In his bilingual CD-ROM, *Truths & Fiction: A Journey from Documentary to Digital Photography* (1995), **Pedro Meyer** (b. 1935) was one of the first photographers to take advantage of these new ways of working to explore how such shifts in visual truth alter our relationship to photographic representation. By combining images, QuickTime video, and narration, Meyer asks: "What should we expect or trust from an image during this time of transition between the analog and digital eras?" Meyer challenges assumptions about where photographic "truth" ends and "fiction" begins (see Figure 18.48). In the "Digital Studio" section of his CD, Meyer takes viewers through the process of making completed images. The "Correspondence" section contains a discussion by people from various countries about the aesthetic and cultural ramifications of working digitally and the struggle with the uncertain nature of the photographic image. His website, www .zonezero.com, is dedicated to photography's journey from the analog to digital world and presents a wide array of work from around the world.

A significant difference between analog and digital imagemaking tools is the scanner and how it collects and records visual information. The shutter of a conventional camera exposes an entire piece of film at one time, while a scanner, whether the frame in a digital camera or the platen of a flatbed scanner, captures only one line at a time as it moves across its recording area. Activity occurring elsewhere in the field of view is not perceived, and motion is not recorded as a blur like it is with film, but as a series of distinct pixels, displaced in a predictable manner based on the speed and direction of motion. Carol Selter (b. 1944) places live animals on her scanner, which records the dynamic patterns of their movement, dispensing with Renaissance perspective and offering in its place a different way of seeing a subject. Other artists, like Maggie Taylor (b. 1961), utilize scanned images to assemble fantastical montages of inner reality.

A key element of postmodern discourse can be understood in terms of photography's relinquishing its role as society's authoritative chronicler, in favor of a position that acknowledges that reality is a constantly evolving construction of our culture. As we have learned, Baudrillard does not see photography, in the words of Oliver Wendell Holmes, as a "mirror with a memory," but instead as an endless passageway of mirrors. The photobased arts, including film, television, and video, serve as cultural agents that provide representational images that society sanctions as simulacrum of the real.[90] The decline in the documentary authority of photography has much to do with American life, where an abundance of images has led to a devaluation of a photograph's inherent believability. Two important questions facing the photographic arts are: Can digital replication, the twin who offers comforting fellowship at the expense of individuality, escape

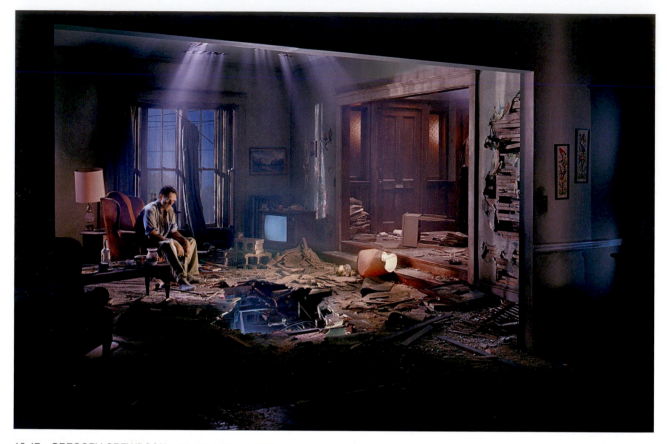

18.47 GREGORY CREWDSON. *Untitled,* Winter 2005. (From *Beneath the Roses Series*). Chromogenic color print, 64¼ × 95¼ inches. Courtesy the artist and Luhring Augustine, New York.

the aura of the original and provide insight into reality? And can this release be effected by making a reproduction that is not only trustworthy, but at times even better than the original?

The Las Vegas casino complex *New York, New York,* is a matchless example of amalgamated architectural playacting. Here the surrogate is not only acceptable but for many becomes a preferred way of visiting New York that eliminates the perceived hassles and risks of a trip to the actual city.[91] This reflects the postmodern mind that believes reality doesn't exist until it is analyzed by the viewer. Another important question is: Will digitization inspire a metaphysical meditation about the one (the original) and the many (the copies), about reality and appearance? By accepting the enigma of doubleness, one can acknowledge the creative dilemma between what the original needs to be securely anchored: the distance and separation of the copy. Like presenting one's self to its reflection in a mirror, the quest for authenticity inevitably involves a doubling back, so that ultimately it takes a multiple view to know the one. The previous system that values an image based on the aura of originality is being challenged by one that prizes the authenticity of mass circulation. Digital copying, file sharing, and website hits boost an image's currency and make it more widely known. This may provide the copy with an importance not available to the original: the sense of being part of an extended collective memory.

In this vein, **Thomas Demand** (b. 1964) remakes the world with paper and cardboard sculptures and then photographs the results. His methodology questions the relationship between the artificial and the real as well as between temporality and permanence. "Sculpture aims for permanence, for presence, while the photograph is destined to render something visible that occurred at a particular moment in front of the lens. Essentially I play these two forms off against each other."[92] For *Grotte* (2006) Demand used a digital program to cut each of the 900,000 layers of heavy gray cardboard, weighing 50 tons, which he used to build his grotto, layer upon layer. Wanting certain parts of the final photograph to lack definition, Demand actually built "pixels" in cardboard, tiny squares that deceive the eye into thinking the photograph is unfocused, when in fact it is faithfully reproducing the "reality" of the sculpted grotto. "Digital is just a technique of the imagination. It is opening possibilities that wouldn't have been there before. But I lose interest in a photograph once I see it is digitally made because it is all about betraying you in a way. I think my work has a lot in common with what digital wants, rather than being digital. Basically, it is constructing a reality for the surface of a picture."[93]

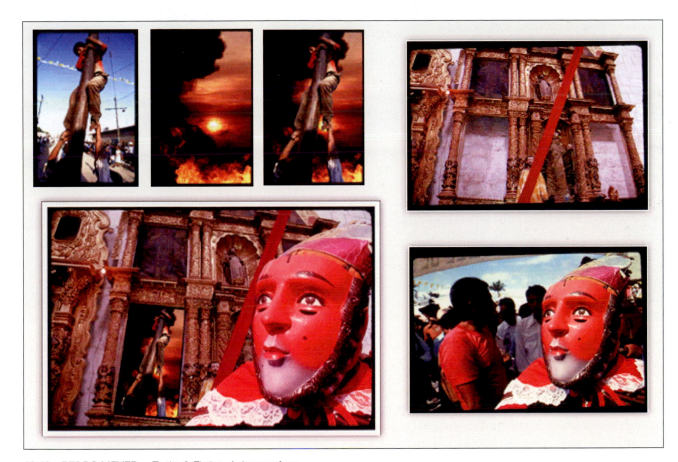

**18.48    PEDRO MEYER.**    *Truths & Fiction: A Journey from Documentary to Digital Photography,* 1995. CD-ROM. This screen shot shows the original images Meyer used to digitally fashion his final representation. In the introduction to the print version of *Truths & Fiction* Joan Fontcuberta stated: "Today more than ever the artists should reestablish the role of a demiurge and sow doubts, destroy certainties, annihilate convictions so that, at the other end of confusion, a new sense and sensibility can be created."

## The Postphotographic Age

The speed with which electronic media has so thoroughly enmeshed itself in Western culture has brought about a very dramatic decline in the overall use of analog photography. Digital imaging has fundamentally altered the photograph's role as trustworthy depicter of nature (the real world)—for some a now quaint, nostalgic notion and mythical artifact from an old-fashioned mechanical era—leaving many people feeling unsettled in the process. The good news is the Internet has become a universe of expanded photographic dialogue with social networking and video sharing websites, web pages, blogs, ezines, discussion groups, and chat rooms. Online auction sites, such as eBay, have facilitated the worldwide, everyday sale of historic and contemporary photographs and equipment. These auction sites have also turned sellers of other items into photographers and their homes into studios as they take pictures of their wares for online display. Additionally, digital publishing services, such as Blurb, are bringing photography closer to the dream Henry Fox Talbot expressed in his *Pencil of Nature* (1844) of everyone becoming their "own printer and publisher."

The primary issue remains not how an image is made, but what it communicates. Photographs continue to astonish viewers because so many do succeed in conveying meaning, regardless of whether they are unfailing containers of an agreed-upon reality. Digital imaging is just the latest evolutionary step in photographic imagemaking. Its importance lies not in the details of the process but in the largely unpredictable future of how it will transform our thinking. For instance, in the 1970s holography was heralded as a revolutionary form of imagemaking, but at present it is used chiefly as a security device on credit cards, and in merchandise bar codes and many currencies, including the Euro. Thus far, photographers have only scratched the surface of the transformative possibilities of digital imaging; the photography of the future will likely be a much different medium from that of the past.

For electronic imagery to radically affect our consciousness and perception of reality, we need to get past the tidal wave of predictable, yet often entertaining, digital images that now circulate endlessly on the Internet. Artists, scientists, and scholars need to go beyond

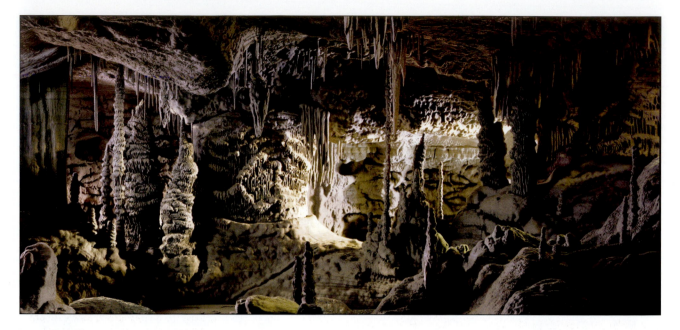

**18.49   THOMAS DEMAND.**  *Grotte,* 2006. 78 × 173 inches. Chromogenic color print.

using computers as convenient means for mimicking visions of the past, and discover the machine's potential native diction(s). The promise of digital technologies and cyberspace provides an exciting arena for the creation of something new. It not only changes the present and shifts the future, but also alters everything that went before it. With its emphasis on nonlinearity, intertextuality, and the development of multimedia, digitizing encourages the further hybridization of artistic practice, which in turn actively challenges the traditional divides between mediums and their atten-

dant cultural spaces. Digitization heralds a rethinking of ideas surrounding cultural identity, nationhood, race, and our sense of place and position. What digital imaging does not change is photography's identity as a visual sign whose strength is its ability to represent the space between the constructs of the artificial and the "natural." While the process may change, artistic, representational thinking remains a fundamental ingredient in making us who we are. Here at the beginning of the twenty-first century, as the first generation of image-makers to have grown up with computers initiates its course and seeks to discover its own syntax, photography is making a conceptual shift from a medium that records reality to one that transforms it.

## Endnotes

1   Chapter 17, "Changing Realities," discusses this topic in more detail.

2   John Baldessari in Jeanne Siegel ed., "John Baldessari: Recalling Ideas," *Art Talk: The Early 80s* (New York: Da Capo, 1988), unabridged reprint of *Artwords 2* (Ann Arbor, MI: UMI Research Press, 1988), 40.

3   Ibid., 38.

4   This book was part of the third project of *Four By Three,* a series of four exhibitions and concurrent artists' residencies in 1980–1981, jointly sponsored by the Albright-Knox Art Gallery, CEPA Gallery (The Center for Exploratory and Perceptual Art), and Hallwalls in Buffalo, NY.

5   Ibid., 42.

6   "Art Without the Artist." Geoff Edgers, *The Boston Globe,* January 8, 2008.

7   Guglielmo Bargellesi-Severi, ed., *Robert Smithson Slideworks* (Verona, Italy: Carlo Frua, 1997), 13.

8   See Simon Schama, *Landscape and Memory* (New York: Vintage Books, 1996), 122–134. Also see Rafael López-Pedraza, *Anselm Kiefer: The Psychology of "After the Catastrophe"* (New York: George Braziller, 1996).

9   Gerhard Richter, qtd. in Lynne Cook, "Gerhard Richter's *Atlas.*" www.diacenter.org/exhibs/richter/atlas/essay.html.

10   Arnulf Rainer, *Arnulf Rainer: Facefareces, Bodyposes 1968–1975,* exhibition catalogue (Paris: Galerie Stadler, 1975), unp.

11   Jill Lloyd. "Gerhard Richter. Paris and Bonn." *The Burlington Magazine* Vol. 135, No. 1089 (Dec 1993): 842–43.

12   See Ernst van Alphen, *Caught by History: Holocaust Effects in Contemporary Art, Literature, and Theory* (Stanford, CA: Stanford University Press, 1997).

13   William Wegman, National Public Radio interview on WBFO, Buffalo, NY, January 15, 1995.

14   Interview with Lynda Morris in *Bernd & Hilla Becher* (London: Arts Council of Great Britain, 1974), unp. Cited in Marc Freidus, et al., *Typologies: Nine Contemporary Photographers* (Newport Beach, CA: Newport Harbor Art Museum, 1991), 15.

15   For details on the role of neoplatonism in the formation of photographic practice, see Kathleen Campbell, "Nature and the Cosmic Circle: A Philosophical Study of Conflicts in Western Culture and Their Relation to Nineteenth Century Photography," unpublished

M.F.A. dissertation, University of New Mexico, Albuquerque, 1994.

16   Douglas Huebler, title page, *Crocodile Tears* (Brief fictions re-sounding from the proposal in Variable Piece #70:1971 "to photographically document the . . . existence of everyone alive.") (Buffalo, NY: The Albright-Knox Art Gallery and CEPA Gallery, 1985), unp.

17   See Roland Barthes, "From Work to Text," in Brian Wallis, ed. *Art After Modernism: Rethinking Representation,* (Boston: Godine, 1984), 169–174.

18   See Jean Baudrillard, "The Precession of the Simulacra," in *Simulations,* translated by Paul Foss, Paul Patton, & Philip Beitchman (New York: Semiotext(e) 1983).

19   James Alinder, *Cumming Photographs* (Carmel, CA: Friends of Photography, 1979), 5–6.

20   Fredric Jameson, "Postmodernism and Consumer Society," in *The Anti-Aesthetic* (Port Townsend, WA: Bay Press, 1983), 114–15.

21   Paul Berger, "Introduction," *Seattle Subtext* (Rochester, NY: Visual Studies Workshop Press; Seattle: Real Comet Press, 1984), unp.

22   Quoted in Suzi Gablik, *The Reenchantment of Art* (New York: Thames and Hudson, 1991), 16.

23   Douglas Crimp, "Pictures," *October 8* (Spring 1979) and "The Photographic Activity of Postmodernism," *October 15* (Winter 1980).

24   Richard Prince, "The Perfect Tense," in Brian Wallis ed., *Blasted Allegories: An Anthology of Writings by Contemporary Artists* (New York: The New Museum of Contemporary Art and Cambridge: The MIT Press, 1987), 416.

25   Richard Prince, *Why I go to the Movies Alone* (New York: Tantam Press, 1983), 63.

26   Ibid., 69.

27   Kruger in Siegel, 307–8.

28   Prince, 70.

29   "After Sherrie Levine," Jeanne Siegel, ed., *Art Talk: The Early 80s,* (New York: De Capo Press, 1988), 246.

30   Ibid., 247.

31   Barbara Kruger in Jeanne Siegel, ed., "Barbara Kruger: Pictures and Words," *Art Talk: The Early 80s,* 303.

32   Ibid.

33   Ibid., 307–8.

34   Douglas Crimp, *Pictures,* catalogue essay (New York: Committee for the Visual Arts, Inc., 1977), 3. This show took place in New York at Artist Space in the fall of 1977 and included the work of Jack Goldstein, Sherrie Levine, and Robert Longo.

35   Cindy Sherman in Jeanne Siegel, ed., *Art Talk: The Early 80s,* 283.

36   Ibid., 275.

37   See Laurie Simmons, *In and Around The House, Photographs 1976–1979* (Buffalo, NY: CEPA Gallery, 1983).

38   Email correspondence between Carl Chiarenza and the author, March 6, 1999.

39   James Casebere, *In The Second Half of the Twentieth Century* (Buffalo, NY: CEPA Gallery, 1982).

40   Nan Richardson, "Sandy Skoglund: Wild at Heart," *ARTnews* (April 1991), 115.

41   Ibid., 118.

42   See: James Gleick, *Chaos: Making a New Science* (New York: Viking Penguin, 1987).

43   Donna Conrad, "Olivia Parker: Constructions," *Camera & Darkroom,* vol. 17, No. 2 (February 1995), 38.

44   R. H. Cravens, "Joel-Peter Witkin," *Aperture: On Location,* Fall 1993, 58.

45   Kathleen McCarthy Gauss in: Andy Grundberg & Kathleen McCarthy Gauss, *Photography and Art: Interactions Since 1946* (New York: Abbeville Press, 1987), 65.

46   R. H. Cravens, "Joel-Peter Witkin," *Aperture: On Location,* Fall 1993, 58.

47   See Hollis Frampton, *Circles of Confusion: Film, Photography, Video Texts 1968–1980* (Rochester, NY: Visual Studies Press, 1983).

48   Barbara London, "Public Spaces and Private Places," *American Photographer* (September 1988), 48.

49   Lawrence Weschler, *Cameraworks: David Hockney* (New York: Alfred A. Knopf, 1984), 9.

50   Holly Roberts, telephone conversation with author, November 30, 2001.

51   Jamie James, "Adam Fuss: Photographer without a Camera," *ARTnews,* vol. 94, no. 2 (February 1995), 98.

52   The work of Andres Serrano and Robert Mapplethorpe led Congress in 1989 to approve restrictions on federal aid for "obscene" art or art lacking "serious literary, artistic, political or scientific value," restrictions that were first struck down and then reinstated by the courts. Conservative members of Congress have attempted numerous times to eliminate the National Endowment for the Arts (NEA) and end federal funding of the arts entirely. In 1994, in an attempt to rescue the NEA from funding cuts, the National Council on the Arts voted to reject Serrano and two other artists, Merry Alpern and Barbara DeGenevieve, who had been recommended by the Photography Fellowship Peer Panel of the Visual Artists Program of the NEA to receive fellowships. Funding was cut anyway. Individual visual arts fellowships have since been curtailed by the NEA.

53   Serrano, unpublished statement, 1989 in Lucy R. Lippard, "Andres Serrano: The Spirit and The Letter," *Art in America* (April 1990), 239.

54   Lucy R. Lippard, "Andres Serrano: The Spirit and The Letter," *Art in America* (April 1990), 239.

55   Serrano, unpublished statement, 1989, Ibid., 240.

56   See Richard Bolton, ed., *Culture Wars: Documents from the Recent Controversies in the Arts* (New York: New Press, 1992).

57   For an accessible account of the controversy surrounding Mapplethorpe's work see Terry Barrett, *Criticizing Photographs: An Introduction to Understanding Images* (Mountain View, CA: Mayfield Publishing, 1990), 110–118.

58   Michael Gill, *Image of the Body: Aspects of the Nude* (New York: Doubleday, 1989), 17.

59   Ibid., 20.

60   John Coplans in Chris Townsend, *Vile Bodies: Photography and the Crisis of Looking* (Munich & New York: Prestel-Verlag, 1998), 99.

61   See Doreen Carvajal, "Pornography Meets Paranoia," *The New York Times,* Sunday, February 19, 1995, 4-E.

62   Richard B. Woodward, "The Disturbing Photography of Sally Mann," *The New York Times Magazine* (September 27, 1992), 36. Mann denied permission to reproduce one of her images because she did not like the text. On February 26, 1999, Mann's gallery, Houk Friedman, NYC said "It would be better if Sally were portrayed as championing a certain venue rather than appearing as if she really might be doing something illicit."

63   Lauren Greenfield, *Girl Culture* Artist Statement, 2002, www.laurengreenfield.com/index.php?p54B32KF87.

64   The Guerrilla Girls, dressed in gorilla masks, fishnet stockings, and black leather jackets, were formed on the streets of New York in front of the Museum of Modern Art during the exhibition *An International Survey of Recent Painting and Sculpture* (Spring 1985) to protest that of the 166 artists only 15 were women. To protect their identities, individual Guerrilla Girls use the names of dead women artists as pseudonyms. The group publishes a quarterly tabloid, *HotFlashes.*

65   Andres Serrano in Richard Goldstein, "The Taboo Artist," *The Village Voice,* vol. XLII, no. 10 (March 11, 1997), 51.

66   For more on this theme see: Deborah Willis, *Imagining Families: Images and Voices* (Washington, DC: National African American Museum, Smithsonian Institution, 1994).

67   Alan D. Entin, "Family Icons: Photographs in Family Psychotherapy," *The Newer Therapies: A Sourcebook,* L. Abt and I. Stuart, eds. (New York: Van Nostrand, 1982), 209.

68   Wall statement by the artist from *Carrie Mae Weems: Recent Work, 1992–1998* at the Everson Museum, Syracuse, NY (September 26, 1998–February 14, 1999) that brought together five of Weems's installations works.

69   This incident occurred at the Everson Museum of Art, Syracuse, NY, which organized the exhibition. See Erin Duggan, "Thoughtful Art, Thoughtless Act," *The Post-Standard* (Syracuse, NY), Tuesday, November 3, 1998, B1.

70   Lorna Simpson, interview with Fatimah Tobing Rony, January 11, 1992, as quoted in "We Must First See Ourselves," *Personal Narratives: Women Photographers of Color* (Winston-Salem, NC: Southeastern Center for Contemporary Art, 1993), 12. This was an exhibition catalogue, October 23, 1993–January 2, 1994, featuring the work of Lorraine O'Grady, Coreen Simpson, Lorna Simpson, Clarissa T. Sligh, Carrie Mae Weems, Pat Ward Williams, and Deborah Willis.

71   For more on public art see *The Citizen Artist: 20 Years of Art in the Public Arena, An Anthology from High Performance Magazine, 1978–1998,* Linda Frye Burnham and Steven Durland, eds. (Gardiner, NY: Critical Press, 1998).

72   See: *China, Portrait of a Country* By James Kynge, Karen Smith. Liu Heung Shing (Ed) Los Angeles: Taschen America, 2008.

73   See: Barbara Pollack. "The Chinese Art Explosion." *Artnews,* September 2008. Volume 107, Number 8, 118–127.

74   Dinh Q. Lê in Robert Hirsch, "Ritual: Social Identity/A View From Within," *CEPA Journal* (Spring/Summer 1994), 4.

75   Jeffrey Hoone, *Clarissa Sligh: The Presence of Memory,* Robert B. Menschel Photography Gallery, 24, (Syracuse: Light Work, 1991), unp.

76   Robert ParkeHarrison, written correspondence with author, April 3, 2000.

77   Robert Dawson, Preface, Robert Dawson and Gray Brechin, *Farewell, Promised Land: Waking from the California Dream* (Berkeley and Los Angeles: University of California Press, 1999), xvi.

78   Liu Zheng, *Liu Zheng: The Chinese.* New York: International Center of Photography; Göttingen, Germany: Steidl, 2004. p. 140.

79   A seemingly alluring juncture of the camera and the computer is the proliferation of 24-hour live camera websites where people encourage strangers to view, even ask questions, about the most intimate and generally banal details of their lives.

80   See Robert Hirsch and AnJanette Brush, "From Dots to Pixels: Tracing Truth & Desire," *U-Turn E-zine* 1:1 (1998) www.uturn.org (Chicago, IL).

81   Robert Hirsch, "Flexible Images: Handmade American Photography, 1969–2002," *exposure,* Volume 36:1, 2003, 31.

82   Edward Burtynsky, *Burtynsky—China* (Gottingen, Germany: Steïdel Publishers, 2006), 7.

83   Frank Van Riper, "Manipulating Truth, Losing Credibility," www.washingtonpost.com/wp-srv/photo/essays/vanRiper/030409.htm.

84   George Johnson, "Soul Searching, Don't Worry. A Brain Still Can't Be Cloned," *The New York Times,* Sunday, March 2, 1997, Section 4, 1, 16.

85   In 2006 Gursky's *99 Cent II Diptychon* (2001) sold for $2.8 million. An extreme example of this phenonmena is British artist Damien Hirst's diamond encrusted skull, *For The Love of God,* which sold in 2007 for $100 million to an unnamed investment group.

86   "Put Your Pictures on Your PC," *The Buffalo News,* Sunday, July 18, 1999, Wegman's grocery store supplement, 23.

87   Vince Aletti, "An Israeli Photographer and His Panoramic Time Machines," *Village Voice,* September 7, 2004. (www.villagevoice.com/art/0437,aletti,56701,13.html).

88   See David King, *The Commissar Vanishes: The Falsification of Photographs and Art in Stalin's Russia* (New York: Metropolitan, 1997).

89   Annette Grant, "ART; Lights, Camera, Stand Really Still: On the Set With Gregory Crewdson," *The New York Times,* Sunday, May, 30th, 2004, Section C, 20–21. http://query.nytimes.com/gst/fullpage.html?res=9800E3DB153EF933A05756C0A9629C8B63&sec=&spon=&pagewanted=1.

90   See Jean Baudrillard, *America,* "Utopia Achieved," trans. by Chris Turner (London: Verso, 1988).

91   Ada Louise Huxtable, "Living With the Fake, and Liking It," *The New York Times,* vol. CXLVI, no. 50,747 (Sunday, March 30, 1997, Section 2), 1, 40.

92   *Thomas Demand.* London: Serpentine Gallery; Munich: Schirmer/Mosel, 2006. p.56.

93   Sarah Crompton, "Gained in Translation," *Telegraph,* May 27, 2006. www.telegraph.co.uk/arts/main.jhtml?xml=/arts/2006/05/27/bademand27.xml&sSheet=/arts/2006/05/29/ixartleft.html.

**A**

Ades, Dawn. *Photomontage*. New York: Thames and Hudson, 1993.

**B**

Baldwin, Gordon. *Looking at Photographs: A Guide to Technical Terms*. Malibu, CA: J. Paul Getty Museum; London: British Museum Press, 1991.

Bannon, Anthony. *The Photo-Pictorialists of Buffalo*. Buffalo, NY: Media Study, 1981.

Barrow, Thomas F., et al. *Reading into Photography: Selected Essays, 1959–1980*. Albuquerque: University of New Mexico Press, 1982.

Barthes, Roland. *Camera Lucida: Reflections on Photography*. London: Vintage, 2000.

Batchen, Geoffrey. *Burning with Desire: The Conception of Photography*. Cambridge and London: The MIT Press, 1999.

Batchen, Geoffrey. *William Henry Fox Talbot*. London & New York: Phaidon Press, 2008.

Bayer, Jonathan, et al. *Reading Photographs: Understanding the Aesthetics of Photography*. New York: Pantheon Books, 1977.

Beaton, Cecil, and Gail Buckland. *The Magic Image: The Genius of Photography from 1839 to the Present Day*. London: Pavilion, 1989.

Benjamin, Walter. "The Work of Art in the Age of Mechanical Reproduction," *Illuminations*. Hannah Arendt, ed. Harry Zohn, transl. London: Pimlico, 1999.

Berger, John. *About Looking*. New York: Vintage International, 1991.

*The Black Photographers Annual*. 4 vols. Brooklyn, NY: Black Photographers Annual, Inc., 1973–1976.

Bloom, John. *Photography at Bay: Interviews, Essays and Reviews*. Albuquerque: University of New Mexico Press, 1993.

Bogdan, Robert, and Todd Weseloh. *Real Photo Postcard Guide: The People's Photography*. Syracuse: Syracuse University Press, 2006.

Bolton, Richard, ed. *The Contest of Meaning: Critical Histories of Photography*. Cambridge and London: MIT Press, 1989.

Bolton, Richard, ed. *Culture Wars: Documents from the Recent Controversies in the Arts*. New York: New Press, 1992.

Booth, Pat, ed. *Master Photographers: The World's Great Photographers on Their Art and Technique*. New York: Clarkson N. Potter, Inc., 1983.

Borcoman, James. *Magicians of Light: Photographs from the Collection of the National Gallery of Canada*. Ottawa: National Gallery of Canada, 1993.

Braun, Marta. *Picturing Time: The Work of Etienne-Jules Marey (1830–1904)*. Chicago and London: The University of Chicago Press, 1994.

Brettell, Richard, with Roy Flukinger, Nancy Keeler, and Sydney Kilgore. *Paper and Light: The Calotype in France and Great Britain, 1839–1870*. Boston: David R. Godine, 1984.

Brewster, Sir David. *The Stereoscope: Its History, Theory and Construction*. Facsimile edition. Hastings-on-Hudson, NY: Morgan & Morgan, 1971.

Bright, Deborah, ed. *The Passionate Camera: Photography and Bodies of Desire*. London and New York: Routledge, 1998.

Browne, Turner, and Elaine Partnow. *Macmillan Biographical Encyclopedia of Photographic Artists and Innovators*. London and New York: Macmillan, 1983.

Buerger, Janet E. *The Era of the French Calotype*. Rochester, NY: International Museum of Photography at George Eastman House, 1982.

Buerger, Janet E. *French Daguerreotypes*. Chicago: University of Chicago Press, 1989.

Buerger, Janet E. *The Last Decade: The Emergence of Art Photography in the 1890s*. Rochester, NY: International Museum of Photography at George Eastman House, 1984.

Bunnell, Peter C. *Degrees of Guidance: Essays on 20th-Century American Photography*. Cambridge and New York: Cambridge University Press, 1993.

Bunnell, Peter, ed. *A Photographic Vision: Pictorial Photography, 1889–1923*. Salt Lake City, UT: Peregrine Smith, 1980.

Burgin, Victor, ed. *Thinking Photography*. London: Macmillan, 1982.

Burnham, Linda Frye and Steven Durland. *The Citizen Artist: 20 Years of Art in the Public Arena*, Vol. 1. Gardiner, NY: Critical Press, 1998.

Burns, Stanley B., M.D., and Elizabeth Burns. *Sleeping Beauty II: Grief, Bereavement and the Family in Memorial Photography, American & European Traditions*. New York: Burns Archive Press, 2002.

**C**

Caffin, Charles H. *Photography as a Fine Art*. Facsimile edition. Hastings-on-Hudson, NY: Morgan & Morgan, Inc., 1971.

*Camera Work: The Complete Illustrations 1903–1917*. "Alfred Stieglitz, 291 Gallery and Camera Work" by Pam Roberts. Köln and New York: Taschen, 1997.

Campany, David, ed. *Art and Photography*. New York: Phaidon, 2003.

Capa, Cornell, ed. *The Concerned Photographer*. New York: Grossman Publishers in cooperation with The International Fund for Concerned Photography, 1968, 1972.

*A Century of Japanese Photography*. Intro. by John Dower. New York: Pantheon Books, 1980.

Chéroux, Clément, et al. *The Perfect Medium: Photography and the Occult*. New Haven, CT: Yale University Press, 2005.

Coar, Valencia Hollins, ed. *A Century of Black Photographers, 1840–1960*. Providence: Rhode Island School of Design, 1983.

Coe, Brian. *Colour Photography: The First Hundred Years, 1840–1940*. London: Ash & Grant, 1978.

Coe, Brian, and Paul Gates. *The Snapshot Photograph: The Rise of Popular Photography, 1888–1939*. London: Ash & Grant, 1977.

Coke, Van Deren. *Avant-Garde Photography in Germany, 1919–1939*. New York: Pantheon Books, 1982.

Coke, Van Deren. *The Painter and the Photographer, from Delacroix to Warhol*. Albuquerque: University of New Mexico Press, 1964. Revised and enlarged edition, 1972.

Coke, Van Deren, with Diana C. Du Pont. *Photography: A Facet of Modernism*. New York: Hudson Hills Press, 1986.

Coke, Van Deren, ed. *One Hundred Years of Photographic History: Essays in Honor of Beaumont Newhall*. Albuquerque: University of New Mexico Press, 1975.

Coleman, A. D. *The Digital Evolution: Visual Communication in the Electronic Age. Essays, Lectures and Interviews 1967–1998.* Tucson: Nazraeli Press, 1998.

Coleman, A. D. *Critical Focus: Photography in the International Image Community.* Tucson, AZ: Nazraeli Press, 1999.

Coleman, A. D. *The Grotesque in Photography.* New York: Summit Books, 1977.

Coleman, A. D. *Light Readings: A Photography Critic's Writings, 1968–1978.* Albuquerque: University of New Mexico Press, 1996.

Collins, Kathleen, ed. *Shadow and Substance: Essays on the History of Photography in Honor of Heinz K. Henisch.* Bloomfield Hills, MI: The Amorphous Institute Press, 1990.

Coote, Jack H. *The Illustrated History of Colour Photography.* Surbiton, England: Fountain Press, 1993.

Crary, Jonathan. *Techniques of the Observer: On Vision and Modernity in the Nineteenth Century.* Cambridge: The MIT Press, 1992.

Crimp, Douglas, with photographs by Louise Lawler. *On the Museum's Ruins.* Cambridge: The MIT Press, 1995.

**D**

Daniel, Pete, et al. *Official Images: New Deal Photography.* Washington, D.C.: Smithsonian Institution, 1987.

Darrah, William Culp. *Stereo Views: A History of Stereographs in America and Their Collection.* Gettysburg, PA: Times and News Publishing Co., 1964.

Daval, Jean-Luc. *Photography: History of an Art.* R. F. M. Dexter, transl. New York: Rizzoli International Publications, Inc., 1982.

Davis, Keith F. *An American Century of Photography: From Dry-Plate to Digital.* 2nd edition. New York: Harry N. Abrams, Inc., 1999.

Davis, Keith F. *The Origins of American Photography: From Daguerrotype to Dry-Plate.* New Haven, CT: Yale University Press, 2007.

Deribere, Maurice, ed. *Encyclopedia of Colour Photography.* London: Fountain Press, 1962.

Diamonstein, Barbaralee, et al. *Visions and Images: American Photographers on Photography.* New York: Rizzoli, 1981.

Dickerman, Leah. *Dada.* Washington, D.C.: National Gallery of Art, 2005.

Doty, Robert. *Photo-Secession: Stieglitz and the Fine-Art Movement in Photography.* Foreword by Beaumont Newhall. New York: Dover Publications, Inc., 1978.

Druckrey, Timothy, ed. *Electronic Culture: Technology and Visual Representation.* New York: Aperture, 1996.

Dugan, Thomas. *Photography Between Covers: Interviews with Photo-Bookmakers.* Rochester, NY: Light Impressions, 1979.

**E**

Earle, Edward W., ed. *Points of View: The Stereograph in America—A Cultural History.* Rochester, NY: The Visual Studies Workshop Press in collaboration with the Gallery Association of New York State, 1979.

Easter, Eric, et al., eds. *Songs of My People: African-Americans, A Self-Portrait.* Boston: Little, Brown and Company, 1992.

Eauclaire, Sally. *American Independents: Eighteen Color Photographers.* New York: Abbeville Press, Inc., 1987.

Eauclaire, Sally. *The New Color Photography.* New York: Abbeville Press, Inc. 1981.

Eder, Josef Maria. *History of Photography.* Edward Epstean, transl. 4th edition. New York: Columbia University Press, 1945. Reprint. Dover Publications, Inc., 1978.

Edgerton, Harold E., and James R. Killian, Jr. *Moments of Vision: The Stroboscopic Revolution in Photography.* Cambridge: MIT Press, 1985.

Eisinger, Joel. *Trace and Transformation: American Criticism of Photography in the Modernist Period.* Albuquerque: University of New Mexico Press, 1999.

Emerson, Peter Henry. *Naturalistic Photography for Students of the Art.* 1889; 3rd edition., 1899. Reprint. New York: Arno Press, 1973.

Enyeart, James, ed. *Decade by Decade: A Survey of Twentieth Century American Photography from the Collections of the Center for Creative Photography.* Boston: Bullfinch Press, 1989.

Eskind, Andrew H., and Greg Drake, eds. *Index to American Photographic Collections.* 3rd edition. New York: G.K. Hall and Co., 1996.

Evans, Jessica, ed. *The Camerawork Essays: Context and Meaning in Photography.* New York: New York University Press, 1997.

Ewing, William A. *The Body: Photographs of the Human Form.* San Francisco: Chronicle Books, 1994.

*Experimental Vision: The Evolution of the Photogram Since 1919.* Denver: Roberts Rinehart, Denver Art Museum, 1994.

**F**

Fiedler, Jeannine, ed. *Photography at the Bauhaus.* Cambridge: The MIT Press, 1990.

Fleming, Paula Richardson, and Judith Lynn Luskey. *Grand Endeavors of American Indian Photography.* London: L. King, 1996.

Flukinger, Roy. *The Formative Decades: Photography in Great Britain, 1839–1920.* Austin: University of Texas Press, 1985.

Foresta, Merry A. *At First Sight: Photography and the Smithsonian.* Washington, D.C.: Smithsonian Books, 2003.

Foster, Sheila, Manfred Heiting, and Rachel Stuhlman, eds. *Imagining Paradise: The Richard and Ronay Menschel Library at The George Eastman House, Rochester.* Göttingen, Germany and London: Steidl, 2007.

*The Founding and Development of Modern Photography in Japan.* Tokyo: Tokyo Metropolitan Museum of Photography, 1995.

Frampton, Hollis. *Circles of Confusion: Film, Photography, Video: Texts 1968–1980.* Rochester, NY: Visual Studies Workshop Press, 1983.

Freidus, Marc, et al. *Typologies: Nine Contemporary Photographers.* Newport Beach, CA: Newport Harbor Art Museum, 1991.

Freund, Gisèle. *Photography and Society.* Boston: David R. Godine, 1980.

Friedman, Joseph S. *History of Color Photography.* Boston: American Photographic, 1944. Reprint. London and New York: Focal Press, 1968.

Frizot, Michel, ed. *A New History of Photography.* English language edition. New York: Könemann, 1998.

Fulton, Marianne. *Eyes of Time: Photojournalism in America.* Boston: Little, Brown and Company, 1988.

Fulton, Marianne, et al. *Pictorialism into Modernism: The Clarence H. White School of Photography.* New York: Rizzoli, in association with George Eastman House and the Detroit Institute of Arts, 1996.

**G**

Galassi, Peter. *American Photography, 1890–1965.* New York: Harry N. Abrams, Inc., Museum of Modern Art, 1995.

Galassi, Peter. *Before Photography: Painting and the Invention of Photography.* New York: Museum of Modern Art, 1981.

Garner, Gretchen. *Disappearing Witness: Change in Twentieth-Century American Photography.* Baltimore: The Johns Hopkins University Press, 2003.

Gernsheim, Helmut, and Alison Gernsheim. *The History of Photography: From the Camera Obscura to the Beginning of the Modern Era.* 3rd edition. London: Thames and Hudson, 1988.

Gernsheim, Helmut, and Alison Gernsheim. *L. J. M. Daguerre: The History of the Diorama and the Daguerreotype.* New York: Dover Publications, Inc., 1968.

Gernsheim, Helmut, and Alison Gernsheim. *The Origins of Photography.* Vol. 1 of *The History of Photography.* New York: Thames and Hudson, 1982.

Gernsheim, Helmut, and Alison Gernsheim. *The Rise of Photography, 1850–1880: The Age of Collodion.* Vol. 2 of *The History of Photography.* New York: Thames and Hudson, 1988.

Glassman, Elizabeth, and Marilyn F. Symmes. *Cliché-verre: Hand-Drawn, Light-Printed: A Survey of the Medium from 1839 to the Present.* Detroit: The Detroit Institute of Arts, 1980.

Goldberg, Vicki. *Photography in Print: Writings from 1816 to the Present.* New York: Simon and Schuster, 1981. Reprint. Albuquerque: University of New Mexico Press, 2000.

Goldberg, Vicki. *The Power of Photography: How Photographs Changed Our Lives.* London and New York: Abbeville Press, 1993.

Goldschmidt, Lucien, and Weston J. Naef. *The Truthful Lens: A Survey of the Photographically Illustrated Book, 1844–1914.* New York: The Grolier Club, 1980.

Goranin, Näkki. *American Photobooth.* New York & London: W.W. Norton, 2008.

Gover, C. Jane. *The Positive Image: Women Photographers in Turn-of-the-Century America.* Albany: The State University of New York Press, 1988.

Green, Jonathan. *American Photography: A Critical History, 1945 to the Present.* New York: Harry N. Abrams, Inc., 1984.

Green, Jonathan, ed. *Camera Work: A Critical Anthology.* Millerton, NY: Aperture, 1973.

Green, Jonathan, ed. *The Snapshot.* Millerton, NY: Aperture, 1974.

Greenough, Sarah, et al. *The Art of the American Snapshot: 1888–1978.* Washington, D.C.: National Gallery of Art, 2007.

Greenough, Sarah, et al. *On the Art of Fixing a Shadow: One Hundred Fifty Years of Photography.* Washington, D.C.: National Gallery of Art; Chicago: The Art Institute of Chicago, 1989.

Grundberg, Andy. *Crisis of the Real: Writings on Photography, 1974–1989.* 2nd edition. New York: Aperture, 1999.

Grundberg, Andy, and Kathleen Gauss. *Photography and Art: Interactions Since 1946.* New York: Cross River Press, 1987.

Guimond, James. *American Photography and the American Dream.* Chapel Hill: University of North Carolina Press, 1991.

**H**

Hales, Peter Bacon. *Silver Cities: Photographing American Urbanization, 1839–1939.* Albuquerque: University of New Mexico Press, 2005.

Hambourg, Maria Morris, and Christopher Phillips. *The New Vision: Photography Between the World Wars: The Ford Motor Company Collection at the Metropolitan Museum of Art.* New York: Metropolitan Museum of Art, 1994.

Hambourg, Maria Morris, et al. *The Waking Dream: Photography's First Century: Selections from the Gilman Paper Company Collection.* New York: Metropolitan Museum of Art, 1993.

Handy, Ellen. *Pictorial Effect, Naturalistic Vision: The Photographs and Theories of Henry Peach Robinson and Peter Henry Emerson.* Norfolk, VA: Chrysler Museum, 1994.

Hannavy, John, ed. *Encyclopedia of Nineteenth-Century Photography.* 2 vols. New York: Routledge, 2008.

Harker, Margaret. *The Linked Ring: The Secession Movement in Photography in Britain, 1892–1910.* London: Heineman, 1979.

Haworth-Booth, Mark. *The Golden Age of British Photography, 1839–1900.* Millerton, NY: Aperture in association with the Philadelphia Museum of Art, 1984.

Haworth-Booth, Mark. *Photography: An Independent Art: Photographs from the Victoria and Albert Museum 1839–1996.* Princeton: Princeton University Press, 1997.

Henisch, Heinz K., and Bridget A. Henisch. *The Photographic Experience, 1839–1914: Images and Attitudes.* University Park, PA: Pennsylvania State University Press, 1993.

*Here Is New York: A Democracy of Photographs.* New York: Scalo, 2002.

Heron, Liz, and Val Williams, eds. *Illuminations: Women Writing on Photography from the 1850s to the Present.* Durham, NC: Duke University Press, 1996.

Heyman, Therese Thau, ed. *Seeing Straight: The f.64 Revolution in Photography.* Oakland, CA: Oakland Museum, 1992.

Hill, Paul, and Thomas Cooper, eds. *Dialogue with Photography.* Stockport, England: Dewi Lewis Publishing, 2005.

Homer, William Innes. *Alfred Stieglitz and the American Avant-Garde.* Boston: New York Graphic Society, 1977.

Homer, William Innes. *Alfred Stieglitz and the Photo-Secession.* Boston: Little, Brown and Company, 1983.

Hoy, Anne H. *Fabrications: Staged, Altered and Appropriated Photographs.* New York: Abbeville Press, 1987.

Hurley, F. Jack. *Portrait of a Decade: Roy Stryker and the Development of Documentary Photography in the Thirties.* Baton Rouge: Louisiana State University Press, 1972.

**I**

*In/sight: African Photographers, 1940 to the Present.* Introduction by Clare Bell. New York: Guggenheim Museum, 1996.

*Italy: One Hundred Years of Photography.* Texts by Cesare Colombo and Susan Sontag. Florence: Alinari, 1988.

Ivins, William Jr. *Prints and Visual Communication*. Cambridge and London: The MIT Press, 1978.

**J**

Jammes, André, and Eugenia Parry Janis. *The Art of French Calotype*. Princeton: Princeton University Press, 1983.

Jammes, André, and Robert Sobieszek. *French Primitive Photography*. Millerton, NY: Aperture, 1969.

Janis, Eugenia Parry, and Max Kozloff, et al. *Vanishing Presence*. Minneapolis: Walker Art Center, 1989.

Jay, Bill, and Margaret Moore, eds. *Bernard Shaw on Photography*. Salt Lake City: Peregrine Smith Books, 1989.

Jay, Bill. *Cyanide and Spirits: An Inside-Out View of Early Photography*. Munich: Nazraeli Press, 1991.

Jay, Bill. *Occam's Razor: An Outside-In View of Contemporary Photography*. Tucson: Nazraeli Press, 2000.

Jeffrey, Ian. *Photography: A Concise History*. New York: Oxford University Press, 2003.

Johnson, Brooks, ed. *Photography Speaks: 66 Photographers on Their Art*. New York: Aperture; Norfolk, VA: The Chrysler Museum, 1989.

Johnson, Brooks, ed. *Photography Speaks II: 70 Photographers on Their Art*. New York: Aperture; Norfolk, VA: The Chrysler Museum of Art, 1995.

Jones, John. *Wonders of the Stereoscope*. New York: Alfred A. Knopf, 1976.

Jussim, Estelle. *The Eternal Moment: Essays on the Photographic Image*. New York: Aperture, 1989.

Jussim, Estelle, and Elizabeth Lindquist-Cock. *Landscape as Photograph*. New Haven, CT: Yale University Press, 1985.

**K**

Kasher, Steven, et. al., *America and the Tintype*. New York & London: International Center of Photography & Steidl, 2008.

Kemp, Martin. *The Science of Art: Optical Themes in Western Art from Brunelleschi to Seurat*. New Haven, CT: Yale University Press, 1992.

Kozloff, Max. *The Privileged Eye: Essays on Photography*. Albuquerque: University of New Mexico Press, 1987.

Krauss, Rosalind, et al. *L'Amour Fou: Photography & Surrealism*. London and New York: Abbeville, Press, 2002.

**L**

Lemagny, Jean-Claude, and André Rouillé, eds. *A History of Photography: Social and Cultural Perspectives*. English edition Janet Lloyd, transl. Cambridge and New York: Cambridge University Press, 1987.

Lenman, Robin, ed. *The Oxford Companion to the Photograph*. New York: Oxford University Press, 2005.

Lippard, Lucy R., ed. *Partial Recall*. New York: The New Press, 1992.

Livingston, Jane. *The New York School: Photographs, 1936–1963*. New York: Stewart, Tabori & Chang, 1992.

Lowry, Bates and Isabel Barrett. *The Silver Canvas: Daguerreotype Masterpieces from the J. Paul Getty Museum*. London: Thames and Hudson, 1998.

Lyons, Claire, et al. *Antiquity and Photography: Early Views of Ancient Mediterranean Sites*. Los Angeles: J. Paul Getty Museum, 2005.

Lyons, Nathan, ed. *Photographers on Photography: A Critical Anthology*. Englewood Cliffs, NJ: Prentice-Hall, 1966.

**M**

Malcolm, Janet. *Diana & Nikon: Essays on the Aesthetic of Photography*. Boston: David R. Godine, 1980.

Margolis, Marianne Fulton, ed. *Camera Work: A Pictorial Guide*. New York: Dover Publications, 1978.

Marbot, Bernard. *After Daguerre: Masterworks of French Photography (1848–1900) from the Bibliothèque Nationale*. New York: Metropolitan Museum of Art; Paris: Berger-Levrault, 1980.

Marien, Mary Warner. *Photography: A Cultural History*. 2nd edition. Upper Saddle River, NJ: Pearson Prentice Hall, 2006.

Mathews, Oliver. *The Album of Carte-de-visite and Cabinet Portrait Photographs 1854–1914*. London: Reedminster Publications, Ltd., 1974.

McCauley, Elizabeth Anne. *Likenesses: Portrait Photography in Europe, 1850–1870*. Albuquerque: Art Museum, University of New Mexico, 1980.

McLuhan, Marshall. *Understanding Media: The Extensions of Man*. London: Routledge, 2001.

Mitchell, William J. *The Reconfigured Eye: Visual Truth in the Post-Photographic Era*. Cambridge: The MIT Press, 1994.

Moholy, Lucia. *100 Years of Photography: 1839–1939*. Hammondsworth, Middlesex, England: Penguin Books, Ltd. 1939.

Mora, Gilles. *Photo Speak: A Guide to the Ideas, Movements, and Techniques of Photography, 1839 to the Present*. New York: Abbeville Press, 1998.

Morgan, Hal, and Andreas Brown. *Prairie Fires and Paper Moons: The American Photographic Postcard, 1900–1920*. Boston: David R. Godine, 1981.

Morgan, Willard D., ed. *The Encyclopedia of Photography*. 20 vols. Little Falls, NJ: Singer Communications, 1977-78.

Moutoussamy-Ashe, Jeanne. *Viewfinders: Black Women Photographers*. New York: Dodd, Mead, 1986. Reprint. New York: Writers and Readers Publishing, 1993.

Mrazkova, Daniela. *Masters of Photography: A Thematic History*. New York: Exeter Books, 1987.

**N**

Naef, Weston J., and James N. Wood. *Era of Exploration: The Rise of Landscape Photography in the American West, 1860–1885*. Buffalo: Albright-Knox Art Gallery; New York: The Metropolitan Museum of Art, 1975.

Naef, Weston. *Fifty Pioneers of Modern Photography: The Collection of Alfred Stieglitz*. New York: The Metropolitan Museum of Art, 1978.

Naef, Weston. *The J. Paul Getty Museum Handbook of the Photographs Collection*. Malibu, CA: The J. Paul Getty Museum, 1995.

Negroponte, Nicholas. *Being Digital*. New York: Alfred A. Knopf, 2000.

Newhall, Beaumont. *The Daguerreotype in America*. 3rd revised edition. New York: Dover Publications, Inc., 1976.

Newhall, Beaumont. *Focus: Memoirs of a Life in Photography*. Boston: Little, Brown and Company, 1993.

Newhall, Beaumont. *The History of Photography: From 1839 to the Present Day*. 5th edition. New York: Museum of Modern Art, 1982.

Newhall, Beaumont. *Latent Image: The Discovery of Photography*. Garden City, NY: Anchor Books, 1967.

Newhall, Beaumont, ed. *Photography, Essays & Images: Illustrated Readings in the History of Photography*. New York: Museum of Modern Art, 1980.

*New Topographics: Photographs of a Man-altered Landscape.* Intro. by William Jenkins. Rochester, NY: International Museum of Photography at George Eastman House, 1975.

**O**

Ostroff, Eugene, ed. *Pioneers of Photography: Their Achievements in Science and Technology.* Springfield, VA: The Society for Imaging Science and Technology, 1987.

**P**

Palmquist, Peter E., ed. *A Bibliography of Writings by and about Women in Photography, 1850–1990.* 2nd edition. Arcata, CA: Peter E. Palmquist, 1994.

Palmquist, Peter E., ed. *Camera Fiends & Kodak Girls II: 60 Selections by and about Women in Photography, 1855–1965.* New York: Midmarch Arts Press, 1995.

Palmquist, Peter E., and Thomas R. Kailbourn. *Pioneer Photographers from the Mississippi to the Continental Divide: A Biographical Dictionary, 1839-1865.* Stanford, CA: Stanford University Press, 2005.

Palmquist, Peter E., and Thomas R. Kailbourn. *Pioneer Photographers of the Far West: A Biographical Dictionary, 1840–1865.* Stanford, CA: Stanford University Press, 2000.

Pantheon Photo Library. *Early Color Photography.* New York: Pantheon Books, 1986.

Panzer, Mary. *Things as They Are.* New York: Aperture Foundation, 2005.

Parr, Martin, and Gerry Badger. *The Photobook: A History.* Vols. I & II New York: Phaidon, 2004, 2006.

Pelizzari, Maria Antonella. *Traces of India: Photography, Architecture, and the Politics of Representation, 1850-1900.* Montreal & New Haven: Canadian Centre for Architecture and Yale Center for British Art, 2003.

Peres, Michael R., ed. *Focal Encyclopedia of Photography.* 4th edition. New York: Focal Press, 2007.

Petro, Patrice, ed. *Fugitive Images: From Photography to Video.* Bloomington: Indiana University Press, 1995.

Petruck, Peninah, ed. *The Camera Viewed: Writings on Twentieth Century Photography,* 2 vols. New York: E. P. Dutton, 1979.

Phillips, Christopher, ed. *Photography in the Modern Era: European Documents and Critical Writings, 1913–1940.* New York: Metropolitan Museum of Art; Aperture, 1989.

*Photography from 1839 to Today: George Eastman House, Rochester, NY.* New York: Taschen, 1999.

*Pictorialism in California: Photographs 1900–1940.* Malibu, CA: J. Paul Getty Museum; San Marino, CA: Henry E. Huntington Library and Art Gallery, 1994.

*Points of Entry.* A series of three books: *A Nation of Strangers.* Essays by Vicki Goldberg. San Diego: Museum of Photographic Arts, 1995; *Reframing America.* Essay by Andrei Codrescu. Tucson: Center for Creative Photography, University of Arizona, 1995; *Tracing Cultures.* Essays by Rebecca Solnit and Ronald Takai. San Francisco: Friends of Photography, 1995.

Pollack, Peter. *The Picture History of Photography from the Earliest Beginnings to the Present Day.* New York: Harry N. Abrams, Inc., 1969.

Pultz, John. *The Body and the Lens: Photography 1839 to the Present.* New York: Harry N. Abrams, Inc., 1995.

Pultz, John, and Catherine B. Scallen. *Cubism and American Photography, 1910–1930.* Williamstown, MA: Sterling and Francine Clark Art Institute, 1981.

**R**

Rabb, Jane M., ed. *Literature & Photography: Interactions 1840–1990,* Albuquerque: University of New Mexico Press, 1995.

Rinhart, Floyd and Marion. *The American Daguerreotype.* Athens: University of Georgia Press, 1981.

Ritchin, Fred. *In Our Own Image: The Coming Revolution in Photography.* 2nd edition. New York: Aperture, 1999.

Roberts, Pam. *A Century of Colour Photography: From the Autochrome to the Digital Age.* London: Andre Deutsch, 2007.

Roberts, Pam. *PhotoHistorica: Landmarks in Photography.* New York: Artisan, 2000.

Rosenblum, Naomi. *A History of Women Photographers.* 2nd edition. New York: Abbeville Press, 2000.

Rosenblum, Naomi. *A World History of Photography.* 4th edition. New York: Abbeville Press, 2007.

Rudisill, Richard. *Mirror Image: The Influence of the Daguerreotype on American Society.* Albuquerque: University of New Mexico Press, 1971.

Rule, Amy, and Nancy Solomon, eds. *Original Sources: Art and Archives at the Center for Creative Photography.* 2002.

**S**

Sandweiss, M. A., ed. *Photography in 19th-Century America.* Fort Worth, TX: Amon Carter Museum; New York: Harry N. Abrams, 1991.

Schaaf, Larry J. *Out of the Shadows: Herschel, Talbot and the Invention of Photography.* New Haven, CT: Yale University Press, 1992.

Scharf, Aaron. *Art and Photography.* New York: Penguin Books, 1986.

Scharf, Aaron. *Pioneers of Photography.* New York: Harry N. Abrams, Inc., 1975.

Schwarz, Heinrich, and William Parker. *Art and Photography: Forerunners and Influences.* Chicago: University of Chicago Press, 1987.

Sipley, Louis Walton. *A Half Century of Color.* New York: Macmillan, 1951.

Sobieszek, Robert A. *The Art of Persuasion: A History of Advertising Photography.* New York: Harry N. Abrams, Inc., 1988.

Sobieszek, Robert A. *Masterpieces of Photography from the George Eastman House Collections.* New York: Abbeville Press, 1985.

Solomon-Godeau, Abigail. *Photography at the Dock: Essays on Photographic History, Institutions, and Practices.* Minneapolis: University of Minnesota Press, 1991.

Sontag, Susan. *On Photography.* London: Penguin, 2002.

Spira, S.F., et al. *The History of Photography as Seen through the Spira Collection.* New York: Aperture, 2001.

Squiers, Carol, ed. *The Critical Image: Essays on Contemporary Photography.* Seattle: Bay Press, 1990.

Stott, William. *Documentary Expression and Thirties America.* Chicago: University of Chicago Press, 1986.

*Strong Hearts: Native American Visions and Voices.* New York: Aperture, 1995.

Stryker, Roy, and Nancy Wood. *In This Proud Land: America 1935–1943 as*

*Seen in FSA Photographs*. Boston: New York Graphic Society, 1975.

Sullivan, Constance, ed. *Women Photographers*. New York: Harry N. Abrams, Inc., 1990.

Szarkowski, John. *Looking at Photographs: 100 Pictures from the Collection of the Museum of Modern Art*. New York: Museum of Modern Art, 1999.

Szarkowski, John. *Mirrors and Windows: American Photography Since 1960*. New York: Museum of Modern Art, 1978.

Szarkowski, John. *The Photographer's Eye*. New York: Museum of Modern Art, 2007.

Szarkowski, John. *Photography Until Now*. New York: Museum of Modern Art, 1989.

**T**

Taft, Robert. *Photography and the American Scene: A Social History, 1839–1889*. Reprint. New York: Dover Publications, Inc., 1964.

Tagg, John. *The Burden of Representation: Essays on Photographies and Histories*. Amherst, MA: University of Massachusetts Press, 1988.

Tausk, Peter. *Photography in the 20th Century*. London: Focal Press, 1980.

Taylor, Roger. *Impressed by Light: British Photographs from Paper Negatives, 1840–1860*. New York: The Metropolitan Museum of Art, 2007.

Teitelbaum, Matthew, ed. *Montage and Modern Life, 1919–1942*. Cambridge: The MIT Press; Boston: The Institute of Contemporary Art, 1992.

Thomas, Lew, ed. *Photography and Language*. San Francisco: NFS Press, 1979.

Townsend, Chris. *Vile Bodies: Photography and the Crisis of Looking*. Munich and New York: Prestel-Verlag, 1998.

Trachtenberg, Alan, ed. *Classic Essays on Photography*. New Haven, CT: Leete's Island Books, 1980.

Trachtenberg, Alan, and Lawrence W. Levine. *Documenting America, 1935–1943*. Berkeley: University of California Press, 1988.

Travis, David, and Elizabeth Siegel, eds. *Taken by Design: Photographs from the Institute of Design, 1937–1971*. Chicago: The Art Institute of Chicago, in association with The University of Chicago Press, 2002.

Tucker, Anne, et al. *The History of Japanese Photography*. New Haven, CT: Yale University Press, 2003.

Tucker, Anne, ed. *The Woman's Eye*. New York: Alfred A. Knopf, 1973.

*20th Century Photography: Museum Ludwig Cologne*. Introduction by Marc Scheps. Koln: Taschen, 1996.

**W**

Wade, John. *The Camera from the 11th Century to the Present Day*. Leicester, England: Jessop, 1990.

Walch, Peter, ed. *Perspectives on Photography: Essays in Honor of Beaumont Newhall*. Albuquerque: University of New Mexico Press, 1986.

Waldsmith, John S. *Stereo Views: An Illustrated History and Price Guide*. Iola, WI: Gazelle, 2002.

Wall, E. J. *The History of Three-Color Photography*. Boston: American Photographic Publishing Company, 1925. Reprint. London and New York: Focal Press, 1970.

Wallis, Brian, ed. *Art After Modernism: Rethinking Representation*. New York: The New Museum of Contemporary Art, 1995.

Wallis, Brian, ed. *Blasted Allegories: An Anthology of Writings by Contemporary Artists*. New York: The New Museum of Contemporary Art; Cambridge: The MIT Press, 1987.

Weaver, Mike. *The Art of Photography, 1839-1989*. New Haven, CT: Yale University Press, 1989.

Weaver, Mike, ed. *British Photography in the 19th Century: The Fine Art Tradition*. Cambridge and New York: Cambridge University Press, 1989.

Welling, William. *Photography in America: The Formative Years, 1839–1900*. New York: Thomas Y. Crowell Company, 1978. Reprint. Albuquerque: University of New Mexico Press, 1987.

Wells, Liz, ed. *Photography: A Critical Introduction*. 3rd edition. New York: Routledge, 2004.

Westerbeck, Colin, and Joel Meyerowitz. *Bystander: A History of Street Photography*. Boston: Little, Brown and Company, 2001.

Williams, Val. *Women Photographers: The Other Observers, 1900 to the Present*. London: Virago Press Ltd., 1986.

Willis-Thomas, Deborah. *An Illustrated Bio-Bibliography of Black Photographers, 1940–1988*. New York: Garland, 1985.

Willis, Deborah, ed. *Picturing Us: African American Identity in Photography*. New York: The New Press, 1994.

Witkin, Joel-Peter, ed. *Harms Way: Lust & Madness, Murder & Mayhem*. Santa Fe: Twin Palms Publishers, 1994.

Witkin, Lee D., and Barbara London. *The Photograph Collector's Guide*. Boston: New York Graphic Society, 1979.

Wood, John. *The Art of the Autochrome: The Birth of Color Photography*. Iowa City: University of Iowa Press, 1993.

Wood, John, ed. *The Daguerreotype: A Sesquicentennial Celebration*. Iowa City: University of Iowa Press, 1989.

**Y**

Yapp, Nick, and Amanda Hopkinson. *150 Years of Photo Journalism*. Köln: Könneman, 1995.

## A

### BERENICE ABBOTT
McCausland, Elizabeth, and Berenice Abbott. *Changing New York*. New York: E. P. Dutton, 1939. Revised and reprinted as *New York in the Thirties*. New York: Dover Publications, 1973.

Van Haaften, Julia, ed. *Berenice Abbott, Photographer: A Modern Vision*. New York: New York Public Library, 1989.

Yochelson, Bonnie. *Berenice Abbott: Changing New York*. New York: The New Press; New York: Museum of the City of New York, 1997.

### ANSEL ADAMS
*Ansel Adams: An Autobiography*. Boston: Little, Brown and Company, 1985; paperback edition, 1996.

*Ansel Adams: Images, 1923–1974*. Boston: New York Graphic Society, 1981.

Newhall, Nancy. *Ansel Adams: The Eloquent Light*. San Francisco: Sierra Club, 1963.

### ROBERT ADAMS
Adams, Robert. *The New West: Landscapes Along the Colorado Front Range*. New York: Aperture, 2008.

Adams, Robert. *Why People Photograph: Selected Essays and Reviews*. New York: Aperture, 1994.

### ALINARI BROTHERS (COMPANY)
*Fratelli Alinari: Florence "1852–1992"*. Bologna, Italy: Graftche Zanini, 1993.

Zevi, Filippo. *Alinari: Photographers of Florence, 1852–1920*. Florence and London: Idea Editions and Alinari Edizioni in association with the Scottish Arts Council, 1978.

### MANUEL ALVAREZ BRAVO
Livingston, Jane. *M. Alvarez Bravo*. Boston: David R. Godine; Washington D.C.: The Corcoran Gallery of Art, 1978.

### THOMAS ANNAN
Annan, Thomas. *Photographs of the Old Closes and Streets of Glasgow, 1868–1877*. Introduction by Anita Ventura Mozeley. Reprint. New York: Dover Publications, 1977.

Stevenson, Sara. *Thomas Annan, 1829–1887*. Edinburgh: National Galleries of Scotland, 1990.

### DIANE ARBUS
Arbus, Doon, and Marvin Israel, eds. *Diane Arbus*. Millerton, NY: Aperture; 1972.

Arbus, Doon, and Marvin Israel, eds. *Diane Arbus: Magazine Work*. Millerton, NY: Aperture, 1984.

Arbus, Doon, and Yolanda Cuomo, eds. *Untitled: Diane Arbus*. New York: Aperture, 1995.

Bosworth, Patricia. *Diane Arbus: A Biography*. New York: W.W. Norton, 2005.

*Diane Arbus: Revelations*. New York: Random House, 2003.

### EUGÈNE ATGET
Nesbit, Molly, ed. *Atget's Seven Albums*. New Haven, CT: Yale University Press, 1992.

Szarkowski, John, and Maria Morris Hambourg. *The Work of Atget*. Vol. 1: *Old France*; Vol. 2: *The Art of Old Paris*; Vol. 3: *The Ancien Régime*; Vol. 4: *Modern Times*. New York: Museum of Modern Art, 1981-1985.

### ANNA ATKINS
Schaaf, Larry J. *Sun Gardens: Victorian Photograms by Anna Atkins*. New York: Aperture, 1985.

### RICHARD AVEDON
Avedon, Richard. *In the American West, 1979–1984*. New York: Harry N. Abrams, 2005.

## B

### ÉDOUARD BALDUS
Daniel, Malcolm R. *The Photographs of Édouard Baldus*. New York: Metropolitan Museum of Art; Montreal: Canadian Centre for Architecture, 1994.

### GEORGE N. BARNARD
Barnard, George N. *Photographic Views of Sherman's Campaign*. Preface by Beaumont Newhall. New York: Dover Publications, 1977.

Davis, Keith F., ed. *George N. Barnard: Photographer of Sherman's Campaign*. Kansas City, MO: Hallmark Cards, 1990.

### THOMAS BARROW
McCarthy Gauss, Kathleen. *Inventories and Transformations: The Photographs of Thomas Barrow*. Albuquerque: University of New Mexico Press, 1986.

### HERBERT BAYER
Cohen, Arthur A. *Herbert Bayer: The Complete Work*. Cambridge: The MIT Press, 1984.

*Herbert Bayer: Photographic Works*. Essay by Beaumont Newhall. Los Angeles: Arco Center for Visual Art, 1977.

### HANS BELLMER
Taylor, Sue. *Hans Bellmer: The Anatomy of Anxiety*. Cambridge: The MIT Press, 2002.

### E. J. BELLOCQ
*Bellocq: Photographs from Storyville. The Red-Light District of New Orleans*. Introduction by Susan Sontag. Interviews by John Szarkowski. Preface by Lee Friedlander. New York: Random House, 1996.

### WALLACE BERMAN
Duncan, Michael, and Kristine McKenna. *Semina Culture: Wallace Berman & His Circle*. New York: Distributed Art Publishers; Santa Monica, CA: Santa Monica Museum of Art, 2005.

### KARL BLOSSFELDT
Blossfeldt, Karl. *Urformen der Kunst*. Tübingen, Germany: Ernst Wasmuth Verlag, 1967.

Blossfeldt, Karl. *Natural Art Forms: 120 Classic Photographs*. Mineola, NY: Dover Publications, 1998.

### ERWIN BLUMENFELD
Teicher, Hendel, ed. *Blumenfeld: My One Hundred Best Photographs*. New York: Rizzoli, 1981.

### CHRISTIAN BOLTANSKI
Beil, Ralf, ed. *Boltanski: Time*. Ostfildern, Germany: Hatje Cantz; Darmstadt, Germany: Mathildenhöhe Darmstadt, 2006.

### MARGARET BOURKE-WHITE
Callahan, Sean, ed. *The Photographs of Margaret Bourke-White*. Boston: New York Graphic Society, 1975.

Goldberg, Vicki. *Margaret Bourke-White: A Biography*. New York: Harper and Row, 1986.

### SAMUEL BOURNE
Ollman, Arthur. *Samuel Bourne: Images of India*. Carmel, CA: Friends of Photography, 1983.

### MATHEW BRADY
Panzer, Mary. Essay by Jeana Kae Foley. *Mathew Brady and the Image of History*. Washington, DC: Smithsonian Institution Press for the National Portrait Gallery, 1997.

### BILL BRANDT
*Bill Brandt Behind the Camera: Photographs, 1928–1983*. Introduction by Mark Haworth-Booth. Essay by David Mellor. New York: Aperture, 1985.

Warburton, Nigel. *Bill Brandt: Selected Texts and Bibliography*. World Photographers Reference Series, vol. 5. Boston: G. K. Hall, 1993.

### BRASSAÏ (GYULA HALÁSZ)
*Brassaï*. Intro. by Lawrence Durrell. New York: Museum of Modern Art, 1968.

Brassaï. *Paris de Nuit*. Paris: Arts et Métiers Graphiques, 1933.

Brassaï. *The Secret Paris of the 1930s*. Published in Paris as *Le Paris Secret des Années 30*. New York: Thames and Hudson, 2001.

Wareheim, Marja. *Brassaï. Images of Culture and the Surrealist Observer*. Baton Rouge: Louisiana State University Press, 1996.

FRANCIS BRUGUIÈRE
Enyeart, James. *Bruguière: His Photographs and His Life*. New York: Alfred A. Knopf, 1977.

WYNN BULLOCK
Bullock-Wilson, Barbara, ed. *Wynn Bullock, Photography: A Way of Life*. Dobbs Ferry, NY: Morgan and Morgan, 1973.

WILLIAM S. BURROUGHS
Sobieszek, Robert A. Afterword by William S. Burroughs. *Ports of Entry: William S. Burroughs and the Arts*. Los Angeles: Los Angeles County Museum of Art, 1996.

EDWARD BURTYNSKY
Pauli, Lori, ed. *Manufactured Landscapes: The Photographs of Edward Burtynsky*. Ottawa: National Gallery of Canada in association with Yale University Press, 2003.

**C**

HARRY CALLAHAN
Davis, Keith F. *Harry Callahan: New Color: Photographs 1978–1987*. Kansas City, MO: Hallmark Cards, 1988.

Davis, Keith F., ed. *Harry Callahan: Photographs*. Kansas City, MO: Hallmark Cards, 1988.

JULIA MARGARET CAMERON
Cameron, Julia Margaret. *Victorian Photographs of Famous Men and Fair Women*. New York: Harcourt, Brace, 1926. Expanded and reprinted, with an introduction by Virginia Woolf and Roger Fry; preface and notes by Tristam Powell. London: Chatto & Windus, 1992.

Cox, Julian, and Colin Ford. *Julia Margaret Cameron: The Complete Photographs*. Los Angeles: Getty Publications, 2003.

Ford, Colin. *The Cameron Collection: An Album of Photographs by Julia Margaret Cameron Presented to Sir John Herschel*. Workingham, England: Van Nostrand Reinhold, 1975.

Gernsheim, Helmut. *Julia Margaret Cameron, Her Life and Photographic Work*. New York: Aperture, 1987.

Weaver, Mike. *Julia Margaret Cameron: 1815–1879*. Boston: Little, Brown and Company, 1984.

Wolf, Sylvia, et al. *Julia Margaret Cameron's Women*. Chicago: Art Institute of Chicago; New Haven, CT: Yale University Press, 1998.

CORNELL CAPA
*Cornell Capa: Photographer*. New York: The International Center of Photography, 1994.

ROBERT CAPA
*Robert Capa*. New York: Pantheon Books; Paris: Centre National de la Photographie, 1989.

Whelan, Richard. *Robert Capa: A Biography*. Lincoln, NE: University of Nebraska Press, 1994.

PAUL CAPONIGRO
*Paul Caponigro: Masterworks from Forty Years*. Carmel, CA: Photography West Graphics, 1993.

LEWIS CARROLL
Cohen, Morton N. *Lewis Carroll: A Biography*. New York: Alfred A. Knopf, 1995.

Gernsheim, Helmut. *Lewis Carroll, Photographer*. 1949. Revised edition. New York: Dover Publications, 1969.

Taylor, Roger, and Edward Wakeling. *Lewis Carroll: Photographer*. Princeton: Princeton University Press, 2002.

HENRI CARTIER-BRESSON
Cartier-Bresson, Henri. *The Decisive Moment*. New York: Simon and Schuster, 1952.

Galassi, Peter. *Henri Cartier-Bresson: The Early Work*. New York: Museum of Modern Art, 1993.

*Henri Cartier-Bresson: Photographer*. Boston: Little, Brown and Company, 1992.

CLEMENTINA, LADY HAWARDEN
Ovenden, Graham, ed. *Clementina, Viscountess Hawarden, Photographer*. London: Victoria and Albert Museum, 1989.

Mavor, Carol. *Becoming: The Photographs of Clementina, Viscountess Hawarden*. Durham, NC: Duke University Press, 1999.

CHUCK CLOSE
Storr, Robert, et al. *Chuck Close*. New York: Museum of Modern Art, 1998.

ALVIN LANGDON COBURN
Weaver, Mike. *Alvin Langdon Coburn: Symbolist Photographer*. New York: Aperture, 1986.

JOHN COPLANS
*A Body: John Coplans*. New York: PowerHouse Books, 2002.

GREGORY CREWDSON
Berg, Stephan, ed. *Gregory Crewdson, 1985-2005*. Ostfildern-Ruit: Hatje Cantz, 2005.

IMOGEN CUNNINGHAM
Dater, Judy. *Imogen Cunningham: A Portrait*. Boston: New York Graphic Society, 1979.

Lorenz, Roland. *Imogen Cunningham: Ideas Without End: A Life and Photographs*. San Francisco: Chronicle Books, 1993.

Rule, Amy, ed. *Imogen Cunningham: Selected Texts and Bibliography*. World Photographers Reference Series, vol. 2. Boston: G. K. Hall, 1992.

EDWARD S. CURTIS
Davis, Barbara A. *Edward S. Curtis: The Life and Times of a Shadow Catcher*. San Francisco: Chronicle Books, 1985.

Lyman, Christopher M. *The Vanishing Race and Other Illusions: Photographs of Indians by Edward S. Curtis*. New York: Pantheon Books in association with the Smithsonian Institution, 1982.

*Native Nations: First Americans as Seen by Edward S. Curtis*. Boston: Little, Brown and Company, 1993.

**D**

LOUIS JACQUES MANDÉ DAGUERRE
Daguerre, Louis Jacques Mandé. *An Historical and Descriptive Account of the Various Processes of the Daguerreotype and the Diorama*. 1839. Reprint, with an introduction by Beaumont Newhall, New York: Winter House, 1971.

Gernsheim, Helmut, and Alison Gernsheim. *L. J. M. Daguerre: The History of the Diorama and the Daguerreotype*. 2nd edition. New York: Dover Publications, 1968.

BRUCE DAVIDSON
*Bruce Davidson Photographs*. Intro. by Henry Geldzahler. New York: Agrinde Publications LTD., 1978.

ROBERT DAWSON
Dawson, Robert, and Gray Brechin. *Farewell, Promised Land: Waking From the California Dream*. Berkeley: University of California Press, 1999.

F. HOLLAND DAY
*F. Holland Day: Suffering the Ideal*. Essay by James Crump. Santa Fe: Twin Palms Publishers, 1995.

Jussim, Estelle. *Slave to Beauty: The Eccentric Life and Controversial Career of F. Holland Day*. Boston: David R. Godine, 1981.

RAJA LALA DEEN DAYAL
Worswick, Clark. *Princely India: Photographs by Raja Lala Deen Dayal, Court Photographer (1884–1910) to the Premier Prince of India*. New York: Alfred A. Knopf, 1980.

ROY DECARAVA
Alinder, James, ed. *Roy DeCarava, Photographs*. Introduction by Sherry Turner DeCarava. Carmel, CA: Friends of Photography, 1981.

DeCarava, Roy, and Langston Hughes. *The Sweet Flypaper of Life*. Washington, D.C.: Howard University Press, 1983.

Galassi, Peter. *Roy DeCarava: A Retrospective*. New York: Museum of Modern Art, 1996.

ROBERT DEMACHY
*Robert Demachy: Pictorialist*. Paris: Bookking International, 1990.

THOMAS DEMAND
*Thomas Demand*. London: Serpentine Gallery; Munich: Schirmer/Mosel, 2006.

ADOLPH DE MEYER
Ehrenkranz, Anne, et al. *A Singular Elegance: The Photographs of Baron Adolph de Meyer*. San Francisco: Chronicle Books; New York: International Center of Photography, 1994.

ROBERT DOISNEAU
Hamilton, Peter. *Robert Doisneau: A Photographer's Life*. New York: Abbeville Press, 1995.

*Three Seconds from Eternity: Photographs by Robert Doisneau*. New York: te Neues Publishing Co., 1997.

E

THOMAS EAKINS
Danly, Susan, and Cheryl Leibold. *Eakins and the Photograph: Works by Thomas Eakins and His Circle in the Collection of the Pennsylvania Academy of the Fine Arts*. Washington D.C.: Smithsonian Institution Press; Philadelphia: Pennsylvania Academy of the Fine Arts, 1994.

Hendricks, Gordon. *The Photographs of Thomas Eakins*. New York: Grossman Publishers, 1972.

Sewell, David, ed. *Thomas Eakins*. Philadelphia: Philadelphia Museum of Art in association with Yale University Press, 2001.

HAROLD EDGERTON
Bruce, Roger, ed. *Seeing the Unseen: Dr. Harold Edgerton and the Wonders of Strobe Alley*. Rochester, NY: George Eastman House, 1994.

WILLIAM EGGLESTON
Szarkowski, John. *William Eggleston's Guide*. New York: The Museum of Modern Art, 1976.

Weski, Thomas, ed. *William Eggleston: Los Alamos*. New York: Scalo, 2003.

ALFRED EISENSTAEDT
Eisenstaedt, Alfred. *Eisenstaedt on Eisenstaedt: A Self-Portrait*. Introduction by Peter Adam. New York: Abbeville Press, 1985.

PETER HENRY EMERSON
Newhall, Nancy. *P. H. Emerson: The Fight for Photography as a Fine Art*. New York: Aperture, 1975.

FREDERICK H. EVANS
Hammond, Anne, ed. *Frederick H. Evans: Selected Texts and Bibliography*. World Photographers Reference Series, vol. 1. Boston: G. K. Hall, 1992.

WALKER EVANS
Agee, James, and Walker Evans. *Let Us Now Praise Famous Men*. Boston: Houghton Mifflin Company, 2001.

Greenough, Sarah, *Walker Evans: Subways and Streets*. Washington, D.C.: National Gallery of Art, 1991.

Keller, Judith. *Walker Evans: The Getty Museum Collection*. Malibu, CA: J. Paul Getty Museum, 1995.

Mora, Gilles. *Walker Evans: The Hungry Eye*. New York: Harry N. Abrams, 2004.

Rathbone, Belinda. *Walker Evans: A Biography*. Boston: Houghton Mifflin Co., 2000.

*Walker Evans: American Photographs*. New York: Museum of Modern Art, 1938.

F

LOUIS FAURER
Tucker, Anne Wilkes, et al. *Louis Faurer*. London: Merrell, in association with the Museum of Fine Arts, Houston, 2002.

ROGER FENTON
Baldwin, Gordon, et al. *All the Mighty World: The Photographs of Roger Fenton, 1852-1860*. New Haven, CT: Yale University Press; New York: Metropolitan Museum of Art, 2004.

Hannavy, John. *Fenton of Crimble Hall*. Boston: David R. Godine, 1975.

Lloyd, Valeri. *Roger Fenton: Photographer of the 1850s*. London: South Bank Board, 1988.

ROBBERT FLICK
Dear, Michael, et al. *Robbert Flick: Trajectories*. Los Angeles: Los Angeles County Museum of Art; Göttingen, Germany: Steidl Verlag, 2004.

HOLLIS FRAMPTON
Jenkins, Bruce, and Susan Krane. *Hollis Frampton: Recollections/Recreations*. Cambridge: The MIT Press, 1984.

ROBERT FRANK
Frank, Robert. *Les Américains*. Paris: Delpire, 1958. Published in English as *The Americans*. Introduction by Jack Kerouac. New York: Grove Press, 1959. Rev. eds. Millerton, NY: Aperture, 1969, 1978; New York: SCALO Publishers, 1998.

Frank, Robert. *The Lines of My Hand*. New York: Pantheon Books, 1989.

Greenough, Sarah, and Philip Brookman, et al. *Robert Frank: Moving Out*. Washington, D.C.: National Gallery of Art, 1995.

LEE FRIEDLANDER
Galassi, Peter, and Richard Benson. *Friedlander*. New York: Museum of Modern Art, 2005.

*Letters from the People: Photographs by Lee Friedlander*. New York: Distributed Art Publishers, 1993.

FRANCIS FRITH
Frith, Francis. *Egypt and the Holy Land in Historic Photographs*. C. 1860s. Reprint. New York: Dover Publications, 1980.

Nickel, Douglas R. *Francis Frith in Egypt and Palestine: A Victorian Photographer Abroad*. Princeton: Princeton University Press, 2004.

ADAM FUSS
Parry, Eugenia. *Adam Fuss*. Santa Fe: Arena Editions, 1997.

G

ALEXANDER GARDNER
Gardner, Alexander. *Gardner's Photographic Sketchbook of the American Civil War*. New York: Delano Greenidge, 2003.

Johnson, Brooks. *An Enduring Interest: The Photographs of Alexander Gardner*. Norfolk, VA: Chrysler Museum, 1991.

## ANDREAS GURSKY

Galassi, Peter. *Andreas Gursky*. New York: Museum of Modern Art, 2001.

## H

### DAVID T. HANSON

*Waste Land: Meditations on a Ravaged Landscape*. Preface by Wendell Berry. New York: Aperture, 1997.

### RAOUL HAUSMANN

Hausmann, Raoul. *Photographies, 1927–1957*. Paris: Créatis, 1979.

### JOHN HEARTFIELD

Heartfield, John. *Photomontages of the Nazi Period*. New York: Universe Books, 1977.

Pachnicke, Peter, and Klaus Honnef, eds. *John Heartfield*. New York: Harry N. Abrams, 1992.

### ROBERT HEINECKEN

*Robert Heinecken: Photographist*. Chicago: Museum of Contemporary Art, 1999.

### FLORENCE HENRI

du Pont, Diana C. *Florence Henri: Artist-Photographer of the Avant-Garde*. San Francisco: San Francisco Museum of Modern Art, 1990.

### DAVID OCTAVIUS HILL AND ROBERT ADAMSON

Ford, Colin, ed. *An Early Victorian Album: The Photographic Masterpieces (1843–47) of David Octavius Hill and Robert Adamson*. Introduction by Colin Ford. Essay by Roy Strong. New York: Alfred A. Knopf, 1976.

Schwarz, Heinrich. *David Octavius Hill: Master of Photography*. London: George C. Harrap, 1932.

### LEWIS W. HINE

Gutman, Judith Mara. *Lewis W. Hine and the American Social Conscience*. New York: Walker, 1967.

Kaplan, Daile, ed. *Photo Story: Selected Letters and Photographs of Lewis Hine*. Washington, D.C.: Smithsonian Institution Press, 1992.

Rosenblum, Walter, et al. *America and Lewis Hine: Photographs, 1904–1940*. New York: Aperture, 1977.

### HANNAH HÖCH

Lavin, Maud. *Cut With the Kitchen Knife: The Weimar Photomontages of Hannah Höch*. New Haven and London: Yale University Press, 1993.

### AXEL HÜTTE

*After Midnight: Axel Hütte*. Munich: Schirmer/Mosel, 2006.

## J

### WILLIAM HENRY JACKSON

Hales, Peter B. *William Henry Jackson and the Transformation of the American Landscape*. Philadelphia: Temple University Press, 1988.

Jackson, William Henry. *Time Exposure: The Autobiography of William Henry Jackson*. Intro. by Ferenc M. Szasz. Albuquerque: University of New Mexico Press, 1986.

### FRANCES B. JOHNSTON

Johnston, Frances Benjamin. *The Hampton Album*. New York: Museum of Modern Art, 1966.

## K

### GERTRUDE KÄSEBIER

Michaels, Barbara. *Gertrude Käsebier: The Photographer and Her Photographs*. New York: Harry N. Abrams, 1992.

### ANDRÉ KERTÉSZ

Ducrot, Nicholas, ed. *André Kertész: Sixty Years of Photography, 1912–1972*. New York: Grossman Publishers, 1972.

Greenough, Sarah, et al. *André Kertész*. Washington, D.C.: National Gallery of Art; Princeton, N.J.: Princeton University Press, 2005.

Kertész, André. *J'aime Paris: Photographs Since the Twenties*, New York: Grossman Publishers, 1974.

Phillips, Sandra S., et al. *André Kertész: Of Paris and New York*. Chicago: Art Institute of Chicago, 1985.

### ANSELM KIEFER

Arasse, Daniel. *Anselm Kiefer*. New York: Harry N. Abrams, Inc., 2001.

López-Pedraza, Rafael. *Anselm Kiefer: The Psychology of "After The Catastrophe."* New York: George Braziller, 1996.

### WILLIAM KLEIN

*Close-up: Photographs and Texts by William Klein*. London: Thames and Hudson, 1989.

*William Klein: New York, 1954–1955*. Paris: Editions de Seuil, 1956. Manchester, England: Dewi Lewis Publishing, 1995.

*William Klein: Photographs*. Profile by John Heilpern. New York: Aperture, 1981.

### JOSEF KOUDELKA

Koudelka, Josef. *Gypsies*. London: Robert Hale, 1992.

## L

### DORTHEA LANGE

*Dorthea Lange: American Photographs*. San Francisco: San Francisco Museum of Modern Art, 1994.

*Dorthea Lange: Photographs of a Lifetime*. Millerton, NY: Aperture, 1982.

Elliott, George P. *Dorthea Lange*. New York: Museum of Modern Art, 1966.

Lange, Dorthea, and Paul S. Taylor. *An American Exodus: A Record of Human Erosion in the Thirties*. Paris: Jean-Michel Place, 1999.

Meltzer, Milton. *Dorthea Lange: A Photographer's Life*. Syracuse, NY: Syracuse University Press, 2000.

Partridge, Elizabeth, ed. *Dorthea Lange: A Visual Life*. Washington, D.C.: Smithsonian Institution Press, 1994.

### JACQUES-HENRI LARTIGUE

D'Astier, Martine, Quentin Bajac, and Alain Sayag. *Lartigue: Album of a Century*. New York: Harry N. Abrams, 2003.

Lartigue, Jacques-Henri. *Boyhood Photos of J. H. Lartigue: The Family Album of a Gilded Age*. Lausanne, Switzerland: Ami Guichard, 1966.

Goldberg, Vicki, introduction. *Jacques-Henri Lartigue, Photographer*. Boston: Little, Brown and Company, 1998.

### CLARENCE JOHN LAUGHLIN

Davis, Keith F., ed. *Clarence John Laughlin: Visionary Photographer*. Kansas City, MO: Hallmark Cards, 1990.

Laughlin, Clarence John. *Ghosts Along the Mississippi*. New York: American Legacy Press, 1987.

### RUSSELL LEE

Hurley, F. Jack. *Russell Lee, Photographer*. Dobbs Ferry, NY: Morgan and Morgan, 1978.

### GUSTAVE LE GRAY

Aubenas, Sylvie, et al. *Gustave Le Gray, 1820–1884*. Los Angeles: J. Paul Getty Museum, 2002

Janis, Eugenia Parry. *The Photography of Gustave Le Gray*. Chicago: Art Institute of Chicago and University of Chicago Press, 1987.

### HELEN LEVITT

Levitt, Helen. *A Way of Seeing*. 3rd edition, with additional photographs. Durham, NC: Duke University Press, 1989.

Phillips, Sandra S., and Maria Morris Hambourg. *Helen Levitt*. San Francisco: San Francisco Museum of Modern Art, 1991.

LIU ZHENG
*Liu Zheng: The Chinese.* New York: International Center of Photography; Göttingen, Germany: Steidl, 2004.

DANNY LYON
*Danny Lyon: Photo-Film.* Heidelberg, Germany: Edition Braus, 1991.

Lyon, Danny. *Conversations with the Dead.* New York: Holt, Rinehart and Winston, 1971.

NATHAN LYONS
*Notations in Passing, Visualized by Nathan Lyons.* Cambridge: The MIT Press, 1974.

*Riding First Class on the Titanic.* Andover, MA: Addison Gallery of American Art, 1999.

## M

MAN RAY
Foresta, Merry A., et al. *Perpetual Motif: The Art of Man Ray.* Washington, D.C.: National Museum of American Art; New York: Abbeville Press, 1988.

Man Ray. *Self-Portrait.* Boston: Little, Brown and Company, 1999.

ETIENNE-JULES MAREY
Braun, Marta. *Picturing Time: The Work of Etienne-Jules Marey (1830–1904).* Chicago: The University of Chicago Press, 1994.

*E. J. Marey, 1830–1904: La Photographie du Mouvement.* Paris: Centre Georges Pompidou, 1977.

MARY ELLEN MARK
Fulton, Marianne. *Mary Ellen Mark: 25 Years.* Boston: Little, Brown and Company, 1991.

DON MCCULLIN
*Hearts of Darkness: Photographs by Don McCullin.* Intro. By John Le Carré. New York: Alfred A. Knopf, 1981.

RALPH EUGENE MEATYARD
Hall, James Baker, ed. *Ralph Eugene Meatyard.* Millerton, NY: Aperture, 1974.

Meatyard, Ralph Eugene. *The Family Album of Lucybelle Crater.* New York: Distributed Art Publishers, 2002.

PEDRO MEYER
Meyer, Pedro. *Truths and Fictions: A Journey from Documentary to Digital Photography.* New York: Aperture, 1995.

JOEL MEYEROWITZ
Meyerowitz, Joel. *Aftermath.* New York: Phaidon, 2006.

Meyerowitz, Joel. *Cape Light.* Expanded edition. Boston: Museum of Fine Arts, 2002.

DUANE MICHALS
Livingstone, Marco. *The Essential Duane Michals.* Boston: Little, Brown and Company, 1997

LEE MILLER
Miller, Lee. *Lee Miller's War.* Anthony Penrose, ed. New York: Thames and Hudson, 2005.

RICHARD MISRACH
Tucker, Anne Wilkes, with an essay by Rebecca Sonit. *Crimes and Splendors: The Desert Cantos of Richard Misrach.* Boston: Little, Brown and Company, 1996.

LISETTE MODEL
*Lisette Model.* Preface by Berenice Abbott. New York: Aperture, 2007.

Thomas, Ann. *Lisette Model.* Ottawa: National Gallery of Canada, 1990.

TINA MODOTTI
Constantine, Mildred. *Tina Modotti: A Fragile Life.* New York: Rizzoli, 1983. Reprint. San Francisco: Chronicle Books, 1993.

LÁSZLÓ MOHOLY-NAGY
Haus, Andreas. *Moholy-Nagy: Photographs and Photograms.* New York: Pantheon Books, 1980.

Moholy-Nagy, László. *Malerei, Photographie, Film, Bauhausbook 8.* Munich: Albert Langen Verlag, 1925; revised edition, 1927. English edition, *Painting Photography Film.* Cambridge: The MIT Press, 1987.

Moholy-Nagy, László. *Vision in Motion.* Chicago: Paul Theobold and Co., 1969.

BARBARA MORGAN
*Barbara Morgan: Photomontage.* Dobbs Ferry, NY: Morgan and Morgan, 1980.

WRIGHT MORRIS
James Alinder, ed. *Wright Morris: Photographs and Words.* Carmel, CA: Friends of Photography, 1982.

Morris, Wright. *Time Pieces: Photographs, Writing, and Memory.* New York: Aperture, 1999.

MARTIN MUNKACSI
Morgan, Susan. *Martin Munkacsi.* New York: Aperture, 1992.

White, Nancy, and John Esten. *Style in Motion: Munkacsi Photographs '20s, '30s, '40s.* New York: Clarkson N. Potter, Inc., 1979.

EADWEARD MUYBRIDGE
*Eadweard Muybridge: The Stanford Years, 1872–1882.* Intro. by Anita Ventura Mozley. Stanford, CA: Stanford University Museum of Art, 1972.

Haas, Robert Bartlett. *Muybridge: Man in Motion.* Berkeley: University of California Press, 1976.

*Muybridge's Complete Human and Animal Locomotion.* 3 vols. Intro. by Anita Ventura Mozley. New York: Dover Publications, 1979.

## N

JAMES NACHTWEY
Nachtwey, James. *Inferno.* London: Phaidon, 1999.

NADAR
Gosling, Nigel. *Nadar.* New York: Alfred A. Knopf, 1976.

Hambourg, Maria Morris, Francoise Heilburn, and Philippe Neagu. *Nadar.* New York: Metropolitan Museum of Art, 1995.

Prinet, Jean, and Antoinette Dilasser. *Nadar.* Paris: Armand Colin, 1966.

Nadar. *Quand J' étais Photographe.* Preface by Leon Daudet. 1900. Reprint. New York: Arno Press, 1979.

CHARLES NÈGRE
Borcoman, James. *Charles Nègre, 1820–1880.* Ottawa: National Gallery of Canada, 1976.

ARNOLD NEWMAN
Fern, Alan, and Arnold Newman. *Arnold Newman's Americans.* Boston: Little, Brown and Company, 1992.

*One Mind's Eye: The Portraits and Other Photographs of Arnold Newman.* Boston: David R. Godine, 1974.

## O

TIMOTHY H. O'SULLIVAN
Dingus, Rick. *The Photographic Artifacts of Timothy O'Sullivan.* Albuquerque: University of New Mexico Press, 1982.

Snyder, Joel. *American Frontiers: The Photographs of Timothy H. O'Sullivan, 1867–1874.* New York: Aperture, 1981.

PAUL OUTERBRIDGE
Dines-Cox, Elaine, ed. *Paul Outerbridge: A Singular Aesthetic; Photographs and Drawings, 1921–1941. A Catalogue Raisonné.* Santa Barbara, CA: Arabesque, 1981.

Howe, Graham, and G. Ray Hawkins, eds. *Paul Outerbridge, Jr.: Photographs.* New York: Rizzoli, 1980.

**P**

ROBERT PARKEHARRISON
*Robert ParkeHarrison: The Architect's Brother*. Santa Fe: Twin Palms Publishers, 2000.

GORDON PARKS
Parks, Gordon. *Voices in the Mirror: An Autobiography*. New York: Harlem Moon, 2005.

MARTIN PARR
Williams, Val. *Martin Parr*. New York: Phaidon, 2002.

IRVING PENN
Foresta, Merry A., and William F. Stapp. *Irving Penn Master Images: The Collections of the National Museum of American Art and the National Portrait Gallery*. Washington, D.C.: Smithsonian Institution Press, 1990.

Penn, Irving. *Worlds in a Small Room*. New York: Penguin Books, 1980.

PABLO PICASSO
Baldassari, Anne. *Picasso and Photography: The Dark Mirror*. Deke Dusinberre, transl. Paris: Flammarion; Houston: The Museum of Fine Arts, Houston, 1997.

ELIOT PORTER
*Intimate Landscapes: Photographs by Eliot Porter*. Essay by Weston J. Naef. New York: Metropolitan Museum of Art, 1979.

Porter, Eliot. *The Place No One Knew: Glen Canyon on the Colorado*. David Brower, ed. San Francisco: Sierra Club, 1966.

MARION POST WOLCOTT
Hurley, F. Jack. *Marion Post Wolcott: A Photographic Journey*. Albuquerque: University of New Mexico Press, 1989.

Hendrickson, Paul. *Looking for the Light: The Hidden Life and Art of Marion Post Wolcott*. New York: Alfred A. Knopf, 1992.

**R**

ROBERT RAUSCHENBERG
Hopps, Walter, and Susan Davidson, et al. *Robert Rauschenberg: A Retrospective*. New York: Guggenheim Museum, 1997.

OSCAR GUSTAV REJLANDER
Spencer, Stephanie. *O. G. Rejlander: Photography as Art*. Ann Arbor, MI: UMI Research Press, 1985.

ALBERT RENGER-PATZSCH
*Albert Renger-Patzsch: 100 Photographs, 1928*. Essays in English, German, and French. Köln: Schürmann and Kicken; Paris: Créatis, 1979.

Renger-Patzsch, Albert. *Die Welt ist schön: Ein Hundert photographische Aufnahmen*. Published in English as *The World Is Beautiful*. Munich: Kurt Wolff Verlag, 1928.

GERHARD RICHTER
Richter, Gerhard. *Atlas of the Photographs, Collages, and Sketches*. New York: Marian Goodman, 1997.

Storr, Robert. *Gerhard Richter: Forty Years of Painting*. New York: Museum of Modern Art, 2002.

JACOB A. RIIS
Alland, Alexander, Sr. *Jacob A. Riis: Photographer and Citizen*. New York: Aperture, 1993.

Riis, Jacob A. *How the Other Half Lives: Studies Among the Tenements of New York*. New York: Charles Scribner's Sons, 1890. Reprint with added photographs. New York: Dover Publications, 1971.

Yochelson, Bonnie, and Daniel Czitrom. *Rediscovering Jacob Riis: Exposure Journalism and Photography in Turn-of-the-Century New York*. New York: New Press, 2007.

HENRY PEACH ROBINSON
Harker, Margaret F. *Henry Peach Robinson: Master of Photographic Art, 1830–1901*. New York: Basil Blackwell, 1988.

Robinson, Henry Peach. *Pictorial Effect in Photography*. Intro. by Robert Sobieszek. Reprint. Pawlet, VT: Helios, 1971.

ALEXANDER RODCHENKO
Elliott, David, ed. *Alexander Rodchenko, 1891–1956*. Oxford, England: Museum of Modern Art, 1979.

Khan-Magomedov, S. O. *Rodchenko: The Complete Work*. Cambridge: The MIT Press, 1986.

Lavrentiev, Alexander. *Alexander Rodchenko: Photography 1924–1954*. Edison, NJ: Knickerbocker Press, 1995.

MILTON ROGOVIN
Herzog, Melanie Anne. *Milton Rogovin: The Making of a Social Documentary Photographer*. Tucson: Center for Creative Photography in association with University of Washington Press, 2006.

Wypijewski, Joann. *Triptychs: Buffalo's Lower West Side Revisited*. Photographs by Milton Rogovin. New York: W. W. Norton, 1994.

ARTHUR ROTHSTEIN
Rothstein, Arthur. *The Depression Years as Photographed by Arthur Rothstein*. New York: Dover Publications, 1978.

ED RUSCHA
Wolf, Sylvia. *Ed Ruscha and Photography*. Göttingen, Germany: Steidl Verlag, 2004.

**S**

SEBASTIÃO SALGADO
Salgado, Sebastião. *Workers: An Archeology of the Industrial Age*. New York: Aperture, 1993.

ERICH SALOMON
Hunter-Salomon, Peter. *Erich Salomon: Portrait of an Age*. New York: Macmillan, 1967.

Salomon, Erich. *Porträt einer Epoch*. Frankfurt and Berlin: Verlag Ullstein, 1963. Published in English as *Portrait of an Age*. New York: Macmillan, 1967.

AUGUST SANDER
*August Sander: Photographs of an Epoch. 1904–1959*. Preface by Beaumont Newhall; historical commentary by Robert Kramer. Millerton, NY: Aperture, 1980.

Heiting, Manfred, ed., *August Sander 1876–1964*. New York: Taschen, 1999.

Sander, August. *Antlitz der Zeit*. Munich: Schirmer/Mosel, 2003.

Sander, August. *Men Without Masks: Faces of Germany, 1910–1938*. Greenwich, CT: New York Graphic Society, 1973.

W. G. SEBALD
Patt, Lise, ed. *Searching for Sebald: Photography After W. G. Sebald*. Los Angeles: The Institute of Cultural Inquiry, 2007.

BEN SHAHN
Pratt, Davis, ed. *The Photographic Eye of Ben Shahn*. Cambridge: Harvard University Press, 1975.

CHARLES SHEELER
Millard, Charles W., III. "Charles Sheeler, American Photographer," *Contemporary Photographer*, vol. 6, no. 1 (1967): entire issue.

Stebbins, Theodore E., Jr., and Norman Keyes, Jr. *Charles Sheeler: The Photographs*. Boston: Little, Brown and Company, 1987.

Stebbins, Theodore E., Jr., et al. *The Photography of Charles Sheeler: American Modernist*. Boston: Bulfinch Press, 2002.

CINDY SHERMAN
*Cindy Sherman: The Complete Untitled Film Stills*. New York: Museum of Modern Art, 2003.

Cruz, Amada, et al. *Cindy Sherman: Retrospective*. New York: Thames and Hudson, Inc. and the Museum of Contemporary Art, Chicago, and The Museum of Contemporary Art, Los Angeles, 1997.

Krauss, Rosalind, and Norman Bryson. *Cindy Sherman, 1975–1993*. New York: Rizzoli, 1993.

STEPHEN SHORE
Lange, Christy, Michael Fried, and Joel Sternfeld. *Stephen Shore*. New York: Phaidon, 2008.

CAMILLE SILVY
Haworth-Booth, Mark. *Camille Silvy: River Scene, France*. Malibu, CA: J. Paul Getty Museum, 1992.

AARON SISKIND
Chiarenza, Carl. *Aaron Siskind: Pleasures and Terrors*. Boston: Little, Brown and Company, 1982.

Siskind, Aaron. *Road Trip: Photographs 1980–1988*. San Francisco: Friends of Photography, 1989.

W. EUGENE SMITH
Hughes, Jim. *W. Eugene Smith: Shadow and Substance: The Life and Work of an American Photographer*. New York: McGraw-Hill, 1989.

Johnson, William S., ed. *W. Eugene Smith: Master of the Photographic Essay*. Millerton, NY: Aperture, 1981.

Smith, W. Eugene, and Aileen M. Smith. *Minamata*. New York: Holt, Rinehart and Winston, 1975.

*W. Eugene Smith: His Photographs and Notes*. New York: Aperture, 1993.

Willumson, Glenn G. *W. Eugene Smith and the Photographic Essay*. New York: Cambridge University Press, 1992.

ROBERT SMITHSON
Bargellesi-Severi, Guglielmo. *Robert Smithson: Slideworks*. Italy: Carlo Frua, 1997.

FREDERICK SOMMER
*The Art of Frederick Sommer: Photography, Drawing, Collage*. New Haven, CT: Yale University Press, 2005.

Weiss, John, ed. *Venus, Jupiter and Mars: The Photographs of Frederick Sommer*. Wilmington, DE: Delaware Art Museum, 1980.

SOUTHWORTH & HAWES
Romer, Grant B., and Brian Wallis, eds. *Young America: The Daguerreotypes of Southworth & Hawes*. New York: International Center of Photography; Rochester, NY: George Eastman House; Göttingen, Germany: Steidl, 2005.

Sobieszek, Robert, and Odette M. Appel. *The Spirit of Fact: The Daguerreotypes of Southworth and Hawes, 1843–1862*. Boston: David R. Godine, 1976.

MIKE & DOUG STARN
Starn, Mike, and Doug Starn. *Attracted to Light*. New York: PowerHouse Books, 2003.

EDWARD STEICHEN
Longwell, Dennis. *Steichen: The Master Prints, 1895–1914*. New York: Museum of Modern Art, 1978.

Steichen, Edward. *A Life In Photography*. New York: Bonanza Books, 1985.

RALPH STEINER
Steiner, Ralph. *A Point of View*. Middletown, CT: Wesleyan University Press, 1978.

JOEL STERNFELD
*American Prospects: Photographs by Joel Sternfeld*. Preface to the new edition and introduction by Andy Grundberg; afterword by Anne W. Tucker. New York: Distributed Art Publishers, 2004.

ALFRED STIEGLITZ
Doty, Robert M. *Photo-Secession: Stieglitz and the Fine Art Movement in Photography*. New York: Dover Publications, 1978.

Greenough, Sarah, and Juan Hamilton. *Alfred Stieglitz: Photographs & Writings*. 2nd edition. Washington, D.C.: National Gallery of Art, 1999.

Greenough, Sarah. *Alfred Stieglitz: The Key Set Volume One 1886-1922*. Washington, D.C.: National Gallery of Art, 2002.

Homer, William Innes. *Alfred Stieglitz and the Photo-Secession*. Boston: Little, Brown and Company, 1983.

Norman, Dorothy. *Alfred Stieglitz: An American Seer*. New York: Aperture, 1990.

Peterson, Christian A. *Alfred Stieglitz's "Camera Notes."* New York: W. W. Norton, 1993.

Waldo, Frank, et al. *America and Alfred Stieglitz: A Collective Portrait*. 1934. Revised edition. Millerton, NY: Aperture, 1979.

PAUL STRAND
Hambourg, Maria Morris. *Paul Strand, Circa 1916*. New York: Metropolitan Museum of Art, 1998.

*Paul Strand: Sixty Years of Photographs*. Profile by Calvin Tompkins. Millerton, NY: Aperture, 1976.

*Paul Strand: A Retrospective Monograph, the Years 1915–1968*. 2 vols. Millerton, NY: Aperture, 1971.

Stange, Maren, ed. *Paul Strand: Essays on His Life and Work*. New York: Aperture, 1990.

Strand, Paul, and Nancy Newhall. *Time in New England*. New York: Oxford University Press, 1950. Revised edition. Millerton, NY: Aperture, 1980.

HIROSHI SUGIMOTO
Bonami, Francesco, et al. *Sugimoto: Architecture*. Chicago: Museum of Contemporary Art, 2003.

T

WILLIAM HENRY FOX TALBOT
Arnold, H. J. P. *William Henry Fox Talbot: Pioneer of Photography and Man of Science*. London: Hutchinson Benham, 1977.

Buckland, Gail. *Fox Talbot and the Invention of Photography*. Boston: David R. Godine, 1980.

Schaaf, Larry J. *The Photographic Art of William Henry Fox Talbot*. Princeton: Princeton University Press, 2000.

Talbot, William Henry Fox. *The Pencil of Nature*. Facsimile edition. New York: Hans P. Kraus, 1989.

Weaver, Mike. *Henry Fox Talbot: Selected Texts and Bibliography*. World Photographers Reference Series, vol. 3. Boston: G. K. Hall, 1993.

JOHN THOMSON
Thomson, John, and Adolphe Smith. *Street Life in London*. Facsimile edition. New York: Bernard Blom, 1969.

White, Stephen. *John Thomson: Life and Photographs*. London: Thames and Hudson, 1985.

U

JERRY N. UELSMANN
*Jerry N. Uelsmann*. Essay by Peter Bunnell. New York: Aperture, 1970.

*Photo-Synthesis: Photographs by Jerry Uelsmann*. Gainesville: University of Florida Press, 1992.

Uelsmann, Jerry N. *Silver Meditations*. Dobbs Ferry, NY: Morgan and Morgan, 1977.

**V**

JAMES VANDERZEE
*James VanDerZee*. Dobbs Ferry, NY: Morgan and Morgan, 1973.

Willis-Braithwaite, Deborah. *VanDer-Zee: Photographer, 1886–1983*. New York: Harry N. Abrams, 1993.

ROMAN VISHNIAC
*To Give Them Light: The Legacy of Roman Vishniac*. New York: Simon and Schuster, 1993.

ADAM CLARK VROMAN
Webb, William, and Robert A. Weinstein. *Dwellers at the Source: Southwestern Indian Photographs of A. C. Vroman, 1895–1904*. Albuquerque: University of New Mexico Press, 1987.

**W**

KARA WALKER
*Kara Walker: My Complement, My Enemy, My Oppressor, My Love*. Minneapolis: Walker Art Center, 2007.

JEFF WALL
Galassi, Peter. *Jeff Wall*. New York: Museum of Modern Art, 2007.

CARLETON E. WATKINS
Carleton E. Watkins, *Photographs, 1861–1874*. San Francisco: Bedford Arts Publishers, 1989.

Nickel, Douglas R. *Carleton Watkins: The Art of Perception*. San Francisco: San Francisco Museum of Modern Art, 1999.

Palmquist, Peter E. *Carleton E. Watkins: Photographer of the American West*. Albuquerque: University of New Mexico Press, 1983.

Rule, Amy, ed. *Carleton Watkins: Selected Texts and Bibliography*. Boston: G.K. Hall, 1993.

WEEGEE (ARTHUR FELLIG)
Barth, Miles, et al. *Weegee's World*. Boston: Little, Brown and Company, 2000.

Stettner, Louis, ed. *Weegee*. New York: Alfred A. Knopf, 1977.

Weegee. *Naked City*. New York: Essential Books, 1946. Reprint. Cambridge: Da Capo, 2003.

*Weegee's New York: Photographs, 1935–1960*. Munich: Schirmer Art Books, 2000.

CARRIE MAE WEEMS
*Carrie Mae Weems: Recent Work, 1992–1998*. Essays by Thomas Piché Jr. and Thelma Golden. New York: George Braziller in association with Everson Museum of Art, 1998.

WILLIAM WEGMAN
*Man's Best Friend: Photographs and Drawings by William Wegman*. New York: Harry N. Abrams, 1999.

EDWARD WESTON
Conger, Amy. *Edward Weston: Photographs*. Tucson: Center for Creative Photography, University of Arizona, 1992.

Maddow, Ben. *Edward Weston: Fifty Years*. Millerton, NY: Aperture, 1973.

Newhall, Nancy, ed. *The Daybooks of Edward Weston: Volume 1, Mexico*. Millerton, NY: Aperture, 1973.

Newhall, Nancy, ed. *The Daybooks of Edward Weston: Volume 2, California*. Millerton, NY: Aperture, 1973.

Weston, Edward. *My Camera on Point Lobos*. Yosemite National Park, CA: Virginia Adams; Boston: Houghton Mifflin Co., 1950. Reprint. New York: Da Capo Press, 1968.

Wilson, Charis, and Edward Weston. *California and the West*. 1940. Reprint. Millerton, NY: Aperture, 1978.

CLARENCE H. WHITE
Homer, William Innes. *Symbolism of Light: The Photographs of Clarence H. White*. Wilmington, DE: Delaware Art Museum, 1977.

MINOR WHITE
Bunnell, Peter. *Minor White: The Eye That Shapes*. Princeton: Princeton University Art Museum, 1989.

GARRY WINOGRAND
Stack, Trudy Wilner. *Winogrand: 1964*. Santa Fe: Arena Editions, 2002.

Szarkowski, John. *Winogrand: Figments from the Real World*. New York: Museum of Modern Art, 2003.

JOEL-PETER WITKIN
Witkin, Joel-Peter. *Gods of Earth and Heaven*. 3rd edition. Santa Fe: Twelvetrees Press, 1994.

**A**

Auer, Michael. *The Illustrated History of the Camera, from 1839 to the Present.* Boston: New York Graphic Society, 1975.

**B**

Broecker, William L., ed. *Encyclopedia of Photography.* New York: Crown Publishers, Inc., 1984.

**C**

Crawford, William. *The Keepers of the Light: A History and Working Guide to Early Photographic Processes.* Dobbs Ferry, NY: Morgan and Morgan, 1979.

**G**

Golding, Stephen. *Photomontage: A Step-by-Step Guide to Building Pictures.* Rockport, MA: Rockport Publishers, 1997.

**H**

Haworth-Booth, Mark, and Brian Coe. *A Guide to Early Photographic Processes.* London: Victoria & Albert Museum, 1983.

Hirsch, Robert. *Exploring Color Photography: From the Darkroom to the Digital Studio.* 4th edition. New York: McGraw-Hill, 2005.

Hirsch, Robert. *Light and Lens: Photography in the Digital Age.* Boston: Focal Press, 2008.

Hirsch, Robert. *Photographic Possibilities: The Expressive Use of Equipment Ideas, Materials, and Processes.* 3rd edition. Boston: Focal Press, 2009.

**J**

Jussim, Estelle. *Visual Communication and the Graphic Arts: Photographic Technologies in the Nineteenth Century.* New York: R. R. Bowker Company, 1983.

**K**

Keefe, Laurence E., Jr., and Dennis Inch. *The Life of a Photograph.* 2nd edition. Boston: Focal Press, 1990.

**L**

*Life Library of Photography,* 17 vols. New York: Time-Life Books, 1970–1972.

London, Barbara, et al. *Photography,* 9th edition. Upper Saddle River, NJ: Prentice Hall, 2008.

Lothrop, Eaton S., Jr. *A Century of Cameras from the Collection of the International Museum at George Eastman House.* 2nd edition. Dobbs Ferry, NY: Morgan & Morgan, 1982.

**M**

Mees, C. E. Kenneth. *From Dry Plates to Ektachrome Film.* New York: Ziff-Davis, 1961.

**N**

Nadeau, Luis. *Encyclopedia of Printing, Photographic and Photomechanical Processes.* Revised combined edition, vols. 1 and 2—A–Z. Fredericton, New Brunswick, Canada: Atelier Luis Nadeau, 1997.

**S**

Shaw, Susan D., and Monona Rossol. *Overexposure: Health Hazards in Photography.* New York: Allworth Press, 1991.

Stroebel, Leslie, et al. *Basic Photographic Materials and Processes.* 2nd edition. Boston: Focal Press, 2000.

**W**

Wall, E. J. and Franklin I. Jordan. *Photographic Facts and Formulas.* Revised edition. Englewood Cliffs, NJ: Prentice Hall, 1975.

Wilhelm, Henry, with Carol Bower. *The Permanence and Care of Color Photographs.* Grinnell, IA: Preservations Publishing Co., 1993.

Wilson, Edward L. *Wilson's Photographics: A Series of Lessons . . . on all Processes which are Needful in the Art of Photography (1881).* Reprint. Rocky Mount, NC: Gardners Books, 2007

**A**

Aperture
20 East 23rd Street
New York, NY 10010
www.aperture.org

**C**

Center for Book Arts
28 West 27th Street
New York, NY 10001
www.centerforbookarts.org

**D**

D.A.P. Distributed Art Publishers, Inc
155 Sixth Avenue, 2nd Floor
New York, NY 10013
www.artbook.com

**L**

Light Work
316 Waverly Avenue
Syracuse, NY 13244
www.lightwork.org

**N**

Nexus Press
535 Means St.
Atlanta, GA 30318
www.thecontemporary.org

**P**

Photo-Eye Books
376 Garcia Street
Santa Fe, NM 87501
www.photoeye.com

Printed Matter
535 West 22nd Street
New York, NY 10011
www.printedmatter.org

Sources of Artists' Books

## History of Photography Websites

The American Museum of Photography
www.photographymuseum.com

Canadian Museum of Contemporary Photography
www.cmcp.gallery.ca

The Center for Creative Photography
www.creativephotography.org

The Daguerreian Society
www.daguerre.org

Early Visual Media
www.visual-media.be

George Eastman House
www.geh.org

Harry Ransom Center, University of Texas at Austin
(Helmut and Alison Gernsheim Collection)
www.hrc.utexas.edu/collections/photography

A History of Photography: From its Beginnings till the 1920s
http://rleggat.com/photohistory

International Center of Photography
www.icp.org

Library of Congress: Prints and Photographs Reading Room
www.loc.gov/rr/print

Luminous Lint
www.luminous-lint.com

Masters of Photography
www.masters-of-photography.com

National Media Museum
www.nationalmediamuseum.org.uk

New York Public Library, Photography Collection
www.nypl.org/research/chss/spe/art/photo/photo.html

Photography Now: The International Online Platform for Photography and Video Art
www.photography-now.com

Smithsonian American Art Museum Photography Collection
americanart.si.edu/Helios/features.html

Use your search engine to discover additional sites, including those devoted to specific photographers, processes, eras, events, places, and countries.

Credits

CHAPTER 1

1.1 Gernsheim Collection, Harry Ransom Humanities Research Center, The University of Texas at Austin

1.2, 1.3 Courtesy George Eastman House

1.4 Gernsheim Collection, Harry Ransom Humanities Research Center, The University of Texas at Austin

1.5 Bayerisches Nationalmuseum, Munich, Germany

1.6 Courtesy NMPFT/Science & Society Picture Library, London, England

1.7 Gernsheim Collection, Harry Ransom Humanities Research Center, The University of Texas at Austin

1.8 Société Française de Photographie, Paris

CHAPTER 2

Figure 2.1 Courtesy George Eastman House

2.2 Museum für Kunst und Gewerbe, Hamburg

2.3, 2.4, 2.5 Courtesy George Eastman House

2.6 Courtesy Division of Photographic History, National Museum of American History, Smithsonian Institution, photo no. 44-215.A. cat.# 4114.A

2.7 The J. Paul Getty Museum, Los Angeles. 84.XT.1565.22

2.8, 2.9 Courtesy George Eastman House

2.10 National Portrait Gallery, Smithsonian Institution/Art Resource, NY

2.11 The J. Paul Getty Museum, Los Angeles. 84.XT.172.6

2.12 National Portrait Gallery, Smithsonian Institution/Art Resource, NY

2.13 Courtesy George Eastman House, Gift of Mr. Donald We

2.14 Courtesy George Eastman House

2.15 Courtesy Harvard College Observatory

CHAPTER 3

3.1 Courtesy NMPFT/Science & Society Picture Library, London, England

3.2 Gernsheim Collection, Harry Ransom Humanities Research Center, The University of Texas at Austin

3.3 Courtesy George Eastman House, Gift of Alden Scott Boyer

3.4 Plate #95, Volume II of Photographic Views of the Progress of the Crystal Palace, Sydenham. Courtesy Collection of the Juliette K. and Leonard S. Rakow Research Library of the Corning Museum of Glass, Corning, NY

3.5, 3.6 Courtesy George Eastman House

3.7 photo © National Gallery of Canada. National Gallery of Canada, Ottawa, purchased 1968 (no. 32443)

3.8, 3.9, 3.10 Courtesy George Eastman House

CHAPTER 4

4.1 From Gaston Tissandier, A History and Handbook of Photography edited by John Thomson, 1878

4.2 Gernsheim Collection, Harry Ransom Humanities Research Center, The University of Texas at Austin

4.3, 4.4, 4.5 Courtesy George Eastman House

4.6 Courtesy Visual Studies Workshop, Rochester, NY. Gift of 3M Company, ex-collection Louis Walton Sipley

4.7, 4.8, 4.9, 4.10, 4.11, 4.12 Courtesy George Eastman House

CHAPTER 5

5.1, 5.2 Courtesy George Eastman House

5.3 Gernsheim Collection, Harry Ransom Humanities Research Center, The University of Texas at Austin

5.4, 5.5, 5.6, 5.7 Courtesy George Eastman House

5.8 The J. Paul Getty Museum, Los Angeles

5.9 The Metropolitan Museum of Art, Gilman Collection, Museum Purchase, 2005. (2005.100.99). Image © The Metropolitan Museum of Art

5.10 Courtesy George Eastman House

CHAPTER 6

6.1 Courtesy George Eastman House

6.2 Gernsheim Collection, Harry Ransom Humanities Research Center, The University of Texas at Austin

6.3 The Metropolitan Museum of Art, Gilman Collection, Purchase, Harriette and Noel Levine Gift, 2005. (2005.100.23) Image © The Metropolitan Museum of Art

6.4 Courtesy University of New Mexico Art Museum, Albuquerque 77.111

6.5 Gernsheim Collection, Harry Ransom Humanities Research Center, The University of Texas at Austin

6.6 Courtesy Royal Photographic Society, Bath, England

6.7 Courtesy George Eastman House

6.8, 6.9 Courtesy George Eastman House, Gift of Alden Scott Boyer

6.10 Courtesy George Eastman House

6.11 Courtesy Royal Photographic Society, Bath, England

6.12 © Topham Picturepoint/TopFoto. co.uk/The Image Works

CHAPTER 7

7.1 Courtesy George Eastman House

7.2 Courtesy George Eastman House, Museum Purchase: Charina Foundation Purchase Fund

7.3, 7.4, 7.5 Courtesy George Eastman House

7.6 Courtesy George Eastman House, Museum Purchase; ex-collection Wadsworth Library

7.7 Courtesy George Eastman House

7.8 Courtesy Collection of the Juliette K. and Leonard S. Rakow Research Library of the Corning Museum of Glass

7.9 Courtesy George Eastman House

7.10 The J. Paul Getty Museum, Los Angeles

7.11 Courtesy George Eastman House, Gift of Eastman Kodak Company: ex-collection Gabriel Cromer

7.12, 7.13, 7.14 Courtesy George Eastman House

7.15 Courtesy Missouri Historical Society, St. Louis

7.16, 7.17, 7.18, 7.19, 7.20 Courtesy George Eastman House

CHAPTER 8

8.1 Courtesy George Eastman House

8.2 Courtesy Philadelphia Museum of Art: Gift of Charles Bregler

8.3, 8.4 Courtesy George Eastman House

8.5 © Rheinisches Bildarchiv. Museum Ludwig/Agfa Foto-Historama Koln

8.6 Courtesy George Eastman House, Gift of Mrs. Raymond Albright

8.7 The Museum Association of Emile Zola, Medan, France

8.8 Courtesy George Eastman House

8.9 © Bettmann/Corbis

8.10 Courtesy Division of Photographic History, National Museum of American History, Smithsonian Institution

8.11 Image courtesy of Collection of Mark Jacobs.

CHAPTER 9

9.1 Courtesy George Eastman House

9.2 Courtesy George Eastman House, Gift of Alvin Langdon Coburn

9.3 Courtesy George Eastman House

9.4 Courtesy George Eastman House. Copyright: Galerie Johannes Faber, Vienna

9.5 Courtesy George Eastman House

9.6 © Pierre Dubreuil. © Photo CNAC/MNAM, Dist. RMN/Philippe Migeat. © 2009 Artists Rights Society (ARS), New York/ADAGP, Paris

9.7, 9.8, 9.9 Courtesy George Eastman House; 9.10 Courtesy George Eastman House. © Anne Brigman

9.11, 9.12 Courtesy George Eastman House

9.13 Print courtesy George Eastman House. Reprinted with permission of Joanna T. Steichen, Carousel Research

9.14, 9.15, 9.16 Courtesy George Eastman House

CHAPTER 10

10.1 Courtesy Musée Picasso, Archives

10.2 Courtesy George Eastman House

10.3 According to a letter written by Lillian Gilbreth to Beamont Newhall on July 9, 1957, these chronocyclegraphs were taken for the Eastman Kodak Company. Courtesy George Eastman House

10.4 According to a letter written by Lillian Gilbreth to Beamont Newhall on July 9, 1957, these chronocyclegraphs were taken for the Eastman Kodak Company. Courtesy George Eastman House

10.5, 10.6 Courtesy George Eastman House

10.7 Copyright © Aperture Foundation, Inc., Paul Strand Archive

10.8 The J. Paul Getty Museum, Los Angeles. © 2009 May Ray Trust/ Artists Rights Society (ARS), New York/ ADAGP, Paris

10.9 Victoria & Albert Museum, London/Art Resource, NY. © 2009 Artists Rights Society (ARS), New York/VG Bild-Kunst, Bonn

10.10 © 2009 Artist Rights Society (ARS), New York,/ADAGP, Paris

10.11 Digital Image © The Museum of Modern Art/Licensed by SCALA/ Art Resource, NY. © 2009 Hannah

Höch/Artists Rights Society (ARS), New York/VG Bild-Kunst, Bonn

10.12 Courtesy Howard Schickler Fine Art LLC. Art © Estate of Aleksandr Rodchenko /RAO, Moscow/VAGA, NY

10.13 © The Lane Collection. Photograph courtesy Museum of Fine Arts, Boston. © 2009. All rights reserved;

10.14 Copyright © Aperture Foundation, Inc., Paul Strand Archive. Print courtesy George Eastman House

CHAPTER 11

11.1 San Francisco Museum of Modern Art. Purchase. © Paul Outerbridge, courtesy Fraenkel Gallery, San Francisco

11.2 © Margaret Bourke-White Estate

11.3 Courtesy George Eastman House

11.4 Courtesy George Eastman House, Part purchase and part gift of An American Place, ex-collection Georgia O'Keeffe

11.5 Reprinted with permission of Joanna T. Steichen, Carousel Research

11.6 Collection Center for Creative Photography (c) 1981 Arizona Board of Regents

11.7 Collection Center for Creative Photography (c) 1981 Arizona Board of Regents

11.8 © Ansel Adams Publishing Rights Trust/Corbis

11.9 Courtesy Imogen Cunningham. © The Imogen Cunningham Trust

11.10 Courtesy George Eastman House. © William Mortensen, Deborah Irmas

11.11 © 2009 Albert Renger-Patzsch Archiv/Ann u. Jürgen Wilde, Zülpich/ Artists Rights Society (ARS), New York

11.12 Courtesy Center for Creative Photography

11.13 Courtesy George Eastman House

11.14 © 2009 Artists Rights Society (ARS), New York/VG Bild-Kunst, Bonn

11.15 © Galleria Martini & Ronchetti, Genoa, Italy. © 2009 Artists Rights Society (ARS), New York/VG Blld-Kunst, Bonn

11.16 Courtesy Galleria Martini & Ronchetti, Genoa, Italy

11.17 © Gyorgy Kepes Estate. Print courtesy George Eastman House

11.18 Courtesy Barbara Morgan Estate

11.19 © Ervina Bokôvá-Drtikolová. Courtesy Robert Koch Gallery, San Francisco

11.20 Courtesy George Eastman House

11.21 © 2009 Artists Rights Society (ARS), New York, ADAGP, Paris

11.22 San Francisco Museum of Modern Art, Purchase. © 2009 Artists Rights Society (ARS), New York, ADAGP, Paris

11.23 Courtesy Philadelphia Museum of Art: The Louise and Walter Arensberg Archives. © 2009 May Ray Trust/Artist Rights Society (ARS), New York/ ADAGP, Paris

CHAPTER 12

12.1 Courtesy Jacob A. Riis Collection, © Museum of the City of New York

12.2 Courtesy Library of Congress, Prints and Photographs Division

12.3, 12.4, 12.5, 12.6 Courtesy George Eastman House

12.7 The Museum of Modern Art, New York, Gift of Lincoln Kirstein. (859.1965.43). Digital Image © The Museum of Modern Art/Licensed by SCALA/Art Resource, NY

12.8 Image E. J. Bellocq © Lee Friedlander, courtesy Fraenkel Gallery, San Francisco

12.9 Courtesy George Eastman House

12.10 Courtesy Stanford University. Horace Poolaw Photography Project. Courtesy Charles Junkerman

12.11 © Donna VanDerZee, New York

12.12 Reprinted by the permission of Russell & Volkening as agents for the author. Copyright © Eudora Welty L.I.C; Eudora Welty Collection, Mississippi Department of Archives and History

12.14 Die Photographische Sammlung/ SK Stiftung Kultur. © 2009 Die Photographische Sammlung/SK-Siftung Kultur-August Sander Archiv, Cologne/ ARS, NY

12.15 Library of Congress Prints and Photographs Division. LC-USF346-009058-C b&w film transparency

12.16, 12.17 Print courtesy George Eastman House. © The Walker Evans Archive, The Metropolitan Museum of Art

12.18 Courtesy George Eastman House

12.19 © Gordon Parks

12.20 Library of Congress

12.21 © Museum of the City of New York, Federal Arts Project, "Changing New York." © Berenice Abbott/Commerce Graphics, NYC

12.22 The Ben Schultz Memorial Collection. Gift of the photographer. Digital Image © The Museum of Modern Art/Licensed by SCALA/Art Resource, NY. © Mara Vishniac Kohn, courtesy the International Center of Photography

12.23 Courtesy Bolton Metro Museums and Art Gallery, Bolton, England

12.24 © Miriam Grossman Cohen. Courtesy Howard Greenberg Gallery, NYC

CHAPTER 13

13.1 Photograph by Jacques-Henri Lartigue. © Ministére de la Culture-France/Association des Amis de J.H. Lartigue, Paris

13.2 Berlinische Galerie, Berlin, Germany © Bildarchiv Preussischer Kulturbesitz/Art Resource, NY

13.3 The J. Paul Getty Museum, Los Angeles. 84.XM.193.29. © Estate of André Kertész. © RMN

13.4 Digital Image © The Museum of Modern Art/Licensed by SCALA/Art Resource, NY. © Estate Brassaï-RMN

13.5 © Henri Cartier-Bresson/Magnum Photos, Inc

13.6, 13.7 Bill Brandt © Bill Brandt Archive

13.8 International Center of Photography, Gift of Dr. Marvin Rappaport, 1979 Acc. #: 1.1979.c. © Colette Urbajtel

13.9 photo © National Gallery of Canada. National Gallery of Canada, Ottawa. Gift of the Estate of Lisette Model, 1990, by direction of Joseph G. Blum, New York, through the American Friends of Canada. (no. 35196) © Estate Lisette Model. Courtesy baudoin lebon, Paris/keitelman gallery, Brussels

13.10 © Helen Levitt, Courtesy Laurence Miller Gallery, New York

13.11 Collection Center for Creative Photography, University of Arizona © 2003 Arizona Board of Regents

13.12 © Harold & Esther Edgerton Foundation, 2009. Courtesy Palm Press, Inc.

CHAPTER 14

14.1 Courtesy George Eastman House. © 2009 Artists Rights Society (ARS),

New York/VG Blld-Kunst, Bonn, Germany

14.2 Photo by Alfred Eisenstaedt/Time & Life Pictures/Getty Images

14.3 Reprinted with permission of Joanna T. Steichen, Carousel Research

14.4 Courtesy Visual Studies Workshop, Rochester, NY. Gift of 3M Company, ex-collection Louis Walton Sipley

14.5 Photo by Nickolas Muray, © Nickolas Muray Photo Archives. Print courtesy George Eastman House

14.6 © Horst P. Horst. Courtesy Art + Commerce. Image © Horst P. Horst/Art + Commerce

14.7 © Joan Munkacsi. Courtesy Howard Greenberg Gallery, NYC

14.8 Photo by Philippe Halsman. © Philippe Halsman

14.9 © Photo by Arnold Newman/Getty Images

14.10 International Center of Photography, New York

14.11 © Robert Capa/Magnum Photos, Inc

14.12 © David Seymour/Magnum Photos, Inc

14.13 © Lee Miller Archives, England 2009. All rights reserved. www.leemiller.co.uk

14.14 Courtesy George Eastman House. © Heirs of W. Eugene Smith

14.15 © Don McCullin/Contact Press Images

14.16 © Larry Burrows/Time & Life Pictures/Getty Images. Courtesy Laurence Miller Gallery, New York

14.17 © AP Photo /Eddie Adams

14.18 © Martin Parr/ Magnum Photos, Inc

14.19 © Susan Meisela/Magnum Photos, Inc

14.20 Courtesy George Eastman House, Gift of the photographer. © Mary Ellen Mark

14.21 © Sebastiao Salgado/Contact Press Images

14.22 © James Nachtwey. Courtesy VII Photo Agency

14.23 © AP Photo/Richard Drew

14.24 © AP Photo/File

CHAPTER 15

15.1 © Ansel Adams Publishing Rights Trust/Corbis

15.2 The Historic New Orleans Collection accession no. 1981.247.1.796

15.3 Courtesy Frederick & Frances Sommer Foundation

15.4 Courtesy Los Angeles County Museum of Art, Ralph M. Parsons Fund. (M.87.81.2). © Estate of Val Telberg, Courtesy Laurence Miller Gallery, New York

15.5 Reproduced with permission of the Minor White Archive, Princeton University Art Museum. Copyright © Trustees of Princeton University. MWA 49-78.1

15.6 © The Estate of Harry Callahan. Courtesy Pace/MacGill Gallery, New York. Image courtesy Center for Creative Photography

15.7 © Aaron Siskind Foundation, Courtesy Silverstein Photography. Image courtesy Center for Creative Photography

15.8 © 1951/2009 Bullock Family Photography LLC. All rights reserved

15.9 Copyright Robert Frank. Print Courtesy of National Gallery of Art, Washington. Robert Frank Collection, Gift of the Evelyn and Walter Haas, Jr., Fund. 1993.27.2

15.10 © William Klein. Courtesy Howard Greenberg Gallery, NYC

15.11 Courtesy George Eastman House. © Mario Giacomelli

15.12 Courtesy Smith Family Trust

15.13 © Kunsthalle, Tübingen, Germany. © 2009 Artists Rights Society (ARS), New York/DACS, London

15.14 Courtesy Wallace Berman Estate and Michael Kohn Gallery

15.15 © 1990 Amon Carter Museum, Fort Worth, Texas, Gift of the artist, P1989.19.104

CHAPTER 16

16.1 Wadsworth Atheneum Museum of Art, Hartford, CT. Gift of Susan Morse Hilles. Art © Robert Rauschenberg Estate/Licensed by VAGA, NY

16.2 © Private Collection/ Alinari/ The Bridgeman Art Library. © 2009 Andy Warhol Foundaton for the Visual Arts/ARS, NY

16.3 © Syl Labrot Estate. Courtesy Visual Studies Workshop, Rochester, NY

16.4 © The Estate of Garry Winograd, courtesy Fraenkel Gallery, San Francisco

16.5 © Lee Friedlander, courtesy Fraenkel Gallery, San Francisco

16.6 © Bruce Davidson/Magnum Photos, Inc

16.7 Print courtesy George Eastman House. © Danny Lyon/Magnum Photos, Inc

16.8 © Duane Michals. Courtesy Pace/MacGill Gallery, New York

16.9 © Ray K. Metzker, Courtesy Laurence Miller Gallery, New York

16.10 © Jerry Uelsmann

16.11 Print courtesy George Eastman House. © Estate of Robert Heinecken. Courtesy Pace/MacGill Gallery, New York

16.12 © Chuck Close. Courtesy Pace/MacGill Gallery, New York

CHAPTER 17

17.1 © Robert Fichter. Image courtesy of Jerry Uelsmann Collection

17.2 © Naomi Savage Estate. Courtesy Francis M. Naumann Fine Art, New York

17.3 Washington Art Consortium: Henry Art Gallery, University of Washington, Seattle; Museum of Art, Washington State University, Pullman; Northwest Museum of Arts and Culture, Spokane; Seattle Art Museum; Tacoma Art Museum; Western Gallery, Western Washington University, Bellingham; Whatcom Museum of History and Art, Bellingham. American Photographs: 1970-1980; gift of the Virginia Wright. © Thomas F. Barrow, 1979. Courtesy Laurence Miller Gallery, New York

17.4 © William Larson. Courtesy George Eastman House

17.5 The Art Institute of Chicago, Gift of Jeanne and Richard S. Press, 1998.593. Photography © The Art Institute of Chicago. © Kenneth Josephson

17.6 © Robbert Flick. Courtesy Robert Mann Gallery, NY

17.7 © Barbara Crane

17.8 © The Estate of Ralph Eugene Meatyard, courtesy Fraenkel Gallery, San Francisco

17.9 © 1970 Les Krims

17.10 © Lucas Samaras. Courtesy Pace/MacGill Gallery, New York

17.11 © Ralph Gibson

17.12 Courtesy of the artist and Luhring Augustine, New York

17.13 © Emmet and Edith Gowin. Courtesy Pace/MacGill Gallery, New York

17.14 © Bill Owens, Courtesy Robert Koch Gallery, San Francisco

17.15 Courtesy George Eastman House. © Lewis Baltz

17.16 © Robert Adams. Courtesy Fraenkel Gallery, San Francisco and Matthew Marks Gallery, New York

17.17 U.S. Geological Survey. Print courtesy Mark Klett. Gernsheim Collection, Harry Ransom Humanities Research Center, The University of Texas at Austin

17.18 © 1979 Mark Klett and Gordon Bushaw for the Rephotographic Survey Project. Gernsheim Collection, Harry Ransom Humanities Research Center, The University of Texas at Austin

17.19 Courtesy the Rogovin Collection

17.20 © 2009 Eggleston Artistic Trust. Courtesy Cheim & Reid Gallery, New York

17.21 Courtesy 303 Gallery 303, New York

17.22 © Joel Meyerowitz

17.23 © John Pfahl. Courtesy Janet Borden, Inc

17.24 Courtesy the artist and Luhring Augustine, New York

17.25 © Ruth Thorne-Thomsen. Courtesy Laurence Miller Gallery, New York

17.26 Courtesy David Levinthal

CHAPTER 18

18.1 © Estate Nam June Paik. Photo by Peter Moore © Estate of Peter Moore/VAGA, New York, NY

18.2 © John Baldessari. Courtesy CEPA Gallery, Buffalo, NY

18.3 © 2009 Bruce Nauman/Artist Rights Society (ARS), New York. Photo courtesy Sperone Westwater, New York

18.4 San Francisco Museum of Modern Art, Gift of Van Deren Coke. © Arnulf Rainer

18.5 © Anselm Kiefer

18.6 The Czech Museum of Fine Arts, Prague. Czech Republic. Marian Goodman Gallery. © Gerhard Richter

18.7 Courtesy Marian Goodman Gallery. © 2009 Artists Rights Society (ARS), New York/ADAGP, Paris

18.8 Courtesy Sonnabend Gallery, New York

18.9 © 1981 William Wegman

18.10 Courtesy Sonnabend Gallery

18.11 Art © Robert Cumming/Licensed by VAGA, New York, NY

18.12 Courtesy Regen Projects, Los Angeles, CA

18.13 The Broad Art Foundation, Santa Monica. © Barbara Kruger. Courtesy Mary Boone Gallery, New York

18.14 Courtesy Judith Golden

18.15 Courtesy of the Artist and Metro Pictures

18.16 © Laurie Simmons. Courtesty Sperone Westwater Gallery, NY

18.17 © Carl Chiarenza. Courtesy of the artist

18.18 © James Casebere. Courtesy the Artist and Sean Kelly Gallery, NY

18.19 © 1981 Sandy Skoglund

18.20 © Joel Peter Witkin, Courtesy Hasted-Hunt Gallery

18.21 © Mike Mandel

18.22 Patrick Nagatani and Andrée Tracey

18.23 © Jeff Wall

18.24 © Marion Faller

18.25 © David Hockney. Collection The J. Paul Getty Museum, Los Angeles

18.26 © Michael Spano

18.27 © Holly Roberts

18.28 © 2009 Mike and Doug Starn/Artists Rights Society (ARS), New York

18.29 © Abelardo Morell, courtesy Bonni Benrubi Gallery, New York, NY

18.30 © Andres Serrano. Courtesy Yvon Lambert New York, Paris

18.31 © Copyright The Robert Mapplethorpe Foundation. Courtesy Art + Commerce

18.32 © John Coplans. Courtesy Howard Yezerski Gallery

18.33 © Nan Goldin

18.34 Courtesy of the artist's estate and P.P.O.W. Gallery, New York

**Note:** Page numbers in *italics* refer to photographs. Page numbers followed by "n" refer to notes.

## About the Author

**Robert Hirsch** is photographer, curator, educator, historian, and writer. His other books include *Light and Lens: Photography in the Digital Age; Photographic Possibilities: The Expressive Use of Equipment, Ideas, Materials and Processes*; and *Exploring Color Photography: From the Darkroom to the Digital Studio*. Hirsch has published scores of articles and interviewed eminent photographers of our time. He has had many one-person shows and curated numerous exhibitions. The former executive director of CEPA Gallery, he is now the director of Light Research in Buffalo, New York. For details about his written and visual projects visit: www.lightresearch.net